By Sidney Alexander

MICHELANGELO
THE
FLORENTINE

❧

A NOVEL BY

SIDNEY ALEXANDER

OHIO UNIVERSITY PRESS
Athens Ohio • Chicago • London

First and Second Printing: Random House, New York, 1957
© Copyright 1957, by Sidney Alexander

Third Printing: Mario Casalini Ltd., Montreal, 1965
© Copyright 1965, by Sidney Alexander & Mario Casalini Ltd.

Fourth Printing: Ohio University Press, 1985
© Copyright 1985, by Sidney Alexander

Library of Congress Cataloging in Publication Data

Alexander, Sidney, 1912–
 Michelangelo the Florentine.

 Reprint. Originally published: Montreal: M. Casalini,
1965.
 1. Michelangelo Buonarroti, 1475–1564—Fiction.
I. Title.
PS3501.L4424M5 1985 813'.52 85-265
ISBN 0-8214-0236-6 (pbk.)

for Frances

Vorrei voler, Signor, quel ch'io
non voglio. . . .
I would want to want, O Lord, what
I do not want. . . .

Davide colla fromba e io coll'arco.
David with the sling and I with the bow.

BOOK ONE

CITY OF THE
BLUE BULL

ROMA

1496

I

Topping the hill, the young man reined his horse with a cry of delight. All Rome had suddenly opened up before him, bright-tinted as a fan: pink domes, golden towers, notched crenelations of palaces all enclosed within a circuit of walls and sharply outlined against a sky cobalt as that popular cheap pottery of Maestro Luca della Robbia. The sky was brilliant, almost inky blue. It was not the sky of his native Fiorenza. He had observed the full transformation on the fourth afternoon of his journey southward: day by day the pearly Tuscan heaven had deepened, thickened, become, as it were, more substantial until dismounting at the inn at Orte on the banks of the Tevere, Michelangiolo had seen overhead, for the first time in its full splendor, that clear cerulean dome.

He clucked at the horse and started down the hill. It was steep but he was twenty-one and the giddy descent pleased him. His short sturdy body sat the horse with centaurian closeness. Pebbles skittered down the path ahead of him, a musical pattering. He began to sing:

> *Chi vuol esser lieto, sia:*
> *Di doman non c'è certezza . . .*

> *Who would joyous be, should be—*
> *Tomorrow's but uncertainty . . .*

The lyrics were the Magnificent's, the music a laud; but Michel found nothing incongruous in such a marriage of the sacred and the secular. Weren't some of Giovansimone's funniest and lewdest verses sung to church chants? But now he stopped singing: under this cloudless sky a cloud crossed his mind. The Friar would not approve. He shuddered, thinking of the Friar. That strange strained voice echoing in the hollow Duomo. And the cloud had descended, exactly as Fra Girolamo Savonarola had predicted: the Magnificent suddenly mysteriously dead and the French irrupting with their new-fangled horse-drawn artillery and their arquebusiers and their six-toed hunchbacked

Charles from beyond the Alps. Ahi, but the times had changed since Lorenzo's death four years ago! Now under Fra Girolamo no one sang such songs. And the masqued carnivals, the allegorical carriages, the verses for escaped nuns, the mirror-makers, wiseacres, the drunken Silenuses on their asses, and the hot Nymphs and the soft-bellied Bacchi—where were they?

Michel shuddered. Under this warm pagan sky, skeletal fingers touched his spine. He drew his rough woolen cape closer. No, he thought, surely the Friar cannot condemn me to eternal damnation for the sins of my youth. I was only sixteen when I danced the cariola in the Via Larga with Francesco Granacci and Iacopo l'Indaco. Sixteen! Remember that, Fra Girolamo. And remember, too, before you set your hordes of little white angels upon me, remember that my brother Lionardo is a Dominican monk like yourself and the holiness in his blood must also course in my blood, for we are brothers. Remember that, O hook-nosed thunderer!

He had reached the bottom of the hill and now the horse was trotting between silver clouds of olive orchards toward the Porta del Popolo. The city gate was a coming and going of farmers, white wooden-yoked oxen, screaming pedlars, a rich succulent smell of mule dung and greens coming in from the country. Among the motley, Michel also saw many pilgrims whose ashen cloaks and dusty sandals revealed how many miles they had traveled to this holy city seeking indulgence from the Borgia.

The gate was guarded by Papal troops. Bright as parrots under gleaming beaked helmets they stood with crossed halberds, halting every traveler. Michelangiolo was accustomed to this ritual: he had passed, between his country and Rome, at least a dozen such city gates.

"Your business?" the soldier began.

"I bear a letter to the Cardinal di San Giorgio."

The soldier turned to his companion. "Another Toscano," he said with a scornful grin. "D' you hear the ridiculous accent?"

"It was Dante's accent—"

"Never mind, never mind," the soldier said. His voice was gruff but his eyes, black and slanting as olive-pits below the flung-back visor, were laughing. "Do you Florentines always have to have the last word? Yesterday it was some courier for a dyer. You know the Strozzi firm?"

"I know," Michel said simply, thinking of Narro there, his brother's round ruddy face among the bales of wool.

"Well, this chap worked for the Strozzi. And every question I put

to him, he's back with another question. What is it?—the wine you Tuscans drink?"

"We're no fools," Michel said. His gray gold-flecked eyes looked arrogantly at the soldier. "Well, may I pass?" And without waiting for an answer, he spurred his horse. But a mailed glove seized the bridle.

"Ho! Just a minute, Messere. I'll tell you when . . ."

He eyed him provocatively. "You're not by chance a follower of the Friar?"

"What friar?"

"What friar?! Listen to the fellow! What friar! There's only one! That mad dog of a Dominican who's barking at His Holiness."

"I don't meddle in those affairs. I'm here on business."

"Always business," the other soldier said rather ill-humoredly. "You'd think they'd be satisfied with their own country."

"Not the Tuscans. Who would they have to outwit if they remained at home? They're sly ones . . ." He reached forth his free hand without letting go of the bridle. "All right, let's see the letter."

"It's sealed," Michelangiolo said. He held up the missive, red seal forward in front of the soldier's eyes. "You see—it's addressed directly to the Cardinal."

"Hm," the soldier squinted; he was examining the letter with that excessive solemnity with which the illiterate look upon the magic of writing. Michel smiled. So it had been at Siena, at Orvieto, at Viterbo. Always these farmers' sons behind the breastplates. But they were really, for all their cuirassed cockiness, simple good-natured souls. They reminded Michel of the Settignano stonecutters. He never failed to get along with them.

"All right," the soldier said at last. "Everything is in order." He had scrutinized the salutation long enough to have read a papal bull. "I suppose you're another of these wool agents. Well, be sure and give honest measure, now. None of your sly Florentine tricks. You've got a broken nose, I see. Well, give honest measure or it'll happen again. Honest measure, you hear, honest measure!"

He was already under the banded shadow of the arch when the soldier's last words reached him. Michel's face flushed. That damned nose, could he ever forget it? And again, it seemed, Torrigiani's fist was crashing against the cartilage, crumpling it like an eggshell. And again through his brain lanced that purple screaming streak, as if lightning had struck the chapel, obliterating in one flash Peter fishing and the Tribute Money and the shivering youth awaiting baptism. It had struck just when he was catching onto Masaccio's marvelous way

of getting the youth's thigh to stand out so round and lifelike from the wall. That beast Torrigiani! He would never learn to paint. And just because he, Michelangiolo, had told him so, the brute had no reply but to let fly with his fists. The other boys must have carried him home. But he didn't remember that, for when he came to, Lodovico was pressing a sponge dipped in extract of rosemary against his nosebleed, and bound a jasper around his neck, and then he chased the boys out, cursing them all as a lot of useless daubers. He had no use for artists, Lodovico hadn't; he would have preferred his second son to have been bound for the law. All artists in his opinion (slapping his hands together behind his long red cloak as he always did on the brink of a banality)—all artists were either ruffians like this Pietro Torrigiani or effeminate idlers like Francesco Granacci who spent altogether too much time with his son, displaying his parts in those vari-colored hose and flaunting, like a hermaphrodite, his outsized codpiece and golden girlish hair rippling to narrow shoulders. Why his son had insisted on such a craft, he would never understand. By Bacchus! Fiorenza had more of these knockabout painters and sculptors than she knew what to do with. Wasn't she exporting them all over Italy? Good riddance, too. And here was his son with a bleeding broken nose . . .

Tenderly, Michel touched the bridge. Misshapen as a root. And the rest of his face didn't help much either: the small horn-colored eyes, the ridged forehead, the stubborn pouting lower lip. Why couldn't he have been blessed with a face like Andrea's or a figure like Francesco's? He scratched his chin on which a scraggly beard was just beginning to grow like gorse-stubble on a rock. Perhaps that will help, he thought, at least it will cover some of my ugly map.

Piqued, he turned in his saddle and shook his fist at the soldier:

"If it's good measure you want, I'll measure your length out on the ground! I'm no grubbing merchant!" But no sooner had he said it when a wave of fear gripped him; his tongue was always braver than his arms, what if the soldier accepted the challenge?

But the soldier only laughed. "Go on, boy," he said. "There's still mother's milk on your mouth."

Now he could put on the face of fierceness again. He spurred his way through the gate. The road to the Cardinal's palace led through the heart of Rome. What a noisy dirty roistering city! Michelangiolo thought. The streets of his Fiorenza were paved and everywhere there were evidences of orderliness and wealth. But here his horse was picking its way through refuse and crowds. The streets were still muddy from the recent rains, and waves of people splashed along

with squishy good humor. Somehow it seemed like a country town despite all the noise and confusion. These faces were country faces, and every few blocks the city would simply disappear and the country sneak in, meadows rolling right into the piazzas, cattle grazing on the steps of churches. And then he would be lost in another warren of narrow stony streets, a labyrinth, a hive buzzing with mendicant Franciscans in brown roped robes, grand polychromed lords mailed and feathered as fighting cocks, the crack of whips and the creak of wooden mule carts, a spill of garbage from balconies, curly-headed Moors bearing mysterious curtained litters. Michel stood aside to let one of these pass. The forward bearer had a monkey on his shoulder, and as the litter passed, the curtains wafted open, exhaling a gamy fragrance of musk, and a courtesan in a low-cut orange damask gown was smiling at him—an outsized marionette. Companies of bravos with pikes and halberds trooped by, shoving everyone off the small dry island of rocks at the street-corners.

Every few blocks he had to inquire his way again. The city was an endless froth: here streets were being widened, here old buildings were being torn down and new ones erected. The palaces all looked like fortresses, grim and implacable from without; but now and then, through an open portal, he would catch a glimpse of a gracious inner court where fountains played and statues stood nakedly and whitely in the sun. Around many of the palaces were clusters of small houses, and in and out of them a maze of alleys which could be chained off at night. These were cities within the City—private strongholds of the great Roman lords: the Orsini, the Colonna, whose internecine warfare was only now held in abeyance by the greater violence of the Pope's son.

Now he had reached the Tiber, a sleepy snake, slow-coiling; and there, ominous against the sky—the blue bulls of the Borgias fluttering —loomed the Castel Sant' Angelo, once the emperor Hadrian's tomb. It was Michel's first sight of one of the great buildings of antiquity and he stared up at it with awe. It was more enormous than he had dreamed: like a round mountain it rose from the river-bank, round as a Siena tart, and crowning its pagan heights the trumpeting Archangel Michael, golden in the sun.

Yes, he thought, to stand upon the heights they had raised. To pose the shapes of his fantasy upon their battlements.

He smiled. Ah, but that was an ambition he would never have dared reveal to Maestro Poliziano when on occasion that worthy strolled into the Medici garden at San Marco. He would come in

with his pupil, Piero, the Magnificent's eldest, a haughty jut-jawed youth, and sometimes with one of the younger sweeter sons, Giovanni or Giuliano, and together the trio would wander amongst the boxed bushes examining the ancient stones and the modern copies the boys in Bertoldo's sculpture school were making. Michel was one of these boys, one of a number, and it was not very likely that he would have much chance to reveal his ambition to Poliziano. Besides, you could never reveal anything to that man; you merely listened. Nor were you likely to understand much of what the balding bulging-eyed tutor was prattling about anyway; he spoke as much Latin as Tuscan.

So, he would pass, leaving a wake of the ancient world behind him, a ripple of Greek epigram, of Latin quotation that seemed to be incised in the air, and Michel would mutter to Francesco Granacci, chipping away beside him: "If only he would say a thing simply! But always with that hand on hip and the sway of a tongue no living man can understand, except a priest, and I doubt they would approve of what he says." And Granacci with a snicker: " 'Tis said Donna Clarissa feared lest Messer Angiolo impart more than classic wisdom to her sons. He has read too much Greek . . ."

They laughed. On every side you could hear the other boys chipping and polishing and brazing away from the headless Latin goddesses and broken-penised gods which the Magnificent's agents were buying up for him all over the peninsula.

So now, looking up at the castle, Michel thought of that Medici garden, of the happy days spent there amidst sculptured bushes and sculptured busts. Those were the first bits of antiquity he had ever seen, and now here—huge, full-blown—before his eyes was the very kind of monument those statues had adorned. He fancied he heard Maestro Poliziano lecturing in his ear. How that man could talk, the floodtides of his erudition! How pleased he had been when Michel, at his suggestion, carved a Battle of the Centaurs, so pleased that he had failed to see how much of Michel there was in the work, and how little of antiquity.

But all those learned men, weren't they all the same?—Poliziano, Ficino, and that Phoenix who spoke as many tongues as the tower of Babel, the Count of Mirandola—they all agreed: no man could hope to better the ancients. To stand upon *their* shoulders! to reach higher than *they!* What nonsense! It was all a modern man could dream merely to be permitted entrance into that Age of Gold.

There was a clatter of hooves, a swirling of banners. A troop of armed knights were galloping along the river road. Over their breast-

plates hung an embroidered trellis of red tassels and on the trappings of their horses an emblem of gilded oak-leaves. Furiously the armed troop rode, pedestrians scurried from their path, an oxcart loaded with faggots creaked hysterically on its great wooden wheels as the farmer swung it to safety just in time.

"Damn those Cardinals!" the farmer shouted. His face was red, he snapped his whip after the flying troop. "May the Madonna strike them with the plague! May they blister in hell!" He spat, and then, incongruously, he was crossing himself. A funeral procession was passing, the black-hooded riders ghostly after the black cortege. Acrid smoke of their long candles hung in the air.

"Pray, what Cardinal was that?" Michel asked the farmer.

"Eh . . . ?" He was leaning forward, palm to ear.

"Those knights who almost ground you to a powder . . ."

"Ahi! May they sizzle in the seventh circle! A pox!—"

"Of what Cardinal are they the retinue?"

"Of the della Rovere. He that's staying at the French King's court, out of reach of the Borgia's horns. Didn't you mark the gilded leaf?" The farmer peered at him a moment. His fury had evaporated as swiftly as it boiled over; now his eyes were twinkling minnows in a laughter-net. ". . . You're not from Rome?"

"Fiorenza."

"Ah . . ." He leaned closer, his ruddy face radiating the stores of sunshine it had absorbed. "Say, is it true your Friar is still preaching?"

"Yes."

"Despite the Holy Father's interdict?"

"It was true when I departed."

"Then God have pity on him for the Holy Father won't. Why did he not accept the Cardinal's hat?"

"He says he prefers the red crown of martyrdom."

"And he'll get it too." The farmer shook his head. "It's a dangerous game, young man, baiting the Borgia bull."

"There are many," Michel said hesitatingly, "who consider him a prophet."

"What? Preaching the Pope is anti-Christ? And that vision he claims to have seen: the black cross over Rome reaching to heaven and on it inscribed *Crux Irae Dei*. You know, Messere, I've seen a drawing of that vision with my own eyes," the farmer said proudly. "They're selling copies all over the Urbs. And others too, terrible sights I tell you: tempests and plagues and fiery sleet and arrows and people groaning and dying: all those prophecies of his . . ." He

shook his head. "He's not very politic, your Friar. Perhaps he speaks truth but—" and he gestured toward the river with an earth-stained thumb "—I've seen too many corpses floating there. They also spoke the truth."

Michelangiolo did not answer. He did not like to discuss Fra Girolamo Savonarola with strangers. Always, along the route, as soon as it was ascertained that he was a Florentine, he had had as many questions shot at him as Saint Sebastian arrows. For five years now the fiery Ferrarese had been boiling up Italy with his denunciations of the Papal court, his wild visions of a day of judgment, his appeals to the Christian sovereigns of Europe. And the Holy Father had finally lost patience and forbidden him to preach. But that had only spurred Savonarola to new lathers of rhetoric. The Florentine merchants were beginning to grumble. Narro especially. Why, the way he talked you'd think he'd been in the wool business not two years but all his life. A clerk. Yet he managed to blow himself up to the pompous rotundities of Lodovico: "I tell you, Michel, if this silly feud continues, we'll have no one left to trade with but ourselves." Puffed up like a prior.

Michel smiled, thinking of his younger brother. You couldn't get ıngry at Buonarroto. Even his peacocking possessed charm. Even when he tried to be pompous as Lodovico he couldn't carry it off. Lionardo had more of Father in him, Michel thought, the same tail-feathers though his are black and white . . .

". . . do you think he'll bend the knee?" the farmer was asking.

Michel didn't answer. Apart from his natural caution, he found it difficult to assess his deepest feeling toward the monk. He had sensed it first when he came home from Bologna after that year away: the city was not the same, there was a new austerity, even the towers seemed more grim, you fancied the Day of Judgment was at hand, and Lionardo coming home now and then, smoldering with piety like a taper at the altar, his eyes burning for his friar. So he too had succumbed—first to Lionardo and then to Lionardo's master. And then he had become afraid. Sometimes when together with his brothers in the close-packed Duomo, he had listened to that voice raining prophecies and jeremiads like blazing arrows down upon the congregation, he had wept in the contagion of penitent weeping that swept them all. Ah yes, the monk exalted him, but was he friend or enemy to his art? That last terrible sermon, the impassioned burnt face turning toward us—that sudden arm jabbing like a spear— "And I say you artists bring vanities into the Church! Do you think

the Virgin Mary would go about in such garb as you have painted her? . . ."

O fortunate to be in Rome, away from all that!

For, as Father always said—health and a whole skin were better than premature enrollment among the blessed. Those floating corpses—

He bade good-by to the farmer and crossed the Ponte Sant' Angelo. The bridge was a hive of hammering, a metallic dong dong dong, a clanging forest where iron woodpeckers ticked against iron branches. Here were the armorers' shops, and riding slowly by, Michel saw them, bare-chested and muscled, striking sparks from cuirasses and casques, the golden reflection of furnaces on naked torsos. Angels and demons, he thought, the nakedness speaking deeply to him.

The bridge crossed, he turned north. From here on, the city belonged to the Vatican. Who commanded the Castle commanded all, and so the Pope had constructed a secret fortified passage running from the Vatican to the Castel Sant' Angelo. Michel inquired his way again of a swirling soutaned priest. The Cardinal's residence was not far from the Basilica. Fortunately he had arrived on the morning of this blue-and-white June day. After he had delivered Messer Pierfrancesco's letter, there would still be plenty of time to find Baldassare and arrange for a lodging. The Cupid business could come later. Apparently, the Cardinal was less angry at having been defrauded than impressed by the skill of the forgery.

Michelangiolo grinned to himself.

Of course, it was all Lorenzo di Pierfrancesco de' Medici's idea. Only a merchant would think of a trick like that. Especially a Medici-merchant smart enough to run with the pack under his new name of Popolano. Francesco's sly lip-twitch when he brought the news. Andrea's lifted eyebrows. What? *Popolano?* A good-enough camouflage-name. You're for the people when the people rebel against your reigning cousins. Why the devil am I always fated to be working for a Medici, Michel thought, either one branch of the family or another? And to think that the false Cupid had brought him here to Rome! Oh, I only trust the emissary did not lie when he said the Cardinal was not angry at me. After all, I was only fulfilling a commission.

Now the crowds were thickening. Bands of pilgrims were flocking the streets, gabbling in tongues Michelangiolo had heard but seldom in his native town: guttural Swiss-German, rapier-swift French. It

seemed he could scarcely push his way through those throngs. Several times his horse side-slipped and only his excellent horsemanship saved him from spilling into the churned-up mire.

Then, suddenly, he understood. The artery of lanes was leading to the Mother Church, the ancient Basilica of Saint Peter. Again the fulminations of Savonarola sounded in his ear. From here, as from a tainted spring, flowed all the corruptions of the Church. And yet Michelangiolo's heart beat faster. The oldest church of Rome. The sacred heart that throbbed on the very spot where the Apostle had suffered his mockery of a crucifixion, hanging upside-down to the jeer of Roman soldiery.

Now, abruptly as magic, the gloomy narrow street burst into sunlit square. Polychromed, the mosaics of its façade gleaming, the Basilica rose before him. Under the broad timbered roof, the façade glistened like a jewel box: prophets in a hundred splintered hues of colored glass stiffly bestowed theïr Byzantine benedictions on the brick-paved square.

Outside, a great crowd of penitents were moving in a sluggish lava-flow along the atrium toward the confessio. Michelangiolo dismounted, and seizing his horse by the bridle, followed alongside the procession. He felt as if he were walking into the past, walking along this road lined with ancient tombs. Who were they? he wondered, trying to make out inscriptions dim and fading as if written under water . . . Leo I . . . Gregorius I . . . Valentinian III (a Pope?) . . . Caedwalla . . . Offa . . . strange names . . . crumbling stones . . .

And the closer he approached the venerated heart of Christendom, the more ecstatic grew the chanting of the pilgrims. He was shivering in the sunlight. A familiar panic. Every few years there would come another preaching friar to Fiorenza from God knows where and stir the town to agonies of repentance. Oh, the times are not good for my art, he thought. The façade was just above him, the Apostles strangely elongated, flashing fire. A thousand feet—some sandaled, some bare—were shuffling; the chant was sweeping him away, he was beginning to swoon, to lose his identity among these God-intoxicated pilgrims.

Angrily, he shook himself out of it. No, he was no anonymity. He was Michelangiolo Buonarroti di Simone, a good Christian of course, but a sculptor with work to do and a new city wherein to prove the worth of his young powerful hands. He drew his horse aside just as he reached the great central gate of the Basilica. The door was open and in the dovegray dimness within, stained with chromatic

emblazements of sun through the painted glass windows, a hundred marvelous stone columns fell away into perspective, one after the other, columns of every hue of marble and precious stone, of golden onyx, of purple porphyry, of blue lapis, of veined milky Carrara— stones pillaged from many lands, even from the infidel Byzantine mosques, each with a different capital, a forest of stone trees. And at the end of the converging lines of columns, rose the bellied apse, maculate with mosaic: a glittering colossal Christ enthroned, a white tufted lamb, the rivers of Paradise. As he looked, the distant priest, small as a puppet, elevated the Host, and the doors being open on the eastern side, a shaft of sunlight fell upon the refulgent chancel and the high altar.

He was still standing by the open door, seized by the mystery of the Host when a new clamor broke him from his trance. Below the penitential weeping of the pilgrims, like a second voice in a madrigal, a new sound was rising—more brackish, more ominous. A murmurous undercurrent rising in pitch until it drowned out the chanting pilgrims. There was something frightening in this new sound: a thunder-rumble lanced with cackles of unleashed laughter.

It was coming from the far side of the Piazza. He turned and saw a mob just as it was emerging from one of the narrow streets that disgorged into the great square. The mob coiled and surged like a mythic multiheaded beast, a colossal reptile worrying some unseen object, something that was stinging it to a frenzy. Now even the pilgrims at the church had turned, broken from their devotion, toward the mob which was boiling ever more violently into explosive shouts, jeers of hysterical laughter, runaway, uncontrolled. It was like a black swarm of hornets swaying across the piazza under the stiff benedictions of the Apostles.

Where, Michelangiolo asked himself, had he heard these blood-lanced cries before?

Oh here it is again! Yes yes, at Santa Croce when the figure in the swaying cart went down under the hail of stones. The same pack-sound. The same pack-feeling. And afterward with Andrea seeing the body, Andrea's sobs, his beautiful eyes flooding, and the poor maimed bleeding meat that had been Bartol . . .

What was it now? This mob was behaving the same way. He approached, tried to see, but could not.

"Filthy whore!"

"Next time try it with a dog!"

Again a clap of laughter. He was buffeted by a woman whose sharp elbows were thrashing like a water wheel:

"Pig! Pig! Pig! Pig! Pig!" she was screaming. Her expression was wild, her long hair streamed loose over her face, her eyes were blood-shot.

But he could not see. He could not push his way into the crowd because of his horse. And here at the periphery, like one at the rim of a lava-flow, he only knew there was a volcano within, a mouth spitting up this rage and steaming filth.

"Black Barbara! Black Barbara!"

"Make him eat them!"

"No, *she*."

"Ahi, Cursetta, look at your Barbara now! Doesn't she have pretty parts?!"

Shouts, sweatiness, vulgarities, soft breasts of women pressing . . . He recoiled. He hated mobs, he was afraid of them. He had always found his dreams warmer than the contacts of any flesh, his marbled shapes more durable than the promises of men.

Suddenly the mass swayed, a crevice opened in it, and forced into the wedge, sickened, he saw a strange procession.

A young woman and a Moor were being prodded along by armed guards. Heading the procession rode a constable on an ass. The constable carried ahead of him, like a lance, a long pointed stick from the point of which dangled two human testicles, bloody-black. The young woman, arms tightly bound behind her back, was clad in a loose yellow mantle ripped open from neck to ankle. She was shapely with small breasts, a red welt across one milky mound, and on her belly a black hand had been painted, pointing downward to the shadow of her shame. As the guards pushed her along, the hand throbbed with the panting of her belly, and even in her agony, the movements of her naked body inflamed the passions of the mobmen. They shouted endearing obscenities at her, unutterable invitations that made Michel wince.

But the woman was not all. Alongside her was the Moor. His arms, too, were bound and he wore a woman's dress of flamboyant multi-colored silk, the skirt drawn up and tied above his navel so that everyone might see his private parts. The Moor bore his punish-ment with dignity, scarcely wincing at the soldiers' blows, defending himself only by spitting upon those of the mob who tried to lay hands upon him. Every time he spat, he was showered with fresh curses.

Though sickened by the spectacle passing through this holiest of squares, Michelangiolo could not tear his eyes away. Below the absurd bundled-up woman's skirts, contrasting vividly against the

colored silk, the Moor's powerful thighs were stained a deep reddish brown like mahogany. And with every stumble under the blows of the guards, ripples flowed across the dark satiny surface, tiny wavelets creating tiny shadows. It was like the surface of a midnight pool stirred by arbitrary winds, Michel thought, all the mystery of the man seemed to reside in those powerful thighs between which, shadowy, hung the wrinkled pendants of his torment. There in those stained flanks, and not in the woolly-headed skull, nor in the full lips pressed tight now in scorn, but there, there in the flanks, lay the secret . . . Michel's fingers itched. With a chisel might he not release that secret from marble? As he had, after the Magnificent's death, begun to probe that secret from the corpses his friend, the ever-smiling portly Prior of Santo Spirito, had been kind enough to let him dissect. Chisel or scalpel, with cold steel you might lay bare the truth. As Andrea's father, the Maestro del Medigo, a surgeon of the long robe, used to say at his lectures: "Here is God's supreme workmanship,"—reading from Galen and pointing with a wand—and I never knew it was a Hebrew that said it, marveling as he carved up those bodies as others carved stones. And though he cared more for disputation and making an anatomy than for my art, yet he was an artist too. How neatly he used to peel back the skin until you saw clearly the great tendon, the striated muscles. And then as it grew dark, he would stick a lighted candle in the open belly of the corpse, and continue his lecture, his shadow ballooning on the walls of the old sacristy. Andrea never seemed to understand my passion for his father's art.

Where is Andrea now, he thought suddenly, and pushed the thought away.

Black Carrara, yes, that would do it, black Carrara flecked with gold. The Moor spat and plunged almost at once to his knees from a violent blow across the flat of his back. He crouched like a wrestler, breathing heavily, and then he raised himself slowly, his face twisted. He seemed to be straining against the air as if it were rock, a Nubian caryatid—in that ridiculous woman's skirt—holding up a mountain, an African Atlas bearing a globe of infamy upon his shoulders. Greedily Michel seized the gesture, memorizing it, his fingertips twitching. He could see that thigh emerging from its prison of black marble.

The girl shrieked. Her molester laughed. The girl's face was a face of one of the damned, Michel thought, a face to be put into some Last Judgment. Her pale lips were contorted with shame and anger; she was weeping without tears, beyond tears, her long dyed egg-

yellow hair streaming down her back like a Donatello Magdalen. Her hands writhed in the fetters, she seemed vainly to be trying, by spastic movements of her shoulders, to cover her nakedness. But every time she succeeded in flapping the loose gown over her breasts, one of the soldiers or a hand from the crowd would rip it away. The men seemed to know her; they called her Cursetta, and listening to their crude shouts, Michelangiolo learned that she was a prostitute well-known in the quarter, who had committed the cardinal sin of lying with this Moor who for disguise had gone about in women's clothing. Hence the cries of "Barbara! Black Barbara!" for such was the name the Moor chose for his disguise. And for this outrage Barbara was being forced to reveal his private parts that all might know the fraud he had perpetrated; and Cursetta was being led nakedly about the holy city of Rome under the aegis of the bloody-black testicles which were those of a Jew who had had intercourse with a Christian woman.

Across the piazza, under the façade of the old Basilica, under the glittering benedictions of the mosaicked saints, the cavalcade of shame passed. Several times the girl stumbled and she was hauled to her feet, the testicled stick waved in front of her eyes; several times the Moor was beaten afresh, the crowd screaming for his blood.

Michel watched until the savage parade had passed out of sight. The pilgrims' chant resumed. He remounted his horse and proceeded to the Cardinal's.

II

"So you are the young man who played this trick?"

"I merely fulfilled the instructions of Messer Lorenzo di Pierfrancesco de' Medici, my master. I had no idea, Monsignore, of the disposition that would be made—"

The Cardinal laughed. He had a bold laugh, hard and jangled as a cracked bell. And his face was hard, too, this Raffaele Riario, Cardinal of San Giorgio, even the fatty jowls and watery eyes could not conceal the hardness, it was there even against the opulence of

those damasked gold-snailed walls. Brilliant as a tropical bird in his scarlet soutane and scarlet skullcap, he stood tall and aloof, looking down like a hawk on a high branch at the stocky figure of Michelangiolo. He was smiling but thinly, it was a smile that made Michel think of frosty nights, sickle moons.

"Well, you can write your Messer Lorenzo di Pierfrancesco that I was never fooled. Not from the first. It was of course a clever bit of work. Very clever. I can well imagine that there are those who might have been taken in by it. But not one who truly knows antiquity . . ."

"He lies," Michel said to himself. His wounded pride was goading him to challenge this smug smooth-cheeked Cardinal. Why, even that most learned antiquarian, Vespasiano, had not been able to discern the difference. Had he not vouched for its authenticity, even to the extent of citing the appropriate passage in Pliny which mentioned the work?

But one did not contradict the great men of this world: one stood before them with head slightly bowed, bowed at least within the limits of one's pride.

"And you may also write that I have sent the Cupid back to that thieving agent. He has refunded the money . . ."

And if you knew from the first, oh learned Cardinal, that the Cupid was an imitation, why did you pay for it?

The Cardinal's eyes flashed ominously. Michel was about to blurt: "But it was not my doing, Monsignore! I merely carried out the bidding of my master, Messer Medici-Popolano. For when he saw the little god of love which I had carved, stretched out in sleep exactly like the boy Saint John I had made for him, he clapped me on the back and said: *Bravo, Michelangiolo! Now we shall earn some florins for your talents. Let us bury that Cupid and stain it with dirt and chip it here and there as if it had lain under the earth for centuries. Then we shall sell it in Rome for a good price. They are mad about antiquities in Rome* . . . And so I did and I was proud of my skill and so was Lodovico who cares nothing for my art but appreciates a clever swindle . . . But the idea wasn't mine, oh reverend Cardinal . . ."

". . . hence whatever further dealings your master may care to have on the matter, let him deal directly with the agent."

"Yes, Monsignore."

"I will admit that I was impressed. Not deceived, but impressed."

"Yes, Monsignore."

Was there a trace of irony in the tone? He eyed the young man before him. Not very prepossessing. Shifting from foot to foot.

Rather like a high-strung contadino. Broad shoulders, shaggy head, rather goatish, that battering frowning brow, flinty eyes. Squat hands. But the emissary vowed this young man had done it. Well, we shall see, we shall see.

In the polished intaglioed surface of the table, Michel saw his head, a shadowy lump, formless, floating amidst inlaid satyrs pursuing inlaid nymphs. He felt uneasy in the presence of this Cardinal. Any Florentine would have been. For this was the Riario who had participated in the plot to kill the Magnificent and his brother; this was the priest who knew what was about to happen—the elevation of the Host—the flashing daggers. In the Cathedral, of course, a favorite spot for such enterprises. During the Mass, of course, a favorite time.

Seeing him now, the sword-sheathed-in-butter deceit of his gaunt temples and fatty jowls, his weak chin and burning eyes, Michel was suddenly plunged back . . . He had been only three during that fatal week of the Pazzi conspiracy_but all his growing years had echoed with the story. Babbo had been in the Duomo when it happened. The stabbing of Giuliano. The miraculous escape of Lorenzo. The corpses that soon dangled from the windows of the Palazzo. Heads down, like punctured chickens, dripping dripping: blood on the heraldic lion, blood on the palace stoop. But not all the conspirators were hanged—so the story went—some had escaped. And so the Signory—against the day when flesh might imitate pigment—had ordered Maestro Sandro Botticelli to paint the absconded criminals hanging upside-down alongside the effigies of those already hung. He had also been assigned to make careful drawings of the hanged men for the city records.

Michel had grown up with those painted figures on the wall. Only two years ago—when Piero was expelled—had they been whitewashed over. Michel had always thought Sandro's painted criminals marvelously real against the rough stones of the Palazzo. It was astonishing what one could do against such a surface. The nine winds raging down from Fiesole might swing the real corpses, but these painted ones did not stir. Art was an unmoved Mover. Like the Eternal Himself.

Soon after the hangings, worms of rumor crawled out of the pit. The Holy Father himself, it was said, was behind the conjuration. Was not Sixtus a Riario—great-uncle of this Cardinal—and had he not chosen as his personal banker Francesco de' Pazzi, enemy of the Medici? And reaching this part of his narrative, Babbo cried No! pounding the wooden table with his fist—and Mamma, doe-eyed with that look of perpetual flight—trembled with the blow, and the

baby, Giovansimone, gurgled with delight. Gismondo wasn't even born yet, he thought. That was the first year I had been permitted to sit at table, bib under my collar, next to Lionardo, already solemn at five. Below the table Narro crawled and pulled my leg. *No!* Babbo had cried, in a manner befitting the former Podestà of Caprese, and the trenchers on the table rattled. And that night there came guests: the apothecary Messer Silvio Manotti, Babbo's oldest friend, and a dour wool merchant named Rinaldi, and a gay young fellow, Guido, who liked Mamma so much he was always visiting Babbo. And they talked about the rumor that the Holy Father had lent his support to the plotters and Babbo said *No!* and the dour merchant said nothing but you could tell that he thought it was so, and Guido, madcap and smiling at Mamma, said it was so, joyful that it was. And then the ruddy-faced pharmacist cried *A pox on all Popes, breakers of oaths, disturbers of the civic peace, for they had rather beget bastards than save souls!* And he spat, a mouthful that threw up the dust in a tiny cloud and set the ants scurrying. And he and Babbo had a terrible fight and when Michel ran to Mamma crying, Mamma hushed him and said: "Be still when your father speaks." But he was not speaking, he was shouting, and Mamma was nursing the baby, and she had a faraway look on her face.

And now he was standing before the very cardinal whose arrival at the cathedral with Lorenzo had been the bowspring that set the arrows of that fury flying. Oh, a man with whom one talked softly, walked softly! In the presence of this flaming figure, Michel felt as if he had suddenly come face to face with the Medusa.

". . . hence I was interested to see the artisan capable of such a worthy imitation. But I certainly did not expect one so young . . ."

Michel smiled timidly. He was not young, he thought indignantly, he had been working at his art for eight years now. Why, even as an apprentice boy in Ghirlandaio's workshop, he had been capable of making copies of ancient drawings so perfect—singeing the paper to simulate age—that he was able to keep the originals and return the copies. Not even the master, Domenico, had been able to tell the difference. But he decided to keep silent. The Cardinal might misconstrue the boast.

"Let me see your hands," the Cardinal suddenly said.

What did this mean? Michel extended his hands. Gravely the Cardinal took them, each in each of his, examined the short square fingers, the callous-paved palm, turned them over, scrutinized the nails, several of them black and broken where the hammer had hit. Yes, the Cardinal thought, the hands of a peasant. But a cunning peas-

sant. That thumb now, the curve of it is almost sensual, the full bursting pad makes one think of a young maiden's rump.

At the soft moist touch of the Cardinal's fingers, Michel had recoiled. But in this world, Father always said, one must learn to forbear all things. Even the clammy touch of a cardinal's fingers. He waited till the examination was done, then permitted himself a tiny sigh.

"Yes," the Cardinal said pensively. He had picked up an ivory-handled stiletto which he used to break the seal of letters, and now, tapping the enchased blade against lacquered nails: "Are you provided with quarters here in Rome?"

"The gentleman you sent, Monsignore, promised to put me up for a while. But if that is difficult, my countryman, Baldassare—"

"That scoundrel . . ." the gray skin flushed.

"Excuse me, Monsignore. I do not refer to the dealer, Baldassare del Milanese, but to my countryman, Baldassare Balducci who works in Gallo's bank. He will, I am sure, help me to find a lodging."

"Ah, then, you intend to stay a while in Rome?"

Michel frowned. Had the Cardinal's emissary lied? Had he enticed him here on false promises? The Cardinal, he had vouchsafed,— clucking over that hand Michel had drawn as evidence of his skill— the Cardinal would surely have a place in his own household for a young man talented enough to draw that miracle with a pen and carve that false-true Cupid. He must come to Rome at once. There only would he find ample scope for his genius.

And now the Cardinal didn't even seem to know why he had come!

"With God's help, yes," Michel said cautiously. "I hope to study further in my craft here. I hope also to see more of the works of the ancients that every day are being liberated from the ground."

The Cardinal nodded his head.

"And that is all you hope?"

The prelate had sat down now behind the table, his posture indolent, the expression in his death's-head eyes softer now. He evidently enjoyed cat-mouse conversation.

Michel hesitated.

"I also hope . . . permit myself the hope of receiving some commissions . . ."

The Cardinal nodded his head.

"Good. Then you shall shape me something. A Minerva perhaps. My Pantheon lacks a Minerva. And without wisdom, figlio mio, where would we all be?"

"In God's hands."

The Cardinal permitted himself a smile. The answer had come so spontaneously; the young man's faith was touching.

"Yes, of course. But God does not want us merely to float in the ocean of his bounty. We must also navigate a bit for ourselves, and the rudder thereof is wisdom, don't you think so?"

"It is a matter beyond my knowing."

"And what is within your knowing?"

"My craft."

The stiletto tick-ticked against the nail. The young man's face, the Cardinal thought, had hardened with the words—*"il mio mestiere"*— A calcification of pride. His head was no longer bowed.

"With whom have you studied?" the Cardinal said presently.

"My father apprenticed me to the workshop of the Ghirlandaios where I remained for two years till the age of fifteen. And then—"

Should he declare it? But there was no escape now.

"And then—?"

"And then . . . I passed some time in the Gardens of San Marco under the Master Bertoldo." Hastily, as deflection, he babbled on: "The Master Bertoldo had himself studied under Donatello and so his manner prevailed . . ."

"The Gardens of San Marco, you say?"

"Sì, Monsignore."

"You mean the Gardens of the Medici?"

"It is sometimes called that, Monsignore."

Oh, now the fat was in the fire! He would be lucky to get out of Rome alive! The back of his neck was hot.

But the Cardinal spoke calmly. Was he playing with him, cat and mouse?

"I suppose you were acquainted with the so-called Magnificent Lorenzo before his untimely death?"

"He may have known of my presence. There were many who studied with the Master Bertoldo."

He hoped the lie was not too apparent. His neck was burning beneath the woolen collar. Suppose this Cardinal knew—*this* Cardinal still wax-pallid with the terror of those few days in prison after the Pazzi plot, until he was acquitted because of his youth, he having been only seventeen then, but, look! the cheeks were still tallow-gray, the fear still burned—Suppose this Cardinal knew that standing before him was a favorite of the Magnificent's? that for two years he, Michelangiolo, had lived like Lorenzo's very son in the gracious palace on the Via Larga, clad in a purple cloak, and that he had sat beside—

and sometimes even ahead of—Piero and Giovanni and Giuliano at those fabulous feasts where lutenists played and wit out-jousted reason and the Magnificent recited his latest poems in his nasal high-pitched voice? And what if this Cardinal knew how many times the Magnificent—his hard eyes gauzed, his ugly lantern jaw broken in a smile—had affectionately patted his hair. Especially that afternoon in the gardens when he had proudly displayed his laughing satyr; and the Magnificent smiling, hand on hip: "*And do you think such an old man would be likely to have a smile so full of perfect teeth?*" And he, Michel, convinced, seizing the mallet in a flash and knocking out all but two of the offending teeth, and the high-pitched laughter then and the approving pinch? . . . Oh, if the Cardinal knew . . .

But if the Cardinal knew, he kept his knowledge hidden behind the glinting diplomatic visor of a Prince of the Church.

"I am, as you perhaps surmise, no friend to that family," the Cardinal began slowly. His words were cat's paws. "But I am prepared to overlook your unfortunate association with that tribe of usurious tyrants. An artist must work for whoever is in command."

"Indeed, he must, Monsignore."

"Happily they are no longer in command, although I would hardly say that your Friar is well disposed toward the arts." The burning eyes were watching him shrewdly now over the handle of the dagger, pressed like a crucifix against his lips.

"I do not know, Monsignore. I am too humble to have had—"

"Oh come now, you know what excellent works he would pitch into the blaze! And mark my word, young man, not too long hence your Friar himself will be consumed in a bonfire of his own vanity . . . But I see that you prefer to limit yourself to what is *within your knowing* . . ." Ironically he accented the quotation. Is he truly as stolid as he looks, the Cardinal was thinking, or is he playing the peasant? ". . . that is, your craft."

"Yes, Monsignore."

"Well, then, tell me something of your craft." The Cardinal's smile was benignant, he enjoyed talking about art almost as much as collecting it.

"My craft? . . ."

"Yes."

"What can I say about my craft? I have hardly begun."

"You have begun very well. The gentleman I sent to Fiorenza declares that he saw you draw with several swift strokes of a pen a hand that seemed alive upon the paper."

Michel nodded his head.

"And your Cupid would certainly be taken—by the ordinary lay humanists, of course—as a genuine work of the past. But tell me, these imitations of yours—"

"Oh, they are not imitations," Michel said with a flush. "I—I do not copy."

"Ah, but you use models."

"Oh no, Monsignore, I merely find them in the stone."

"Find them?" The Cardinal was leaning forward; he liked talking to the young man.

"Yes. I—" He was stumbling less now, the hammer of his thought beginning to strike home. "—I merely free from the stone the shapes already hidden there."

"And how do you do that?"

"By taking away."

"By taking away?"

"Yes, Monsignore. By taking away the covering that hides the figure within. Oh, there are so many shapes hiding in the rocks! One day I was walking in the mountains near Settignano and it was getting on toward night and the quarries were all embrowned with dusk. And suddenly I saw that the pits were full of sleeping men— oh not the stonecutters, Monsignore, but sleeping men!—I saw them right through the stone, clear as I see you, sleeping in it like figures in ice. And suddenly I knew that all I had to do was remove that mineral blanket, that hard shroud . . . and there they'd be, curled up naked in their beds, and at my summons they would stand up and walk . . ."

Slowly, the Cardinal put down his stiletto. Well, the young chap certainly was intense. An unsuspected intensity.

"So you think there are men hidden in the stones?"

"Yes! Yes! Buried in the mountains! But not dead. All you have to do is set them free. That is the secret. That's why I came to Rome. I want to study the works of the ancients, for those too are being brought up out of the darkness into light. And that—" He stopped suddenly. The Cardinal was regarding him with lunar wonderment. Dio, he must have spoken like a fool! "And that—" he ended lamely —is my craft."

"Ah, but that is also our craft," the Cardinal said.

III

Well, at least he had escaped from the flame-robed Riario without being too badly burned. And now the business of the Cupid must be swiftly settled. He must find quarters and get to work.

Gallo's bank, before which he stood now, was a frowning fortress-looking structure on the Canale di Ponte. A narrow unpaved street that flooded with every inundation of the nearby Tiber, it was lined on each side by splendid residential palaces, and grim brownstoned structures with barred windows. Here were located the Rome representatives of the great bankers of Fiorenza, of Siena, of Genova; here were the Ricasoli, the Tornabuoni, the Medici, the Pazzi, the Altoviti. The names were echoes of home to Michelangiolo.

He was not far from the uncompleted Riario Palace. But he had not come here directly from the Cardinal's. Instead, he had begun to wander, aimlessly at first, and then he knew what he was eager to see and he stabled his horse and eagerly pushed his way across the teeming city—through the chicken market of the Strada dei Baullari, flying with feathers and lanced with cackles, and into a great square called the Field of Flowers—the Campo dei Fiori—blooming with a pillory on which a wretch was screaming, and where, in front of taverns surrounding the square, aproned German innkeepers and their guests were laughing; Michel hastened away and through noisy throngs of sweaty Romans and pungent goats and adagio oxen and suddenly into orchards dotted with little houses, and once again into cool shadows of turreted palaces, great piles of frowning stone, and many old churches, and through a street of dark shops; then he was in a quarter known as Sant' Angelo—a gloomy reeking labyrinth of alleys twisting in and out of fallen ruins.

Another market, he marveled. All about him, bearded men were selling fish laid out on marble slabs still softly incised in Latin characters. Fragments of a hundred white goddesses lay scattered in marmoreal butchery amongst river reek, hawkers' cries, and the rainbow flash of fish hauled out of the Tiber nearby. They were laid out on broken bits of peristyles, on stone petals of acanthus leaves, on sarcophagi.

Suddenly he realized he had blundered into the Quarter of the Hebrews: these venders were of Andrea's race though you could not distinguish them from the other Romans by their appearance. These

too were dark, flashing-gestured, these too spoke with their bodies like all the Romans. Only a certain ancient look in the liquid eyes as if these very eyes had witnessed the construction of that Portico of Octavia whose stalked columns and archway dominated the quarter. A group of young men were lolling by a red brick wall into which was affixed a funerary plaque of the family Claudius: three figures in high relief, exquisitely eternally frozen above the volatile dark-haired heads of the young men.

Michel walked over to look at the relief. The carving, he thought, was excessively detailed. Even a mole on the woman's cheek . . . why, you could even see the stitches on the hem of the *paterfamilias'* toga, but the man's eyes were blank.

The young men's eyes were not blank. They were regarding Michel suspiciously. He passed through the Portico and through the gloomy archways of the Theatre of Marcellus and found himself at the brink of the Forum, the goal of his wanderings.

He was shocked.

He was standing at the edge of a shallow pit, littered with carious green-bearded ruins amongst which cattle grazed. His knowledge of antiquity was limited to what he had absorbed, almost unwittingly, in the Magnificent's household; he could not read even the simplest Latin inscriptions on the scattered debris of columns and lapide that lay helter-skelter about the Forum. And yet he had expected more than this.

Bemused, he looked.

A breath of the ancient world—austere, profound—seemed to emanate from that huge opened grave. Blued with distance, above olive groves and creepers, he could see, to one side, the towering Baths of Caracalla and further away, the round pocked mass of the Colosseum. But in the shallow pit below, cattle were grazing where Caesars had bled. Time-brazed, the broken capitals were strewn in beds of tall weeds; a shepherd had leaned his crook against some temple-ruins. From afar, the haggling voices of farmers and trades-men floated thinly to his ears. Where once had flowered the sacred flame of the Vestal Virgins, pigs were urinating. For this was the big-gest cattle-market of Rome; and Michel could hear the country peo-ple swearing, the tintinnabulation of trade, the sharp smack of palm against palm as a deal was consummated. Leaning against the Arch of Severus, like drunken beggars against a fine down-at-heels gentle-man, were the wooden huts of artisans who made two-wheeled carts and huge ox-yokes. In this forum where Cicero's swelling periods had rolled, Michel could hear only the low-toned mooing of cows,

jackasses braying indignantly against an idiot world, the slobber of pigs, the mournful bleating sheep. Sadness seemed to blow with the breeze that spoke against the reeds.

He saw something, descended into the pit. An arm was struggling upward out of the earth as if the day of the Last Judgment had come. An arm blanched, bloodless, blotched here and there with ochre earth-stains as a new-born babe stained with the placenta. A marvelous arm, Michel thought, the modeling of the elbow liquid and sure, and though most of the fingers of the hand were broken, what remained was shaped with wonderful skill. Anonymous, emergent, stark it spoke out of the earth, and when Michel stooped to touch it, he had the strange, slightly shivering sensation of touching—across the centuries—the long-dead hand of the sculptor who had shaped it. Across fifteen hundred years they touched, fellow-craftsmen, the quick and the dead.

But the arm resisted capture. It was still connected to its parent-body deeply buried; and regretfully Michel gave up the attempt and turned back to Gallo's. It was getting late and he was exhausted from his peregrinations, the bombardment of the new city.

But all the way to the bank he could not forget—he did not want to forget—the image of the white arm. Where had he seen it before—that agonized reaching out of the earth, from the dark toward the light? He stopped before a butcher shop to admire the carcass of a calf, split open like a monstrous bleeding butterfly. Outside the shop, the butcher's name was painted on the wooden signboard— L'INSEGNA DI RELLI . . . Signorelli, of course! He suddenly remembered, the Master Luca of Cortona, that was where he had seen the white arm of the Forum, in Master Luca's fantastic frescoes in the cathedral at Orvieto. Because Francesco had insisted, he had ridden miles off his course to see that pictured Dies Irae, switching off the straight path to Rome, making his poor horse toil up that precarious mountain road to that marvelous city perched like an eagle on the rock.

But it had been worth it; Francesco Granacci had not been mistaken; he was grateful for his insistence. For surely nothing had ever issued from Messer Domenico Ghirlandaio's hand to equal that Last Judgment of Signorelli's: those firm-muscled young men, naked as Greek gods, those bat-winged demons, and the ash-colored resurrected dead reaching out of the earth as that arm in the Forum had reached. Oh, nothing of the Master Domenico's pearly elegancies—his Madonna Tornabuonis and Vespuccis, delicate ladies all, with discrete bulging little bellies against which they held upgathered in

tapering ivory fingers the sumptuous gold-and-pearl embroidered stuffs of their skirts—nothing could match that thunder on the wall. No, not even loyalty to his first master in whose workshop he had learned to mix the plaster of marble dust and water and grind colors and upon whose scaffoldings behind the high altar at Santa Maria Novella (which in an idle hour he had sketched, workmen and all, scaffolding and all, to Master Domenico's astonishment) he had climbed, a delirious monkey, paint on nose, to fill in garlands the master had outlined, and even a minor figure or two— No, not all that splendour of silks and ladies and furniture and silver light could compare with a single bare arm of Maestro Luca's.

Always the flesh spoke, he thought, the pure flesh. Not all of Ghirlandaio's overladen satins could outspeak it. And Luca knew it. Never had Michelangiolo seen so many naked figures grouped on the walls of a church. In every position—leaning, crawling, reaching, struggling—it was a vocabulary of the body, it was the primal protean Word in all its possibilities. And as God said it first. As Adam was. A man.

Now on his way to the bank, the two images kept flowing into each other: the same ashen aspiration, the same agonized thrust. But the white arm in the Forum, he thought—oblivious in his fantasy to the white plump arms of Roman girls jostling against him in the narrow streets—was even purer, more limpid, than those of Maestro Luca. For despite his awe, something had repelled him in those tormented figures at Orvieto. For all their sufferings they seemed oddly constructed of wood, and all the colors were mixed with smoke.

He had reached the Canale di Ponte. Dead ahead across the bridge, he could see the Castel Sant' Angelo again, darker now, more massive against the declining light. His legs ached; he felt a twinge of hunger. So eagerly had he explored Rome after the Cardinal's, that he had forgotten to eat. The atmosphere had turned gold, a nimbus hazed every figure on the river-bank. The blue dome had deepened, the sun was about to leap in martyrdom off the Tarpeian Rock.

He entered the bank, washed in violet shadows, and inquired of a dozing porter for Messer Balducci. And when at last his countryman appeared, tall and thin and sober in his black banker's robe, Michel heard with a lift of the spirit the familiar inflections of the Val d'Arno.

"Michelangiolo Buonarroti! Dear boy! Ma che gioia! I have been expecting you. Several days ago I received a letter from Messer Pierfrancesco de' Med . . . Popolano advising me of your coming. I

trust you had a pleasant journey. Rather fatiguing—all week bumping over those mountain roads."

"I didn't take the post. I rode."

"Ah? . . . And your horse?"

"Stabled near the chicken market. He is exhausted, poor beast."

"You didn't ride him all the way down?"

"Yes."

"I don't wonder he's exhausted. Why didn't you change mounts?"

"Couldn't afford to. But we came slowly—ten days in all. I by-passed to Orvieto and thence by way of Viterbo here."

Balducci had an odd manner of twitching affirmation with the end of his long sharp nose. His thin lips flickered ever in a whip-smile. He had known the young sculptor at Fiorenza and had liked him. Michel had, Balducci thought, all the brusqueness of a Settignano stonecutter, but a streak of humor, too, that revealed itself in the alacrity with which he accepted Pierfrancesco de' Medici's suggestion. That business of the Cupid tickled Messer Balducci's fancy. He had already told the story to Messer Gallo and Messer Gallo had almost laughed. He had requested to meet the young man as soon as he arrived.

Hence, before Michel realized what was happening, he was being conducted through the bank, past rows of double lecterns propping heavy parchment ledgers into which clerks were squinting in the dying light. The system of double-entry bookkeeping, invented by the Florentines, had now spread to Rome, and Balducci had been summoned to inculcate the most modern methods in Gallo's bank. He was also acting as agent of the Medici.

"But you are occupied!" Michel protested as the older man whisked him down the aisle between the rows of clerks. "Tomorrow would be time enough—"

But Balducci was not listening. He was striding ahead, his cloak flying. Obviously he was in command here; the clerks nodded their heads in mute deference, like tulips in a wind, as his black cloak swirled by; quills scratched more eagerly for his passing.

In an oak-paneled room, rich with tapestries and porphyry portrait busts of black pedestals, Michel was introduced to a middle-aged thickset man with a head like a senator of ancient Rome. This was Messer Iacopo Gallo. He surveyed Michel with gimlet-shrewd eyes, his nose was bulbous but pinched at the nostrils with caprice, his white hair thin as gossamer and brushed forward over a rocky brow. His expression was sober, hard, and he did not smile as he said to Michel:

"If you possess but half the talent your countryman here claims, then you shall carve something for me too."

He was stroking the smooth bronze back of a Ganymede that stood upon his desk; and Michel saw at once that this banker was a true lover of sculpture. You could tell it by the way he stroked the Ganymede. Those fingers had eyes in their tips, those fingers playing with delicate antenna-like insistence over the gleaming bronze flesh of the figurine.

". . . because here in Rome, you see, we have few artists of our own. It's quite peculiar. Something in the air perhaps that dries up those particular facilities. But whatever we possess of beauty has either been brought to us from other cities—or left to us by antiquity."

"Messer Gallo has a marvelous collection," Baldassare said enthusiastically.

The older man muttered a disclaimer. "Too many lacunae," he said, "a weak Apollo, no Diana, no Bacchus . . ."

"And no St. John the Baptist," Balducci said with a trace of irony.

Gallo smiled for the first time. Indeed, one could not call it a smile; it was rather a cautious twitch at the corners of his lips, an almost imperceptible puckering of the eyes.

"I find the subject rather distressing," he murmured. "It's all right in a church."

A servant entered with a branched candelabra, already flaming, and set it on the desk. Highlights flared on the banker's stony face, deep shadows gouged his cheeks. For almost half an hour he questioned Michel closely. Like the Cardinal he wanted to know all about the Florentine's methods of work. Did he prepare a wax model first, or directly attack the stone? And if he made a wax model, was it in miniature or the actual size of the contemplated work?

This banker seemed indeed more interested in art than in banking; and toward the carved nude, in particular, he evinced a passion that revealed itself less in words than in the faint quickening that crossed his eyes as he spoke of the latest discoveries. In digging the foundations for the Palazzo Massimo, a fantastic Hercules had been unearthed; and just at the foot of the new apartments which the Borgia was constructing at the Vatican, several river gods—enormous beyond anyone's conception. One of them, representing the Nile, was more than ten braccia long, a giant old man, bearded, with many exquisitely carved children, representing tributary streams, clambering about his naked limbs. It was a marvel, an absolute marvel! Ahi,

richer than all the gold of the new-discovered lands beyond the sea were the treasures of this Roman earth!

In the flickering candlelight, Michel listened. Merchants and bankers who were enthusiastic about art were nothing new to him. Had he not spent two years of his boyhood in Lorenzo's household? Was he not familiar with the great collections of the Rucellai and the Strozzi? These were the men he had to work for, without their aid he could do nothing. Carve, yes, for himself—but that would be like carving in the empty air. He would bring no honor to his family and no florins to his pockets by such self-indulgence. Of course, when these Croesuses were too busy to devote themselves to art, then one might amuse oneself, and occupy the idle restless hand by shaping something for oneself. So he had done after Lorenzo's death, working in the garden to Lodovico's irritation and Andrea's big eyes watching and Granacci chattering away to the tick tick tick of his chisel and the flying white dust out of which had finally emerged a Samson straining against the pillars. It was still in Lodovico's woodbin. Without a sponsor the statue was like a foundling exposed in the Loggia degli Innocenti.

Yet, he was wary always of these merchant-princes. Of any princes—whether of the Church or of the counting house. They were too wayward; one had to learn to fly in sudden tempests, to float easily—without impatient tugging at the sails—in inexplicable dead calms. They loved art, some of them, yes, but they were out-side—they took and they paid, and by taking and paying, made possible.

But the giving-birth, he though stubbornly, as the candle-flames danced on the tapestried walls and Gallo's low incisive voice flowed on and Balducci nodded—the giving-birth was only *his*: that agony was never shared, that possession never truly relinquished. For though a hundred works might stand in a hundred palaces, they would always be his; children frolicking about his fantasy as those tributary streams of Father Nile.

IV

That night after dinner at Baldassare's home, the two Florentines sat talking in the high-ceilinged salotto. The dinner had been a silent one; Michelangiolo was too hungry and too weary for conversation and Baldassare respected his mood. He was accustomed to silence; Donna Balducci had died of the plague two years before, and though the merchant spoke casually of a daughter, she was not present at the meal. Baldassare wore that dry air of self-sufficiency which respects the inwardness of others, as pleasing to Michel as the tart white Frascati wine with which he washed down the fat capon grease. After the meal, as the serving-woman bore away the bone-strewn wooden trenchers, they washed their fingers and repaired to the salotto.

Then Michel began to expand. The room was so austerely graceful, his stomach so full, his body ached with pleasant weariness. Baldassare sensed that the bridge had been thrown at last across the moat of his guest's privacy and he spurred to his questions. He was eager to learn all the latest news of his native city. He had not been home for fifteen months, and here in bustling Rome he felt a nostalgia for the maroon bulge of Brunelleschi's dome against a milky blue sky. The air in the Campagna was too fetid for his tastes; and the gyrations of Alexander VI and his family had certainly not helped to purify it. The Florentine was no prude on such matters; but the Spaniard was going too far; the intelligence from the Vatican sounded like reports from a brothel.

To that extent, at any rate, the Friar spoke truth.

Which led Baldassare to the inevitable questions about Savonarola. Were those nuisance gangs of children still ranging the four quarters, pointing their puerile fingers at the sins of their elders? Were the merchants still stirred up over the threat of Papal excommunication? Oh, the Holy Father was butting back now where it hurt Florentines most—in the purse. Here in Rome it was better to bite one's tongue on the subject. The Borgia Bull was really beginning to snort: the Dominican had jabbed too many banderillas too deeply into those massive, well-fed shoulders; the blood was running. Why, even an Alexander was hardly to be expected to nibble grass while barbed accusations of simony, corruption, nepotism, pederasty and other

crimes more unmentionable were being hurled daily by the Do-
minican.

But if the charges were true? Michel asked.

That didn't matter. What did matter was *survival*: a mouth like
a drawn drawbridge, an eye like a slit in a castle wall; one struck only
when one was sure of success. The trouble with the Friar was that
he scorned success.

"And there is a monk here in Rome," Baldassare went on, "who
is heaping up the faggots for him. Fra Mariano da Genezzano, that
Augustinian who used to preach to such crowds at Santo Spirito,
quoting as much from Aristotle and Plato as from Holy Scripture.
Oh, watch out for him! He gobbles followers of the Friar. He con-
siders him an instrument of the devil and all Florentines perverted.
And now he has the ear of the Holy Father. He has undertaken a
series of preachments against Fra Domenico. I dread to predict the
end."

"I am no lover of our monk, you know," he added after a thought-
ful pause. His hands gestured impatiently. "He has brought as much
harm as good, despite his meritorious reforms of government and
morals. Yet, when last I went home—" and Baldassare's hazel eyes
clouded in sorrow "—I felt that a happy period of my life was dead.
The Magnificent may have held the reins tightly in his hands, but
there was a *light* then, a gaiety, we all sang in the streets. You are too
young to remember but—"

"I am not too young," Michel said, hotly. Like all young men, he
resented his most precious possession.

". . . summer evenings," Baldassare went on, unheeding of the
interruption, "we used to gather on the cool flagstonès in front of
the Baptistry and gossip and flirt and some would play their lutes
and others sing airs. Oh, and the frequent festivals in the Piazza
Santa Croce . . . Giuliano jousting under his brother's eyes and the
lovely Simonetta flinging lilies from the stand . . ." And the older
man shook his head: "All gone now. Now it's nothing but sin and
redemption."

Ah, but had not the Friar's prophecies proved true? Michel was
thinking. Had he not predicted the coming of a scourge and had
not the French King come? And in the flickering candle-flame Michel
saw again the thousands of torches that night two years ago when he
and his brothers and Andrea had stood at the San Frediano gate and
watched the pageantry of those troops—the fierce gamecock Gas-
cons and mercenary lard-colored Swiss—and heard the terrifying
brmmm brmmm brmmm of the tambours.

And if the Friar was a soothsayer then, was he less one now?

". . . impossible to believe though, Heaven knows, there were celestial portents enough," Baldassare was murmuring. "It was as if —" He reached over and pinched out one of the candles with his fingers. "Like that."

For several moments he was silent: musing on those vanished Lorenzian days. He sat very erect in his robe, the long tassel of his woolen cap draped gracefully down one side of his head onto the bony shoulder. His clean-shaven face possessed a certain excess of refinement, the candle-flame lent a lambent lustre to his melancholy reminiscence.

Politely, Michelangiolo waited for the older man to resume. Meanwhile, he gazed about the apartment in which he was to spend the night. An octagonal heavy-legged oak table, several stiff upright chairs, a prie-dieu, a cassone with flaked painted scenes from the life of San Giovanni, patron saint of Fiorenza. It was a room—indeed the entire apartment—that reflected the austere but pure taste of a man of business. Yet here was Messer Balducci bewailing the hushed lutes, the stilled madrigals.

"Here in Rome," he said at last, "you will not find yourself alone. We have a growing Florentine colony in this quarter. We even hope soon to construct our own church. You will have friends. But caution. We are not particularly loved here. And our exiled Piero is creating scandal after scandal that hardly redounds to our credit. Even the Cardinal Giovanni cannot bridle his brother's appetites."

"I feel sorry for the Cardinal," Michel said simply. "He's kindly disposed. I often sat next to him at table, and once when his father bestowed a gift on him for his birthday, the Cardinal bestowed one on me. We're exactly the same age, you see."

"Ah."

"But Piero was scarce aware of my existence. He recalled me to the household for a while, but he preferred his Spanish groom."

"Well, now he has his Spanish groom," Baldassare said sarcastically, "and precious little else."

Yes, Michelangiolo thought, he who had loved the unbridled must now himself be bridled, he who had such a passion for the hunt is now himself hunted. And memories of Piero brought ruefully to his mind that white winter day after the Magnificent's death, when the unworthy son had summoned him to the Palazzo to fashion a statue of the fresh-fallen snow. An amusing idea, why not? What difference did it make whether one carved in snow or stone? in butter or in basalt?

But even as he bowed, velvet cap in hand, to that Medicean whelp, something in him rebelled. Surely the shapes of his imagining deserved a more permanent medium than snow! Were his dreams no more worthy of endurance than patterns heaped up by the wind? But he spoke nothing of this to tall, thrust-jawed Piero; he fashioned the desired figure and the Medici was pleased. And not long after, the sun emerged and melted the snowy Hercules. And a few weeks later, Piero himself—that lion-killer—melted away in the heat of an anti-Medicean revolt.

Now he was here in Rome with the Cardinal his brother. Another to avoid.

"He's a stiff-necked fool," Baldassare said sharply. "If he'd learned to sway with the breeze, he'd not have broken with the blast. But that business of the fortresses was too much. Could anyone believe his explanation that he'd given them away to Charles to safeguard our domains? His father played a cleverer game when the King of Naples threatened—but then Piero possesses nothing of his father except perhaps his jaw—out of which issue inanities instead of wit."

A girl entered the room, first curtsying at the door. "Father," she said in a low musical voice, "the notary Guido Palanzini has arrived with the deeds and requests your presence."

"Ah . . . You will excuse me," said Baldassare and left the room. The girl remained, looking at Michelangiolo with what he thought was excessive boldness. She was about sixteen, her eyes seablue, skimming candidly over his surface now like gulls. He squirmed under her pellucid examination. The girl's face was round, simple, with the serene prettiness of a child. But the suckling dimples in her full cheeks, the tiny whirlpools twinkling in the bare expanse of throat, the pert breasts outlined even to the nipples under the tight-laced yellow corselet, the amphora-shaped hips—these did not belong to a child, and Michel felt himself burning with familiar surges.

"You are Messer Michelangiolo of Fiorenza?"

"Yes."

"Babbo greatly admires your talent."

"He is excessively kind." He spoke so brusquely that one would have imagined he resented Baldassare's praise.

The girl continued to look at him with unflickering tranquil eyes. There was the faintest suggestion of a smile in her pouting small mouth.

"May I sit down?" she said, indicating the chair her father had vacated.

"Oh . . . of course. Forgive me." He had even failed to rise when

she entered. So now he jumped to his feet as she sat down, folding her hands in her voluminous skirt.

"My name is Bianca," she said, and then, whisperingly: "I hope you will come here often. Do you know why?" And she leaned toward him so closely that he saw the pulsing of her throat; a fragrance of spice coiled round him like a rope. Her hair, silky and black, flowed loosely from a headband of gold brocade; to her bodice were attached puffed sleeves in tiers, slitted to show the purple undergarment; her square décolletage framed a fleshpink landscape rising to low hills, her gold belt caught the candlelight and glinted like armour round her waist. "Do you know why?" she repeated, for he had not answered.

He drew back, frowning, clumsy. "Why?"

She giggled, a lamé of laughter, arpeggio on a harp. "Because Babbo's business friends bore me. All they talk about are bales of wool and trade with Antwerp and interest rates. And the young men are already stiff and pompous as their elders. I find artists more enchanting."

"You do?"

"I do." She said it straight ahead, her eyes looking at him blunt as lances. The contrast between her childish face and her sophisticated manner threw him into a terrible agitation. He wished that Baldassare would hurry back. He was twenty-one and he was afraid of this girl, afraid of these strange creatures who had always floated with languid and peculiar fascination on the periphery of his world. For his world was always a world of men—of his brothers, and of his father Lodovico and Zio Francesco who joined to beat him with crusted hands because he drew pictures instead of absorbing the Master Francesco da Urbino's Latin lessons; and afterward the world of the two Ghirlandaios and the apprentice boys in that shop with their crude jokes and strong smells made stronger by the pigments they ground and the lime-dust in their hair.

And the Magnificent's garden was a male garden too, though there were many goddesses in stone. When fleshly ones intruded, he watched them pass among the box hedges, or down the corridors of the palace, as if they were creatures of another world. There might be the Magnificent's inamorata (for Donna Clarissa had died too soon), or any of the three daughters, disturbingly about Michel's age, at the passionate brink-years, rustling by in satin, their hair pearl-bedangled; there they stood hovering like iridescent butterflies over a glass case of their father's curio and gem collection. If one of them had touched him, Michel would have gasped like a fish breaking

out of water. For these creatures soared in another element. He could not breathe there. He could only dive home into his comfortable, if sunless, self.

Once, indeed, he had been touched. It was in the Medici garden. He was sketching a *Hermaphroditus,* prone, with muscular shoulders, gracile undulant hips.

"Bellissima!" a girl's reedy voice murmured. It was Contessina, the Magnificent's youngest. With admiration-brimming eyes, she was gazing at Michel's drawing of the androgynous figure. It was too late to crumple the paper.

". . . Exactly as Master Marsilio described it to us from the writings of the divine Plato," the girl said. She was sixteen and preened her erudition like a peacock. "Did you know that originally male and female were one?"

"I know nothing of it," Michel said. Chalk blackened his nose.

"Yes, but now sundered, each half seeks to fly into the arms of the other."

He would have flown into her arms then. Beneath a veil of ice, he burned. He was sundered and her pink finger was pointing at the Hermaphrodite. Her neck was long and slender. He returned furiously to his drawing. She touched him then, lightly as a cloud. A few months later she was married to Piero Ridolfi. Granacci did the decorations for her wedding.

Of Mamma who had died when he was seven, he retained merely a sweetsick memory, caresses that were the caresses of dreams, gray, without touch. He never saw her when she was not giving the breast to Giovansimone or to Gismondo, and hushing his fears: "Be silent when your father speaks . . ." Then she was gone (though sometimes she visited him in the night like a scolding angel), her memory painted over as in a monk's palimpsest by the second woman Babbo had brought into the house.

This was Donna Lucrezia, a timid girl of burgher family, frightened of Babbo's long forked official beard and pompous manners, frightened of the five boys over whom she was expected to assume an abrupt motherhood. She was thin but with hectic cheeks; she spoke little to anyone, and especially to Michel. For from the day Lionardo had joined Fra Girolamo's order, Michel was the eldest and not much younger than his step-mother. At first he resented her, for she was young and pretty despite her lack of flesh; hearing them in bed at night he felt vaguely that his father was seducing the servant-girl, outraging Mamma in Paradise. But soon he grew used to the flushed presence of Donna Lucrezia; besides, once he was apprenticed at

thirteen years of age in the workshop of the Ghirlandaios, he was seldom in the household. And then, two years later, he went to live in the big Medici palace on the Via Larga, and saw his step-mother only once in several months. She did not intrude into his world. He seemed to see her always quivering like some caged bird beside the stove, the glint of the copper pots on the wall over her head, her hands fluttering aimlessly across her bosom while Lodovico thundered maxims. Poor Donna Lucrezia!—she was always kind to him in her ineffectual way. Always clearing her throat and trying to spit like a lady.

The only other woman had been his wet nurse at Settignano. He scarcely remembered her—Mona Clara, the stonecutter's wife— neither the rude lineaments of her face, nor her ample flowing bosom. Of Settignano he remembered only sounds: the unceasing *tchck-tchck-tchck* of the stonecutters, the *tchck-tchck-tchck* of the chisels all day long—*tchck-tchck-tchck*.

Birds in a stone forest. White dust. And evenings of a sickle moon, thin as a lemon-paring.

So now, as Baldassare's daughter began to tuck her little birdlike hands in the voluminous folds of her skirt, and smiled that disturbing little smile at him, he trembled. She wanted to know what were his first impressions of Rome? He tried to tell her, blundering, his tongue all knots. The spice-smell was growing stronger every moment; he thought he would faint. What was keeping Messer Balducci? Why did a notary have to bring documents at this hour of the night?

The girl was insisting, with a nudging melodious voice: What did he think of Rome?

What could he say? He had just arrived, by God's help, this day.

Well, his *first* impressions . . .

So he told the girl—reaching for the first subject that came to mind so that that tiny pulse in the throat, ticking like a clock— *tchck-tchck-tchck*—might not hammer so in his ears—he told her of the Moor and Cursetta. And telling it, he was suddenly ashamed to be telling such a tale to a maid, and his ears reddened.

"And then, Ser Buonarroti? . . . Is that all? . . . Are you warm? . . . It *is* a sluggish night . . . How red your ears are! And pointed like a faun's! . . ."

She was not scandalized. She had to hear it all. For though he tried to stop midstream, he could not; he could not struggle against that soft relentless current of her curiosity. He had to tell it all, every lurid detail. And with the telling, Bianca became quietly excited, her little mouth broke open and he could see the gleam of teeth in the

candlelight, her bud-bosom heaved, her fingers folded and unfolded in her lap.

But she pretended all the same to a sophisticated calm. Like any woman of the world, without flinching, she listened to his stammering account, and when he had done, she calmly remarked: "But of course these public women must be curbed. They have simply gone beyond all bounds. Do you know, Messer Buonarroti, how shameless they are?—"

He was on the brink of denying vehemently, too vehemently, any knowledge of the subject, but her question had been rhetorical.

"Why, one day walking with Father by the Pantheon, two of those creatures emerged from behind the pillars—right out of a nest of cats—and made lewd proposals to Father. Both of them right in my presence! The city is full of them; there are, I am told, more than five thousand and every day hundreds more arrive from the provinces, from France, even from Spain. Why, they have taken Santa Maria Egiziaca as their patron, on the excuse that she too had been a prostitute before she became a saint! And do you know where they have the audacity to worship her? . . . You do not? . . . In the ancient temple of the Goddess Pudicizia . . . the Goddess *Modesty!* . . . Oh, the poor are bad enough—shameless creatures—but the courtesans, oh my dear young Messer Buonarroti" (her girlish voice incongruously arch now), "you do not know the courtesans. Your Fiorenza has nothing like them—with their pompous names of Fulvia and Olympia, and their Lybian slaves and their monkeys and their marble-paved damask-walled apartments. And because they are accomplished in playing musical instruments and compose poetry and presume to discourse on Plotinus and the doctrines of the Church Fathers, they—they—" Her voice broke in indignation "—why, they have ensnared the weak hearts of some of the finest sons of Rome."

He did not question her indignation but there was in it, he thought, a motive less than lofty. She had cocked her head in a rather haughty way now, she was sitting very upright in the high-backed chair, her thigh was outlined in the skirt. Of a sudden he remembered the Moor's thigh and began sketching it in his head.

"You are silent, Messere," Bianca said, her voice edged with malicious humor. "Am I to interpret your silence as sympathy with these —women?"

She had, he thought angrily, a curious nudging desire to embarrass him.

"I know nothing about the subject," he said harshly. She laughed again—a lower register of the harp, a trickling sarcasm.

He wished desperately that she would talk about something else. He was twenty-one and he had never known a woman. The female flesh he had most lately touched had been those of the dissected dead at Santo Spirito. He would not join Francesco and the other boys on one of their laughing visits to the Stinche, that rectangular stews where public prostitutes had been housed ever since the Duke of Athens' day. Every time Michel stepped out of his father's house on the Via Bentaccordi, he could see that huge brown building moldering against a clean sky, and he would be drawn by curiosity and repelled by revulsion. Turning quickly in the opposite direction, he could see the stone stalk of the Palazzo dei Signori at the town's center. Oh, how he envied Andrea his friendship with Bartolomeo's sister Tsiporah, that Spanish girl, whose accent was so curiously sweet, a sheepsoft slushing.

If only he possessed Andrea's charm. But Andrea's charm was to give himself and Michel could never give himself.

Nor would he join Torrigiani's expeditions to available ladies. The thought of purchased love sickened him. A certain finickyness of temperament repelled him in advance from these carousals of his companions. His ego was a proud bubble that would not break. The same stubbornness that would not be swept away in Savonarola's sermons, refused to lose itself in orgiastic delights. Some vague ideal of the Ideal which he, unschooled in philosophy, had absorbed from the neo-platonizing of Lorenzo's circle—floated in his mind. And it was an Ideal that could maintain its purity only insofar as it was not realized: every realization being at once a coming-down, a tarnishing.

And so the real forms of women which drew him with a terrible attraction were at the same time always inferior to the ideal forms of his imagining. Fearing the actual, he turned from it in contempt and accused it of vulgarity. Fearing to sin, he was guilty of the sin of fear.

Whenever one of the Ghirlandaio girls came to the workshop, and the other boys would preen like gamecocks, painted (and painting), he would withdraw to the back of the shop and furiously grind pigments. He was terribly ashamed of his short stature (he was of middling height), of his broken nose (which lent a woodland charm to his features), of his flat small eyes (which possessed a penetrating fire). He imagined himself far more ugly than he was. His tongue, when it would speak the flattering words, rattled like his uncle's wooden-wheeled peasant cart over rough roads. He envied the easy way the apprentice boys performed before these visiting maidens.

There was Renzo, scratching an air on a rebec, while Carlo sang and the others danced in and out among the pots of paint and gilded altarpieces. Both Masters were away at San Gimignano where Master Domenico had received a fine fat commission from the Franciscan monastery. How lovely Carlo sang! And he, who had such a passion for music, could only croak like a crow! Morosely, venomously, he ground the clove-scented ochre. Dust rose in a yellow cloud; he sneezed.

He was twenty-one and he had never known a woman. So, looking now at Bianca Balducci with her head cocked and her pert inquiry, he wanted to flee. Because soon he knew he would become dizzy with her perfume and the sharp forms of things would dissolve. He hated the sensation. He had to contain his world within hard lines. Else he would drown in the chaos of it. It had happened to him too often, when, his loins aching, he felt he would burst if he did not lie with a woman. And it was at such times he had experienced that sensation which he feared: the dizziness which swept over him as if he were about to faint from hunger, the quotidian world dissolving into a miasma of desire, the known boundaries of objects, things, the firm familiar outlines of Fiorenza's palaces, the shapely church towers and campaniles, the roundness of the wooden plate on the table, the known too-known faces of his father and his brothers—all this becoming a blur, melting into the hot fog boiled up by his want. The real world undulated, wavered, pullulated, the landscape was an obscenity of mammalian hills and pubic groves . . .

Then Francesco knew and he laughed, and once he prevailed upon him to visit the Stinche. Michel found himself alone with a girl of fifteen, with tiny breasts, hard as buds, and a belly golden with fuzz. She was ignorant but gracious and she had been taught by her mother. She sought to accommodate him but he was like a plum too ripe. As soon as she touched him, he fell from the branch and burst. Then, he wept, cursing, while the girl sat cross-legged on the bed, perplexed, gazing at him. Even in his misery, something in his mind fixed that curious gesture: the thin ivory flanks cross-legged, the small pathetic head cocked, the ingenuous child-sad eyes.

He never went again. He was sick all that day and locked himself in his room. That short bumpy-bridged nose, the ridged forehead, the dirty eyes staring back at him from the mirror filled him with distaste. He smashed the mirror. Oh, if only he possessed Granacci's grace, Andrea's beauty, a froth of curls, a noble neck. He who loved beauty so much that he suffered from its presence almost as much as he suffered from its absence, he who needed desperately to love

and be loved—condemned to go through life with this face of a satyr!

That night he dreamt of the Virgin. And she was very young and very beautiful and his arms went out to her, beseeching, but when he approached, she faded away, and her features were lost in milky cloud. And then when he dropped his arms in resignation, she emerged again, and her face was calm, impressive, she wasn't angry that Donna Lucrezia had usurped her place and she reproved him for thinking ill of Babbo. And all the while he felt a warm contentment, pressed against her breast, but he couldn't see her face now, it was vague, looking away, lost in clouds, a milky unfinished disappearing-ness. And he tried to see what she was staring at out there in space, something that gave her such a silent sweet pleasure. And he longed for her but the Magdalen was smiling ever so slightly, letting down her long peach-fuzz colored hair that was Donna Lucrezia at night fluffing it over her shift and still she did not look at him. Then she was seated cross-legged on the bed. He woke violently.

And there were other nights of falling from Arnolfo's tower into the jaws of the heraldic lion.

Then he would waken in a sweat, his head roaring with pain, and range the streets, often as far as to the round of walls, there to be challenged by the sentry, and all night long hear the bells proclaim an ordered sanctity.

And now this girl laughing like that—worse than the bells . . .

Baldassare saved him. He re-entered, smiling at the spectacle. He knew his daughter, and although the specific subject of conversation between the two young people was unknown to him, the cause of Michelangiolo's discomfiture was obvious.

" 'Tis time you went to bed," Baldassare said sternly.

Without a word, Bianca rose, kissed her father on both cheeks, and bade him good night. At the door she spun around and curtsied, her skirts blossoming with the motion. Her swift departure left a fragrance in the room. But the manner of her obedience—the half-humorous acquiescence of it—made it perfectly clear that she had obeyed so promptly merely to preserve a fiction of parental authority. It was a game they both played: Baldassare's part in it flickering at the corners of comically stern lips.

And Michelangiolo was suddenly struck with a jealous pang. There was no such play between Lodovico and his sons. Father's love seldom bubbled to the surface so. It was a hidden spring; of course, it was there, deep and pure (who could doubt the natural affection between fathers and sons?). But never did Lodovico reveal it, never

did he put by the official manner that went with his rose-red cloak, never had the filial kiss melted his ice-locked eyes.

The two Florentines talked on until the nearby campanile struck three. Michelangiolo told Baldassare of his encounter with the Cardinal, and Baldassare laughed.

"You need not have been so nervous," he said. "All the energy of the Cardinal Riario is consumed in the construction of his new palace He has summoned Bramante to Rome, and is undertaking the most colossal private residence in the City. Did you think so great a prince would gobble you up because you had deceived him in the matter of a false antique?"

"He denied that he was ever deceived."

Baldassare's fingers flicked against his chin, his smile a wee scimitar of disbelief.

"Of course he would not admit it. Besides, the affair really no longer concerns him. He's got his money back from Messer del Milanese and Milanese has the Cupid again. Messer Popolano"— he could never repress the sly expression that accompanied every mention of the Medicean pseudonym—"writes me that he wants the statue returned to him. Tomorrow we shall go together and see what can be done. Meanwhile," and he rose, wrapping his long robe around against the night chill, "dreams of gold."

Michel dreamt of Bianca. She was naked, of young adorable flesh. But her arms, imploring, with broken fingers, were of earth-stained marble.

V

The dealer was furious.

He had one of those uncontrollable tempers that explode at a mere questioning glance. A conversation with Messer Baldassare del Milanese—if one could call it a conversation—was a series of eruptions, splutterings, fist-poundings, splatters of saliva, eyes heaven-imploring, and a firecracker string of Trastevere oaths.

Michelangiolo and Baldassare Balducci had arrived at the shop

early in the morning. The shop was located near the Via
Flaminia; ruins of an ancient sepulchral pyramid cast a wedge-shaped
shadow upon it; the quarter was dominated by the abrupt cliff of the
Pincio, cultivated with vineyards until the rock went vertical. Nearby,
the green Tiber ran. As in so much of Rome, it was as much country
here as city: turreted towers nestled in green turf and bushes; sheep
were grazing amiably on the verdure-carpeted steps of a roman-
esque church.

The antiquarian was built like a windmill: he stood planted and
swung his arms about. He seemed to bristle from all quarters: the
shock of jet-black hair, the biforked angry beard, the belligerent
eyebrows, the crackling black eyes. He spluttered saliva as he
talked: a garlic-scented spray. At the door of his shop, cluttered with
statuary—broken-armed Apollos, headless Aphrodites, languid Ledas
—porcelains, terra-cotta jugs, Assyrian coins, glazes of Limoges, manu-
scripts of pergamum—the choleric antiquarian stood guard like a
barking snapping Cerberus.

He did a good business with the great men of Rome—particularly
the princes of the Church—for the rage for antiques was now at its
height. Cardinals vied with each other in building up great collec-
tions: in ecclesiastical palaces wing-footed Hermes leaped jocundly
beside the Man of Sorrows; pagan gods, marmoreal and cool, gazed
serenely at tormented saints roasting on gridirons or with skulls split
by axes, or with bodies stuck full of arrows like a pincushion. To
serve these Greco-Romanizing Christians, merchants such as Baldas-
sare del Milanese had sprung up all over Rome. Among them were
genuine lovers of the arts as well as a number of others whose chief
interest in the discoveries was the opportunity to make a profit.

While the dealer was reading Messer Popolano's letter which Mi-
chelangiolo had presented, the young sculptor was peering through
the dimness of the shop. Finally he saw what he was looking for—
gracefully reclining against the wall next to a Hermaphrodite; and
seeing it, he smiled with the pride and affection of a father seeing
again his wandering son. Yes, the sleeping Cupid—with its artificial
stains and carefully contrived scratches and chips—possessed all the
harmony of these disinterred works among which it reposed; had he
not known it for his own, he would surely have assumed that it too
had been dug out of the earth . . . The right arm, of course, could
be bettered. He should have brought the line of the scapula
around more boldly, that would have accentuated the tiny bump of
the shoulder bone, there would have been more tension. A more in-
teresting result: a tense sleeping . . .

A volcano rained fire into his meadowy meditations.

"—return the Cupid! And why should I return the Cupid! Did I not pay for it?! Thirty golden ducats! I have papers to prove it! Thirty golden ducats! The transaction sealed and legal! Thirty golden ducats! I was the one who was cheated, not that pig of a false-named Medici!"

"You were not cheated," Michel said, himself taking fire from the dealer's flame. "The piece was sold to you as an imitation. So you were advised when you purchased it. And you resold it to the Cardinal for two hundred ducats. As a genuine antique."

"That is my business."

"Surely it is not your business to profit on my art."

"*Your* art?"

"Messer Buonarroti carved the Cupid," Baldassare said calmly.

The dealer glared at Michel, his black eyebrows arched, a glint of admiration in the churned-up anger.

"Ahah. It is not bad. A worthy imitation. If you have others I should like to see them . . ."

"Not until I get my Cupid back. For which I am authorized—as you see in that letter—to return you your thirty ducats."

"Listen, Florentine!" the dealer roared, "I have already been forced to return two hundred ducats to the Cardinal. And now you would recompense me with thirty!—"

"But that is exactly what you paid," Baldassare said. "You lose nothing. You get back what you—"

But the dealer was apoplectic again. His whole squat frame was trembling, the windmill had been seized in a tempest, the arms churned, the body shook. His beard, his hair, his eyebrows seemed charged like the stroked backs of cats: bristling, individual, each separate hair stood forth, the pupils of his eyes had turned red, like the needles which the barber-surgeons held in the fire. He seized an iron porcupine-headed Crusader's mace that leaned in a pile of bric-a-brac near the doorway, and shaking it threateningly over Michelangiolo's head, he shouted:

"Listen, you Florentine dogs! Before I return that Cupid, I would —I would—"

Fury-choked, he could not go on. Michel and his friend had retreated from the madman, lifting their arms to ward off the hail of blows. But the dealer was not looking at them now, he was searching wildly about the shop, and at last he found it, and ran over, swinging back the mace—

"No!" Michel screamed, "No!" shocked at the sound that issued

from his throat. His scream froze the dealer's attempted assault. He stood now in furious action suspended, the mace drawn back and trembling over the Cupid's innocent head, Michel and Baldassare frozen too, their arms upraised, their bodies arched like crossbows against the imminent splintering destruction. So they all stood a hung moment—an interval arrested, timeless—like a battle of centaurs fixed in a frieze, marmoreally gripped, furious hooves stamping in a soundless space.

And then the dealer grinned, horribly:

"And who is to stop me?—" the toothed rusted ball of the mace moved back a fraction, quivered. Michelangiolo paled, he was afraid to breathe. "Eh?! *Who?*—"

"Most respected Messer Baldassare—" his namesake was speaking now, the voice silkily snaking so as not to slip the stone that hung at the lip of the cliff—"most respected Messer Baldassare, we pray you put away that mace. It is not an easy thing for a young sculptor to see his work destroyed. Per carità . . ."

Again the dealer smiled his horrible smile.

"I wish merely to demonstrate that it is no longer *his* work. I bought it. I have documents to prove it. And rather than give it back to your Messer Pierfrancesco de' Medici-Popolano, I would smash it to a thousand pieces! Do you understand? Now, out of here, both of you! Via!"

Oh never had the blue dome of heaven seemed so blue! They stopped at the Tiber bank and Michel stooped to cool his sweated face. His whole body was trembling with the encounter. He and Baldassare had not exchanged a word after they left the shop. He had clutched the older man's arm and felt it trembling too; they had stridden in silence across the grassy meadow that was the Piazza del Popolo and then through crooked streets under slanted wooden buttresses. And Michel's thoughts were sweeping along in a black river, storm-swollen, floating with debris of shattered assurances, wrenched gardens of certainties.

His work! Accidenti! How dare the dealer speak of the work as *his*? Was not the Cupid born of Michel's hands? And had the dealer, by the mere payment of thirty ducats, the right to destroy what he had never created?

But he did, of course he did, Michelangiolo thought bitterly. There was surely no great difference between one artisan and another. The shoemaker relinquished control over his shoes, the tailor over his garment, the carpenter over his credenza. No matter how cunningly carved. No matter how much love had gone into the making. *Caveat*

factor. Let the maker beware. And once having bewared, the bargain struck, the price agreed, the product delivered—the possessor might do with it as he wished. He might enjoy or destroy.

They went down the Via Ripetta until they came to a little gate on the Tiber where boatmen paid their toll. Nearby rose the mossy ruin of Augustus' tomb. Michel saw broad-cheeked men who spoke a slushy strange tongue, hacking the ancient marble slabs out of the tomb and conveying them mule-back to a pit where the marbles were being ground into limestone for a new construction. "The Hospital of San Girolamo," Baldassare explained. "These people here are all Slavonians." They continued on, past a great garden where an obelisk lay in a bed of grass, toward the center of the city. Baldassare had to return to his .bank, and Michelangiolo had been summoned once more to the Cardinal's. That morning a messenger had called with a note.

They parted at the portone of the bank. Michel was in a morose mood, brown and frowning as the stones of the huge archway in which he stood. "Tonight I shall write to Ser Pierfrancesco how matters have gone with our Cupid. I fear we cannot hope to persuade that madman—"

"It doesn't matter," Baldassare said, laying a paternal hand on the young sculptor's shoulder. "There will be many more commissions for you here. Gallo has spoken again about the Bacchus. Perhaps the Cardinal is calling you for a similar reason—"

"I dare not think. He has that devouring look in his eye."

"As far as the Cupid is concerned—" Balducci shrugged his shoulders.

Michel turned to his friend. His horn-colored eyes were troubled, question-brimming.

"But does he have the *right*? Does he really have the right to destroy my work?"

"I am afraid he does, caro mio."

"Are we no better, then, than shopkeepers? I have always hated that. I have never been able to accept the notion that some day I shall keep a shop like my Master Ghirlandaio, painting shields and garlands on wedding chests, and any other odd commissions that come my way. Do you know Maestro Verrocchio's studio near the Old Market? He's dead now but they're still carrying it on the same— a dozen apprentice boys all day long decorating sword handles, coloring gesso Madonnas, why, I am told he even designed the sugar cakes for the wedding of the Magnificent and Clara Orsini. And all

that is supposed to be the natural obligations of an artist. Porcami-
seria! I find it distasteful! I cannot tell you how distasteful."

He kicked a pebble from the path.

"I am no pastry-maker," he said dourly.

Baldassare laughed. "Oh we are all pastry-makers in one way or an-
other. What difference does it make? Amass the florins, amico, and
then you will be a lord. You have heard of the famous Chigi of
Siena? Yes? . . . Well, this same Chigi is closer to the ear of the
Holy Father than any other counselor, except perhaps the Cardinal
Cesare himself or yellow-haired Lucrezia. His Holiness declares no
war, grants no absolutions, signs no treaty without the yea or nay of
this mighty Sienese, Ser Chigi. And do you know wherefrom he de-
rives his power?"

Baldassare rubbed his fingers together. His thin lips were curved
in that wee blade of a smile again.

"Ducats, my boy, many ducats. Five hundred galleys on the seas.
He has lent Alexander so much money that he partakes, one might
say, in the Papacy without a tiara."

"What has all this got to do with my craft?" Michel asked simply.

"Everything. Here in Rome you must learn to deal with these great
lords, and to deal with them you must know what they are. Your days
in the Magnificent's garden are finished. There is no one here to pat
you gently on the head. You are far more likely," Baldassare added
with a kindly and melancholy air, "to receive blows. You are living in
the city of the Borgia, figlio mio. Here you must learn to be as agile
with a dagger as with a brush."

Michel felt his bowels turn over at the calm words. He was timid,
he feared bodily contact, he had always avoided strife. This was the
city for a Torrigiani, not for him. A dagger for a brush. A taste for the
stews. By contrast with Rome, the Stinche was a field of flowers. And
he had been sick then. What would happen to him now in the big-
gest brothel of them all? Why, even in Fiorenza, where the noisome
stench was somewhat distilled by distance, the bizarrerie of the Bor-
gias was beyond belief. The Holy Father and his eldest son, Cesare
—whose tonsure was practically invisible, and who dressed more often
in silks and armor than in ecclesiastical robes, and spent most of his
time in the chase, either of boar or women, always mounted for a
hot encounter—this twenty-three-year-old Cardinal was said to be
competing with his brother, the Duke of Gandia, for the favors of
their sixteen-year-old sister, Lucrezia, and there was another, unmen-
tionable suitor. As for blond Lucrezia's husband, the Count Gio-

vanni Sforza—so said the Roman wits—he had the choice to be either cuckold or corpse. Three years ago he had wed Lucrezia (she was scarcely thirteen then) at a great ceremony in the Vatican before the Pope and his concubine, the beautiful Giulia Farnese, after which the Pope accompanied the young married couple to their marriage bed and was present at the ritual disrobing. Since then, the Count was more often out of Rome than in it. Apparently he was willing to forgo the thrusts and parries of Lucrezia's bed to avoid the thrusts and parries of Cesare's blade.

Impossible to disentangle the skein of filth.

And now he was at the very mouth of the gilded cesspool. The air was purple with corruption. ". . . *And what do these fat kine signify? . . . the whore of Rome . . .*" Fra Girolamo's words. Here, in this holy city, if he but learned to wield a knife, he might be permitted to wield his mallet and chisel.

A simple matter of developing that sad cynical little smile of Ser Baldassare.

That scimitar-smile.

VI

His Reverence, Raffaele Riario, Cardinal di San Giorgio, had apparently been waiting. For as soon as Michelangiolo had sounded the bell outside the great lion-crouched portone of the half-completed palace, a servant appeared and led him at once to the Cardinal. He was pacing back and forth in front of the gold-embroidered arras, tossing the stiletto-letter-opener up in the air and catching it skillfully by its handle.

"Ah, young man," he said blandly as soon as Michel appeared in the sumptuous apartment. "You are like most artists, I note."

Michel cocked his head in silent inquiry.

"Always late," Riario explained with a feathery smile. "But it's no matter. Come along with me."

Following the swirling devil-red robe that flew ahead of him, Michelangiolo wondered what this summons might mean. His

curiosity was no longer shot with fear; the Cardinal's greeting had dissipated his misgivings at once. But it was strange all the same to have sent so early in the morning a servant to his quarters. Apparently a matter of some importance.

Room after room he followed after the crimson cloud flying ahead. The palace was immense. The floors shone with polished marbles in a variety of intricate designs; fine tapestries opened warm out-doory vistas into the stone walls.

Finally, the Cardinal stopped. They were in a great salon: all around, wherever Michel turned, stood pieces of antique statuary. Amidst a forest of stumps: fluted columns, corinthian capitals on pedestals—a host of pagan deities disported, serene and elegant, in their white uncorruptible flesh.

The Cardinal paused before a Diana, his right hand with its two ruby rings resting lightly on the figure's cool thigh.

"I brought you here," he announced, "to show you my collection." Pride was evident in his voice. "I think I may safely say this is the finest collection of ancient art in all of Rome. And I am interested— I am always interested—in the judgments of a sculptor."

"You are most kind," Michelangiolo said. He spoke with genuine humility. After all, he *was* only a young man; what had he achieved, he thought—his eyes hungrily sucking in the milk of all this marble— what had he achieved? The Battle of the Centaurs? The Madonna of the Stairs? The imitation Cupid? But they were all imitations, he told himself impatiently. Imitations of poor imitations. For what the Magnificent had in his garden or even in his great house on the Via Larga were shadows compared with these gods before him now. He did not know that these were also Roman copies of Greek proto-types, but he sensed that they were truer—truer in spirit and in modeling to an original impulse. His eyes began to throb. The white-ness was palpitating.

"This Diana," the Cardinal was saying, "was unearthed several years ago in the vineyard of the Circus Maximus. The contadino hit upon it while plowing. You can see where he broke the bow-arm. But the restoration is excellent, don't you think?"

It was indeed; one could scarcely note the crack in the marble. Riario had stepped admiringly back to take in the whole figure; his manner had lost the slightly menacing razor-edge Michelangiolo had noted at their first interview. Now, the personality was entirely ab-sorbed in the passion of a collector; one no longer thought of him as a Prince of the Church or as a great secular Lord; he was a Col-lector and his eyes were shining and he was moving on to another

work now with an eager little hop, his arm already sweeping in pos-
sessive demonstration.

Three hours they passed thus together: the Cardinal discoursing
about every piece with that peculiar passion that makes all collectors
sound as if they themselves had created the works in their possession.
And the young man followed after, lost in his own fantasy, a fantasy
of the fingers, of the body, as much as of the mind. For whenever he
looked at sculpture, Michelangiolo's fingers twitched, his whole body
made involuntary little movements, he felt the cool chisel in his
palm, the mallet in his left hand, his back arched against the stone.
He could never look without *making*; he was an artisan and even as
the Cardinal discoursed about the mythology here embodied in the
stone, Michel was chipping out the articulation of that elbow.

And yet—though his eyes glistened as he followed after the prelate,
softly, gingerly declaring his judgments—he found to his own sur-
prise that his admiration for the works of antiquity was not unquali-
fied. For many of them were, he realized, real and not real; the
Olympian calm of those faces might also be considered blank; the
staring pupil-less eyes of these gods might also be the eyes of the
dead; these Dianas, Venuses, Persephones were sexless all, despite their
nakedness. Who could believe that voluptuous goddess of love was
really covering her breasts against prying eyes? For her breasts were
cold—mounds of snow—her hips contained no passion. And who
could conceive of those male divinities in the act of love? . . . No,
they all moved in a peculiar anemic medium beyond the senses:
their expressions, Michel thought—taking pleasure in this private
debate with that Attic-worshipping bulging-eyed tutor, Maestro Poli-
ziano—were quite as vacuous as deific. There was a languid, some-
what melancholy air about all of them, a passionless purity as re-
moved from human striving as marble was from flesh. He admired
them, as a workman he marveled, but now for the first time seeing
these creations in abundance, one after the other, he knew that he
wanted something more—Aphrodites that really yearned, Apollos that
really bled. Among all these nude goddesses there was not a single
Bianca. He reddened at the thought which had pranced into his
mind with indecent haste, and hoped the Cardinal did not notice.
But the Cardinal was too busy admiring a Mercury that leaped on
marmoreal toes into still vibrationless air. What did he think of this?
the rippling of the back particularly? Wasn't it a marvel? It is said to
be a late Roman copy of a work by Myron. At least, so declared
the bristling-with-learning academician Pomponius Laetus. Of course,

all that knowledge was of no concern to a stonecutter. But as a stone-cutter, simply as a stonecutter, how did the piece strike him?

Michelangiolo told him.

Afterward, they sat in the study again, and the Cardinal, whose saturnine jowls were flushed now and whose eyes sparkled with excitement, made a little cage of his hands, fingertip against fingertip, and asked:

"Now that you have seen, do you think you might fill in the gaps? The Minerva for example. Can you make me a Minerva that might stand beside those others?"

"Better," Michel said sharply, his voice cracking like a whip. But he did not say it aloud. Aloud he said—

"Most Reverend Cardinal, it is not likely that any living man could hope to better these marvels of the ancients. But if it be lawful to rate one's talent—"(the private voice, the arrogant whip cracking now, he could not keep it down, it was cracking amidst the soft soggy humility) "—at its true worth—and I speak of works; not aspirations—then I may perhaps hammer out a figure of stone that would not be ashamed to stand even in this celestial company."

The Cardinal listened with amusement. The oblique twists and turns of the reply . . . oh yes, there was a fox lurking in this rustic's mind. Of course the twists and turns were clumsily carried off; the young man had not yet acquired the kind of polished indirection the Cardinal was accustomed to encounter in his circles. But the intelligence was surely there, he could see it watching him warily out of the pale gold-flecked eyes, a rustling of suspicion in the underbrush.

"Very good," said the Cardinal. "Then you shall have the opportunity. The contract will be drawn this week."

"There is no need for a contract, Monsignore. I consider myself honored merely to have such a work requested of me. And to think that it will stand here—amid such company."

"My son, the honor I do you—if you choose to consider it that—will be lessened in no way by the assurance of a contract. These agreements should be drawn up in a businesslike way. You will work here. You have no objection to setting up a shed in the cortile of the palazzo?"

"You are most gracious. The surroundings are more august than—"

"Oh, enough of that," Riario cut him short with a jeweled wave of his hand. "I want you here that I might conveniently look in from time to time to see how the work is progressing."

VII

He found a block of travertine in the studio of the Pollaiuolo brothers and had it transported to the shed. The block was not perfect. For one thing, this local stone was softer than the Carrara marble in which he was accustomed to work. This had a tendency to crumble, its pale grainy flesh was seamed with greenish-black veins like some kinds of goat cheese. Working it, his chisel would suddenly sink into a soft black carious mass wherein he could see forms of leaves or skeletons of fish which had died millennia ago. But these were not the figures he sought; these imaged the real and he was searching for shapes that existed only in his mind.

Sometimes he pursued this shape so ardently the shed rang with blows like a blacksmith's shop and his fingers bled. But this Roman limestone was too soft; it failed to offer the resistance he needed. To surmount obstacles, to hammer his passage to the creature sleeping in the heart of the rock—that was Michel's way. His dreams were always encased in obdurance; and hacking inward to them he felt an ecstasy beyond all weariness. Only to project *in petto* did he sometimes model in clay, but the act itself, the soft yielding stuff, gave him no pleasure. His mind needed resistance as the hammer needs an anvil to set off sparks; he would have rewritten the initial act of Genesis and put a mallet in the Creator's hand.

Apart from the mollescence of the block, it had already been worked by an inept or impatient hand: Michelangiolo could vaguely make out a carving, an amorphous something, scarcely blocked out. His first task was to chop away all vestiges of his predecessor's work and then smooth one face of the stone for his frontal sketch of the Minerva. He was like a monk writing over the palimpsest of an ancient faded parchment.

The stone rendered virginal once more, he transferred his full-sized sketch to the face of the marble and then set to work. Days passed happily in the shed: only when he worked did he know true happiness. The chipping sound of the mallet and chisel was the music that moved him most; sometimes his hands flew and great gashes of stone leaped from the block; he even accompanied the hammer's tympani with a rough-voiced song of uncertain pitch. At midday, white with dust, his palms aching from four hours of gripping the sweaty chisels, he would step outside into the courtyard and rest a while among the

columns pillaged from the Circus Maximus. They were gray columns, flecked with orange-gold like his own eyes, slender with just the suggestion of a bellying curve like young maidens, a stately formalized dance.

And sometimes—weary, dreaming—he would lean his cheek against the chill smooth columns and they would speak to him as stone always did. They spoke of the cruelty and courage they had witnessed in the arena, of nights when the huge deserted stadium had seemed a graveyard; its white marbles lambent in the moon, its copper cornices glimmering with a dull diseased light, uric, bloody . . . And they spoke of the roar of the plebes and the roar of the lions, and of the blond-bearded barbarians that came later from beyond the Alps with their leather shields and how they sacked and pillaged and burned, and of the slow soft silt that fell upon them—lying now— over the centuries, slow and slow and soft and soft, time's featherbed —and how their eyes looked upward ever through the dust at the same hard blue sky, the same star-pocked night, the same seductions and murders over their heads.

All this the columns spoke, risen again in the cortile of the Palazzo Riario.

It was only partly completed, this palace, but already it was the most awesome private residence in Rome. Not far from the winding Tiber amidst green fields and country cottages it loomed like another Tomb of Hadrian—a tremendous rectangle of rustic stone blocks, the lower storey already worked and embroidered with stone flowers, a great doorway over which lions crouched, and barred fortress-like windows.

Standing amidst the half-risen grandeur of this courtyard during his noonday rest, under a sky that looked lapis lazuli, precisely boxed between the cornices, Michelangiolo felt an exultation he had never known in his native Fiorenza. This Roman earth was so rich, he thought, rich not only with statuary but with all that men had dreamed and done. It resonated like a great bell when you walked on it—you heard all Time ringing.

Michel was proud, as all Tuscans were proud, of his own country. But yet he was happy to be here. Here there was no Lodovico to lecture him, no Piero to humiliate him, no Fra Girolamo to frighten him and make him doubt his art. He was alone, he missed his companions—the bland fripperies of Francesco, the sweetness of Andrea the Jew, Iacopo's boisterous crudities. Iacopo would be in Rome soon; he was planning—according to a letter from Il Cronaca—to become a journeyman in the workshop of the Pollaiuolo. It would be

wonderful to have him here: his red hair was a tonic, his laughter a rumbling affirmation.

But now, alone though Michel was, at least he was free, he could concentrate on his art. And ever since the fall of the House of the Medici, he was happier away from Fiorenza. There was little work for artists now under the grim dominion of Savonarola. Too many Weepers—the party of the Friar—suspected the esteem Michel had once enjoyed under the Magnificent. Even the many months he had spent away in Bologna had failed to allay their suspicion. He had come home to find the mood even grayer. Many painters had become ardent followers of Savonarola—Baccio della Porta and Lorenzo di Credi and even the *stravagante* Master Sandro Botticelli. Some of them even talked of assuming the cowl. The atmosphere was much too grim for art. The only art this Friar would accept was that which prepared the soul for repentance. Michel was glad of the chance to leave again after only six months at home. Had there not been the business of the Cupid he would have found another excuse. Even Lodovico approved of his departure, Ser Lodovico, who usually held his sons restricted within his embrace like drawn laces of a jerkin. "Well, then, go to Rome" he announced at last after the usual half-hour of homily and homeopathic advice (the Cardinal's emissary had just left the house). "Go . . . and take precautions for your health, else in this enterprise of stonecutting you will not earn a scudo. I will manage although my eldest sons forsake me one by one . . ."

Cool-cheeked against the column, Michel recalled his father's voice, the curious authority and whine in it, the stubborn peasant calculation and offhand airs of a government official, the independence and dependence. ". . . and if you cannot send me money, don't fret. I shall borrow from the Monte" . . . knowing full well Michel would sell himself into slavery rather than have his father borrow from the Public Loan Office. No, he thought happily, Lodovico will not have to borrow. I have already received this commission from the Cardinal. Rome was aboil with great enterprises; there would surely be work for him. Palaces like this were rising crazily all over the city, and although the Pope Alexander VI was hardly to be compared with his predecessor Nicholas V in the matter of enriching the Urbs, yet even he—the ineffable Borgia—had moments of concern for his adopted city. He was decorating a new series of apartments in the Vatican; he had reconstructed a gateway of the Aurelian Wall and even repaved some sections with square bricks plundered from the ever available ruins. New streets were being pushed through; old quarters razed; the Popes were ruining the ruins, laughed the

Romans; the Colosseum was being pillaged like an open quarry for its marbles; pagan columns lined most Christian naves.

Afternoons, his body aching, Michel strolled about the city or sometimes visited Baldassare in his bank and accompanied him home. He would not admit that Bianca had anything to do with this, but as soon as he was in the girl's presence he began to tremble and he knew what magnet had drawn him.

She was always laughing at him: into the suckling dimples of her cheeks he would sink in confusion like a ship caught in a whirlpool. The candid burgeoning of her breasts in the tight-laced green bodice set him bumbling for the door.

"Why, Ser Michelangiolo! You have scarcely arrived! Surely you have time for a cup of wine! Father, prevail upon him . . ."

And she was laughing laughing with those little white teeth, a nipping laugh, up and downscale, scampering fingers on the strings.

He stayed sometimes. There was no withstanding her. And Baldassare in his black cloak humorously seconding her appeal. He liked the awkward young man; the letters from their joint employer had urged him to look out for him; and it was not difficult for him to understand why those knees, sturdy as olive roots, were knocking knobbily in the rude tan peasant stockings. At the right moment Baldassare always left the room on some pretended errand.

One day Michel was talking to the older man about the current Borgia scandal, when Bianca came into the room. He did not recognize her at first, her black hair was brilliant gold. He felt entrapped in a shining net. So she had received her father's permission at last to dye her hair the prevailing blond. She had plucked her hairline too, so that the brow rose higher, rounder. Michel could see the irritated red line of the forehead where her hair had been depilated with tweezers.

"You are staring, Messer Michelangiolo."

"Oh, excuse me. I was only admiring the new color of your hair."

"Do you consider it an improvement?"

"That is hardly a fair question," Baldassare said with an affectionate rasp. "You place Messer Michelangiolo in a position where he would deny the perfection of your previous, more Moorish state. Now go sit there and be still. Don't you see that we are two gentlemen in conversation?"

She moved softly away with that imperceptible jest of obedience. Michel could not take his eyes off her. That new radiance wafting down her back, artificial of course, artificial as the spun gold hair of Maestro Sandro's Madonnas, or the long luminous tresses he had painted on that naked Venus in the Magnificent's apartment . . .

Yet it was surely lawful to improve upon nature? A secular halo, he thought. Though Bianca was hardly a saint. But all saints were golden-haired, at least as the Blessed Angelico rendered them. And God the Father too. And His Son. All golden-haired in a golden radiance. She was sitting down now, lifting up her skirt in a flaring movement so that she might crease only the petticoats.

"But do you believe that they will really go through with it?" Baldassare asked, resuming their conversation.

"Oh . . . I" From the corner came plucked sounds like water drops. Bianca was idly tinkling on her lute. Thinly smiling, Baldassare realized that further conversation was impossible, and he found an excuse soon after to leave the room.

"Then it is true, Messer Michelangiolo?" Bianca asked, brushing an indolent chord.

"What?"

"That Madonna Lucrezia intends to divorce Count Giovanni Sforza?"

"I know nothing about the matter."

"Of course you do. I heard you speaking to Father about it when I came in."

"It is only gossip."

Bianca smiled. She had her father's tiny smile, not quite as sharp. She enjoyed baiting this talented bear. She was only sixteen but so much more sophisticated than he. All this sunny afternoon, she had been sitting out on the terrace, washing and dyeing her hair in a new lotion which her Venetian maid had recommended. What excitement when dear Father yielded to her importunities! Giuliana had prepared the recipe: two pounds of alum, six ounces of black sulphur, four ounces of honey all distilled together with water. Oh, this was guaranteed, cried Giuliana, to achieve the goldenest goldenest filo d'oro which was all the rage among fashionable women. Then Bianca had to remain out in the blazing July sun for hours to fix the tint. So all afternoon on the terrace, she had sat with her brand-new yellow hair spread out like flax drying upon a broad-brimmed crownless hat which at least threw a shade over her face. Sipping lemonade to prevent herself from fainting, while Giuliana sponged her sweating forehead, she had amused herself by listening to the gossip that rose like hot steam from the street below. She knew the Roman gossip better than her father and surely better than Michelangiolo. But she enjoyed the little game.

". . . and the talk is that the divorce will be on the grounds of *impotenza coniugale* . . ." She eyed him with saucy cynicism. "It

would be *too* much, would it not, to expect a daughter of His Holiness to remain bound in an unfruitful marriage?"

"Oh, that is all a lie," he said brusquely. "The Sforzas are no longer useful to His Holiness. He and Cardinal Cesare are seeking new alliances. And once the Sforza is cast off, they can plan a more advantageous marriage for Madonna Lucrezia . . ."

"How clever of you . . ."

"Of *me?* . . ." Ah, she was poking fun at him. He flushed angrily. "I mean, how well you understand these complicated matters."

He growled and thought to turn his back on her. But that would be acknowledging defeat. No, talk, it didn't matter what, talk until Baldassare returned or until he could make a decent dignified retreat. Over her bodice today she wore a little jacket with wide loose sleeves, quite Oriental in effect, falling almost to the floor. Lute in hand, she sat gracefully smiling at him, and he, so sure always of his step in unyielding avenues of stone, was lost now in a pink scented labyrinth. He suddenly felt he hated women: their softness, their yieldingness, their thumbprint-taking clayeyness.

Desperately he looked around the room. Bianca put the lute down and began to toy with the ends of her long hair.

"Father says you are carving a Minerva for the Cardinal Riario."

"Yes, I am blocking it out."

"Does it go well?"

"It goes."

"What a marvelous thing it must be to make the stone breathe! I have seen ancient busts of Roman ladies you would have thought of flesh rather than stone: the marble seemed to pulse—it was so milky, so real—you would have thought blood coursed through it."

And she placed her long tapering fingers on her own very real bust. Her intelligent eyes were laughing at him. There were, he noticed in the light staining through the window casement, hints of darkness still in her glinting gold coiffure. He felt a vague satisfaction at this imperfection of her artifice. The same satisfaction he knew in perceiving marks of the rough stone in the finished statue. The untampered stuff of Nature. The uncounterfeited truth. There was a pleasure in . . . She was asking him what his diversions were? An odd doe-like leaping from conversation to conversation, he thought. He did not realize that the girl was choosing new points of attack simply because he failed to respond to the last.—Diversions? he said, what diversions?—Here in Rome.—I have no diversions other than my work.

At the sound of approaching footsteps, she turned her head. Magi-

cally with the movement, the great tendon of the neck, the gentle V of the collarbone leaped into prominence. It was like the wind writing on a fresh page of snow. Whenever Bianca moved there would be this twinkling and dimpling of the exposed flesh; she talked so animatedly that her throat and bosom always spoke with her: a language of lights, hollows, prominences, ripplings. It was like the surface of a river. He licked dry lips. Then, struggling, he would see all at once, beneath that creamy surface, the stripped-away tissues: red, crisscrossed with wet gleaming muscle-tape, and she was lying nude on the rough plank in the flickering candlelight of Santo Spirito and the Maestro del Medigo was lecturing right under the faded Last Supper and Andrea was trying to attract his attention, he was hissing through his father's lecture, Andrea . . . No, it was Bianca . . .

"I say, did you attend the bullfight last Saturday?"

"I know of no bullfight."

"Oh, everyone in Rome speaks about it. A tremendous spectacle . . . Ah, Messer Gallo, you were there, were you not?"

"Where, my dear?" the banker said in his bland deep voice. The banker had just entered with Balducci. He nodded to Michel as Balducci poured a cup of wine for his new guest.

"At the Piazza Navona when the Cardinal Cesare fought the bulls."

"Ah, that? . . ." He glanced at the girl with odd attentiveness. "I see that our poor Italy has been enriched by yet another head of gold."

Bianca laughed.

"It was the same question every day," Baldassare said, returning with the wine which he handed to the banker. With a silent toast to all, Gallo drank. "I could not withstand her importunities any longer. You would think black hair was a sign of low birth."

"There is no withstanding them . . . any of them," Gallo said. "I remember some years ago there were laws passed by the magistrates against excessive finery of the women. They were wearing false hair in those days piled up to the heavens, twined around and around with braids like the seven-storey mountain of Purgatory, and bespangled with pearls and emeralds and whatnot. As for the cut of their sleeves which were fuller and heavier than a Portuguese galleon at full sail, and of the tiers and tiers of their dresses, and the necklaces and huge ropes of pearls and other fripperies—I won't speak. As I say, the magistrates passed legislation to curb all this which had come in—together with the French disease—with King Charles' troops. And how do you think those fine ladies circumvented that legislation?"

"Yes?" said Bianca.

"They refused to grant their favors to their husbands." Gallo leaned back, rubbed dry palms. "The husbands pressed for revocation."

"Ah, but that's marvelous!" Bianca exclaimed. "But—" and she laid a caressing hand on the banker's shoulder. "You have not answered my question."

"About what?"

"The bullfight."

"Ah, you would hear about that? . . . I would prefer to talk to this young man about the Minerva he is making for the Cardinal."

"Later! Later!" She seemed to be devoured by a demon of curiosity in all matters that concerned the Borgia.

Gallo looked at Balducci who shrugged his shoulders.

"Well, then," said the banker in his slow balanced voice. "I am not of your country but sometimes I begin to comprehend the fury of your Friar. For had your Fra Girolamo been at the Piazza Navona last Saturday he would probably have suffered more torments than the bulls the Cardinal Cesare slew that afternoon. The place was hot and rank with a screeching mob and the whole Spanish cabal in the stands of course watching the Pope's bastard at his bloody work. And His Holiness beaming down from his beflagged canopy with his daughter the Contessa Lucrezia on one side and his concubine Madonna Giulia Farnese on the other—framed in females you might say. The Cardinal put on quite a performance—seven bulls he killed that afternoon, decapitating one of them with a single blow of his sword. And the blood spurting over him like a fountain and he seeming more pleased at it than if he had been bathed in the blood of Christ Himself. After it was over, the Cardinal bowed stiffly, hand on hip, to the roaring crowd—that silly mincing bow of these Catalans —and then paraded around the entire Piazza like a marionette with the bull's ear in his hand. He presented it to his sister of course. A fitting business. His Holiness looking on with his mistress and his daughter and any number of equivocal ladies draped around—oh, I tell you, it was a spectacle calculated to feed your Friar's thunder . . ."

The Florentines were thoughtful, sipping the cold wine. Bianca had put down her cup and was leaning forward, her eyes glittering with excitement. As she leaned forward, the tiny gold cross winked on her bosom, swung like a pendulum in a glinting arc.

"Do they . . . suffer?" She asked in a small voice.

The banker looked slowly at her, his hard lips almost smiling.

"The bulls?"

"Yes."

"I should imagine they do. But they are only beasts. Whereas we Christians are being gored daily by these Catalans . . ."

Now the lurking smile had escaped. But she did not understand and would have spoken again had not her father motioned her to silence. Michelangiolo was appalled. The girl seemed to relish such tales. She took, he thought, a perverse delight in bathing her virginity in the Cloaca Maxima. Her reaction had been similar—too similar—at their first meeting when he had been trapped—yes—into telling her about Cursetta and the Moor.

Well, he had learned his lesson. Here in Rome apparently the stream of blood was endless if one chose to wade in it. Not far from the Palazzo Riario was the Campo dei Fiori where, together with the dewy sweet-smelling vegetables and flowers stood the pillory and scene of public executions. Crossing to the Palazzo on blue blazing days he always sought to avoid the Campo because always there would be some wretch bloated on the crosstree, another chained to a block near the great elm with a crowd of ruffians dancing around and ridiculing him. And Michel would push his way through them, wincing at the smell and touch of bared dirty shoulders and boulder-like fists, and rush past the German-run taverns and hotels fronting the Square —the Cow, the Angel, the Bell, the Crown, the Sun—whose guests were privileged to see, at no extra rent, executions from their front windows. The hotels had been constructed of the bricks of the Theatre of Pompey, once on this site, and so there was a certain fitness in the spectacle. But it always sickened Michel, and swiftly he would turn down the Via della Berlina Vecchia and into the Riario courtyard lined like a geometric forest with the old orange-flecked columns and so escape at last into the shade of the shed where his Minerva still slumbered in the cool stone. Ah, how good to be alone with that stone! —the purity of it, the shaping all his to do, no alien hands, no blood.

So he would blot out the image of the hanged man with his black tongue protruding, and the tick of his chisel would drown the howling of the mob. He had seen enough of that sort of thing in Fiorenza. He wanted to forget forever that horrible day with Andrea when Bartolomeo . . . Oh, better expunge that bloody business . . . the only true happiness was to be alone with one's dreams and one's hands . . .

"And how is the work proceeding?" Gallo asked. He was twisting a fine carnelian ring on his forefinger as he spoke.

"Oh, I can't do anything now," Michel said with a frown. "The shed has been removed. The Cardinal seems to have forgotten all about me. Once our contract was signed and the stone purchased, he seemed to lose interest in me. At first, he would come into the shed and glance around as if to be satisfied that I was working. But now I never see him. I don't understand . . . He wanted me to work there in the court and now he doesn't even know I exist."

"Has he paid you?" Gallo asked. His voice was the dry turning of a ledger-page, his gray eyes glinted like a metal scale.

"No . . . that is, except a preliminary payment for the stone."

"Well, be careful, young man. These great lords have a habit of commissioning . . . and then failing to pay."

"Oh well, if he does not pay, I shall simply refuse to go on with the work." He tried to sound bland but through the tissue of his attempted sophistication, the fist of anger ripped.

Baldassare laughed. His laughter was shockingly similar to his daughter's—a running up and down scale—but deeper, in a register of amiable scorn.

"If you should be reduced to such a pass," he said, turning to his employer for confirmation, "I am sure Messer Gallo would be happy to provide you with a commission."

Gallo nodded solemnly. "I am still interested in a Bacchus," he murmured. Stolid as a sphinx the banker bestrode the narrow-backed chair. He spoke almost without moving his lips, the stiff sobriety of his manner removed as far as possible from the dionysian god of revelry and wine whose image he desired. The only trace of movement in the figure was the methodical way in which he played with the ring on his first finger, finely engraved with the loves of Daphnis and Chloe.

"But now I have no place to work," Michel said dolefully. "Last week, a gang of workmen came into the cortile and dismantled the shed. They built a stage of some sort for a performance of one of Plautus' plays."

"Which play?" asked Baldassare.

"I regret I cannot say. It was in Latin."

"I have difficulty myself," Baldassare said with a small smile. "But Plautus is amusing."

"The trouble is," said Gallo, "the fine Latin of those days has become the jargon of our priests."

"Meanwhile my figure sleeps in the stone." Michel's voice had taken on a ring of indignation. "The stage is still there and every time I have inquired of the Cardinal's secretary when I might get back to

my block, he tells me that the Cardinal plans another play soon and
so the stage must remain for another few weeks."

"Riario has a passion for plays," Gallo said. "I saw the Amphitruo
there. He would rather perform at a play than at Saint Peter's."

"Then I finally got permission to see His Reverence and when I
requested permission to remove the block elsewhere, he patted me
on the head and said: 'Patience, young man. Patience moves moun-
tains.' Well, it may move mountains but it does not move my
Minerva. So I spend my days waiting . . ." He looked in distracted
anger at his hands, as if they were alien, the square fingers uselessly
chomping the air.

"Why don't you visit us more often?" Bianca said. Her small white
teeth flashed nippingly. "I'm sure my father will find work for idle
hands."

"And idle tongues too," Baldassare said dryly. Bianca primly
smoothed her skirts and continued laughing with her eyes.

Why, Michel wondered, fascinatedly watching the twinkling ripples
of her throat—as so many times he had stood along the Arno bank,
lost in a sculptor's revery at the river's motile hatchings—why was it
not possible to float on such a stream without drowning? Was there
never love without submersion? without possession? And now there
rose to his mind (against the dry counterpoint of the two older men
talking banking affairs) the ladder of love which Marsilio Ficino had
climbed so gracefully that afternoon of the banquet at Careggi, up
and up on rungs of rhetoric, from love of one fair form to love of all
fair forms, from carnal multiplicity to Love's Idea itself, unsullied and
unfleshed. The thirteenth of Octob—no, November it was, yes, the
birthday and the death-day of Plato, and the entire Academy had
gathered at Lorenzo's villa for the annual banquet, and on his plate
Marsilio had found the theme he had drawn by lot, a sentence
from the Symposium. And that was five years ago when he, Michel,
was only sixteen, a shy boy permitted to hang around the fringes of
these Immortals only because he had been art-adapted so to speak,
living in the Magnificent's household. He hadn't understood much of
what went on—immortality seemed somehow connected with gar-
rulity—there was besides an excessive amount of formal and coy
courtesies, and what was worse, in Latin. But he remembered that
Poliziano had arrived pantingly late because of a disciplinary prob-
lem with Piero—"I fear, Excellence, your son prefers *pallone* to
Plutarch!"—and he remembered the Maestro del Medigo's gaunt
disjunctive gestures and the blond curls of the Phoenix next to him
and the way Pico was leaning forward with eager slightly popping

blue eyes under the blind-eyed bust of Plato before whom the birth-day candle burned, and the Magnificent's hearty high-pitched voice and jutting jaw and Ficino's shy stammering eloquence. Years afterward, Andrea told him what his father had told him and Michel knew then what the ladder of love was. It was not this Bianca. It was something he knew sometimes with Andrea but not that either, it dwelt in skyey spaces.

A hand touched his. It was Bianca. "Let us walk in the garden," she said. Tremulously he went and when she kissed him, he laughed because he was falling through space, the ladder had collapsed.

BOOK TWO

CITY OF THE
RED LILY

FIORENZA
1493-1496

I

As he approached the dreadful spot he felt his heart jumping like a fish in the hand and he was afraid as always that he would vomit. Swiftly he cut across the columned market, reeking with the blood of slain lambs and lanced with the cries of hawkers, but to Andrea reeking only of the blood of Bartolomeo, the cries of Bartolomeo. For it had been here, in this new covered market that one clot of the furious mob had foregathered like a gathering of waters preparatory to assault; here they had buffeted him and Michel so that they could not escape and found themselves swept along in the tide of fists and stinking bodies, a carnival of curses.

To here. The dreaded spot. Here. In front of Simone Ferrucci's statue of the Madonna, in the second niche, gentle as a seashell, from the Street of the Shoemakers.

Andrea crossed the street. It was dark and there were no curious hangers-around in front of the image, and yet Andrea felt he could not stand there. Strange, he thought, that he should have returned on the very day—three years later—of that agony. He approached her and then withdrew as if he were drawing nigh the edge of a cliff. No, he could not. Not since that day had he been able to bring himself to stand directly in front of that mild and murderous Madonna. He could not—he saw Bartolomeo's eyes being gouged out, what had once been an eye spurting, the blessed globes of vision a reek, a gush of blood and lymph. And when that had happened, Simone's Madonna seemed to smile, oh just the faintest flicker at the corners of her delicately carved lips. Just a flicker of approval.

She had been avenged.

Andrea stood across the street. It was an unusually cool night for August, he had to wear his cloak. The narrow strip of sky entrapped between the eaves was spangled with stars that seemed even more brilliant in the constricted space. The church was a black bale of shadow; it looked more like a warehouse than a church; indeed, the upper storeys above the closed-in arches of the loggia were still used

as a granary. The most fitting church of Fiorenza, Andrea always thought bitterly, a mart of merchandise, a square-hewn piety. Only two blocks from here the money-changers sat all day at their stalls in front of green tables, waiting for business, their leather pouches jingling with gold florins, their wooden bowls bright with silver soldi, and every morning a brand-new clean sheet of parchment in which to make the entries.

And they dare call us usurers.

Down the Via dei Lamberti looking toward the market, lanterns were joggling along the sides of donkeys clomping on the paving stones. Despite the chill of the summer evening, artisans were still sitting outside their shops, benches straddled between their thighs. Even now after dinner the Florentines were busy: there was a sound of hammering and sawing, and from the silhouetted knots at the base of the columns the murmur of haggling and explosive rough bursts of laughter. Torches set in iron ringholders cast gulping shadows.

Huddled in his cape across the street from the church he stood vigil. Familiar sights, familiar sounds. Fiorenza the hive. Nothing had changed. Ah, yes, but it had. Those hagglers at the columns, weren't they looking at him? He hunched a little deeper into his cloak. He was being watched. No, impossible, they could not see him. And even if they did, what would they know? He wore no sign. Not since the days of the old Cosimo had his people been obligated to wear that huge yellow O, "of a circumference not less than a third of a braccio," according to the decree. "Otherwise, it being impossible to distinguish Christians from Jews . . ."

But in practice the decree was ignored. Not even after the thing of Bartolomeo had the decree been enforced. The Medicis had truly swept all that away. A family of merchants and humanists and bankers had no trouble getting along with Jews who were also merchants and humanists and bankers. Andrea's family was not untypical: his step-father, Elia del Medigo, was a philosopher-physician; his uncle Jochanan, a famous scholar; his great-uncle, the banker Dattilo da Pisa. Here in Fiorenza there hadn't been many of them before he left, some thirty families or so, and they had never been restricted to a quarter—a giudecca—next to the prostitutes as Miriamne's grandfather had. Why, there were even intervals between the storms when they might feel almost as free as Christians.

But now huddled in the doorway Andrea was certain that every passer-by must know his secret. He wore the yellow O in his mind. He had worn it ever since Fra Bernardino returned, he whom the Magnificent had expelled for rabble-rousing, and then the rumor

spreading that the Magnificent's death was caused by a ministration of diamond dust in water, and if the doctor was blameless, why did he commit suicide by jumping down a well? Ahi, perhaps that doctor was not a Jew but it was very strange. Despite the signs in the sky.

Andrea shivered and drew his cloak closer. Posted there in the stone hollow of the doorway he might himself have been a statue in a niche staring across the street at all those statues in the niches of Orsanmichele. He felt himself ringed by enemy eyes, but that was the flagellant condition of his pilgrimage. He had to come here because he had to suffer here, he had to relive the events of Bartolomeo's martyrdom.

Black-hooded, great-eyed, pallid, he quivered in the doorway like some strange bird poised to swoop off a crag.

II

Andrea's step-father, Elia del Medigo, had come originally from Crete. Among the Christians there were many who knew him only by the name he used in his printed works—*Ebreo Cretensis*—the Jew from Crete. He was a doctor as well as a philosopher and there had been doctors in the family as long as they could remember. Indeed, their name probably derived from their profession; it was an honored profession, the least affected by restrictive laws. In Fiorenza Jewish doctors had always matriculated freely into the *Arte dei Medici e degli Speziali*—the Guild of Physicians and Apothecaries—and there had never been any canonical injunction against them. And when Elia came to Fiorenza as Hebrew master and Averrhoist mentor of Pico, he discovered that there had been Jewish physicians there long before him. In fact there had been Jewish doctors before there was any true Jewish community in Fiorenza. They practiced in monasteries and they were never required to wear the yellow sign in practice. The del Medigos were an old family, studded with rabbis and scholars as well as doctors. They had come out of the mist, God knows from where, perhaps from the north, perhaps from the east, and drifted to Crete, that sunny etched island, another rock of Exo-

dus. There Elia saw the light in the sixth decade of the fourteen hundreds; and it was only inevitabile that when the isle fell under the sway of the corsairing Venetians, Elia should transfer his activities to the peninsula.

He was an ambitious young man, more ambitious than one would gather from his calm gray eyes, his placid demeanor. But he had aspirations that went way beyond his caduceus. Elia was after the philosopher's stone. For many years he had immersed himself in the Kabala (which he rejected) and in the Arab Averrhoes' commentaries on Aristotelian texts. He read these commentaries in Hebrew translations and it was not surprising that so equipped he should, in classic peripatetic style, drift to Padova, also under the dominion of the *Serenissima*. Besides, Padova was the seat of one of the greatest universities in Europe, its medical school being especially famous and Jewish students were permitted to enroll. Occasionally the rabbis debated whether ritual fringes should not be added to the graduation gowns. Occasionally the ecclesiastical authorities—especially when pressed by the Observant Franciscans—would remind the faithful of the perils that lurked in entrusting mind and body to these enemies of the Church. But who could take seriously such admonishments in view of the fact that almost every Pope for more than a hundred years had had a Jew as his personal physician and almost every prince in Italy followed suit?

So Elia had little doubt that he would be permitted to practice his profession after receiving his laureate from Padova. But even more than medicine, another attraction had drawn him to that university: Averrhoism reigned supreme there. Already in 1480 Elia had composed his *Quaestio de efficientia mundi*, and his philosophical reputation at Padova soon resulted in an appointment as a private docent. His public lectures were thronged; his disciples were not only Jews but, prevailingly, Christians. One day a blond young man came up to him after his lecture and questioned him searchingly upon an obscure point in Aristotle. So began his friendship with the Count of Mirandola, the miraculous Pico. The rich and handsome young count, whose thirst for learning knew no bounds, set about studying Hebrew with Elia; meanwhile he commissioned the translation into Latin of various philosophical treatises available only in the language of the prophets.

About this same time Elia performed a most unphilosophical—if Biblical—act. He married his widowed sister-in-law. Elia's elder brother had preceded him to Venice where he had been engaged as a merchant, importing silks and spices from the East. When Elia

received word that his brother had suddenly died of the plague, he hastened to Venice to help settle his brother's affairs. Perhaps it was the dreamlike air of that city on the lagoons, perhaps it was the hazed gold-and-crimson sunsets, perhaps it was the narcotic rocking of gondolas like black swans, or the mazy alleys between embroidered palaces or the climbing up and down eggshell arcs of bridges. Whatever it was, Elia fell in love, his sharp hard Aristotelian logic was blurred in a delicious mist. When he was not attending to the liquidation of myrrh and damask accounts or disputing dialectics with a young priest named Grimani (whose singsong Latin, Elia decided, swayed like the gondolas), he was paying court to his brother's young widow. Ruth was five years older than Elia; she had a five-year-old son, an abundance of undulant honey-hued hair, a hushed way of speaking and delicate table manners. Elia was infatuated; he blessed the law of Deuteronomy which enjoined him to do what he was more than disposed to do. Within the year he had married Ruth and taken her back to Padova with him. Although no children were born of their union, the boy Andrea was to Elia as his own son.

Of those early years in the Veneto, Andrea recalled only the lilt of the dialect. For as soon as Pico removed himself to Fiorenza, Elia went along with him. Mother was happy to go. She had been born there and her family, from San Miniato, had been among the first money-lending Jews permitted to settle in Fiorenza. That was back in 1437 and they had been in and out ever since. For their freedom was always a tentative thing, a bird in the hand that took flight when the hand was opened or suffocated when the fist closed. A precarious creature, freedom, a feathered evanescence. As Andrea grew up, he heard Mamma tell the story and sometimes Uncle Dattilo from Pisa came and added his whiskery addenda.

For ten years they might live at peace under the contractual *condotta,* and then either the *condotta* would not be renewed or else they would be expelled as heretical enemies, charged with fantastic crimes—the ritual slaughter of Christian children whose blood was allegedly needed for Passover bread, or witchcraft, or the desecration of holy images. It was always worst at their Easter time, Mamma said, then it was wise to remain within locked doors. For at that season, after the drunkenness of the pre-Lenten carnival, the legend of their Jesus was vivid and the monks would preach against us and inveigh against the Priors for permitting us within the walls. But the Priors had invited us in to set up loan-banks because their needy were being gouged by Christian moneylenders who practiced usury illegally

against the canon law. They needed us, and they called upon your grandfather, Abramo di Dattilo, to open up a loan-bank, and they even permitted some few non-lender Jews—doctors, scholars, trades-men—to enter with him.

And yet, Mamma went on, they never knew how long they would be permitted to remain. All depended on caprice and economic need: periodically they would be expelled and periodically sum-moned back. They grew used to camping in the fields outside the walls at San Miniato, waiting for a change of weather. Mamma's father died on the road to Siena. And her two brothers had fled to Lucca where they dealt in precious stones.

But with old Cosimo, *pater patriae*, things got better. The Medici understood; Lorenzo especially had been a true friend. Had he not forbidden that rabble-rousing Fra Bernardino to preach within Fiorenza's walls? So they lived in shifting winds and practiced what-ever trades and professions were open to them. There weren't many: they could not own land, they could not enter the guilds, they could not practice the arts. So there remained medicine in which their skill was legendary, or merchandising in cloths, or loan-bank-ing in which they could survive because their legal rates of interest were lower than those of their illegal Christian competitors.

Sometimes Andrea met the far-flung members of his family. There was great-uncle Bonaiuto at Siena and his two uncles in the jewel trade at Lucca. There was a cousin named Rubino who had been commissioned to buy books for the Magnificent and had traveled for that purpose to Byzantium and the Holy Land, discover-ing precious manuscripts in monasteries and carting them back at intervals to the great palace on the Via Larga. Andrea had seen him only two years ago—brown-skinned and sere as his pergamum codices. He spent much time in Messer Vespasiano's bookshop near the Bargello where all the savants of the city gathered to savor with a succulence, a smacking of the lips that was almost indecent, Cousin Rubino's new finds. There was Uncle Moshè, many years in the loan business in Fiorenza. And there was Giovanni Maria, master of the flute, who had—Uncle Moshè said with scorn—become a Christian and now spat on the floor as did the filthy Gentiles instead of using a proper cloth at the mouth. Giovanni, who fortunately was only distantly related, had become a Christian because he delighted in writing lauds and could find no outlets for his talents among his own too-austere co-religionists.

All these were Mamma's family. Father had none after the death of his brother. Andrea always thought of Elia as Father. The Venetian

who had died—his true father—he remembered only as a hard clasping, inextricably mingled with the scent of cloves. Andrea's world was Fiorenza, he felt nested there among the hazed hyacinthine hills.

And then, five years ago—the year after the Genovese Captain had sailed west to India—a new element had entered their midst: Jews who were called Marranos and who spoke only Spanish and whose manners and rainbowed shawls and red turbans were as exotic as the Byzantines whom Uncle Moshè had seen riding elephants through the narrow turreted streets of Fiorenza during the year of the attempted reconciliation.

He did not think they were Jews at all, but Father said they were, and in the synagogue they practiced the same ritual although their Hebrew had a strange singsong to his ears. And they stood at the Ark of the Covenant and told their story—tall men with parched skins and embers-of-hell eyes.

Everything about them looked burned, and when Andrea glanced up at the women's section he saw their wives and daughters, stiff and motionless as the limbs of charred trees, their posture, skins, eyes— black desiccate crusts. They were all that were left of the fires of Torquemada; Andrea wept at its telling.

For what the newcomers told was of the uprooting of their ancient communities of Spain, the expulsion from the recently combined realms of Ferdinand and Isabella, of the auto-da-fé lurid in every square of Spain, of the shrieks and prayers of the dying and of those who had renounced their faith and become Christians and those who had not renounced and yet managed to survive and of those who had sought to buy safety as one might buy a prayer shawl and of those who knew it could not be bought. Standing at the Ark they told the story almost as matter-of-fact, with no ritual rocking, without tears. They were beyond that. They had already crossed the sea of blood, they had already wandered in the tearless desert. To Andrea's ears it sounded like a retelling of the ancient Exodus.

For while thousands of them had been burning like faggots in every square of Spain, not even Ferdinand the Catholic, who was disposed to spare them (for a price) dared outface the thundering Torquemada. "Your Christ was sold for thirty pieces of silver," that incendiary priest had remarked to the frightened king. "Would you sell him again for thirty thousand?" The King would not, of course, and so for love of the Prince of Peace several thousand more Jews and Moors and assorted heretics had to be served up as faggots to Love.

And those of us who survived, the quiet man at the Ark said, sway-

ing just a little as if the freshfat smoke of those fires had dizzied him again, *those of us who survived were finally permitted to leave. For a price. And we paid that price: for the Lord's will is inscrutable, Blessed be His Name, and we left our homes and we left our possessions and we carried what we could upon our backs and we parted from Spain forever and floated for a year in rotten ships upon the Mediterranean.*

And they had drowned in storms and been rejected at ports and they drank warm water from kegs green with scum and they died of scurvy and typhus and unnamable diseases and they carried their gaunt-eyed horror with them port to port along the sunny rim of that blue goblet of a sea and a fleet of them lay at harbor for three months outside of Genova until there were almost as many dead and dying on the ships as there were living. Then they were permitted to land.

And if the Lord God had not permitted us to land it would still have been good.

And if we had all died in the fires or drowned in the sea it would still have been good.

For the Lord, Adonai, Blessed be His Name, is a jealous God. And He looks after His children.

III

Among the new Spanish families there was one named de Cases. Andrea became acquainted with the son, Bartolomeo, a lad of eighteen, of a sardonic bitter cast of mind. They had met one day when Andrea had accompanied his father on a visit to Bartolomeo's father who had begun to suffer belatedly from the agonies of the past year. The old man lay in bed, his sticklike arms crossed on top of the ragged blanket. Even his full beard—black and bushy—could not conceal the gashed pits of his cheeks. He wore his skullcap in bed; and as he spoke in labored tones, Andrea sensed a gauze of bewilderment about the words as if the old man had only now begun to realize what he had been through and did not quite believe it. He

was ill and in Fiorenza and he had been hearty and in Sevilla. But what had happened in between?

The door had been opened by a bloom-cheeked girl with moist lambent eyes. She ushered the Medigos into the domed cavelike rooms which had not only to house the de Cases family—the sick man, his silent monolithic wife, his two daughters and son—but also serve as the office of his business. They lived in one of the blackest alleys on the other side of the Arno, along the Borgo San Iacopo; from a chink in the wall one could see the sluggish river, fat and yellow with mud brought down by the spring rains, and beyond, the turreted tower of the Palace of the Priors.

While Father examined the old man, Andrea looked about. The rooms were dark and damp. There was practically no furniture save for the few sticks provided by the Florentine Jews. But on shelves that lined the white plaster walls of the front room facing the street there was a strange collection of objects. Andrea heard a cry from the sick man and then Father's quiet professional voice: "We shall need another basin, señora."

"Yes, Master." Hurrying footsteps. Another groan from the sick man. Then girls' voices: birdlike, stifled, whimpering. The blood-letting had begun; Andrea went into the front room to avoid the sight. He found the son there, lurking in the gloom like a squirrel in a tree-trunk, his small eyes glittering.

"Did you bring all these from Spain?" Andrea asked wonderingly, indicating the objects on the shelves. Goblets of strange design, several pairs of shoes, a rolled-up dark red cape, a compass, a pair of silver candlesticks, an hour-glass with its upper bell broken, a peacock-feathered hat, an embossed poignard, dozens of gold and silver rings hanging on nails, woolen pied hose dominoed in yellow down one leg and black down the other . . . It was these latter that made Andrea wonder. They were so familiarly Florentine.

"We brought nothing out of Spain but our skins," the boy answered. His bitterness pic'd the gloom as at a black bull. He had replied in Spanish to Andrea's Italian but they understood each other.

"But all this—?" Andrea motioned toward the shelves.

"My father is a pawnbroker."

There was a groan from the back room, then the sobbing of a girl, hushed.

"Courage, Father, a minute longer." The Doctor was speaking Hebrew.

"I thought you could not bring any money out of Spain."

"We hid jewels in our assholes," the boy said with a sneer. "Whatever wasn't needed to bribe the border guards. And since we've been in *your* country—" (the words rang sarcastically) "—my father has been unable to practice his own craft. He is a skilled silversmith. But they won't permit him to enroll in your precious guild. And so he started lending money on interest. We had some capital. What else would you have us do?"

The voice grated like a burr. He was glaring at Andrea, his head down like one of those ram's heads at the ends of long battering poles. His manner seemed to say that the misfortunes of his family were Andrea's fault.

"I have family engaged in the same affair." He did not mention that Father spoke illy of it, and that Uncle Moshè had once stormed out of the house infuriated . . .

The boy was glaring glaring. Uncomfortable under that glare Andrea picked up the strange goblet with the filigreed rim.

"Oh, that one's not on pawn," the harsh voice spoke out of the gloom. "My father made it."

He took the cup brusquely, explained its workmanship with angry pride. You could see that he too had studied: his fingers traced the engravings, admonitory professional fingers, with black bitten nails. He had worked this part himself. And the fires of his fury were stoked by the added fact that he had also tried to enroll as an apprentice in one silversmith shop after another along the Via Por Santa Maria and no one would have him. The guild was closed to Hebrews. The family had been here six months now and neither he nor his father was permitted to practice his art.

Now he had spilled into Italian: a garbled macaronic Italian riddled with Spanishisms. It made Andrea—schooled already into a Florentine's pride in the purity of his Tuscan—wince to hear. It was like two flutes out of tune. And from the other room the murmurous obbligato of the sick man's groans, the plaintive ululations of the women, the trickle of running water (or was it blood?).

Now Bartolomeo's manner had eased somewhat: how could you ram against Andrea's mildness? How could you batter down walls that weren't there? He was thrown off balance. He looked at Andrea with a baffled air of unemployed belligerence. Andrea was peering into the pawnbroker's account book.

"My Uncle Moshè has one even bigger than this."

"He has been in the affair longer," the Spaniard said wryly.

The leatherbound volume was carefully penned in curlicued Hebrew characters. Along the top of the parchment page Andrea read:

*With the aid of God, may we work and prosper, Amen, Monday
said to be the 18th (April 1493). May it be blessed, Amen & Amen.*

And then in three columns:

Paolo di Zobi, waxmaker young, popping eyes, S. Marco	4 lire 7 large scudi I paid and took security on the Ides of March (1493)	One winter coat, worn out, open on the sides
Cristofano di Simone di Cristofano, plasterer, young, thin S. Lorenzo	1 big florin. I paid and took security on 13 April (1493)	One little nun's chalice, dark red tending to black

"You will find that sometimes they fail to redeem the security,"
Andrea said. "And then they come back six months later and are
furious because the thing has been sold."

"I know nothing about it. In Spain we weren't in this cursed
business."

"My uncle says he is helping the poor who need money and would
otherwise be robbed by the Christian usurers." He felt a need to
placate this bitterness. "You know, every few years the Signori Priors
decide they must expel our people from Fiorenza. The last time
was soon after the death of the Magnificent. But two categories are
almost always permitted to remain within the walls: the doctors and
the moneylenders."

"For that we should be most grateful," Bartolomeo said. "They
need money for the blood of their businesses and doctors for the
blood of their veins."

"Ah, but I think you will find a difference here. We Fioren-
tini . . ."

The young Marrano laughed. But he laughed without humor, al-
most without sound; in the semi-obscurity of the shop his laughter
spiraled acidly like parings of a very bitter fruit.

"*Noi Fiorentini* . . ." he mimicked scornfully.

"But I *am* Florentine."

"Are you? And I was of Sevilla. And my father was of Sevilla. And
my grandfather and great-grandfather and great-great-grandfather.
We were all of Sevilla." The irony was unmistakable.

"Andrea!" They went back into the sick room. The old man lay still as death, his eyes closed. Father was drying his hands. On the floor beside the bed was a pan full of blood. Andrea's gorge rose. This mysterious red river that ran through the body, this quick fluid that he had seen so often and that always made him ill—how did it contain the soul?

"Clean the instruments, Shem," Father said. He had been speaking Hebrew to de Cases and now he was continuing automatically in that tongue, even using Andrea's Hebrew pet name. "Don't leave it to these poor women." Gingerly Andrea picked up the crimson-stained knives. The mother was already carrying off the pan of blood: the color was exactly the same as the flames that licked around the damned in Orcagna's fresco in Santa Maria Novella. The beauty of color took away the curse of the blood, Andrea thought, perhaps God designed it so. He was fighting down the sickness he always felt when he witnessed one of Father's bloodlettings. The little girl was squatting against the whitewashed wall like a brown monkey, wiping her runny nose with the back of her wrist. The older daughter, a short olive-skinned girl, with braided hair, was arranging the coverlets about the old man's bed. She moved with hushed grace, the bloom upon her cheeks faint as a pink veil over the olive skin. But it was her eyes especially that drew him. Andrea had never seen such eyes. Once she paused in her duties to look straight at him a lingering moment: the eyes huge, deep velvety brown, and still wet with tears. Andrea felt a twinge of guilt and turned his gaze away.

"Tsiporah," the old man murmured.

"Sí, Papá," the girl stooped over the bed brushing back the falling brown braids. Her voice, Andrea thought, it was like a sheepsoft slushing. He could not help staring at her as she stooped over her father's bed. Then suddenly he was ashamed that he was more aware of her breasts blooming in the blouse than of the pain on the old man's face. His eyes were still closed, his forehead dewed with pain. Tsiporah wiped his brow.

"Bartolomeo," he said and opened his eyes, looking for his son. Bartolomeo stepped forward. "Where have you been all this while?"

"In the shop."

"When the doctor bled me, I wanted you by my side."

"I am sorry, Papá. It makes me ill to see it. No lo puedo resistir."

The old man frowned. His eyes were vague: resentment swimming in them, moons in mist. "Your duty is here. Even if it makes you ill. Why do you let your mother and sister attend to all this unpleasantness? Help them. Do not stand there."

"Be calm, old man," the Doctor said. "It is unwise for you to arouse yourself."

"A son's place is here."

"Barto cannot bear to see you suffer," the mother said anxiously.

"Be silent. A son's place is by his father."

Bartolomeo's lips tightened. Now in this lighter room Andrea could see him more clearly: the fierce round eyes, the pinched mouth. He resembled his sister but with her sweetness gnarled. He was small, small as a thirteen-year-old, you would not think him a man. His body was lean, every movement tensile, arched, a bow ready to spring. He was compounded of anger rather than flesh.

And Andrea's soul went out to him: he felt like enfolding this furious boy in his arms as one might enfold a troubled child.

IV

They met often in the following weeks. The old man improved as a result of (or despite) del Medigo's bloodletting. He thanked the Lord for sparing him and went back to his affairs. And Bartolomeo, who seemed, together with his splenetic nature, to have a taste for brooding idling, wandered the brown-shadowed streets between the introspective towers. He hated to remain in his father's shop. He considered it a continuous affront. He felt demeaned to be lending money to these Christian dogs. They came into the pawnshop with their tight parti-colored hose and their elegant hip-flowering doublets and their long hair spilling from coy velvet caps to their shoulders— they stood arrogantly, hand on hip, one leg forward, and they pretended, these Florentines, to be great lords. But they haggled for every scudo and their fingers, more often than not, were stained purple with dye and they were dogs. All of them, merchant dogs pretending to be princes. The necessary security was always cast on the counter as if in scorn, as if they were doing a favor to the de Cases for deigning to borrow money from them. He knew why they had come. At the Christian banks the rate was forty percent. And they had to leave security there too.

So he fled the loan-bank whenever he could and roamed the

streets. He would emerge from the dark cave into the sift of sunshine that filtered into the Borgo and then down the muddy cat-raddled alley to the river. Passing down the Borgo between the stony towers was like running a gantlet of men-at-arms: the great bolted doors were visors down. But once he reached the hollowed space of the river he could breathe again. He was at the hinge of a great shell of mother-of-pearl space; through the limpid atmosphere he could see the pale blue hills of Fiesole rolling gently in the distance; they formed a curtain behind the orange dome and the turreted stone stalk of the Palace of the Priors and the many hundreds of fierce toothy towers rising like a prickly forest from every quarter of the city.

Here, the city wall ran along the river. He would pass the gate and cross the Ponte Vecchio between the butcher shops and into the Street of the Silversmiths. His choler always rose when he reached this point. Here he had been denied. And yet he always went this way, as if there was a deep need to exacerbate himself, always to grate upon his nerves and so prove he was alive and not like those others who had survived Torquemada's fires. He was no ghost. He was alive because he was still capable of suffering. He had to walk the thin edge of doom.

Andrea accompanied him on many of these prowls. After their first meeting the two young men had seen each other in the synagogue which was on the same Borgo San Iacopo. And they were drawn to each other; or rather, Andrea was drawn to the Spaniard. His gentler nature melted against the blunt onslaught of Bartolomeo's belligerence.

So, with communal pride, Andrea introduced the newcomer to the wonders of his Fiorenza: the shops of the dyers near Orsanmichele where the great wooden vats bubbled with Tyrian purple and the workmen poked and stirred the sodden stuffs with long poles like the fiends in the Inferno; the caves of the carpenters who cross-leggedly carved and chiseled and curlicued out of blocks of neutral wood the most fragile garlands and frames and tiny shrines; the great workshop of the Master Ghirlandaio where a dozen assistants were painting the wooden panels of marriage chests or predellas with marvelous scenes from the life of St. George, one of the favorite Florentine heroes One day they went to the workshop of a certain Roselli where they were undertaking new embroidery designs prepared by the Master Sandro Botticelli. Or, wearying of these intra-urban prowls, they might wander to the hills that cradled the City of the Lily in a gauzed lavender embrace; and pant up steep goat paths, until they reached

the heights of San Miniato whence they might look down upon the walled town bristling with its five hundred towers and read the green page of the valley written with the river's silvery S.

To all such marvels Bartolomeo's invariable response was either silent scorn or indifference. He seemed to move ever in a medium of his own brooding. He was like one of those deep-sea fish who light their way along the blackness by the phosphorescence of their own nature, and who can survive only under the great pressure of the sea. So Bartolomeo cast his baleful light, consuming himself, and when he rose to the sunny surface it was only to burst.

Andrea pitied him and was fascinated by him.

His pity became fear with the news of Fra Bernardino's coming.

Because Fra Bernardino's preachments were green-white flashes in the heavy doom that hung over Fiorenza. Ever since the Magnificent's death, they had felt it. Oh, they were busy as ever—the city was a hive —but something had changed: over all brooded a prescience and a reminiscence: things ended and things to come. Had not even the Magnificent's death been accompanied by the thunderstorm? Had there not been celestial portents after? omens?—strange birds in phalanx-flight? cocks crowing at midnight? And finally the vision of the Magnificent himself, armed cap-à-pie, that had appeared to the guitarist Cardiere? Wildly, the story had raced around the city one eerie twilight, like the swallows round the belltowers. Warnings warnings. And it was said that when the guitarist ran to relate his vision to Piero, the unworthy son had laughed in his face. Perhaps he laughed as a counterpoise: he was not lacking in courage, Piero, not the way he raced his blooded barbary horses through the hills. Perhaps he laughed because he knew his father would not have appeared again from beyond the grave unless there was something to appear about. There was talk of an invasion from across the Alps. Hunchbacked Charles of France—did he not have six toes? was he not actually a devil? The world was reeling toward the end of the century.

Or reeling toward its end.

Within this dark atmosphere of premonition, the Florentines continued to buy and sell: never for a moment did their agents cease to weave spider-strands of commerce from Antwerp to London, from Paris to Bruges—but the light had dimmed: Lorenzo, that poetic tyrant, was gone, something of the melancholy of Maestro Sandro's angels now stained the golden light.

V

Into this crepuscular gloom Fra Bernardino da Feltre returned.

"Court of owls," Elia muttered. His wife gazed silently at him as she poured the steaming broth. At times like this, dark prophetic moods came over Elia; he dipped deeply into his Isaiah. Mysteriously the words grumbled out of a kabalistic gloom. "Court of owls."

They were at dinner; a bitter winter day, the nine winds howling down from Fiesole. And Father's face was winter too: ". . . *the screech owl shall also rest there . . .*" He was thoughtfully scratching his chin, his gray eyes inward-looking . . . ". . . *There shall the vultures also be gathered . . .* Yes . . ."

Andrea was about to speak but he caught his mother's warning glance. They ate silently. At the window the wind whined, a stray dog wanting to be let in. Familiar pools of darkness flooded Father's muscles twitching there; he was as clean-shaven as any of the Christians of Lorenzo's circle. His piety had never gone in for temple ringlets and beards. In those learned jousts—peripatetic, aristotelianizing Jew versus academic, platonizing Christian—his glittering mind was armor-plate enough—he had no need for hirsute heraldry.

His lank cheek twitched. So now the bloody spiked wheel has turned again, Elia was thinking. We are back in '88—the same monk, the same sermons . . . and inevitably the same riots. Oh, of course, Fra Bernardino will insist his preachments are not directed against us; he inveighs against all banks, all lending on interest. So at least —with supercilious smile and spread-eagle bow—he had "explained" to the Magnificent. Elia remembered the scene. He had been at Careggi when the monk arrived. For after the riots the Jews had protested and the Magnificent had finally forbidden Fra Bernardino to preach, and when Bernardino departed, the rumor spread that we had bribed him to depart. And when Andrea asked his father if this rumor were true, the Doctor replied that there was wisdom to be known and wisdom beyond knowing. The monk was gone, that was sufficient: the Red Sea had closed again: no cicatrix remained.

And now he was back. Approaching Fiorenza like an invading army and wherever he passed, the ground was black and there were white bones. Elia sighed. There was no end to it. Piero was incapable

of keeping this Franciscan outside the walls. Within a week he
would be preaching in Santa Maria del Fiore itself.

Elia rose and walked to the window, staring out at the wind-curled
cypress, while his wife and son munched silently at the table.

And so it was as Elia had predicted. The Franciscan entered and
preached in the cathedral. And that very afternoon Andrea went to
visit Bartolomeo for their usual stroll. As he approached the Borgo he
sensed something in the air. He heard shouts, children's shouts, thin
but hysterical-edged, needle-lanced. He began to run down the narrow
street, not knowing why he was running, and others were running
too. Now he could scarcely struggle through the street. It was like a
narrow high-banked river, flooding. From wall to wall the Borgo was
crammed thick with boys; there was a fetid smell of two thousand
young unwashed bodies: it seemed as though every youth in Fiorenza
between the ages of ten and fifteen had flooded here after Fra Ber-
nardino's sermon. For the preacher had inveighed as always against
the loan-banks, and called for the setting up of a municipal Monte
di Pietà; and after his inflammatory words, the boys had zealously
rushed here to the street of the Hebrew loan-shops, and now they
were hurling pious stones at the windows of da Vacca's bank. At
the brink of the mad tide, Andrea turned.

And then he saw something that made him turn again.

Further down the Borgo, grinning horribly, Bartolomeo stood out-
side the door of his father's shop. He was gesturing obscenely at the
mob. Andrea felt a sick feeling in the pit of his stomach. These faith-
flogged boys, they were capable of anything; this mob was a multi-
headed multilegged bull and Bartolomeo, swordless, was waving a
flaming cape in front of holy horns. He would be torn apart. Andrea
fought to get through to him, but he could not; the street was hope-
lessly choked.

And now the rock-throwing had become a hail: glass was crashing,
glittery showers fell. The boys were screaming scriptural imprecations.
Andrea was swept by sudden panic: suppose they knew he, Andrea,
was a Hebrew? But they were not interested in him, they were intent
upon da Vacca's bank. They wanted to sack it in their holy zeal.
And beyond them, taunting, Andrea saw that mad grin—it was the
grin of a skull—and he thought: *If I do not get around to him by
the river-path, he is doomed.* He struggled to get out of the mob, but
he was pinned. Tugging and pulling to extricate himself, his struggles
stirred up a froth and now Bartolomeo had spotted him and his con-
tempt had to lash out even more, he had to perform for Andrea; he

began to curse the child-mob, screaming at them in his garbled Spanish-Italian: "Baby swine! Christian piglets! Farted children of the devil!" A howl went up, a high-pitched sting of fury, and they began to lunge at the Spaniard.

Andrea felt a ball of fire in his groin. He had been kneed. He had to get out of here. He had to get to Bartolomeo. But he could not. He was pinned. He was fated to see what he would not see.

And then his terror subsided. He could breathe again.

For just as the mob plunged at Bartolomeo, the door behind him suddenly opened and an arm shot out and pulled him, squirming and cursing, into the house. The knobbed portone banged shut, a bolt shot home.

Shouldering his way into the clear again, Andrea ran to warn his father of the sack of da Vacca's bank. But when they returned to the Borgo, the mob was already dispersing. Armed knights on horseback were patrolling the area.

From Isacco da Vacca who was standing outside his shop when Andrea and his father arrived, they learned what had happened. Da Vacca spoke with suppressed fury, sweeping up the glass of his shattered windows. Apparently, the tumult had reached the ears of the guard at the Bargello. Several knights had been dispatched to restore order. But—as da Vacca could observe through his broken windows—not even the knights, no matter how bloody-mighty seemed the crimson of their sleeves and stockings, the glint of their breastplates, the coiled vipers and roaring lions of their helmets, the quick prick of their pikes—not even the knights had been able to budge the children. It seemed a choice of actually killing a few of them in order to restore order and that the knights would not do.

Then it was that the Eight themselves had been summoned. Only two of them were in the Bargello, bowling in the courtyard when the frantic messengers arrived. So the two had reluctantly given up their game and donned their rose-red ceremonial cloaks, and to the sound of trumpets and rolled drums had issued augustly from the grim brown tower.

They proved as useless as the knights. The mad children jeered at them, jerking at their robes. By this time the frenzy had reached boiling point; the Borgo was a crunch of crinkling glass, a swirl of angels was fluttering against da Vacca's portone, rattling at rusty hinges, and the general roar was punctuated by terrible screams that told of some child—the smaller ones especially—being crushed in this mill of sanctity.

Then how, asked the Doctor, keeping a weather eye on the cleanup

operations of the two knights, had the fury finally been subdued? Splotches of blood rubied the stones: elsewhere, especially along the edges, the Borgo seemed to be paved in diamonds where rays of sun glinted on broken glass. One of the knights' horses, Andrea thought, was honey-colored as mother's hair, the other black as father's phylacteries. Against the swishing of his rush-broom, the bearded banker was muttering:

"So after the representatives of the Eight proved as useless as the knights, Messer Bartolini—he was one of them—and I could see him plainly through the broken pane—and he knew me and liked me—Messer Bartolini turned red with fury because those children would not heed him and he appealed to the parents who by this time had also flocked into the Borgo. Judging by the way they were laughing they had come to take pleasure in the savage sanctity of their off-spring. At any rate, Messer Bartolini appealed to them. First appealed, then cajoled, then begged—and finally threatened. If they would not call off their little heaven-hounds, he said, steps would be taken against *them*—a tax of reprisal perhaps."

"Ahi! Then you saw it. The parents went to work. Slapping and buffeting. Palm first and back-hand. Their authority finally clipped the wings off Bernardino's angels."

He brushed glass-splinters into a basket, glancing angrily at his cut palm.

"And did Fra Bernardino appear during all this while?"

"Never once." Da Vacca's face took on an expression of scorn. "Having set the fire, he played on his harp."

Andrea started up the street. He wanted to see Bartolomeo; he knew he must be quivering with rage in the darkness of the pawn-shop, a furious feather-rustling owl, his great eyes aglare amidst the goblets and pied-hose. And perhaps Tsiporah was trying to calm him with the softness of her voice.

But Father was calling. He was already striding up the Borgo with long determined steps.

"Well, at least, we may depend on the justice of the Eight," Andrea commented as they left the scene of the outrage. "Messer Bartolini at any rate is our friend . . ."

The Doctor shrugged his shoulders. His eyes were sadly cynical. "If the Magnificent were alive . . ."

It was always the same story. If the Magnificent were alive. As it was, the Doctor was convinced, the mob had been dispersed only as a kind of after-glow of authority. It was not that the Eight—not even Messer Bartolini—liked the Jews; it was simply that they disliked dis-

order more, especially the kind of disorder that only a monk could whip up. This simply could not be tolerated. By the beard! Wasn't there a sufficiency of these preaching monks in Fiorenza? And they were all trouble-makers. Even the eloquent Ferrarese, Fra Girolamo, who had been called to become prior of San Marco three years ago at the express invitation of the Magnificent,—had not even he turned to bite the hand that fed him, preaching against the Magnificent himself, so that Lorenzo had to set Fra Mariano sermonizing as a counter-blast? At least, Savonarola whipped up repentance, not disorder. . . . Children, old women, monks—they were all right in churches. But they had no right to be racing through the streets of a civilized city, disturbing the peace. Even the peace of Jews, who after all served a function too.

All this the Doctor explained to his son with his sad civilized little smile, his shrug of centuries.

That night the elders of the community met and authorized Elia to seek audience with Piero de' Medici. Perhaps he might be able to urge the young man to deal with Fra Bernardino as his father had dealt with him five years ago. And who else, other than Elia, great friend of these merchant-lords, might prevail upon Piero to halter the monk? Surely something had to be done, da Vacca shouted, raising a bandaged fist. At once.

So the Doctor agreed to go. But it was not so easy to obtain an audience with pleasure-busy Piero. Today he was falconing and tomorrow racing with his groom; or else he must with fist or foot demonstrate his prowess with a leather ball; he had no time for one-man delegations of Jews. All summer Elia sought in vain to see the arrogant young man whose curls he used to pat up at the villa. All summer and fall and it was not until the sky had grayed and freezing winds were blowing that his request was granted. By that time the situation was indeed perilous. During the summer Bernardino had sharpened his rhetoric in other cities; now he was back in Fiorenza preaching violently against the Jews. There were other incidents. The matter was growing ever more serious. If the Franciscan could not be forbidden to preach within the city walls—as had ruled the Magnificent of blessed memory—at least he might be urged to desist from stirring up the rabble, especially children, for surely faith and intelligence were not mortal enemies.

Surely God did not expect man to believe what was irrational. For had not Elia always sought in his exegesis to so interpret Scripture as to avoid the least contradiction with the postulates of human reason? Had he not always—in Aristotle, in Maimonides—been able

to single out those hidden threads which might be gathered into a web of shining sense—O harp of Reason!—and did not these philosophic threads always vibrate most profoundly with the allegories of the Holy Word? Surely then faith and intelligence were not mortal enemies.

So at least argued that good Aristotelian, Elijah called Elia del Medigo, Doctor and Jew.

It was possible to believe and to reason. Otherwise faith was a consuming flame and intelligence a strangling-cord.

VI

On a strange snowy day, Andrea accompanied his father to the Medici Palace on the Via Larga. The city was unfamiliarly white, the fleece of all the angels had fallen, never in anyone's memory had there been such a snowfall. And with it terrible winds so that no one had been able to issue from his house, no windows had been opened, no shops. From morning to the Avemaria it had lasted and then to the following Avemaria; and so heavily it fell and so wildly it blew the wind that there was not the smallest chink in wall or roof through which the snow did not sift, so that it was heaped up even inside the houses. "A gift from Heaven," said the Jews, for in such weather Fra Bernardino could not preach.

Then the wind finally ceased and Andrea went out into the streets. He saw white clouds being hurled out of windows by bucketfuls. He saw glittering white mountains along the streets. He tried to get into the Borgo but it was completely blocked, neither man nor beast could pass. It would take at least eight days for all this to be removed, Father said.

Now, crossing the Ponte Santa Trinità, Andrea noted the white trim furring the banks, and San Miniato niveous and immaculate upon the heights. The Via Calzaiuoli was an ermine carpet: rolling carts, horses' hooves, even venders' cries—all muted in the blanched muff of the snow. It lay heaped up like sand in the crenelations of the Palazzo di Parte Guelfa, it lurked among the rude stones of the

Spini façade: a sprinkling of white powder everywhere as if a goddess had scattered the fluff of her boudoir down to gentle the rough masculine city.

He crunched along beside Master Elia through a glistening neverland. Master Elia was tall. Taller than he, Andrea, and when Master Elia strode, his black cloak swirled. Everyone knew who he was— friend to the Medici, teacher to Pico. But today it seemed the bowed backs were drawn crossbows. Fra Bernardino's sermons were having their effect. Father's eyes were clouded with an ancient trouble.

They passed through the great portone of the Palazzo Medici— under the inscription NURSE OF ALL LEARNING—and entered the courtyard. It was piled high with snow; drifts lay against the feet of the delicate corinthian columns; and up in the architrave, medallions sparkled with unexpected highlights. Beyond, Andrea saw a second courtyard dominated by a sculptured fountain—a bronze statue of a girl with sword upraised to strike off the head of a captive kneeling at her feet. Snow limned the sword, whitened the victim's tangled hair with fearful anticipation. Andrea did not know that this statue of Judith and Holofernes, and the medallions in the first court were by Donatello; he had never been here before, though he had often looked into the court through the arched doorway on the Via Larga. But Father was a familiar of these precincts and of this family, and Andrea felt a puff of pride. Fra Bernardino might be able to stir up a mob of foolish children, but what were his words against Master Elia's? These merchant princes had no patience with fanatics; they respected order and measure. Suddenly Andrea was sure everything would be all right. The snowfall was an omen: it covered all blotches.

In the center of the first courtyard a household servant was modeling a Hercules out of snow. A short young man with a fuzz of moustache darkening a stubborn mouth. He wore an earth-colored knee-length cloak against the cold, and a berretto; he was working away at the statue with frowning intensity. Unaware of their approach on the muffling flaky carpet, he was patting a ridge of snowy muscle along the white thighs. Then, nimbly he leaped off the platform and stepped back to survey his handiwork, blowing on his purple frozen fingers. Walking backward very fast, his eyes riveted on his work, he almost knocked Andrea over.

"Oh," Andrea cried and then he felt his arms grasped by steel fingers checking his fall, and a pair of cold graygold eyes were looking at him. The servant mumbled an apology in a harsh undertone, then nodded respectfully to the doctor:

"Maestro del Medigo."

The physician nodded in turn. Despite his haste, he had stopped to admire the huge figure, whiter than any marble. It dominated the courtyard, and from all the bi-foliated windows above, faces peered, curious and entranced at the statue growing before their eyes. The sun glistened on the snowy hero, leaning on a knotty pocked club, a lion's skin pendent over his great-bicepped arm. But from the tip of the lion's skin, drops were glimmering like tears, and the ponderous chest and deep flanks were already patina'd with wet. Under that brilliant sun the statue was melting almost as soon as it was finished; the servant cursed and furiously patted a new ridge of muscle to replace the one dissolving under his fingers. "Beh!" he muttered between his teeth. "What a ridiculous commission!"

He wore the desperate expression of one who would write a poem on water. Now he turned to the Doctor, flinging wide his arms in disgust, and bursting into harsh laughter. "Oh, it's no use!" he said, drying his snow-wet palms along his cloak. He shot a swift glance upward at his audience at the windows; all the servant-girls and housemen and cooks and pages were gesturing at him in a crazy pantomime; noses squished against windows, hands shaping in air the desired proportions for his Hercules. He gestured contemptuously back at them—thumb in mouth, the vulgar *fico*. All his movements seemed to Andrea containments of force, coilsprings; his small terse body, silhouetted against the white dissolving giant, seemed to explode with energy. He made a move as if to kick the Hercules; soundlessly the audience in the windows laughed.

Meanwhile, the Doctor, who had been surveying the statue in the same manner with which he studied a patient stretched out on a table, delivered himself of his opinion:

"Well, Michelangiolo, I note that you have profited much from Maestro Bertoldo's teachings. Of course, I am no artist—but I have made an anatomy or two. And that deltoid muscle—" he pointed "—is incorrect. It belongs here, flatter, more triangular, shaped like the Greek letter *delta*, attached to clavicle and scapula, thus linking the shoulder to the biceps."

With an eager and somehow desperate air, the servant named Michelangiolo listened to the lecture. Now and again he glanced up at the sun, fearful that soon his statue would disappear completely before he had even finished it. His forehead was corrugated with concern; he spoke in a peculiar mixed tone of irritation and humility.

"I've never had the good fortune to dissect a corpse . . ."

A curious notion of good fortune, Andrea thought.

". . . so I do the best I can from studies. Madonna, but what a joy it would be to anatomize! Then I would know, really know the structure of the human body. Whereas now I have to guess. Or imitate the stupid errors of others."

He stepped closer to Elia, his eyes golden-eager. "Might you not arrange it, Master?"

"Arrange what?"

"That I might dissect?"

Elia frowned. It was a difficult matter for him to talk about. Ever since he had performed those public autopsies, he had been troubled in spirit. For although he never made a spectacle of it, as did the Christian doctors with their reading of papal indulgences and their choral singing and their banquets after—yet, as a Jew, Elia looked upon the human body with reverence. He knew it was to be swiftly buried after death, and never mutilated. He recalled how the other Jewish medical students had regarded him as heretical when he eagerly studied the *Anatomy of Mundinus* just published at Padova. Did he not realize that to make an anatomy required the license from ecclesiastical authorities? And who would these corpses likely be but criminals or Jews? Would he dissect his own brother?

He did. Or perhaps he did, for Elia never asked who the corpse was. Coldly, tight-lipped, he dissected whenever and wherever he was given churchly permission to do so. Because he was driven by a passion to *know*. Already he had begun to doubt many venerable theories—he had searched among the two hundred and forty-eight bones for Adam's missing rib and he had not found it, and he had searched for the Bone of Luz from which the body would be reborn anew, and he had not found that either. But already he had discovered that the uterus was without horns nor was the liver lobed. In these assertions then the older prophets and even Galen had written falsely and who knew if perhaps there was much else that was false could he but probe into enough bodies to find out. Nor would Elia, like Christian doctors, merely sit on a stool pointing with his wand, while an assistant performed the actual dissection. No, the knife had to be in his own hand; somewhere in those glutinous shiny coilings, in that sop of blood, in those gray fatty involutions—was God. No matter how much his talmudic conscience might rebel at what he was doing, Elia was stubbornly convinced he was demonstrating the wonders of the Most High all the more. For what greater proof of His glory and His creation was there than the workings of the body itself? So, whenever he could, Elia pursued his quest for God in flesh and in spirit, the God who was pure Reason, everywhere

to be demonstrated and by best demonstrating Him you best revered Him, Blessed be His Name.

So, now, frowningly he pondered Michelangiolo's request, and then quietly:

"You are acquainted with the Prior of Santo Spirito?"

"No."

"Well, go to him and say that the Maestro del Medigo desires that you be granted permission to attend when next I make an anatomy."

"Ah, I am beholden . . ."

Someone was tapping upon a window. They glanced up and saw a dark-visaged man in a green doublet. He pushed open one of the leaves of the bi-foliated delicate window and yelled down into the cortile in Castilian-tinted Tuscan: "—Maestro del Medigo, His Excellency requests you do not dawdle there because of a silly statue. Within half an hour we depart for the hunt."

"Half an hour," Elia spluttered, "half an hour . . ." even as he bowed low in acknowledgment, velvet cap in hand. He suspected that Piero was standing at his groom's back, watching. He hurried toward the staircase, Andrea after him. "No, no, wait here," Elia said, talking as he ran. "This young man—you have met before?—No?—Michelangiolo Buonarroti—my son Andrea—"

And he was gone.

The young men looked at each other. They were the same age—eighteen—but Andrea was taller, slenderer, an elm beside this stocky oak. And there was about Andrea an air of gracefulness—the very fall of his cloak, the tilt of his head—which made the other seem plebeian. Gray gimlets were boring into Andrea's soft liquid eyes—those eyes which had haunted Elia through the lagoons and ripped the nets of his logic. Only for a few seconds did Andrea try to cope with that intense glance; then he lowered his long lashes and turned to gaze up at the Hercules.

With the same nimble leap as before, the sculptor jumped back on the platform and resumed work. He began re-pinching the line of deltoid muscle which the Maestro had criticized. From one of the upstairs windows, there came the sound of many dogs, howling and baying; and then voices sharply stilling them. Michelangiolo was reaching on high tiptoe now, transforming the amorphous whiteness of the head into a luxuriant mass of ringlets. Andrea was fascinated: it was like magic to see the snowy curls appear beneath the flying fingers like earth turned over by the passage of a plow—the short spatula-shaped fingers flew: twisting, turning, pinching, passing on

—and wherever they passed, rich ringlets emerged like wavelets blossoming with the wind's breath.

"Ahi, che meraviglia!" Andrea couldn't help exclaiming.

The other had hopped off the platform and was backing away from his work again to see it as a whole. But now, at Andrea's long-sighed praise, he turned slowly about and smiled. It was his first smile, very warm, emerging from that tense frowning face like a sun bursting out of clouds.

"You are a sculptor?"

"Oh no . . . I only admire."

"Well, if this cursed sun doesn't let up there won't be very much to admire . . . except a pool of water . . ." He gestured impatiently. ". . . but if it pleases His Excellency, I suppose I should be satisfied."

Irony curdled the last remark. He had a low voice, but rather harsh-timbred, grinding. He was looking curiously at Andrea. Upstairs the dogs were howling again.

"The Maestro is your father?"

"Yes."

"The Magnificent is said to have admired him greatly."

Andrea nodded imperceptibly as if the compliment were directed at him. "My father admired the Magnificent . . . and loved him."

"When I was in the gardens I saw them together on occasion. And once with the Count of Mirandola. Arm-in-arm . . . Physicians are peculiar people, though," he added abruptly.

"Why peculiar?"

"Well, they persist in judging all things from their own point of view. My statues for example. Your father always and only considers them as problems in anatomy."

"But surely you cannot have true sculpture without true anatomy?"

"Oh, of course, of course. But the anatomy is not the art. Else why make a statue? We cannot better the living man . . . Oh, plague take that cursed sun!"

For the sun had really burst forth now and the hero was melting. There was a cackle of laughter at the windows. The young man looked upward and, with a thumbnail, flicked his teeth contemptuously at his audience. He acted, Andrea thought, like a peasant at a fair competing in a game of skill before his comrades. He scooped up some snow and patted it along the dissolving edge; it too showed signs of immediately melting.

"No use going any further with it," he said disgustedly.

"Marvelous," Andrea couldn't help repeating. "Those ringlets are a miracle."

"They are much like your own," the sculptor said softly.

Andrea flushed. He was always self-conscious about his beauty. Especially his whipped froth of black hair, which, roguishly under the red velveteen Florentine beret, framed the gentle oval of his face and fell in gentle waves to his shoulders. But in his embarrassment he realized that this young man, with all his irony—the cold penetrating eyes, the harsh voice—was as shy as he was. As they talked on, now and again the dogs baying echoes in the courtyard, he revealed himself as a strange mixture of abruptness and backing-away, of courage and timidity. He had a way of saying harsh things and then acting immediately as if he had not said them, or regretted that he had said them. And all the while he spoke, his fingers were speaking too; apparently he could not keep them still: they seemed to have a life of their own so that they had to busy themselves with the Hercules despite the sun and the sculptor's will.

So, all the while as Master Elia was in audience with Piero de' Medici, Andrea remained in the frost-sparkling courtyard conversing with the young sculptor. They spoke—as everyone in Fiorenza was speaking these days—of the threats of an invasion by the French King.

"Oh, he'll never get past the Alps," Michelangiolo said. "And if he does, the Sforza of Milan won't give him passage through his domains."

He sounded boastful as if he personally were blocking the new French army. It was—so the rumor ran—the most terrifying army in all of Europe: with hordes of men-at-arms, and fierce cavalry, and new secret weapons—cannon that were said to hurl a stone ball for a mile and a half. "And if he does get into our country, we'll stop him dead at Pisa."

He mentioned several preaching friars who had predicted the coming of the anti-Christ. Surely they were referring to King Charles, he said. Of course, there were other monks—Fra Girolamo for example—who held just the opposite point of view. If the French King should come, it would be as a scourge of God to punish the sins of Italy. So said Fra Girolamo. Therefore the Florentines should welcome the French King.

"And are you in accord with Fra Girolamo?"

"No. Even if they come as friends to protect us. Perhaps Fra

Girolamo speaks so because he is not of our country. He is of Ferrara."

The talk of monks chilled Andrea. At this very moment somewhere within these heavy walls, Father was seeking to protect his people against one of those monks. "And Fra Bernardino . . ." Andrea put in cautiously . . . "Has he also predicted the coming of the French King?"

"I don't know. I never heard him preach." Then scornfully: "He seems to appeal chiefly to children." Idly he turned back to his statue, smoothing the muscled calf. "Listen to that one! A beautiful soprano, vero? Should sing in the choir at Santa Croce." The dog's baying rose and fell, ululating in the gathering light.

The sun declined. The white statue was varnished in the gold of evening. Father's audience was surely longer than he had expected. Almost an hour now. Was he succeeding? Andrea wondered. Above their heads the square patch of sky was dimming like a magic screen. Now it was pale blue, a powdery dusk. A crescent moon swam into view, the sky patch of the atrium twinkled with a few stars. It was getting cool. He hoped Elia would hurry. He began stomping from foot to foot. Michelangiolo remarked with pleasant irony that at least his work might last another day.

A servant came out with several flaring torches and set them into iron ringholders at opposite sides of the cortile. At that moment, a young man ran into the courtyard from the Via Larga, exuberantly kicking up drifts as he came, so that he gave the impression of an eccentric dancer as he called out in a jolly voice—"Ho! Michel! Babbo wants you home at once." He stopped abruptly, V-planting his sturdy green-stockinged legs, and examined the Hercules. In the flickering torchlight, the frosty muscles seemed to pulse. "Well, so you've finished it at last! There's a real hero! What stuffing for a codpiece!" He circled the statue, hoar-smoke dancing from his legs. "Hurry! Babbo says—"

"I must wait for approval."

"Babbo said at once."

Michelangiolo frowned. "Wait a moment. Let me inform His Excellency." He went into the palazzo. Silently Andrea gazed at the newcomer, an apple-cheeked young man, surely no more than sixteen, with clear ingenuous eyes.

There was a rattling at an upper window. Andrea looked up to see his father and Piero de' Medici appear. Then the window opened and the Medici thrust his long-jawed bronzed head outside. He stared down at the statue for several moments then turned around and

nodded once or twice, speaking to someone in the room. The window closed. Father's expression seemed troubled.

A moment later, Michelangiolo was in the courtyard again. "His Excellency considers the commission fulfilled to his complete satisfaction." He spoke in a gruff whisper as if to be sure that his words—unmistakably burred with sarcasm—could not be heard above. "Have I introduced—? No? Well, this is my brother, Buonarroto . . . Narro, as we say. And your name—? Your *Christian* name, I mean . . . Andrea? Ah yes, Andrea, son of the Maestro del Medigo."

My Christian name, Andrea thought as he shook hands with Narro. Meanwhile, Michel turned around for a parting glance at his precarious work; then mumbling something under his breath, he departed with the boy.

As they crossed beneath the columns Andrea saw him put his arm affectionately around his brother's shoulders.

When Master Elia finally issued from the palace, his face was that of a city from which the siege had been raised. He was not smiling but there was a sense of relief in his eyes; he strode with lively long steps down the Via Larga, kicking up the snow.

"At first I considered my plea hopeless. Imagine that young whelp holding an audience with six hunting dogs in the chamber, all howling at once. And every five minutes an interruption by some fool or other. And this arrogant boy whom I have seen more than once with his nose running, scarcely looked at me as I spoke, so intent was he on a new falcon hood he has just received from France . . ."

"Then he has done nothing—"

"Ah, but he has. To my surprise, I must admit. For when Piero finally got around to the matter at hand he acted with a speed and firmness worthy of his father. He will request of the Eight that henceforth the monk be permitted to preach only outside the city walls. And furthermore, he is not to touch upon any of those themes which provoked the riots of '88 and this recent riot in front of da Vacca's bank. That is to say, he is explicitly enjoined against mentioning money-lending Jews or the ticklish question of the creation of a Monte di Pietà."

"Can we depend on him?"

"For the moment, yes. He fears any disorder. Especially now with King Charles camping at the borders."

"No matter what his faults," Andrea said with the secure guilelessness of youth, "Piero is a patriot. He will not permit our country to be invaded."

The Doctor snorted disdainfully. "Oh, he'll make no stand against the French King if he comes, you may be sure of that. He'll try to buy him off, or flatter him into an alliance."

. Then he was silent again, thinking—*And for today's benevolence what will Piero's price be? For surely he will submit a price. Even his father did. As they all do.*

Although it was night, their way was lighted by the chaste reflections of the snow heaped up on every side. Many citizens were out with wooden shovels, cleaning off the paths. The air was clear and not too cold. Above, between wide projecting cornices, the horned moon swam in a narrow strip of sky. Against the luminous night the eaves were jet-black; a thousand secrets seemed to lurk under them; bats were weaving eccentric orbits in their shadows.

"It might even be better if the French King came," Elia said pensively, less to his son than to himself, thinking out loud. "Against a strong enemy one takes the necessary precautions. But what protection is there against weakness?—and Piero is weak."

"But the French King is a devil," Andrea said. "Monna Luisa, the laundress, says he is the anti-Christ. And Michelangiolo asserts the same . . ."

Elia looked at his son, from great heights it seemed, a lunar glance. "If their Christ is not our Christ then Charles can hardly be our anti-Christ." He spoke with feather-softness, but Andrea felt the weight of the reproach. Silently they crossed the Ponte alla Carraia between the tailor shops and then turned left along lung'Arno for the long walk home, near the huge tower-gate of San Niccolò. Andrea wanted to ask his father many questions—not about Piero de' Medici nor Fra Bernardino nor the chances of the Jewish community remaining in Fiorenza at all. He wanted rather to ask about that fascinating servant-sculptor in the courtyard. And because he was ashamed of the frivolity of his interests at so crisis-hung a moment, he said nothing, his thoughts weaving eccentrically as the bats.

VII

Eight days the snow lasted. Three times Andrea went slushing through the brown-and-white streets to the courtyard of the Medici Palace but Michelangiolo was never there. Only the Hercules remained as fragile evidence, each time amusingly less: the final visit found the Hero with only one arm, half a head, soggy thighs and a groin liquefying into hermaphroditic ambiguity. To Andrea's inquiries about the sculptor he was told only that he resided with his family on the Via Bentaccordi.

It was a section of town Andrea knew well. One block from Santa Croce where the tournaments were held, Andrea found the house: a four-storied simple sand-stuccoed building on the corner of a curving street appropriately named the Eel. The neighborhood was dominated by two great buildings: the church of the Holy Cross and the stews of the Stinche. One could see the church's rough-stoned unfaçaded majesty across the dusty great square; and the brown ugly mass of the public house of prostitution to the left.

Andrea paused before knocking at the gate. He was not sure in his own mind why he had come here. Since he had met Michelangiolo he had been unable to cast the sculptor from his head. Once or twice he had tried to speak to Bartolomeo about it, but after his encounter with the mob of boys, the Spaniard had grown more irascible than ever. He spat incessantly, his great eyes always fury-bright. When Andrea announced the happy conclusion of his father's mission, Bartolomeo had laughed so harshly, with such disbelief, that the Florentine felt sick at heart. Here, Fra Bernardino had been silenced, if not banished; they could all breathe easy for a while— and Bartolomeo scoffed. Did he *want* them to suffer?—in order to prove that it was in the nature of things for Jews to suffer? The only sweet note in the acerb atmosphere that day had been Tsipora. For while Bartolomeo scowled in the shop, Andrea had sat with the girl in the kitchen under the chaperoning eyes of the mother; afterward, they received permission to stroll along the river. He told her of the young artist he had met, of his statue of snow:

"Can you imagine anything more wonderful?"

"Than a statue of snow?"

"No, no, not that! The material doesn't matter. But to make men

of *anything:* of paint, of stones. So that you almost see them breathe."

She smiled shyly, brushed a truant braid back from her shoulder. "It is against our Law," she said. Her voice was soft; they were sitting on a boulder near the Ponte Vecchio watching the eddies under the arches.

"Yes, yes, I know," he said impatiently. "But only within the house of God. Outside—"

"Besides—" She tossed a pebble in the stream. "What is so wonderful about a man of snow?"

Andrea went home with her image singing to him.

So now knocking at the gate of Michelangiolo's dwelling, he thought of the girl's remark and he felt, seeking entrance to this house of an image-maker, as if he were seeking entrance to the Stinche. And yet he was drawn to these mysteries of the flesh.

An elderly maidservant responded to his knock. He was ushered into a sparsely-furnished room on the ground floor, rather gloomy, with its heavy oak furniture, wooden refectory table, painted chest, and the uncomfortable narrow-backed chairs. A few moments later a young, pretty, flush-cheeked woman came into the room, rubbing her hands on her apron.

"Prego?"

"I seek a Messer Michelangiolo Buonarroti."

"My son?"

"Your *son!*" Even the demands of politeness could not quite exile the surprise from his voice. She looked little older than Michelangiolo himself.

"I am his step-mother," the pretty woman explained, reading his wonder. "What is it you want?"

What indeed did he want? He did not know. He wished merely to see again what he had once seen—that young sculptor who made miracle ringlets flow from the plow of his fingers.

"I—I—have a message for him. From the Maestro del Medigo."

"You will find him in the garden. No, you may go through the apartment, and out the back."

She led the way. They passed through several rooms, each as heavily furnished as the first, and then into a study where behind an octagonal table, an account book before him, sat a white-bearded man in a rose-red cloak. He stood up as they entered, and the young woman said very softly: "My lord, this young man has a message for Michelangiolo. From a Maestro del Medigo."

"What is it?" The voice was strangely harsh and cringing at once. "Oh—a small matter. My father wishes to demonstrate to your son the correct conformation of the deltoid muscle. He is a physician you see, and he observed that your son erred in his statue in the courtyard . . ."

Oh, he was lying beautifully, he thought, making it up faster and faster as he went along, the long-bearded man in the red cloak was glancing at him oddly, but with apparent respect, and the young woman had raised frail stemlike fingers to her pursed lips.

"Indeed . . ." Messer Lodovico muttered. "And what purpose will that serve, pray?"

His nose was beaked, his eyes sky-colored as the eyes of a high-flying bird, there was a slight tremor to his spittle-flecked lips. He wore his red cloak like one of those banners that flapped advertisements of wares outside shops: playing with it constantly, flaunting it, swirling it, his nervous thin hands winding and unwinding in its thick woolen folds. "You'll find him in the garden out back . . ." he indicated with a thumb, and then, in a slightly querulous voice: "Your father is a physician, say you?"

"Yes, he was physician to the Magnificent for a while."

"Ahi . . ." the man's voice changed. He visibly bowed in his red cloak. His lips coiled into a weak smile. In the beard uneven teeth were yellow as buttercups. "Show the young man to the garden, Lucrezia. Show the way."

Madonna Lucrezia emerged from the corner beside the clay stove. "Yes, my lord," she said, quiveringly. As they left, Messer Lodovico murmured: "Perhaps your father might speak to the Lord Piero that Ser Lodovico of the Customs—" His hands strayed solemnly behind his cloak. From the garden came a burst of jabbed metallic clicks, and then an ejaculated "Hah!" Messer Lodovico frowned. "—would appreciate a decent commission for his son. We would be beholden, beholden . . ."

The garden was a small plot of weed-grown ground still muddy from the recently cleared-away snow. On boards across the damp soil rested a rough block of marble, and working at it with the same intensity Andrea had observed in the Medici courtyard, was Michelangiolo. He was hammering so furiously at the block that he was unaware for several moments of Andrea's presence. Then he looked up, surprised—

"Oh . . . *Salve!* This time, you see, I'm making something that will last."

"What is it?"

"A Samson wrestling a Philistine. It's too early to see anything. But it'll be a marvel all right. A marvel!"

"Who ordered it?"

"Nobody. I'm doing it for my own amusement."

He was restless after a morning of carving. To Andrea's regret he cast down his chisel and suggested they go for a walk. "One moment till I get my cap." He walked into the house, moving in quick hopping little steps like a sparrow, banging open the wooden door and neglecting to close it. "Narro! Narro! My cap!" Downstairs came tumbling the apple-cheeked boy with a tawny cloth beret and flung it laughingly at his brother.

"Where are you going?" asked the boy.

"A stroll. Want to come along?" Michel turned to Andrea: "Do you mind if—"

"Of course not."

Outside the door, they met Messer Lodovico in conversation with a friend. He examined his sons sternly as they stood silent and stiff as soldiers on inspection. "Go inside and change your hose," he ordered Michel. "And put on the woolen cloak. This is no weather for carnival costumes."

"Yes, Father," said Michelangiolo. He spoke humbly and returned immediately to the house. When he came back he once more stood inspection, head bowed in an attitude of such filial submissiveness that Andrea was amazed, recalling the sardonic pride with which this same Michelangiolo had behaved before the great lord of the Medici.

But once they were out of sight of Messer Lodovico, Michel's manner changed again. He became gay, his steps were bouncy, he seemed possessed of a slightly uncontrollable hilarity. Only once did he frown during their walk and that was when Narro said:

"Giovansimone claims it's your turn to chop the wood. He says you're the best chopper in the family anyway."

"He hasn't done it, then?"

"No, he says you're the chopper in—"

"He'll find that out!" Michel's face had darkened, he kicked viciously at a patch of innocent snow. Then he turned to Andrea with a half-apologetic smile: "We all take turns with the wood, you see, but my brother always finds an excuse."

"Another brother?"

"Oh, we're five altogether. But the oldest, Lionardo, is seldom at home. He joined Girolamo's order two years ago. He's a lay brother at San Marco."

Ah, Andrea thought, at least he is not a Franciscan. Those preaching Franciscans are the worst for us. Once in the pulpit the milk of their gentle founder turned to gall.

But now, while Fra Bernardino sulked outside the walls, a Dominican once more had stolen the flame. Everyone was flocking to hear the fiery Savonarola.

"You have heard Fra Girolamo preach?" Andrea asked.

Michel looked at him, strangely, Andrea thought. He was sorry now that he had brought up the subject.

"Why yes, of course. I go often with my brother. But have you never heard him?"

"No. I—I have heard Fra Bernardino. And Fra Mariano."

He hoped his lie was not flaming on his cheeks.

"Oh those are cracked trumpets by comparison. When Fra Girolamo speaks, sometimes you cannot hear him for the weeping of the congregation."

"He is a true prophet," Narro cried out. "Lionardo says he can foretell the future." He skimmed a flat stone and watched it skip upon the river. "Three, Michel," he said.

"What does he prophesy?" Andrea asked.

"Oh but you must have heard. The coming of a scourge . . ."

They idled along the grassy shores of the Arno watching the clay-dredgers arched against their buried shovels. Michel did not say further what the precise nature of the scourge would be, and Andrea asked no more. There were so many of these preaching friars. Fra Bernardino was silenced. Let sleeping dogs lie, he thought. He had heard Father declare that Fra Girolamo was a friend: that he preached only against the abuses of his own church and against the corruptions of the times. Perhaps he did not attack the Jews—his enemies called him a Jew—simply because he would not borrow ammunition from the Franciscans. Oh, he was said to aim far, this Fra Girolamo, his burning eyes bulged as if they were impatient to see the future; his prominent hook nose was a cleaver, his thin lips pressed in determination. A Dominican—*Domini canis*—a hound of the Lord. Black and white like those that romped across the frescoed wall of the great chapel of Santa Maria Novella.

Leaving the river the three youths turned up the Canto della Parte Guelfa and issued from gloomy alleys into the huge windswept space of the Piazza dei Signori. Under the high brown arches of the loggia, a few beggars were sleeping in their rags. Soldiers with pikes guarded the main portone of the Palace. A wide platform, the ringhiera, whereon the Lords Prior sat during celebrations, ran around

the base of the lofty Palagio and Narro jumped up on the platform and pretended to deliver an oration in the pompous manner of the Eight. The boy was inventing a macaronic Latin. Michelangiolo doubled up with laughter. He seemed to find Narro's silliest pranks inspirations of wit. Now the boy had struck a ridiculous pose directly under the heraldic lion. He roared and lashed out with his paw, then pretended to play calcio with the stone ball on which the left paw of the lion rested.

The Piazza was bare of all ornament. The enormous brown-stoned Palagio with its thin-throated flying tower dominated all. The young men leaned back back until the crenelated turret slanted to heaven, flying against a cloud-streaming sky. Blackly the Marzocca soared, an aerial lion, against whose menace the swift sheep of clouds fled.

"Do you imagine the tower of Babel was higher than that?" Narro said.

"There's never been a higher tower anywhere," Michel replied.

"The temple of Jerusalem was higher," Andrea said. "And more magnificent too. It was the most magnificent temple that has ever been. It had columns of cypress and beams of gold and it was so enormous that the dove-sellers in the porticoes could not hear the High Priest at the altar."

Whenever he spoke about the Temple, it was as if he saw it before his eyes. How many times had he listened, a round-eyed boy in the parlor, as Elia and Rabbino Davide da Prato rehearsed the wonder of Solomon's temple. All history was an eternal present to them. The Temple had been destroyed yesterday; they remembered it well, not only from the Pentateuch, not only from Josephus, but from an undocumented inwardness. His friends were observing him with expressions of wounded civic pride.

"A belltower more beautiful than our Giotto's?"

"I do not know about the belltower. But its roof was tiled in gold."

"A crucifix as great as that in our Duomo?"

"No . . . no crucifix at all."

"No frescoes in the chapels?"

"No frescoes."

"It must have been pretty barren," Narro commented scornfully.

"Barren!" he exclaimed indignantly, and the picture rose before his eyes, blotting out the tall stalk of the Palagio. "Barren! Why, the façade was covered from top to bottom with huge plates of gold, and as soon as the sun rose, it blazed so that you couldn't look at it. From a distance it seemed a mountain of snow for where it wasn't

gold it was pure white. And inside there were Babylonian tapestries, designed with hyacinths of byssus and purple and grain. And this was an image of the universe since in the grain was figured the fire, in the byssus the earth, the air was the hyacinth, and the purple was the sea. And woven into the tapestry one could see the orders of all celestial things except the animals, for that is forbidden. There were seven chandeliers signifying the plants, and twelve sheaves signifying the zodiac, and thirteen thuribles for all' thirteen varieties of perfume which signified all came from God—"

He had grown hot with the wonder of it and now he ceased. He had spoken too much. But he could not help it: his words were bricks rebuilding the temple of his phantasy.

"You describe it vividly," said Michel. "Have you perchance seen a painting of it?"

"There are no paintings of it."

"What! You Hebrews dream only of your Temple and you have kept no image!"

Andrea flushed. He had not realized Michel knew . . . but of course he must have known, for was he not acquainted with Elia and did not Elia flourish his faith like a shining sword? So they have known all along I am a Hebrew, Andrea thought, yet they ask me silly questions about crucifixes and statues.

Yet how can you tell a sculptor that graven images are anathema in the house of God?

They sat, feet dangling, on the ringhiera and watched the spectacle of the Piazza. Farmers crossed the windy space in their red-painted two-wheeled carts drawn by mules with sad white-ringed eyes. Priests walked to and from the great Palace of the Lords Prior, their black cassocks whipped up by the untrammelled wind. Brown-hooded Capuchins with dirty bare feet and Dominicans in black and white and Carmelites and Augustinians came in twos and threes and bunches, discoursing as they went, their shaven heads bent against the wind, their beards flying. A tapestry hung from a window of the palace, flapping against the rough stones; within that room the Priors met. Hawkers came by: sellers of sponges, of ladies' ointments, of unguents and spices from the East, of dyed stuffs and Florentine woolens. Apprentice boys—leather-aproned, hair bound in a thong— rushed through, loaded down with all manner of merchandise; black-robed clerks sauntered by, their noses pointed as quills, their frowns worrisome, their sallow brows engraved with speculation. Merchants richly attired in velvet with fur sleeves and caps, walked swingingly and ponderously as camels, accompanied by their retainers to whom

they issued orders with wide, slow, commanding gestures. In the silver light all the movements were a dance; while northward, over the housetops brooded the orange-colored cathedral dome—huge egg of the Mystery—and nearby, the pointed steeple of the Badìa and the crenelated tower of the Bargello.

But they were eighteen, two of them, and one sixteen, and what drew them most were not palaces or merchants, the egg-shaped dome or the hawkers. Now and again—not too frequently—damozels passed, walking slowly and mincingly because otherwise they would have tripped over their long gowns, and also because the wind blew, and their feet were shod in narrow elaborate pointed shoes, and it was ladylike to walk slowly with head held high and bosom spilling over the cupped bodice and hands demure over the puffed-out bellies so that even maidens seemed to be ever in a state of early pregnancy. They strolled by, these damozels accompanied by their donnas or their fathers or their servants or, if they were themselves servants, alone.

And Buonarroto had something to say about each of them. He sat on the ringhiera, and his feet dangled like a pendulum, the faster as the girls struck his fancy, and his tongue wagged like his feet.

"Blood of the Virgin . . . look at that throat . . . there's something to sink your teeth into, eh, Michel? . . . God stretched out on a billiard table, she makes my thighs ache . . . O sow of a Madonna, there's a pretty piece to play the thumping double-backed game with in a haystack . . . Hey, twinkle-toes, pretty ankles, look this way, don't fix your eyes so straight ahead, don't press your lips so primly. . . . hello! twinkle-toes . . ."

"O shut up, Narro! Zitto! Zitto! If jackasses could speak they'd speak with your tongue."

Narro grinned salaciously. He drew his coarse-stockinged feet up under him now, cross-legged, hugely amused.

"You can't bed with a statue, Michel."

"O shut up!"

Michelangiolo was frowning. Whenever he was moody, Andrea noted, Michel had a habit of rubbing the broken bridge of his nose. He was doing this now, offended because his brother was prattling like a peasant. We are no peasants, Michel was thinking, Father is a customs official and he wears the long lucco and had not he, Michelangiolo, eaten many times at the same table as the Magnificent? Where the devil was Narro's dignity? Why did he speak as if his mouth were gummy with the mud of a pig-pen? If he wanted a woman so badly, why didn't he . . . ? He thought his brother be-

haved at times like those shameless donkeys at Settignano who every Fall walked around with enormous flaming phalluses, slapping their bellies as they went, braying outrageous protest to the world.

Frowning, he drew a sheaf of buff-toned paper from within the laces of his jerkin, unlinked the horn of gall ink from his belt, and began furiously to sketch.

Andrea had also been silent as the girls came by, but his eyes had not failed to note a single one of them. The walk of women particularly . . . ah, that was the key to the Mystery . . . if you noted how they walked, you might know all . . . The mincing ones, the trippers, the swayers, the languorous ones, the large-thighed, the lollers. They drew him with a terrible appeal but he was silent as Michelangiolo was silent. But he was silent because these were Christian women and he was afraid. The punishments meted out to those of his people who lay with Christian women were awful. And the sinful ornaments of these women: their plucked eyebrows, their shaven high foreheads, the sweetsick wake of perfume as they passed, the great puffed masses of false hair piled up on metal armatures and intertwined with pearls and ribbons and gold threads and flowers and feathers, the smoldering rubies and diamond-studded crosses that pulsed on creamy naked throats. The more naked the throat, the bigger the cross, Bartolomeo had once sneered. "*Because the daughters of Zion are haughty, and walk with stretched forth necks and wanton eyes, walking and mincing as they go, and making a tinkling with their feet . . .*"

Ahi, but of course, these were not the daughters of Zion and he thought of Tsiporah's doe eyes and her placid soft ways. These were Christian women and they jingled as they crossed the square. Squirming, he turned to see what Michel was up to.

He was sketching the passers-by—rapidly, with no care for detail, seeking only to fix a movement: the swirl of a cape, the lift of a thigh. Fascinated, Andrea watched him slashing at the paper as he had slashed at the marble block, cross-hatching until miracles of flesh rose full-rounded from the sheet. He drew merchants and friars and the soldiers standing guard at the door of the old Palace.

"O there is a subject worthy of a master's pen!" exclaimed Narro, as a blond girl, plump-bosomed as a pigeon, swept across the piazza.

To his brother's salivatingly clucking approval, Michel sketched the girl. He glanced swiftly at the sheet, then crumpled it and cast it to the ground. As Narro leaped down to recover it, Michel's eyes were already roving the piazza for new subjects.

Most of all, he seemed to prefer to sketch groups of idling young

men. They stood in various postures under the three lyrical arches of the loggia, or over by the shelter of the Pisans. Rapidly he did a dozen studies of them, dropping the sheets as soon as he was done, indifferently letting them flutter to the earth, castoff petals of creation's rose.

Narro had already lost interest in the sketching. He was fidgeting, eager to be on his way. But Andrea was all eyes, all questions:

"But don't you understand?" Michel explained, "Young fellows are much better as subjects. The women are all swathed in stuffs so that you don't see the truth of them. For truth is in the figure. Look at that fellow there. Notice the wonderful bulge of his calf? The men's clothes hide nothing, they're like a second skin, that's all. A pied skin, eh? A bit of color. But what is color? A surface thing, a nothing . . . It's only the figure that counts."

He drew buttocks tight in parti-colored hose and the free explosive gestures of expostulating arms, and—as if he saw clean through the clinging woolen jerkins—he sketched the lift of rib-cages, the ripple of muscles along a sturdy back. But the faces, Andrea thought, were too beautiful; they were surely not the faces on the square.

The wind had ceased at last. Andrea felt restless. He took off his cap and ran his fingers through his wealth of ringlets. Then he strolled over to the Marzocca in front of the Palace door. Proudly the heraldic stone lion stood with his paw on the lilied shield. Like the twin lions embroidered in gold on the purple velvet curtain before the Holy of Holies, Andrea thought. Did they realize, these Fiorentini, how much of theirs is *ours?*—for the lion is their herald and ours too, and our David is their favorite hero so that the Master Donatello had carved him twice and so had the Master Verrocchio, and so is the Samson growing now in Michel's garden. And our Judith too, he thought, musing in front of the doorway of the Public Palace as the two soldiers eyed him, glad of any break in the monotony of the guard. Our Judith, too, remembering the Judith of the inner courtyard of the Medici Palace, the green-bronze heroine against a wintry sky. She had grasped Holofernes by the hair as he slept and drew him up to a seated position, her avenging sword raised. "And so she slew that hated champion," as it was written and so would Fra Bernardino be slain. For the Lord God, Blessed be His Name, always protected His people. As He had slain them in Gaza, dragging the idolatrous temple down upon their heads. As He had winged the stone that struck the giant down at the foot of a shepherd boy—poet, singer, king. A swallow was flitting in and out of the Loggia of the Priors, above the heads of the sleeping beggars. Andrea gazed across

at it, his left arm bent, holding the cap on his shoulder. He started to walk toward—

"Don't move!" It was Michelangiolo's voice.

Andrea twisted his head, surprised.

"No! Don't move!" Michel was sketching him, and Andrea stood there immobile in flattered embarrassment. He thought the soldiers by the door were laughing. Swallow-swift the artist's quill flew.

After a moment, Michel called out: "All right." Curiously Andrea looked at the sketch. Michel had drawn him nude, the face a mere blur, but the ringlets lyrically there, and the torso cross-hatched and vigorously modeled. But most clearly designed was the left arm twisted back to the shoulder, the muscle of the neck and the poised head looking toward the loggia.

"A curious position," Michel said, thoughtfully, "I imagine that's how David might have stood just before he fired off his sling."

VIII

Down the hill he raced and across the Ponte Rubaconte, the shortest way to the Santa Croce quarter. He was eager to see how much further the Samson had emerged from his womb of stone. Every day he watched it come forth. A slow birth. Chip by chip, the living grew from the engirdling rock. Oh, what Kabala of the Rabbino Rubino could compare with this? Sheer magic. He who had slain the Philistine was now slaying the arch-Philistine, Death. Not with the jaw-bone of an ass but with the hands of Michelangiolo.

He could never get to the Buonarroti household soon enough. Invariably he found Michel's father, the Customs Official, seated in his rose-red cloak at the octagonal heavy-legged table, busy at his household accounts. The coffinish credenza, the prudish chairs, every stick of furniture in the stiffly-appointed room expressed the severity of Messer Lodovico. It was incredible, Andrea thought, how much time that man could spend at his accounts; you would think there were a dozen in the household instead of Messer Lodovico, his young wife, his four sons and a maidservant. Occasionally, Andrea would

encounter Michel's uncle, Francesco, and his wife, Mona Cassandra. A coarse-visaged noisier version of the Customs Official, Zio Francesco was a money-changer by trade: partner in an outdoor counter in front of Orsanmichele. But he spent much time up at the family farm at Settignano; he had dust-caked horny hands, a tearing manner of laughter, and he smelled too much of sows. Michel did not like his uncle; he never forgave him for having slapped his face. A father's reprimands were in the course of nature but an uncle's—Ah, that was hardly to be borne.

As usual, Messer Lodovico was so intent on his bookkeeping—dipping his quill cogitatingly into the ink, sucking the feathered end in his beard-shrouded lips, that he scarcely gave Andrea more than a curt nod as he entered. "Ah, giovanotto . . ." (he never remembered his name) ". . . Yes, yes . . . back there as always . . . An unworthy waste of time for a grown man, if you ask me . . . Were he receiving florins for it, I might understand . . . But for his own amusement! . . ." Messer Lodovico shook his head and buried his long beard in the accounts. As Andrea walked on to the garden gate, he heard Michel's father shouting in a furious voice: "Donna Lucrezia! Donna Lucrezia! Where the devil is that girl? . . ." And tiny steps came running.

Today, Andrea found several newcomers in the garden, in addition to Michel and his youngest brother, Gismondo. Gismondo was twelve. He was squatting at the foot of the block, dodging the hail of white chips with a stolid air. He had a red face and spoke rarely, and then in grunts. But his small flint-colored eyes were shrewdly appraising. A sharp sliver of marble flew whitely through the air and lodged in his thick hair. As he placidly picked it out, Michel shouted: "Madonna puttana, would you kindly haul your carcass a bit?! Do you want to lose your eyes?"

Heavily, Gismondo moved.

The newcomers in the garden were two young artists who had been fellow-apprentices with Michel in Ghirlandaio's workshop. One was named Iacopo l'Indaco, a husky young man with a face round as a pumpkin, a stormy voice and a tempestuous mop of orange hair. His remarks, punctuated by explosives from one or the other end of his digestive tract, seemed to amuse Michel.

"Eh! That's it!" Iacopo was chattering. "A deeper under-cut. No! No! No! No! Not there, you idiot! What are you trying to do?— Castrate your Samson?"

Michel laughed but did not remove his eyes from his work.

The other young man was Francesco Granacci. Living nearby on

the Via Ghibellina, Granacci was a frequent visitor to the Buonarroti household. He was tall and thin and foppishly beribboned. Andrea recognized the face at once, though he had never met Granacci. But this was the same young man who had once posed for the kneeling nude boy in the fresco which Masaccio had begun and Filippino Lippi finished—a delicate, even beautiful face, a pale untarnished stripling. Now the stripling had grown. But the face was still beautiful: with its long chestnut hair shimmering to the shoulder, and a hazy lazy expression in the eyes, bulging and color of surf just before the wave breaks. It was a face of sensual excess—the lips too full, the eyes too large—but this excess mitigated somewhat by the finely-modeled nose with its pinched nostrils flaring delicately as small birds.

But it was his dress that struck Andrea: Granacci wore a form-fitting ruby tunic whose olive-green sleeves were pierced and slotted with silk ribbons; a milky spume of lace frothed from the cuffs and fine underlinen showed through the elbow-slits. A pair of woolen gloves embroidered in gold lay languidly in his palm. Andrea caught the faint fragrance of perfumed skins.

This bird of paradise together with the snorting farting Iacopo made a strange pair around Michelangiolo. Granacci's handsome tart face wore the expression of a knowing connoisseur as he stood, one hand on hip, swaying on long black-hosed legs that tapered to soft pointed shoes. His musical voice rippled in a gentle counterpoint to the intervals of Indaco's eruptions:

"Within five years I aim to have a bottega of my own . . . It's a fine business if you manage to secure the commissions. And now I've had an opportunity to observe how the Ghirlandaios manage things" (he was still working in the shop though now a full-fledged member of the guild) "I tell you, Michel, given time enough Master Domenico will cover every wall in Fiorenza."

"I don't doubt it," Michel grunted, blinking his eyes shut as a fine chip flew.

"He can't keep up with his commissions, you know. The orders keep flooding in like the Arno last spring. Impossible to fulfill them all. Everything from painted wedding chests to damascened sword blades . . ."

He had, Andrea thought, a rather mincing manner of speech, over-ripe, trippingly polite.

"I really don't understand your ambition to own a shop," Michel laughed. It was a gruff laugh. He talked on as he worked, the chisel clicking an accompaniment. "I hold my art higher than that."

"What has art to do with it? I speak of a fine living, that is all. Do you realize how much Ser Rucellai paid for the garlands of his daughter's wedding? One hundred and twenty ducats! One hundred and twenty ducats! Just for garlands!"

His voice piped off in an excited squeak.

"What I do not understand about the brothers Ghirlandaio," Iacopo said, "is why they continue to work like beasts of burden. They've already got money enough to live like grand lords—popoli grassi. You only need two commissions a year like that of the Rucellai."

"And what would you do the rest of the time?" Michel asked, biting his lips as he drove the mallet home.

"By Bacchus! What would any sane man do? I would lie on the grass and pick my teeth. I would let old Sol lick my belly where it is too white. And when I was hungry I would eat and when I wanted a wench I would find one and tickle her tickleables and squeeze her squeezables and bounce her up and down merrily as a ball. But mostly I would sleep. It is unchristian to work too much."

They all laughed. Shyly Andrea stood at the entrance to the garden until Michel thought to introduce him to his friends. Andrea felt himself coolly surveyed as under a spring rain by the greenish eyes of Granacci. But Iacopo was warmer; he gripped his hand in a bear-squeeze: "You're not of the guild? I haven't seen you before. No? . . . Ahi, a sensible man not to stain his hands with pigments and cut them with stone-splinters."

"It is my dream to be an artist. But I do not dare. I do not possess the talent."

"Talent! It is not talent you need, but simply the nose to stand the smell of it and not to get dizzy up there, that's the important thing . . ." His ruddy face became reflective for a moment, the roaring March voice zephyred: "You have heard of young Marco?" He turned to Michel and Granacci. They nodded silently, obviously loath to talk about the tragedy. Young Marco, an apprentice at Ghirlandaio's, had fallen from a scaffold and broken his neck. For a few moments the garden was silent of voices save for the steady tchip tchip tchip of the chisel.

"Well, how do you like this arm now?" Michel asked. "It's beginning to rise pretty well out of the block, eh?"

"Like a swimmer out of water," Iacopo said, scratching his orange mop.

"Like Venus from the sea," murmured Granacci, index finger idling with the perfumed glove.

Michel was backing away, his head cocked. Suddenly he stumbled. "Sow of a brother, would you haul your damned carcass out of my path!" Lazily, Gismondo moved six inches further back. Michel was surveying his work now, rubbing absently at the bridge of his nose. His crisp hair was powdered white with stone dust.

From the house a boy skipped out into the garden. The boy was lean with the electric look of a terrier. "Babbo says you will be kind enough to take your friends off for a walk. He wants to sleep before returning to the Customs. The hammering disturbs him."

"We're leaving right away."

"And Babbo says not to forget the herbs. He says to stop off at Ser Baldi's, the spice-merchant, just behind the Orto San Michele. The package is already prepared."

"Bene."

The boy started to return to the house. He hadn't even glanced at the Samson. He was, Andrea thought, the handsomest of the Buonarroti brothers: slender and graceful, taller than the lumpish silent Gismondo who was up on his feet now, his interest in the statue done, prepared to track after his favorite, Giovansimone. Giovansimone was taller even than Narro who was two years older. He was only fourteen, Giovansimone, but a permanent mockery was already stamped upon his lips. His eyes were the eyes of all the Buonarrotis —small, coolgray, flecked, challengingly intelligent. They looked out into the world; but they did not permit you to look in.

"Giovansimone!"

"Yes?"

"Have you prepared your lessons?"

"Don't concern yourself," Giovansimone said blandly. "It won't take me but an hour tonight." With a sly smile he slipped into the house, Gismondo yawningly after him. Michel frowned. Francesco clapped him on the shoulder. "You're like a mother hen always clucking about your brothers. Let them be. They'll manage very well without you."

"I'm not worried about Narro. Nor Gismondo either. It's this one. He idles away his time. My father has hired a fine Latin teacher for him: Maestro Landucci declares indeed that Giovansimone is gifted in the tongue. I never mastered it myself; but Maestro Landucci says that if my brother will only apply himself he might achieve something for the honor of our family."

"Your family honor is in very good hands," said Andrea shyly.

"Right now, they're very tired hands." Michel cracked his knuckles.

They left the garden together. And as they strolled toward the Duomo, where they were accustomed to spend the spring sunset hours sprawled out on the flagstones, Michel and his two artist-friends began to talk as fellow-guildsmen. The three of them had worked together on Ghirlandaio's frescoes in the choir of Santa Maria Novella, and Michel and Francesco had studied together under Bertoldo in the Medici garden school. Granacci, indeed, to Andrea's annoyance, seemed to consider himself a sponsor of his friend's career. Had he not introduced him to the Ghirlandaios? Had he not helped persuade Ser Lodovico to permit his son to study in the sculpture-school of the Medici?

So now they spoke of their craft and of the increasingly popular invention of painting with oils. The innovation had reached Italy from Flanders and the friends did not agree about it. Michel said contemptuously it was an art for old women because any duffer could correct a mistake by painting over it. But the other two rejoined in a madrigal of sweet-soft boulder-rude. "But that is fine! To be able to correct an error and not have to chop out a whole segment of the wall and replaster it for fresh painting . . ." They argued with vigor and with wit, Michel ever upholding the difficult arts as against the easier ones: fresh painting in wet plaster against the newfangled oil technique, direct carving in stone as against modeling in clay and casting in bronze. He was like a centaur, Andrea thought, as the four of them strode through narrow alleys, through amber shade and banded blazements of sun lancing down from the sky-strip above—he was like a centaur—his brow furrowed, his pointed ears seeming to prick, his little round eyes glittery-bright. He was a woodland creature ill at ease upon paved ways. And he was always alone, even in the midst of his many companions.

Now they were discussing the pranks of apprentices and the style mannerisms of the various Master-Artists of Fiorenza. Granacci liked Master Piero di Cosimo because his imagination was so fantastical and he drenched his dreamscapes in color. "Ah, but Master Piero refuses to keep a shop," Michel said. "He is not of your opinion. Why do you praise him?"

Piero's eccentricities were the joke of Fiorenza. He ate only hard-boiled eggs and refused to sweep the hovel in which he lived or even kill the flies that buzzed around his refuse.

"I speak about his sense of color, not his foolishness in trade," Francesco rejoined. He began to chide Michel in a purling voice:

"You'll never be able to command a decent price unless you use more lapis lazuli, more vermilion. That is why these printed books

are only a passing fancy. They simply do not possess the color of the hand-painted codex. Why, within a decade these wooden types will serve for nothing but firewood . . . Color! Color! That's the thing. And that's what you neglect, amico mio. All this drawing of yours may be all right as preparation, but what your merchant wants is to see himself and his lady on the walls of his chapel, bright as a rainbow, adoring the Virgin . . ."

"A week ago," Iacopo chimed in, "Master Domenico almost lost his ear. I was in his bottega when it happened. In stormed Monna Lucrezia Grenaldi with her new Book of Hours. *Where are the blues?* she was yelling, *why is there not at least as much lapis lazuli in my book as in that of my friend Monna Lucia?* And when Domenico wheedled about the expense of lapis these days, Monna Lucrezia grabbed him by the ear and began to twist—*Never mind the expense! My husband is prepared to pay. More blue! I command you—more lapis in those angels' wings!* Poor Master Domenico's ear was flaming, she was pinching hard, I tell you, and then she threw the book in his face and stormed out, holding up her skirts."

They all laughed at Iacopo's story, his laughter roaring above the rest.

As they approached the unfinished façade of the Cathedral, Michel slipped his arm under Granacci's. Andrea felt a twinge of jealousy that so crudely smooth a fellow should command Michelangiolo's affection. Why, for all his foppishness he was cruder than Michel with his broken nails, cruder even than this gurgling demijohn of a Iacopo. And for all his talk of art, Francesco Granacci was no different really from Levi the basket-weaver or Hershel ben Moshè the gem-cutter or Adlai the saddler, hunched over on their stools in front of their cave-shops along the Borgo. They made well and they sold. But Michel was different . . .

So, as the trio talked on about their craft, Andrea listened, biting his lips. He felt on the outside of their world. How he envied them! How he wished he too could make others see what pressed within him to see, rebuilding the Temple on the wall so that others might look upon its wonders wordlessly.

But how could he explain such desires to a father who revered only the Book?

IX

All that week while the strange mountains of snow were melting and
Andrea was running excitedly to the garden where the Samson was
rising, he had seen Bartolomeo every day. Invariably he would be
lounging outside his father's loan-shop, gazing through half-closed
eyes, and with a supercilious expression on his face, at the steady
procession of farmers' mule carts, the priests lifting their skirts over
the mud, the merchants coming down the Borgo San Iacopo in
search of loans.

Although the direct route to Michel's was across the Ponte
Rubaconte, Andrea always went these two blocks out of his way.
Several times he met Tsiporah returning from the market. She walked
like music, he thought, balancing the basket of greens on her head,
the upraised arm lifting her firm young breasts. And she was less shy
now. His blood beat at her presence.

"Señor Shem!"—a queer Castilian twist to his Hebrew name—
"Off among the Philistines once more?" She teased his admiration
of the Samson. Once as she passed into the house, she hung a stalk
of parsley on his ear, so that he stood looking stupidly after her, like
a burlesque poet crowned with laurel.

A snort by the portal reminded him why he had come. "Venga"
he invited Bartolomeo along. He waxed rhetorical about the mar-
velous blossoming stone, loveliest flower of that garden. "Come along!
Come along! I am sure Michelangiolo Buonarroti will not mind
another admirer."

And Bartolomeo refused. He refused with a remark about Christian
dogs who carve idols for other Christian dogs to worship. The wor-
ship of dogs is performed by lifting a leg: hence the necessity of
idols. You couldn't lift a leg against the Unseen, the Unnameable.

He laughed harshly. And Andrea, eager to get on, left him there,
lounging against the old wall.

But one day the Spaniard and Michel met by chance. A curious
meeting. It was outside the south doors of the Baptistry on a gray
March day. Tramontana was howling down from the hills: Andrea
and Francesco Granacci clung to each other as they leaned to the
wind; as usual, Michel was pushing along alone. Suddenly, from
around the black-and-white striped octagonal baptistry, Bartolomeo
appeared. He loomed upon them unexpectedly, his head also down

like a battering ram, not because of this wind but because he always walked so, bucking a furious internal storm. He ran smack into Michel.

They both fell, a lovely cadenced fall, almost together, like the sacred ballets of Pisano's door. They fell and Michel laughed gruffly, but Bartolomeo rose to his feet black as the clouds overhead. "Dog!" he shouted and began to swing his fists.

Andrea seized him. He felt as if he had seized a wild boar. He was astonished at the strength of this undersized young man with the parchment skin and burnt-by-hell eyes.

But more astonishing was Michel. For, once the assault began, he recoiled. Actually recoiled, flattening himself against the wall away from the flailing fists. The delicate-scented Francesco had at once entered the battle, but Michel remained apart, not running away, but watching, cautiously watching.

Andrea was astounded. Even amidst the tangle of curses and struggling bodies, he was astounded. For Michelangiolo had never impressed him as a timid one: his manners were gruff, he freely expressed his opinions of great and small, of priest pauper and prince. And his hands, those cut calloused hands that so capably swung a mallet . . . surely they could just as capably swing a fist? . . .

But he was not swinging his fists. He was pressing against the striped wall, a statue of caution in a shallow niche; he was smiling a wary wee smile while he permitted his two friends to battle it out with the volcanic Bartolomeo.

Francesco had whipped a dagger out of his belt. "No! No!" Andrea shouted. "There's no need for that!" Fear doubled his strength and he managed to subdue Bartolomeo, knocking him down and pressing his knees against the Spaniard's biceps. A brown distorted face raged up at him. A twisting wiry body worked against his weight, the breath going like a bellows.

Then it was the rains burst. Thunder rumbled, lightning lanced from black clouds. The four young men took refuge in the Baptistry.

And it was there, in the cool gloom of the Baptistry, under the huge mosaicked benediction of a Byzantine Christ, grotesquely naked-footed, that Michelangiolo and Bartolomeo had commenced their curious brief acquaintanceship.

The thunder rumbled. The rain came down. The clouds coughed and spat lightning. *And in the dark doorway across the street from that blood-battened Virgin, Andrea, huddled in his black cloak, owl of inwardness, felt not this present rain but that rain of five years ago, that rain that had streamed in such fine silver threads past the*

quadrangle of light. There, in the open doorway of the Baptistry they had all taken refuge from the downpour, their private storm superseded by this celestial one. In the dry dimness within they stood looking at the streaming radiance without. And Francesco was cursing because his fine new puffed sleeve had been torn in the mêlée. Were it not for this holy place he would have resumed battle with this foul-tempered Spaniard. As it was, all he could do was curse. So Francesco was cursing as only a Florentine can curse— a choice assortment of oaths in which the Immaculate Virgin and white oxen and leather calcio balls were wonderfully confounded. In the dim vestibule his sharp dagger glinted in his hand. Andrea stood between him and his intended victim. "Put it away, I pray you," Andrea said hoarsely. "It's all over now. È finito. È finito." He felt as if he could never catch his breath again.

But Bartolomeo, who had commenced this imbroglio, and Michelangiolo, who had been the object of it—these two were grinning at each other. It was idiotic. Andrea's left thumb throbbed, his shoulders ached. He was angry that Bartolomeo was not angry.

How mysteriously Andrea reflected many times during the next few months, how mysteriously the affection flared between these two. Perhaps there was an elixir, an arcanic juice of sympathy that ran between certain men. Whatever it was, the few moments together in the Baptistry baptized their battle-born friendship.

Bartolomeo began by apologizing for his bad temper—and Andrea could not believe his ears. That Bartolomeo should apologize to anyone! And to a dog of a Christian in particular! His apology stumbled along in his broken-gaited Andalusian-Tuscan, and Michel accepted it graciously:

"Of course, of course, I find myself flaring up the same . . ."

"Of course, of course . . ." Francesco muttered. He was trying to see what might be salvaged of his torn sleeve. His fine-featured face was smeared with mud. He glared at the two of them. They were chatting amicably and his sleeve was torn.

"You speak strangely," Michel was saying. "You are not of our country?"

"No . . . from Andalusia."

"Andalusia? . . . Ah, that is Spain."

"Yes."

"And what did you take me for? . . . a two-legged bull?"

But he was smiling as he said it. Granacci shrugged his shoulders in disgust. He was breathing heavily, trying to put his torn sleeve to rights. The rain was ceasing now. Fat drops fell from the Apostle's

nose over the doorway. Across the street under the loggia of the Innocents a group of priests were huddled, their black soutanes wet and clinging so that the outlines of their legs showed. One of the priests was sneezing.

"Did you see the procession of the Genovese when he returned with those savages all naked? That must have been a marvelous spectacle."

"What Genovese?"

"The captain named Colombo. He who is said to have found a new route to the Indies."

"I never heard of the man."

"Strange you should not know of him. He sailed in the service of your king."

Bartolomeo's lips curled but he said nothing. When the rain ceased, he walked off swiftly alone, without even the courtesy of a farewell.

But Michel seemed to be looking after him with curious sympathy; and at that moment, baffled and battered, sharing a chagrin, Andrea and Granacci almost liked each other.

X

So he joined the circle.

All during the spring months when the Arno ran high and muddy and threatened to wash away the wooden footbridge near the Ponte Rubaconte, and the snow melted on the heights of Vallombrosa and the green hillsides were tapestried with flowers; and all during the limpid days of early summer when the pink-and-green campanile of Giotto bloomed against the bright sky—most exotic flower of them all—the "Spaniard" joined in their excursions.

That was their name for him—"lo spagnuolo." Only Andrea knew . . . And so long as Bartolomeo chose not to flaunt his faith —as apparently he did—Andrea had no intention of betraying his confidence.

Indeed, it was happier he did not flaunt it, Andrea often reflected, for Bartolomeo's faith was not a shield but a sword: he had to swing

it: wounding or being wounded. He could not rest calmly, as Andrea did, behind his otherness. This was the finest gift Elia had bestowed upon his step-son.

Bartolomeo was inexplicable anyway. And so was Michelangiolo. Andrea was irritated by the sculptor's choice of close companions. That fop Granacci, that silly crude brother Narro, the bumbling Iacopo, . . . and now, strangest of all, Bartolomeo. What had they in common, Andrea thought, except their mutual inexplicability? Perhaps Michel's scorn of his money-lending uncle ran to meet Bartolomeo's scorn of money-lending in general? Surely it was not love of art that drew them together: Bartolomeo had even less interest in art than had the Doctor. The Spaniard had been in the garden when the Samson finally emerged, triumphant and gleaming. And he had gazed at it with those burning eyes, gazed at it as rapidly as a bird's shadow might dart over a stone.

And said nothing.

Andrea had burst into exclamations of wonder; Francesco had judged it with the profound respect of a fellow artisan; Iacopo had clapped Michel on the back; Narro had boasted to all his fellows about his brother's magic-making powers. Even his step-mother and father had come out into the garden to see it: Monna Lucrezia praising with tiny bird sounds; while her bearded husband stood with legs portentously aplant, hands clasped behind his long red cloak, nodding his head in sage approval. Who knows, his manner seemed to say, perhaps this stone-cutting might prove of some use after all? An inexplicable number of these great lords seemed to share the Magnificent's peculiar passion for such things; perhaps the son might prove as helpful as the father and even offer a decent living to Michel. Who knows? In God's providence, for God's tastes were not man's, even art might prove of service to coffer and honor of the Buonarroti family.

Even Gismondo, who already at twelve was a miniature version of the Customs Official, silently mimicked his father's praise. It was then that Giovansimone, lithe and electric as a terrier, darted into the garden, circled the white muscled figure, patted a bulging bicep, tickled a stony toe, and admitted that Michel had some talents other than reprimanding. And Giansimone, who possessed a gift for rhyming, improvised a sonnet which began:

Once more the Philistines are slain . . .

But Bartolomeo said nothing. Amid the jubilee of family and friends, he had stood dour and contained. And that night, after

excitedly describing the marvelous statue to his father, Andrea wondered whether Bartolomeo's silence was but his mode of expressing what Elia philosophized. For Elia had remarked coldly that the true Samson was a hero of the mind. There was no need to see him. Indeed, seen, he ceased to be a hero. His strength lay in his abstraction, his invisibility to the fleshly eye, his inaccessibility to all save the vision within.

Andrea was troubled: all that night, Samsons—the invisible and the visible—wrestled in a gigantic struggle within him.

Now the Samson was put down in the cellar, until, as the Customs Official said, some great lord might choose to buy it. Meanwhile, there was no need to leave it cluttering up the garden.

Bartolomeo even helped them haul the heavy stone. His brown arms clasped the Samson round its white belly and he cursed marvelous Andalusian curses. And Michel laughing laughing as he grunted and puffed . . . How could one explain it? The sympathy that drew them together certainly wasn't art. It was as strange as the weather: that outlandish snowfall, the repeated storms, the sudden thunders out of nowhere, the lightning that bolted from the blue and smashed the lantern of the Duomo and sent two columns of it crashing into the Via dei Servi, while inside, plaster dust rained down on the worshippers. Oh, there were many strange events these days, all connected no doubt with the mysterious death of the Magnificent. A monstrous child had been born at Settignano, a child with two heads and four arms; it lived for several days. And red sunsets, the sun a malignant eye.

XI

That was when the plague came. Huddling in his cloak across the street from Simone Ferrucci's Madonna, Andrea tried not to think of it. But the memory returned softly insistent, taking momentary preeminence among the host of memories that thronged about him in the shadows like insects. And he saw his mother then, as now even through the gloom of the evening street he could see the glitter of

the Madonna's gold mosaic ground, the uneven-surfaced stones picking up the light of lanterns jogging on the sides of the donkeys. Along the Street of the Shoemakers a young man was sauntering, singing to the evening star that now hung trembling like a vivid tear from black eyelashes of projecting eaves.

And he saw his mother, lying stiff and dead. All over Fiorenza others lay the same, falling darkly and deliberately as in a dream, not even groaning but perhaps a soft muffled cry as they toppled over in the streets, over shop-counters, on the bridges. There were so many of them that the Hospital of Santa Maria could not contain them all and so straw pallets had to be laid out in the Piazza alongside Giotto's campanile, where the dying might watch through glutinous eyes the monks hurrying by with cloths tied around their mouths and noses and holding smoky torches to ward away the pest as they gathered up the stricken.

And there was murmuring against the Jews as there always was at time of plague; but fortunately this calamity passed almost as swiftly as it came, like a sickle cutting down a field of grain. For, had Fra Bernardino been in Fiorenza to rouse them, the superstitious frightened people would have burned the Jews alive, accusing them of causing this *pesta* by poisoning the wells and by black magic. But luckily Bernardino was not in the city and the pestilence had gone before anyone thought to attribute it to the Jews.

And so, during those dreadful weeks even the Franciscans were willing to overlook the fact that Father was a Hebrew. And he saved the lives of some Christians but Mamma's life he could not save.

Thinking of it now, Andrea's eyes were stung with tears. He saw his mother—shuddering like a shot bird, her honey-colored hair long and spread out on the pillow, and Elia tall as a mountain by her bedside, clenching and unclenching his fists. And when the end came Elia did not weep, not even at the grave. Instead, dry-eyed he stood amidst the chanted prayers of the rabbi and Uncle Moshè and the weeping of his sister-in-law. He had not seemed aware when the rabbi cut a piece off his tunic and cast it into the wounded earth where Mamma unbelievably lay.

For months afterwards Elia buried himself in the *Consolations of Philosophy* by Boethius, comparing it textually and anagogically and ontologically with the sublime Maimonides, while Andrea ranged the streets lost as a dog. Once Bartolomeo and Tsiporah accompanied him to the cemetery and waited silently as Andrea left a little stone on Mother's grave so that she might know he had been there. And though Bartolomeo's mouth was twisted in customary scorn, he had

said nothing as the three of them made their way down the hill of San Miniato. When they parted Tsiporah touched his wrist in voiceless sympathy. For days afterward, he felt its warmth in the chill hushed household.

At that time of loss, they were both—father and son—spinning in private darkness: a planet and its satellite belonging to the same system but each imprisoned in its separate orbit. And then they had rediscovered each other, drawn closer in the dark, pooled their loneliness. The Doctor, who was not given to effusive sentiment, expressed his feelings by an act of the deepest respect: he began to expound his Averrhoes and his Galen and his Aristotle to his son. He could do no more. And Andrea listened. He bowed his head and listened. With profound filial respect.

And all his interest was feigned.

For Andrea loathed medicine and was bored by philosophy. His passion was art. Since he had seen those forms, one of snow and one of stone, emerge under Michel's hands he could not forget the magic of it. He had begun to haunt the artists' workshops. The smell of ground pigment was in his nostrils. He shook away his dread of being seen by a co-religionist and went openly into the churches, to worship there not at the shrine of a tormented Jew nailed on a cross but at the frescoes of Masaccio and Ghirlandaio, the rounded flesh speaking from flat plaster walls, the elegant young men in yellow doublets looking out boldly and forever at visitors, the merchant-patrons and their wooden-faced wives who would kneel in jowly dignity as long as these walls would last. And Andrea would be so lost in the sound of a painted bell that he did not hear the tinkling of the priest, and so ravished by Uccello's imaged hyssop and narcissus he did not smell the strong smell of the censer. He would emerge from the dim church blinking like an owl and suddenly looking down the Via Larga there were shapes and colors he had never seen before, never had the blue Fiesolean hills rolled across the sky with such rhythm, never were there such pictures everywhere—that Strozzi cornice cutting the sky into a neat paleblue triangle, the coachman's russet whip against the spinning black blurred wheel. He had not seen and now he saw! And it was the artists who had made him see: they who had removed the scales from his eyes so that the world became fresh and clean again as on the first morning in Eden after the first rain.

He suddenly realized that even in his grief at the graveside he had been staring at the greenness of a blade of grass; even in his misery he had not failed to watch with fascination the wind's fingers pinch-

ing and molding the clouds into the Magnificent Lorenzo's face, jaw and all. And he felt ashamed that at such a time, even for a moment, his grief could be dazzled by the sheer shining envelope of the world. But after Mother's death, art alone seemed to justify the cruelties of reality.

But if Andrea's passion was art, things of art meant nothing to the Maestro del Medigo. He was a philosopher and a doctor; his father and his grandfather had been philosophers and doctors before him; he assumed his brother's—his—son would be a doctor too. It was not a subject of discussion, it was born with you like the color of your eyes.

So Andrea did not openly challenge his predestined future. His passion for fair forms, fair hues, the world of harmonious relations could not be shared with his step-father.

For the good Doctor was color-blind in a city flaming with the colors of a new morning—the orange of baked tiles; the hazed yield of female thighs; the laddered shadows of boyish ribs; the pungent taste of wine and the sweet moist mouths of girls; the ochre pour of the Arno after heavy rains; the gold mosaics of San Miniato sparkling at sunset; the pink baptismal finger of Fiesole's campanile; the grim hundred towers of Fiorenza, prickly as a band of visored knights; the frequent cavalcades gaudy with silken flags in black and gold and yellower than the jaundices he cured and redder than the blood he drew; the rainbow-robbing banners written over with strange devices of the twenty-one guilds; the ominous roll of the drums; the stately marchers; the funerals with their black-hooded companies of the Misericordia holding yard-long smoky torches incongruous in the sunlight, while around the black-and-gold hearse a dog frisked its profane hopeful comment; the religious processions with their cassocked priests under embroidered canopies and their ranked choirs of boys chanting the Gregorian which had grown from the bosom of his own cantorial chant; the gay jousts and tourneys which the Magnificent and his brother, the too-soon-slain Giuliano, had loved so to perform in the wide sandy Piazza di Santa Croce (the horses caparisoned in the richest brocades, the sun glinting on halberds and damascened blades and arabesqued lances; the thunder of hooves and the clank and clash of broadswords and the roar from the crowd as a jouster was thrown and struggled helplessly to rise under his weight of armor, and the grace of Giuliano as he bowed deeply to the ground, left foot forward, right arm back and high with a gay dab of a velvet feathered cap, and the blond Simonetta in the stands rising to acknowledge the bow); the spring evenings when every sunset

over the Arno was a hush of pink and a haze of pearl engraved by
black cypresses and square hard towers . . .

All this meant precisely nothing to the Doctor.

For the bright drench and fabric of the phenomenal world were
only signs of Jahveh: the One, the Unnameable. To the Doctor,
sensory splendor was nothing but the organs of Being: the world
lay open like a patient on an operating slab; and the color of its
blood, the shapes of its organs, the throb and smell of its concerns
had diagnostic value only. So Beauty might arouse him as an Idea
but it failed to stir him as an experience.

Had Andrea tried to communicate the excitement he felt in the
presence of a statue, a picture, the vibrations of a lute, the inter-
twined pungency of madrigals—the Doctor would have smiled.

And there were times when Andrea could not stand his father's
superior smile.

XII

Early in May, Michelangiolo's most ardent wish was fulfilled.
Through the Prior of Santo Spirito he learned that del Medigo had
been promised the corpse of a criminal soon to be strangled by the
public executioner. If ecclesiastical sanction were granted, a dis-
section would be performed. And in exchange for the promise of
a large wooden crucifix, Michel would be permitted to attend.

The Prior had little doubt about securing the ecclesiastical sanc-
tion. He had spoken up for it himself, as he had done several times
before. For the Prior, who was round and fat and always smiling, had
a passion for anatomy. Every time he witnessed del Medigo at work,
he was fascinated. The Jew was said to have studied under Mundinus
at Padova; and unlike the Christian doctors, he did not leave the
actual dissection to an assistant while he contented himself reading
from Galen and pointing—at a safe distance—with a wand. No, this
del Medigo actually performed the anatomy himself after the Prior
had read aloud the papal indulgence, and stamped the corpse on the
forehead with the seal of the University of Fiorenza. Usually, as a
good Christian, the Prior chopped off the head which had housed

the fled soul. The Prior was not very much troubled by the spectacle of a headless man capering about on the Day of Resurrection. He always enjoyed singing with the choir of physicians, and always ate heartily at the banquets that customarily followed a dissection.

Andrea deliberately came to the refectory after the ceremony had begun. He hated these affairs and always sought to avoid them. But avoid them entirely he could not, for del Medigo took it for granted that his son would become a physician, and these were opportunities to study not to be missed. So Andrea arrived with an excuse all prepared for his tardy appearance.

The Piazza di Santo Spirito was amber with the dying sun. Outside, on the church steps, under the two great lyrical S's of the unfaced façade, ragged children were playing and beggars slept twitchingly in the golden breeze. Regretfully, Andrea entered the barnlike refectory that had been converted into a morgue during the recent plague. He had been here several times with Master Elia at previous dissections and during the plague. He fancied he could still see the corpses lying row on row on the rough oaken tables, the decaying flesh and the smoke of the fires continually burning there to purify the air.

Now, at the far end of the dim vault he saw a vague gathering. Approaching, he recognized various physicians, the Prior, and the medical students gathered under some minor master's flaked and fading fresco of the Last Supper. He could not see his father but he knew he was at the core of that crowd, bloody knife in hand, and that it was he demonstrating what mysteries resided within the precise Death who lay there: his belly open, his blood dripping, his bones picked—offering himself up as a ghoulish last supper to these medical students gathered under the painted Last Supper on the wall.

Andrea fought down his queasy stomach and moved between the rows of this sacred charnel house. Now, as in the synagogue at certain passages of the reading, he heard a murmur of admiration welling up and echoing in the vault, and then his father's face, flickering in candlelight. Elia's hand was holding aloft, for the edification of the company, a slimy something.

Andrea felt like vomiting.

Every time he saw a dissection he felt like vomiting. He never told Elia, of course. He never told him that it was not only the dissection but the mangled bodies of those criminals that sickened him: the broken bones, the stumps of tongues cut out for blasphemy, the limbs ripped asunder by the rack.

This one, he now observed, as he joined the audience, to his
father's nodded acknowledgment—this one had been strangled: you
could still see the blue-black ring around the neck. In the ghoulish
company Michelangiolo was leaning attentively over the corpse
about which del Medigo was discoursing. The naked body of a young
man lay on a plank resting on several crosstrees. The cadaver had a
black tangled beard through which could be seen, running from
ear to chin, a white vivid scar. Nakedly on his back he lay, his in-
testines slimily crawling on the stone floor; and in order that the good
Doctor might lecture more clearly in the dim hall, a lighted candle
had been stuck in the corpse's belly.

And he was grinning.

He was grinning just like the Prior who stood at the head which
he should have, as a good Christian, removed. Around on both sides
were students busily jotting in notebooks. Like them, Michel's apron
was leopard-splotched with blood. Several physicians in long purple
robes were whispering. They wore turbans, and one of them held
an open parchment text of Galen, in which he was following the
lecture with a tremulous finger, as he peered now and then through
half-moon spectacles at del Medigo's wand, darting pedagogically in
and out of the viscous bloody aperture.

But Michel was not taking notes. He was sketching, rapidly sketch-
ing, and the students had difficulty attending to the Doctor. They
could not tear their eyes away from Michel's drawing. How it all
emerged on the paper! How miraculously clearer than there upon
the plank before them!—the flat cross-layers of muscle that overlay
the ribs, the gleaming ball-and-socket of the right elbow (the other
arm had been amputated for theft), the mysterious architecture of
fat and bone and tendon, the tangled lace of veins and arteries, the
interlocking hinges of the jaw— Oh, what text of Hippocrates, what
Galen could reveal what that living drawing revealed!

Rapidly, nervously, his pen darted over the paper, a living black
insect leaving these traceries as a spider leaves its shining geometry
written on branch and breeze . . . not copying, but isolating, bring-
ing to the eye what the mind alone saw . . . Now and again he bit
his lower lip in concentration, rubbed his broken nose with the back
of an ink-smudged finger, cleaned the sticky quill point in his begin-
ning beard. In the dancing candlelight his eyes sparkled.

A terrible joy, Andrea thought . . . Father would prefer him as
a son. A pang shot through his nausea, ever at the brink.

"Ah, Andrea . . ." Michel whispered, suddenly aware of him. He
whispered yet lower that Elia might not be interrupted. "Oh, isn't

this a marvel?! I am so grateful to your father for permitting me . . ."

Del Medigo coughed. Michel smiled an apology and returned to his sketching. "Now you will observe please that the *Renes* . . ." The words echoed in the chill vault; the Doctor's long shadow gulped on the wall; the Apostles seemed to sway in the candlelight. And then there was a rising murmur as Elia skillfully extracted with a forceps a severed kidney. He held it aloft, yellow, glistening. ". . . *viscus elegantissimum* . . . most elegant of the viscera . . ." He wasn't even aware of Andrea. Nor was Michelangiolo. The black insect scurried over the paper.

Though he had come explicitly to join his friend, Andrea tiptoed alone out of the vault.

XIII

From that low-lying island to this philosophic hill, Elia was thinking. Down there, years away, the island floated, red as a ruby in the scalloped blue Mediterranean. Every time Elia toiled up this steep hillside to Count Pico's villa, the island shimmered in his mind. For Candia meant his youth, from that low place he had arrived at last upon these crisp green heights.

Ahead of him on the narrow path he caught a glimpse of Andrea's purple cloak. He was moving gracefully, surefooted as a mountain goat. Perhaps, thought Elia, the brisk exercise of the two-hour climb to Fiesole, and the exercise of the mind later at the villa (*would any of the others be there?*) might help to purge him of his fancies. He was a strange son, Andrea, stranger yet since his mother's death. He had Ruth's great eyes and her honey-tinted hair, but there was in him an impenetrable enclave, a tabernacle of privacy, that was not Ruth's.

Now, thinking of her, Elia felt the tears come and he stopped to cling to an olive root. He must not, she was gone; and that was the way of the world; the Almighty, Blessed be His Name, gathered you to his bosom. "Like sheep they are laid in the grave; death shall feed on them; and the upright shall have dominion over them in the

morning; and their beauty shall consume in the grave from their dwelling . . ." So sang the Psalmist and Elia swayed on the path, a little from the heat, a little from the familiar habit of his prayers. "But God will redeem my soul from the power of the grave: for He shall receive me. Selah."

Up ahead on the path, Andrea was suddenly aware of the silence behind him. He turned around. Father was clinging to a tree and breathing heavily, his lips murmuring. Andrea scrambled down. "You are not ill?" he said anxiously.

"No. But I am not eighteen."

"Ah, forgive me."

Elia smiled. It was a real smile, not his usual acerb slightly superior benediction. He gripped his step-son's hand and a warmth passed between them. Andrea helped him up the steep place to where the path widened and leveled. Although there was no longer need for it, they continued walking hand in hand, until the path narrowed again and forced them to separate.

Early that morning they had departed in order to avoid the heat of the sun. It was a long climb to Pico's villa at Querceta and there was nothing to be gained in taking mules, they would only have to be walked most of the way up the mountain. But Elia didn't mind, he was curious to see his former pupil again. When he had received the message, it was as if he had received a message from his past. Breaking the seal and reading Pico's familiar beautiful hand—the tiny perfectly formed calligraphy, bending all one way like reeds in an intellectual wind—Elia felt a pulse of joy although you would not have suspected it from the calm still features. Ahi, but he had not seen much of the Phoenix this year or more since the Magnificent's death. Several times they might meet at Vespasiano's bookshop—still a gathering place of humanists, although old Vespasiano himself had retired after the popularity of the printed books he so abominated. On the few occasions Elia had met Count Pico there, he had sensed a withdrawal of his former pupil: the boyish bloom was quite gone now, although the Count was only thirty-four, five years younger than himself. But it was not a matter of years. The bloom was spirit and the spirit had turned dark and foreboding now. So, they had met, clasped hands, exchanged a few trivial words.

But it was not the same.

Indeed he had not been the same since the fiasco of his nine hundred theses. For when the disputation had been forbidden by the Pope and the ban put upon his theses, a darkness had fallen upon him, that bright and brilliant youth who would reconcile in one

great Summa—like the Christian Thomas' or our great Rambam's—
all that was diverse, all that clashed, all the seeming discord of this
world. How he had dreamed of that masterpiece of reconciliation: of
Plato and Aristotle, of Christian and Jew, of Paul and the Kabala, of
Jesus and Zoroaster, of Averrhoes and Avicenna—all tossed into the
"mixed bowl" that was man—and they had together slaved over it,
brewed and stewed and stirred the sometimes noisome components.
Of course, Elia reflected, he knew—how could he fail to know?—
that I did not share his fanatic dream; how could I share with Chris-
tians and with Persians the unique patrimony that is ours? For the
Lord, Our God, is a jealous God and thou shalt worship no other
gods before Him. Selah!

They had reached San Domenico now, midway up the mount, and
they paused to rest. Below them in the valley, shimmering already in
the heat, they looked upon the multitowered city, ringed and grim
as a knight in armour, with its ever-familiar and ever-thrilling trinity
of floating Dome, stalked Palagio, and Giotto's fantastic belltower
pink and pale green and white like a lady's treasure box with its sing-
ing jewels of bells. The picture was framed by the steeple of the
Badia and the square-towered Bargello. Already in the morning sun
the river was flashing. A faint tintinnabulation murmured from the
valley, mingling with the sound of bees working the flowery hillside
on which they sat. Now and then distant dogs barked. It was getting
quite hot. Andrea wiped his brow. Father was humming softly. Not
since Mother's death had Andrea seen such softness on his father's
stern face. Embossed on this hillside with the gemlike city shimmer-
ing below, with the bees and birdsongs and warblings and the faint
shushing of the wind swaying the tall cypress and the ilex, they felt
closer to each other than they had felt for a long while; tenderness
enfolded them as these mollient mountains enfolded the hard city
in the valley. This wind swaying the cypress, this flood of light and
haze of distant hill, and everywhere the green, the reposeful green in
which the mind could sink as into a green pillow. Ahi, the darkness
which had descended with Lorenzo's death was surely an illusion,
Elia was almost tempted to think. The golden time was back again.
He was climbing this philosophic hill to Marsilio's villa where the
lamp ever burned before the bust of Plato, and Pico would be there
and Angiolo and laughing Luigi with his lute and the Magnificent
himself and the Chancellor Scala and his beautiful daughter Ales-
sandra. He frowned and shook off his thoughts. No, that was all
gone, they were still alive, most of them, but it was as if their col-
lective head had been struck off. For once the Magnificent was

gone, they had all scurried: Old Ficino was ensconced at Careggi; he seldom came down to the City now, nor did Poliziano nor Pico, all of them hidden away in their villas embosomed in the woods of this superb hill as if, like Boccaccio in the olden times, they feared contamination from a plague.

And in a sense, was it not a plague? Elia murmured to himself. A drop of sunlight glinted in the river. Between the branches of the holm oaks a swallow darted. Was it not a plague that down there, in that bowl of wisdom, monks now barked? And the only philosophic disputations now were those of a Fra Bernardino, a Fra Girolamo, a Fra Genezzano? For the moment, at any rate, the first was muzzled, Elia thought with gratitude. And Fra Girolamo was too busy attacking the Church to attack us. And Fra Genezzano —he smiled to himself—was too busy attacking Savonarola. Thus the Lord God set them each against each other for our momentary favor.

"Come," he said aloud, glancing up the steep hill. "We still have an hour's climb." Andrea scrambled to his feet. They resumed the path. They passed through a silver-green olive orchard and past plump vineyards where tendrils twined, thought the Doctor, like the network of veins leading to the Medulla Oblongata. Curious the passion with which that young sculptor, Michelangiolo Buonarroti, attended his anatomy of the scar-faced thief last week. He stared ahead at his son. Ah, if only Andrea might show some of that very passion. But he was too soft, he was like Ruth, he was all Ruth and none of him. Not even my own son, he suddenly thought, and the thought—together with the memory of Ruth—saddened him.

The olive grove opened, and sheer above them, in the saddle between two peaks, on the site of the ancient Etruscan town, was Fiesole: atop the left peak the square walls of the Franciscan monastery were white geometry against an azure sky. It was said that near here the engineer Lionardo da Vinci had once projected a flight by means of some contrivance that would make a bird of a man. Pico had spoken of it. As he spoke of everything in those days. Ah, but he had been more open then, thought Elia, his only passion had been *to know*. But now like Poliziano, like Benivieni, he talked of taking orders. The absurdity of it! Poliziano whose morals were such that Madonna Clarissa had removed him as tutor to her sons, Poliziano who wrote such amusing Greek epigrams of a not so nice character— Poliziano in a cowl! And his Pico too, he who had challenged the entire church with his nine hundred theses—Pico, a monk! It was inconceivable.

Yet he had not been the same since Pope Innocent's ban, Elia reflected sadly. From that time on, he feared hell like all the others and there had been a different look in his eyes when they discussed Kabala or Mishna together. Even when he wrote his apology for the theses, the earlier self-confidence was gone. He was no more the young nobleman who held there was nothing more wonderful than man, center of all things, the very navel of the world, the "mixed bowl" of beast and god as he had written in his superb De Dignitates Hominum. No, the Prince of Concordia's blue Christian eyes no longer gazed candidly into Elia's brown Jewish ones. He had fallen under Savonarola's spell; indeed, to think it was his Pico who had urged the Magnificent to invite the Dominican from Ferrara to become Prior of San Marco.

His Pico.

He who would climb Jacob's ladder on the rungs of Philosophy.

Now they were walking between high garden walls over which pink oleanders and purple wisteria fell in showers of lovely indolence. Ahead of them the tan merloned turret of Pico's villa suddenly loomed above the treetops. A musical fall of pebbles accompanied their ascent. New vistas opened with every turning of the path. Elia felt as if he were breathing again, the first true deep breaths he had drawn since that terrible week of the plague. He tried not to think about Ruth. He was once again in his beloved countryside in the soft civilized hills; his spirits were refreshed, the human plant was aflower. He held Andrea's hand until they reached the gate.

A servant ushered them into the great hall. Several members of the Academy had already gathered there. Judging by the expressions on their faces, Elia surmised that they had been summoned to celebrate some good news. Everyone was smiling, the post-Lorenzian gloom pierced by rays of a vanished sun. Poliziano was jiggling from foot to foot, chattering with old Ficino. Benivieni was reading a letter, his eyes bird-bright. Pico was talking excitedly with a Dominican monk whose back was turned. They were so deep in ardent conversation that Pico failed to greet his old tutor.

Then Elia heard the monk say:

"Then you have not yet arrived at a decision?"

"I hesitate . . . Padre. I fear I am not worthy. I have made too many errors in the past . . ."

"Well, in that case—" the monk's voice contained a sting of irritation "—in that case, meditate upon it a while longer. I shall always be ready to receive your confession."

He wheeled abruptly to depart. It was, Elia saw with a start, the

famous Prior of San Marco. He recognized Fra Girolamo's burning bulging brown eyes, the iron thrust jaw that seemed as if it had been designed to stamp out words as a die stamps metal, the prominent beaked nose, the burnt manuscript complexion. Without even a word of addio to the company and with only a passing hawk-glance at the newcomers, Savonarola departed. As he walked, his cassock swirled like a white sail: he seemed driven by an inner wind. Pico accompanied him to the gate. When he returned he was aware for the first time that Elia had arrived. Smiling, he held out his hand:

"Forgive me! This is so joyous a day, Master Elia, that I am quite incapable of the niceties of courtesy. But I wanted you to be here—I wanted all my friends to be here—" he turned to include the company with an ingathering motion of love "—to rejoice with me."

The smiles broadened. They all seemed to breathe a balsamic air today, Elia thought, what was it? Benivieni's fragile body was arched like a bow over the letter. And Master Angiolo had been drinking too much. He was filling another silver goblet with wine. He raised the goblet:

> *Ognun segua, Bacco, te!*
> *Bacco, Bacco, eù oè!*
> *Chi vuol bever, chi vuol bevere,*
> *Vegna a bever, vegna qui . . .*

And he quaffed the drink as everybody laughed and applauded his Bacchic hymn from *Orpheus*. A vain man, Andrea thought, seeking the opportunity to quote himself. But what a voice! What sonority! What musical feeling! It made you forget the too-vigorous beaked nose, the pasty complexion, the bags under the eyes.

Pico waved his guests to chairs and poured wine for them. "So this is your son?" the Phoenix said, fixing the brimming blue bowls of his eyes upon Andrea. Andrea felt ill at ease. He was not accustomed to be in the company of Immortals. It did not seem they should be walking the green earth. He had heard both Elia and Michel speak often of these men: of their disputations and celebrations, of their literary and amatory quarrels, and of their master Lorenzo, especially, whom they had worshipped as if he were Jupiter. That old man standing there by the fireplace—that must be Marsilio Ficino, he decided, founder of the Academy. He was swathed in a somber black cloak, a fringe of straight white hair depended from his bald impressive dome. His expression was tired and his downward drooping lips trembled as he spoke in a shy stammering voice. Surely not very impressive, Andrea thought. His pale eyes were abstract:

they were not gazing at this world but beyond at the world of Plato's eternal Ideas. He turned his head and seeing him in profile Andrea was struck by the truth of Michelangiolo's observation, a sculptor's observation: "It's most curious, you know, but Messer Ficino's nose and forehead are exactly parallel as in the statues of those Greeks he so much admires."

But most of all Andrea was fascinated by Pico, his father's beloved Pico, this young man with the straight large nose and long blond hair and shining, slightly popping, blue eyes. He was explaining to Elia now the reason for the gathering:

"Master Elia, the ban has been lifted! The ban has been lifted! You must read it for yourself! I just received the letter yesterday from Rome!"

And he reached over and took the letter from Benivieni and handed it to Elia. Pico's thin fingers were trembling: his face, Elia thought, was pale as Death itself. The thought chilled him. This young beautiful face, burnt with study, already touched with the tomb. He sighed. He was not well, Pico. Perhaps that helped explain . . .

". . . read it, Master . . ."

He spread the brown paper on his lap and read: It was a copy of a Papal brief absolving Pico, Count of Mirandola, of the errors promulgated in his nine hundred theses, twenty of which had been adjudged heretical by the previous Pontiff, Innocent the Eighth. The letter was sealed with the seal of the reigning Pontiff, Alexander the Sixth.

So the Borgia has absolved him and now he will go to Heaven, Elia thought. Silently he handed the letter back to Pico and nodded. His face betrayed not a sign, neither of rejoicing nor of irony. "I am indeed happy for you," he said tonelessly.

"When the news arrived," Poliziano said, "Pico sent his gardener to rouse me with it. I tell you it was a most welcome interruption." Indolently he fixed his brown eyes on Andrea as he talked. The corner of his wide lips twitched. "I am so weary of these eternal requests," he went on. "Do you know that at the moment your news arrived, I was walking back and forth in the olive grove trying to contrive a Latin epigram for young Mario, of the Duke of Urbino's staff . . . a motto which he wished to engrave on the hilt of his sword, something that only his mistress might interpret."

Benivieni smiled: "Oh, I am certain it was no task at all for you," he murmured.

"It was indeed," Master Angiolo cried with nasal emphasis. "I tell you I am sick of being forced to put up with that sort of persecution.

I am being dragged about like an ox by his nose—every lord, lady, ecclesiastic, virtuoso, in Italy is bothering me for pasquinades, sweet sayings to fit inside the circle of their rings, inscriptions for their silver and their plates . . . *Ille mihi proprios amores stultus stultori narrat . . .*" he went on in Latin, and when he had done there was a burst of laughter. Andrea, who knew Latin but had difficulty negotiating Poliziano's swift nasalism, could tell by the expressions on the faces that the witticism had been salacious.

It was an all-afternoon celebration. They drank and reminisced of Lorenzian days. Poliziano grew ever more gay under the effect of the wine and began to berate Pico for having burned his youthful Latin love poetry. His face revealed actual pain as he recalled that act of literary vandalism.

"Those poems are best forgotten," Pico said irritably. "Fra Girolamo . . ."

And Poliziano was struck dumb. The very name was a spell. And yet those marvelous verses . . . those verses. Ah, how the songs flowed in those days: his own, and Pico's, and Benivieni's over there, whose lyrics were like sacred rain, and the Magnificent himself who surely wrote better than Dante:

> *Nell' acqua all'ombra delle sacre fronde*
> *Cantan candidi cigni dolcemente;*
> *l'acqua riceve il canto e poi risponde.*

The deliciousness of it! the late afternoon light was staining through the casement windows; the air was golden, tinged with melancholy. We are all sinners, Poliziano thought, and refilled his goblet. He must remember to call on Maestro Arrigo Isach in the morning. Next week would be the anniversary of the Magnificent's death, and he hoped the Fleming had completed his musical setting of the dirge:

> *Ut nocte fleam,*
> *Ut luce fleam . . .*

they would all sing it together. He drank another cup of wine . . . That young Jew, son to the physician, had beautiful ringlets. Ah, how could one live torn between the flesh and eternity? He thought of Alessandra, married now and lost to him, the swinging swift undulation of her stride, her tall figure with the auburn hair and sweet uptilted nose and small uptilted breasts and the miracle of those Greek epigrams with which she had replied to his courting. She spoke Greek better than that impotent Greek to whom she gave

herself, and were it not for her pompous father, that half-educated dolt who presumed to challenge his scholarship, they might have. . . . Where was the Chancellor today? he wondered. The famous voice lisped ironically.

"I invited him, of course—" Pico's tone was circumspect. He knew the bad feeling between these two—"but he said his years forbade the ascent . . ." What bad temper could coexist with learning? You had to speak to some people, Pico thought, as if you walked on eggs. But not with Elia. He glanced at his Hebrew master. He was happy that Elia had come.

"Fra Girolamo seemed rather severe with you," Elia said dryly. "I sensed a reprimand."

"Yes . . . He fears I vacillate too long on the question of joining his order."

"Then you still have that in mind?"

"I do." Then, seeking to read the meaning of Elia's bland expression: "You do not approve?"

"It is not for me to approve or disapprove. I aided you in drawing up your propositions when I most certainly did not approve of your conclusions."

Pico smiled and touched his mentor with an affectionate hand. It was a flash of the old Pico, that touch. A sensual man despite the gnats of knowledge that never ceased to plague his skull. Women were powerfully attracted to that face, that grace. Marguerite de' Medici had intercepted him on the road to Rome for that famous disputation and threatened him with not being a gentleman if he did not take her. What could he, a true cavaliere, do? He took her. Elia recalled the scandal of that affair, the paternal letters he had written, the shameful imprisonment. How the wheel had turned! Pico a monk!

Elia gazed about. Voices echoed in his head. The very walls spoke. Here, in the presence of this very company—and the Magnificent—he had debated for two days with that apostate Sicilian Jew, Guglielmo Raimondo di Moncada. And the first day he, Elia, had carried the burden of the Lord alone, and the second day Abraam had been on his side and those apostates, Raimondo and young Clemente, on the other—those two, Christians now, bearded and we not. All afternoon these walls echoed with the argument: Did the Prophets foretell or not foretell the coming of their Joshua whom they call Jesus and think to be the Messiah. And though young Clemente and bearded Raimondo sought to ensnare us in a net of words, yet they

could not—their logic was a spider web but we were the blast of the Lord, Blessed be His Name. They could not contain us. Ahi, how we ripped them from their moorings and destroyed them. Selah! For every proposition a counter-proposition.

Elia sighed and pursed his lips. No, the flash of happiness on Pico's pale face today was not the happiness of that former blessed time. There was, Elia fancied, watching the Count who was deep in conversation with Benivieni, leaning over the thin violet-tunicked figure, his long blond hair swinging like a curtain—a certain hectic coloring to this happiness, it was not quite healthy. A pulmonary flush. Even his laughter had a tired ring, a broken bell—and how he used to laugh! After the debate, how he had clapped Elia on the shoulders and said: "Master Elia, if you would but put that marvelous logic at the service of Holy Church . . ."

And yet, though like all Gentiles he persisted in adhering to his faith, he respected me in mine. His playful attempts at proselytizing me were in the nature of a game—the sport of matching wits that was his chief delight, to trace out the Unity in the Many, to seek out the golden thread in Chaldaic texts or in the writ of our Fathers which I helped teach him to read and so marvelous did he learn it that in three weeks he could write a passable letter in Hebrew . . . My own son, Elia thought—seeing Andrea's image, openmouthed and shy in this learning-freighted atmosphere—can do no better.

He coughed and reached forth for an unaccustomed second cup of wine.

But now he does not play at my conversion, Elia thought. Ah, perhaps that is my punishment for helping to arm him for that learned joust at Rome? Might not the Lord God be full of wrath that I should be the whetstone to sharpen the weapons of an infidel? For the Lord Thy God is a jealous God . . . But O Holy One I was intoxicated by the wine of learning and if my feet have strayed, it was only that I sought to praise Thee wherever Thy light might shine and so I followed Thee—Divine Glowworm that Thou art, Thunderer, Pillar of Fire—for I thought I saw Thy light shining in the blue shinings of this young count's eyes, and his lust to know was like a ram climbing the steep rock of Carmel and the whiteness of his neck was like the Shulamite's. So I thought I served Thee even in serving him.

He stirred uneasily. He was not used to so much wine. Ficino had risen. He was crossing the room, slightly stooped, absent-eyed, setting one foot before the other with the excessive care of age. His

black cloak fell in an unbroken line from shoulder to ankle and set off the whiteness of his locks. At the corner of tremulous lips tiny bubbles of spittle foamed.

"You are acquainted with Clemente?" he asked Elia.

"But of course, he knows him well!" Pico interrupted. "It was Master Elia sent the boy to me in the first place that I might exercise my conversation in the Hebrew."

Yes, Elia thought, but not that you might wean him from his ancient faith. That is when I should have realized the full turn Pico was taking. Of course the boy was a Marrano and they were all unstable; having shifted once—if only on the surface—for self-preservation, the habit of accommodation was too strong. It had already happened several times in Fiorenza.

"What of Clemente?"

"Well, he has told me of a formula—"

Still searching for formulas, Elia said to himself. Unlike Pico, who had written a book against astrologers, Ficino would not don his robe or issue out of his house until he had consulted his zodiac. He was always searching for correspondences whether in Zoroaster or in the stars.

"—that, according to the Jewish doctors, will assure one of eternal beatitude."

"Indeed?"

"To recite three times a day—morning, noon, and night—the one hundred and fifty-fifth Psalm." The old eyes loomed close, brilliant with a lunar light. "Can you tell me where I may find this doctrine written? For if it be true, I shall most certainly impose upon myself the task . . ."

Elia was racking his memory, but he could not recall the Psalm. So with a tired offhand wave of the hand he said: "What the Lord giveth he may take away. I know of no assurances . . ."

He was angry at Clemente. Because the boy's conversation had revealed that in Pico which Elia did not want to know. For the first time he had realized why the Count of Concord was so eager to learn Hebrew and Aramaic. That he might, out of the very armory of the Jews, seize weapons, and by Kabala and by Talmud refute the enemies of Christianity and convert them to the true faith. This then is what he meant by Concord.

And now this traitor, Clemente, was paving roads to salvation for his seducers. Old Ficino's lips were atremble.

"You do not concur with young Clemente?"

"He is a foolish boy," Elia said brusquely.

"Ah, Master, you speak out of anger," Pico interposed gently. "If only you might share the felicity which Clemente enjoys since he cast off those ancient errors in which you are still encoiled . . ."

Elia shrugged his shoulders. No, he would get into no disputes today. He was happy for Pico that the ban had been lifted. Let this afternoon in the waning light be festive. The Wheel turned and turned and Fortune was a bitch.

In the cool of the late afternoon they all strolled out on the terrace. The green valley stretched before them, somnolent, under a broad expanse of sky. Benivieni leaned on the parapet. His friend Messer Angiolo had fallen into a heavy wine-induced sleep. Clinging to Elia's arm and walking back and forth on the terrace, Pico spoke excitedly of the illumination which Fra Girolamo had brought to him. Oh, if only Master Elia would cast off . . . The sun was a ball of fire over Mount Morello, the atmosphere was amber-gold engraved by the black cypresses. Tinkling as water drops, whitehaired Ficino was playing on a harp. He played well despite his stiffening fingers, but his voice ground like a mill wheel.

Returning homeward in the dying light, Elia felt the sweetsickness of first love, and the sadness of the transitoriness of all things. He was descending to the valley of barking monks. He glanced up for a last look at the villa. But what he had left up on those heights were no longer philosophers but headless frightened men. Once this hill had been a truly philosophic hill, once every turning of the path had been a turning of dialectic, and every cypress a stylus, and the bees murmured only of the Philosopher and the Commentator, of Plato and Plotinus and Thomas and Avicenna and the holy Maimon, storing up the honey of their wisdom. Accompanied by the avemaria bells, dogs were barking in the valley. In less than a generation— Ah, that was it! "One generation shall praise Thy works to another, and shall declare Thy mighty acts . . ." that was the Psalm. Eternal bliss. Guaranteed. Oh, foolish old man! Yet how eloquently had he spoken on the Symposium there on that lavender hill, an evening like this, and all of us entranced, even that boy who comes to my anatomies, he too with his peasant face gaping at the fringes of the crowd.

"Andrea!" he called. Where the devil was he? He had been right there at the turning of the path. Soon it would be dark. They must hurry.

Andrea was waiting, silhouetted slimly against the sunset. He was

grimacing and spitting. He had bitten into a green olive. "How bitter!" he said.

"You should not eat fruit out of season," Elia said.

XIV

At Easter time Fra Bernardino resumed his preaching.

All winter, following Elia's interview with Piero de' Medici, the monk had been silent. Piero's decisions—restricting the Franciscan to preachments outside the city walls and explicitly forbidding him to discuss the "ebrei forestieri," the foreign Jews (which meant largely of course the newcomers, the Spaniards) or the creation of a Monte di Pietà, a municipal loan office—all these wise decisions which had so surprised Elia that winter afternoon, were dutifully echoed by the Eight, in whose name—since Fiorenza was a tyranny only in fact and not in law—the restrictive edicts had been issued.

And so all winter the monk was silent. If he could not preach within the city walls, he would not preach at all.

And the people were angry. The silence of Fra Bernardino they interpreted as expulsion. They considered him a saint.

Then suddenly in May, Bernardino announced that he would resume his preaching. Promptly the authorities reminded him of the restrictions. Especially now, with the oncoming of Holy Week, popular passions were most inflammable. He was not to cast burning brands. He nodded his head.

But the city shuddered with excitement. Fra Bernardino was preaching again! Outside the city walls, it was true, but yet his voice was going to be heard. The steep flowering hillsides leading to San Miniato on the Mount were thronged.

Small, intense, his leathery face brown as his robe, Fra Bernardino stood in the exquisite marble pulpit beside the carved Romanesque lion, and his high-pitched voice rang through the marble church: "Soldiers of Christ . . ."

And the congregation shuddered. A congregation of boys, almost of children, for these were Fra Bernardino's favorite "soldiers." They

followed him everywhere, a frantic horde. And now they quivered in expectation for they knew Fra Bernardino had a tongue of fire.

But today he was strangely mild. He limited himself to a simple homily on obedience. Afterward, outside the church, you might have heard the murmurings of young wolves denied their prey.

And so that dangerous season of the Passion passed without incident and then it was summer and Fra Bernardino continued to preach but ever outside the walls and ever mild and meek as one who never had it in his heart to stir up controversy. Some few of his childish followers began to frequent instead the sermons of Fra Girolamo. There at least, the fires still blazed though they licked their tongues against other evils. By contrast now Bernardino was a lamb, sweet as the sainted Founder of his order. Until finally Piero, yielding to the pressure of the populace, permitted Fra Bernardino to preach within the walls. And he spoke again in Santa Maria del Fiore, and always to ever-greater crowds and always with moderation.

But suddenly, in the blazing heat of July, as if his blood had been raised to boiling point, he reverted to his old themes. The dormant volcano had reawakened. He spat fire and hot ashes from the pulpit.

One day Michelangiolo and his brothers went to hear the monk in the great barren spaces of the cathedral. They had gone at the behest of Lionardo, the eldest, who, as a Dominican was curious to hear what manner of Franciscan this was who so stirred up the plebes. A dour man, Lionardo, his face long and intelligent as the face of a pensive dog, his eyes brooding, even the stoop of his prehensile figure seeming to suggest an inner watching. He was ever poised on the brink of some strange action. He was seldom in the house since he had joined his Master, Fra Girolamo Savonarola, at San Marco; but every once in a while, mysteriously and silently he would appear in his black scapular and white habit and haunted wolf-face, saliva flicking the corners of zeal-sharp lips, a veritable dog of the Lord, *Domini canis*, and gnaw them all to a week or two of repentance. Then he was gone again.

Several times Michel had visited him in his cell at San Marco; he enjoyed the sun-bathed court with its central well and damask rose tree and the monks brushing by under the arcades and Fra Angelico's painted friar, fingers on lips, enjoining silence. He never had much to say to Lionardo, a message usually of domestic detail from Father; but in the bare dim cell—seventh of a long file—the little window slightly open lent just enough hazed light upon the Blessed Angelico's fresco. Michel was particularly impressed by the modeling of San

Domenico's head. Angelico had undoubtedly learned much from Masaccio, he thought, watching it throb and pulse in the gloom, although in general he found the works of the artist-monk too sickly-sweet for his taste.

So now Lionardo had come home again and the brothers knew they would be expected to attend Mass and take communion that week. Lionardo did not insist. He scarcely spoke. But there was a passion in his eyes. Michel thought he might like Lionardo if only he could get to know him. But no one knew him.

So five Buonarroti brothers—the first in a Dominican frock—trooped through the narrow stony streets to the cathedral.

Three thousand young men and boys overflowed the bounds of the chapel in the transept where Fra Bernardino spoke. Stronger than the incense and the dampness of the open space rose the rank smell of many young animals. Breaking into falsettos of passion, his arms extended, the Franciscan cried:

". . . and this is how ye shall pray . . . Each morning ye shall pray the body of Christ . . . And ye shall remind these Lords Prior that they are not to forget their promises . . . Expel the Jews! . . . Erect the Communal Mount of Charity! . . . And every morning, in this very chapel, ye are to kneel and say three Paternosters and three Avemarias . . ."

They knelt, three thousand candle-flames flickering to a single breath, and repeated the prayers in unison. The many boyish voices became one voice, a giant voice, not human, rumbling in the gray stony reaches. And Michel was afraid. He felt as if he were drowning in burning waters. Around him were the familiar faces of his brothers and all around them the familiar Florentine faces. But they were not the same. The change frightened him whenever he saw it. It was the eyes . . . the eyes turning up to heaven . . . all these boys . . . so short a time upon this earth . . . already looking up to heaven . . .

They thirsted for a Voice. They flocked after every itinerant friar who wandered his way to many-towered Fiorenza. Now, kneeling in the church, Michel suddenly remembered when Savonarola had returned three years ago through the Prato gate, and began to preach such fiery sermons that everybody wept in the cathedral and afterward people passed through the streets more dead than alive. That was when Lionardo had been swept to join his order, and there were many others besides Lionardo.

And now, Lionardo's eyes glowed like embers blown upon as he

listened to the intense figure in the pulpit. Between the two orders there was somewhat less than Christian love. Yet, Lionardo's lips, slightly parted, seemed literally to be drinking in the words. Next to him, Narro was gaping with a rather stupid expression at the inside drum of Brunelleschi's dome, his mouth round and open like the dome itself. And next to him, fidgeting as usual, snapping bony fingers, was Giovansimone. Of course, *his* eyes, Michel thought with an involuntary smile, were not rolling up to heaven. His eyes were always strictly on the earth; now, like water bugs, they were darting from painted wall to glowing apse, from Uccello's strange tapestry-like fresco of the English mercenary Sir John Hawkwood to the banks of candles shimmering at the high altar. And next to Giovansimone was young Gismondo, so still you would think him pious did you not know he was simply lumpish. His hand was inside his jerkin; he was scratching his armpits.

Michel turned away in disgust. These brothers of his! Lionardo, at any rate, had something more than the vision of an ant. He saw heaven. It was reflected in his eyes; and therefore he was oblivious to aery floating domes, painted Englishmen in armour, shimmering candles. But his mouth was twisted in a curious grimace.

Afterward, at home, as the family sat about the long board with Lodovico and Donna Lucrezia at the head, and the five brothers ranked in order of their ages, Michel understood what the grimace meant. For brother Lionardo did not altogether approve of the preaching of Fra Bernardino. Unlike his Master, he said, this Franciscan's concerns were altogether too worldly.

"Ever this Franciscan cry about the Monte," he said scornfully. "Are they not married to their sister Poverty? Yet they do speak of nothing but the setting up of loan-banks."

"Well, with regard to that matter, Bernardino is quite right," said Lodovico stiffly. "But he should not preach it from the pulpit. Such affairs should be left to the competence of the Priors. One does not accomplish just ends by stirring up the rabble. Especially children . . . I do not understand the predilection of so many of these Frati Minori for children . . ."

Narro sniggered. Lodovico regarded him with freezing disapproval, then he went on: "Of course, he's not alone in stirring up the children. Your own Master—"

Lionardo bit his lip.

"—is equally guilty of playing havoc with immature minds."

The Customs Official spoke in a slow measured voice, a voice ris-

ing from depths of oceanic smugness. Even when he asked for bread
he sounded as if he were pronouncing an infallible judgment. Donna
Lucrezia was looking awesomely at her husband, her lips mimicking
in tiny soundless movements the quiverings of Lodovico's long beard.

The sons maintained a respectful silence until Babbo had done,
then Lionardo said softly, not lifting his eyes from the plate:
". . . and a little child shall lead them. The innocence of the young
is the purest earth in which to plant seeds of righteousness."

Those eyes burning into the plate. Giovansimone tittered. He
found his eldest brother a pretentious bore. Narro kicked Michel's
foot under the table. He always enjoyed the struggle between his
father and Lionardo.

"Beh!" Lodovico said, "Righteousness is planted with this . . ."
And he indicated his walking stick leaning in the corner by the
heavy oak cassone. For a hung moment, Michel thought he was go-
ing to pick it up and smite his monk-son over the head with it. Be-
tween these two, resentment always hung in the air like an invisible
curtain, but when they looked at each other the curtain moved and
then you saw it. And the curtain came from this—that Lodovico
would never accept the notion of a son's departure, no son of his
could ever depart, not even if he became a monk—the Father-Prior
was never the Father, and since the true mother was dead, father was
also Father-Mother if not a comic trinity of Father, Mother, and
Holy Bore.

So now he was saying: ". . . 'tis about time the Orders refrained
from stirring up commotion. Hoods and Capuchins fighting all the
time, in every borgo, in every quarter, 'tis a disgrace to a civilized com-
munity. And all in the name of purity, whereas—" he added now,
a malicious twinkle in his small eyes, "there're more than one of your
fellow-monks who wear breech clouts for only one reason. A leashed
dog is more eager for the game." And he leant back his head and
roared.

"Ahi, there's the planting that's being done, eh Lionardo?" Narro
said, and for reply Lionardo cuffed him across the cheek. For a mo-
ment, a fight brewed, but then Lodovico banged his fist on the ta-
ble for order and the mugs jumped and Donna Lucrezia jumped with
them, and then the maid entered with chunks of lamb sizzling on a
salver. They fell to, eating with fingers and forks and knives, and as
always between bites, Lodovico preached his daily sermon:

". . . the important thing in this world is to keep your feet dry,
your head covered, and your mouth shut. Let your counsels be pri-

vate, locked up in the strongbox, you see" (he tapped his head) "as your accounts should be, always in order, locked up. That's the important thing. Then even great Signori will not be able to find fault with you. That is how I have always managed my life and that is how you should manage it. All of you, even you, Lionardo. It's true you may have found your vocation, but believe me, figlio mio, I know things that your Fra Girolamo will never know. And I have learned them in storms. Praise God—"

"Amen!" Lionardo burst out with rather comic fervor.

The Customs Official frowned at the interruption. Gismondo was picking his nose, examining his findings with great interest.

"—that He hath taught me to distill wisdom out of great trials as the bee distills honey. Yea, even over the grave of your mother—" his pale slightly bulging eyes were moist and Donna Lucrezia reddened. She never knew how she was supposed to behave when she heard these speeches about her predecessor in her lord's bed. "—I learned it and what I now impart to all of you . . ."

Michel sighed. At this point of the discourse he always became impatient. He rubbed his greasy fingers on the common cloth passed among them; he longed to rise from the table and get away from this voice droning on and on, bowing to the image of itself.

"—Podestà of Caprese and of Chiusi . . . or would I have achieved my present position . . . had I permitted my tongue to run away with my good sense? Oh, my sons, the tongue is like a horse: it needs a bridle and the bit, then it may convey you far . . . It was this quality in me that so impressed the Magnificent, he knew at once I am a man of prudence and offered me the post I now hold . . ."

Oh, this was impossible! Hurriedly Michel speared a melon with his knife and busied himself carving an acanthus leaf out of the thick skin. This passage in the discourse was always impossible. How could he go on like that? Had he forgotten the fuss he raised the day Francesco and I came home with the message from the Magnificent?

"*What?! My son to be a common stonecutter!*"

"*Not a stonecutter, Ser, a sculptor! a sculptor!*"

Francesco tried to explain. But it was useless. Sculptor. Stonecutter. It was all one. Dirty work fit for contadini but not for any son of the former Podestà of Caprese and Chiusi. Wasn't it come-down enough that he had permitted his son to be apprenticed to the Ghirlandaios? A dauber was bad enough, but a stonecutter! . . . His thick fingers were combing angrily through his beard and he

was glaring at Granacci (who, anticipating just such a row, had accompanied Michel home with the letter) and his eyes were raging and burning like Lionardo's eyes now burning into the plate.

"*What?! And live in his household, too? Is that what he wants? For what purpose, pray!*"

"*Why, Ser, think of the honor.*"

That shook him a little but still he puffed in his rose-red cloak.

"*What an opportunity to study! The Magnificent's collection—*"

"*Beh! Beh!*"—Granacci withdrew out of the rain of spray; Michel stood with head down, rubbing the bridge of his nose. "*Works of art, you call it? I know the kind of art practiced in that Palazzo! It's buzzed of in every dirty alley of Fiorenza! No son of mine—*"

"*But—*" and at this point in the narrative, Francesco always burst into laughter, wheezing donkey-laughter, incongruous amidst his silks—

"*—but when he finally appeared before Lorenzo he sang a different tune. 'In faith,' said he, 'not Michelangiolo alone, but all of us, with our lives and all our faculties are at the pleasure of your Magnificence!' And when Lorenzo asked him then what he desired as a favor to himself (for you see, the Magnificent was making an exchange— you for the favor—) then all your father asked for, or begged, according to Master Angiolo Poliziano who happened to be in the room at the time, just having delivered his monthly report on the progress of his pupils—was the vacant post of Marco Pucci's companion in the Customs . . . Marco's friend had just died, you see, and your father thought that might be a nice position to have. And when Lorenzo heard it, he laid his hand on your father's shoulder and said with a smile: 'Ser Buonarroti, you will always be a poor man.' Messèr Angiolo said he had to turn around then to conceal his smile. 'Ser Buonarroti, you will always be a poor man! . . .'*"

And Francesco brayed his donkey-laugh. Michel felt the blood rise. He would not hear his father laughed at so. And Granacci was swiftly sorry in his foppish graceful way. Michel had to forgive him. Indeed, he thought now, watching Lodovico's long white beard bobbing with the sermon, he had joined in the laughter himself. May God forgive him, for thou shalt honor thy father and thy mother . . .

While Ser Lodovico droned on.

XV

By mid-August the sun and Fra Bernardino had reached meridian. They both blazed. Fire was the atmosphere within and fire without. After a morning's work at goldsmith's bench or banker's books, at dyeing vat or wool mart, faces glistened with sweat like a film of oil and the roots of the hair itched and legs were slow-filled with lead. No one made love at noon; a hot steamy mist hung over the stony city; and through it, the river, a thin trickle, an emaciated Lawrence, panted on a grid of broiling stones.

Only Fra Bernardino and his beardless soldiers seemed unaffected by the heat. Together with the sun his fire mounted day by day; and after some of the sermons you might see roaming the streets of Fiorenza thousands of young men and boys with eyes like meteors.

And the Jews crouched back and waited. They remained in their houses though there was no curfew. They associated with Christians as little as possible though there was no law to this effect. They felt the yellow O upon their souls if not upon their breasts.

Especially was this true of the Spanish newcomers. The Italian Jews—like Mamma's family—were less appalled by Fra Bernardino's scirocco blasts. The Doctor, of course, preserved his habitual philosophic calm. Mad monks had come and gone before; the Jews had been expelled from Fiorenza and returned a dozen times; the noose tightened and then relaxed. It was Job's path. All was in the hands of the Almighty: they would survive, they always had. And besides, said Elia, with a rueful twitch to his thin mouth, these merchants needed them—they needed the physicians and they needed the moneylenders—and a Florentine, you might be sure, would dispense with a Franciscan before a florin.

So spoke the older Florentines to the Spaniards. But such counsels were not likely to convince those who had just been through the holocausts of Torquemada. The dead sooty eyes glowed with memory. In every cry of Fra Bernardino they heard again the accents of a too-recent terror; and some of them would not wait once more for what they felt was the inevitable: they left Fiorenza, dragging their few possessions along dusty roads to nowhere, eternal wanderers.

It was a summer of comings and goings; for with every departure there were new arrivals, new bands of Spanish refugees trickling through from Livorno and from Pisa. Some of them were Marranos—

those who had feigned conversion in Spain to escape the flail of the Inquisition, until they too had been denounced and their deception proved vain. So now in Italy, they cast away the false cloak and revealed themselves once more in the ancient body of their faith. But Andrea heard his father and even Bartolomeo's father speak of these new arrivals with distaste. They were only birds of passage anyway. By the middle of the month they had fled again, ten other families with them. Andrew watched them go with the same slightly aloof sense of puzzlement with which he had seen them come. They were strangers, they spoke a different tongue, their ways were not his ways. Nor did he feel any closer to the Spaniards who did not flee before Bernardino's blasts; even these, with whom he sat each week in the synagogue, were not his people: all they had in common was an enemy.

But Bartolomeo continued to attract him.

The short wiry Spaniard with his hell-baked eyes and bitter mouth drew him with a strange and disconcerting appeal. And Andrea resented the appeal. Somewhere in the deeps of his nature he felt with humiliation that it was only his softness responding to the other's driving hatred.

Or perhaps, he salved his pride, he went to Bartolomeo's really to see Tsiporah. Tsiporah, the bird . . . a brilliant flash between green leaves, and afterward the trembling empty bough. That was how he saw her: an occasional glimpse of a red-scarved form behind the lattice of the women's section of the synagogue. Afterward he might catch up with her and walk along the river. Once, following a particularly violent sermon by Fra Bernardino, the Jews held a special service and it must have stirred up memories she could not contain. Seated on the Arno bank, Tsiporah described the terrible scene at the Genova water front where they had landed a little more than a year ago.

". . . and we were more dead than alive and then the monks came with loaves of bread in one hand and a crucifix in the other and cried *Repent!* And only those who accepted the cross received the bread . . .

"And when they came to us, my brother—" She buried her face in her hands for a moment, then looked at Andrea from soundless brown depths. "—My brother knocked the crucifix out of the monk's hand, and ran. Had they found him—" She shook her head and then her head was leaning against Andrea's shoulder and he felt a pride in it, as if he were a tree on which this bird had alighted. Softly he stroked her hair, and then they were kissing until they could no longer.

He took her home, hand in hand down the Borgo, between danc-

ing towers. But her mood had changed again. The brooding eyes were back at the Genova water front.

"O Shem! If only you were—" She hesitated.

"What?"

"Nothing. I worry about Barto."

She shook out of his attempted embrace. Andrea felt that he had suddenly seen deeply into the cauldron of Bartolomeo.

But what he could not understand was the seeming good fellowship between Michelangiolo and the Spaniard.

For, ever since the collision at the Baptistry, Bartolomeo no longer remained ensconced all day in the dark Borgo San Iacopo beside his father's pawnshop, mocking the passers-by. Now, he was a constant member of Michel's circle. He had come often to the garden while the Samson was in the making, and he trooped around with Andrea, and Iacopo, Francesco and the Buonarroti brothers, latest and most incongruous member of the little band.

Francesco made no effort to disguise his dislike; Narro mimicked Bartolomeo's macaronic Italian and his head-on battering-ram walk. But Michel seemed to find the Spaniard amusing. Andrew could not understand it. Bartolomeo certainly was not amusing. Yet the more tart his remarks, the more Michel laughed. Andrea began to wonder whether Michel was a very good judge of wit: the way he roared at his younger brother's stupidities, at Iacopo's vulgarities, at Bartolomeo's acidulous observations . . .

In the dog days of August, they often went to the Piazza di Santa Liberata to escape the fury of the sun. In that great open space between the ancient Baptistry and the yet-unfaçaded Duomo, some breeze always blew, and the white marble flagstones were always cool. A short flight of steps led up to the area, which by late afternoon presented a marvelous contrast of sprawled-out youths, legs akimbo in long hose of all colors against the dazzling whiteness of the flags.

Michel loved to sketch there, nowhere were the infinite possibilities of the human body better exposed. In the tight parti-colored hose and snug jerkins, the figures, seated or prone, full length or foreshortened, leaning forward in muscle-displaying intensities or lounging at flaccid ease, offered themselves to his vision in an endless series of variations.

So, when he was not laughing at one of Narro's or Iacopo's absurdities or Bartolomeo's wry remarks, his crayon was flying over the sheets of paper he always carried with him. No wonder the Lord, who might have chosen, had He wished, to manifest Himself as a

tree or a toad, had selected instead the body of a man, a young man. In His *own* image God had created Adam. That alone explained the miracle of the expressiveness of the figure. It was god-like because God had inhabited it, it was invested in the godhead. Else why should a torso, a head, two arms, two legs speak deeper than a beast, a mountain, or a cloud?

The Piazza was a favorite gathering place for Florentine youths: here, stretched out full length on the cool stones, they exchanged gossip, news, jests; here business was transacted, mistresses compared; here practical jokes and old stories danced in the gauzed gold of the setting sun like tinted gay balloons; here wit jousted with wit, and fist sometimes with fist.

When Michel and his friends arrived they headed at once for their favorite spot against the north wall facing the Via dei Servi. But to-day a lout with a huge orange codpiece was snoring there. Stepping gingerly among the hundreds of sprawled-out bodies, their passage followed by a wake of curses and ribaldries, they found an empty space near the steps across from Ghiberti's golden doors.

It was still hot. Even the pleasant chill of the flagstones relieved the oppressiveness but a moment. Today no breeze was blowing. And the faces, Andrea thought, gazing about, seemed unusually strained, there was a heavy laden air today, and instead of the usual chattering of jokes, a freighted stillness.

It must be the heat, he thought.

It was an unusually hot August. Indeed, ever since the death of the Magnificent the weather had been eccentric. That great fall of snow when first he had met Michel. Those thunderbolts striking the Duomo. The torrential rainy spring. And now this heat. The world was surely changing. "The Apocalypse," Father had said.

Someone was talking about the Virgin. "Her eyes" . . . Andrea chose not to hear. The world was too beautiful. Veils over the sun, those theological disputes. Father loved them but he, Andrea, preferred to gaze, as he was gazing now, up into a pale blue sky, endless endless, a pale blue endlessness, a shoreless sea across which caravels of clouds slowly sailed. It was across just such a sea, just such a vast unknown that the Genovese with the name like a dove had only two years ago sailed to find a new route to the Indies. Curious that Bartolomeo, so recently from Spain, should know nothing about the mariner Colombo and apparently did not care to know.

He sat up and smiled at Bartolomeo. He was squatting, hunched up like a quivering monkey, his arms around his brought-up knees, his small flashing eyes surveying the anatomical scene with contempt.

"Why don't you lie down?" Andrea said. "It's so much cooler. And you can watch the sky."

"The sky does not interest me. But the conversation of these cretini—"

Michel guffawed.

"—affords me a rare pleasure."

I wish he would curb his tongue, Andrea thought. I wish he would lie down. His very posture bespeaks doom.

"Curious heaviness today," Granacci said, looking around at the still tangle of bodies. His fine thin pointed nose was sniffing like a dog's. "Something in the air."

"It's only the stifling stupidity," Bartolomeo said.

"Roberto! Roberto!" Narro waved. He started after his friend.

"Watch where you're going!" Tempers were certainly testy today, Andrea thought.

He lay back again. Now the white cloud caravels were bobbing across the blue toward the pink Campanile. The Niña, the Pinta and the Santa María. How marvelous that voyage must have been! How astonishing to think the world was indeed, as the Genovese had insisted all along, round, and you could not fall off its nether edge. But how could such a story

". . . where the left cheek of the Madonna had been scarred . . ."

really be true, for if the Genovese had reached the East by sailing West then there was no longer any logic to things, East and West ceased to have any meaning, and if the world were a globe what prevented those on the bottom from falling off into endless space? Surely they could not walk upside down on the bottom of a globe. But still Colombo had

". . . a filthy stain across her. . . ."

reached the Indies by sailing West and that was a puzzle. A cumulus-ship with a prow like a swan's neck was skimming over the Baptistry and then it crashed against the Dome, the prow bobbing along above the belltower, the battered hull sinking behind the Misericordia. Now the prow was tinged with pink, it was the color of blood, blood of the skyey voyagers who had just gone down in her. Andrea closed his eyes, the blood turned to purple . . .

It was really getting hot. In the pulsing inner gloom he heard mingled murmurings:

". . . where the madman, you see, had daubed mud all over the Madonna di Sant' Onofrio . . ."

Iacopo, his voice laced with laughter, and then:

". . . mix it with a smidge of vermilion and you get it. Paolo tells me that his master Perugino has devised a formula . . ."

And now someone singing in a sweet reedy voice to the tinkling accompaniment of a lute:

> Ho scavalcato le mura di Dante
> e ho visto Beatrice prigioniera,
> di belle bimbe ne ho baciate tante:
> colla morina ci ho fatto primiera.

> I've leaped over the walls of Dante
> and Beatrice seen imprisoned there,
> O lovely ladies I've kissed plenty:
> the dark ones first and then the fair.

Another voice, thinner, younger, with an edge of irony, was improvising a variation on the stornello:

> Innamorata io son del campanile,
> ma non del campanil, delle campane;
> ma nè del campanil nè le campane,
> ma del morina che tirò la fune.

> O I'm in love with the tall belltower—
> No, not with the belltower, with the bells—
> No, not with the bells nor the belltower—
> But the boy who pulls the rope with power.

"Bravo! Bravo!" exploded in his ears: an excessive applause. Andrea opened his eyes. Michel was sitting up, shouting noisy approval to the singer. A boy about twenty yards away took off his velvet cap and bowed mockingly across the space of sprawled bodies. It was Giovansimone. He was proud of his gift of improvisation, and he came here often to display it. "Gian," Michel called again. "Sing that stornello about the Friar and the Duchess." He had put away his scarce-begun sketch. He needs only, Andrea thought (and was irritated that it was so) the slightest pretext to be proud of his brothers: whether of Lionardo's piety, Narro's boisterousness, or Giovansimone's flashes of sly wit. Even of the lumpish one, the youngest, what was his name? And now Michel was gazing fondly at the brother he so often reprimanded and he was calling out—

"You know, the one with the line: *Maidens all be wary* . . ."

Giovansimone began:

> Maidens all be wary
> of the frail Franciscan friar

In the darkness of confessionals
the priest is all on fire.

". . . frail Franciscan . . ." The Friars Minor were always a favorite butt: their begging, the stink of their sanctity, their dirty feet in sandals. There was a burst of harsh laughter. It was Bartolomeo. He was laughing uncontrollably, bent over, a wild cataract of laughter so unexpected that they all sat bolt upright, Michel, crayon in hand, and the singer's mouth a wondering O, and Andrea who knew the cause of the wild goose-flight of laughter (*these Christian dogs . . . always eating their own . . . Franciscan and Dominican*), all of them frozen in a wild wondering circle, a posture of amazement, at the violence of the burst issuing from so small an orifice, as if someone had thoughtlessly removed a brick from a dike and the whole ocean had poured through. So this cataract of unprovoked laughter was breaking out of Bartolomeo while around him formed another and another ring of uncomprehending wonder and silence and antagonism. For almost as if it were a signal, all the prone bodies had sat up now and they were looking at the singer and the laughter.

And he was laughing absolutely alone.

Andrea was suddenly frightened. What was it today? He had heard Giovansimone recite those verses (or similar verses) before—and always to a roar of applause. But today no one was laughing, no one except Bartolomeo, and his laughter, Andrea thought, looking at the Spaniard's hell-singed laugh-contorted face, had better stop. He felt a sudden chill amidst the heat, the back of his neck was prickling, he knew even before he glanced around to confirm it, that they were ringed with enemies.

Then all at once he understood.

The piazza was thronged with Fra Bernardino's angels. He recognized some of the faces. They were the same faces he had seen in the Borgo that day of the stoning of the Vacca bank. And now, remembering this Jew who had insulted them and called them farted children of the Devil, they were glaring at Bartolomeo with unconcealed distaste. Here he was again, laughing. Andrea tensed. Even Michel seemed to have realized that something was amiss. They were not only glaring at Bartolomeo, they were also glaring at Michel's brother. For was it not his song which had provoked the madman to laughter? And the madman was still laughing. Michel stood up and called warningly: "Giovan! Gioooovaaan!" His voice was like the protective whirr of a mother hen's wings. "Come here! I have to tell you something—"

Giovansimone began to pick his way through the crowd. Andrea heard a quiet voice say: "You would do better to praise monks than to slander them . . ."

"Amen!" a voice screamed across the square. It was Bartolomeo. He had taken leave of his senses. "Amen" he screamed and then leaned back his head and laughed, the tears rolling down his dark cheeks. It was broiling, the sun has gone to his head, Andrea thought in terror, they were all sizzling on a plain of Hell, and if Bartolomeo didn't stop . . . But he was yelling again now: "Amen for Fra Bernardino, and amen for Torquemada, and amen for Haman, amen for all butchers and hangmen and hell-hounds! For the Almighty, Blessed be His Name, hath chosen them as a needful scourge. . . ."

Oh God, Andrea thought, and he seized Bartolomeo by the sleeve. But the other shook him loose as if he were an insect. And everyone was staring, for now they did not know if Bartolomeo was preaching to them or against them, they were accustomed to these sudden bursts of pietism and they could not tell from the speaker's words that he was castigating them as Gentiles, they thought he might be another among the many mendicants who rode up and down the land those days calling for repentance.

And then it happened.

Afterward, thinking back to that apocalyptic moment (*as he had thought back to it last year on this very night, watching the black gondolas bob along the Grand Canal*), Andrea would feel again his whole body go limp with the happening, and the pulsing terrible headache harrow his skull and the red rockets roaring up in the blackness behind his eyes. So it had whirled up, spiraled, burst, and only afterward, when Bartolomeo was already locked up in the Bargello (and his mad absolutely untrue confession already raging through the town) only then, running home through the dark (darker) streets was he able to link in cause-and-effect what had seemed uncaused, inexplicable, the violent terminus of what was never a chain of events and therefore all the more violent.

Bartolomeo was screaming and when they realized at last the purport of his "preaching," the angels set upon him. There were five or six of them, the nearest group to theirs, the lout with the orange codpiece loping over, a youngster no more than twelve swinging his fists, his boygirl face contorted into a mask of hysterical anger—"Judas! Judas!" he was yelling—and then another, bigger boy whose long gold neck-chain on which was suspended a cross swinging in furious rhythm as the boy kicked Bartolomeo in the stomach, again and

again—"Here is the beast! here is the villain who committed the abominations against Our Lady!"

Bartolomeo had fallen with the first rush. First Iacopo, then Michelangiolo had tried to hold him but they were unable to stay the lunging angels. A knife gleamed amidst the swirl of arms and legs. It was Bartolomeo. He had gotten to his feet now, and from his tunic whipped out a long Toledo blade and was swinging it with hard perilous grace. The boy-girl's neck was gashed, the others fell back for a moment, panting heavily, a phalanx of piety regrouping for another lunge. And now the small boy's cry was echoed all over the piazza: "It's the Jew! It's the Jew! The Jew who has been defacing Our Lady."

Bartolomeo shouted defiantly, "Yes! Yes! Of course! I stabbed your Lady as I will stab any one of you who steps a braccio nearer!"

He is doomed, Andrea thought with a sick heart, he is doomed, he was born to be doomed. He turned to Michel in unspoken appeal. But Michel too was staring at the beleaguered Bartolomeo, staring with a look of astonishment, he was absolutely paralyzed at the Spaniard's repeated and mocking asseverations of his crimes. Bartolomeo was laughing again now, spitting into the faces of those who dared to come near his quivering knife; along one dark cheek a trickle of blood ran; his tunic was torn open and his thin bony chest heaved. Like a gamecock within the ring, he kept circling around and around—his movements menacing, sure, tensile containments of violence.

But it was the laughter that froze Andrea—It was those mad gusts of laughter which rang jubilee for a doom that might otherwise have been avoided. At the circumference of the ring (it was a hangman's noose, drawing tighter and tighter) Andrea stood, paralyzed, unable to move. He saw Granacci with a bitter laugh draw his knife, and join the angelic ring that was preparing for another attack.

Iacopo had simply disappeared. The ring was about to lunge now. "Narro! Giovansimone!" Michel shouted as he grabbed both brothers and drew them back. They too wanted to enter the battle. They were both laughing as if it didn't matter which side they fought upon. It seemed indeed that they wanted to join Bartolomeo.

There was another lunge. Another flash of Bartolomeo's knife. A boy fell, clutching his stomach. Blood splattered the steps. Everybody in the piazza now had converged around the battle-pit, in the center of which the gamecock stood, with bleeding knife-talon, crouching and circling ever in a slow dance flamenco, an adagio death.

Now, out of nowhere, out of no time, bailiffs arrived. Someone at the periphery of the crowd had summoned them. They piicked their way through the mob, a half dozen brawny peasants in chain mail with pikes and saw-tooth halberds. So, swearing, sweating, and poking they reached the explosive nucleus of the mob and seized Bartolomeo.

"But he is not responsible!" Andrea protested. "He did not begin it." The crowd-beast growled. "That is true," Michel said in support. But he spoke so without conviction, retiringly, running away from his own words scarcely-issued from his mouth so that the bailiffs could not hear him. Besides, the crowd was protesting that the Jew was responsible not only for this affray but also for the various mutilations to holy images that had been occurring during the past week. And with every shout, Michel was drawing further away from the embattled ring, dragging his unwilling brothers along, away from besiegers and besieged.

Then suddenly he was gone.

Andrea followed the mob as the bailiffs led Bartolomeo to the Bargello. Outside that brown stony fortress, under the barred windows he stood for an hour with the mob. The narrow street grew darker, the strip of sky stained violet and then blue and then blue-black. Servants of the Priors came out and set torches in the iron ring-holders and the crowd shouted for news as if they were attending a calcio match. Their rage had turned now into a festival, the torch flame painted their faces with infernal lights. Some boys had climbed up on the barred windows and were trying to peer inside the court-yard where the rack was set up. They could see nothing, but interpreted the shadows. The wildest rumors circulated. The Jew had denied everything. He was not even a Jew. He was a Moor recently from Spain. He inhabited a cave outside the walls near the Prato gate. He lived on roots and the milk of wild boars. He had stabbed the Host until it bled. When the doctor had examined his wounds, he had discovered the mark of Satan, a strawberry stain over his heart, and three-toed hooves. He was a devil and they were going to put him to the rack.

Then Andrea fled.

XVI

The details of Bartolomeo's "confession" shocked all Fiorenza, Christian and Jew alike. For under the rack at the Bargello, he had admitted to all the recent atrocities:—that he had wounded with a knife the statue of the Madonna outside Orsanmichele, that he had stabbed the Bambino in her arms, that he had despoiled a Pietà in the church of Santa Maria in Campo, that he had splattered with mud the Madonna di Sant' Onofrio.

"Lies! lies!" Andrea cried in anguish. "I was with him many of those nights he is said to have committed those deeds. He is confessing only out of fury, he is confessing to a lie merely to spit in their faces."

And sick at heart, his eyes blinded with tears so that he saw each sunrise through a veil, another curtain lifting upon horror, Andrea sat day and night by the window and gazed at the birds. He spoke to no one, he never went out into the streets, he scarcely ate, he moved like a sleepwalker from bed to window, from window to bed. And as the groups came and went, he heard their conversations, their anguish, their lamentations only as a distant ululation, lunar, remote. The house was always full of them, for Fra Bernardino's pulpit was a cave of winds and a pit of snakes, brimstone spat from his mouth and seventy souls once more turned for succor to the Doctor, Elia. Once more he must go to the great palace on the Via Larga, once more he must try to intercede with his friends the Medici. Either by wealth of words or by ducats.

The afternoon the sentence of the Eight was announced, Bartolomeo's father came. Despite his recent illness, de Cases' face seemed less pallid, his beard more bushy, he stooped not at all. He entered like a bitter wind and demanded of the Doctor if he had yet seen the Medici.

"No," Elia said wearily. "You know as well as I that Piero is not in Fiorenza. He has gone to Pisa on a mission to the French King. He will not return for ten days."

"In ten days there will no longer be any need to see him."

"But what can I do?" Elia's voice rose, barbed with irritation. "We cannot interrupt him in the midst of these delicate negotiations. He is trying to deflect the French from our territories . . ."

"It might be better if the French came," the old man said. He

spoke very quietly but his voice had an edge to it; he seemed to be challenging Elia.

And then (only then!) he mentioned it.

"You have heard the sentence of the Eight?"

"Yes."

By the window, his back to the two of them, Andrea felt the thick palpable silence. Then Father:

"I am certain it will be revoked . . ."

And de Cases:

"You are certain? . . ." His voice seared. "You are certain. And if it were your son, would you be so certain?"

"I am doing everything I can."

O Father, so weary! so weary!

Now the Spanish-Italian began to stumble and they were speaking Hebrew. Andrea sat by the window and saw the sky over the river stain with evening, flaring with color like a peacock's tail. Across the Arno the angelus bells began to toll. Christian chiming mingled with the Hebrew words. At this hour, when the bells were ringing and when God's palette ran, the sky was always inhabited with birds. Small bats fluttered eccentric ambits between the eaves, fork-tailed swallows swooped with astonishing grace, an occasional hawk sailed by. Oh, the birds! the birds! they were his salvation in a time of trouble. And now, in his agony he fled to them as he had fled to them the day Mamma had died, sitting as now, a smaller bud-curled Andrea by this same window, hearing the droning prayers, the lamentations of the mourners as now he heard the ululations of this Hebrew; and then as now soaring out of horror on the feathered backs of the birds. The swallows, especially, seemed to reflect his thoughts: their wild gustings up, their pit-sick plummet falls. They inhabited every belltower of Fiorenza, they skimmed low over the brown Arno, they looped and swung, dove and pirouetted, flared together in twos and threes, fanned away in superb aloneness, they flocked over the Ponte Vecchio in the green air of evening, they were signatures on the air's luminous page, prophecies, auguries. Sometimes Andrea felt the swallows were not birds at all but God's little angels.

No, it was not merely comfort they gave him. It was more than that. In time of torment his eyes always lifted to the birds. One part of his being might remain on earth, rooted in misery, another part took flight with the swallows.

Now more than ever he needed the birds. For this morning the sentence of the Eight had been announced. To every quarter of the town

the heralds had come, blowing on their long trumpets, and reading the long scrolls:

That the Ebreo, Bartolomeus de Cases, having duly confessed under pena dura, etc., etc., to having committed certain desecrations against sacred images in the City of Fiorenza, was hereby condemned to a punizio befitting the crimes committed, said punizio to be effected at the desecrated shrines on 17 August as follows—

> *the right hand of the said Jew to be cut off before the Madonna of S. Onofrio whose right hand he had scratched.*
>
> *the left hand of the said Jew to be cut off before S. Maria in Campo whose left hand he had mutilated.*
>
> *following which, the eyes of the said Ebreo de Cases to be gouged out in front of the Madonna of Orsanmichele as just recompense for violations perpetrated against those sacred eyes.*

When the announcement came, the followers of Fra Bernardino raged through the city in indignation. The Jew would live! Handless and eyeless, perhaps, but he would live! Resentfully they gathered in front of the violated statues and cried out to the crowds: Was any better proof needed that the Eight were creatures of the Medici and the Medici were creatures of the Jews? How else explain this leniency? Look!—and like Marc Antony holding the tunic of assassinated Caesar, they pointed to the wounds, the gashes and scratches on the statues of the Madonna, and cried out in voices breaking with passion and puberty whether any heretic who could perpetrate such crimes should be permitted to live.

". . . It is aother Inquisition."

"No." The Doctor's voice sounded indignant. "There is no Holy Office here."

And suddenly the old man was gone. But Andrea still heard his voice relentless as a lava-flow, a march of mobile stone. "It will come. It will come. And they will light the faggots in your squares. And they will heap the living and the dead together on the flames. And the bells will toll and the pack will roar and the dying will scream. It will come, I tell you . . ."

"I do not believe it."—But Elia's voice was quavering . . .

"I believe it. Soon you shall see the prisoners in their yellow sacks

embroidered with devils and flames. You shall see them . . . But may I die before I see it again."

Andrea turned around. His father's face seemed to have grown gaunter in the twilight. And the old man said—"Better you had let me die."

"That is a sin."

"Better to have let me die—" the head lifted, the lips stubborn as a cliff "—than to see my son in their hands."

And he was gone. Andrea and Elia ate together without a word. The sun had gone down. The birds were gone. The river was a wet passingness without color.

He thought he read a hopeful augury in a ring of swallows. Through the city, brooding as before a storm, he hastened to convey this solace to Tsiporah. But though she came to the door in response to his frenzied knocking, she would not let him in. As soon as she saw him, her eyes burst into tears. Guilt-stricken, he pleaded, his father was friend to the Medici, he would surely get the sentence revoked . . .

But Tsiporah merely wept and shook her head, unable to speak. The heavy door banged in Andrea's face.

That night and all the following day the Doctor seemed driven by a devil. He visited every one of the Priors at his home. He tried to reason with them. He tried to bribe them, contemptuously flinging on the table sacks of gold he had collected from the Jewish community. But even those Priors who were moved by his pleas or tempted by his gold were afraid to revoke the sentence. The town's temper was beyond control.

In desperation, Elia decided on a last wild measure. All day and night he rode at breakneck speed over the Tuscan hills to Pisa. He would beard the beardless Medici there; he would convince the boy as he had convinced him that snowy day and Piero would prove once again that he was Lorenzo's worthy son. And if the Doctor rode home at the same breakneck speed—the stay of execution in his hands—there might still be time.

But when Elia del Medigo arrived in the city of the leaning belfry, it was only to find Piero off on another of his hunts. The French were about to cross his realm; meanwhile there were the falcons.

So del Medigo waited. He waited as the hours passed and he kept hearing that lava-flow premonition of the old de Cases. "You had better let me die." When finally Piero returned. He was flushed, sitting his Arab charger with a dignity and grace that belied how slack he sat upon his soul's steed; he rode in so proudly with his falcon bearers, his Spanish groom, his pikemen, that you would never know

that he was here in Pisa almost as a suppliant before the French King, that he had come to kneel before the pop-eyed six-toed hunchback and beg him that if he must enter Fiorenza, he should enter on velvet feet, as friend, not conqueror. Then he would be billeted in gentle amity until he had resumed his just and righteous expedition against the usurpers on the throne of Naples.

But you would never know that Piero had come to beg. The clashing chromatic retinue of the Medici was a mollusk-mask: outward he was all ceremony and dash; and inward a snail, curled up and crouching.

So Piero pulled off his boots and stretched his long legs out with a sigh. Meanwhile, he listened to the Doctor with gracious disinterest. He knew the man; he had seen him often as a child when, bored by his tutor Polizian's eternal Latinizing, he would lift truant eyes from the book and glance into the garden at that group of learned and strange men Father rejoiced in conversing with. Always among them was this tall clean-shaven Hebrew, whose voice had a peculiar ring of the East, and who walked in a solemn swaying manner, hands clasped behind his cloak, and sometimes stroked his head with absent-minded fondness as he passed. Piero remembered him and so he listened, graciously but with disinterest, because he had greater cares on his mind than the hands and feet and eyes of an eighteen-year-old foreign Jew.

Besides, had not the lad confessed? Obviously he was a madman.

At which the Doctor's habitual calm forsook him, and he became angry, boldly crying out now that if the Medici were looking for a madman, then one was all made to order in the person of Fra Bernardino, who not only was mad but enmaddened all the youth of Fiorenza and so had provoked this young hotheaded Spaniard into confessing to a lie.

Then Piero laughed. He was handsome, Elia thought, his father's jutting jaw softened by the blood of the Orsini. You might even imagine, the Doctor mused as he waited with his fur hat in hand before this young man, that Maestro Angiolo's teachings had even had some effect, for certainly the boy possessed what the hook-nosed Polizian was alone capable of imparting—grace. . . . not moral grace for he, Polizian, possessed none, nor grace of soul—but grace of body, and love of countryside, of flower and field and all things fair. From ugly Poliziano he had learned to love the beauty of this world, if not in painting or figured stone, then in the ever-living painting of landscape and the giant uncut sculpture of mountains. He loved to ride, to hunt, to watch his falcons soar, he loved—even while on missions

delicate as this—to escape from the quicksand of politics into the surety of a rocking saddle.

He laughed and said—"Maestro, do not be so concerned about the fate of one poor little Jew. There will be a sufficiency of your tribe left—and as for that Franciscan, my father used to say that the only way to cap a volcano is to let it splutter itself out—and meanwhile keep away from its mouth."

He was tired, it had been such an exhausting day in the woods. He clapped the Doctor affectionately on the shoulder and went to bed.

And again Elia waited. There was no other hope. But all the next day Piero was incommunicado with the French King. They had begun their negotiations in the Communal Palace. Another day—and sadly del Medigo returned to Fiorenza. He did not prod his horse on the winding road back. There was no hurry. It was too late.

XVII

And now, as the day set aside for the sentence approached, the passion of the city rose in pitch. Around each of the violated Madonnas, like rocks in the Arno at floodtide, crowds swirled day and night, pointing, listening to the orators. The streets were dangerous: fights erupting out of nowhere, tempers rubbed raw, this hellish unrelenting heat . . . And all the while, encamped less than forty miles away, were the French with their frightening new weapons and the people were confused for Fra Girolamo preached as if these invaders were the scourge of God, sent to purify the corruptions of Italy. But skeptics rejoined—why must the purifying host past through Tuscan land? The French were marauders, nothing more. So the people were confused and did not know if they should welcome or resist, and their terrestrial confusions were accompanied by celestial signs: strange nocturnal whizzings. And now these desecrations. . . .

So not only did the Jews keep to their houses, but many Christians as well. Especially those suspected of friendship with Jews or with the Medici. For the cry was already beginning to spread that

the absent Piero was incapable of upholding the freedom of the
City against the French (for though they came to do God's work, the
freedom of the city must be preserved). *Abasso le palle!*—murmurings
and then shouts; friends of the Medici thought it wiser to stay in-
doors.

Thus, while Andrea pondered the aerial auguries of the birds,
Michelangiolo was also keeping a vigil. But it was not only the vio-
lence in the streets that kept him in. He was ashamed, ashamed be-
cause he had not lifted a finger in Bartolomeo's defense. For while
the Spaniard was being dragged to the Bargello, Michel's only
thought had been to protect Giovansimone whose song had unwit-
tingly provoked this explosion. And now Giovansimone was ever out
roving the streets with a hundred other boys, not because he shared
their zeal but he would share their excitement, and Narro too more
often than not, both of them flushed and excited at dinner, relating
the latest outrages, the latest tidbit picked up at the forum-shrines.
But Michel stayed home and nursed his shame. He had abandoned
Bartolomeo in his moment of agony. What if he was a Jew? Be-
sides, all his confessions were obviously wrung from him on the rack.
Even he, Michelangiolo, would confess to anything once he felt his
limbs being torn from their sockets . . . He wiped the cold sweat
from his forehead. The times were fearful.

"What are you so glum about?" the Customs Official asked.

"I am not feeling well."

"What is it?"

"My . . . my stomach. I have a pain here."

"In that case you must take a mixture of loam and grape leaves,
grind them well together and apply them to your stomach. And
leeches. This will draw the blood away from the spot. But sitting so
hour after hour will only settle the black fluids in your abdomen.
First of all you must drink a purgative. Here, let me prepare it for
you."

"I cannot take anything. I am feeling ill."

"Then especially must you take it." He rose briskly, and busied
himself in the alchemistic preparations. Lodovico loved to perform
these tasks; he was almost as happy surrounded by vials, flasks,
pharmaceutical apparatus as he was with his account books. Michel-
angiolo drank the vile mixture and then at the first opportunity went
into the garden and threw it all up at the very spot where his Samson
had been. He felt a dizziness; the sky was melancholy, black clouds
were charging. He went down cellar and looked at his Samson in the
dim light that trickled from the staircase. He felt as if he were look-

ing at the work of another. A Samson, a hero who, blinded, had pulled the Temple down over his enemy's heads. A man of honor and of pride.

And he—his neck prickling with sweat—he who shaped heroes out of dead stone—when the moment came to act the living hero—he always fled.

XVIII

Among the crowd waiting outside the Bargello in the Via del Proconsolo when Bartolomeo was led out of the dungeon, was Andrea. He could not remain home any longer, the birds now wove meaningless loops in a burning sky, the moment of Bartolomeo's agony had come. And against the explicit instructions of his father, Andrea broke out into the cauldron of the streets, and came to this Golgotha. He was in the pack close by the portal when the great knobbed doors creaked open and the mob roared, and there was Bartolomeo in a tumbril drawn by a mule, escorted by four sheriffs. Above their heads he stood: you could see him plain, clad in a coarse garment from neck to foot, chained, and his drawn face paler than ever before and his small figure bearing the marks of recent torment. He could scarcely stand and on his arms, naked to the shoulder, Andrea could see the ring-marks of the rack. With his chained hands he was clasping the rail of the tumbril in order not to fall, he was looking out upon the furious faces with a curiously impersonal air as if a passenger stood at the rail in a storm, watching a churning sea, but could not conceive that the sea might devour him. The sheriffs shouted "Clear the way! Clear the way there!" and a path reluctantly opened and the tumbril creaked slowly ahead on its great solid wooden wheels. It moved slowly and sometimes not at all: a ship gripped in a frozen sea. The mob was roaring and pushing and struggling to get closer. And all the while the deep bell of the Bargello was tolling tolling tolling and Andrea fancied he saw the flicker of a smile cross Bartolomeo's thin lips and in his dark eyes

lurked contempt. He made a feeble move as if to protest still—the protest of one half-dead—then he slumped against the rail.

As soon as the doors had swung open, as soon as he had seen Bartolomeo, Andrea had wanted to cry out to him—to let him know that he had one friend in that moil of agitated faces, and hands to clasp in that angry forest of fists, and a voice that greeted his appearance with something other than a curse.

But Andrea did not dare. He knew he would be torn apart the moment he revealed his sympathy. He could only pray that the other might *feel* it somehow: his heart was beating like the Bargello bell— he felt a green stalk of gall rise into his throat; the nausea cramps began.

And now the cart was pushing through the dense mob down the Via del Proconsolo to Sant' Onofrio where Bartolomeo's right hand was to be cut off. In order to advertise this punishment, the prisoner's robe was sleeveless so that the arms hung bare from the shoulders. They were thin arms, gray as granite, veined with blue and corded with angry twitching fibers. Andrea watched as the little procession pushed its painful way through the mob; now and again the arms would feebly lift to ward off a blow, those graywhite arms seeming to possess a life of their own, lifting out of the slow figure in that impotent gesture of defense, a twiglike flailing like thin branches of a skullwhite birch whipped by a storm. And now Andrea couldn't see him any longer, but knew where he was because there the shouts were loudest, the agitation greatest. Now the street was thick with the mob from palace wall to palace wall and they were pressing forward after the sheriffs and the prisoner in a great sluggish tide, out of which waves of voices lifted—"Give us the Jew! Give us the Jew!"—the voices spilled over, mingled to a roar without contour, in which no words could be distinguished, only the grumble of a great beast, the anonymous thousand-headed crowd sea-serpenting and flailing its way along between the palaces on its thousand arms and legs, pushing and shoving and buffeting down the pinched winding streets after the sheriffs and Bartolomeo.

And Andrea was in it, swept along in the fury, swirled about sometimes in a cross-current of sweating clutching bodies.

At the corner of the Borgo degli Albizzi the press eased a bit, he caught his breath, and looked ahead to see if he could distinguish Bartolomeo. But he could see nothing. He knew only that Bartolomeo and the sheriffs were about three hundred yards ahead because there the agitation in the mob was most intense. Shouldering and pushing, he pressed his way forward. The mob was fighting now,

they wanted to seize the prisoner from the sheriffs; Andrea could see the sheriffs again fighting back with fist and dagger; their faces red, sweaty, fear-twisted. Behind him now the Bargello bell seemed to be ringing more violently. It seemed to have leaped in pitch; and from that hive of ringing, soldiers all at once appeared who with leveled pikes forced their way rapidly to the sheriffs and formed a protective cordon around them.

Then suddenly they were gone. They were being pushed to the city wall and then they had doubled back like a hare and at the Street of the Little Market they disappeared as if the earth had swallowed them. Baffled, the mob flailed and flung its multiheads and multi-arms like a sea-monster cheated of its prey. Boys were trampled under foot. Screams arose out of the earth. Shouts arose that the sheriffs had decided to cheat the Virgin of Sant' Onofrio of her prey; that was why they had taken to the back alleys.

But they were simple men, the sheriffs; they had been ordered to conduct the prisoner to the holy places in a given sequence, so that the sentence might be legally carried out; they were not trying to cheat the Virgin at all; they hoped merely to bring Bartolomeo (and his hands) to her by a more devious route. For it was obvious that this mob was not going to be satisfied with mere hands and eyes.

And now many voices were crying—"*this way!*" and "*this way!*" "*No, down the Canto del Mercatino! . . . I saw them, porco, on Via Ghibellina!*" The multiheaded monster divided, trivided, splitting into many nameless furies, siphoning off at every streetcorner; then the entire quarter was a boil of running and cries; disjoined segments of the monster meeting again at streetcorners—"*Have you—? . . . No! . . . Have you—? . . . No!*"—and rejoined and met another segment and rejoined that, so that the mob-monster was constantly being sundered like a huge amoeba and resuming its awful oneness.

They were gone, swallowed up, Andrea could see nothing of the tumbril and the gaunt figure in the sack swaying above the agitated sea; he had lost Bartolomeo and he began now to push his way in the direction where he had last seen the cart. The sheriffs had been swallowed up in the labyrinth of back streets. They had fled. They had no choice. At each Madonna an executioner waited and the sheriffs had to deliver their prisoner alive.

So swept along in the anonymous fury, Andrea was suddenly disgorged into a great space. Through a forest of exploding arms he saw familiar buttresses and gay frescoes running along palace fronts and he knew he had come out into the Piazza di Santa Croce. And

here in the churning mob, under the broiling sun, he ran into Michelangiolo.

They stared at each other, panting. Then without a word they embraced. They had not seen each other since the afternoon of Bartolomeo's arrest. Brooding in his garden, gnawed by the worm of conscience, Michel like Andrea had remained at home until, hearing the Bargello bell, he could no longer hide from himself, he had to see, to see—driven by he did not know what demons: curiosity, guilt, morbidity.

So now they stared at each other. And Michel did not know if his friend was still his friend. Andrea had been witness to his betrayal.

They were silent. Michel waited for the condemning word. It did not come. Perhaps then Andrea had not seen his pusillanimity that day? or perhaps he had put his disappearance down to a normal brotherly concern to get Giovansimone out of the maelstrom he had stirred up with his song?

"Have you—Have you seen him?" Michel finally said.

"Yes. When he was brought out of the Bargello."

"Is he—? Are his limbs broken?"

"He is alive." That was all he said: "He is alive"—but even as he said it, the words rang false, he wondered if it were still true. For he had not seen Bartolomeo since the tumbril with the frightened sheriffs had disappeared around the corner of the Little Market. And that was at least forty minutes ago.

Then there was a roar as the Roman mob in the Colosseum must have roared when the slavering lions bounded out of the dark corridor into the sandy sunny arena where the Christian slave knelt, a roar that made his flesh crawl like a rumpled rug at the nape of his neck, and Andrea and Michel turned in the direction of the sound, and saw that the tumbril and the sheriffs had now blundered their way into the piazza where the mob waited. Bartolomeo's cheek was bleeding. He was somehow slumped and erect at once, his coarse garment was torn and his thin hairless chest ran with blood. The soldiers were still flanking the cart but the lawful justice they represented was a ghost: their pikes had been wrested from their hands, the sheriffs' fat faces were sweaty and red as beef, they were shouting hysterically: "Stand back! I tell you! Orders of the Eight!" But it was impossible, they were blocked on all sides, they could not move.

Then the rock-throwing began; the mule screamed as a jagged stone tore its mild eye out of its head. With a wild whinnying the

mule pitched in the shafts, then splintered the shafts and kicked its way free. That was when the sheriffs and the soldiers fled, and Bartolomeo, his hands shackled behind him, was left alone to face the hail of stones. His graywhite pallor shone with sweat and blood. His eyes now were on the nether side of anger, he opened his mouth to speak but no words came, he was vainly trying to avoid the stones, grotesquely pitching back and forth in the cart above their heads like a puppet on a stage. The dumb mouth opened and shut, gasping like a hooked fish. Then all at once the words came, "*Shma Yisroel! Adonai! Ech—*"

Then he went down. The last thing Michel and Andrea saw (Michel suddenly sobbing, and burying his face in Andrea's shoulder) was that wild unrepentant expression, that hand jerking loose and upward with a spasmodic motion. There had been a fraction of silence when the words finally burst, but only for a fraction of a second, then the wild roar resumed, surging in waves with every hail of stones, a deep furred roaring from the abdomen of ages, a sanguine spouting tearing ripping roar rising out of the earth and flooding the piazza like tangible waters of a flood so that Andrea imagined he could see the sound lapping the gray rough unfinished façade of the church and rising rising, drowning them all in its waters.

It didn't take long. When they finally fought their way through the pack to the cart, the body had already been dragged to the ground. The face was still recognizable. A flight of Bernardino's angels were tearing off the last shreds of the dungeon sack. A boy leaped with a knife and cut off the testicles. Bartolomeo's thighs spouted blood. Andrea was suddenly sick. But he could not fight his way free; he pressed his palms against his mouth and dirtied himself. He couldn't see, his eyes were blurred with tears, the gimlet sun was boring a hole in the back of his neck. He hung onto Michel's strong arm and when his vision cleared he saw that a little space had now been cleared around the body, the mule was gone, the shaft-tongue of the cart lay on the earth at a peculiar disconsolate angle. And, hysterically laughing, several boys were now tying a cord to Bartolomeo's neck and another to his arm, and they began to drag him then—the pack falling in behind as in a procession, beating the naked bleeding corpse with sticks—toward the west end of the square.

Andrea and Michel followed. They did not know why they followed but they could not leave, they could no longer hide by their window or in their cellar, they had to see this horror to its end. All

day they followed the savage procession: through more than fifty blocks of Fiorenza, up the narrow streets to the Piazza Signoria, and then across to the Via Larga, where in front of the Medici Palace, they saw it hauled up by the neck—a torn bleeding thing—from the great wrought iron lantern and then cut down again and the procession resumed, beating the corpse and singing, and stopping for impromptu celebrations at streetcorners. Down every street they passed, windows bloomed suddenly with grape-clusters of heads, and there were those who crossed themselves and turned away and those who laughed and those who cursed, but you could not tell always if they were cursing the corpse or the monk out of whose preaching had grown this thing. Fra Bernardino was nowhere to be seen, he did not issue forth; some said he was not even in the city that day. But now and then a Dominican follower of Fra Girolamo would curse these boys for the scandal they were doing and sometimes fights erupted between Girolamo's angels (for he too had them) and Bernardino's angels—the Hooded Hosts versus the Caped Ones. And some merchants stood outside their shops and cried—"Plague on all these pestiferous mendicants for the trouble they stir up!" Then the savage parade marched on, dragging the corpse to the joyous chant of *Dies Irae.*

And Andrea and Michelangiolo followed. They followed the pack across the Ponte Santa Trinità and down the Via delle Caldaie, until by the fourth hour after noon, bored now by the game, and fatigued with passion and the raging heat, the procession abandoned the miserable remains outside the Gate of San Pier Gattolini. The gold-shine was already beginning to tinge the afternoon, the high gate and crenelated wall ran here close to a stream, tall grasses grew in the marshy patches, and here the remnants of the mob— several hundred still who had survived the passion and the furious heat of the long pious day—dispersed.

In a swamp, Bartolomeo lay but Andrea and Michel could no longer tell it was Bartolomeo: that squish of bloody meat was hardly a man. A score of boys still hung around the corpse, looking curiously at it. Fragments of rope still clung to the neck and arms, the castration-flower was a rustblack gorge. Outside the ring of boys, Andrea and Michel lurked, their eyes still upon what had once been Bartolomeo. Like Joseph of Arimathaea and Nicodemus, they would wait till nightfall to gather him up. They clung closely to each other, arm in arm, unspeaking.

And then through the lofty knobbed wooden gateway Justice appeared once more—several score of horsemen in armor headed by

a gonfaloniere wearing the colors of the Eight of the Guardia and Balia. They halted at the corpse and reassumed control over the ravaged body.

And now the incredible second procession began. To the sound of rolling drums, they rode slowly, dragging Bartolomeo behind a horse, gathering up a new crowd in his wake. Back across the town they rode, back across the Ponte Carraia, back down the Via dei Servi. Until they halted at the first violated shrine of the Madonna at Santa Maria Novella. And here the sentence pronounced by the Eight was carried out on the dead body. They cut the right hand off the unresisting corpse. And then solemnly, they proceeded to the Madonna of Santa Maria in Campo where they cut off the left hand. And finally, in front of Simone's lovely Virgin in her seashell of a niche outside Or San Michele, the just sentence of the Eight was fulfilled by gouging out Bartolomeo's sightless eyes.

Thus it was clearly demonstrated, to the satisfaction of the Priors, and as a warning to the citizens, that in the long run no lawless mob could circumvent Justice.

XIX

And now again he felt his heart jumping like a live fish in his hand and he was afraid that he would vomit. Across the street Simone's Madonna seemed to smile, oh just the faintest flicker at the corners of her delicately carved lips. Just a flicker of approval.

As she had smiled when Bartolomeo's eyes were gouged out, what had once been an eye spurting, the blessed globes of vision a reek, a gush of blood and lymph. Then he and Michel had gone together to the river-bank and squatting, wet their brows in the cool water. Quietly they sat for a long while. The sun was just beginning to set now. Over the Old Bridge where the butchers had their stalls, a cloud was running with blood. Swallows, intoxicated in a sherry sky, were swirling round and round. And under the bridge, as if stained by the butchers' slaughter, the painted river ran, crimson and orange; now

and again a low-skimming swallow dipped its brush-wings into the waters and stirred a mirrored sunset up.

Silently, they sat at the bank. The sky grayed. They could not speak. What they had just witnessed had drained all words out of them. It was enough to sit and watch—with the hypnotic melancholy with which one gazed into a hearth—the dying embers of the day. At last, when earth and sky were ash, Michel spoke:

"Men are beasts," he said. He spoke quietly, but Andrea felt the lash of bitterness. "Bestie . . ." He was staring down into his palms, crisscrossed with work-lines like a fisher's net. "What is the good of all this?" He closed his palms into fists. "Those—"

He couldn't go on. Deep furrows in his forehead quivered as if a violence within the skull were seeking egress. "These are not the times for art," he muttered in a peasant's voice— "Stalls for swine, that is what one should make."

Andrea cast a rock. To a note of music it sank, Giovansimone plucking, the river a silver lute and Bartolomeo was dead . . . Bartolomeo was . . . No, up that path a grinning dragon lurked . . . he must not let his thoughts go. It was too awful. And Michel talked of art. How could he now. . . . When Bartolomeo's entrails . . . ? Was it only another dissection? . . .

Andrea rose.

"I'm going home," he said. "I feel ill."

Michel accompanied his friend to the Ponte Santa Trinità. He stood there a moment watching him go off. Andrea's head was bowed, his legs dragged. Michel watched until the melancholy figure was swallowed in the darkness, then he turned homeward. What was it he had noted in Andrea's face? A sorrow beyond all plumbing. This boy with the miracles of curls frothing around his fawn-pointed ears, this boy with the long black lashes and tremulous mouth—had suddenly seemed centuries old.

Poor Jew, he thought.

That night, at dinner, Lionardo said sharply: "It is only what one might expect of Franciscans."

He was talking—as around every dinner table in Fiorenza they were talking—about the disorders connected with the heretic's death.

"They were not Franciscans or Dominicans—they were maddened boys," Michel said.

"Who maddened them? . . . Fra Bernardino. And what does this Fra Bernardino preach? Reform of morals? No. Does he touch upon

our primped and painted women? No. Or the frippery of our artists?
No—"

"What frippery?"

"—of all this he says nothing." Lionardo went on unheeding. "His
main concern is setting up a Bank. He is more interested in saving
money than saving souls." His lips curled.

Less than three weeks ago, Michel thought, we were together in
Santa Maria del Fiore and Lionardo seemed enthralled by the very
monk he was now denouncing.

"Do you approve of none other than your Prior?" the Customs
Official said ponderously. The words rolled down from Sinai at the far
end of the table where he presided as always—Madonna Lucrezia
next to him, looking timidly into her plate with eyes like pressed
violets—and he dazzling in his red cloak. Six heads turned toward
him like weathercocks.

"I approve of many preachers, Messere."

"So long as they are Dominican?"

"So long as they preach true doctrine." Lionardo's anger, always
restrained with difficulty, was raging back and forth behind the bars
of filial politeness, like the lion in the cage near the Palace of the
Priors. He was always an angry man, Lionardo, even his calms were
only moments of recovery or preparation.

"Well, surely the elimination of usury is true Christian doctrine,"
the father said. "If this Franciscan achieves such a reform, think of
the benefits that will accrue to our city. Think of how much more
wool could be dyed and how much more would be sold in Brussels,
in London, in Paris . . ."

Whenever he talked of buying and selling, Messer Buonarroti's
gray eyes glistened and his voice recited the cities in a lyrical litany
of trade. Lionardo tried to conceal the scorn of his reply:

"I am speaking of the riches of the Kingdom of Heaven . . ."

"Ah, but that automatically follows if one attends rightly to one's
affairs with due prudence."

"I speak of what our Prior, Fra Girolamo calls—" Lionardo's holy-
haunted eyes were ablaze again; he considered Savonarola a true
prophet. "—the decline of morals in our city. Why do you think
this Charles is coming? As a scourge. Why do our women pile false
hair upon their heads and pluck their brows—?"

"To trim the meat for better tasting."

It was Narro, a chicken bone greasily in hand. His lips, bright in
the candle-glow, were busily munching and he grinned as his teeth

chopped until Babbo fetched him a blow across the face. He coughed, a rain of half-masticated chicken spitting from his mouth.

"In the future do not interrupt your older brother," the Customs Official said calmly.

Giovansimone blew his nose hard, followed by his habitual examination. And now Ser Lodovico really exploded.

"By Bacchus! Must you glare upon your snot?! What do you expect to find there?—pearls or rubies fallen from your brains?!"

He appealed to the spirits of the air, his eyeballs rolling: "Oh, what has happened to our youth? When I was a boy no one dared to blow his nose at table. But now good manners no longer exist. If someone makes a wind in company, someone else is sure to pinch his nose and cry: *What a stink! Who do you think it was? . . .*"

Melodiously he sucked the last remnants of marrow from the last chicken bone and continued with his sermon, now speaking to his sons and now to Donna Lucrezia, who bowed her head lower under the spray of words—"And you, Gismondo, must you ever pick your teeth? What do you think to excavate there? Gold? I tell you, moglie mia," he said to his wife, "our times are quite lacking in all decencies. Mind you, it would be bad enough were it but confined to my own household. But it runs riot in society, there is a rot of good breeding. This very morning I saw that popinjay Messer Tornaquinci —who should know better—being scion of a noble family—nonchalantly strolling down the Corso of the Dyers. And what do you think was dangling on a gold chain from his neck?—an ivory toothpick! Surely that is a bald jewel for a gentleman to pull forth out of his bosom. It makes men think either of a barber or—" he turned to Gismondo, waving an admonitory finger in the boy's face "—mind this now—or that a man loves his belly full well and is provided for it. I see no reason why he should not as well carry a spoon about his neck as a toothpick . . ."

Then after this circuitous detour in the realm of etiquette, during which familiar tour the brothers sat still, with heads slightly anod in boredom and feigned humility, Lodovico turned with a triumphant smile to his dour eldest son: "Decline of morals indeed! False hair! I tell you what your Fra Girolamo should preach about: Manners! Manners! The manners of our youth. That is what needs attending to!"

And he coughed then in self-satisfaction; a jovian rumbling that ended with a crash that shook the plates. Round-startled, Marina the cook's veal-pink face, popped into the doorway, then out again

Female marionette in this male household, she had spent years in the Customs Official's service, long enough to consider Madonna Lucrezia an interloper—but she had never been able to accustom herself to this thunder: she was always sure something terrible had happened. But it was only Lodovico's explosive way of signifying the end of the debate.

Now sopping up the grease with the good thick country bread, the sons hastened to get out of their father's righteous range. After dinner, thank Heaven, he would sit out front on the stone bench, until his friend Silvio Manotti, the apothecary, arrived, and then they would stroll off arm-in-arm to the Piazza dei Priori, where for fifteen years a group of them met beneath the loggia and acrimoniously passed judgment on all things Florentine. What was not Florentine was not even worth discussing.

As soon as Lodovico had gone and Lucrezia had retired to the kitchen, Lionardo whirled around at Narro and Giovansimone. He was furious at their belched and nose-blown comments during his aborted sermon. His white skirt flew, there was a tangle of arms and legs for several moments. Then they broke loose: Lionardo chasing after Narro and Giovansimone; the boys, young and agile, having no difficulty eluding him. They were laughing, Gismondo following the chase with dull happy eyes, and Lionardo using words not found in any missal.

Finally Michel made peace between them. Always he had to make peace in this family: between father and brother, or between brother and brother. Usually he did it with a word, or a pained protest, or a plea that he might work. And sometimes, in the case of Giovansimone, he had to use a blow.

Tonight, especially, he was weary of the endless bickering in the household. What a cage of baboons they were!—Lodovico so smugly content and Lionardo infrequently home but always purging their souls when he was, and Giovansimone so ready with the sarcasm of his fourteen-year-old superiority, and even Gismondo whose too-red face annoyed Michel because it always made him think of a squash. Oh, there was only Narro—he didn't know why—but he forgave Narro almost everything. Perhaps it was because he was the closest to him in years. Or perhaps it was that healthy outward-goingness of his; not sly like Giovansimone or brooding like Michel himself or Lionardo. Narro was a happy dog. He lifted his leg against all this turmoil, then shook himself off, joywagging his tail. You could take him no more seriously than a dog—but you had to love him. But even Narro . . . Why did he so frequently behave as if he had been

brought up in a stable? He had not been brought up in a stable. After all, was not Lodovico a government official?

He sighed and left the house for a breath of air. The oppressive heat of the afternoon had diminished somewhat. Between the night-eaves, the stars were cool geometry. How beautiful and pure was the world of non-men! Stars, mountains, rivers—what dignity they possessed! They burned none, and tortured none. Only man, whom God had created in his own image, committed atrocities. Whence then had divinely-created man derived his taste for evil? Had the great Artificer blundered? Was evil, cruelty, the horror he had witnessed this afternoon, a flaw in the great design? Or was it an essential part of the design: a necessary Fall which Christ had to expiate again and again? That Christ who had been born a member of Bartolomeo's tribe and died a member of that tribe. And here was another Mystery. Bartolomeo's tribe had betrayed Him; therefore they were execrated by all men. But had He not preached love and was it love that had been doled out to Bartolomeo? Was he not—had he not been (the thought like a suicidal hornet stinging itself into the change of tense) —had he not also been a man? Why then was Christ's love, Christ's pity, Christ's forgiveness denied him in the name of Christianity?

He let his feet take him where they would. And as he aimlessly wandered the stony alleys, he tried to plumb the meaning of the terrible thing he had seen this day. But at the bottom there was only darkness and more darkness.

His mind a tangle of torment, he found himself unexpectedly at the city wall. Until midnight he walked along it. At every gate, he stopped and listened to the country night sounds outside, the strange and soothing night sounds of nature: the bird that sang so incongruously down scale, the rustling of wind in the olive leaves, the distant barking of a dog. The sounds comforted him. They were the breathing of this earth, it was a living creature like himself. It suffered and it slept.

He looked up at the stars. What were they—light? rents in the curtain of Elsewhere? There were some new astrologers who said they were nothing but whirling rocks. And this earth too. The greatest part of it stone. Perhaps the clue to the Mystery lay there. Some spirit imprisoned within the stone.

At the Porta alla Croce he climbed the hill past black olive orchards. In the fuzzed light of a horned moon, the crooked gnarled trunks of the olive trees were gnomes, imprisoned souls. In the second round of the Seventh Circle they were, in the dismal wood of the Suicides. "*E il tronco suo grido: Perchè mi schiante?*"—"*Why dost*

thou rend me?" Cypresses swayed pointy black against the twinkling sky.

From the top of the hill, he looked down upon Fiorenza. In the cup of the hills it lay, dark and ominous. The towers, wooden houses, bridges—all were gray ghostly forms around which a few twinkling lights defined inky shadows.

Fierce within its walls the night-city frightened him. He felt imprisoned, as often he felt imprisoned within his family. Even here, on these heights, outside the walls, he could breathe the partisan fury of his city, the churn of its ideas, the warfare of its citizens. They who had exiled the Poet, who had soaked every street with blood of Guelph and Ghibelline, who had tormented this poor innocent Jew this afternoon—they pitiless and hard as the dun-gray pietra serena of their buildings. They who could be shaped only by the hard blows of a Magnificent.

But now, on the brink of an invasion, how hard would they prove? Would Piero's melting Hercules stand up against the French King?

Oh, the times were bad for art! Perhaps beyond those hills there was still some hope.

XX

And when King Charles' troops came—oafish pimply-skinned Swiss and Germans with straw-colored hair and knobby knees, fierce mercenaries all, and gamecock little Gascons and Normans with enormous lances—Michel and I stood at the Porta a San Friano & watched them march in. It was the twenty-first hour when the French King finally arrived & though it was a cool November afternoon we were not cold because of the heat of so many thousands of bodies pressed together at the gate. Because two days earlier the Signoria had issued a ban that all the citizens were to appear at the gate, festively dressed to do the French King honor. And Francesco Granacci was there alongside us in a purple cape, and Iacopo and Buonarroto and Giovansimone, all of us except Bartolomeo, he was no longer there.

But as the troops passed behind the brrrmm brrrmmmm brrmmm of the tambours and the shrilly yellow blasts of the trumpets & we saw the terrible new cannon grumbling by on their wooden wheels and the arquebusiers and the infantry with halberds gleaming in the light of thousands of torches and the new rifles that were said to rip through a man's flesh as a hand rips guts out of a slaughtered chicken, and the endless files of infantry and cavalry, I thought I could see Bartolomeo smiling his cynical smile alongside me. And I thought I could hear him saying: *What does it matter to me, your Charles or your Medici? They are all Christian dogs.*

Then I turned back to look at the pageantry of the troops because Bartolomeo's smile always troubled me. It troubled me more after his death than before. It had a way of appearing in outlandish places and times where no smile had a right to be. And Michel apparently didn't see the smile because he was intent upon the spectacle, he was wedged between his brothers, his arms interlaced with theirs; & seeing their faces in profile in the dancing torchlight I was struck by the family resemblance in the small stubborn hazel-gray eyes and the slightly protruding lower lips. And all around us thousands of our maidens dressed in the French style to do them honor were cradling lilies in their arms to let the French King know that we Florentines had come to the gate in good faith and wished him only well & that he must have trust in us and not permit his fierce troops to put our city to the sack as the terrible rumor would have it. With every wave of infantry a new shout of *Viva Francia!* went up in which I could descry Michel's *sotto voce* dissent. Then Narro shouted: "Here he comes! Here he comes!" and Michel and his brothers began jumping up to see because all of them were slightly less than middling height & they had difficulty seeing over the crowd.

Then there was Charles on his horse and he was certainly an ugly man. He was stiffly sitting a palfrey, under a canopy held by four young nobles; he had a hooked nose and he was clean-shaven and pocked and he had protruding enormous watery brown eyes like the eyes of a sick bird. And he wore a simple sepia-colored cloak with a gold chain around his neck and from under his cap, dust-colored hair fell straight as rain to his shoulders. He was smiling proudly at the roar that went up at his appearance—a crooked little smile but you could see the pride in it, & despite his ugly appearance he seemed truly regal the way he sat the palfrey and walked him slowly through the enormous crowds. The girls were tossing the lilies now at his feet so that the palfrey was crunching along on a path of flowers. And all the bells were going & there was an endless roar of Jubilee as they tried

to clear a lane for the French King. I felt such a press upon my chest as I had not known since that mob in Santa Croce, & the memory of it flooded me then as if a skeleton were dancing among all the masquers and I could not understand him there lying in the ground. For I never can understand the dead, even he who was so much more dead than most, his body torn beyond the recognition of a man so that even if the spirit should return there would be no flesh to house it. But then the excitement seized me again & I waved all this away, these cobwebs dim the eyes and I wanted to stay in the world in which I was, there would be time enough to know the other.

So we followed the French King's slow progress through the applauding crowds. And along every street you could see the chalk-marked houses which were to billet the troops. But I knew already that these houses were only a part of those that would be occupied because there were twenty thousand of the Frenchmen come & the chalked houses could not possibly hold them all. And they would not be too patient with our protests because I had already witnessed how the Frenchmen behaved when earlier this month the advance guard had come to mark the houses. There was a Baron, burly as a barrel, came rumbling into our house. He knocked at the door & when Master Elia opened it, there he stood, enormous with a loose-jowled globular face embroidered with fine winy-red veins. And he and the two soldiers with him marched in as soon as Elia opened the door and clumped through the entire house examining this room and that, and mumbling in that nasal jabber of theirs: "This room for Baron So and So, and this room for Monsieur This and That." And so they had done throughout the city & everybody was afraid because we had heard that the French King had promised his soldiers to let them put Fiorenza to the sack. And even though Piero de' Medici had come back from Pisa greatly satisfied that he had reached a good accord with the king, nobody took him seriously despite all the confetti he had thrown out of his palace & all the free wine he had dispensed. Because already there seemed to be brewing up much anger against poor Piero as if he were primarily responsible for the incursion of this French King into our country. Actually he was not a bad one, Piero, he had tried his best to negotiate with the King, promising him much money it was said, & giving him the keys to Serezano and Pietrasanta.

Perhaps that was why he was not here with us today in the place of honor with the Priors and the Friar and the Gonfalonieri at the gate, instead of wheresoever he was now, in Bologna rumor had it, whence he had fled with his younger brothers—Giuliano and the Cardinal Giovanni. For, Michel says, if he had not given the keys of those

two cities away to the King only to make it more commodious for the King to put them to the sack, the terrible anger would never have risen against Piero. Because Michel, who has lived with the Medici & knows them well, says that Piero is unfortunate but not malicious, and though he does not possess his father's genius, or the charm of Cardinal Giovanni, yet he is not evil in his heart. But still he should not have given away the keys to those cities. For when Lorenzo di Giovanni Tornabuoni, who had been with Piero at Pisa, came back to the Signoria & said the French King wanted official confirmation of what Piero was promising, the Signoria refused to give it to him & they said angrily that Piero had acted like a foolish boy.

And then after the sack of those two cities, and Fiorezzino as well, the French started pouring in in force and the Signori ordered us not to hide anything away in the houses that were set aside to lodge the French. And everyone was afraid that so many men-at-arms would steal or violate & we were sure they would not pay for their lodgings though they promised to pay. And Michel's father said that even if they did pay, they would pay for the horns and eat the bull.

All month long, before the coming of Charles, Michel and I had watched the Frenchmen as they poured into the walls in ever-greater numbers, chalk-marking the houses. They didn't seem to care whether rich or poor, & they came down into our street and into the Borgo and marked the house of Bartolomeo's family, and the women were terribly afraid. But we saw that in this respect at least they were honorable men, they never spoke an evil word to a female and yet many families were afraid and sent away their younger daughters to relatives in the country or into convents until the King should depart. But Bartolomeo's family had no kin outside the walls & obviously Tsiporah could not go into a convent, so they simply tried not to see the guests in the house. Old de Cases didn't know what was happening anyway. He had been in bed since the news of Bartolomeo came. He was more dead than alive. And the Señora de Cases was like a well that had run dry with weeping. Father and I were often there to try to cheer them up but our felicity was forced, our sparks fell on damp moss. It was like joking in a tomb. Besides the old man turned his face to the wall whenever Father entered. Because he felt that Master Elia should have been able to prevent what had happened & it was impossible to convince him otherwise. And it was almost three months now and every time I tried to talk to Tsiporah, she burst into tears and ran away. But later it was even worse: she no longer wept but acted as if I were not even there; if she passed me on the street it was without salutation. And I had a terrible feeling that she held me

somewhat responsible for the death of her brother for I had induced him to go to the square with us, & even the little girl seemed to look at me reproachfully. Father said the old man would surely die soon and no medicine could save him.

So there they were with these unwelcome guests in their house, & we had a Baron of some sort too sleeping in Mother's former bedroom. He was as lean as a pike, he had a bristly orange-colored beard and he hummed all day between his teeth so that I thought a thrush was hidden in his beard. And his habits were filthy, he left his offal swimming in the bowl, all the broidery on his velvet jacket was unraveling & the plume in his hat was mangy as a summer hound. And he spoke only that droning barbaric French until one day he came into the study when I was looking at Father's Hebrew copy of the Canon by Abū Ibn Abdullah Iba Sīnā whom some know as Avicenna. Father always kept the book open on the reading stand & I loved to look at it because it was written on vellum in brown beautifully formed letters with illuminations in gold leaf against a purple arabesqued grill like the iron gates of a mosque. Father had got this book from a Spanish Jew & there were strange mathematical devices in Arabic along the margin. But most of all I enjoyed the miniature paintings of naked ladies bathing together in big wooden tubs, and apothecary shops under arcades with many bright-colored jars of medicine on the shelves, and the tiny blue and carmine and gold figurines mixing prescriptions in big earthenware pots and the coiling Hebrew letters describing the recipes. I used to spend idle hours in the pages of this big parchment book and Master Elia was pleased, thinking it betrayed an interest in his profession and my profession-to-be, when of course all I cared about were the bright colors and the drawings and the many different worlds I could travel in looking at them, & how I wanted most of all to be a painter myself and create such imaginary worlds to voyage in. Well, I was leafing through these pages, when in stomps the orange-bearded Frenchman and drones something at me and finally I understood he wanted to know the name of the book. And I said "Avicenna's Canon," and the seedy Baron's lemon-colored eyes lighted up and he finally got across to me, with many grunts and motions, one skinny hand down his collar all the while, scratching away like a hound, that he wanted to speak to Father. So that night Master Elia went to him & after a while I heard them gabbling in Latin and they seemed to be getting along fine. Then Father came out, smiling, and the Baron was left in the study looking at the book, & Father told me that the Frenchman was a doctor and had studied medicine at the famous

University of Paris and that he was a worthy scholar and we should be honored to have him as a guest in the house.

But I didn't see any honor in carrying off his stinking bowl of offal every morning.

Every night then the Frenchman and Father would talk, mostly about medicine but sometimes also about other things, and Father told me that all the soldiers of the king who were already in Fiorenza had a secret fear. And then I noticed that every day the Baron would ask: "How many men can Fiorenza muster?" And Father would smile ever so faintly and say: "At the ringing of the bells, one hundred thousand men from within and without the walls." And then the Baron would sniff in a twitchy kind of agitation & pull his long earlobes and insert his hand inside his no-colored blouse and scratch away vigorously, and say: "One hundred thousand men? At the ringing of the bells? Are you sure? One hundred thousand men?" And the truth was, they were afraid, for they counted only twenty thousand, and they had come with a mind to put us to the sack, and the King had promised it to them, but they couldn't see how that game could be put into play. Then Father would shift the talk to Galen and Avicenna and the Baron would seem less agitated for a while.

So the Frenchmen were afraid and we were afraid too, every day it grew more tense so that at the slightest tintinnabulation of the bells, all the folk would rush into the Piazza dei Signori thinking it was a call for a grand parliament. Then the Priors would appear and enjoin us to return to our homes and remain calm, assuring us that the French King meant us no harm. But everyone was rebellious & in great fear. And very few believed that Piero could play with this French King the way he played with a leather ball. When there was need for tact he would smash & when there was need to smash he would go mincingly as a girl. For hè did not possess what most Florentines possess: an open heart and a closed mouth. So very few had faith in Piero de' Medici in this perilous moment; and our people were more divided than any. For there were those who argued (and with reason) that the Medici had always been our friends and protected us against the Friars and had not even Piero—weak as he was—restricted Fra Bernardino outside the city walls until the pressure of the populace grew too great? And there were others who said that since Piero had ultimately failed to hold the Franciscan in check, he certainly would be unable to curb this Dominican, Girolamo, a far stronger man who had the citizens on his side. And who knew when Girolamo might turn his wrath against us? Had he not already hurled the charge of Marrano against the Pope? Therefore, it was better that

the King of France had come. And my father, Elia, was of the company of those who defended the Medici in the loud disputes in the synagogue, though he did so with only half a heart since he had observed Piero too closely to rely on him.

And among the Christians also there was dissension—some who feared & hated Charles and others who welcomed him as Savonarola's predicted scourge, for surely under the Borgia their Church was in need of scourging. So then not trusting Piero who 'twas said—despite his beauteous wife, Clara Orsini—was wenching like a rabbit these days, when he should be at negotiations, so that he fell asleep at meetings with the Frenchmen, the Lords Prior appointed five ambassadors to go to Pisa where Piero still was, treating with the King, & the five ambassadors were Fra Girolamo of Ferrara, and Tanai de' Nerli, and Pandolfo Rucellai, and Giovanni Cavalcanti and Piero Soderini, these four being citizens of Fiorenza. And to further calm the people, the Priors ordered that so long as the French King remained in Fiorenza, no one need pay a tax on firewood or victuals; & on wine, only half-tax, and everyone might have the right to sell wine or set up a tavern.

And this served to tranquilize a few, but not many, for all the while there was this growing fear of a sack and some French soldiers violated a twelve-year-old maiden near the Porta Santa Croce and they did it in the cloister. There was a fearful commotion then for several days, the churches filled and they were offering up special Masses against the sack, and our people also prayed all day in the synagogue. At morning prayers a terrible debate broke out between the party of Charles and the party of the Medici (Father the foremost) and Master Elia stood at the High Altar and spoke bitterly against his opponents. And that night I noticed there was scarcely a minyan in the synagogue and I asked Father where everyone was and he replied sadly: "The Spaniards refuse to join us in prayers for the welfare of the City. They say this City has brought them nothing but woe. They hold me responsible for the death of that de Cases boy." He looked awful; his voice was slow and deep as doom. When he prayed I could hear the note of sadness in his praying & it was a personal sadness now, not the sadness of centuries. He bent his knee deeply and he swayed to the chant as I had never seen him do, & when we walked down the Borgo together, his face was engraved with melancholy and all of a sudden he said:

"The Phoenix is dying." And I was not listening, my mind was away with the swallows skimming the evening violet river, and I said: "He is an old man, and since Bartolomeo's death . . ." Then Father

interrupted harshly: "The Phoenix, I said. . . . Count Pico of Mirandola. He is dying in his villa." And I understood my father's sadness because he loved this count ever since they had met at Padova and I knew my father had taken joy in translating many Hebrew works for him & now he was dying. And Master Elia was murmuring. . . . "It is a time of dying. The Magnificent . . . and now the Count." And he reflected a bit and murmured as if to himself: ". . . thirty-six years old and master of twenty-two languages and all his nine hundred propositions cannot save him. Young sweet Prince of Concord! No wonder he is dying. He who would reconcile everything: religion and philosophy, Christianity and our own sacred faith— How can he go on living in this age of Discord? They say it is the plague, but it is not that. I know the Count. He is dying of an unassuageable grief."

Early the next morning Father left for Pico's villa near Fiesole, & so he wasn't in the city when it happened. For not all of Piero's free wine and bland assurances of having reached a good agreement with the King, could save him.

And I saw it all because Michel and I had been sketching together that very afternoon, sitting on the ledge of the Loggia dei Lanzi. I was beginning to sketch these days, trying my best to copy Michel's swift manner but I worked with my right hand instead of my left, as he did, & perhaps that was the reason my work was awkward. I would show it to him but he rarely criticized, declaring only that my general conception was good or bad, that I had seized or failed to seize this movement or that, but my efforts at accurate rendering didn't seem to matter much to him. I liked especially to sketch the young maidens as they passed in their lace bodices and embroidered velvet gowns and jewel-sprinkled high-piled hair. I wanted to see if it was possible to capture all that lovely detail in a crayon drawing, from which I might later try to elaborate in tempera. But Michel didn't care at all for this subject & he laughed at my laborious attempts to render stuffs and jewels. We passed many Sundays so, arguing and sketching, and sometimes Francesco and Iacopo joined us and sometimes not.

Then the sun went down and the air went gold and the birds began swirling around the towers and vesper bells were just sounding when Piero came riding into the Piazza with a great company of armed men. He rode so beautifully, so straight in the saddle, & in the proud way he held his head and the graceful hang of his free hand, you could see the grace with which he played football and fist-ball and you understood why sportsmen came from cities all over

Italy to learn from him how to play. For I remember Piero with the wooden pocked glove on his fist slamming the leather palla with such force that it was like a French cannon ball whizzing, his opponents could not return it. And many there were who wished he had been able to slam with equal force the enemies of our country, but in this game he was weak as a maiden. And I have noticed this often—that the strong in body are the weak in spirit. The Lord, Blessed be His Name, probably wishes to preserve the balance that no man may prove too vain. For to possess all virtues & all attributes is to be a god, and there is only One God, Adonai.

And we watched while Piero and his men-at-arms trotted across the piazza to the great gate, and then there seemed to be an argument with the guard at the gate, & I heard shouting, and tall Piero was very red in the face. He was a choleric man and he was shouting, when several of the Signori appeared in their black cloaks. Of course Michel and I were unable to think about sketching now; we had sneaked along the loggia to the side nearest the door of the Palagio & we heard one Signore say: "You may enter alone and unarmed through the small door." And Piero said with terrible violence: "No one ever dared speak so to a member of my family." And the Signore calmly: "No member of your family ever dared conclude treaties without a proper commission from the Priors."

So then Piero turned back and galloped out of the Piazza, beating his horse. And a few minutes later, people, hearing of the commotion, began to gather there and they were crying: *Popolo e Libertà! Popolo e Libertà!* And others were yelling that there be held a Parliament and every window was clustered with people shouting: *Popolo e Libertà!* Michel seemed to be very upset by the uproar; one minute he declared the plebes were right and the next, he was on the side of the Medici. Nor was I surprised at his vacillation because he personally had been well treated by the House of Medici and he had no rancour against Piero despite that silly Hercules of snow. And I too felt that Piero was a good young man who had acted in good heart for our people, even bridling that runaway beast of a Franciscan for a while. But on the other hand Michel did not like Piero's high-handedness and lack of interest in art and though he could speak Latin, all he cared about were women and horses—he rode bareback on both. For though Michel continued, even after the death of the Magnificent, to live in the great palace on the Via Larga, he was soon offended by Piero's indifference to him and to his art, & so he returned to his family. So Michel was

torn by all the shouting, because some of the people (most of them) were yelling *People and Liberty* and others *Palle! Palle!* signifying the balls on the escutcheon of the Medici and there was one part of him that shouted with one camp and one part that shouted with the other. I could read the indecision on his face. It was plain enough.

We heard a great row coming from the direction of the Medici Palace and we decided to go there to see what was happening, but then we couldn't get out of the piazza, because a tide of citizens were rushing in, all armed, and they told us that the prisoners had been released from the Bargello and the arms seized and distributed. And at the head of this horde was Messer Francesco Valori on horseback, followed by other mounted men, and then all the gonfalonieri, each followed by many citizens of his quarter. Now it was getting dark, and we saw torchlights bobbing and heard sounds of commotion from the Corso and we managed to fight our way out into the Via Larga. There we saw a band of mounted men issue from the Palace of the Medici and at their head the younger brother of Piero, the Cardinal Giovanni. He wore a vest of chain armour over his purple and he had no helmet on, and as he rode ahead, sword drawn in a flourish, he was shouting and all his troop were shouting *Popolo e Libertà!* like the others. I turned to Michel & said:

"Why are they shouting *Popolo e Libertà?* Are they not Medici?"

"It must be a ruse."

"But everyone knows the Cardinal. He'll fool no one."

"Oh well, that's the Cardinal," Michel said. "He never walks a straight path when he can find a crooked one."

But we could not go on talking, there was such an uproar in the Via Larga. "Watch out!" I yelled and pulled Michel aside just in time. People were throwing stones out of windows and from rooftops onto the Cardinal's men & when they reached the corner to turn to the Piazza they were met there by hundreds of men at sword point. So then we saw the Cardinal turn back, & a stone had gashed his pink smooth cheeks, the blood was running thick red in the twilight, it was the same color as his vestments, and he was crying. We watched the troop return up the Largo & re-enter the Palace.

Until midnight the mobs were rushing to & fro and the Signori tried to stop it because they were sacking houses everywhere, the palace of Giovanni di Ser Bartolomeo, and the house of Antonio di Bernardo, and the palace of the Tornabuoni, all those friends or

relatives of the Medici, or suspected of being so, and they even sacked the Bargello again to get more weapons. So the Signori issued a ban that they should put no more houses to the sack under pain of the gallows. And all that night the gonfalonieri patrolled the streets with lighted torches, continuing to shout *Popolo e Libertà* so that no one could sleep even if he had a mind to. Michel and I didn't even try. All night we were wandering from quarter to quarter, & everywhere it was the same, gonfalonieri with lighted torches to keep the peace. And they did keep the peace: no one was robbed or done harm to except a certain family of the Bargiello quarter, who were out in the Piazza crying *Palle! Palle!* so that a mob set on them and they were killed.

The next morning we learned that Piero and his brother Giuliano had fled by the Porta San Gallo, which had been held open for him by Signor Pagolo Orsini with a great body of infantry and men with firearms, and they had gone to Bologna. It was said that Piero went disguised as a Franciscan monk and that there were very few who went with him, most of his supporters having turned against him. And the very afternoon Piero and Giuliano fled, Michel and I passed the palace on the Via Larga, & there at the corner facing San Lorenzo, we saw the young Cardinal Giovanni who had remained behind. He was on his knees, hands together, praying, and down his smooth cheek ran the livid scar of yesterday's rock-throwing, & his eyes were half closed, and his expression was one of profound melancholy. As we walked away, his figure seen through the cross-bars of the window was as if we had seen him in prison, & in a way it was so, because he was lucky to escape later with his life. And Michel said: "I feel sorry for Giovanni. He's a good enough fellow, and surely not responsible for Piero's imbecilities."

Well, that was typical of Michel, I thought. One minute he'd issue the harshest judgment as when he said the Cardinal preferred a crooked path, & the next his bowels were all turned over in compassion. I had seen this in him before so that I never was troubled by his harshest statements, knowing full well he'd most likely reverse them afterward. I guess he was never very sure which side he was on, especially with regard to the House of Medici. They'd treated him so well, and he'd eaten at the same table with Piero and the Cardinal Giovanni who was his own age and with Giuliano, sometimes seated even ahead of them at the table if they arrived late, because that was Lorenzo's way, his own tardy sons had to sit below the earlier-comers as a punishment. And Michel told me that the Magnificent

had treated him like his own son, & you couldn't expect him now in this uproar to turn against the house that had fed him for two full years. But at the same time, Michel thought of himself on the side of the plebes & so I could understand his confusion.

Well, the day after the flight of the Medici, the Signori issued a ban which was posted all over the city that anyone who should kill Piero de' Medici would receive two thousand ducats and anyone who killed the Cardinal would have a thousand. For now the Cardinal had escaped as well. And mobs were rushing up and down the streets robbing and sacking the houses of the supporters of the Medici & it was difficult for the Signori to maintain order.

And every day more and more cavalry and retinues of King Charles were appearing & people were so wrought up that the slightest rumor—the slightest tremor of the bells—would send them packing to the Piazza Signoria, arms in hand, crying *Popolo e Libertà*. And the same night that King Charles lodged at Empoli, the Signori ordered the Porta a San Friano opened. And Michel and I were there when it was done and it was like the gate where they had finally left Bartolomeo & I was sick remembering it. And I could read the sickness in Michel's eyes too. We never spoke of Bartolomeo since the thing happened, but when we passed certain places—especially the Piazza di Santa Croce—that look came into Michel's face, his eyes seemed clouded as the Arno in winter mist, his lower lip would jut out a bit more, & sometimes he would take my hand and squeeze it. We seemed closer because of Bartolomeo and he asked me all kinds of questions about the Jews, even running his hands through my hair to see if I had horns.

So now we were at the gate & Michel frowned and told me for the first time that he was resolved to leave Fiorenza.

"But where will you go?"

"I don't know. Perhaps to Venice. Perhaps to France. It doesn't matter. But my father is becoming fearful for all of us. He says our house is too identified with the House of the Medici . . . Even though Lionardo is a Piagnone," he added in a curious tone—half scoffing, half timorous. Then he began rubbing the bridge of his nose and his forehead was all corrugated with concern—"Besides these are bad times for art, this constant uproar in the streets. All you hear talked about in Fiorenza is political intrigue and assassination. So I think I'll try my fortune elsewhere . . ."

"I would like to go too," I said.

His face brightened up then. "Come with me."

"I can't. My father would not permit it. When I leave Fiorenza it will be for the University of Padova where my father studied medicine."

"Then you will become a doctor?"

"I am afraid I must."

"Oh, it will be marvelous!" he said enthusiastically. "Think of all the cadavers you will provide me!"

And he tilted his head back and burst into donkey-like guffaws, wheezing and asthmatic. He had the strangest moods, Michel, one minute deep in the depths and then high up in the sunny air, swooping around like the swallows. He liked to laugh, he laughed as if he enjoyed the laughter itself, and looking at him now, guffawing like that, I thought there was a crude streak in him, a part not quite finished like a bronze cast statue that hadn't all been smoothed down at the seams. There was that in Michel too, grieving for Bartolomeo one minute and then laughing like a donkey the next.

It was only one week between the expulsion of Piero and the coming of King Charles, but I had never known such a week of excitement, of alarums, of armed men riding furiously through the streets, of people gathering at the. slightest rumor that Piero was coming back, of wild arguments for & against the French, of news of the uprising at Pisa where the citizens dragged our heraldic lion, the Marzocca, through the streets & tossed it into the river as a demonstration against Fiorenza. And all the while more and more troops of the King were pouring in: such a rabble you never saw, French and Swiss and even Scots and others who seemed to belong to no known people, a race of demons they were, lard-colored and oafish, and everybody was terribly afraid for they filled every house, rich & poor, up to Camaldoli. And everyone was afraid having this rabble in the houses, especially since by orders of the Signori no one had removed his household goods, & even the young girls were in the houses and had to wait upon these barbarians.

Meanwhile, the orange-bearded Baron was filling the bowl in our house.

When he wasn't doing that, he was poring through the Avicenna though he couldn't read a letter of the Hebrew. And whenever Father came home, the Frenchman would ask him to translate this passage or that into Latin & Father with a weary shrug would accede to the Frenchman's request. Because Master Elia was very depressed those days, & I thought it was because of the expulsion of the Medici and

the coming of Charles, but it was not really that. He was spending almost all his time up at Pico's villa: that was what was troubling him; his philosophic son, Pico, was dying and he had no time even for me, and all the excitement in the city in expectation of the coming of the French King touched him not at all. The Priors had ordered flowered triumphal arches to be set up & the standards and shields of France placed on the Palace of the Signori & on the Medici Palace and on the Bargello. And they commissioned Francesco Granacci, who already had a talent for such things, to make giants five arms in height and imps with machines inside them so they danced and triumphs on gilded carriages & he ornamented the façade of the Nunciata with the arms of the King of France and Francesco became famous for it so we were all proud to be his friend, & he strutted like a cock at mating time. But Master Elia seemed not to care about all these excitements. At least so it seemed on the few occasions I saw him that week. He came home only twice and when I tried to speak with him he waved me aside with an impatient air. "Let me be, son, let me be. Don't you realize that all the lights are going out in the world!" Master Angiolo Poliziano had just died of a fever (some said for a boy) and now Mirandola was going. That night my father sat with me by the river and spoke of the dying Pico. He said that the philosopher Ficino was in constant attendance up at the villa. "I am certain that he is praying to his Plato," Master Elia said with a bitter little laugh. "But even that won't save the Count. I suspect he has been poisoned. 'Tis said a Phoenix rises from the ashes. Then, alas, he must be ashes again." His face was twilighted with sadness.

Most of the time I ate my evening meals alone with our maid & several times at Michel's house.

And once we were at Michel's, when Francesco came in and said: "Have you heard the news?"

And the Customs Official said: "What news?"

"The Medici have come back."

We all sat bolt upright at that, as you can well imagine. And Francesco burst out laughing.

"No, not Piero and his brothers. His second cousins, the ones whom he had exiled two years ago. . . . Lorenzo di Pierfrancesco and his brother."

"I met il signor Lorenzo three years ago," Michel said. "He came to the gardens and saw my carving of the Centaurs and liked it. He even spoke of giving me a commission but shortly afterward he had to leave the city."

I noticed that Messer Lodovico had been listening very carefully. Now he coughed once or twice—always the trumpet-call to a proclamation—and I knew that up from the bottom would swim some bloated fish of platitude:

"In that case, you must not hesitate to remind him of the commission. These grand Signori have a way of forgetting their promises. I would recommend that this very afternoon you go to these brothers—"

"He made no promise. He merely—"

"I would recommend that this very afternoon, you go and call upon Messer Lorenzo di Pierfrancesco."

Michel's face reddened with bottled disagreement. "But Father," he breathed very softly, "It's hardly very wise to call on a Medici in times like these."

"Oh they're not Medici any longer," Francesco said. He too had taken a seat at the long refectory table & he was nibbling on a stick of bread in that delicate finicky way of his.

"Not Medici!"

"Già." He hesitated before explaining, savoring of the effect. "They have changed their name to Popolano. Isn't that beautiful? *Popolano*—for the people, you see. The Signoria has officially taken note of the change of name."

The Customs Official frowned. "There is no longer any sense of propriety these days."

Afterward, he went into the salotto and I noted that he was sitting very silently & alone at the table, not examining his accounts as was his wont, but just sitting there, staring into space. He looked tired and old. Giovansimone was humming vilely through his nose, a flat vibration that set my teeth on edge. Michel sent him out on an errand and while Narro and Francesco were playing cards, slapping them down with exaggerated force, Michel went into the salotto and touched his father gently on the hand.

"What is it, Father?"

The Customs Official looked at him as if from the lunar sphere: "I'm afraid my post is lost. This new government will not permit anything established by the Medici to stand. They've already abolished the old Council. I don't know what is going to happen to us."

"I have strong hands, Messere."

Ser Lodovico smiled at that, a rather pathetic smile, I thought, and a whine crept into his voice: "I know that. Of all my sons I place

my faith mostly in you. Since Lionardo has taken the cowl, you are the eldest . . ."

I discerned a trace of bitterness in the mention of his monk-son, but then he continued, more briskly, metallically: "The first thing you must do is procure that commission promised you by Messer Lorenzo di Pierfrancesco . . . Popolano . . ." He pronounced the new cognomen with a sneer.

We all went out together after that, Francesco and Michel and Narro, walking along the river, and Michel was very solemn, weighed down with the worries of his father. I never knew from day to day how Michel felt about Ser Lodovico for sometimes he ridiculed him before his friends, & sometimes he took terrible offense if any of us dared to suggest that his father was nothing but a pompous bore.

We crossed the Ponte Vecchio and all the butcher shops were closed; I suppose there was more interesting butchery going on in the streets these days. And when we came to the door of the Dogana we saw men with buckets of plaster covering over the images of those who had been hanged in the Pazzi rebellion & later we saw they were also whitewashing into oblivion the painted culprits on the Palagio del Podestà. And at this, Francesco laughed:

"You see," he said to Michel, "why I am content to devote my art to carnivals, decorations of a day, of an hour? Nothing lasts in this world. When the wheel of fortune turns, you cannot predict where the ball will fall."

"Well, the Medici have never suffered from a want of balls," Narro said.

We came to the house of Lorenzo di Pierfrancesco Popolano & saw that they had already taken off the shield of the Medici with the seven balls and substituted for it the emblem of the people, which was a red cross on a white field. But Michel was unable to get in to see Messer Lorenzo or his brother; they were both attending a Council meeting.

And the next afternoon when Charles' troops came, Michel and I stood at the Porta a San Friano & watched them march in. And Granacci was there beside us and Buonarroto and Giovansimone, all of us except Bartolomeo, he was no longer there. So after the reception at the gate by the Signori (but not Piero) and a delegation of elderly honored citizens, and the girls throwing the lilies, we followed the procession through applauding crowds. And because of the commotion and the throngs, the procession of clergy who had come to the Gate to greet the King was completely dis-

rupted, & to make matters worse, there was a slight fall of rain. Then the King went on, in great pomp, along the river and we followed, and then down the Borgo di San Iacopo sopr' Arno and he passed right by our Synagogue. There the procession stopped to receive the delegation. I looked to see who stepped forward to greet the King; it was my Uncle Moshè cradling the Torah reverently in his arms & beside him the banker, Abramo da Vacca and all his brothers and many others I knew—all wearing their most elegant tallithim: prayer-shawls embroidered in gold and silver threads. But my father Elia wasn t among them. And this was strange, for Father was always in the forefront of such ceremonies. And I realized how ill Pico must be that Master Elia should not be present on so important an occasion.

Nor was old de Cases there & I was thinking about Tsiporah and how I hadn't been able to speak to her these many months; and even amidst the excitement of Piero's expulsion and Charles' coming, I felt an ache for her & I missed the bird-touch of her hand. I was thinking of her as I watched Moshè step forward to present the Torah to King Charles and then I heard Michel's voice—

"What is he doing now?"

For ever since that thing of Bartolomeo, Michel seemed seized by an endless curiosity about our people. He was always asking me questions—why we refused to acknowledge his Christ who had come of our people; & whether it was true that the blood of Christian children was indeed necessary to bake our Passover bread. I would get very angry at that & told him that these were lies—that none of us violated the Host, and if there was blood shed it was not us shedding the blood of Christians but rather Christians shedding the blood of innocents like Bartolomeo.

"You saw it!" I cried. "You saw it!" and I couldn't go on, tears clouding my eyes, and Michel took my hand gently and said—

"I saw it."

From then on I had to tell him everything—what we ate & how we prayed and he suddenly had a desire to visit our synagogue to see the statues and paintings in it. And when I told him we had none he could not believe it. So I quoted the fourth of the commandments which they also profess to obey: *"Thou shalt not make unto thee any graven image, or any likeness of anything that is in heaven above, or that is in the earth beneath, or that is in the water under the earth."* And even as I quoted it I felt it was a harsh injustice to deprive man of his power to create beauty—beauty that

never was in heaven or on earth or in the waters under the earth—
but I did not intimate my doubts to Michel. And when I had quoted
this, he said Yes but these laws were to be understood analogically
and not literally. He had at times a fondness for scholastic jargon,
which surprised me in an artist, most of whom are as inept with
ideas as a philosopher with a brush.

And as the French King received the honorary gifts from Uncle
Moshè I had a vision of my father up at Pico's villa & I felt very sorry
for him, missing the great pomp and ceremony of this day. And I
explained to Michel what the fringes on the prayer-shawls signified,
and what the gold-embroidered lions on the Torah meant and while
I was talking so I saw Simone, youngest son of Mendez, glance super-
ciliously at me & turn to remark something to his brother Abramo.
They were lounging in the doorway, wearing balzos, that ancient
turban round as a diadem and clasped with a brass pin; and I knew
what Simone was saying, the sign of his saying was on his mouth. He
knew my fondness for the company of artists and since all artists
were Gentiles he interpreted my interests as camouflaged apostasy.
And in this he was abetted by several of the Spaniards who blamed
me for Bartolomeo's death because I had led him to the Piazza; I
was no longer at home among my co-religionists; and Father con-
fessed he also felt under the surveillance of too many disapproving
eyes.

Sometimes I thought of going away from Fiorenza—& I talked
to Master Elia about it and he said—"Wait. We shall see."

Well, then the procession went on and I was glad to escape the
disapproving eyes of those Mendez brothers. And we went down
the Borgo and across the Ponte Vecchio through the Porta Santa
Maria and then down the Vacchereccia into the Piazza dei
Signori. And all the while the bells were booming until the air
seemed full of flying needles & we could feel a prickling in our
skins. We crossed the Piazza which was golden bright with thou-
sands of torches and there were lighted cups of oil placed on all
the merlons of the tower so that it was outlined, shimmery against
the dusk like a huge bank of altar candles. We went diagonally
across the Piazza and stopped at the Palagio del Podestà and came
up behind the back of Santa Maria del Fiore so that looking up you
could see the huge dome filling the entire sky with its blackened
rotund amplitude.

And so at last we came around to the main door. So slow had
been the progress that it was long after sunset when we arrived. But

the Piazza between the Baptistry and the main gate was bright as sunset, for the light was golden in the pulse of those thousands of torches.

The Clergy was already there, having taken a short cut from the Borgo, & they stepped forward now to greet the King. And as soon as he dismounted, the baldacchino under which he had ridden was tossed to the people and torn apart, the pieces of it distributed, as was the custom. There was a continuous shout of *Francia! Francia!* and behind it ever the solemn boom boom boom of the bell in the pink-and-green campanile and you felt the deep tones like blows in your groin. The King went up the steps between the double row of lighted torches that traced right down to the high altar a luminous path banked by thousands of shouting citizenry. And King Charles walked slowly & gravely followed by his Barons and other important personages, and the shouting was like waves, one after the other— FRAN-cia! FRAN-cia! FRAN-cia!—you would think that all Fiorenza was either inside or outside the Church. Everyone was shouting—big and small & old and young—and all with a true spirit, without adulation but as if we would let this King know that we wished him no harm but we were not afraid of him either, & therefore he should not think to let his barbarous troops do unto us what they had done to Serezano and Pietrasanta.

And as soon as the King dismounted, there were many smiles in the crowd.

"How fortunate," said Michel, "that his fame is not measured by his person."

And indeed, dismounted, the King seemed not a little diminished in fame, for in truth he was a very tiny man. He disappeared into the church, and the crowd spluttered into excited murmurings:

"Is it possible that such a dwarf should strike fear into the Holy Father?"

"The King may be a dwarf but his soldiers aren't. Did you see those Scots? They must be almost four braccia in height." It was a maiden and she spoke with shivery delight. "And those beef-red complexions . . ."

"I hear the Holy Father is fortifying the Castel Sant' Angelo and intends to stay within the walls all the while King Charles remains in Rome."

"He fears a sack."

"Well, we do not fear him." I could not see who spoke, but it was country talk all right, a voice accustomed to shout across fields. "We greet him in good faith. Let him see to it that he repays us in kind."

". . . in good faith, you say? He is a swine, un porco. When the Pisani threw our Marzocca into the river and gathered before his palace, Charles spoke to them as if they were heroes. He promised them freedom! . . . I have it from my cousin who was there in the retinue of Lorenzo Tornabuoni. Freedom! . . . from us! As if Pisa were the King's to give away!"

"Well, we shall see what arrangements the Signori make with him. Piero's agreements of course are null and void."

"God on a billiard table! If we had to depend on that jackal of a Piero we would meet the fate of Serezano and Pietrasanta."

"I still think it unwise to keep the young maidens at home."

"Mine are not. I don't care what the Signori may decree, I have locked my Maria and my Antonia in the convent of Sant' Angelo. Where is the decree that ever held a German in leash?"

"We have two in our house. They do nothing but drink and swear. But I must admit they have never acted other than correctly to my daughter when she serves them. Isn't that true, Angelica?"

"Sì, Mamma," Angelica said. She was young & very pretty and she was smiling saucily when she said it; she had a lovely bosom with a mole on it like a tooth mark and she was pressing against me in the crowd & it was pleasurable.

"Unless there are things you do not choose to tell me," the mother said with sudden suspicion.

"Eccolo!—Here he comes! Here he comes!"

Charles was issuing from the Church again & Angelica threw her lilies like the other girls, and I lost her in the swirl when Charles remounted and proceeded—now without the canopy which had been torn to bits—to the Palace of the Medici.

We followed him there and saw him disappear under the ornamented flowered portal. And then the crowd dispersed slowly, but all night until dawn according to the decrees of the Priors, there were lanterns lit in every window of Fiorenza facing the street so that the streets were bright as day. And the Gonfalonieri patrolled to keep order & there were trumpet-blasts and tambours and cries of *Viva Francia!* incongruous in the night. It was after midnight when I got home but Father had not yet returned; the French Baron was waiting up. He was squatting on my bed, scratching, and as soon as I arrived he surveyed me with his muddy puddle eyes & wanted to know if I could translate from the Hebrew into the Latin. I said *No*, though I could, stumblingly, and then he grunted and said *When will your father return?* and I said I didn't know. He went out of my room then and I sat up awake in bed

until I could no longer hold my image-weary eyes open: all the pomp & ceremony I had seen weighed me down.

Father did not come back till noon of the next day. As soon as I saw him I knew that Pico was dead. Master Elia's face was ash & he sat on my bed (his coming woke me), stroking my hand and looking deeply into my face as if he might rediscover in me—in my youth, perhaps, or in my simply being alive—what he had lost in Pico, his philosophic son.

"He died full of piety—" Father said & then he smiled with ironical sadness "—that good good Christian who only yesterday was half a heretic & who had soaked his parched soul as much in the waters of our Talmud as in the blood of his Christ." And he stood up & walked up and down my bedchamber twice or thrice, hands clasped behind his back, and suddenly he slapped his hands together there—the back of one into the palm of the other—and his sad ironical smile broke into a sad ironic laugh—". . . so pious now he tried, on his death bed, mind you, to convert me! Me! Whom he knew to be as faithful a Jew as he was now a re-baptised Christian . . ." And he walked again, to and fro, to and fro, smacking his palm behind his back hard as if the whacking sound of it planted somehow a root into reality, the old reality he had known, something to keep him gripped to the earth on which he had walked with sure tread but that now seemed to be no earth at all, a disappearingness underfoot. ". . . and old Landino was there, tears trickling down his nose and into a parchment Dante which he had to read even at such a moment, and Ficino too and gentle Benivieni. Just before he died, Pico suddenly sat up in bed & his eyes were glistening and he whispered that he had just seen the Virgin and she promised him he would not die . . . He died an hour later. Then Fra Girolamo came and interpreted his vision to mean the second & eternal death . . . And Ficino burning his candle before his Plato in the hope that some God—Greek, Christian, it didn't matter—might spare the Phoenix' life and then declaring that Pico looked as if he had passed from exile to a celestial country . . .

"And suddenly," Father said, turning around and looking more directly & deeply at me and into me than he had ever done before—"they all struck me as false. It was all manners, you see, their Christianity false and their Hellenizing false & their Romanizing false—it was all elegant surface, you see." He shook his head & I could read in the heavy gesture how much the awful insight had

cost him—"It threw me back, I saw old de Cases' face again in that bedchamber with its incense & its intoning priest and Pico wasted and yellow but beautiful still, murmuring to me that his proudest achievement in philosophy was the conversion of Clemente and would not I, his oldest teacher, his dearest master, acknowledge the only true faith, the only Catholic Christian Church. At that moment, I saw old de Cases' face, I tell you—it swam into that bedchamber of a dying man—just as he had looked at me when he came after Bartolomeo's death—& I didn't even answer Pico. I think he saw de Cases' face in my face."

He sighed then and sat down again on the bed. I don't think I ever remembered my father like that—I felt an intimacy between us —warmer, more binding than I had ever known, for I had never had a father so much as a preceptor, he was always the Rabbino. I told him about yesterday's great events & I said—

"Isn't it strange that Pico should go on the very day that Charles came?"

And Father: "Why is it so strange? Dying is only another form of coming. At the last moment, I read that in his face. His beautiful pale blue eyes opened wide, and they looked right at me with a most astonishing limpidity—then they went dead. He was offering me this moment in exchange for all that I had taught him."

He got up then and said he was going to lie down in his chamber; he had not slept all night. Outside the door apparently the Baron was waiting with some inane question, for I heard my Father say brusquely—"Devils? What devils, Monsieur? Possession?—The art of medicine, my dear man, is knowing when not to interfere . . ." A door slammed.

I went out into the streets & I heard citizens talking about the fact that the King had been given the keys to the gates of San Friano, San Gallo and San Pier Gattolino. But this was only a gesture of honor because the King was already within the walls. The same day, the King went to Mass at San Lorenzo & then he walked around Fiorenza on foot & he went to see the lions in the cage behind the Palace of the Capitano. And he asked that as amnesty in his honor, certain prisoners be released from the Palace of the Capitano. And so it was done. Oh, he was trying hard to create good will, that dwarfed King of France; his affair was with Naples not with us, yet our people were suspicious, there was constant fear of a sack. And during the ensuing days, while the King was in negotiation with the Priors, the rumor flew like a black bat that

one of the conditions the King insisted on was the return of Piero de' Medici. And people murmured angrily that if he insisted on that, they would seize their arms & if there was need to fight they had no fear of Charles. For if he had twenty thousand we had ninety thousand within the walls alone. And everybody took to blaming everything on Piero. Though where this hatred was born only the Lord knows.

And every day now my father spoke of leaving Fiorenza, he said his Fiorenza was buried in the grave with Pico and with Lorenzo, and he talked now of returning perhaps to Padova, perhaps to Venice, perhaps even to Crete where he'd been born.

And in Michel's household one heard the same talk—the Customs Official had indeed lost his job as he had dolefully predicted, and there were no great houses now to take Michel in and give him commissions for works: for who cared about shaping stone when great events were being shaped?

And every day now Michel was saying he would leave Fiorenza and try his fortune elsewhere because the uproar and perturbations of our city were not conducive to his art. And in my mind the resolution grew that if Michel departed I would depart with him, without informing Master Elia. Because I knew my Father was set upon enrolling me in the Faculty of Medicine at Padova.

I was resolved I would not be a doctor.

Almost two weeks went by before the French King resumed his march toward Naples. Oh, we were glad then because all the time he had been among us had been a time of dread. The presence of those barbarians was like that new-style gunpowder that sometimes explodes in the breach of the gun. We never knew what was likely to happen; and while the negotiations dragged on, the wildest rumors flew. Everybody was ready to fight and Michel and his brothers and Francesco and Iacopo and I spent every day waiting with the great crowd outside the Medici Palace where the King was lodged.

One afternoon we were there when our pikeman came out. The pikeman was a boy from the San Friano quarter: he had a neck red as his pantaloons and candid sun-filled eyes. We all waited for him every day because he was stationed in the chamber where the King and his agents were treating with our men. So we were able to follow, day by day, the progress of the negotiations.

Today our pikeman came stomping out with a look fat with news. We gathered round. "If all goes well," said the pikeman (he spoke

deeply and slowly, like a judge, savoring of his audience), "the treaty should be signed tonight."

"And Piero?" someone asked.

"No Piero. Not a word about Piero. What the King seems most interested in is money. He asks for a loan of one hundred twenty thousand florins—"

"One hundred twenty thousand florins!"

"—fifty thousand now and for all July twenty thousand and then each year during the war to lend him twelve thousand a year. And after the war he guarantees to keep us free—"

"We don't need his guarantees!"

"—from any and whatever thing. Even after he dies, he says, Fiorenza will be forever free. But he wants the fortress of Pisa—"

The crowd groaned.

"—and certain other fortresses he's captured near Serezano to guarantee his safe return to France after this Naples affair."

"He doesn't ask much, the dwarf!"

"Well, let us sign and get him out!"

"And Fra Girolamo says this usurer has been sent to Italy as an instrument of God!"

"Instrument? For what purpose, pray?"

"To scourge us for our sins."

"Then let him get on to Rome. There is plenty of scourging to be done there. But one hundred twenty thousand florins! . . . Porca miseria! . . ."

The pikeman's sun-bright eyes glanced calmly and bluely at us, waiting till the exclamation simmered down. Then he resumed:

"While our agents were disputing the amount of the pecunia, the King who had been sitting right beside my lance" (He touched the blade as if it had absorbed into its blank ominous metal some of the majesty of the King) "stood up in annoyance and began pacing back and forth. His sallow complexion was flushed and I could see beads of perspiration trembling around his mouth. Finally in anger he shouted at our agents—*What is all this quibbling? Will you sign or will you not?*"

"*Well, your Majesty, we merely consider that one hundred twenty thousand flor—*"

"Then the King got furious and banged his fist on the table and shouted—*If you do not sign, I shall give orders for my trumpets to be blown.*"

The crowd stiffened. Then it was going to be war after all. The pikeman waited a minute, smiling—

"At these words, Pier di Gino Capponi, one of the Sindaci, grabbed the treaty which was lying on the table and tore it to bits. *If you sound your trumpets, we shall ring our bells!*—"

"Bravo! Bravo!"

"—He shouted these audacious words right in the King's teeth, I tell you. And off he starts for the door, trailed by his company. But before he reached it, the King called him back, because he knew him, you see, Capponi had been an orator in France at the court of His Majesty. And the King was smiling and he said—*Ah Chapon, Chapon, you're a naughty Capon.*"

Mincingly, with delicate delight, the pikeman imitated the Frenchman's accent. The crowd chortled. He sounded like a cat walking with a stiff tail.

"—So all betides well," the pikeman concluded. "The meeting ended amicably enough and 'tis said the articles of the treaty are ready for the signing."

"He acts as if he had helped draw up the treaty," Michel said, laughing as we strolled across the piazza.

"Oh well, a farm-boy daily in the seat of Majesty."

"Yes," Michel said, thoughtfully scratching his nose. "What Florentine is not proud to be a fellow citizen of Pier Capponi today? That naughty capon outpecked the Gallic cock."

So the articles were duly signed and my father, hearing of them, laughed—"How magnanimous! He offers graciously to overlook several Florentine offenses to his august person. He kindly permits this city to lend him one hundred twenty thousand florins. Not to mention the fortresses. And in generous return he guarantees our safety now and forever. Even his ghost guarantees it!" He laughed. I was overjoyed to see Master Elia laugh, for he had not laughed very often since Fra Bernardino came, and even this present laughter —bitterer than alum—was welcome. For usually these days my father seemed to brood deeply and lonely, and I was an intrusive speck of dust that fell into his melancholic universe.

And so at last the French King left with all his men-at-arms & his Barons and the horde of prostitutes who had come with them. But he did not leave until Fra Girolamo had gone to him & advised him to depart because the temper of the people was in no way placated by the treaty. For those French soldiers were truly beasts and every day new incidents occurred. One afternoon I saw a young Florentine led along by a troop of these Frenchmen & they had tied a rope around his neck like a heifer and they were dragging him. And I learned that he had committed no crime at all but had

been seized so merely to extort a ransom. Upon hearing which, a group of our young Florentines suddenly attacked the soldiers with stones and sticks so that the prisoner escaped. And it was amusing then to see the soldiers trying to run after him, but they could not catch him in a hundred years because of the ridiculous garments they wore. Their feet were cluttered with floppy oversized boots and they fancied ballooning pantaloons and big flapping caps with more feathers than a chicken coop. So the fleet prisoner had no trouble escaping. He disappeared behind the Palace of the Guelph Party & though the people laughed at the clumsy overdressed French, there was no good nature in their laughter, for everyone truly hated those troops & every day wondered how soon they would depart.

All this, Fra Girolamo boldly told the King. And Fra Girolamo warned that the good will with which the King had been received was daily being destroyed by the insolence of his troops who did not seem to distinguish between friend and foe. And Fra Girolamo told him further that he had prophesied his coming four years before, when he had preached the advent of a *flagellum Dei* that would scourge Italy for her sins. So that Charles' invasion was interpreted as the fulfilment of this prophecy & hence he had been meekly received as an instrument of God. But, said Fra Girolamo, if an instrument was blunted of its purpose and rusted of its resolution, why then God would certainly cast it away and forge a new one. And this latter argument convinced Charles most of all for he was vain & conceived of his war against the Aragonese dynasty of Naples as a holy war—as most Kings usually do.

So he hearkened to the Friar, who every day was gaining greater prestige in our city; and this success in hastening Charles' departure and all his troops added another feather in his cap.

So, the King marched out the Prato Gate, and we were truly glad to see him go. For despite the success of the negotiations, it had been a sore trial to lodge those brutish troops.

Then they were gone and I no longer had to empty the Baron's bowl, and the reign of the Friar began. He did not call it his reign for he considered himself only the servant of God and it is true that he expanded the council so that many more voices might be heard and nowise did he behave as a tyrant. But every day his power grew so that even Lorenzo had never ruled so decisively and there were many who considered him a prophet and he never denied it, and those that did not love him feared him.

Almost every week Michel went to hear Sàvonarola preach and he asked me to go with him and when I said, "You forget I am a Jew," he laughed and said, "All the more reason for you to hear him," —and I said, echoing the words I had heard Master Elia say many times to Count Pico, "—I am as proud of my faith as you are of yours. I have no intention of abandoning it."

"I do not ask you to abandon it. I ask you merely to listen."

So I went grudgingly into that Christian church of Santa Maria del Fiore and I felt fear that I should be there and many I thought looked at me because I did not dip my finger in the holy water font nor make their sign of the cross nor genuflect. But perhaps they didn't notice me at all: it was all in my imagination. For that throng was hypnotized by the preacher. And he almost hypnotized me too. His voice rang out in the great gray spaces till doom seemed palpable, you smelled the burning and you heard the celestial choirs. Far away in the pulpit, small, an owl on a branch of midnight, he struck terror into me. And at times the congregation burst into penitential weeping and Michel's customary coat of mail— the sarcasms and boorishness which kept the world at a remove— was ripped through to the naked quiveringness by the eloquence of this Friar. And I was afraid of the Dominican, yet never had he preached against us; he was no Fra Bernardino who, thank the Almighty, Blessed be His Name, was no longer in the City, swept into oblivion by the greater thunder of the Dominican. Savonarola's followers now walked with a mighty pride. Several times I saw Michel's brother sailing by in his white habit and black hood like a galleon at full canvas, and he did not even see us, as if his immersion in a contemplative order had suddenly busied his life with more obligations than a merchant.

But Michel was terribly confused by the authority of the Friar. He admired his boldness in dealing with Charles, he applauded every rhetorical thunderbolt that winged its way to Rome, he felt this monk was truly bringing back the great and haughty days of Fiorenza. But at the same time he could not bring himself to hate a family which had only been kind to him, and every time he heard bitter words spoken against the Medici he thought of those happy years he had spent in their household and Lorenzo patting him on the head and praising his satyr-mask. And he had to bite his lips against those that spoke ill of the Medici. Nor was he happy when the monk's denunciations extended from the evils of false hair to the evils of painted canvases. For now Fra Girolamo was beginning to preach that it was not Christian to portray the Virgin in the

guise of one's mistress as Fra Filippo Lippi had done, nor was it Christian to paint their Lady with strands of pearls upon a naked bosom. And many more injunctions he urged upon the artists so that they were confused, since most of them were now his followers, and it was said that the Maestro Botticelli despite his reputation as a practical joker and a jolly man, was now so disturbed he could scarcely bring himself to paint at all. Only Maestro Perugino was not disturbed, but everybody knew he was an atheist.

Michel did not know what to make of it. He agonized over this new direction of Savonarola's preaching. How could this Friar be a friend of liberty and not of art? How could he sweep away the tyranny of the Medici only to impose his own tyranny?

One day I met my father and Michel as they were issuing from the sacristy of Santo Spirito where Michel continued to attend my father's anatomies. I met them in the midst of a warm discussion:

". . . But you are a philosopher, Master," Michel was saying and his brow was wrinkled with worry-lines, "Perhaps you might explain to me why Fra Girolamo inveighs so against us artists? Why is it unchristian to render a beautiful image of Our Lady?"

"I do not know," Master Elia said (and I detected a trace of wryness in the tone). "There are many things about Fra Girolamo I cannot understand."

I joined them, and after a cursory greeting, Michel continued, as if he had not been interrupted either by my arrival or Father's unsatisfactory reply.

"Surely the Beautiful is only an expression of the Divine . . . God revealed behind the cloak of appearances. Surely the artist is as holy as the monk. When we have discovered a beautiful form, is it not only another way of discovering God? Ficino says—"

My father smiled. He considered Master Ficino a foolish old man, especially since that query about the guarantee of eternal life. We were crossing the sandy piazza now and the sun was varnishing the façade of the church with amber light. The volutes of the façade leaped like music.

"Perhaps your Friar is right," Master Elia said to Michel, ignoring his reference to Ficino. "Perhaps he half-intuits a truth we Hebrews understood millennia ago. That is, you cannot symbolize the Ineffable. You cannot reduce the godhead to a painted form or a statue—"

"But—?"

My father went on, unheeding. "The moment you do that, you cheapen God, you render Him trivial as the paltry material in which

you seek to render Him. The idol becomes worshipped for its own sake rather than for the Mystery which it symbolizes. You dance around a Golden Calf. And Moses smashes the tablets—he must smash them—in his anger. Hence your problem of the suitability of iconography does not exist for us. All icons are equally unsuitable. Every attempt to humanize the divine is as false as the attempt to deify the human."

"Ah, but that is exactly what we should seek to do!" Michel exclaimed.

"Do you think so?" my father said. He stopped and looked down at both of us, from a great height it seemed, and on his thin lips flickered that amused, mysterious, lunar smile.

XXI

It was that stone that did it.

We were on our way to the Carmine when one of those white-robed obnoxious little angels came around an unexpected corner and he was screaming: "Jackal of the Medici!" and then he let loose with the rock. It struck Michel on his right cheek, glancing off the high protruding cheekbone and he began to bleed. The angel had already flown off. There was nothing to do about him but curse. Then Francesco and I took Michel home. He was pressing a cloth against the wound (Francesco's bright shining silk kerchief glaring with the blood) and as soon as we explained to his father what had happened, we all had to listen, sitting around like children at school, to one of his homilies on the value of caution. Caution was the Alpha and Omega of all virtues, he said (how Michel's eyes were talking above the pressed kerchief!), especially in times like these. One must never, oh never, offend anyone, particularly not monks or friars or members of the Podestà or knights or Frenchmen. One must mind one's own affairs, keep a tight lip, save money in the bank, never wash, and above all keep one's head covered. The younger boys were roaring around the house. Donna Lucrezia hovered in the background, Michel was sitting quietly listening to

his father's sermon and I could read that in his eyes which told me
that his thoughts were grazing in other pastures.

So when I heard that he had fled I was in truth not surprised.
Michel had been speaking of flight ever since that thing of
Bartolomeo. I had noted then the wariness of his nature. And when
the expulsion of the Medici deprived him of his patrons and it did
not seem likely that he would be able to secure work under the
reign of the Friar, and the sight of his father despondent since the
loss of his post at the customs—all these things urged Michel to
flee his own country and seek his fortune elsewhere.

But even before that, there had been the omen of his friend
Cardiere. This youth had played the lyre and the guitar to the
Magnificent's delight when Michel was in the Palace. Now, one day
he came upon us while we were sketching at the Loggia (this was
before Piero's expulsion) and said that the vision of the Magnifi-
cent had appeared to him all clad in black but with his garment so
torn that the naked flesh showed through. And Lorenzo had com-
manded Cardiere to tell his son Piero that soon he would be
driven out of his home never to come back. Of course, Iacopo and I
laughed when Cardiere, a tall redfaced youth with fingers like ten-
drils, told us this tale: But I saw Michel's face turn white with fear
and he urged Cardiere to hasten to Piero and relate the prophecy.
But seeing that Piero was so insolent a man, Cardiere feared to go
and did not go. And several mornings later Michel and I and Iacopo
were in the courtyard of the Medici Palace when Cardiere ap-
peared once more, with an expression of terror and said that
Lorenzo's specter had come again and had slapped him in the face
because he had failed to relate his warning to his son. So then
Michel began to shout:

"Why do you not tell him?! Why do you not tell him?!" and he
raised such a hullabaloo that Cardiere ran off at once to Careggi to
bring the prophecy to Piero. But, as we later heard, he met with
Piero and his corteo less than a mile from the walls and Piero
laughed him to scorn and his chancellor mocked Cardiere saying:
*You are mad! Whom do you think Lorenzo loved best, his son or
you? Why would he not rather have appeared to him than to a
stranger?* And when Cardiere returned and told Michel this, Michel
declared that he would flee at once, for he was convinced Cardiere's
vision was true and that soon Fiorenza would not be safe for those
considered friends of the Medicis.

And indeed he did disappear the very next day and was gone for
a week but then returned as inexplicably as he had gone, nor would

he say where he had been. And I was not surprised by all these mysterious comings and goings, for Michel was of a fearful and suspicious disposition. I remembered it from the time he had flattened himself against the Baptistry wall while Bartolomeo and Granacci fought. And I remembered too how he had run away when Barto was seized by the sheriffs.

So when that guitarist's prophecy was fulfilled and Piero was indeed expelled and King Charles came, I was surprised that Michel should remain in the city through such turbulent events. He was hoping every day affairs would soon be on the mend. But things went instead from bad to worse until that angel cut him with the stone. Then Michel was gone. And with him went Francesco and Iacopo, and I was truly sad to be left alone in Fiorenza amidst all these perturbations. I went often to Michel's house to learn whither he had gone but they had not yet received news, or else they would not tell me out of caution. For they were cautious men, all the Buonarrotis, even though Narro and Giovansimone were frantic to escape the endless homilies of the ex-Customs Official. For now that he was unemployed and home all day there was no end to it. The sons were sore bedeviled by the everlasting admonitions and preachments. Meanwhile I would catch glimpses of Donna Lucrezia in the kitchen hiding behind a barricade of pots. Bathed in the steam of a roasting pig she could avoid the steam of her roasting husband.

Michel's flight precipitated certain ideas that had been floating in my own mind. Now these ideas burst like thunder over Vallombrosa. I could not stay in Fiorenza any longer. I had lost Tsiporah and I had lost Michel. It seemed as if every street I looked down echoed with alarms. Everywhere, in every lonely alley, I seemed to see Bartolomeo rocking to his doom in that cart, his head bobbing like a marionette above the sea of his tormenters; I seemed to see the panoply and pomp of King Charles and hear again the brrmmm brrmmm brrmmm of his tambours. It was almost more than the streets could hold. They were overflowing with events and it was enough to choke a man.

But I didn't know what my father would think. I felt if I remained here in this ever more gloomy city, I would be stifled. Every day more and more of our people were departing because although Fra Girolamo was no enemy, neither was he our friend as the House of Medici had been.

And so for a week after Michel's departure I said nothing to my father. Then when I learned that Michel had written and was indeed in Venice and his address known, I resolved to unveil my heart

to Master Elia. It was on a gray bird-flashing morning, just after prayers, and he still wore his fringed shawl and amulets. He listened for a long time without a word. Then he said:

"Where would you go?"

"I want to join Michelangiolo Buonarroti in Venice. He hopes to secure commissions there."

"Commissions to do what?"

"Carve statues. Paint pictures."

"And you? What would you do? Wipe his brush?"

"I—I might study."

"What?"

I paused and then at last I said it. "I want to become an artist, Master Elia. I want to enroll in some workshop and learn the crafts —all of them, painting in tempera and oils, and silversmithing, and the decorating of walls al fresco, and the shaping of statues. I think I would be happiest doing those things."

He took off his spectacles and rubbed the lenses slowly and deliberately with a handkerchief. He had just recited the *Tefillath Shahareth* and the little black phylacteries were still enbanded round forehead and wrist. Now he took them off, unwinding slowly so that I saw the pressure of the bands on his flesh. Then the blood suffused those pale indentations and Master Elia said:

"I have always assumed you would be a doctor of physic."

"I know."

He stood up and put the prayer-objects in the bag of dark blue velvet embroidered with golden lions which Mother had made for him, and then he put the bag in the drawer.

"How can you live as an artist?" he asked gently. "Have you thought about that? Nine-tenths of your commissions must come from churches—Madonnas, Depositions, Crucifixions, saints with hatchets in their heads, Magdalens with long tresses modestly engulfing the former whore's body . . . Do you think they will hire a Hebrew? Even assuming that you possess a great talent, which if you do, may I add, you have certainly managed to keep well hidden from me . . ."

"I—I have sketched considerably. Michel says my drawings are not without interest."

"Ah . . . And did he explain how a Hebrew will secure commissions from Christian churches?"

"But there are other commissions . . . Mythological pictures. Greek gods. And portraits of bankers and merchants. Did not Master Botticelli paint a birth of Venus for the Magnificent? Did not

Piero di Cosimo paint several weird Perseuses and Andromedas? How many merchants want Medusas, Ganymedes and Ledas? And then there are battles to be memorialized and victories celebrated and the ornamentation of wedding chests . . . and now especially that they are uncovering the decorations of the ancients at Rome, there is much desire to emulate them in modern works. Oh, there are many possibilities of commissions which will in no wise involve the Church."

My father paused quite a while before answering. Hi voice when he spoke contained a weary half-acquiescence which I, scenting the wind for the slightest suggestion of approval, took for the rarest perfume. "And it would give you pleasure to do these things?"

"Oh, more than I can say!"

Swiftly, a bird's appraising glance, my father gazed at me. Then after a while he said blandly, "Well, you shall soon be near enough to your friend Michelangiolo. We leave for Padova in a week."

"In a week! I didn't know!"

"You would know soon enough. We are all being expelled."

His face wore the expression of centuries.

"Everyone?"

"Everyone. Bankers, doctors, every living soul amongst us. Fra Girolamo has now declared for the creation of a Monte di Pietà. The Franciscans have won him over. And so they have no need for us. We have a year of grace to settle our affairs, but I shall not wait a year. My work here is finished. The Magnificent is gone. Pico is gone. Luckily, I have received an invitation to resume my position as a reader in Averrhoes at the University of Padova. As for your being an artist, we will talk about that some other time."

I remained silent. From Padova to Venezia was less than half a day's ride.

"Meanwhile you will enroll in medical courses at the University."

He looked at me with his cool gray eyes but I could see the softness melting at the corners and then he did a surprising thing. My father kissed me.

"If, after a year, you still feel that the art of medicine does not appeal to you, then we shall see about enrolling you with some worthy maestro in the arts."

I bowed my head. I could have told him now.

As soon as possible I ran to the Borgo. But Tsiporah would not open the gate in response to my knocking. I knew she was looking down at me from the barred window above. After a while I turned

sadly away. Where would they go, I wondered, after the expulsion? Would I ever see her again?

We left Fiorenza on a silvery dawn. The Arno lay coiled like a sleeping scaly dragon.

XXII

When I came back, the town had changed. Changed so much it wasn't Fiorenza any more. Oh, the buildings were the same, the equine tower of the Priors still gnashed its notched teeth against a runaway sky, the walls still wrapped us snugly round as a mother wraps her child.

But it wasn't the same. I couldn't remember when pious gloom had reigned so. I entered via the Prato Gate and I saw it right away: those three maidens by the wall, all in dun-colored tunics: hair, shoes, sleeves all the color of a mouse—taupe, dead. And they wore no pearls in their hair, no bangles on their bosom. And they walked with downcast eyes and no trace of sweet flesh could you see. From throat to ankle the gloomy dresses fell—a bleak cascade. No hint of swelling breast. No flashes of warm ankle. They simply weren't the same damozels who used to step with such provocative tinklings and quiverings across my vision at the Piazza dei Priori so that my crayon slept at the drawing while Michel, unseeing—or seeing only his own—sketched on.

The first thing I did was to go to our house near the Porta San Niccolò. A knife-grinder was working in front of the door, surrounded by children dancing in a rain of sparks. There was not a face I knew. They eyed me as a stranger. I felt a pain in my heart and turned toward the Borgo, though I knew everyone had been expelled. But my feet dragged me there. The Borgo was steaming hot in the noonday sun. The shops were still open. I saw Jechiel, the basket-weaver, and Benedetto di Lucca, the tailor. They were in their dark shops working away with the in-boring intensity of bees. Hunched over in the semi-darkness, they seemed as if they had not moved at all since Master Elia and I had left.

Two years. And they had not moved. I could not understand it.

Suddenly, glowing in the gloom I saw the yellow circle on Jechiel's doublet. And yet he was still there, he was not in exile. The year of grace was long since gone and they were still there. I could not understand it.

I passed de Cases' shop and the cold trembling hit me again. It was not to be forgotten, ever. But de Cases wasn't there, none of them, neither the old man nor his wife nor Tsiporah nor her little sister. . . . Only Bartolomeo in that cart . . . in that swaying cart I could see whenever I wanted to see it and sometimes when I didn't want to see it. Abramo da Mantova had taken over the place; it was no longer a pawnshop. Abramo used it for his silver-work. He smiled toothlessly as I passed:

"Shalom, Andrea. Well well well. So you are back with us at last . . ."

He told me the de Cases family had fled south, somewhere vaguely south, vaguely long ago. A thousand questions tripped on my tongue but I could not speak to toothless Abramo. I ran to my Uncle Moshè's house and to my amazement found him still there, smiling and shrugging sardonic shoulders. He explained the mystery to me:

". . . We were all supposed to be out by the twenty-first of April, a year ago. And some would not wait for the end of the year of grace but departed in bitterness immediately—all the Spaniards and also Dattilo da Camerino and he was ruined. We sent delegations to the Friar declaring that we were not opposed to the Monte di Pietà but we resented bitterly being exiled from Fiorenza. Then the Council reinstituted the yellow sign" (he gestured contemptuously at his heart, though here in the house he wore no sign) "and it seemed affairs were hopeless. But with faith in the Lord nothing is hopeless. The departure of King Charles left in its wake the Pisan War, and war costs money, even a war which Fra Girolamo considers sacred. So when the brothers da Vacca came forward with their proposal, he was disposed to accept it . . ."

And Uncle Moshè smiled, a weary wise smile.

"What proposal?" Andrea asked.

"An exchange, a simple exchange. We would lend money to the state, without interest, if our people would be permitted to remain within Fiorenza. And this was accepted, partly because it lifted a financial burden from the backs of the Christians and partly because of the influence of Savonarola who has always been gentle with us . . . in his fashion. He declared that our residence among

Christian populations was not contrary to scripture, but rather we should be tolerated and comforted to remain as a testimony to the true faith and in the hope that we might be induced to convert. For this *quid pro quo* we lent him seven thousand florins in July and another nine thousand in November, without a scudo of interest, and they have three years to pay during which time we may remain . . . without practicing banking, of course, or any other art other than those needful among ourselves. . . . So here we are still . . .''

And he eyed me kindly with a light of hard unbroken survival in his eyes.

"And Master Elia . . . ?"

"Oh, he is still teaching at Padova . . ."

"Why does he never write?"

"He is busy . . ."

How could I tell my uncle the truth? I remained an uncomfortable hour and departed. How could I tell my Uncle Moshè that my father was gone too?—not gone in that irrevocable sense in which a man who dies is gone, but more vaguely and therefore more troublingly, the swallowing up of departure and silence.

For I had fled from him at Padova and when I came back to Padova he had fled from me. The University people seemed almost as disturbed as I. They wanted him back. The students clamoured. But he had suddenly departed for Crete, and how was I to know he really was in Crete? There were no letters waiting for me . . . and perhaps instead of Crete he was at the bottom of the Mediterranean, or perhaps? . . . I tried not to think about it. I felt that my flight was responsible. And now he was gone. It was worse almost than death. For then you know a place, a time, a way. You could fix the black day like a black moth on a pin.

But this way you knew nothing. Only that he was no longer at Padova. And he might as well be dead.

So with this on my mind, the city's gloom struck me harder than ever. It was all like a dream in which the bits are real but the togetherness is not. The streets were the same, the palaces the same, I recognized it all, I saw the pink familiar belltower and I saw all the people whom I knew, all my people who had remained. But it was not my Fiorenza. Father had always spoken of the gloom after the death of the Magnificent but this gloom was darker, heavier, the city lay under it like a drowned man at the bottom of the sea. I could feel the weight of it pressing on my chest.

Then all at once I realized that I had come back on the very day

—two years later—of Bartolomeo's death. I had not planned it so but
there it was.

I was crossing the Piazza dei Priori on my way to the Via Bentac-
cordi when I realized it. And I stopped in my tracks and decided I
would not go on to Michel's house until the next morning. But this
night I knew I had to stand vigil in front of the Madonna.

It was as if all events had meshed to bring me here—everything
that had begun with my running away from medical school at Pa-
dova when Master Elia unexpectedly announced that we were return-
ing to Crete. No, I could not. I hated the school, the dreary drafty
lecture rooms, the morbid gathering around corpses (though I found
this did improve my sketching), the quibbling over texts of Aver-
rhoes, the trivium and the quadrivium. But to return to Crete!—that
dreary wasteland where never could I see a work of painted art,
never hear a lute, doomed to spend my days in a succession of sea-
gazings and desert dreams. No! I cried (and it was the first time I
had openly opposed my father) I would not go.

He slapped my face.

That night I fled. Through the stony echoing streets, through the
high gate and across the night-sleeping flatlands leading toward Ven-
ice. It was raining, a fine gauzy drizzle, it penetrated my skin, I heard
dogs barking, I felt more alone than I have ever felt in my life. The
countryside seemed webbed with waterways: canals ran through the
fields, lagoons, it was a swampland unlike anything I had ever ex-
perienced before. I felt the sting of my father's hand and I was cry-
ing in the drizzle but I would not go back.

I came to Venice at dawn and I did not believe it. The sky was
mother-of-pearl and the city seemed to be floating between the sea
and the sky. Everything was shimmering: the black swans of gon-
dolas, the whipped lace of palaces, even the dialect with its curious
singsong like the bobbing of boats. And there were tall masted
ships moored at the Zattera and they were speaking to each other,
the tops of the masts swaying in conversation and more strange types
upon the narrow winding streets than I had ever seen before: Moors
and Turks and Greeks and Arabs, men with gold rings in their ears,
and shining ebony blackamoors bearing litters on which reclined
women in many-colored robes, and venders of all sorts carrying
parrots and monkeys. And everywhere light glinting off scallopy
waters.

I had Michel's address. I had gotten it from his family before we
left Fiorenza. His lodging turned out to be in a salmon-tinted flake-

fronted hotel on the Giudecca. The owner was a Swiss. He had a belly like a. barrel. He spoke Italian as if it were gurgling from a spigot.

"Ach, ja," he bumbled. "Mi rigordo guei drei ardisdi . . . I remember those three artists you speak about. They stayed less than a week . . . No, they did not say where they were going. One of them—a foppish fellow—liked it here. They were always arguing—then—poof!—they were gone!"

For a week I made the rounds of all the ateliers seeking Michel. But no one knew who he was. No one remembered a young man with a broken nose, small horn-colored eyes, a scraggly little beard just beginning to grow and an intense manner.

So I decided I had lost him. But what I had seen in the workshops made up for that loss. I had never seen such color in Fiorenza. Not even the Master Ghirlandaio could match what I saw in the workshop of a certain Maestro Gian Bellini. And there was another named Ser Palma and he had a son and their brushes seemed dipped in the sunsets that every evening set the lagoons aflame. I decided I would stay in Venice and learn my craft there, the craft that had lost me my father but would perhaps gain me a world. One day on the Rialto bridge I made the acquaintance of one of my co-religionists who kept a little shop where he sold copper pots. He agreed to let me board with him until I should be bound to some master in the craft I had set my heart upon. For two months I stayed with this man and he was a good and kind man and made me think of my father. But I was stubborn and would not go back to Padova though often my heart ached with the loneliness.

I wrote many letters but they were never answered. Then I knew that Master Elia must be very angry or else he had already returned to Crete. But I had to remain here—I could not undo what I had done and I could not return until I had the mastery of what I wanted already in my hands and brain and it could not be taken from me. So I stayed in that shop on the bridge and watched the throngs passing and it was a ceaseless procession that offered much material to my pen.

And finally I succeeded in signing as an apprentice in the workshop of Giovanni Bellini. I slept on a heap of old painted-over linens in the dark foul-smelling corner of the shop. Next door was the slaughterhouse and the mingled smell of the carcasses and the pigments which I ground all day sometimes made me vomit. But I learned something of my craft. I ground colors and learned to know the gritty feel of lapis lazuli and the flashing eye-aching pulse of gold

foil. I trimmed brushes and I swept the floor and I hung like a monkey on dizzying scaffolds laying the intonaco on which the masters painted their day's quota of tempera al fresco. I learned how to transfer the design from the pocked cartoon and how to shape a hand in benediction and the undulations of the Magdalena's hair.

And no one knew I was a Hebrew and I told no one. For my passion was to learn this art and I was afraid that I would not be permitted to learn, if they knew. There was one apprentice in our shop with whom I became close friends though he was younger than I—a jovial stoutish fellow with a small pouty mouth and cheeks that had the soft yielding pinkish bloom of a baby's buttocks. His name was Sebastiano and we became very good friends. He was much more talented than I but had only kind things to say about my efforts. He corrected the awkwardness of my drawings, taught me how to make the baptismal water ripple transparently over their Lord's feet. But most of all, he made me aware of color.

"Notice that streak of amber," he would say as we strolled along the Grand Canal at sunset. "See how it fades into the gold-orange beneath, and how the whole shape of that cloud—that one like a two-humped camel—melts at the edges into a sapphire lake. There are no sharp edges around those forms. One flows into the other. There is no separateness there, don't you see, it's all a oneness, a sfumatura. And everything vibrates. You have to dapple it: one against the other. You can't just fill in outlines with planes of flat color. Nature is more subtle than that. See, now it's changing . . . the lake is violet . . ."

And he smiled. He looked like a well-fed young innkeeper but he was sensitive as the lute he played so beautifully.

When I departed from Venice it was to this Sebastiano that I gave my ring on which the tables of the Law were engraved.

"But why do you give me this?" He was embarrassed.

"As a sign. Perhaps we shall never see each other again."

"Per Bacco! Of course we shall see each other. We shall meet on some scaffold or other. Artists are rovers. It is said that great things are stirring at Rome. I should like to go there some day."

"Well, may the ring be a token of that."

He kissed me. "Remember the color," he said. "You especially, Andrea. It will lift you from that dark well of melancholy in which you seem to float."

Then I was back again at Padova and it was as if the two years had never been. I went to the university and I knew I would not find my father. But I hoped against hope.

"The Maestro del Medigo?" the Rector asked. He had a skull on

his desk and his black eyes were almost as deep as the skull's. "He departed from us more than a year and a half ago. He said he was returning to Crete. We sought to dissuade him but it was impossible. He seemed to have become a bit distraught, melancholy. If you are a former student, you will remember how sharp and precise a sense of logic this Hebrew was capable of."

"I am his son."

"Ah . . . ?" The Rector rose a bit in his seat and leaned across the heavy oaken desk. The light stained chromatically through painted windows. "Ah yes . . . one can see the resemblance." He sat back again, tucking the thick maroon robe neatly beneath his buttocks. Now the skull-eyes glinted with memory. "Were you not at one time a student in our Faculty of Medicine?"

"Yes," I said softly.

"I remember now. I believe it was your sudden departure that contributed perhaps to your father's melancholy."

I rose to go. I felt as dead as the skull.

"If you should by any chance resume communication with your father"—was he being ironical?—"advise him that we would be delighted to have him rejoin us whenever he feels so disposed. We have never been able to find his like."

Nor had I. As I rode my horse out of the flatlands and up into the winding mountain roads leading to Fiorenza, I saw in my mind that ring with the tables of the Law engraved upon it and I realized that already I had violated two of those commandments.

But there was no turning back.

XXIII

Precisely balanced on the market roof the moon lay—a phosphorescent egg. Then the edge of the egg was broken and miraculously, from the other side of the world, dawn was born.

With the breaking of the moon-egg, Andrea broke from his vigil. Long hours ago, he had grown weary of standing; he had squatted on his haunches and then at last stretched out in his cloak in the

doorway and so half-dozed, half-dreamed the long night through. And now it was really through. He was home again. But what home was this?—an empty hall? a cistern of memories, a city drained of everything meaningful for him despite the hive-buzzing busyness of its citizens.

He rose, aching with morning damp. The market was already swarming with farmers, the donkey carts were lined up along the gray columns and the donkeys, whose white-ringed eyes wore an air of perpetual amazement, were adding their aromatic ploppings to the damp fresh fragrance of greens. As Andrea passed, the early-morning heartiness of the country folk, the braying of the donkeys, the bright pallets of fruits, the wet green smells, dispelled the phantoms of his long night.

He would find Michel and together they would decide his future. Heading across the Piazza, he saw that Donatello's Judith and Holofernes which had stood in the inner courtyard of the Medici Palace, had now been set up on the ringhiera in front of the Palazzo dei Signori. Inscribed on the new base were these words: *Exemplum Salutis Publicae Cives Posuere MCCCCXCV.* Andrea remembered the statue on the snowy day he had first seen it. How long ago that seemed! Now Judith the Jewess stood as an example of the public safety, a warning to tyrants. But all the living Judiths were tolerated within the walls only at the price of a bribe. And Uncle Moshè smiled.

He was passing the Strozzi warehouse on the Porta Rossa when he heard a familiar shout. It was Narro, amazingly grown, a fine fuzz of moustache adorning his lip. The hinge had turned and Narro was a man. He was wrestling with a heavy bolt of undyed cloth which now he hefted off his shoulder and leaned, with a sigh of relief, against the rough-stoned warehouse wall.

"Andrea! When did you arrive?"

"This morning just before dawn," Andrea lied. His vigil-night was not to be explained.

"Ah but it's good to see you," Narro said with more warmth than he had ever displayed in the old days. He spoke with a certain heaviness of tone, a maturity that seemed to carry with it a bit of self-satisfaction as if the transition from young manhood to manhood were a personal achievement. He was wearing a black mourning band on his sleeve. *Who?* Andrea wondered.

"As a matter of fact I was just on my way to your house to see Michel," he said. "All of you . . ."

"Oh, you won't find Michel—"

A pang stabbed Andrea. *Was it—?*

"He's at Rome."

Andrea sighed. "Ah . . ." He pointed to the band. "I was frightened for a moment."

Narro laughed. Within the mourning band his laughter was a bird in a black cage. "No. Not Michel. Donna Lucrezia. Last week. Suddenly." He snapped his fingers. "Bubonic fever. It's best you don't come to our house now. My father's inconsolable. He was very fond of Donna Lucrezia, I guess."

I guess! Andrea looked at him in wonder. The round demijohn face, full of blood and health, the red pouting mouth—*he* certainly wasn't troubled by his step-mother's death. When Mamma had died, Andrea recalled, the world's walls had fallen. Narro was a boor.

"At Rome? . . ." Andrea said. "I thought he had long ago returned from Venice. I searched for them up there, you know, at the address you gave me, but the innkeeper said that they had departed after a few days."

"That's true," Narro said. "Michel didn't care for Venice."

"Oh, it's a marvelous city. An enchantment."

"That's just what Michel didn't like. He said it was all enchantment, all embroidery. He said it was no city for a sculptor, too much froth, nothing you could strike your hammer into. At any rate, the three of 'em went from there to Bologna and almost landed in a dungeon because they didn't have the red seal on their thumbs at the city gate. And they were haggling about this when a merchant, hearing Michel was a sculptor, put up the tax moneys for him. A complete stranger, mind you. You know my brother," he said with a pinch of jealous irritation. "He always finds *someone*. Can you imagine? This Messer Aldobrandi kept him in his house for six months . . . And all Michel was expected to do was read Dante or Petrarca to this merchant of an evening. At least that is what Michel says . . ."

"And Iacopo and Francesco? Did they also remain—"

"Oh no, they came back after a few days at Bologna. Granacci's still here, waiting for more carnivals to decorate. He says the wheel will turn. Iacopo went on to Rome shortly after Michel did."

"Rome? I don't understand. How—?"

"Oh, artists are a flock of birds," Narro said. From the warehouse came a troop of apprentices hauling cloths. They greeted Narro with rowdy familiarity.

"They're all like that," Narro said. "And Michel more than most. I never really know what my brother is up to. Perhaps he was waiting

until things quieted down a bit here. Anyway, after six months at Bologna he drifts home, telling some kind of a tale about having to leave Bologna for fear of his life. It seems he had carved some angel-candlesticks at San Domenico there and the Bolognese sculptors were fearful that he—a man from another nation—would steal commissions from them. At least that's Michel's story. All dark hints and mysterious suggestions. You never know what's going on inside my brother's head. What's more, he didn't bring back a blessed scudo for those supposed candlesticks of his. And times are not easy for us here."

"You are working I see."

"Yes," Narro said proudly. "I am learning this wool trade with the Strozzi. Some day I shall have a shop of my own. Michel promises to help me."

He chuckled.

"More likely I'll help him. If he doesn't find a rich man to keep him what can he do? He wants me to go into business with Giansimone but Giansimone says business is a bore. What a family! My father hasn't earned a florin since Piero was expelled." His face assumed an unwonted sobriety. "And now since Madonna Lucrezia's death, all Father does is sit and brood, flapping the pages of that big account book—you know it?—forward and then back again . . . Where do you propose to stay?"

"I'm not staying at all," Andrea said, deciding at the moment. The city was a closed book. "I'm on my way to Rome."

"Ah, in that case, could you convey a letter to my brother? He doesn't know yet of poor Donna Lucrezia's passing, Father thinks perhaps the news of it will bring him home. He's been away almost a year now . . . I don't know what he's doing down there. He's certainly not putting any ducats in our coffers."

He laughed. He had always laughed heartily but now there was a gruffness in it,.a disparaging bass note befitting the only wage-earner of a family of incompetents. He leaned against the bolt of cloth in an indolent proprietary manner, and told Andrea that if it weren't for Fra Girolamo's foolish feud with the Holy Father life would be much easier in Fiorenza. ". . . Now the entire City is threatened with an interdict. If this Friar doesn't curb his tongue we shall soon have no one left to trade with but ourselves."

These Christians! And his own brother a Dominican!

The sweet bells of Giotto's tower struck. Narro seized his bolt of wool and hefted it to his broad back again. "I must deliver this

to the Adriani," he said. "If Ser Strozzi finds me here chattering . . ." He grunted under the load.

"Here, let me help," Andrea said and he seized one edge of the bolt. It was heavy cloth, undyed, gray. Chromatic Venice flashed in his head. And this neutral gray merchandise, this was Fiorenza.

They walked along, one behind the other through early-morning swarming alleys. Even grunting under his load, Narro eyed every girl within his vision.

"Ah, there's the chief curse of this Friar," he exclaimed as a maiden with hair of old gold tied in a prim knot walked softly and swayingly across the Street of the Stocking Makers. "Now look at that lovely creature. Robed gray as this cloth. Nowadays you are only permitted to guess what she is like beneath the winding cloth this monk considers suitable for our women. But you can't *see* any more. I mean the delicious parts . . ." His lips were wet, his little eyes glistening. "Grab it a bit further to the right, will you? . . . There . . . Ah, grazie, that's a mite easier."

And so, goggling and grunting, they made their way along and Narro told Andrea how his brother had happened to go to Rome. He had been fretting under the idleness when he came back from Bologna. Not even Savonarola's sermons could fill his emptiness. "And he was. truly seized by the Friar," Narro said. "Another Lionardo." But commissions were not to be found. All the artists were waiting. Some weren't painting because they were truly affected by the admonitions of the Friar. Others weren't working because the chief sources of their trade—the painting of wedding chests, cassoni, fans, designing embroidery, decorating rich chapels—all this lucrative trade had withered like a meadow of gaily-colored flowers—the flowers of Benozzo Gozzoli's walls in the Medici Palace—in the hot desert blasts of Savonarola.

"So he was becoming more dour every day," Narro said, "not knowing what to make of the new spirit of the city or how to occupy his idle hands . . . Luckily, just about this time the *Popolano*"—he pronounced the name with unconcealed amusement—"commissioned the work they'd long promised Michel. So he did a Cupid for them and Messer Pierfrancesco *Popolano*, who has a sharp eye for business, thought it was so good an imitation of the ancients that with a little aging they might sell it as a true antique down at Rome. Well, this amused my brother so he hacked off a bit of the nose and chipped and scratched the arms and they buried it in our garden for a week to age it like a wheel of cheese. Then Ser *Popolano* sent it

down to Rome and some idiot of a merchant down there bought it for thirty ducats. Thirty ducats! Can you imagine?"

He roared with laughter under the load. There was more than a trace of peasant slyness in all these Buonarrotis, Andrea thought.

"And not long afterward he went to Rome because the Cardinal who bought the Cupid discovered the fraud and wanted to see the sculptor who had passed it off so cleverly. Michel was frightened plenty, I tell you, when agents of the Cardinal came up here to find him."

"Diavolo! First he thought of running off, and then he decided to face the Cardinal's men, but to lie, telling them he had had nothing to do with the false Cupid. But they were just as sly as he—just as furbi—those agents of San Giorgio. All they did, you see, was ask my brother to draw a hand with a piece of chalk. Of course Michel, big-headed as the Duomo, couldn't help but show off his skill. Well, then they knew at once who had faked the Cupid. So poor Michel had to confess to everything though he was shaking like a leaf! . . ."

He chuckled.

"But I guess the matter has gone off well enough since we have not heard of him being put to the rack. But why he remains down there is beyond me. His letters tell us nothing. And he certainly isn't sending us any money."

They had arrived at the Adriani. Inside the courtyard between the high arches, ropes were stretched for the drying of linen. Standing at the foot of a column, Giovansimone was waiting. He too had grown, and despite the universal dinginess of the prevailing dress, he still arrogantly wore his tight parti-colored hose—red and black—puffed out at the waist. He had developed into a tall slim fine-featured youth who talked and looked at Andrea with a slightly amused supercilious manner.

"Benvenuto, Andrea," he drawled as Narro went into the palace to deliver his merchandise, "So you have decided to lend your joyous presence to our gloomy precincts again?" He had always considered Andrea excessively melancholy.

"No, I am merely passing through. I am on my way to Rome."

"Ah, then you will see my brother?"

"I hope to."

"Well, when you do, tell him that Narro or I will visit him one of these days and when we do he should be prepared to put us up at his lodgings."

Indolently leaning against the column, he began to hum an obscene ditty. And suddenly Andrea saw again the youth-sprawled

Piazza in front of the Duomo that August day two years ago and Giovansimone singing the stornello that had set off the explosion. Indolently as he was standing now, the same gesture, hand on hip. Andrea felt a sudden need to go. He waited till Narro had emerged and then, with hurried hand-shakes, bade both brothers addio.

"Wait!" Narro shouted. "Here is the letter for Michel."

Andrea took the missive, folded in a small square and sealed with red wax. It was addressed to Michelangiolo Buonarroti at the residence of the Cardinal Raffaele Riario, at Roma. He inserted it within the laces of his doublet.

"Tell him I'm learning the business well. Tell him whenever he's got the money ready we can set up the shop."

On the hill above the Porta San Pier Gattolini, he halted his horse for a brief last glimpse of the city. It was his home but it was not. Above the froth of olive trees rimming the walls, the Duomo floated like a pink bubble on a milkygreen pond.

Then he reigned his horse around and headed resolutely toward the Eternal City.

BOOK THREE

BETWEEN BACCHUS
AND MADONNA

ROMA

1497-1501

I

The Papal Magister Cerimoniarum, Johannes Burchard of Strasbourg, had trained himself over fourteen years of diligent scribing to look upon his world with the unblinking eyes of a fish.

He was official chronicler, this dour black-gowned Master of Ceremonies, and it was not for him to pass judgment; perhaps the gelid blood that flowed sluggishly in his veins made it possible for him to witness with such outward equanimity scenes that might have turned the stomach of a weaker man.

Now, seated in his study in the high-ceilinged record room of the Vatican, with his great leatherbound Diarium open in front of him, he was staring at the yet untarnished page with a wrinkled brow, indulging himself in those slightly comical movements of all authors before they begin to write: pulling systematically at the lobe of his right ear, twitching his fine-pointed nose as if he detested the heap of offal in which he was obliged to sniff, the quill pen quivering in his hand like the comb of a fighting cock.

The events he had witnessed last evening were rather difficult to indite. It had been a send-off party in honor of His Holiness' sons —the Duke of Gandia, soon to leave to take over his new-granted lordships of Benevento, Pontecorvo, and Terracina; and the Cardinal Cesare, just appointed Papal Legate to the coronation of King Federigo of Naples. His Holiness was uncomfortably aware of the rivalry between these brothers. A party would be a good thing, he thought, it might soften Cesare's rankling over the fact that his younger brother had received preferment before him in the coveted lordships.

Besides the gold-bearded Duke, the tawny-bearded Cardinal, and their clean-shaven father, the old Pope, there were three young women at the party: the fiery Aragonese, Sancia, wife of the absent third Borgia brother, Don Gioffredo; young Lucrezia; and the Pontiff's twenty-year-old concubine, Giulia Farnese, the "bride of Christ" as Roman wits liked to call her. They were a handsome lot: these elegant and soldierly looking Spaniards, you could even see the

iron of Roderigo in the fatfolds of the septuagenarian Pope; and the three young women with their pert noses, small mouths, and heaped up masses of jewel-bedecked hair: Lucrezia's and Giulia's, gold, and Sancia's, black black.

But this was not the problem facing Vater Burchard. He was hardly interested in tracing out for posterity's sake the degrees of beauty in the Borgia family. They were all, despite the excesses to which they subjected those fine bodies of theirs, a good-looking tribe. But there were things that were difficult to say, things that happened at these celebrations that were not easy to record. Now, thinking about it, Vater Burchard, accustomed to do his duty toward the reigning Borgia as he had done it for his predecessors, Innocent the Eighth and Sixtus the Fourth, was seeking in his unimaginative clumsy knobby-kneed Latin for the exact phrase, the kind of indirect direction, the ingenious obliquity which he had developed over the years and which managed to say so much and yet so little.

There was an air about the party. Reflectively glancing up at the gold-coffered ceiling, the Magister tried to cast a net of words about this elusive beam. Ach, but it was always the indefinable which he could not put into his Diary! All those phalanxes of heavy Latin sentences—ranked in armour, phrase after phrase—they told nothing, Burchard knew, and it was better they did not. Indirection was the secret weapon in this war.

A peculiar charged atmosphere—like one of those cloud-streaming days in the Castelli when you never knew whether the sun would come out or a storm would break. Alexander was smiling and so were the brothers. But that was deceptive, the Borgias all smiled easily. And both of them—the gold-bearded Duke and the tawny-bearded Cardinal—playing their usual brotherly roles toward their sister Lucrezia and their sister-in-law Sancia. Vater Burchard had no taste for these scenes: his limited imagination ran in more sober channels but it was not for him to criticize the doings of Christ's Vicar on earth or his family. Duty was duty and though some voices might whisper that the Borgia claim to the triple tiara was questionable in view of the fact that the election had been purchased at auction and was therefore hardly entitled to the veneration of the faithful—all this, nevertheless, had nothing to do with the obligations of a Master of Ceremonies. His task was clear: to record, day by day, in that stumble-footed Latin the events of His Holiness' Pontificate. And surely last night's doings had to be considered an authentic part of the record.

It was after dinner, the usual dull restrained dinner. Gluttony, alas,

was not a papal vice; fine-figured at seventy, with strong white teeth and a soldierly bearing (though the lance he bore was not on a field of battle), the Pope served so frugal a table that Burchard always rose from it famished. Last night's wine, particularly, made him angry. Why, it was no better than water! His Holiness had probably ordered it diluted to save money. Burchard twiddled his quill and pulled at his ear and sniffed. Then he began hurriedly to write in his quirky hen's-track hand:

"... *Prandium fuit satis feriale et sine bono vino* . . . and without good wine . . ." Now the quill lifted and he continued to compose the sentences in his head, preparatory to setting them down, seeking the exact muffled word, the diplomatic visor that would let just enough light through the eye-holes. ". . . After which, several dancing girls, scantily clothed, performed to the great satisfaction of His Holiness and concubina papae, Giulia Farnese. But Madonna Lucrezia seemed to take no pleasure in the festivities. She was not at all her usual seventeen-year-old gay self. Was she depressed over her impending strategic retreat to a convent? Was she unhappy because her husband, Giovanni Sforza, becoming understandably nervous over the attentions of his wife's brothers, had suddenly decided to bolt. Now he was up at Milano, out of reach of their—"

No no no, that would never do! Burchard frowned. He could certainly not commit *that* to paper; it was foolishness enough writing it in one's head. The quill hovered like a hummingbird above the parchment. How could he say it? He had only managed to set down that one sentence about the bad wine. Ach, words were such traps. He moved with greater ease amongst the fixed avenues of the Holy Office. There everything was clear: the words, the gestures even, prescribed; a man was never lost in mist, never fell into traps.

He tried again.

". . . After the dancing, while His Holiness with much jocularity was instructing the Duke with regard to the management of his new fiefs, the Cardinal Cesare suddenly leaped from his seat in a fit of anger and left the room. Everyone was puzzled at this unwarranted display of passion. The Pope dispatched a man after him but the Cardinal refused to return. Instead, he sent back a message declaring that he was *going fishing in the Tiber,* at which the Pope blanched. Then Madonna Lucrezia sought to comfort him, saying—"

No, that would not do either, Burchard decided. He thought a moment longer and then suddenly the perfect words came to him in a rush, the perfect bland noncommittal words, the precise ambiguities. Gratefully the hummingbird landed:

"In addition to the poor wine, the Pope served roast partridge with chestnut stuffing, and a green leaf salad. After dinner, while the Holy Father was instructing the Duke of Gandia with regard to his new duties, the Cardinal Cesare took ill and begged to be excused. The Pope dispatched a physician to the Cardinal's quarters and was much relieved to learn that the Cardinal was suffering merely from indigestion occasioned by some fish from the Tiber which he had eaten that afternoon."

That covers the matter sufficiently, the Magister murmured. He closed the Diary. His round green eyes were watery and unblinking. He had a slight headache.

II

Under the full moon, this river seemed to run more swiftly than the Arno. Andrea walked along the Tiber bank searching for the inn which the hostler had recommended. He was in Rome and it was midnight and he was tired and aching for a bed. The nearest inn was the Seven Milkfed Virgins, the hostler said, the wooden sign would show them all. Curious river, he thought, how swiftly it flows, and yet ominously: those whirlpools aren't dimples. Moon-silvered, quick. Oh, how he ached to slip between cool sheets.

He came to a slow adagio curve. Here the river swung lazily under a stone arched bridge. Under the bridge's lute-shaped bell, the river's pebbly rippling was amplified. On the other side of the bridge it was lost in darkness. The bank was deserted. Andrea frowned. The hostler has assured him the inn was here. There were only tall reeds soughing in the night wind. An embankment. Across the stream he could vaguely make out a rectangular mass of columned shadow. That would be the Hospital of the Slavonians. The reflection of the moon played on the surface of the river so that it seemed to be quivering like mercury. Above the sleeping city the roundfaced moon yawned in bland indifference.

Now, where will I spend the night? Andrea wondered. He was angry at the hostler. There was surely no inn here. He could not wander about in a strange city at this hour. Scouting the embank-

ment, he found a patch of sand, clean and still elusively warm with daylight sun. He wrapped himself in his cloak and lay down. He fell asleep at once.

He dreamed he was being rocked in a cradle, mollient hills were flowing by, then jag-toothed mountains, then the rocking was a boat and wavelets were dappling up his nostrils. He had to sneeze.

"So you're a live one," a voice said. Andrea sat up, startled. He was shivering, his cloak had slipped off. A short squat peasant, his back bowed under an enormous load of faggots, was standing over him; behind his silhouetted figure Andrea could see the flatboat in which he was loading the faggots. "You'd be likely warmer over there," the peasant said, pointing to a declivity of the sand-pit walled off against the wind by the embankment wall. He spoke with a peculiar slavic accent. His bowed figure in the shine of the moon had the immemorial quality of an ancient tree-trunk.

"Thank you." Aching, he rose and headed for the embankment wall. But now he could not sleep. He lay watching the peasant periodically disappear into the path that led down to the river at this point and then reappear after a while with another load of faggots which he loaded into the boat. After the first remark, the peasant paid no more attention to him than if he were a rock by the path. Peculiar that he should be working at this hour, Andrea thought. Probably stealing wood from a private preserve.

He heard the crackling sound of horses' hooves coming down the path. The peasant, who was down at the boat, cocked his head and suddenly dashed into the tall grasses and was still. Swiftly, Andrea flattened himself against the rock-wall. He did not know why he hid unless it was an involuntary imitation of the faggoteer. Now out of the path into the moonshine came a horseman, two horsemen. They stood still a moment, lambent statues in the moonlight. Andrea could not see their faces, their backs were toward him. One of them seemed to be peering down into the river. Then they disappeared back up the path. A moment later, two others appeared; now Andrea could see that they were masked, their spurs glinted in the moonlight. They looked around and one of them made a signal: a hissing cautious whistle, between the teeth. At the sound, another horseman issued from the path, mounted on a white steed, and behind him across the croup dangled a corpse, head and arms on one side, legs on the other.

"Right there. Where the garbage goes," one of the men said. He laughed. He had a harsh voice. He pointed to the right of the boat. "There, by the reeds."

Then they were out of sight. Andrea heard a grunting sound, soft curses. They must be dragging the corpse over to where the man had indicated. Cautiously, his neck aching with the effort, he moved his head forward a bit. Now he could just make out their shadowed moving backs. There wasn't a sign of the faggoteer. He heard a splash and then a soft voice: "Did you cast it well?"

"Sissignore!"

One of the men had remained on horseback, the others had dismounted. Now the mounted man pointed; there was a sound of splashing stones.

"No, no! That won't do it!"

It was a voice of command. Andrea leaned further forward. One of the men on foot was scrambling down the embankment. He waded out into the stream and now Andrea saw that the dead man's cloak was floating. The man was trying to heft rocks onto the floating cloak. He kept slipping and cursing, the rocks falling out of his hands. Then he managed to tie a big one in the folds of the cloak and with a bubbling murmur the corpse sank. Swiftly the man clambered back up the embankment, remounted, and with a clatter of hooves, they disappeared.

Andrea waited two minutes, five minutes. He was afraid to move. His fear was a huge resonating chamber, the faintest stir echoed terrifyingly; he tried to pull himself back into the rock-wall, to become a part of it.

He was sure that his body was bright as day in the moonlight; his flesh quivered in expectation of a lead ball, a flying dagger. But nothing came. The horses' hooves died away up the path. And after a moment, the faggoteer appeared again. To Andrea's astonishment he was bearing another load of wood down to the boat as if nothing had happened.

"Did you see it? Did you see it?" Andrea said excitedly.

"What? . . . Ah! you frightened me, leaping out like that." The faggoteer's voice was resentful. In his anger, his strange accent was stronger. He cursed in an unknown tongue.

"Did you see it? The assassins?!"

There wasn't a trace of the corpse. It was amazing how swiftly it had disappeared.

"Oh, that." Now the anger faded and a pair of shrewd button eyes were peering quizzically at him in the moonlight. "You're a stranger to Rome?"

"Yes, but—"

"Listen, young man. I've been gathering wood here for seven

years. I must have seen at least a hundred bodies dumped into the Tiber at this point. There's a strong current here, you see . . . I mind my own business and I'd advise you to mind yours."

"But shouldn't we seek to recover the body? Shouldn't we at any rate—"

"There's an inn just around that bend," the peasant said, pointing. "The Seven Milkfed Virgins. It's open all night and if you've got the scudi in your pocket and a care for your health, I'd advise you not to sleep out here in this damp night air."

"Oh blessed Lord," Andrea prayed as he hastened away from the terrible spot, "Is there no peace anywhere in this land?"

Looking out on the molten rippling waters, indifferent in the shine of the moon, he fancied he saw Bartolomeo's face floating there, and then it was gone in a gurgling drowning burst of mad laughter.

III

"And are you pleased with it thus far?" the banker asked.

"It is not for me to say," Michel answered.

"You see," Baldassare laughed, "even some of our Florentines are modest."

"It is a fine piece of marble, I will avow that. Pinkish, veiny, really looks like flesh. Would you like to come to see it? It is only half blocked out."

"Oh, I have perfect confidence in you, young man," Gallo said. "I shall wait until you feel you are ready to show it."

"You are most kind."

"Not at all. I don't presume to advise you in matters beyond my competence."

"Ah, but in that you are unusual, Messer Gallo," Michel said. He could not keep the bite out of his humor. "When our Florentine merchants order a statue or a painting, they never hesitate to tell us exactly what they want, to the finest flick of gesture, to the subtlest nuance of color. The Annunciating Angel must be posed so and so, and the Madonna's hand must be raised so, and there must be a

portrait of Messer Rich Wool kneeling over here—in brocade of course—and Madonna Rich Wool there with much lapis lazuli in the ground."

"When you come to my bank for a loan," Gallo said dryly, "I don't expect you to advise me how to conduct my business . . . But will you be able to complete this Bacchus before the Cardinal absorbs all your time?"

"Oh, the Cardinal has even forgotten I exist."

"Pazienza!" Baldassare laughed.

"Patience?! What patience?! I have been here for more than a year now and except for the Bacchus Messer Gallo has so kindly commissioned I have accomplished nothing. All the Cardinal's promises have come to naught."

"And Piero?" the banker asked in his slow inflectionless voice.

"Oh Piero! What can one ever expect from Piero? He summoned me just about a month ago—it was the time we went to Ostia to see the new excavations—just when we returned. Anyway, I found that damned groom waiting at the Cardinal's palace. It was a good thing the Cardinal's men didn't know who he was. Else he'd have found his back a scabbard for a knife. The Cardinal Riario isn't very fond of anybody connected with the Medici. Even connected through the stables."

"And vice versa," Baldassare said. He gazed out across the heights of the Capitoline Hill toward the Colosseum, blackly impressive against a lemon sky. The banker slowly nodded his head; in this setting he looked more than ever like a reincarnation of the ancient emperors.

"At any rate, I managed to slip off with the groom without the Cardinal's men knowing. Piero was waiting for me . . ."

"Changed much?" Baldassare asked.

"No. A bit more serious perhaps, more at loose ends. Jiggling an exquisite medallion as he talked, couldn't keep his hands still."

"If it weren't for those exquisite medallions, he'd be a poor man," Baldassare said. His voice honed into sharpness. "He may have looked like a Franciscan when he fled but under that brown robe he was carrying off his father's collection."

"Not the collection Lorenzo bought from the Cardinal of Mantova?" Gallo said, looking at his associate with round moon-wondering eyes.

"Già! The very one."

"Ahi, had I but known, I would have bid for it. A marvelous collection."

"Yes, almost two hundred gems, cameos, intaglios. And now I understand Piero has sold the lot to Agostino Chigi at a good profit. He's not suffering from poverty, you may be sure of that," Baldassare said in his cynical voice.

"Nevertheless, he seemed unhappy, distracted," Michel said, resuming his story.

"Oh well, he doesn't have much to do here in Rome, except trail after the silly young Cardinal, his brother, or Giuliano who's younger and sillier still, or roister about with loose companions and wait for the day to get back to Fiorenza."

Michel sat down on a ruined capital, half sunk into the earth. His fingers crept exploringly into the abrased acanthus leaf as he talked. "Well, Piero wanted a statue. Not of snow this time." He laughed harshly. "A Cupid. A kneeling Cupid. It seems that all the Medicis want Cupids—both sides of the family. So I spent twenty ducats for the stone and fashioned it and then I find that Piero is no longer interested and I am left with the work and the cost of the stone."

"The life-size Cupid? The kneeling one?" Gallo asked. A faint ripple of eagerness crossed the placid pool of his voice. "The one I saw lying over back of the well?"

"Yes."

"Well, if Piero doesn't want it, I might be willing to purchase it," the banker said. The expression with which the young man received this news almost made Gallo smile. "Of course," he added, "I shall have to see it again before I take it. First impressions are not always judicious."

"Oh, I vouch for the judiciousness of this one," Baldassare said enthusiastically.

Michel felt suffused with warmth. What good friends they were! How confident in the flowering of his talent! He felt a glow of happiness. For no matter how lonely the making, there was always the need for others to want what you have made. It flattered him that Gallo, whose impeccable taste was reflected in his own small, but excellent collection, had already commissioned the Bacchus. And now he was interested in the kneeling Cupid as well. It made up for the Cardinal's procrastination and Piero's shilly-shallying. And for Lodovico's incomprehension. Those foolish letters about his litigation with the merchant Consiglio over ninety golden florins. And that not too subtle complaint that if his own flesh-and-blood son could not send him money to settle his affairs, he would have to borrow money from the Monte. Why, he knew well enough that Michel didn't have money to send but would find some even if he

had to sell himself into slavery. He wouldn't let his father borrow from the Monte and Lodovico knew it. Yet he said it. And then that constant business about *What are we going to do with Buonarroto and Giovansimone.* Why wasn't he a bit patient? Let Narro attend to his trade and learn the business well and as soon as he, Michel, could raise the cash he'd help him set up a shop. Didn't Lodovico believe that? Was it necessary all the while to be annoying him with nagging letters as if he didn't have troubles enough of his own?

He pushed the unhappy thoughts of family out of his head. He was in Rome, far away from all that and Gallo had already commissioned one statue and now was offering to buy another. Michel felt a fresh bounce to his steps. He was treading on storied ground: a thousand sculptors dead and gone had left scattered about here the marks of their passing. It was like his first view of the sea that day at Ostia—the tide had just receded and the beach was starred with shellfish and with wrack. So artists, he thought, left their shells, the cunning carvings and whorls of their fancy, upon the beach of centuries.

They descended the steep hill, carefully threading their way amongst green-bearded ruins, and then passed under the arch of Septimius Severus which was still buried halfway up so that it looked, in its truncated proportions, like a tall man whose legs had been cut off at the knee. Beggars protruded skinny arms out of their rags and whined for alms. Mules and cattle roamed the grassy marble-studded expanse. Blackly etched against the deep blue sky, an iron cross crowned the ruined roof of a pagan temple.

On the opposite hill, once residence of Caesars, a flock of sheep grazed. "The Baa-latine," Baldassare said dryly.

Regaining the high ground, they strolled homeward along the river. When they arrived at the adagio curve the Tiber made near the Hospital of the Slavonians, they saw a crowd collected at the bank. There were perhaps two hundred persons of all ranks, plebes and patricians, all milling about with an air of morbid merriment. A steep embankment ran down to the river here, and from this point on, all along the shore as far as the eye could see were boats, hundreds of boats, large and small, some close to the reedy bank, some floating further offshore. Men were standing in the boats, swishing about in the reeds with long poles; others had waded into the water; they were pressing down the tall grasses, searching for something.

Baldassarè laughed. "I see the fisher of souls is still fishing for his son," he said. He turned to the banker and quoted a ferocious

Latin epigram that had been making the rounds of Rome ever since the Pope had given the order to dredge the river for the missing Duke:

> *Piscatorem hominum ne te non, Sexte, putemus:*
> *Piscaris nothum retibus ecce tuum.*

"What does it mean?" Michel asked in a small voice. He was always embarrassed by his lack of Latin.

Baldassare translated:

> *Lest we should think you not a fisher of men, O Sextus!*
> *Behold! For your bastard boy with nets you fish!*

"How unkind!" Michel exclaimed. "Even if he is the Holy Father, does he not suffer the agony of all fathers?"

"One hardly expects Pasquino to be kind," Gallo said with lifted brow. Pasquino was the mutilated Roman torso on which the epigram had been hung. Baldassare was smiling a scimitar smile.

They stood a while, watching, and then proceeded. "Do you think the Colonna are really behind it?" Michel asked. The enmity between Colonna and Borgia was a commonplace of Rome talk. And since the river had been the aqueous grave of so many enemies of the Borgia, it was not to be wondered at if a Borgia should also be so liquidated.

"I doubt it," Baldassare said. "The talk is of a 'long tooth' and you know who the long tooth is."

"The Cardinal Cesare?" the banker murmured.

"Già. The Cardinal Cesare. He cannot tolerate that shadow of his brother always blotting out the sun of his ambition. Especially since Alexander gave Giovanni the Neapolitan fiefs. The Cardinal is out in the open now. He doesn't care any more. He's already crossed his Rubicon, our Cesare . . . he fancies himself like the ancient one, you know. Twenty-three, handsome, vigorous . . . but Gandia was too much his father's favorite. Besides, Donna Sancia—ardent as she is—couldn't very conveniently be in the Cardinal's bed and Gandia's at the same time. Our Cesare's on the march. He's already managed to frighten Lucrezia's husband into flight and soon she will be divorced. That's one stone out of the road. Now the Duke . . ."

"If indeed he is dead," Gallo said. "It's quite possible that he will reappear tomorrow or the day after, a bit tired, and mysterious about where he has been."

"When he reappears," Baldassare pointed to the river, his lean

saturnine face wearing an expression of cynical certainty, "he'll re-appear somewhere right out there. Mark my words."

Back in his shack, lying on a bed of straw, Michelangiolo reflected on the cruel talk of the two bankers. In the year and more he had already spent in the Holy City he had never been able to accustom himself to the violence and corruption in which everyone seemed to paddle as in a cesspool. The cooings and clawings in the domestic den of the Borgias, the incredible crimes hinted behind palmed smiling lips, the succession of Cardinals who suddenly died of vio-lent stomach spasms and whose property rapidly found its way into the coffers of the Pope, the talk of incest, now with Alexander, now with Cesare, the impending divorce of blond Lucrezia on the grounds of her husband's impotence . . . and she therefore invio-late as the day she was born. All Rome rocked with laughter.

But Michel didn't laugh. It was an atmosphere more fetid, more violent than he had ever known. Not even the coming of Charles—now dying, it was said, in France—had brought such violence to Fiorenza, not even the lynching of that Spanish Hebrew, Barto-lomeo. For there it was a momentary upsurge, an occasional ex-plosion. But here violence was endemic, it was in the air of the Urbs as that marvelous art was in her soil. Assassination was common as assignation; the sight of man tormenting man which he had seen on his first day in the Holy City, he was now accustomed to see every day.

He had even trained that queasy stomach of his to lie down like a dog at command. And he had to give the command every time he crossed the Campo dei Fiori on his way to his lodging. Field of Flowers! The flowers hung on crosstrees: blossoms black, with contorted muscles, frequently the hanged man's tongue sticking out. The tongue was a favorite gathering place for flies.

Today had not been so bad. There were only six wretches sitting in the pillories with paper mitres on their heads. He had written a cagy letter home about it, signing himself Piero. This was no time to take risks.

IV

And on Thursday afternoon, the 15th of June, fourteen hundred and
ninety-seven, at the quarter-hour after nones—the Master of Cere-
monies was a stickler for such details—the old faggoteer who had
been heard to speak was finally found and summoned before His
Holiness. The Pope was redfaced with weeping, enthroned, and
flanked by Swiss guards and a retinue of Spanish Cardinals. The
peasant began his story thus: "I was loading up my faggots, Holy
Father, ahi, it was a black sticky night and the collection of faggots
has not been very good this year because the winter . . ."

Alexander struck him across the face with his key. "Never mind
your faggots! My son! My son!" he screamed.

Lying on the floor then, bleeding, the peasant told what he had
seen. Like most of the wood-gatherers and carpenters of that area, he
was a Slavonian and at times it was difficult to understand all that he
said. But in the main his story tallied with what had already been
reported to us. And I noted that the Pope was so lost in his grief that
he was no longer looking at the man, so I stooped and helped him to
his feet, pressing a handkerchief against the gash in his cheek. He
was an old man and bowed with many years of heavy labor. "Why
didn't you interfere?" I whispered. Above our heads, enthroned, the
Pope's anguished breathing soughed rhythmically as a bellows. "Or
at the very least, if you were afraid to interfere, why didn't you come
forward later and report what you had seen?"

He looked at me with frightened shifty gray eyes that yet had a
flash of defiance in them. "Ah, Eccellenza, but there are so many
bodies dumped into the river at that point. Sometimes as many as two
or three a night. One pays no attention to it—et nunquam aliqua
eorum cura est habita, the quill was writing—I must have seen a hun-
dred men dumped into the river in my time. And then again I didn't
know who it was. Perhaps it wasn't the good Duke, at all. Indeed, I
pray it was not, O Holy Father, I pray not—"

"Take him out! Take him out!" the Pope cried.

His Holiness immediately gave orders for the river to be dredged
and all that day and night and the following day, the sixteenth, the
Pope had hundreds of men with poles and nets fishing for his son.
When finally the body was recovered it was fully clothed, booted and
spurred and it was all bloated and there were nine knife wounds in

the thigh and neck. His hands were tied and he had thirty ducats in his purse. I was called at once when the unfortunate Duke was found and I could not forbear to look upon that young man whom I had known so well, all slimy with river weed adding a new and marvelous gloss to his elegant velvet cape, his blond beard weedy, and his tall young body and handsome face swollen like a dead fish. And as soon as Alexander learned the news he shut himself up in his rooms and wept most bitterly. And all the Cardinals, except Cesare, went to wait upon him but he would see none of them. For four days he remained thus in a terrible state of grief and the valets outside his door reported that the Pope wept unceasingly and lamented in loud tones that his dearest child had been thrown into the Tiber ut stercus . . . *like garbage. I tried desperately to enter his chamber and console him but he would not admit even me, nor did he eat and drink for the entire four days, and certainly he knew no sleep. Finally, as a result of the insistent prayers of the Sacred College, he yielded to our importunities* majus damnum et periculum quod personae suae evenisse posse considerans . . ."

The quill skidded to a stop. The face of the Master of Ceremonies was more metallic than ever. It was like the face of a shield, engraved with the lines of many battles and yet, elegant among these scars, the gold arabesque maintained its mythic poise. He glanced over what he had written: scarcely half a page of harsh incommunicative Latin. But not incommunicative enough. Writing was an impossible lie. He had trained himself to keep the sluice gates down but today under the pressure of emotion he had lifted them a hair, and too much—much too much—had seeped through.

Motionless he sat for a moment, an impeccable mass of black-robed gravity, the small aqueous green eyes floating in space, the finest corners of the thin lips twitching a filigree. Then he rose, and glanced at the door to reassure himself that it was still bolted. Slowly with wet deliberate thumb he leafed his way back through the great book and tore out every recent page dealing with the Duke of Gandia. In the tall graystone fireplace, on whose cornice flying putti held a pious scroll, Burchard watched the slow curl of the burning pages. He would do them over another time.

It might be a good idea to take a rest from this accursed Diary, he thought. It had become at times an incubus. Better let events flow by unrecorded. Perhaps he would accompany the Cardinal Cesare on his ensuing trip to Capua. It would be a pleasant change.

V

Andrea saw the long line of torches—hundreds and hundreds of them casting a smoky glare in the purple dusk—turning from the banks of the Tiber toward the Piazza del Popolo. In a pack of spectators he followed; never had he witnessed so impressive a funeral cortege—the line of mourners seemed to stretch forever, a slow undulating black serpent glistening with torchlights. Behind muffled drums whose ominous beat fell echoless in the huge spaces of the square, the mourners shuffled: ahead were prelates and servants and steeds in black velvet trappings, and then the bier on which lay exposed the body of the Duke dressed as a Captain of the Church, and after him the tail of mourners, real and feigned, lords temporal and ecclesiastical, hundreds and hundreds bearing the smoky torches.

Yesterday the reclaimed body had been transported on a barge to the Ponte Sant' Angelo; and the wailings and lamentations of the Pope at the bridge were heard above all the others. "I was packed right in the middle of it," a voice near Andrea was saying. "He was carrying on worse than a woman, I tell you . . . But I don't see him now, do you?"

"He's probably already in the church."

Andrea did not understand. He knew nothing of the event that was rocking all Rome. Who might this grand personage be? he wondered; and turned to inquire of a man who was gazing at the spectacle, with his nose crinkled, and a peculiar smile on his lips. "The Duke of Gandia," the man said, and his smile widened, his head cocked as if to ascertain the effect of this information on an obvious foreigner.

But the name meant nothing to Andrea, the remarks of the crowd were dimensionless to him; nevertheless, he could not fail to sense the scarcely suppressed jubilation, the atmosphere of a comedy in its final hilarious unfolding.

". . . He looks as if he were sleeping."

". . . A long sleep."

"Ahi! A long sleep from a long tooth. The Cardinal Cesare—"

"Shh! There may be Spaniards about."

"Ahi! Have you noticed them roving the streets these past few days? Daggers unsheathed and weeping and cursing."

". . . of course, it was the work of Madonna Lucrezia's husband, the young Count . . ."

"No! No! Impossible. The Count fled Rome a month ago. I have it from my cousin whose nephew is a dustman at the Vatican. Sforza fled to avoid just such a push into the Tiber like this—"

A voice laughed raucously. "With sufficient ducats you can be in Milano and push a man into the Tiber. Ducats have long arms. Young Sforza doesn't have to be here to get rid of the Duke. There are plenty of assassins! . . ."

"Be quiet, I tell you! . . . The Spanish cabal is all about."

"Well, damn them! Maledetti! Today is our day."

". . . and both brothers paying court to their sister. What do you expect? How long can a husband tolerate—?"

"Husband?"—there was a fresh burst of laughter, seeds in a dry pod. Far across the Piazza, Andrea could see the head of the mourning-snake disgorging itself slowly into the church.

". . . said to have a broken lance." Now the laughter really rang. "Poor Madonna Lucrezia! Pure as the day she was born . . ."

"Well, my cousin's nephew—he's a dustman in the Vatican and he should know—says she's the biggest whore in Rome."

"Calumny. Isn't she retiring to a nunnery? . . ."

". . . virile as a soaked spaghetti . . ."

". . . it wasn't Sforza at all. It was the Duke's own brother. Cesare hated him because Gandia was the Pope's favorite."

"No. No! It wasn't Cesare either. It was one of the Orsini. They have good reason to hate a Borgia."

"Beh! There are more good reasons for that than daggers to fulfill them."

"Have you heard that Gandia's ghost appeared last night in Cesare's chamber? and he was lamenting fearfully? My cousin's nephew —he's the dustman at the Vatican—said . . ."

The voices hushed, took on an apprehensive tint. The people of Rome believed this Pope to be surrounded by infernal powers. How else explain the peculiar cosmic events of his pontificate?— The great flood of the Tiber which two Christmases before, shortly after the departure of the French troops, had inundated half of Rome, so that Cardinals were seen everywhere comically lifting their soutanes, stepping into boats moored at the palace doors. The lightning bolts which repeatedly hit the angel Michel atop the Castel Sant' Angelo—oh surely these were all signs of celestial anger. Perhaps the Pope was, as many alleged, the Devil himself who had

managed to insinuate himself into the highest spot of Christendom. Perhaps beneath those robes there was a forked tail?

Andrea felt his arm struck. A woman was fervently crossing herself. On the far side of the Piazza, diminutive, in the sweet perspective of distance, the black coiling procession was slowly being swallowed up in Santa Maria del Popolo, black-domed against the dusk. Alongside the church, the curious crenelations of the gate looked strangely like a line of decapitated knights.

Listening to the speculations of the crowd, Andrea remembered the corpse he had seen thrown into the Tiber two nights ago. That might very well have been the Pope's son! Oh, he had better forget what he had seen. The Pope's own favorite son, and he, a Hebrew, there! The story was—the crowd was a froth of stories breaking over him—and Andrea began apprehensively now to shoulder his way out—that the evening before the discovery of the body, the Duke's servant had been found mortally wounded in the Piazza of the Jews whither the Duke had gone on some mysterious errand, some said whoring . . . At the *Piazza of the Jews!* Oh, it wouldn't take too much to put it all together, Andrea thought—and his skin prickled at the thought—the Duke's man discovered in such a place, and he, a Hebrew, at the scene when the Duke was tossed into the river. If that woodman talked . . .

Nervously he eyed the crowd. They were continuing to chatter, mingling into one torrent the streams of their ignorance and certainty, superstitions and fears, indifference and jubilation. But dominating all—as a river takes its color from the day—was a holiday mood. The procession was just tail-ending its way into the church: now the bells were tolling, a mournful chiming inter-threading the dusk, the shuffling feet, the chaffering of the crowds, the last torches. Andrea's shoulders ached. The bed at the Seven Milkfed Virgins had been designed for saints desirous of martyrdom. And the riot of bedbugs. And all that long sleepless night imaged with the splashing corpse and the figure heaping stones upon it. To think it might very well have been this Duke . . .

He had better be on his way. There were Bartolomeos everywhere.

Walking past what seemed like a forest of columns, Andrea realized why the gateman had given him such detailed tedious instructions; otherwise he would never have been able to thread his way through this labyrinth of a palace to Michelangiolo's quarters. For

this was the hugest palace he had ever seen, huger than anything in Fiorenza, in dimensions it matched the Palace of the Doges at Venice. But it utterly lacked the coral and lacy grace of that dream on the lagoon: this square mass expressed, Andrea felt, power, only power, unadorned, and even unostentatious: you would have taken it as the seat of a merchants' organization, a Podesteria, anything but the private residence of a Cardinal.

So this was where Michel lived. Not like that simple stuccoed house on the Via Bentaccordi. From there he had gone to the Medici Palace. From the Medici Palace to here. He must already be accustomed to surroundings of great wealth. Would he still be friendly? They had not seen each other for more than two years. Ah, here was the corridor, now left to the bust with the chipped nose, then left again.

Andrea was surprised. Apparently Michel had been assigned a studio room in the servants' quarters. It was anything but elegant; he lived in the flank of the huge gray Palazzo Riario like a flea in the hide of a maharajah's brocaded elephant.

The door was ajar. Andrea stepped in without knocking. A large high-ceilinged room flooded with light through two uncurtained windows. On a cot, face downward, Michel was sleeping with dirty boots on the rumpled sackcloth. He was breathing heavily; Andrea decided not to wake him. He looked around the room. It was bare as a monk's cell: a table, some plain wooden chairs, and in the center, a round sculptor's stand, on it an almost completed Cupid, life-sized, kneeling, of white marble. The Cupid wore, in this city of the Borgia, an expression of the purest innocence. Against the wall leaned a wooden panel on which was a sketch of St. Francis receiving the Stigmata; and another piece of sculpture, half-blocked-out, pinker stone, a standing figure apparently; Andrea could not make out what it was intended to be.

The young man on the cot groaned, turned over, his arms flailing like a slow windmill. He had grown older, his body was thicker, Andrea saw. The little fuzzy forked beard, though still sparse, succeeded now in shadowing the stubborn lower lip. He seemed to be in pain as he slept, his brow was furrowed, the little beard twitched around his mouth. One hand clutched the rough-spun stuff of his tunic, the other hung in a fist, tremulously, over the edge of the cot. The fist seemed to have a life of its own, twitching in a rhythm separate from the rest of the body.

Andrea sat down quietly and waited. As he shifted in his chair, he heard the crunching sound of marble dust underfoot. It lay

like snow in the center of the room. At the foot of the sculptor's stand, and here and there amidst the powdery whiteness, were chunks of stone three and four inches wide. Lying on a chair by the stand were a dozen chisels of various widths, a drilling bow, a wooden mallet, and a pair of calipers.

Now the twitching of the sleeping figure diminished; the furrows in his brow smoothed themselves out, the breathing—which had been irregular—fell into a slow oceanic rhythm. The nightmare, whatever it had been, must be over. Better let him sleep, Andrea thought; and he rose and tiptoed across the snowy crunchy field of marble dust to the Cupid and examined it. It was a more ambitious piece than anything Andrea had seen thus far of his friend's work. Except for the back of the head it was almost finished. Did he intend, he wondered, to polish away those fine cross-hatchings that surfaced the entire figure? He hoped not; and walking around the figure he saw how the light was captured in those tiny hollows, that myriad of dimples, diffusing a soft luminous veil over the form, softening its saliences, warming the shadowy recesses. It was the same cross-hatching Michel used in his sketching, Andrea thought, remembering with a glow those afternoons together in the Piazza dei Priori or the Bardi Chapel of Santa Croce, where Michel had so wondrously copied several of Giotto's figures leaning over the bed of the dying Francis—it was the same cross-hatching he used in order to make a drawing emerge in the round from the paper. And it had been a mistake, Andrea realized now, to have polished that Samson the way he did; Andrea had thought it was wonderful to see the muscles gleam but now, his fingers feathering this Cupid's shy stony flesh, he realized it would have been better to have left the Samson rough. And certainly more in character. To think of that marvel radiating its white force in the pungent blackness of Messer Buonarroti's wine cellar! No wonder Michel had come to Rome. With such a father . . . and the darkness rushed to his eyes . . . Where was Father now? Where was Tsiporah? Where—?

Trembling, he turned, a chunk of marble cracked underfoot. Michel groaned and opened his eyes, then startled at the unexpected sight of a stranger in his room, he sat up in bed with a frightened cry. His head was splitting with the habitual headache that almost always accompanied his sleep. He had been dreaming that he was imprisoned in the white heart of a mountain and he was trying in panic to chop his way out but the anguished passageway always fell upon his head and outside the mountain he knew there was the love that moved the stars but inside all was whiteness and terror, tons of

whiteness on his head, and he would not be admitted through the city gate without the proper red seal on his hand and he smashed his hammer down again and with a crack the corridor collapsed . . .

They ate at a tavern near the Settimiana Gate in Trastevere, one of the most ancient sections of Rome. Strolling through the dark labyrinth of narrow streets, past brick palaces, small miserable houses, pre-gothic basilicas, Michel kept up a steady bombardment of questions. How was his father? How was Narro getting on at the warehouse? How was Giovansimone behaving? It was impossible for Andrea to dike this flood of questions. When at last he managed to explain that he too had been away from Fiorenza almost two years, and had spent merely a day there in passage, Michel was disappointed.

In the tavern, which specialized in fish, and was thronged with a crowd of wine-guzzling swearing Genovese boatmen who occupied the quarter, Andrea, cheered by the effusiveness of Michel's greeting, wondered whether he might not give him the letter tomorrow. No one wants to be a bearer of bad tidings. But he had to, Michel was asking point-blank if he had brought any messages. He reached into his tunic and took out the letter.

"From my father?"

"From Narro."

He studied his friend's face as Michel broke the seal and read the letter. He had grown older, more sunburned, new lines were engraved around the eyes. And there was something that Andrea couldn't define, an impenetrable something, a warmth that did not permit you to get too close, like the warmth of a fire, perilous to touch.

"I am sorry," Michel said quietly, as if to himself. "My father must be lonely now."

"I didn't see your father. Narro told me the news."

"I must write him at once. But I hate to write letters. I have troubles enough of my own."

Aside from those few remarks, he evinced no sorrow on hearing of the death of his step-mother Lucrezia. His face had grown a shade more sober, that was all; and after a moment's silence, he shifted the subject. What were they saying back home about Fra Girolamo? Here—and he launched into a mocking account of the various spectacles offered by the Borgia circus. While he talked he dipped his country bread into the bowl of steaming fruit of the sea, while

all around them in the candle-smoky air, the Genovese roared. Every once in a while, one of them would, with an affectionate slap on the shoulder, hail Michel. Apparently he was well-known here; secret jokes passed between him and some of the men; and seeing him wiping his little beard, and laughing in this brawling company, Andrea felt like an intruder. His friend was talking about his first year and a half in Rome. The indifference of the Cardinal Riario, his new good friends Baldassare Balducci and the banker Gallo, the Cupid he had almost finished, and the Bacchus underway. . . . But never once did he think to ask Andrea about *his* affairs. Listening to him now, observing the play of expression on that mobile face, the sharp staccato gesture-bursts, the muscular bunched shoulders, Andrea felt encamped outside his friend. He has grown harder, he thought with a twinge of hurt, he is enclosed like a city within a wall of self. Why, he hasn't even asked once why I have come to Rome, what I have done these past few years, what *my* plans are. He is interested only in himself, his own family, his own ambitions.

And that scornful laughter!—he swings it like a broadsword.

"What? . . . the funeral? . . . Porca miseria! . . . I never watch them carting away trash . . . Who knows? . . . Any one of a dozen . . . No?! Davvero? . . . You really saw them toss it into the river? . . . Well, I'd keep my mouth tight bolted. . . . Oh, it's all right here . . . these people are my friends . . . But you'll have to learn when you can and when you can't. Rome is overrun with spies . . . It's not Fiorenza, amico mio, the air in this town is fetid . . . è una sporchezza . . . But you learn to breathe it after a while . . . What? You're thinking of departing already? . . . But why? You just came!"

It was the first indication of genuine warmth. Andrea felt happier. He told Michel of his fears. It might be unsafe to stay because of where the Duke's man had been found murdered . . . Another Bartolomeo . . .

Michel laughed. "Oh, no! Not here. Nobody takes a murder that seriously. But I'd carry a misericordia if I were you."

"A misericordia?"

"Yes . . . a lingua di manzo . . . a beef tongue . . ."

Smiling at Andrea's puzzlement, he unbuttoned his tunic and withdrew a thin Armenian dagger, six inches long. The silver tongue of the blade gleamed in the candles. "It's not my craft," Michel said thoughtfully, looking at the blade. "But there are times when you have to draw with this kind of a pen."

VI

He decided to stay. Despite his fear, despite the troubling change in his friend. What convinced him finally was the discovery that Rome, with all its violence, might prove a refuge. He was circling the massive Theatre of Marcellus, and behind the amphitheatre came upon a marvelous white archway flanked with crumbling columns. It was the Arch erected by Octavian for his sister. Passing through it, Andrea knew at once he was in the quarter of the Hebrews. Not that anyone wore yellow caps or bore the yellow O upon their tunics. But he knew it by the names the children were calling each other—Davide and Isacco and Dattilo and Moshè—and he saw it in the brooding eyes. On these streets were meditative strolling scholars like Master Elia and work-worn shoulders like de Cases'.

A garrulous old man spoke freely to him of the community. The Borgia Pope was not unfriendly to Jews; indeed he was at times *too* friendly. Andrea regarded the old man wonderingly. Ah, but you do not understand, the old man said, the Pope *forced* us to take in thousands of those Spanish newcomers. And how could we explain our cautious reluctance? How would we tell the Pontiff that an influx of these foreigners would arouse the latent hatred of the Christians against all of us, even though (and the old man's thin lips pursed with pride) we have been here in Rome before they were even Christians.

A strange community, Andrea felt, strolling the redolent streets. These burly boys might have provided the gladiators that fought the wild beasts in the Colosseum, and some of them might be descendants of the captives Vespasian and Titus brought back from the Holy Land. This afternoon, from the Palatine Hill, Andrea had looked upon the victory arch through which those stiff-necked rebels had been forced to march. Yes, these Jews had been Romans long before Borgian Popes . . . who were not Romans at all. Perhaps it was not so surprising therefore that in the instance of the Spanish exiles, the Pope stained with so many crimes, should have been on the side of mercy.

But he could not help wondering cynically whether another explanation might be the crass desire to have available a larger res-

ervoir of moneylenders—the only moneylenders permitted in Christendom—to help finance one's courtesans and crusades, a reservoir of ready money into which Christian hands might dip without fear of usurious stainings.

But whatever the reason was, Alexander VI was not unkind to the Jews, and so Andrea decided to remain in Rome. But he would not live in this Giudecca. A time for walls and a time for the breaking down of walls. Even invisible ones.

He asked Michel if he might stay with him for a while. But Michel could not put him up. Indeed, he was planning, as soon as he could do so diplomatically, to decamp himself from the Palazzo Riario. Meanwhile, he helped Andrea find quarters at the Albergo del Montone across the square from the Pantheon. The hotel was a four-storeyed round-windowed structure, painted chrome-orange that contrasted brilliantly with the grayblack austerity of the magnificent ruin nearby. Andrea was delighted to be living here: the daily presence of that ancient temple, now converted into a church, compensated greatly for the loneliness of spirit he felt these first few weeks in Rome. He was troubled by Michel's aloofness, he was searching for an atelier in which he might apprentice himself. And he was lonely, terribly lonely. It was difficult to resist the temptations of the prostitutes who haunted the Pantheon like the cats. But Andrea knew the penalties meted out to Hebrews caught in fornication with Christian women. It was not likely that any of these women were Jewesses or Moors or Saracens. When he came across one, he silently vowed, he would lie with her. There was one girl who might possibly be a Tartar: she had slightly slanting eyes and high cheekbones and she walked like the cats in the moldering moat of the Pantheon. But Andrea had not yet summoned up sufficient courage to talk to her. By the end of his first week at the hotel, he and the girl had formed an eye-acquaintance. She would glance at him so boldly that after a moment his eyelids fell and he would walk past her in a half-blind confusion. Once he heard her soft mocking laughter behind him.

He spoke to Michel about the girl.

"Oh, the town is filthy with them," Michel said. "Every whore on the shores of the Mediterranean has drifted here. No wonder Rome is called the sink into which all filth flows. Have you seen the Cloaca Maxima yet? . . . No? . . . It's the great sewer built by the ancient Romans and it's still used. If you stand on the Pons Aemilius you can see the pipe discharging into the Tiber. Creates a whirlpool

where the two currents converge—the current of sporchezza and the river. And that's how it is with these puttane—they create whirlpools of filth all over the city."

As for female companions, Michel's invariable reply was: "I have my art. She's mistress enough for me."

It was curious. Had anyone else said it, Andrea would have been skeptical. But he knew that Michel was not lying. He had always evinced a singular oneness of resolve: a dry hard willfulness that reminded Andrea at times of Master Elia. Contrasted with Michel's austerity, Andrea was all the more aware of his own voluptuous nature. Indeed, Michelangiolo was strangely unlike the other artists Andrea had known in Fiorenza or Venezia. All of them without exception—Francesco Granacci, the Masters Ghirlandaio, the Master Sandro, the Venetian Sebastiano—why, even dolce-far-niente Iacopo —all of them responded as Andrea did to the bright-colored garment of the world—the hues, the textures, the smells—with all their senses quivering.

But Michel seemed more like a philosopher than an artist: his world seemed altogether gray: an abstract space filled with relationships and moral precepts: a hard rocky landscape formed of Euclidian and Savonarolean peaks and valleys: No brooklets ran through this dry lunar land, no birds sang there, no fanciful rabbits and dancing maidens gamboled in its groves as they did on Benozzo Gozzoli's painted walls or even amidst Paolo Uccello's curious perspective-battles.

A dry man, Michel, sometimes surly, frozen at times in an ice-bound isolation. And then he would be laughing with almost hysterical shrieks at one of Iacopo's remarks. Andrea was delighted to see their old friend again. He was the jovial shadow to Michel's dour reality. They met again in the restaurant frequented by the Genovese boatmen. Iacopo was waving a fish-skeleton like a prickly baton and singing in a loud voice. Across the table Michel spluttered with laughter. Iacopo's face was rounder than ever, he seemed incredibly to have packed more freckles into his cheeks, his tempestuous mop of hair seemed more carrot-colored by contrast with the green Phrygian stocking cap he now wore. His voice greeted Andrea like the rumbling of an empty barrel.

Perbacco! It was wonderful to see Iacopo again! A necessary touch of earth, his occasional pictures blossoming out of his laziness like wild flowers. He was working with the Pollaiuolo brothers here and he promised to introduce Andrea into the shop. Michel said he would stand sponsor.

One day they were all in Michel's studio, helping him to gather his few belongings together preparatory to moving to new quarters. Messer Gallo was sending a cart for the Cupid and the blocked-out Bacchus. Michel would complete them in the banker's garden. Iacopo picked up the drawing of San Francesco receiving the stigmata which Andrea had seen on his first visit.

"Where shall I put this?" Iacopo yelled across the room.

"—What?"

"—This San Francesco." He examined it with cocked head, making snorting sounds as he did so. "A first-rate copy, do y'know, really fine."

Michel turned around, a bundle of old clothes in his hand. "What do you mean, copy?" he said, with good-natured indignation. He sketched rarely from models now, and prided himself on his originality.

"Why, isn't this Ghirlandaio's San Francesco? The one on the upper left wall of the Sassetti Chapel in Santa Trinità? We studied it together, don't you remember?"

"Let me see that," and Michel glanced at the drawing for several moments, then he smiled. "Strange, I drew it without even realizing that I was copying a memory in my head."

"Oh, caro mio," Iacopo said, "I'm not criticizing you. I'm all in favor of copying. Better to take one's composition from an accepted masterpiece than rack one's brain creating a new one."

"Ah, but that's just being an artisan," Andrea put in. "The artist invents, the artisan copies."

"The artisan lives longer too, I'll wager," said Iacopo. He began to wrap the wooden panel in a pair of dirty long hose.

"Oh, leave that here," Michel said. "I promised it to the Cardinal's barber. He likes to color things."

VII

The Cardinal Riario was unaware of Michel's departure from his household. His early interest in the young sculptor had swiftly been swept aside in the rush of events this past year: in the wake of

Charles the Eighth's departure a hundred dogs of discord had been unleashed in the Papal City: Colonna fought with Orsini, the throne of Naples was a bone gnawed at by Spain and France, and through this field of ravaging and tearing, the Borgias roamed, most violent beasts of all. The Cardinal had been quite sincere when at his first interview with Michel he had promised him commissions, especially the Minerva he so sadly lacked; and as evidence of his good faith, he had summoned his Maestro della Casa immediately and had the young man added to his household budget, listing him among the domestic servants. And then like so many cooks, so many barbers, so many candle-makers, Michelangiolo was forgotten in the shuffle and bustle of the huge palace. He was paid a regular stipend and once in a while he even saw the Cardinal who nodded to him with the distant absent friendliness reserved for household servants.

Michel was irritated; but had he considered the matter, how could the Cardinal think of him? Surely, he had much more serious concerns to think of, this year of Our Lord, Fourteen Hundred and Ninety-Eight. Cardinals were dying at an astonishing rate—especially the rich ones—and their property, real and movable, somehow wound up in the coffers of Alexander. There had been the Cardinal Giovanni Sclafenato, who passed to a better life last October. Of malaria. There had been the Bishop Duerkop; and the Bishop of Cortona, and there had been the Cardinal Zeno, and Fregoso— All suddenly among the blessed; and their terrestrial vanities—the dust and nothingness of real estate and brocades and statuary and gems—all sequestered by the Vatican in the interests of keeping the legal heirs from being corrupted by so much wealth.

And what was also most disturbing, the Cardinal reflected—such troublesome reflections coming upon him even as he laughed at a silly plotted play of Plautus in his courtyard, or strolled meditatively between the spacious boxed bushes of his country villa—what was most disturbing was the surprising number of prelates who were being discovered these days to be hidden Jews—Marranos. Why, a very nest of vipers had managed to crawl into the paradisiacal garden of the true faith. How terrible to think—how unbelievable —that beneath the mitre of the Very Reverend Bishop of Calahorra (one of the Spaniards, too! formerly master of the Pope's own household) had recently been revealed the leering face of a Hebrew! He was in the Castle now and the Pope had confiscated his huge fortune. Which was only just. But what was truly appalling were the many other ecclesiastics accused of the same crime—hidden Judaism. God

be praised, a number of them had offered tangible evidence of their innocence in the form of large payments. The erstwhile Archbishop of Cosenza was also in the Castle, in the dungeon, went the rumor—after having confessed to forging briefs of dispensation. The Archbishop was said to be well on his way to a better life.

So, with all this on his mind—for the Cardinal Raffaele Riario had no intention either of dying or offering pecuniary proof of *his* Christianity—and what with the price being paid for red hats these days, and the white powder that seemed to be, even if it was not, dissolved in every cup from which he drank, it was not surprising if Riario was unaware of the twenty-two-year-old Florentine stonecutter who happened to live in a corner of his palace.

He was too much in the know—that was it. While an obscure little stonecutter was at the periphery of events—feeling the ripples only after their force was spent—Riario like Vater Burchard was in the boiling center of the pool. For example, when Michelangiolo heard of the annullamento granted to Lucrezia on the grounds of her spouse's impotenza, that was something that he together with all Rome could laugh about. But poor Vater Burchard had to find a way of writing down such an event with invisible ink in his Diary; and the Cardinal who was close enough to the Vatican to observe with his own eyes Lucrezia's obvious pregnancy at a time when she was officially being declared a virgin—ah, it was much harder to control one's laughter in such a case. Riario had voted for the annulment together with the other Cardinals. They were great secular lords with some holy trimming—they could not help—any of them—being buffeted by the full force of events.

It was not Michel's way, as it was with so many artists, to measure his years by his accomplished merits. He possessed the supreme art of knowing when to wait. For he knew that those sleeping figures, about which he had spoken to the Cardinal, lay not only in the white mountains of Carrara but in the white cells of his brain; his hand only obeyed a secret summons; and what was carving in his mind had to be carved without clamor. So, Michel, driven and demoniacal as he was when the mallet was in his fist and the marble chips flew, was also capable of long periods of stillness; then he would await mysterious steps coming toward his chamber, potent and fruitful, and he reclining in a wise womanly passivity. He knew periods in which his hands rested idly in his lap and there would be a curious languor about his person. At such times he would stay in his room and read Dante or try his skill at sonnets, none of which

satisfied him, or wander idly through the streets of modern or ancient Rome. The Forum was a favorite haunt. Sunsets, he would sit on the broken head of a gladiator and let his gray eyes glaze slowly over the eloquent wreckage. The cats knew him as a fellow haunter.

But at the same time he was young: and to be young is to be impatient. Curious that those richest in time are most niggardly in wasting it; those farthest from the grave act as if they were ever tottering on its brim. "I am almost twenty-two and what have I accomplished?" . . . A familiar complaint. The old, whose savings-balance of days is almost depleted, spend time like wastrels; while the prodigal young rush frenziedly about, squeezing the interest out of every moment as if they did not have a lifetime ahead for serener investments.

And so Michel. Periodically, the cycle of his somnolence was irrupted by a hard driving impatience. He had been in Rome almost a year and a half, and the Cardinal had failed to commission anything, and the promise of Piero de' Medici proved even as watery as his snowy Hercules, and back home Lodovico's chief concern was that stupid lawsuit with the merchant Consiglio, and if it weren't for Messer Gallo, life would be without purpose.

He was angry at the Cardinal. But could he share for a moment the Cardinal's preoccupations, he might have been less carping. They occupied the same world, ten celestial spheres above and seven infernal circles below; they lived in the same city, they were even, if at remote social corners of it, in the same palace. But one was a planet and the other was a speck of cosmic dust: and though their orbits inter-ringed, traversed the same space, they did not touch. Red as Mars, the Cardinal's world revolved around personal and financial survival in a field of high and perilous politics. There was the incredible desire of the Cardinal Cesare Borgia to be depurpled —so to speak—released of his priestly robe so that he might wage more effective war as a secular lord. There was the ambiguous role being played in France by Riario's relative, the self-exiled Cardinal Giuliano della Rovere. Rovere had goaded the French King's invasion into Italy, detesting a Borgia Pope even more than he loved his native land. But now Charles was dead and Rovere was blowing less hot against the Borgia. A reconciliation was even possible. There was this mad monk up at Fiorenza—still preaching despite the Holy Father's interdict. There was Piero de' Medici, still hopeful of resuming residence and power in the palace on the Via Larga from which he had been booted.

Minervas indeed! You needed more wisdom than the contemplation of any naked Greek goddess was likely to offer. Merely to survive.

VIII

When Pasquino laughed you could hear the echo all over Rome. He was quite a wit, this battered old statue. Out of his mouth that was practically no mouth at all flew barbs that drew blood in the farthest and highest places, and though time had abrased his torso into a smudge of a man, you knew, looking at him on his pedestal, that he must have been magnificent in the Rome of Marcus Aurelius. Now he was the chief gossip of Rome.

Andrea had arranged to meet Michel and Iacopo in front of Pasquino. It was a favorite gathering place because here you heard the news. Pasquino's gray stone bulk was always adorned with a fluttering of broadsides, atrocious puns (usually in Latin), lampoons, epigrams, insults, jibes, rhymed ridicule. Pasted on his pedestal, on his truncated limbs, on his backside, the papers rustled like dry leaves on a gray old tree; you could almost fancy that Pasquino was whispering his delightful maliciousness.

Issuing from his hotel into the lovely end-of-May sunshine, Andrea paused as always to gaze wonderingly across the square. He was still living in the four-storeyed old hotel Mentone on the Piazza del Pantheon which Michel had found for him. It was a dreary hotel, inhabited by traveling merchants, farmers, commission agents, representatives of Pisan banks, and a number of bedbugs of endless variety. But Andrea was happy in his new quarters—bedbugs and all —because every time he stepped out the door, he was greeted by that magnificent ruin across the square.

The Pantheon amazed him. A giant Polyphemus of a building with its single great eye in the dome, alive to every weather. Andrea spent hours in its circular marbled interior, staring up at that hole in the ceiling whose pictures no painter could outdo—scudding white clouds and blue blue Roman skies in a tondo frame, the orifice sometimes lanced with the black streak of a passing bird. He seldom

failed to step into this church, once a temple of all gods but his own and the Christians'; he was there on days when a bright brush-shaft of sun painted a perfect O on the pavement; and he was there on rainy days, when the rain streamed down from the hole in a fasces of brightness, a sheaf of silver threads incongruously inside the building, collecting in the drain.

But today there was no time. He glanced swiftly at the round columnar structure brooding upon itself like a coiled cat. In the sur-rounding moat a hundred real cats lurked, leaped, wound sinuously about the bruised stones. Wherever there were ruins there were cats. Their eyes, timeless as the stones, had looked upon Roman and Goth as now they looked upon Andrea. He felt toward these Roman cats a kinship he had felt with the swallows over the Arno. His people, like that orange-eyed tabby gliding over the gray fluted column, were also contemporary with Pharaoh and with Caesar.

Passing the Pantheon, he heard a hiss. It was the puttana with the Tartar-eyes. "Bel giovanotto," she said with a peculiar singsong intonation, "you walk like the wind."

"I have an appointment."

"I am always here." She leaned against the column, hips thrust forward.

"I know."

She touched fingertips to her forehead and salaamed slightly in salute. At any rate, she is no Christian, Andrea thought, heart pounding, remembering Michel's story of Cursetta and the Moor. Perhaps—

But he hurried on. He feared being late. He remembered vividly his friend's irritation when he had come running breathlessly to Antonio Pollaiuolo's workshop. Michel was standing sponsor for his friend's apprenticeship and now his friend was proving irresponsible. Michel felt humiliated in the older master's eyes and he hissed his displeasure as Andrea gazed enrapturedly about the workshop—the great blocks of partially unhewn statues half discerned like figures in mist, the silver chandeliers proportioned like crosses, the painted wood-panels leaning against the walls, the apprentice boys strad-dling wooden three-legged stools as they ground pigments in wooden bowls, singing as they scraped, and all this atmosphere permeated by the wonderful pungent smell of oil and gesso and Levantine mastic. It was a kitchen of art, a brews of marvelous creations. Yes, he was grateful to Michel for having gotten him enrolled there, eternally grateful despite Michel's new mood—his Roman mood—of being scraped down to the quick. He flared so easily.

From the scented shadows Iacopo appeared and lent his grin and his pen to the contract. Old Master Antonio, energetic at sixty-eight, asked several questions but fortunately not too many. Nervously Andrea listened as Michel grumbled the excellences of his friend. Master Antonio was willing. He had so many commissions that he was happy to enroll any assistants he could get. He was one of the most successful artists in the Holy City; he had come to Rome many years ago with his brother Piero at the invitation of Pope Innocent VIII. But his speech was still Tuscan and his happy disposition contained a bite. Michel had known his distant cousin, Simone, called Il Cronaca, at Fiorenza; they had stood a committee together and when Michel came to Rome he bore a letter to the Pollaiuolos. He found Master Antonio assuaging his grief over the recent death of his brother Piero by engraving with cold cutting fury on a copper plate. The subject was one of his favorites (he had already executed it numerous times in low relief, in bronze statuettes, etched or drawn)—a combat of male nudes. The writhing furious figures, the sinuous flamelike line without a trace of suavity, the burning bush of pubic hair, the harsh strained style spoke to Michel. It seemed true as the stretched-out corpse on Master Elia's trestle.

In Pollaiuolo's workshop Andrea was now perfecting the elements of the art he had learned in Venice. Sometimes he troweled in the wet intonaco on which the fresh colors were to be applied. Sometimes he pricked the great paper cartoons which the Master had prepared; and later helped to transfer the design to the wall by tamping powder through the pricked drawing.

Usually he worked in the redolent workshop near the Piazza del Popolo, but frequently, too, he had to work in the various Roman churches where most of the frescoes were being installed. And whenever, with his joking band of fellow-apprentices, Andrea entered a church, he felt a twinge of guilt. As his skill grew, he was permitted to paint the halos on the heads of Christian saints. Once, assigned such a task in San Pietro in Vincoli, he grew dizzy on the scaffold and almost fell. He thought he felt his father's scorn burning down on him—an Eye in the realm of absence thick as death.

"Dear son, don't neglect to heap plenty of gold upon that halo. More! More! Heap up the gold so that it is thick and real and sits like a plate on your Saint's head. A real plate reflecting the bald top of a real head. Not like Master Sandro's gossamer halos that even I learned to admire at the Magnificent's palace: those fragile cobwebbings, those golden aureoles, those spiritual vibrations. No, my dear boy, if there is to be an image, let it be a material one—no

half-hearted compromise between Flesh and Spirit . . . that's it! another flick of carmine, more blood! more blood! You can't stick a man full of arrows and expect him to remain dry as a pincushion. See how ecstatic he stands—your Saint Sebastian—bound against the tree, full of arrows, and my son's gold plate so neatly balanced on his head! . . ."

Then a great wave of darkness fell over Andrea and he felt the scaffolding shiver. From behind the altar came the murmur of mid-day prayers, like bees. Father's Eye had vanished and now, orange-irised in the vaulty gloom, there was the Eye of Bartolomeo.

Mockery.

Fortunately, these terrible visitations were infrequent. For the most part, Andrea was happy in his craft and happy to be near Iacopo again. He had hoped to see more of Michelangiolo. After a day in Pollaiuolo's workshop, he used—sometimes with Iacopo, sometimes alone—to explore the city. But Michel was seldom the comrade of these wanderings as he had been at Fiorenza. For not only was Michel more occupied—he was working steadily at his Bacchus now—but he had changed. Oh, he was pleased, Andrea felt, that they were once more together in the same city. And yet there was an aloof-ness: Michel was so furiously tilling the garden of his ego that he seldom issued from the enclosure. And his humor had a new acidu-lousness, Andrea thought, as if it too had become corroded by the all-pervasive vice of the Borgian city. He was in his work as in a cave. When he did emerge, he seemed to prefer as companions the most ingenuous people—a coachman, a stonecutter, a barber—anyone who could make him laugh, simple folk with whom he himself could be simple.

Of course, his favorite here as in Fiorenza, was Iacopo l'Indaco. But Iacopo was not so simple, Andrea soon realized. That ready laughter was a shield. And though you would not suspect him for an artist—he fancied the Phrygian fisherman's cap almost always—Iacopo was really very talented. Master Antonio sought his aid in the most complex undertakings. But Iacopo hated to work. "It's not Christian to do nothing but work, eh Andrea?" he used to bellow in front of the apprentices to the accompaniment of a slow gravid wink. Andrea would blush furiously—asking *him* what was Chris-tian!—and then laugh. He could understand Michel's love for this man. Though he was clumsy-moving as a peasant stomping in a manure-pile, though his hair was a sunset-lit scattering of carelessly tossed hay, though his nose was the dip in which sat Fiesole—his

eyes were the most honest blue. And whenever Iacopo smiled—and he smiled often—his upper lip became a bird in flight, shaping itself exactly into a pair of broad powerful wings. Then you saw his inner grace.

Now, crossing the Corso toward the Palazzo Orsini near which Pasquino stood, Andrea could spot Iacopo's bright green stocking cap dancing in the knot of people that always surrounded the garrulous statue. Michel was beside him, and as soon as Andrea appeared, the sculptor said eagerly:

"You read Latin, vero?"

"Sì."

"You see," Michel said triumphantly, turning to Iacopo. "Now we shall know what he was chuckling about."

He explained that only a few moments ago, an elegantly dressed nobleman had appended several epigrams to Pasquino. Unfortunately the epigrams were in Latin and today's crowd being plebeian, there were no Latinists among them. The nobleman had disdained to offer any translation.

"What does it say? What does it say?" the crowd was shouting impatiently. Apparently they had all been advised by Michelangiolo and Iacopo that a very learned young friend of theirs was coming along any minute. Michel pointed to a long sheet of paper fluttering from Pasquino's battered nose. Andrea read:

> *Vendit Alexander claves, alteria, Christum:*
> *Emerat ille prius, vendere iure potest.*

> *De vitio in vitium, de flamma crescit in ignem,*
> *Roma sub hispano deperit imperio.*

> *Sextus Tarquinius, Sextus Nero—Sextus et iste:*
> *Semper sub Sextis perdita Roma fuit.*

He hesitated. The ring of faces were eagerly waiting, expectant. This was pretty strong stuff, Andrea thought. But *he* had not written it. Besides, only his friends knew about him and his friends could be trusted. Aloud, he translated:

> *Alexander sells the keys, the altar, Christ himself:*
> *He has the right to sell; he bought them first.*

> *From vice to vice, from flicker to flame,*
> *Under the Spaniard Rome shall lose her fame.*

> *Sextus Tarquinius, Sextus Nero—now another Sextus*
> *Always under the Sextuses Rome is ruined.*

The spectator-ring tangled with laughter.

Michel was pointing to another sheet stuck to Pasquino's backside. "And this one? What does this one say?"

> *Hac Ianus Baptista iacet Ferrarius urna*
> *Terra habuit corpus, Bos bona, Styx animam.*

"Here lies Giambattista Ferrari," Andrea translated. "Earth has his body, the Bull his real estate, the Styx his soul."

"Magnifico!" spluttered Iacopo. ". . . *the Bull his real estate, the Styx his soul!* . . . I'd give my balls to write a sentence like that!"

The Cardinal Ferrari of Modena, Treasurer of the Church, had died recently, yielding the Pope fifteen thousand ducats in money alone. Poison, the famous white Borgian powder, was suspected. The avaricious Cardinal had amassed enormous wealth during his tenure. It was indeed necessary, for the health of his soul, to remove him from such temptations. Pasquino's auditors were overjöyed. This Roman mob, Andrea had already noted to his distaste, was not outstanding for its civic integrity. But it seemed to delight in ridiculing the depravities of others, particularly in high places. These Romans, Andrea thought, looking at their crude red faces tipped back like wine jugs pouring laughter, had not dreamed of rebellion since Rienzi's day; and now Pope Alexander's bread and Cesare's circuses are siphoning off whatever traces of rebellion remain. But here around the hulk of Pasquino their lurking sense of guilt is releasing itself in cowardly joy at anonymous jibes. They loved particularly any references to Bos—the Bull—favorite symbol of the Borgias. The Pope had adorned his own apartments with the device: it expressed his undeniable virility.

Iacopo wiped the laughter from his eyes. "Oh, I wish I had the patience to learn Latin," he cried. "The trouble is that every time I so much as look at a grammar, I get a terrible headache . . . Right here, behind the ears . . ."

"I might have mastered it," Michel said regretfully. "My father sent me to a learned notary to study. But even as a boy, all I wanted to do was draw."

"Ah, how I wish I had drawn then instead of parsing Cicero," Andrea said. "I might have been further along in my craft now."

"But in that case who would tell us what Pasquino is saying?" Michel said with a feathery smile.

IX

That night, Pasquino's anti-Borgian jibes still ringing in his ears, Michel had a strange visitor. Exactly at midnight like a ghost, his older brother Lionardo appeared. He was not wearing his black-and-white Dominican frock and hood but a threadbare rust-colored cape and long black hose that hung loosely on his bony knees. The cape awakened vague memories in Michel, a warm cozy feeling he could not place. Lionardo's pale cheeks were dirty and smudged with a week's beard; his eyes were troubled.

"Have you left the order?" Michel asked after he had recovered from the shock of this apparition.

"No." Lionardo glanced suspiciously around the simply furnished room still piled up with drawings and stone blocks from the recent move. He had first gone to Cardinal Riario's palace and learned of Michel's new address. Satisfied they could not be overheard, yet dropping his voice to a whisper, Lionardo said: "It wasn't safe to be seen as a Dominican. I hid at home for three days and then Narro gave me his old cape."

"Hid? Why?" Lionardo was sitting at the edge of the bed, wringing his hands in a dry obsessed way, and now at Michel's question, he stared at him uncomprehendingly.

"Then the news has not yet reached Rome?"

"What news?"

"You do not know?" Lionardo murmured as if there were no need to tell this news, it was in the very air, one breathed it in.

"What are you trying to tell me, brother?"

"Fra Girolamo has been hanged."

The phrase struck Michel between the teeth. He stared dimly at his brother, swaying slowly, pendulum of grief, hanged corpse in the wind. His eyes, pious marbles, rolled whitely to heaven; he was crossing himself. ". . . among the holy martyrs, among the blessed . . . After the body was burnt . . ."

"O Dio mio!" Michel cried. A wave of blackness shook his frame, a ringing was in his ears and over it the thunderhead of the Dominican, soaring hawk in gray spaces. He thunders no more.

". . . Fiorenza . . . a city of madmen . . . unsafe for a Dominican to walk the streets . . . And so I hid, first at San Domenico and then home again and it was still perilous to tread those riotous

streets. And Father so distressed he even ceased to brood over the death of Madonna Lucrezia . . ."

"Ah, our Lodovico still grieves?"

"Yes . . . but at my coming he broke out of his private sorrow for this public one and gave me good counsel. So I fled to Viterbo and the arrabbiati raided our monastery even there and my cassock was pilfered. . . . Luckily I had Narro's cape . . ."

In his cheek a tiny muscle ticked ticked ticked. He rubbed autumnal palms dryly against each other. Michel had never seen his brother in such a state.

So all that night, owl-hooting with nightmare, Lionardo recited the events that had led up to the martyrdom of the Dominican Friar. Pale echoes of these doings had already reached Rome, but immured as he was in his Bacchus and his young green-blooming ambitions—all the excitements of life in the Borgian city—the thunder of Savonarola had seemed very thin, very far from Michel this past year and a half. But now Lionardo's presence brought it all vividly back again: he was in Fiorenza, in Santa Maria del Fiore, he felt a familiar chill, heard the familiar heartbeat of the bells, saw the familiar hawked figure in the pulpit. Within his new frail armor of Roman cynicism, Lionardo's words pierced his flesh to quivering.

". . . and many said it was the fiasco of the Trial by Fire that sealed his doom . . . But he was betrayed long before, when many turned against him because of the Bonfire of Vanities . . ."

"Another Bonfire?" Michel exclaimed.

". . . for surely the women did not like to see their false hair & lutes & corselets & ornaments blazing upon that heap. For these were the same women, remember, who had used every trick to circumvent the old laws against excessive finery in dress & went on with their false hair and their dice and their gaming tables and all other diabolic things. But our Friar would not hold with such vain adornments & shouted against the women for their furbelows and forbidden gowns and mantles of raised cloth & so the women were angry. And that was the beginning of the anger.

"For not only were the women angered. Some artists now began to grumble, although God be praised, there were many more this time who saw whither the Devil was leading them, & themselves fed the blaze with their dirty pagan fancies . . ."

Again? Michel thought with a twinge of pain. *Again they have committed that sacrilege?*

He remembered Granacci's long cynical letter of last Easter

about the first *bruciamento delle vanità*, describing it all so vividly
—the tongues of flame, pale in the sun of the stony square, and
Lorenzo di Credi and Sandro Botticelli and Baccio della Porta fear-
fully offering up their works to be immolated upon the fiery pyramid
—that Michel felt it was his very heart and limbs being consumed.
Reading that letter, Michel knew he had been wise to leave his
native city, he would have left it even had not the business of the
fraudulent antique offered him the excuse.

But he said nothing aloud, listening to his brother in the night.

". . . Yet other artists resented our Friar, declaring he was no
friend to their art. And worst of all were the merchants whose
trading activities were pinched as a result of the Pope's interdiction
of our City. So now they too turned against Fra Girolamo & began
to cry that all his new reforms merely took government out of the
hands of an orderly few & threw it into the hands of a disorderly
many.

"And then the Franciscans began a dirty whisper that our Fra
Girolamo was really a Marrano, a secret Jew, or at the very least
their friend and defender because he had permitted them to re-
main in our city after the Pisan loan & then later even to resume
their money-lending when the Monte di Pietà proved not sufficient
for the city's business. And though it had been the merchants
themselves who had requested of our Friar that he relicense the
Jewish bankers, the Franciscans put a different color to the business
and began to bruit it about that our Friar was himself a dirty Jew
and a heretic.

"Oh Michel Michel, I tell you, you could feel the hatred growing
every day! . . . I tried to warn Lodovico what was coming but you
know Lodovico . . . he waved me off . . . He has changed much
since the loss of his post and of Madonna Lucrezia. I think he is be-
coming deaf. He looks at one strangely, trembling palm to ear. He
no longer argues with Messer Manotti, the apothecary, but spends
much of his time alone, fishing in the Arno though he catches noth-
ing but minnows. So Lodovico would not listen to my warning, so
sunk was he in himself. And your brother Buonarroto was unaware
of the rising wind for the blowing-up of skirts. And Giovansimone
was completely unbridled now that Lodovico was too lost in private
grief to punish his transgressions & Narro ever in the warehouse
and I at the monastery. So that Giovansimone was with those ruffians
who scrawled filthy things upon the walls of our monastery at San
Marco and when I found my own brother in that doing, I beat him
till he bled & my fist ached. For I could not believe that Giovan-

simone could be of that mad band of arrabbiati when his own flesh and blood was of the opposite party & himself a monk. . . ."

In the darkness outside a cat howled, setting off an echoing chorus. The candle on the plank table guttered, painting and erasing mobile shadows on Lionardo's lank face. His voice was low and full of doom and all that night Michel listened and it was as if a parchment were being unrolled, written in the blood of martyrs and illuminated with fanaticism and fear . . .

". . . and though his adversaries were crying ever that our Friar was weakening obedience to the Marzocca, yet he continued to preach & he drew ever more followers, of every profession, of every age, & even Lodovico was swept into the wonder of it & it eased his grief and his mockery of me ceased & he became a pious man. And on the morning of Christ's nativity, there were more than a thousand of us—Narro and even Giovansimone and Lodovico —gathered to hear him preach at Santa Maria del Fiore, and three hundred children with their own confessors. But when Fra Domenico da Pescia entered the pulpit, there was a stir of excitement that he preached instead of Fra Girolamo. For then we knew how much stronger must be growing the adversaries of Fra Girolamo that he should send his companion to substitute for him. But later we learned it was done in order not to lend fuel to these enemies. And from that day until Easter, Fra Domenico continued to preach & though he was held to be a simple man & of little doctrine, he spoke with such spirit that he persuaded the people to cast out of their homes all the so-called Latin books as vulgar and lascivious things, and all statues and all kinds of paintings that might incite persons to bad and indecent thoughts . . ."

Passionately the voice flowed on, unaware of Michel's stricken look. The Bacchus had flashed into his mind, that drunken just-born boy, whom he had fleshed with his own lascivious thoughts, that soft winegut of a belly he had caressed into being with his chisel, the reeling eyes, the flaccid phallus. Was this all sinful then, to be cast out of houses by his own brother? It was almost completed, to Ser Gallo's sober delight. His head ached, the familiar night-stab. His brother talked on and on and the gulping of the candle-flame was a soul in torment and he had to polish smooth the pink-veined thighs. And the grape-stealing satyr was not quite right yet either, although Andrea thought it was adorable behind the falling tiger-skin. But the thing was to chip off the ligament near—

". . . and after that sermon, as the year before, the children

went, sometimes alone *&* sometimes accompanied by their elders, to all the houses of the citizens in their quarter *&* gently asked that all objects of anathema be cast out of the houses as dirty things, cursed by God and by the Canons of Holy Church. They did this from the beginning of Lent to Carnival and usually they were courteously received, but by the enemies of our Friar they were hooted out of doors and even abused so that more and more they had to be protected on their missions. And by Carnival time they had gathered together a marvelous quantity of those statues and indecent paintings and false hair and women's head adornments and orientalia and colored silks and aqua lanse and rouge and dandy-boxes and perfumes and similar vanities together with card tables and chessboards *&* finely-carved chessmen and playing cards and dice, harps, lutes and zithers, *&* other instruments and the writings of Boccaccio and the *Morgante* of Pulci, *&* all such filthy and magic books, and a marvelous quantity of wonder-working charms. And on Carnival day all these unclean things were brought to the Piazza della Signoria where a special round wooden pyramid, with seven steps for the seven deadly sins, had been erected the day before. Then everything —the false hair and the paintings—were heaped up in order on the steps, with brush and faggots beneath. And on the last day of Carnival, instead of their usual bestial games of casting stones and their masks, all our Florentines thronged to the Piazza to see this second Bonfire of the Vanities, *&* it was greater than the year before.

"That morning all the children in each quarter had gone to a Solemn Mass of the angels, *&* then, led by the custodians of their quarters, they marched to the Church of San Marco, all dressed in white, with olive wreaths on their heads, *&* red crosses in their hands, and then having returned to the Duomo they offered to the companies of the poor all the charity they had collected during these days. And then the citizens gathered at the Piazza—a wondrous sight! . . . all those children in white on the ringhiera so that when they moved you would truly think it was the hosts of heaven fluttering their wings. And everyone in the square was singing psalms and ecclesiastical hymns, some especially written by Messer Benivieni, and popular lauds and over all you heard the great steady booming of the bells. And then, as everybody sang the Te Deum, solemnly from the loggia descended the four captains of the quarters, each with torch in hand, *&* they set fire to the pyramid—the "dirty arbor" as the people called it—*&* there was a great shout and blast of trumpets as the faggots flared. And Giovansimone pointed as the flames sucked

up in a roar & I saw that the naked and painted women atop the pyramid were twisting and agonizing in the flames as a sign to the makers of all such lewdnesses.

"And just at that moment a man near us dropped to his knees and began to weep loudly and strike his breast. So we turned to look and it was the painter Baccio della Porta and upon his face remorse, for several of those writhing undraped women had been shaped by his hand . . ."

So listening in the Roman night, Michel heard of this second burning of the vanities. And in his mind echoed the last Easter sermon he had heard Savonarola preach two years before. It was shortly before he went to Rome and it was indeed one of the reasons impelling him to go. All the artists had been summoned to the Cathedral for a special sermon. Numbered among that congregation, young Michel was guilty of the sin of pride. But the Frater was not impressed by the presence of some of the most distinguished artists of Italy. Instead, he excoriated them for clothing poor fishermen in the vestments of rich bourgeois merchants; he cried out against the scandal they created in the churches, portraying their mistresses and whores in the guise of holy persons. ". . . so that boys run about our streets now pointing to this harlot or that: *There is the Magdalen, there is the Blessed Virgin* . . ."

They bowed their heads: Oh, it was a storm! Only Granacci sailed above it: a sickle smile.

Shortly after that terrible sermon Michel had met Master Sandro Botticelli. The heavy-lidded man was gibbering with fear, stretched on the rack between his naked Venus and the Virgin, between his Primavera and the Passion. All his wonted jollity was gone. And in every workshop Michel visited those days, the painters, the goldsmiths, the sculptors seemed stricken by a palsy or sat about with idle murmurous hands in monumental groups of indecision.

How fortunate that the business of the false Cupid permitted him to escape that gloom!

Just before he left for Rome, he had visited with Granacci the cobwebby studio of Piero di Cosimo. The fantastic old man was chewing on a hard-boiled egg (he prepared them in batches of fifties when he boiled the glue for his gesso); leaning against the wall was a panel of grimacing centaurs attacking weird boars. Master Piero was more irritable than ever. Even oak-hearted Cronaca— Simone del Pollaiuolo—seemed shaken in the blasts of the Dominican. Only the apprentice boys had the energy to saw the still, dead

air with disputation: Savonarola was no friend to art: he was, he was, but must not art serve a Christian end?

Granacci alone was cool, waiting . . .

"And did you see Francesco at the burning?" Michel asked now.

"No, not a trace of him," Lionardo answered with something of scorn. "But the youngest della Robbia I saw, and there were many more artists offered up their foulness this time. Master Sandro—"

"Ah . . ."

"—prayed so fervently he fell ill of a fever afterward. He came to our monastery and talked of taking orders. And so did Master Baccio. It was the fear of those flames . . .

"For instead of the usual bestial stone-throwing games and other damned customs of our corrupted century, we witnessed that day a carnival of devotion. Nevertheless there were many voices that muttered against our Friar and made great scandal for all new things are hated no matter how good they be, & they are interpreted in bad faith. And some complained bitterly against the loss of so many objects of great value, saying it would have been better to have sold the things at a good price and given the proceeds as charity to the poor.

"So, from that day on, the hatred and persecution against Fra Girolamo grew apace. O, but it was no new thing, that hatred, it had been growing for a long time—all last year—the roots of it were deep. And not only amongst the laity but even more amongst the preachers and religious of all orders. And the Franciscans were worst of all, Michel; I tell you whenever I went home to visit Lodovico and passed a Franciscan in the street, he would turn away his face in a grimace, and spit. Then, soon after the first *bruciamento*, Narro showed me that letter you had sent secretly from Rome, signing yourself Piero, but we all understood your meaning and Lodovico made a big speech about it as you may well imagine, holding you up as a model of caution. And when you spoke of Frate Mariano and the bad things he was saying here about our Friar & declared that there was nothing new except the creation of seven new bishops with paper mitres on their heads—we knew you meant hangings—& when you said you were writing the letter in the dark we knew you meant there were troublous times here in Rome too. And then Narro said he had met Master Sandro who declared he had delivered the letter you secretly sent Lorenzo di Pierfrancesco Popolano in Botticelli's name—and the meaning of all these precautions of yours was perfectly clear, it didn't take too much imagination to know what you

meant. But Father explained it anyway as you may well imagine.

"Then last year came a monk to San Marco from Rome and he told us how Fra Mariano of the Augustinians was inveighing against our Friar & charging him with being a false prophet. And one day, our visitor said, he had been in the consistory when Fra Mariano was preaching, & he saw the preacher turn to the Holy Father and he said violent things against our Friar—how he was a rotten heretic and all & then he cried out: *Abscinde, abscinde hoc mostrum ab Ecclesia Dei beatissime Pater,* & then darkness passed before my eyes and I knew what was coming.

"For soon terrible times fell upon us, Michel, we wrote to you often but you never answered, or perhaps the letters never reached you. For not only were there these persecutions of the Pope & the bitter controversies that are never lacking among our Fiorentini, but there also came a pestilence upon us and a famine & there was no work and the city was in great travail. Because within our walls there converged entire families of peasants and foreign beggars great and small and so many of them & so wasted away and weak from the long famine they could no more be restored. And the hospitals were full of them & we had many special places set aside but there weren't enough to accommodate them all. They were falling dead by the thousands, in the streets and leaning against the low walls near the doors & slumped over the counters in the shops. And nothing seemed to avail, though we spared no precautions & gave abundantly of charity, even for the foreigners who had invaded us, although there were many who thought charity began at home & yet we could not find it in us to drive these sick wretches out of our walls. But we had no food to feed them for the corn-vessels of our merchants from Provence had been either captured by pirates or frightened away, & this was one of the causes of the pestilence. So our Friar ordered processions of children to collect gifts for the poor & one day when the streets were full of people chanting *Christ is King! and Mary is Queen!* there galloped a courier full speed through the gate and I saw him, a horseman with a green bough in his hand & he cried out: *One of the corn-vessels has arrived!* And this was confirmation of Fra Girolamo's prophecies.

"But then to cap these troubles, came Piero de' Medici, informed by spies that he had many friends left in Fiorenza, as well as relatives; & so he thought to try his fortune to return. And as if the famine weren't enough & all those factions for and against Fra Girolamo, now we heard that Piero and his brother, the young Cardinal, with the aid of their relatives, the Orsini, and the Pope, had bor-

rowed thousands of florins & as secretly as possible outfitted a goodly number of cavalry and men-at-arms on the outskirts of Siena, & riding at night they came at the second hour before dawn to the Monastery of San Gaggio outside the gate of San Pier Gattolini with five hundred light cavalry and much infantry in good order & a flowering of gentry. And it was only Divine Providence that saved us because on the way Piero was forced to dally for two hours at a little tavern sixteen miles from the city because of a tremendous rain. And while he was sloshing slowly through the muddied roads, a contadino raced ahead by short cuts & brought word to our Signoria that the Medici were coming & so we closed the gate and were ready for Piero when he came. And the Signoria would not distribute arms to our citizens, as is usual, because they feared that Piero had many friends, but only those of us whose loyalty was unquestioned were summoned to the wall. And I was in the tower & I saw Piero and his men riding furiously down the borgo from the Church of San Gaggio to the spring & there he pressed himself close against the wall in order not to be hit by the great stones and cannon balls of our springals and falconets that we had mounted on the tower. And there all day he waited, expecting his followers within the city to rise and open the gate. And all the while the inhabitants of that borgo were silently watching Piero and his company as at a spectacle, but not showing either by word or deed the slightest sign of favor toward him. So finally he realized that he was waiting in vain & that the gate was not going to be flung open in greeting and that the only greeting he would get was this hot hail of cannon balls. So he and all his company turned back that night for Siena, riding at breakneck speed & and not stopping once for fear the road would be cut.

"But this episode left us all trembling. For when it was observed with what arrogance Piero had advanced right to the very gate, everyone felt that he must have had spies within our city who had assured him that he would find the gate open. And so indeed he would have, had it not been for the Divine intercession of that storm. So I knew God was with us, but it was a strange sensation, Michel, to peer through the chinks in the tower and see by the light of flares, tall Piero handsome as ever on his horse, & remember how his father had been a friend of our family & to reflect that he had lately come from Rome where perhaps you were even then receiving commissions from him, & it was a terrible thing to think that I was raining fire upon a man who might be helping my brother. But the times are evil and we are often forced to do that which we would not do.

"So things went from bad to worse with the divisions growing ever sharper among our citizens despite the many good reforms instituted by our Friar. You are lucky, Michel, away from our acrimonious citizenry. For our Fiorentini will always find some political bone to fight over, they had rather dispute than eat. So now everyone had forgotten former divisions because of this new one—partisans of the Friar deemed Weepers, Piagnoni, and his enemies, Angry Ones, Arrabbiati. And you heard nothing else in the streets and Lodovico was a bore with it.

"So it happened that on the morning of Ascension Day when Fra Girolamo was to preach, some insolent youngsters aided by several corrupt priests—most probably Franciscans—stole into the church the night before & filled the pulpit with dung and committed other abominations so disgusting that I cannot even speak about them, things that not even Turks or Moors would think of doing if they wanted to profane a Christian Church. Nevertheless, on Ascension morning came Fra Girolamo into the church with a goodly number of his followers, & he went up to the pulpit and he cleansed it & purged it of its ordure and cast off the asses' skins that had been flung over that filth. So he began to preach without saying a word about all those abominations that had been committed & right in the middle of his sermon those same insolent youngsters, not content with what they'd already done, lifted up the big alms box that is set in the center of the church & they let it drop so that it made a great noise and then they ran out of the church. And many in the congregation were furious and shouting & they wanted to pursue those boys into the streets, but Fra Girolamo, realizing that there would be peril of riots throughout the city, lifted up his arms and made everyone to kneel & gave the benediction and then he descended from the pulpit & went out of the church and returned to San Marco accompanied by a great multitude so that the Street of the Watermelon was filled with people all the way to the monastery. And because we could not depend upon the Magistrates to protect him, there were nobles amongst us with weapons drawn, & the Magistrates never punished those evil boys.

"And after the news of the excommunication, violence and riots grew daily apace, and everyone disputed for and against Fra Girolamo & filthy Latin epigrams were pasted on our monastery walls of San Marco while we were saying our matins—villainous things which I would be ashamed to repeat to you—songs, sonnets, and vituperative and vulgar epithets, and invective against our Friar. And our own brother Giovansimone was of that company & that was when I

thrashed him for it so he bled. Meanwhile there were some members of the Franciscans like Maestro Giorgio Benigno who defended our Friar, and philosophers like Giovanni Nasi Fiorentino and literary men but there were an equal number opposed and especially the merchants. And in every household the arguments about the Friar never ceased, even in ours, though Giovansimone was now silent, but I could not speak to Narro without him becoming red in the face & shouting profanities and Father now agreed with me and now with Narro who said the brief of excommunication was ruining the wool business and nothing else seemed to matter to him. Sometimes I wondered if this were indeed my brother, so little did he seem to care about the moral issues involved. But yet he was our brother and I prayed daily for him as I prayed daily for you, Michel, so blessedly removed from the turmoil of our country but more subject to peril in this sink of abominations. For when news reached us of the assassination of the Duke of Gandia I feared for you here in this Sodom where brother slays brother for the favor of a sister. But then they were saying that the Pope feared the murder as the hand of God upon him & that he had withdrawn into his chamber to repent of his sins and was even considering yielding up the papacy. And word came that he had appointed a commission of six cardinals to consider reforms in the Church & there was great jubilation among us for this seemed only to prove the prophecies of our Friar & we thought that soon the excommunication would be lifted. But shortly after we learned that Alexander's good intentions were transient like the crickets we gather on Ascension morning: it was all a chattering and a thing of the moment and then a dead creature in the cage.

"O there was no end to it, Michel! Every day the passion growing more tense like the string of a viol about to snap; & after some elections there was scarcely a friendly face in the government and the merchants were almost all opposed to our Friar for fear of the Pope's threats. For now His Holiness was declaring that if Brother Girolamo did not cease his attacks, & his letters to all the princes of Christendom calling for a new council to purge the Church of its corruption, then a ban would be placed upon Florentine merchandise everywhere, & it would be seized by agents of the Pope and we could do no business.

"Meanwhile, the miasma and stink of what was happening at Rome reached even us in our sweet valley, & we heard of the flight of the Lord of Pesaro, Madonna Lucrezia's husband, and of his alleged impotence, & all manner of shameful things that were being spoken

about it, & we heard that after the murder of the Duke of Gandia
the Pope had set all Rome afishing in the Tiber for his favorite
son. Then Lodovico was terribly afraid for you, alone and young
in this swamp and sink of perdition, & he sent you several urgent
letters by the hand of Messer Donato who was coming down to do
business for the Strozzi. And Lodovico urged you to return that
you might aid your family and save yourself. But we received only
scattered letters from you & you spoke only of your troubles with
the Cardinal and never a word about our troubles. Then we de-
cided that Father's letters had not reached you or that you were
afraid to say anything directly touching on it as you had been afraid
that time you wrote to Master Sandro, the artist, knowing well he
would convey your letter to Messer Lorenzo di Pierfrancesco Pop-
olano. Yet we were troubled at the rarity of your letters. Then,
shortly after Madonna Lucrezia died of the fever, Narro told us he
had encountered that pretty curly-haired Hebrew, just arrived from
Venice and proceeding on to Rome, & Narro gave him the sad mes-
sage to convey to you. But you never even answered that.

"And that was the week Fra Girolamo resumed his preaching and
never ceased to inveigh against the bad lives of the clergy & the sins
of the Prelates and the tepid piety of princes. And though they had
been warned not to attend, on pain of being deprived of the sacra-
ments, the people flocked to hear him so that it was necessary to
replace the benches and steps around the wall of the cathedral to
hold them all. And Fra Girolamo had a book of his sermons pub-
lished which he sent to all the princes of Europe, predicting the
victory of the Cross. Then we learned that the Pope had be-
come so angry that he was of a mind to order reprisals in the form
of confiscation of the goods and properties of all Florentines & the
sacking of their properties no matter where in Christendom. And we
dispatched a delegation of our merchants in Rome to beg him not
to do this, so instead he sent a threatening brief to the effect that
that son of perdition, Fra Girolamo, be delivered forthwith. So you
can imagine the furor that went up, & despite the excommunication,
the number of his listeners increased so mightily the church could
not hold them all so that finally the congregations were limited to
men only. And it was decided that Fra Domenico da Pescia should
preach to the women in the Church of the Monache di San Nic-
colò, in the Street of the Watermelon. And our Marina went every
day and Lodovico said that though he admired her piety, her skill in
the kitchen had fallen off because she did not put her mind to it,
being full of heavenly things and not of sauces and roasts. Which

Lodovico regretted but yet he did not wax righteous about it & pour forth those long speeches against me as he once had done. For he has changed, our father Lodovico; he is more silent now, & perhaps it is because Monna Lucrezia died and he is a lonely man too full of juices; & perhaps his strange silence is fear because on the one hand he supports our Friar & on the other he supports the Medici for the favors they have done our house, & so he is torn like the city of Fiorenza itself and so it will always be among us. Because you know, Michel, how impossible it is to get two Fiorentini to be of accord on any subject whatsoever, whether it be falcons or feast days. For our Fiorentini though they belong to one breed are no sooner together than they must tear at each others' hides like a pack of wolves & I think they enjoy it, the passion of dispute runs hot in our veins.

"So when this Easter came, Fra Girolamo preached to thousands in the Square of San Marco. And then, as I have said, the bands of children went out again and gathered up vanities for the second burning. But our enemies had waxed in numbers since last Easter & though the city seemed consecrated and dedicated to the glory of Christ, yet when those children were in procession to the piazza crying *Viva Cristo il Re di Fiorenza! Viva Maria la Regina!* they were buffeted and booed by many impious scoundrels & called all manner of vile names and their red crosses torn from their hands and splintered, and other villainies done to them that I wouldn't dare to repeat.

"So that the more grew the goodness of our followers the more grew the rancor of our adversaries. Then it happened that a certain Observant friar of the order of San Francesco, a Fra Francesco di Puglia, preaching in Santa Croce declared one morning that he did not believe that Fra Girolamo and his followers spoke the truth or that the things they were affirming were spoken by divine inspiration & *in verbo Domini*; & therefore, he said, the excommunication against our Friar was valid and reasonable. And then he challenged Fra Girolamo to a trial by fire, crying out that though he himself should perish in the flames, as he believed he would, he was ready to enter the fire if Fra Girolamo would enter with him. And if Fra Girolamo should emerge unscathed, this would be the supernatural sign showing the truth of his prophecies. And I burst out weeping at this news because I knew our Friar would accept the challenge, as indeed he had to, because many times he had exhorted us & even published that the verity of what he preached must not be based upon natural reasons alone, but there would not be lacking supernatural signs to prove them. And I felt like Peter because I knew that my fear was a betrayal of my Master.

"But Fra Domenico, that sweet and simple soul, had no hesitation in answering the challenge of the monk from Apuglia, & he said that he would gladly enter the fire to prove the truth of Fra Girolamo's preachings, & he was sure that by the Grace of God, he would emerge unscathed. And as the time drew near for the trial, Fra Domenico grew happier and happier, his round rosy face seemed to grow rosier with the days as if the flames were already flickering upon it, & often I saw him moving amongst the roses in the monastery courtyard humming psalms and lauds as he walked in the spring sunshine with that beatific smile upon his pudgy face that Fra Angelico had painted on the faces of his angels in our cells upstairs. So that when you opened the little window shutter, the light fell upon those golden-haired angels and the golden beard of Our Lord and the bright crimson drops of His blood and there was a spring freshness upon all that martyrdom, the sweet gentle pastel colors of springtime, of daisies, and fleshsoft pansies and the petaled velvetiness of violets and the soft pale green of baby grass and above this verdure and springtime, hosts on hosts arrayed in white and arranged in heavenly choirs and the gilt flashing of long trumpets and the ecstasy of the Blessed ranked around the throne of the Most High which was a light, a point of glare that you could not see into as you cannot see into the sun. Oh, I know nothing of your art, Michel, but the paintings of the Blessed Angelico I do know, because I have lived with them and they spoke to me from the wall. And I tell you it was with that incredible sense of sweetness that our Fra Domenico approached the trial. For he loved Fra Girolamo and would willingly have died for him though he did not believe he would die. And his naïve simple faith bolstered my weak sick soul so that I even dared to think he would emerge unharmed. But our brother Narro scoffed at all this and said openly that no one would enter the fire, and that it was about time the Friar's mouth be stopped up anyway so that the interdict against our city be lifted and our merchandise flow freely again in the world's marts. And once when I was home visiting our father— whose spirit grew darker with the days, even his skin browning like a Moor, brown as Savonarola's, drawn tight as his over the gaunt bones—Narro and I began to dispute and it came to blows and I bloodied his ear. So it was throughout Fiorenza, brother against brother, and neighbor against neighbor, & everyone arguing the six conclusions Fra Domenico proposed to prove in the flames. And these conclusions were painted on big sheets of paper and pasted to the walls everywhere and they read:

Ecclesia Dei indiget reformatione, & renovatione.
Ecclesia Dei flagellabitur, & post flagella reformabitur, & renovabitur,
 & prosperabitur.
Infideles ad Christum, & fidem eius convertentur.
Florentia flagellabitur, & post flagella renovabitur, & prosperabitur.
Haec omnia erunt diebus nostris.
Quod excommunicatio facta de patre nostro frate Hieronimo non tenet.
 Non servantes eam non peccant.

"Ah, Michel, but you stare at me now with incredulity. Then you do not believe? . . . Oh, you do not know the meaning, you say? Yes, yes . . . I forget my brother has no Latin. Here then are the conclusions in our Tuscan tongue:

That the Church of God would be reformed & purified.
That the Church of God would be scourged, & after scourging, would
 be reformed & purified and would prosper.
That infidels would be converted to Christ & the true faith.
That Fiorenza would be scourged, & after scourging would be renewed
 & prosper.
That all these things would happen in our own days.
That the excommunication by the Holy Father against our Fra Girolamo
 has no validity. & that those who do not heed it do not sin.

"And so you see how true they were, binding us in our faith as iron hoops bind a strongbox. Such were the conclusions which Fra Domenico was disposed to prove like a salamander in the flames & so violent were the disputes & so raging the contentions that finally the Signoria gave permission that the thing be done because from such an experiment the right and the wrong would be separated in the heat of the fire. And they also felt that after such a proof, their credit and reputation and authority would have so grown that not even the'Pope would dare oppose them.

"But then Fra Francesco di Puglia, seeing to what conclusion matters were drawing, & that not only the adversaries but also the friends of the Friar desired the experiment, said that he was willing to enter the flames only with Fra Girolamo and with no one else. And Fra Domenico replied indignantly that he had already accepted the challenge and all the conditions and the argument should be settled thus by him alone, reserving Fra Girolamo for more important things. But Fra Francesco would not yield and after much dispute, another in his order offered himself in his place, & this one was called Fra Niccolò dei Pilli Fiorentino. But almost immediately this poor devil of a Fra Niccolò thought better of what he had so

bravely blurted out in haste and he also withdrew. So then a third Franciscan, but this one not even a priest but only a lay-brother, Frat' Andrea Rondinelli offered to enter the flames. And as for those who offered to take our Friar's part in the trial, oh Michel! there were so many moved by love and faith and devotion and a desire to prove his prophecies—almost all the friars of his province and many priests and laymen and even women and children. And I too was moved to offer up my name but I was afraid and so I knew the terrible imperfection of my faith & I wept and prayed but I could not bring myself to do it. Kneeling on the cold stone floor of the church I felt the flames sizzling my flesh & I cried against the pain.

"Yet, every day Fra Domenico's sermons were being interrupted by the acclamations of the people offering themselves for their Friar's sake & they inscribed their names at San Marco & I was ashamed that I could not bring myself to do what those simple people did. But finally it was decided that Fra Domenico alone, as he desired, and Frat' Andrea Rondinelli for the opposing side should inscribe their names with the Signoria. And this was done. Then the Signoria appointed ten citizens, five for each side, to arrange the how and the where and the when of the matter.

"So the day came and it was on a Saturday, the seventh of April of this very year, fourteen hundred and ninety-eight, and it was a beautiful day, Michel, clear blue and not a cloud in the sky but hot. And the streets clamorous with citizens rushing to the Piazza dei Signori like bees aswarm. I went not with my priestly, but my fleshly brothers—Buonarroto, impiously gay as at a carnival; and Giovansimone, unusually silent out of fear; and Gismondo whom I had dressed up in white like an angel though he protested he was too old for such a costume. And despite the heat, Father wore his red Notary's cape upon which his long beard fell in a white cascade. And he was grumbling that all his sons should be at his side this day, except you, Michel, and complaining that you had chosen such a trade to keep you so far from our country and in a nest of corruption and furthermore precarious in its earnings and even, as our Friar declared, a bed of vanities and bedevilment. And Lodovico said he had not heard from you for many months and he had no idea how you were faring at Rome. So I was trying to pay respectful attention to him while we pushed our way through the crowded streets & the crowd kept pouring into the Square & on every side the disputes raging hotter than ever, some crying that there would be a miracle and others that both monks would go up in smoke and

a good thing that would be for peace and tranquillity. And these were the merchants who hate disorder worse than sin. So buffeted and pushed we finally made our way into the Piazza but it took a long time for only three entrances were left unbarred and unchained. And this was to avoid a tumult. So finally when we managed to squeeze our way into the Square, we were standing alongside the ringhiera & never had I seen so great a throng there, not even when the bells rang and all the citizens were summoned for a Parliament. For they were clustered and bunched in every window, on every rooftop, like bees in a swarm, & suspended from eaves and hanging onto the torch-holders, & clinging to the roof of the Pisans and the Loggia dei Lanzi and some were shouting: *Miracolo! Miracolo!* and others abuse.

"Now, from the Marzocca alongside the ringhiera toward the roof of the Pisans they had built a firebox of heavy boards forty braccia long and five braccia wide and all covered with clay and lined with crude fire-resisting bricks & in the middle of this alley of brick and clay a passageway had been left open one braccio wide where our Brother was to enter for the glory of God, & on the right and left of this opening was heaped up a great pile of heavy dry oak logs mixed with brush and faggots that would take flame in a second, so that he would have to pass through the very eye of the flame. Ah, I see by the expression of your face that just hearing about it makes you tremble! You can imagine then how I felt seeing that terrible apparatus for testing the faith of a man and though the flames had not yet been lit I felt my flesh sizzle just to look at it.

"And it was late in the afternoon and very hot and clear, & though there had not been a cloud in the sky all day you could hear slight rumblings & Giovansimone said it was the lions in the Via dei Leoni for in the excitement the keeper had forgotten to feed them. For Giovansimone knew the keeper and he saw him in the Piazza. So then at last both parties to the dispute appeared, first the Franciscans with a very silent and humble Frat' Andrea Rondinelli in their midst & they were a sober company indeed in their dun brown and roped girdles and bare feet & they had no external ceremony whatsoever, but I thought Frat' Andrea looked frightened. And then appeared the procession of our Dominicans; & first came Fra Girolamo in a habit of purest white silk and he carried the tabernacle of the Sacrament in his hand & it glistened silvery in the sun so that our Friar's swart face seemed darker than ever, like a Moor's. And he walked with a cold pride, holding the ciborium high in the

air, & I could see those powerful jaws clenched and the carved line of his cheekbones and his beaked nose like a prow cleaving the waters of corruption. And behind Fra Girolamo came Fra Domenico da Pescia walking firmly, ecstatic even, & not fearful and he in sacerdotal garb of flaming red velvet and holding a Crucifix and on his face such simple-natured bliss you would think one of the Blessed Angelico's angels had flown off the wall and was walking in our midst. And it seemed to me that Fra Domenico was not treading the ground at all but floating just above it and a tiny cloud frothing at his feet & this was a miracle even before the miracle he was about to prove in the fire, & I prayed for him silently that he might emerge unscathed from that flame and prove the prophecies of Fra Girolamo, & behind him a long procession of Dominicans all with tall red crosses in their hands and then followed many noble citizens and the common people with lighted torches in honor of the Sacrament. And I too would have been in that procession had not I felt my place was with my father and my brothers at this time of trial & so my superior had advised me and that was why I was with my brothers in the flesh instead of my religious brothers.

"So we watched breathlessly as both processions met in the center of the Piazza & turned each toward the Loggia and took their places in the section set aside for them. For the Loggia had been partitioned in the center by planks & so both parties remained a while in their places, the Franciscans ever silent while our Dominicans continuously chanted hymns and psalms.

"And now a great hush had fallen over the crowd as we waited for the lighting of the fire. The bell had ceased. We waited. But instead there seemed to be a great dispute going on between the Signori and the leaders of both camps & much running to and fro of the burghers into the Palazzo and out again and the crowd was becoming impatient and murmurous. 'Well, if they're going to fry these damned monks, let's fry them,' your brother Narro said and I grew angry at him and would have cuffed him across the ear had not others in the mob repeated the same sentiment and worse. 'What are they waiting for?' asked a fat little man with a flushed face and a nose like a wine cork. He was munching sunflower seeds and spitting the husks into everybody's faces as if this were a carnival. 'There seems to be something of a theological question involved,' ironically replied a carter. He was thin as a hangman; he had a voice deep as the seventh circle of Hell, happily lugubrious: 'The Franciscans refuse to go on with the trial unless Fra Domenico removes that red sacerdotal robe.' . . . 'Why? Why?' . . . 'Because,'

the carter said—he had been standing near the door of the palace and had heard the wrangling as the Signori emerged from the meeting within. '. . . Because they claim Fra Girolamo has cast a magic spell upon Fra Domenico's red robe that will permit him to walk unharmed through the fire.' . . . Ah, but isn't that what the trial is intended to prove?' . . . 'Yes, but this spell is no proof of piety but rather of the devil.' . . . 'They lie! They fear the power of our prophet.' . . . 'He is no prophet; he is a wizard and a disturber of the public peace!'

"So, while it grew ever hotter and the light more golden and I was sweating in the press of the mob, the arguments continued all around us, crackling like firecrackers and exploding into fist fights and the excitement rising as before a joust with much laughter amidst the anger. Meanwhile, we could see the disputes continuing between the Franciscans and our side & it soon became apparent to me that our enemies were afraid of the trial and were attempting in every possible way to delay it. For even after Fra Domenico consented to put off that red cape they considered enchanted, & came out in ordinary habit, even this would not content them. So he had to go into the courtyard of the palace again and strip himself naked and put on new garments. But then they would not let him come nigh unto Fra Girolamo for fear he would be enchanted anew as if our monk were a common chiromancer and wonder-worker and not a man of God. So then a new argument ensued over the Sacrament — I realized that those Franciscans were delaying of a purpose with the connivance of many Priors that they might gain a victory without singeing a hair. For Fra Domenico said he would not enter the flames without he bore the holy sacrament in his hand, & at this the Franciscans balked anew. For they alleged, and not without reason, I must admit, that the burning of that consecrated host would be likely to set off great scandal & commotion in the minds of weak and ignorant men. And then Fra Domenico, that most tenderest of men, became angry & said he would not yield on this point for his good angel had appeared to him in the night & told him to enter the flames with the sacrament in his hand; & Fra Girolamo sustained him, arguing that even if the host should burn, only its accidents would be destroyed, while the substance would remain intact. So the disputes continued more and more bitterly, with deputies hastening continuously from the Loggia to the Palazzo & the anger among the citizens grew so great that not even Fra Girolamo could still it by holding up his hands as he was wont to do in the Cathedral. But this time nobody would

listen to him; they had come to see a miracle and instead they were witnessing a theological dispute; & now there was an ugly undertone to the shouts and insults and I began to fear for our Friar. For truly it was a shameful thing that among religious men there should have been such arguments and standing upon small points and lawyer's tricks as if this were a secular competition to be settled by the wits of men instead of by the will of God.

"And all the while you never even saw the cowardly champion of the Franciscans: he was shivering in the courtyard while his brothers sought to delay the trial by these tricks. And I heard a man laugh & say that their Frat' Andrea de' Rondinelli was a man of wax: the mere sight of the fire-pit made him melt with fear.

"And so the better part of the afternoon was consumed with these shameful controversies and the people growing ever more angry. And even those who were on the side of our Friar were disgusted at these arguments & there were voices crying out that Fra Girolamo was to blame quite as much as the Franciscans and that he never had the intention to permit Fra Domenico to enter the fire. Then suddenly right in the middle of these disputes, there fell a tremendous rain, with thunder and with lightning, as violent as it was unexpected for the day had been serene. And we all had to run for cover, & when the great rain had ceased, we saw that it was out of the question to hold the trial that day. For the wood and the kindling were all soaked & a small river was gurgling down the path where the fire was to have been.

" 'It was the will of God that no trial should be held,' I heard many say; and others: 'No, the rain is God's expression of wrath at the tricks of these friars!' And others: 'It is a sign in favor of Fra Girolamo.' And others: 'It is a sign for the Franciscans.' And when at last, after much gazing at the still gray sky and holding out of palms to the drizzle, the Signoria declared officially that the trial would be called off, the plebes were furious. For all afternoon they had tediously waited to see this miracle, not only in the Piazza but for blocks around, uncomfortably pressed together on every rooftop and at every window, & what is more, most of them had fasted so they were rubbed raw with hunger. So now I heard from every side the low grumbling of the people like the lions in the Via dei Leoni when they have not been fed, & this was the same sound—the low rending roar, the sound with claws in it. And I was terribly afraid for our Friar, for as he was led away under guard of many soldiers, the crowd booed him, & impious hands reached out and tore the shining white cassock from him so you could see the coarse under-

garments, & he and Fra Domenico and their followers had to hold up their arms before their eyes against the rain of blows. O Michele mio! then it was that I saw a pre-figuring on our Friar's face! the bulging brown eyes were shining globes in which I read the sorrow that was to come, & his powerful lips were set in a hard line as when an axe strikes a blow against a block of oak. So then seeing the proud agony in my Friar's face, I burst into tears and I left my brothers and my father & ran to join the procession, taking the blows upon myself and they were sweet to my flesh.

"So, through the drizzle and always under the guard of the soldiers, we returned to San Marco & all along the Street of the Watermelon we were buffeted and slapped and called hypocrites and sniveling weepers and excommunicates and gallows meat. And Fra Girolamo himself would have suffered great peril had it not been for the sacrament which he bore in his hand. And the next day being the Sunday of the Olive branch, Fra Girolamo ascended the pulpit and said that he was ready to die for his sins and to offer himself up as a sacrifice to God and many other words that made us all wonder & then he gave us the benediction. But in the days that followed, the compagnacci roamed the city streets like wolves & stirred up the citizens against our Friar, saying he had prophesied falsely. And these evil young men were acting, as we all knew, under the silent approbation of the magistrates who closed their eyes to their doings. They were stirred up by perverse prelates and envious monks, & soon these unleashed dogs began to cry publicly that everyone should take arms and they came to San Marco where we were at vespers and they began to trade blows with us & citizens came running from everywhere to defend Fra Girolamo. Whence, the Signoria ordered all the guards of the Piazza to storm, as they said, our monastery & take our Friar by force. And this caused fights to break out all over the piazza & we hastily barred the doors of the church and monastery and prepared to defend ourselves.

"And locked in with us were many private citizens unarmed & one of these you know well: the painter Baccio who keeps a shop with that scoundrel near the Gate of San Pier Gattolini. And I knew the end was nigh merely by looking at Baccio's face, for he was trembling & he could not disguise it.

"Outside you could hear the shouts of the compagnacci and the thudding against our doors & the women were huddling in the dim light of the church and singing psalms while we manned the doors and windows with a few halberds and crossbows & the small bombard which Messer Francesco Davanzati had secretly introduced

into the cloister several days before, against even the knowledge of
Fra Girolamo. And it was indeed a strange sight to see Fra Luca
d'Andrea della Robbia and Fra Benedetto with helmets on their
heads, and cuirasses over their frocks and carrying long halberds
and crying *Viva Cristo! Viva Cristo!*

"Then Fra Girolamo appeared from his cell in the monastery next
door & I thought he was already a doomed man: his back was bowed
like the arch of his nose and his eyes gauzed with sorrow & he didn't
say a word to us despite the commotion in the church. He knelt
before the altar and prayed silently a long while & then disappeared
again like a ghost into the passage leading to the monastery. And
Brother Benedetto cried out: 'He is about to yield himself up!'
& we rushed down the passageway after him to prevent him from
going out for fear that he would be torn apart by those mad wolves
outside. I remember I grasped his sleeve before the others and he
turned about & looked at me with those bulging brown eyes
brimming with sorrow and with reproach too, as if he had wanted
to go to his martyrdom & resented our interference. And he said not
a word, neither that he had intended to yield himself up nor was
merely returning to his cell.

"Meanwhile, several nobles and great citizens were secretly led
out of the monastery by the door near the wall into the orchard, &
among these was Francesco Valori, an old man, a noble and wise
citizen, our former Gonfaloniere of Justice, & I saw those ruffians
seize him and lead him off. Later, we heard that they had taken him
to his own palace on the Borgo degli Albizzi, and that Valori's wife
appeared at the window to plead mercy for her husband & a coward
in the mob threw a paving stone at her and she was killed. Then they
killed the old man too & rushed in such insane fury through the
palace, seizing the silver and the linens, that they unwittingly asphyx-
iated his grandchild in the cradle.

"But of course I learned all this later, for all those terrible
hours of the siege I was in the monastery with my Brothers, praying
against the sounds of that pack outside like a circle of fire crackling
around us, or a ring of wolves howling for the kill. Through the
windows we could see them congregating in front of the church
with torches and lanterns bobbing & they were armed with cross-
bows and sticks and long toothy pikes. Then, a page of the Signory
appeared, flanked by mace-bearers, & read in the loudest voice he
could manage a ban of the Signory, ordering Fra Girolamo to give
himself up together with Fra Domenico and Fra Salvestro, in which

case the siege would be lifted. And our Fra Girolamo declared that
he would go for he did not wish us to stain our hands with blood,
but we interposed our bodies between him and the door and Fra
Benedetto cast himself on the ground before him and wept and
kissed his hand declaring that his Master would never reach the
Palazzo alive if he issued forth into that mob. And I heard Fra
Malatesta Sacramoro murmur that at least we should deal with the
lawful rulers of the city & treat with them as long as they presented
their orders in proper form, & therefore we should permit the page
into the monastery that we might verify the writing of the ban.
And it seemed to me that Fra Malatesta's gloomy countenance
wore the expression of a Judas but no one hearkened to him. So
then Fra Girolamo acceded to our importunities & went to take
confession from Fra Domenico whom he loved.

"And it was at this moment that we saw smoke curling through
the sides of the great wooden door into the church & I ran there
with Baccio della Porta, the artist, and Fra Silvano of Fiesole and
when we got there the flames were already coming through & we
realized that the mob had set the door on fire. And we formed a
bucket chain inside the church, even back to the holy water font,
may the Lord forgive us. And Fra Benedetto urinated on the fire
with the women looking on but that was the most convenient water.
And while we were fighting this fire, the arsonous mob set ablaze
the other door leading into the monastery. So we saw it was no use,
the church being brown now with thick smoke and everyone chok-
ing and coughing. Then, that we might breathe, we broke the
windows which only caused the fire to flare with greater fury. And
Fra Girolamo wanted more than ever now to yield himself up, to put
an end to this violence, but we made him to go into the choir of
the church. But soon he began to choke there too, so he departed
thence into the Greek library where he stood with many monks,
singing psalms, whilst he remained at prayer around the tabernacle
of the Sacrament which he had borne with him. And then we heard
a terrible crash & the flaming doors of the church burst open and
the mob surged in bearing torches and armed with staves and long
pikes and swords and everywhere in those sacred precincts fights
broke out, for we would not let them seize our Friar. Now, next to
me in the fray was Baccio della Porta and when that mob surged
in, he dropped his crossbow (which indeed he handled much less
adroitly than his brush) and his face went ashen & he looked about
to faint. So then I picked up his weapon and gave it back to him,

saying 'Courage, brother,' and he wept: 'If I live through this day, I vow that I shall become your brother indeed.' With which, that gentle soul began to level his bow.

"As soon as the doors were breached, Fra Luca della Robbia tossed aside the bag of dried figs which he had been munching & seized a sword leaning against the altar and began to swing it valiantly, crying: *Viva Cristo!* And just at this moment the Piagnone began to toll & whether it was one of our order had gone up in the belfry to lend heart to our defense, or whether one of our enemies was doing it, I do not know. But above the roar of the mob and the fracas of swords and the suckings of the fire, the bell continued steadily to ring like a great heartbeat in the night. And because we had earlier put aside our arms at the behest of Fra Girolamo, now some of us had no time to run into the sacristy where they were stored, & we had to fight back with whatever was at hand. So we rained blows upon those villains with our crucifixes, and swung brass censers like discus-throwers, & hit them over the heads with holy images. And that young German monk—you met him once— Fra Enrico, he with the blond beard like a goat—fought his way into the cell where the bombard was secreted & mounted it in the pulpit facing the flaming door, so that he raked the oncoming mob with a deadly fire and his peculiar glassy blue eyes had a glory in them & his little yellow beard jutting out like the banner of Santo Spirito and he was shouting in his thick Swabian accent: *Salvum fac populum tuum, Domine!*

"Then Fra Benedetto hurried down from the roof where he had been dropping tiles upon the besiegers and lent his great strength to the fight. And he wore a helmet and a cuirass over his cope and he was laughing and weeping. By this time several of our number were wounded and some killed & of the attackers at least an equal number so that it was a terrible scene what with the clash of weapons and the boom of Enrico's bombard and the screams and weeping of the women and the deep ever-tolling bell. The church was thick with smoke, & even as I crashed my wooden crucifix over the pate of one villain, I saw our Fra Girolamo moving sadly through the smoke and carnage like a ghost & he carried no weapons but was imploring us not to commit violence even for his sake. O Michel, I tell you the holy temple of the Prince of Peace became that day a battlefield. Here, brother, look, I still bear the marks of those compagnacci upon my arm. See this long cut; that was from a lance that went right through to the other side and I bled like those pigs we used to slaughter at Uncle's farm at Set-

tignano. But even while I was wrestling with those ruffians and my chest aching with blows and I vomited behind the altar from a pole thrust in the stomach, even then I knew that it was no use, our Friar would be taken. So we formed a phalanx around him & fought our way back to the cloister, and barred the door. And I proposed that Fra Girolamo leap over the orchard wall & so make his way to safety, for surely if he once let himself be taken to the Palace of the Priors he would never emerge alive. And Fra Benedetto added loud seconding to my counsel and so did the others but Fra Girolamo said nothing, his brown eyes seemed not to see us, he was murmuring with his lips upon the cross. Then he woke out of his trance and said hopefully: 'Do you truly think there is a possibility? . . .' 'Yes! Yes!' we shouted, for the door was beginning to rattle. 'Go now!' Frat' Andrea cried, 'I will lead the way.' And at that moment, Fra Malatesta turned to him and said darkly, 'Should not the shepherd give his life for his sheep?' I saw Fra Girolamo shake at these words; he was still as a lake, & while he was reflecting—'Judas!' shouted Fra Benedetto, and lunged at Fra Malatesta, and it was with difficulty that we restrained him. But then our Friar calmed Fra Benedetto with a soft touch of the hand; & with a strange smile, he kissed Fra Malatesta who had said those words, & then he turned to Fra Domenico and kissed him and all of us that were gathered there. After which he calmly unlocked the door, & as that sea of madmen rushed in, held up his hands with the familiar imperious gesture of the Duomo so that the wild wave froze at once.

"So he let himself be led away with them, & as soon as he departed, Fra Benedetto flung off his helmet and fell sobbing and cursing to the ground. And with our Friar went Fra Domenico, whom the Signory also wanted; but Fra Salvestro Maruffi could not be found, he must have been hiding somewhere in the library.

"Thus, while we gathered up the dead and consoled the wounded, those two, accompanied by mace-bearers and well-guarded by troops of the Badia, were led to the Palace of the Priors. And I could not remain behind to do my work of healing as he had urged us, but I had to follow him instead. It was almost dawn now and the Duomo was heavy-black and pregnant with woe against a pinking sky, the cypress points of our orchard waved mournfully. And as I followed that howling procession, I felt as if I were watching my Lord on the way to Golgotha but he held his head high and seemed oblivious of the fists being rained upon him and Fra Domenico seemed indeed to be smiling. So with difficulty, they proceeded down the Street of the Watermelon, the mob screaming mockery all the way

and committing outrages. For they tore his white cassock and shoved flaming torches in his face & some of those hoodlums even dared kick him, crying: 'Prophesy who kicked you!' and similar abominations too disgraceful to mention. So it was all the way down the Street of the Watermelon and past the Duomo where he had moved to tears many of the same mob that now reviled him & down the Street of the Stocking-Makers until we reached the Piazza. And I followed until I saw my Friar swallowed up within the Palace & when the soldiers at the door crossed their pikes again, I began to weep.

"Now, all this was on the ninth of April, the day after the Sunday of the Olive branch. Nor was I to see our Friar again until the eve of the Ascension which fell upon the twenty-third of May & then it was to see him hanged and burned in that very piazza. Now all those weeks between, while the city ran with rumors like the colors in the great dyeing vats of the Strozzi, I remained in hiding in our father's house, & came out only at night for a breath of air. And Narro and Lodovico brought the news to me so that I felt I was in prison the same as my Friar. So, I learned that Fra Salvestro had finally given himself up & was undergoing examination like the others. And we heard that the Pope had sent emissaries to the Signory. But it was difficult to know what to believe, so contradictory were these rumors: some saying that after one turn of the screw, Fra Girolamo had confessed that he was a false prophet and not of God, only to recant his very confession no sooner was he relieved of the torture, and that he had done this not once but several times. I wept for him, for I knew it was only the pain that made him to deny himself, for I had seen how brave he was in the trial by fire and in the siege of our monastery and only in this matter of the torture was his flesh weak, though his spirit remained unbroken. And every day there were new tales and often at midnight when it was safe, I walked alone in the Piazza and looked up at the tall slender tower in which my Friar was imprisoned & I thought of him there in the black cell and it seemed I saw his orisons like a tangible mist, rising from the tower.

"Then we heard that the Pope's emissaries had arrived, sent to Fiorenza in haste, & they were wroth because Fra Girolamo had more than once confessed and more than once recanted his confession. And it was also said that when the Holy Father heard from our couriers the news of the monk's taking, he was immoderately delighted & got up from the throne and did a little jig of joy, snapping his fingers. But I was not surprised because Fra Girolamo had con-

tinually sought to stir up against him all the Christian Princes of Europe and summon them to a General Council & depose the Pope as an usurper and anti-Christ. Whence, the Holy Father issued immediately several new briefs, the first to our Signoria, expressing his gratitude for the thing they had done but ordering summarily that once having completed the examinations, our Friar be delivered into the hands of the emissaries the Pope would send to the border of our territories. And the second brief was written to the Vicar of our Archbishop giving him the power to absolve the followers of Fra Girolamo of any sin they had committed, even to the sin of homicide.

"And when he heard of this, your brother Narro burst out laughing. For though Narro never was, as you well know, a friend of our Friar, yet he said that by this plenary absolution the Pope was obviously seeking to draw into his camp those followers of Fra Girolamo who were frightened by recent events. And Narro said the Pope was surely a shrewd manipulator though the spirit of religion was entirely lacking in him. At which Lodovico declared that in times like these the spirit of true religion was one thing and obedience to the Pope another and it was Fra Girolamo's mistake to make the second dependent upon the first. For this was unrealistic, Lodovico said, & would only lead to a weakening of the Church. And I had a terrible fight with Lodovico who wavered with events like a weathercock, swinging with Fra Girolamo when he was in the ascendant & now with the Franciscans and the Signoria and the Pope when they were in the ascendant. And I ran out of the house with my eyes streaming for I did not want to quarrel with my father and I feared that I would strike him.

"And of course as soon as these things were known, everybody ran to confession to receive the absolution, & they were the same persons who had flocked to hear Fra Girolamo in despite of the excommunication. But many citizens fled from the city because the Eight were taking some followers of our Friar & putting them to the torture to force them to retract & to confess nonexistent conspiracies and other infamies against Fra Girolamo. And there weren't lacking many lords and others impassioned against us who took this opportunity to castigate and punish those whom they knew were fervent for the Friar.

"Now, just about this time, letters arrived from France telling of the death of King Charles at Amboise. And the amazing thing was that he had died on the very day of that unhappy trial by fire—the seventh of April, of this year fourteen hundred and ninety-eight. And

the letter said that the King had died a miserable death, being suddenly taken with an apoplexy and borne to a place nearby filled with all manner of filth & where men were wont to piss and so he expired upon a stinking heap of straw. Now this was according to the prophecies of Fra Girolamo because King Charles had failed to heed the communications and protestations, by mouth and by pen, of Fra Girolamo, calling upon the French King to summon a Council of Europe against the Pope. And because he had ignored these appeals, he had been justly castigated by God. But many interpreted the death of the French King in another manner, saying that both he & the Friar had deceived the Florentine people who had confided in them and in their promises.

`"In the meantime the new Signoria had entered into office and we heard that they were continuing to examine Fra Girolamo as had their predecessors. And according to what they said, he was confessing and retracting as he had previously done. Whence the Signoria requested permission of the Pontiff to put these three to death, but he desired instead to have them rendered alive into his hands. So finally after much controversy it was decided that the Pope should send his own judges to ·deal with these delinquents according to the usual procedure of the Church, the Pope having first *vivae vocis oraculo* condemned Fra Girolamo as a heretic & schismatic and persecutor of Holy Church and seducer of the people. And the judges sent were the general of the Dominican Order, Fra Giovacchino Turriano of Venice & Messer Francesco Romolino, a Spanish cleric, a doctor of laws. So we heard they had begun their examinations in the presence of several of the Priors and the Eight. And we were told that even now Fra Girolamo insisted that what he had preached in the past was the truth & his retractions all false and a consequence only of the terrible pain and fear which he suffered under torment, & furthermore that he would deny and confess and retract his confessions as many times more as he was put to the torture, since he knew that he was very weak and could not stand the punishment. And hearing this the examiners were furious and put him to the rack again. And the same it was with the other two—confessing & retracting—but they being weaker broke down and finally excused themselves, affirming they had been led astray by their simple faith in Fra Girolamo.

"So the terrible ordeal continued until one day as many citizens who wished were summoned to hear the signed confession read at the Hall of the Grand Council & I dared not go but our father did. So I remained at home in terrible fear until Lodovico returned and

that evening he came back, his face drawn and white, and he told us what he had witnessed.

" 'The hall was packed. I looked around me and I thought: These are wolves, not men. The very ones who flocked to his sermons. Now they are slavering for the kill. And all because they have been cheated of a miracle.

" 'So then the Chancellor of the Eight appeared & began to read excerpts of the trial record, which he said Fra Girolamo had signed. And perhaps he did, but if so, it was the pain made him do it. And I tell you, my son, as a notary and former Podestà of this Republic, I have grave doubts about the veracity of that record. The form was utterly out of order but those bestie in the hall did not know it. Then the chancellor read a formal statement which sounded to me as having been subsequently added to the trial record, it was so obviously false. And this was to the effect that when Fra Girolamo was asked if he would confess these things in public, he replied: "I fear I would be stoned." At which a great roar went up from those wolves, but I knew the record was false.'

"O Michel, I cannot tell you the effect of Lodovico's words! All that night I wept for I knew my Frater would depart from that tower only to meet his Lord. So then the sentence being announced, came the eve of Ascension Day & it fell on the twenty-third of May. And in the Piazza Signoria had been erected an earthen platform, higher than a man, extending from the ringhiera of the Palace across a quarter of the square to the roof of the Pisans. And when we came we saw that on the ringhiera were already seated as a tribunal the Magistrates of the Eight. They wore their black judicial tunics & upon their faces and in their hard eyes I could read only death death death. And at the end of this platform stood a great pole, about ten braccia high & heaped around with kindling and wood. And near the top of this pole was affixed a cross-bar on which to suspend the noose. And I trembled as if unwittingly I had come upon the hill of Golgotha and saw the cross on which Our Lord died. And the citizens were murmuring at the sight of that cross and I could see that even though they had come for a spectacle, the apparition of that cross-bar put them in dread. So the authorities ordered the carpenter who had built it, to climb the ladder with a saw and shorten the bar. This he did several times, until he could no more & still it bore a resemblance to the Cross. And the Piazza was thronged as never before, not even as on the day of the trial by fire. And we had left Gismondo home in care of Marina though they both of them had cried they were being deprived of a spectacle. But Lodovico

and Narro and Giovansimone were beside me and they had to hold my arms for I thought I would collapse at the sight. Yet I had to see my Frater ascend to Heaven though my soul were to fly up with him & I dared not come in my habit for those beasts would have torn me to bits.

"So then I saw my three Brothers emerge from the Palace where they had been confined for forty days & they all three walked with firm steps, Fra Domenico indeed seemed to be dancing as if he were going to a festival. And Fra Girolamo's face was the face of one who had already departed: his eyes were closed and his dark visage seemed to me to be ringed by a nimbus. And even Fra Salvestro who was said to have spoken against his master during the examinations, now seemed calm and resolved. So then they three were degraded by the hands of the General of San Domenico and the Bishop of Pagagnotti of the same order & other venerable priests. And though I was far away I could see that the Bishop's hands trembled as he performed the office. For he had been disciple and friend of Fra Girolamo and now, in obedience to the Pope, he had to consign him to the secular arm. And I could not hear the words that were spoken but Francesco Granacci who was close to the ringhiera told me later that during the act of degradation, the Bishop had trembled so that he had confused the office, saying—'I separate you from the Church militant and triumphant,' to which Fra Girolamo, with absolute composure, remarked, 'Triumphant, no—that is not within your power.' And this was heard clearly by Francesco near the ringhiera but not by me because I was too far away. Only I saw the three of them, small in the reductions of perspective, & like three puppets across the sea of faces moving slowly and stiffly in their coarse white woolen frocks & then they knelt to be absolved of sin by the Papal emissaries and I saw the slight nodding of their heads that said they did accept that absolution. Which made my brother Narro to whisper: 'If they are absolved of all sin, then why are they being hanged?' And indeed it was a knotty question not easily to be answered.

"Now an awful hush fell upon the densely thronged Piazza. I could see the actors in that puppet-drama on the ringhiera. A whisper rippled across the crowd from the platform. But when it reached us it was no longer a ripple, a whisper, but a wave, an alarm. And I knew that my three Brothers were being sentenced to death at that very moment by the secular arm, the Magistrates of the Eight. And then they were walking in bare feet, arms bound behind & in their coarse undergarments down that long platform to

the foot of the gallows. There they were left alone a moment to face the crowd, whose insolence had now risen after the momentary hush of fear, & the mob nearest the gallows being mostly Arrabbiati and villains and ruffians who had been cast into exile by the former Signoria and now released from jails and allowed to return by this new government in order that they might humiliate our Friar further, I saw them crowd up around the circular platform, & cry out, and spit, & cast stones.

"So then, one after the other, they ascended to Heaven. Fra Salvestro first, & he climbed the ladder boldly, and when the hangman had slipped the noose around his neck, Fra Salvestro cried out, *In manus tuas Domine commendo spiritum meum.* Then the executioner pushed him off the ladder and he flew like an angel until he stopped with a broken neck & the hangman chained his limp body to the pole. And all the while Fra Domenico is impatiently dancing from toe to toe at the foot of the gallows like a child eagerly awaiting his turn to skip a rope, and I never saw anyone scramble up a ladder with such nimble happy feet, you would think he was flying to Heaven. And he assisted the hangman in slipping the noose around his neck, & smiled and jumped off the ladder before the executioner had a chance to push him. While his body was being chained, I fainted away but it was only for a few seconds. When I opened my eyes it was to see Fra Girolamo already at the top of the ladder, and that huge many-limbed monster crowd was still as a spider waiting & it seemed I saw only Fra Girolamo's eyes burning down from those heights. When suddenly a voice screamed: 'Prophet! Now is the time to perform a miracle!' But he said nothing or perhaps I could not hear for the mob was screaming obscenities now and he had not spoken but merely glanced over the thousands of uptilted heads as he used to glance from the pulpit just before he began his sermons. Oh, I had seen that same mob waiting with lips parted like parched men in a desert thirsty for the water of his words, but today they wanted only to drink his blood.

"The executioner pushed him off.

"And now we saw a horrible sight that made my gorge to rise. For Fra Girolamo's body was still squirming & the executioner was playing the buffoon with it, gouging his fingers into the black popping eyes, and swinging the squirming twisting body between the other two limp bodies, now banging it into Fra Salvestro on the right arm of the cross & now into Fra Domenico's on the left, and now making the body to spin while the crowd roared its delight. And the more the crowd roared, the more obscene games did that

hangman play with the squirming body which was half-naked, the undergarment scarcely covering the limbs, thus affording more opportunities for a hangman's jest. And I would have cried out but I was afraid and even Narro's lips were pressed whitely together & Giovansimone had turned his back, & he made no witticisms. So then the Magistrates decided that the hangman had jested enough & they ordered him to desist and chain the body like the others to the pole so that the fire might be lit. And hastily the hangman began to bind the chains around the still-squirming body and you could see the black distended veins in the forehead & Fra Girolamo seemed to be trying to speak from the end of the rope. Then Lodovico said in a low voice that that beast of an executioner was hurrying now because he wanted to see Fra Girolamo burn while life still remained in him. But the Lord willed it otherwise, because the hangman's haste made him to drop the chains and while they were handing them back to him, Fra Girolamo's soul had fled.

"So the executioner descended from the ladder to ignite the brush but a villain who had been waiting impatiently with a torch in his hand rushed forward out of the crowd and set the blaze, crying out loudly, 'Now let him burn who would have burned me!' And this villain was one of those who had just been permitted back in the city from exile. So the flames licked up at my three Brothers dancing up there in that burning ballroom, suspended from a truncated cross. And though it was several hours before noon and a clear day, the world was black with the blackness of thick smoke & I was choking, pressed in a pack of thousands of wild beasts & I could not look. Then I heard cries: *Miracolo! Miracolo!* and the crowd nearest the scaffold was drawing back in terror. For the wind had suddenly shifted and the flames were not touching the three bodies at all as if it were a sign that they were not to be burnt. But a moment later the wind shifted again and began to consume them. And at that moment, I saw Fra Girolamo's arms which had been tied behind his back, suddenly swing forward & it was his last benediction out of that heart of fire. And at this sight, the cries of *Miracolo!* began again & here and there among the crowd women dropped to their knees and others whom I knew to be followers of our Friar, and despite the menace of our enemies, I too knelt although it seemed much to disturb our father who kept pulling at my sleeve. And Narro, of course, did not kneel but he was not grinning his habitual grin.

"So sobbing we knelt and the women wept and the children trembled—and all that while in the very ring and sanctum of our

foes. From one side sounded the cries of sheep and from the other the baying of wolves. At the foot of the flaming gallows children were dancing & clamoring and throwing pebbles at the three corpses so that sparks of fire scattered down and it was raining viscera and blood, and every time the children scored a hit, one part of the crowd would moan and another shout with joy.

"So we remained kneeling and sobbing in the bright sunshine as those three were dancing up there above our heads in the flaming air & we remained until the bodies were consumed and many women pressed forward, heedless of the antagonistic mob, and tried to gather up the ashes and bones as relics. But the soldiers drove them away. Then afterward I saw several women whom I knew not to be servants but disguised as such approach the gallows & flirt with the soldiers whilst their sisters secretly gathered up relics. And to prevent this the soldiers were ordered hastily to heap the ashes in a cart, which they did and drove it to the Ponte Vecchio & dumped them into the river. And I & your brothers & your father followed after in the great throng picking up whatever fell off the cart. On the shelf near Lodovico's bed there is a jar filled with holy ashes and I have some here in this snuffbox. You see . . . there is a secret bottom . . . now lift it . . . *vedi* . . . there is the painted effigy of Fra Girolamo and those ashes are his very own for I picked them off the cart.

"And later, Father met his friend Manotti, the apothecary, who drew him into a hallway and showed him a box also painted with the effigy of Fra Girolamo & there was a piece of his heart which he said he had fished out of the Arno one night. And he declared—as have all those who possess those relics—that Fra Girolamo's bones have already performed miracles, curing the ill and thrusting forth devils & he is truly a saint, may he pray for us in Heaven!

"So that terrible day ended. But immediately began the terror. For no man, not even a nobleman, could walk safely through our streets if he were known to have been a partisan of our Friar. For then he was hooted and insulted and called Hypocrite & Sniveler & Gallows fruit and Plebeian and there was no limit to the insolence and audacity for now the Arrabbiati and Compagnacci held uncontested sway over our city. Now everyone suspected was summoned to the Palace and questioned and many were put to the rack. And we were deprived of our benefices and our monastery was closed for the duration of this Signory, that is, two months, & several priests and clergy who had at any time written or spoken favorably of Fra Girolamo's writings or opposed the validity of the excommunication

were now summoned to Rome to face an ecclesiastical court. And being afraid, they paid money to the Papal examiner, the Cardinal Romolino, who absolved them from going. And other seculars, considered to be heretics, were condemned to pay. And as if these offenses against men were not enough, the Signory ordered that our great bell, the Piagnone, be exiled from Fiorenza because it had sounded on that day of tumult so it was removed from San Marco & loaded on a cart and driven through the streets while the hangman whipped it all the way up the hill of San Miniato to the Church of San Salvatore where the Franciscans took it for their own tower. And such was the persecution against us that many of my brother monks fled into exile & I fearing the rack and the injustice went away to San Domenico and then I secretly returned to borrow Narro's cape and come to Viterbo and thence to here.

"O I am weary, Michel, I can say no more."

X

Lionardo remained in Rome scarcely a month. Seldom did he stir out of doors. He spent hours sitting on the cot, hands clasped between his knees, and his eyes—those pits of fury—seemed to have gone dead as if their fire had burned out with Savonarola's ashes. He was entirely possessed by fateful images of that Florentine spring.

". . . And Lodovico? Has he settled the lawsuit at last? . . ."

"No."

"But surely he received my letter?"

"I do not know."

"I urged him to pay a part of the debt. Else he may be placed under castigo . . . He spoke nothing of it?"

"Nothing."

He would not talk about family matters. He was imprisoned in a glass bell. You saw him: death-pale, gash-cheeked, stubble-bearded, but you could not touch him. He seemed taken by a great weariness. One night, moondrenched and heavy with July, Michel awoke. The room ululated with strange sounds: he had dreamt that he was

suckling from the teats of the wolf of Rome; there were thousands fighting to take their places under those fertile dugs and it was the hissing chortling sounds that had awakened him. Lionardo had flipped over on his back; the moon was full on his tormented face; blue-gray veins embossed his temples; he was making choking sounds, and rigid at his sides, his arms twitched spasmodically as if they sought to break from bonds. From his open mouth a foul smell issued. Michel shook him awake. He gasped and twitched; then he was sitting up, running his hands through his matted hair. But he would not speak of his dream.

Late in July, Lionardo disappeared as mysteriously as he had come. Michel found a note saying that his brother had returned to the monastery at Viterbo; he left behind a pinch of Savonarola's ashes; he bade Michel preserve his purity in this Sodom. The admonition was cryptically phrased. Michel wasn't entirely sure he knew what it meant. He placed the ashes in an alabaster Roman rouge pot he had picked up at Ostia.

So Lionardo was gone. But his shadow remained. And the tale he had told remained. It hung over Michel's days: a trail of acrid flesh-scented smoke. He felt that he was breathing it ever, it pervaded his room, befogged his mind. It hung, a prophetic plume, in the plate-blue Roman sky; and sometimes in the summer thunderstorms Michel fancied he heard the cracklings and flashings of Fra Girolamo reverberating—a cloudy pulpit.

On the night when the city celebrated with fireworks the nuptials of Lucrezia to Don Alfonso of Naples, the flesh-smell was particularly pungent. Together with Andrea and Iacopo, Michel stood in the great square of San Pietro. With linked arms the three young men watched the fireworks spiral erotically up up up into the wombdark sky and burst—*O guarda!*—into fireblossoms. A suitable celebration. A public act. Everybody laughed. There were rude jests. The Pope's daughter was scarcely eighteen and this was her second marriage. Her union with the Lord of Pesaro had been annulled the previous September. The fled Sforza, safe in Milan, but despairingly diplomatic, declared that he had never "used his wife" and Lucrezia maidenly concurred. "Ahi," Iacopo exclaimed in the jolly square, "perhaps he never used her—" The basilica was outlined with torches, the sky carnival-bright with wriggling whooshing exploding colors, "—but everybody else did."

Andrea recalled the low comedy at the Pantheon when the annulment was announced. He had gone there at last, unable to subsist upon phantoms. The Tartar girl was leaning against the huge

column by the entrance. Cats coiled round her feet. Laughter echoed in the huge gloomy portico. "Why, she's the biggest whore of us all!" Never had the girls been in gayer mood. They celebrated the event as if the Pope had bestowed his apostolic blessing upon their craft.

Andrea whispered to the slant-eyed girl and led her to his quarters in the Mentone. Afterward, lying beside her nude exudent body, he felt as if he had copulated with a cat. When she saw him she had been most curious; as a mark of her special favor, she had scratched a Greek cross on his belly.

The crowd roared jubilee. On the lighted balcony, puppet-small in the distance, appeared the cone-tiara'd Alexander, flanked by the young bride and groom. Alexander raised his arms in benediction. The crowd knelt. The smoke smell, Michel thought, was particularly acrid tonight. Perhaps it was the fireworks.

When he got home the ashes in the alabaster rouge pot seemed to be glowing.

Oh, in this brothel there was only one thing to do—work work and work. His hands had been too idle since he had completed the Bacchus for good kind Messer Gallo. Fortunately the banker had also purchased the Eros he had fashioned for Piero. And he had paid him well for it. So now two children of his hands, two pagan spirits— the godling of love and the god of wine—stood side by side in Gallo's courtyard. And he was proud of them, a pleasurable flush would warm his cheeks when he heard these works praised by the best artists and cognoscenti of Rome. He was making his mark, he thought proudly.

But now, after Lionardo's apparition, now under the smoke-plume, he was wracked by doubt. Flaccid and tipsy his naked Bacchus stood. And it would stand forever, longer than flesh, tipsy as it was; its flaccidness was frozen into stone.

While Fra Girolamo was that pinch of ash in his urn. A heart fished out of the river.

O would he not have inveighed against this pagan god? And was there not a sign in the dying of so many artists these days? For art might be eternal but artists were dying like flies. Benozzo Gozzoli and Andrea's master, Antonio Pollaiuolo. All in the year of Savonarola's martyrdom. And now the news that old Ficino who had platonized Christ and christianized Plato had just published a denunciation of the Dominican. Michel heard himself laughing sickly.

Then his pride was of the Devil?

No, he said, clenching and unclenching horny fists, I have sought

only for Beauty and Beauty is surely not of the Devil. Beauty is God and what does it matter to Him where I find Him? For did not He exist even before He sent His Son, and is He not therefore prefigured in every work of beauty—pagan statuary as well? If You are not there (for now in his torment he was speaking directly to Him, striding back and forth in his room, empty but still echoing with the chronicle of that night), if You are not there, even in the superb stones of the Greeks, would a Prince of the Church, the Cardinal della Rovere, spend thousands of ducats to purchase that Apollo just excavated at Anzio and set it up in the gardens of his great palace of the Holy Apostles?

He heard raucous laughter.

It was the same laughter he had heard the day he had gone to see the much-talked-about statue. The Cardinal Rovere was still out of Rome, out of reach of the Bull's horns, at the court of the new French King Louis XII. Not only were this Cardinal and Michel's former employer, the Cardinal Riario, kinsmen; many of the house servants were kinsmen too. Michel had no trouble gaining admission to the apostolic palace.

So he had stood, more pleased than not at certain likenesses he discerned in his Bacchus and this Apollo, still stained with the earth out of which he had emerged—a similarity in pose, in the lyrical uplift of a heel, in the exquisite modeling of calf and thigh, in the outstretched arm, even in the stump against which both gods leaned an indolent leg. But this broken-armed Greek, he thought, is stiff as wood in the groin. Whereas the belly of my Bacchus is soft as . . . No, in all humility he could not declare his wine-god inferior.

So he had ascribed a Christian grace to his work. And then it was he had heard the laughter.

It was the chattering of his split soul.

Oh, the debate was useless! He could not reason himself out of this riddle. Perhaps it was the burning heat of this Roman summer. Perhaps he should return home to the Arno and aid Ser Lodovico in his never-ceasing legal quarrels and help set up Narro and Giovansimone in the wool business. That was the thing to do in these apocalyptic times. Thinking of home, of the green Arno valley cupped in the gentle lavender hills, of the turreted town and narrow streets, he felt that sickness for his own belltower which all his countrymen suffered from in this shapeless city of the Borgia. He had not been home for two and a half years now, and his father's letters were growing ever more importunate. It was his duty— No,

by Bacchus! by the Bacchus he himself had shaped, it was his duty to remain here and secure commissions and make his name.

Make the name of Michelangiolo Buonarroti ring like a chisel on the stone.

XI

Seeing that procession of penitents in yellow robes, carrying torches in broad daylight as they marched to the Minerva, Andrea thought nothing of it. There were so many processions here in Rome, pilgrims from all corners of Christendom: cardinals in scarlet and priests in black and children in angelic white and nuns with great starched headgear flapping like the wings of gulls and bearded beggars in motley—oh, it was a very circus of piety! His developing painter's eye had always struggled here in Rome against all that he had absorbed from Elia—a certain scorn for the externality of these Christians, an austere conviction that in the Tabernacle of the Mystery there was never anything for the corporeal eye.

So Andrea stood only long enough to let the slow procession wend by. But just as he was about to resume his way to the Palazzo Gallo he heard a word he had not heard for several years. "Marranos!" someone yelled from the crowd and spat at the penitents. "Marranos! Pigs!" It was the name applied to Bartolomeo's folk, to the Spanish Jews. Suddenly he realized the import of the yellow robes. It was always the color used to set them off: a bit of ribbon sewed on the cap, or an entire berreto made of the vile stuff, or a circle of yellow cloth on the tunic. It was a color he detested; he never wore a scrap of it on his person, not on undergarment or long hose or tunic or soft square-toed felt shoes. Sometimes he had trouble finding shoes not of that color—yellow was fashionable in footwear— but he would rather have gone barefooted.

It was the color of humiliation.

But why, he wondered, scanning the sad shamed faces in the yellow line, were these so clad? They were no Jews, he *knew*, he knew it in his bones, he could not tell how he knew it, but he was

sure that these bowed and shuffling figures were no kinsmen of Elia.

Kinsmen of Elia. The name had appeared in his head unbidden though not unwanted. But unbidden because its presence made him unhappy. He saw his step-father's face now—the keen gray eyes, the thin evaluating mouth—and he wondered if Elia were still alive? Was he still in Crete? Would they ever meet again?

It was suddenly chilly in the warm glare of the sun. He tore his eyes away from the yellow line and proceeded to Gallo's.

Although Andrea had been in Rome more than a year now, he had never met the banker. "A perfect gentleman . . . un vero cavaliere"—so Michelangiolo always referred to his new patron. For was not Iacopo Gallo truly a patron? Had he not purchased the kneeling Cupid which Michel had made for Piero de' Medici? Had he not commissioned the fabulous Bacchus which was the talk of Rome? If at twenty-three Michel was already becoming famous, he could thank the good banker for that. What the Cardinal di San Giorgio had failed to do, Gallo had done.

But Andrea had never met him. Indeed, here in the Eternal City, he saw Michelangiolo far less frequently than he had at Fiorenza. There was an ever-growing taciturnity, Andrea thought, a drawing inward. He was enshelling himself against violent tides. Secretiveness was in his eyes: a pearly iridescence.

Furthermore, Andrea had little time for vagabonding. He was fully occupied in his craft. After the Master's death, Pollaiuolo's bottega was continued by his oldest assistants; they were hard taskmasters; the days were long. Andrea would be exhausted after hours on spidery scaffolding. His shoulders ached from the pungent thumping of pigments. But he was proud that at last—at last—he could fraternize as a member of the circle. For although he might still be an apprentice, no longer did he feel himself the outsider who had watched the Samson grow in Michel's garden, envious of Granacci and Iacopo. Now he and Iacopo worked in the same shop and if foppish Francesco could be induced to join them, the Fiorenza circle would be complete.

And Father had said there would be no place for him. Only Michel and Iacopo knew his secret and they had not informed the guild. Never a word. Sometimes Andrea interpreted Michel's silence as a conscience-offering to the memory of Bartolomeo. Or perhaps it was simply his Roman indifference to everything that did not directly concern him.

As for Iacopo—if at strategic moments he held his tongue (which was against his nature) it was only in order to protect a Hebrew

who had no business in a workshop of art. How fortunate, Andrea thought, as the Castello swam round and massy into view, to be working in the same bottega with laughter-bumbling Iacopo. He was a charm that exorcised the eye of Elia whenever that dread portent loomed in the gloomy vault. His torch-red hair even managed to set off blazements of laughter in Michel. And that was certainly uncommon these days. A terrible melancholy seemed to have enshrouded Michel since his brother's visit. What was it darkened him? Andrea wondered.

The Palace was on the Canale di Ponte. A grim street. Dusky-rude dwellings. Barred windows. They were beginning to pave the street. Great flat stones were piled in front of the palaces. Hunched upon one of these heaps was Michel. From a distance, silhouetted against the riverlight, he seemed curled up on himself, one knee up under his chin, a bowstring stillness.

They passed under the ferocious portal into the sunny courtyard within. Grouped about a musically plashing fountain—a sea nymph astride a dolphin—were several men Andrea had heard spoken about but never met. The stony-faced man with a heavy red nose and silky white hair was the banker, Iacopo Gallo, proprietor of this palace. He wore a long dunbrown cloak with a slight trim of lapin about the collar. Short and heavyset as an Etruscan tomb figure, he acknowledged Andrea's introduction with a curt nod and a few resonant formalities. Then he resumed his conversation with Baldassare Balducci, the thin pointy-nosed man in black, wearing a magenta cappuccio whose muffler hung gracefully down his lank cheek. He smiled smally and shook hands bonily. He seemed very fond of Michel, drawing him at once to his side.

"Michel! Great news! The French Cardinal likes your sketch. He agrees to commission the work."

A smile, tentative at first and then flooding, washed across Michel's habitual frown. He began to thank Balducci stammeringly.

"No! Do not thank me! It was Messer Gallo convinced the Cardinal."

"Ah, Ser . . ." Michel bowed his head to the banker.

"No, not I either . . ." said Gallo with the faintest of smiles.

He pointed to a white statue standing in the arcade. "There is the gentleman who convinced our Cardinal," he said.

Andrea looked. It was Michel's Bacchus, softfleshed and tipsy in the cool colonnade, the goatfooted satyr playfully munching a bunch of grapes behind the god's fatty flank. The winegut belly bulged. The marble was faintly veined in pink. Off one shoulder

slipped a tiger skin, and it was like the lionskin, Andrea thought, of his snow Hercules the first time we met and Father then . . . He felt a sadness. The yellow procession still marched in his mind. Next to the Bacchus was a kneeling cupid.

"We have agreed to sign the articles next Thursday. At the Cardinal's palace. I shall stand you sponsor."

"I am beholden."

"The one thing the Cardinal insists upon—you know how finicky these French can be—is a time clause in the contract. You must stipulate to deliver the work within a year. I told him he need have no fears of that. I guaranteed him that not only would you complete the work on time but that it would be the finest statue any sculptor could shape in the city of Rome."

Like a jewel heightened by a sober setting, Gallo's words flashed against the banker's grave demeanor. Balducci was nodding pleased assent. Andrea listened with drinking eyes, luminous in the sunshine.

"You are too kind."

Behind Gallo's bronzed head, Bacchus reeled in the shade.

And so my tipsy Greek has induced my Christian cardinal to have me carve for him the Mother of God and her blessed Child. In the boxed blue over the courtyard, a smoke plume hung.

"The pay will be four hundred and fifty ducats."

"It is a good pay."

A year, Michel thought, with quiet exultation, it should last a year and I will be able to send money home as well. Babbo will bank it for me at Santa Maria Novella.

Into the courtyard, followed by a stout maidservant bearing linen, stepped a young woman. She walked with difficulty because of her great belly. She had a small mouth and golden hair softly contained in a pearl-spangled web. From languorous looping sleeves of lavender, slim wrists flickered pinkly, hinged delicate as watchworks. Her blue glance was ironic and tired as Michel introduced Madonna Bianca Gallo to Andrea.

She turned to give some instructions to the stout maid, who laughed, patted the young woman playfully on the stomach, and departed. Then Bianca turned to Messer Balducci:

"Father," she said happily. "Niccò will be home for my lying-in! I am so pleased. I had been afraid that the business would never be settled."

"Yes, we know," said Balducci, his fingers grazing his daughter's full dimpled cheeks, "Ser Pucci writes that Messer Niccò has com-

pleted the business to everyone's satisfaction. But do not be so upset—" he glanced at his daughter's burgeoning: her hands softly lapping one above the other on the great globe of her pregnancy "—if he fails to appear in time."

Her thin lips quivered.

"No. No, my dear. You must be patient. You are, after all, in—" He gestured at the fountain basin. Water spilled in a singing shining sheet. "—an advanced state, shall we say? Indeed, had you not better remain out of this sun? There, sit over there, tesoro, on the cool ledge of the arcade." He started to take her arm, Messer Gallo maneuvering with silent heavy grace to take the other, but Donna Bianca shook them both off with a wan smile. "Oh, I am so tired of just sitting. Always sitting sitting . . . And waiting. And being most patient. I am so *impatient* of patience." She turned to Michel with the old playful glimmer in her eyes.

"And you, Ser Michelangiolo, you have had some experience with bringing things to birth. Are *you* patient? Do you merely wait and listen to the music of it growing?"

"Donna, I fear our pangs are not quite comparable."

Bianca laughed. Her laughter, Andrea thought, was the tinkling of the fountain. And hearing it, Michel heard strains of a lute and remembered the night he had fallen off the topmost rung of the ladder of love. When Bianca kissed him. After that, he had avoided being alone with her, avoided this terrible falling that blurred his vision, so that he could not see the forms he was impelled to pursue. And she had mocked him with her arpeggio laughter and the scimitar-shaped smile that was her father's. Until, last year she had been wed to Niccolò Gallo, nephew of the banker, and now she occupied an apartment in this palace. He had met her occasionally when he came to see Messer Gallo. The last occasion had been to install the Bacchus in this courtyard. She had leaned out of a window then and smiled down at his huffing and puffing and the way he growled at the workmen. She still played her little game of tease and secrets shared, but he was more at ease now that she was married. Her husband, a tall lean young man who spluttered like a badly-made torch, was more often than not away from home engaged in business missions for his uncle. For the past four months he had been in Fiorenza seeking to safeguard the Gallo firm's financial alliances with the Medici against the reforms of the Savonarola party.

Although Bianca now possessed a dignity befitting her new status, the sight of those suckling dimples still troubled Michel. He saw

her only infrequently, but when he did, a clumsiness would fall upon him, his movements thickened, he was icebound. For though she was a married lady now, Madonna Gallo, her cheeks were still soft, her wit still flickered above her gravity like butterflies above a new-ploughed field.

"Niccò writes there is more confusion than ever, now that the Friar has been cast off—"

Cast off, Michel thought, seeing Girolamo's arms swinging out into smoky space, Fra Domenico flying—

"—the Arrabbiati and the Palleschi still struggle for command. Niccò writes—"

"Why do you trouble your head with these matters?" Baldassare cried with a trace of acerbity. "Such concerns are not for pretty children," he added hastily and with a rueful little smile, as if he would not offend his darling. Solicitous as a gardener, he was leaning over his heavily-burdened daughter.

"But Niccò writes there may soon be war in the Romagna and if there is war, I want my Niccò home. I want him home before my lying-in."

Her lips were trembling again. Michel looked on in wonderment. She seemed so soft now, so little like the Bianca who used to tease him to torment.

War in the Romagna. That would mean war at the very borders of Tuscany. Lodovico's last letters were already speaking of it. He would have to go home soon. But he could not go home now. The Madonna—

"—of course the Cardinal Cesare's request was inevitable. He must be disencumbered of the purple to free his sword arm."

"Oh, his sword arm doesn't seem to have been encumbered very much by his Cardinal's robes," the banker said dryly.

Andrea had heard the story. It was the current gossip of Rome. The Pope's son had requested to be returned to secular life. Everyone wondered why. Cesare had never permitted his ecclesiastical status to interfere with his secular ambitions.

"Has the Cardinal's request been granted?" Andrea asked.

"No, but it will be, young man, it will be." Gallo turned to the company, slowly fanning out his arms in mock benediction. "The Holy Father himself appeared before the College of Cardinals last week and declared that his son's red hat be put aside for the health of his soul—*pro salute anime*—"

"An interesting phrase," Baldassare laughed.

"It is indeed. And as testimony of the purity of Cesare's inten-

tions, it was pointed out that secularization would deprive the Cardinal of benefices amounting to thirty-five thousand gold florins."

"Whose health might the Pope have been referring to? His own? Or Cesare's?"

"Or perhaps Donna Lucrezia's new husband's?"

Urbanely, they all smiled in the sunshine. A swallow swooped under the colonnade, wove a dizzy flight to freedom again. The dolphin-fountain tinkled. Marmoreally balanced, Bacchus reeled.

"Perhaps," Gallo mumured, "the Holy Father is simply casting about to cement his French alliance. By marriage, you see. Hence Cesare must be released of his vows. In that way the Pope may forestall what is now so much bruited about. King Louis—so our ambassadors report—thinks of repeating what his predecessor did."

"Of course," Baldassare said calmly. "Once having raped our poor Italy, the French have probably developed a taste for that sort of thing."

His pointed nose seemed to sniff the air as if it were polluted. Then with his cutting little smile:

"Whatever it may be, the Holy Father is undoubtedly in need of funds for some great undertaking." He paused a hung moment. Michel was sitting on the fountain rim, idly stirring the placid pool. Bianca dabbed tiny beads of moisture from the plucked dome of her brow.

"—Interesting about the Bishop of Calagora, is it not? To think that a Marrano—"

Hotly, Andrea turned.

"—could have insinuated himself to so high a position. Truly astonishing. And now thirty more, lurking behind priestly vestments. Happily they have all decided to confess."

"They will pay well for their absolution . . ."

An insect scratching the dry terrain, the chirring voice went on. Yes, Andrea thought, flushing, there had been about thirty in that procession. He dappled the pool, touched cold water to his head.

Borgia's Jews.

Sere as the rustle of the pages in his bank, Gallo was saying:

"The amusing bit is there are those not above accusing the Holy Father *himself* of being a Marrano."

Andrea looked at Michel. His expression was remote. He was staring at his reflection in the pool; he frowned and erased the reflection with a disparaging hand. No, Andrea thought gratefully, he will not speak of it. He never does. He had not spoken of it since that thing of Bartolomeo. Andrea felt sudden tears well into

his eyes. How kind he was beneath the gruff exterior! To stand assurance for me in the guild where no member of our faith has ever been permitted to enroll! To bring me to the Master Pollaiuolo's studio that very first month of confusion and to vouch, in the presence of so exacting a man, for my small talents! Oh, but he was an angel! Michel, the angel!

The angel was gazing again at his shimmering fawn's ears, the tiny biforked blackenings of a beard to be. He rubbed his nose and the invert figure in the fountain did the same. He was not thinking of the Borgia or their peculiar means of raising cash. He had not even heard Baldassare's cynical story of the new-found Marranos. Already the Madonna which the French Cardinal wanted was looming in his mind, shimmering in the depths. She had a cool small mouth and a high plucked brow softly mantled by a hood, and about her capacious form rich undulations of a robe.

And lying on her knees—O Death!—was Fra Girolamo.

Sunlight penetrated the arcade. Bacchus was white as snow. His glazed eyes looked uncomprehendingly at the Man of Sorrows. Silkily, stalk of millions, his malehood flowered from two languid pods. O forgive me! hook-nosed Thunderer, I cannot, like Master Sandro, smash what I have wrought. But I can redeem.

O forgive me, Andrea was crying to a ghostly Elia, I have forsaken but I can redeem.

XII

On the day Cesare Borgia, no longer a Cardinal, departed for France, Michel was beginning his voyage into a more than man-sized block of creamwhite Carrava marble that stood on a low wooden platform in the center of his rude studio. Seated on the rumpled bed, watching with quiet intensity, was Messer Iacopo Gallo. Michel felt his presence as an intrusion. He hated to work in front of witnesses. Love-making, Michel thought, was best performed in private.

Besides, to have this banker, habituated to the everyday elegance

of his palace, in such a place was embarrassing: the room seemed dingier for his presence. Michel regretted that he had failed to tidy up a bit before Gallo came—he might at least have hidden away that dirty slashed codpiece and those breeches dangling from the outstretched arm of a fawn.

He was embarrassed. But how could he avoid inviting him? Gallo not only liked statues. He liked to see them in the making. It had been the same with the Bacchus. And would he have had this commission at all were it not for Messer Iacopo's enthusiastic publicizing? For when the French Cardinal (who had accompanied Charles to Fiorenza, and who, as a Benedictine was partial to the cult of the Madonna) had made known his desire for a statue to honor the late departed hunchback, ah then Gallo had cried, with unaccustomed warmth, "I have just the man for you! A brilliant young Florentine . . ." As proof, Gallo showed him the Bacchus.

So it was done. It pleased the Cardinal. And the Cardinal knew it would please the Pope. Alexander was also devoted to the Virgin. It was as if, Michel thought with perplexed excitement when he went to sign the contract, all of them had suddenly become aware of the savonarolean smoke plume that hung above his days. Now that smoke had become stone. He was doing what he had to do.

He looked across at the banker, impassive on the bed. How that heavyset granitic face had smiled when the Cardinal de St. Denys had handed him the quill . . . "And you are quite willing to sign even this?"—pointing to the incredible clause—*And I, Iacopo Gallo, pledge my word* (pledge *his* word!) *to His Most Reverend Monsignore that the said Michelangiolo will finish the said work within one year, and that it shall be the most beautiful work in marble which Rome today can show, and that no master of our days shall be able to produce a better.*

"In my business I am hardly accustomed to take foolish risks."

So he had signed with a tiny neat hand, exact as spiderweb. Michel turned away, tears in his eyes. He wanted to kiss this man but the Cardinal was watching. It was not a bad contract. Four hundred and fifty golden Papal ducats. Of course out of that would have to come the cost of the stone and the expenses of installing the finished work in the chapel of Santa Petronilla in San Pietro. And Lodovico thinks I have no expenses, he thought angrily, remembering last week's wheedling letter. Ser Lodovico's letters were becoming ever more shrill. Since he had lost his place in the Customs—four years now—he had no income of his own. It was lucky at any

rate they owned the house on the Via Bentaccordi and the farm at Settignano. Narro's earnings at the Strozzi were hardly enough to sew a pair of drawers for a cricket. Had Giovansimone returned home yet? he wondered frowning. That madcap, enlisting in the wars.

Alongside the platform was a large tin tub. It was filled with clear water and Michel now took the wax model on which he had been working for the past month and submerged it in the tub. Then he slowly lifted it. The first thing that broke the surface of the water was the Saviour's limp right hand. Michel advanced boldly to the block. He looked as if he were about to storm a castle, the chisel sharp-forward like a lance. On the smooth surface of the block he had already sketched in charcoal the frontal view of his design. He raised his mallet and smashed out a chunk of marble the size of a fist.

Gallo gasped. How bold this young man was! Now he was chipping rapidly away around the hand, crisscrossing, now right, now left, his bushy head bent to the task, the strong right wrist curving with the chisel, and the mallet in the left tapping surely away like a furious bird. Baldassare had not exaggerated. Who was there left in all of Italy, Gallo thought, to compare with this young man in the art of stone-carving? His orderly accountant's mind began to check off the names—Quercia dead, Ghiberti dead, della Robbia dead, Pollaiuolo dead this very year. There was only Andrea da Sansovino of whom fine things were being spoken. But the banker didn't know his work; besides he was in Portugal, in the service of the King. No, Gallo decided, he had not indulged in any sentimental weakness in that guarantee. Certainly, there was no finer sculptor here in Rome.

The floor was already white and glittering. Tchp-tchp-tchp. Now he had exchanged the broad chisel for a narrower one and was hollowing out in swift parallel strokes the articulation of the wrist. Those three lines furrowed in his forehead, Gallo thought—they too seemed engraved by a chisel. What prehensile hands! And those muscular knotted shoulders incongruous on the small frame. And the kerchief tied around unruly hair. Tchp tchp tchp.

Michel paused a moment, submerged the model again, and resumed his carving.

Gallo examined the sketch on the stone. The head of the Madonna seemed suddenly too small for the enormous torso. He was about to speak of it, then decided not to. Never speak to the cook about a goose half-done.

A twinge of pain crossed Michel's face. He stopped, breathing heavily. "What is it?" Gallo asked.

"A stab in my side. It will pass in a moment."

"Rest a while."

"Thank you, Messere. But if I am to fulfill this work in one year, there is no time to rest."

He stood quietly for a moment, mallet and chisel in hand, then drew a deep breath and resumed his work. From the street sounded a clatter of hoofs, someone was running down the hall and banging furiously at the door. It was Dino, the banker's portiere. He was a tiny surly-natured man, stooped in a lifetime of service to this master. His flat fish eyes glistened in a net of concern—"Messer Gallo! Messer Gallo! Donna Bianca has come upon her time!"

"The midwife—?" Gallo said, rising at once. He moved with surprising alacrity for so monolithic a man.

"Already come. And my Diana is at her side. But you must hurry if you want to welcome your first grandnephew into the world." Dino's wife Diana, the stout jovial maid, had decided the sex of Bianca's child with the announcement of her lady's interesting condition. She had consulted her confessor, who was also a necromancer. After drawing a circle and sprinkling various herbs in a fire, the priest had read in the boiling noxious clouds of smoke the gender of the babe-to-be.

"—and Messer Balducci has arrived and if I may be so bold as to say so, he could do with more comforting than his own daughter."

So Gallo and his manservant, flushed with human concerns, left Michel with his stone.

He heard them galloping off and he thought of Bianca, sweating and toiling in her bed, and the mystery of her undertaking assailed him. His side was aching terribly. He stretched out, boots and all, on the straw pallet. He wasn't feeling right these days; he hadn't felt right since Lionardo came with that awful news. Was he still at Viterbo? Narro's letters never breathed a word of him. His head began to ache. He wondered whether he shouldn't abandon this city for his own country. The fetid air of Rome didn't agree with him.

Gallo and Dino had ridden at breakneck speed down the Corso toward the quarters of the Banchi. But suddenly they found their way blocked. The Ponte Sant' Angelo had been closed off for a cavalcade of some sort. They tried to get around it but could not; Vatican guards, with breastplates and plumed helmets, cut off every

street five blocks from the bridge. What was it? Gallo inquired of a soldier.

"The Duke Valentino is on his way to France."

Ah yes, Gallo remembered. Indeed, it might have been more circumspect for him in his capacity as banker, connected by business if not by affection to the Borgia, to have attended the ceremonies at the Vatican this morning when the Pope had blessed the departure of his son. But Gallo had been so eager to see the actual commencement of young Michelangiolo's new statue that he had quite forgotten about the Duke.

He was passing now at the head of his procession gazing coldly down from a fine white horse. He lacks the human qualities of his father, Gallo thought, but he is undoubtedly handsome. The thin face was sun-flushed, drawn tight with physical activity and braised with ambition. On the delicate nose there was a black wart like an insect. A small sand-colored beard lent a touch of sensuous masculinity to his fine modeled features. His expression was cruel and hard, flesh and spirit honed to ultimate edge. The crowd cheered, seeing him. The Pope's son was popular with the Roman mob. Gallo's thin lip twitched. *Panem et circenses.* Because he can decapitate a bull with one stroke. As he had dispatched his brother Gandia. The Duke wore a black plumed beret and a white damasked jerkin embroidered with gold threads, and over his protruding sword a black velvet mantle draped gracefully. All very much in the French style, Gallo thought with a grimace. Preparing himself for his hosts.

Now hundreds of young Romans followed in the Duke's wake, sycophants of his power, fellow-roisterers. Gallo recognized young Orsini among them. They sat upon fine pure-blooded horses shod in silver. Now came a train of mules bearing the treasures the Duke would present to Louis XII. The sum was a scandal among those who knew: was it the Duke's humor or the Pope's to flaunt two hundred thousand ducats in cash and precious ornaments on parade through this quarter of the Banks?

Drmmm Drmmm Drmm. Tambours ricocheted from barred windows. From stone walls trumpets trilled a shrilly blast. Gallo shifted uneasily foot to foot. He hoped he would not be too late to greet his grandnephew.

He had fallen asleep, the pain in his side boring into him like a sculptor's drill turned by the bow. He had fallen asleep wrapped up in his cloak and the handkerchief still bound around his unruly

hair. For no matter what else you may neglect, keep your head warm, Babbo always used to say. The bells of Rome were ringing for the Duke and the pulsation of the bells chimed sometimes together in unforeseen miracles of harmony and sometimes not together so that he felt the headache he always suffered from in sleep. And now the bells had become the white shapeliness of a woman's hips, the important thing was not to undercut too deeply where the clapper hung, for that would ruin the design but the design was pain, underwater, the hand breaking the surface first though it should be the head and the head that issued forth from Bianca's bellthrobbing agony was ringleted, the marvelous ringlets of Andrea the Jew.

He opened his eyes. Out of a beautiful haze Andrea was gazing down at him. He smiled and said something but Michel was sure he was still dreaming, the lips that spoke were shaped too perfectly for daylight lips, they were the lips of dream, something to be bitten into like grapes. He groaned and turned over on his side.

Ah, but how he resembles his brother, the Dominican, Andrea was thinking, all wrapped up so in that cloak and with the handkerchief for a hood. The resemblance had struck him as soon as he came into the room with Iacopo and found Michel sleeping. They had come together directly from the shop. The whole town was celebrating. The Duke was off to France.

"Shake him again," Iacopo said. "How the devil can he sleep through all those bells?"

He let out a loud "Ho!" Michel sat bolt upright in bed. It was already the nineteenth hour. Sun was slanting horizontally through half-opened shutters. The beam splashed brilliantly upon the block, so that its specks of mica glistened. The block cast a long shadow, color of lavender smoke. Now the shadow moved. "Wake up! Wake up! How can you snore through all those bells!" It was Iacopo and he had a wine bottle in his hand, half emptied, and he reeled like Bacchus. Michel smiled. The pain in his side was gone and he felt a sense of euphoria.

And at that hour did Madonna Bianca Gallo, born Balducci, give forth to the light a new male child in good health in all his members, and he was squalling mightily and outside the cannon still boomed and he was graced with the name of Iacopo in honor of his great-uncle and as good omen of a future stake in a profitable business.

By the time they reached the Ponte the procession had already passed. So instead of chasing the parade they decided to celebrate the occasion at *Il Sasso di Dante.* This was a Florentine tavern, they felt at home there amidst familiar accents and familiar wine. The serving-maid was named Beatrice and she was so fat she could scarcely maneuver her way through the noisy close-set tables. Her flushed pretty face seemed to float upon enormous billows

The leviathan vision of Beatrice revived an old argument. For every time he saw Beatrice's boisterous bosom bursting from her dress, Iacopo insisted that for certain renderings marble was unsuitable. "How can you possibly achieve that *softness* in stone?" he said now.

"He achieved it in the Bacchus," Andrea said. "The thighs and belly are as soft as—"

"Nothing is as soft as that," said Iacopo. "Hey, Beatrice, thwacky-thighs, come here, bring us a fiasco of Chianti."

She was moving pantingly, pushing her great buttocks like an elephant through a jungle. And the tavern was a jungle, rude hands clung to her like creeper-vines, laughter crackled like paroquets in the thick wine-soaked air. The Duke was off to France and nobody knew why or what it portended but it was sufficient excuse for another festa.

". . . wax, I tell you, or soft clay. No other material gives you the feel of flesh. Then when you get that feel into it, you can cast in bronze . . ."

"Anything done by pushing is not sculpture," said Michel calmly.

"Ah, perhaps not. But what a pleasure!"

He clapped his hands at Beatrice.

"Come here, my darling ball of lard! Come here, my pillow of delight!"

"Wait your turn!" the serving-maid yelled back. "Don't you see I've got my hands full?" She was juggling a half dozen glasses of wine.

"That's not all you've got full," leered Iacopo. He flung his arm around Andrea's shoulder. "Caro mio, how would you like to spend a night rocking on those billows?"

Andrea reddened. Michel was disgusted. It was less Iacopo's jibes than the sight of the mountainous girl that disgusted him. He was always disturbed by deformed bodies. He had never been able to understand artists like the Master Piero di Cosimo who seemed to take perverse joy in depicting humanity's grotesques—old women whose noses and chins kissed, cripples with hairy warts. Michel had

done a few drawings of a similar nature himself while working with the Ghirlandaios, but swiftly realized that such truth to nature was not for him. Was not art an Ideal? a refinement? Why repeat what one could see every day in the streets? . . . Piero was a strange one anyway—a *stravagante*—refusing to eat the fruit of his own orchard, letting the figs go to seed, living on hard-boiled eggs and never sweeping the cobwebs out of his studio or weeding his garden, insisting that nature should be left alone, even when she indulged in foul caprice. Michel recalled the day the wizened gruff-voiced solitary had traced for him an equine combat and extraordinary landscapes from urine stains upon a wall near the Shrine of the Five Lamps. Piero's peculiar manner was said to be an imitation of the manner of the engineer Lionardo da Vinci, absent from his country for many years now in the service of the Sforza at Milano, and though Michel had never seen any of his works, he had spoken to those who had and it was said by some that Master Lionardo was more wizard than painter . . . But all such distortions disgusted Michel. He hated the meticulous realism of Flemish artists with their knobby-kneed saints and Magdalens with hanging breasts. No, there was quite enough distortion in nature. The artist must rise above that to the realm of pure form. The artist was a phoenix reborn in the fires of reality, not just a copyist.

"Beatrice bella!"

How could Iacopo jest with her? Now, with his carrot-hair flaming and a rill of sweat cupping in the hollow of his throat, he reminded Michel uncomfortably of Narro. He even seemed to emanate the same smell of goat cheese. What were they?—centaurs or men? Andrea was blushing at another of Iacopo's rough remarks. Wheezing above the laughter now sounded the sweet pungence of a bagpipe. Two singers were improvising on the Duke's departure. Beatrice stood before their table, billowing.

"Vieni! Vieni! my darling spigot!" Iacopo cried and threw the scudi on the wooden table.

He reached out to pat a rollicking valley and Beatrice slapped his hand. Then she made a lewd gesture at him and walked away. Michel could not bear to look at her. He visualized her nude: the shapeless sea of fat; and his gorge rose. For the human form was divine and all aspired to the divine or was a memory of it. Where did a Beatrice fit into this scheme of the perfect Creation? But perhaps Creation was not perfect? Perhaps it was flawed. As his marble was sometimes flawed and God had to fling down his chisel in disgust and leave unfinished a hulk like this? Then God was never the

achievement but only the Promise, the Idea in the stone, the perfection in his Mind . . . Breathy bagpipes. Goatsmell. Sanctity of the body. The spiritual was in the material and so the material was transformed and radiant. And yet it was nothing in itself . . . "*Va Valentino alla corte di Francia*" sang the singers . . . it was an envelope that faded like dew in the sun, even the hardest stone was only an envelope. "*Per combinare un bel matrimonio . . .*" Then this thing of beauty, this micaflecked marble, veined like flesh, out of which he could, by a violent assault, birth shapes of his imagining —then all this was unreal? only a shadow on the cave wall?

Suddenly he felt tormented, pulled in all directions at once. It must be the wine, the fetid air of this place. The faces were unclear, wobbling as if under water. He was moving and standing still, it was a movement without locomotion. He had an impulse to flee. For though he might laugh heartily in the presence of these centaurs, the core of him remained stonily apart and now this core was growing soft, billowing like the thick too-sweet smoke of that fat roasting in the kitchen. He was losing his shape. A repulsive caricature of the divine moved heavily between the tables. His eyes turned gratefully to Andrea; he wanted to drink from the Jew's face: the gentle hazed perfect cup, the liquid eyes, the sweet arched mouth. Iacopo was grunting an obscenity.

He rose abruptly and bade them addio.

Returning to his studio he passed many bonfires lit in honor of the Duke. Swishing fireworks zoomed in the purpleblue sky. Cannon boomed dully in the distance. He was deeply depressed, the mood had deepened when he left his friends at the *Sasso di Dante*; he felt a little sick to his stomach. For though he sometimes might joke as rudely as any of his companions, the moment he was alone his face took on an expression of the profoundest sorrow; he would know a nameless melancholy, a sense of torpor; life was utterly meaningless. And these moods angered him because they threatened to stay his hand. Then he would drive himself all the more to his art. Whenever he was assailed by melancholy, whether by day or sleepless headache-racked night, he sought to climb out of the pit on marble stairs. And sometimes he did climb out and sometimes he did not.

So now he was rushing back to his studio and he lit the candle and took up his chisels. He approached the roughly-blocked-out Virgin, struck a tentative blow . . . No, tonight it was impossible. He felt as if his chisel were sinking into the soft disgusting clayeyness of Beatrice. His vision was blurred. He must be giddy with Chianti,

he thought. He had become used to Frascati wine and that was not
so strong. Andrea's body . . . no, it was surely not like the serving
girl's, but hard and silky smooth and when he smiled there was an
ancient sadness in his eyes and his lips were like grapes and his ring-
lets . . . were those ringlets repeated below, he wondered.

Drums were beating in his brain.

With excessive care he put away his chisel and strode back and
forth in the studio. Outside in the Roman night sounded the revel-
ers. The whoosh of fireworks laced the sky.

Yielding to a sudden impulse, he locked the door and stripped
himself naked. In the tall mirror he surveyed his body, sepia in the
candle-glow. Heritage of Adam. The form in which God had re-
vealed Himself. He was short, his legs solid but slightly bowed, there
was a red scratch across one rocky knee. His chest was covered with a
tangle of curly black hair, and the hair flowed in a silky stream
across the curve of his belly and down into a shadowed grove where
his sex lurked, supple as a serpent. A line of red circled his neck and
dove to a V: he stood too often in the sun with jerkin unbuttoned.
Satyr-face, spit-colored eyes, broken nose, scrawny beard, gashed
cheeks, protruding brows.

What woman could love this thing?

And if the body was, as Marsilio had taught, language of the soul,
then what sort of soul had he? And if this envelope of flesh was
merely the outward speaking of the inner voice, if its passions im-
aged the soul's passions as that spotted mirror images me, and if my
legs are bowed, then is not my soul somewhere bowed? Ficino's
words echoed:

"Vengo a dire che se l'anima vorrà levarsi . . . and if the body
choose to yield herself unto luxuriousness, she will become uncomely
and defiled . . ."

The serpent was creeping from the bush, beckoning. "And if the
body choose to yield . . ." He trembled, moved away from his
temptation, he saw the naked man stride with stricken eyes out of
the mirror-frame, a flesh-ripple disappearing into limbo, Masaccio's
man walking off the Carmine wall. The serpent was offering him the
apple now—the reared, the pearly-eyed serpent—and he was Adam
and he was Eve, the juices of all rivers ran. From her house of stone
the unfinished Madonna looked coolly on. Hurriedly he pulled on
his breeches, dressed, fled the marmoreal Garden.

For two hours he walked the streets of Rome. Bonfires still cele-
brated the Duke's departure. He found himself at the Colosseum.

Fires had been lit within: a lurid glow framed in heavy arches. A girl hissed at him from behind moldering rocks.

With the face of a sleepwalker he went to her.

And on the 22nd day of May fourteen hundred and ninety-nine did the Holy Father decree that all Rome be illuminated in jubilee of the marriage of the Duc de Valentinois, known as Valentino, and the Princess Charlotte of the House of Lorraine, and this marriage had been gladly acceded to by King Louis (to whose house the Princess was akin) because the Pope's son had borne with him the decree of annulment permitting the new French sovereign to marry his predecessor's, Charles', widow. And this was what King Louis had long desired and so he welcomed Cesare into his house. And fireworks blazed again over the Piazza Navona and Michelangiolo was just beginning to undercut deeply his Saviour's arm.

And when the French King, assured by his alliance with the Holy Father, did enter Milano to retrace a bloody palimpsest of Charles' invasion, the Milanese greeted his coming with great joy for finally were they rid of murderous Sforza, il Moro. And on one side of King Louis rode the Duke Valentino and on the other a strange new ally, the Cardinal Giuliano della Rovere, who had at last decided that his long feud with the House of Borgia had best come to an end. For Duke Cesare brought tidings to Avignon (where the Cardinal still lurked at the King's court) that Giuliano's forty thousand ducat debt had been remitted by his arch-enemy, Pope Alexander. In balance thereof did the Cardinal Giuliano find it most expedient now to write directly to the Holy Father praising the gentlemanly conduct of his lusty son.

And Michel was striding back and forth in his studio, kicking at the dirty heaps of clothes, crunching across the marble dust which now lay like snow at the foot of the block from which, dim and half-perceived as if written under water, the figures of the Madonna and her Son, limp upon her knees, were just beginning to emerge. And Michel was biting his lip to stem the curses that strove to issue forth, for he would not curse his father although the constant whining of these letters was more than a man could bear. And how—he cried out to the walls—how could he be expected to shape out of this block a cool monument of agony if Lodovico was ever crying for money and Giovansimone had not returned from the army of whatever con-

dottiere he had enlisted with and Narro did not write at all because he had no time to spare from ogling the maidens as they passed the Strozzi warehouse, and Gismondo was a dolt at school? And the months running out and the stone still recalcitrant. Ah, yes yes, echo the arch of the Saviour's left foot with a branch protruding under. *Tchp tchp tchp*

And on the hot August day when blond Lucrezia departed to take her post as Papal Regent of Spoleto, her mule train was richly caparisoned and with her she bore many precious objects and a bed of silk and another of velvet and her belly was round as the new-discovered hemisphere (Whose? Pasquino asked) and her thick powder was streaked with tears because her new husband Don Alfonso had mysteriously fled to Naples while she was in her sixth month. Then to console her, did the Holy Father appoint his daughter as his Papal Regent—a thing unheard of for a woman—and induced Alfonso to return to his wife's lawful bed, which he did, rejoining her at Spoleto. And the next month there was held a family counsel of the Borgia at Nepi (—tismo! chortled Pasquino), the town clinging like a desperate climber to the rocks above the crater-lake, round as a blue eye from those heights, wherein the sunken galleys of Tiberius lay. And breathing heavily upon a gold divan was Madonna Lucrezia, fine sweat beading the thin upper lip, her eyes blue as the lake (what galleys were sunk in them?), her hair that, unloosed, hung so heavily it hurt, twined in a Medusa-knot, her grapetiny tits, her middle taut as a tambour. And though she was troubled, her eyes were clear as the lake in which frogs croaked and men spat and left their offal and nonetheless blinked innocently back to heaven, like the veritable mirror of Diana it was called; and the small head of Madonna had emerged and she was gazing at the partially hacked placenta of marble from which her Son would issue forth and Michel thought that it was good

And with the great heat of Ferragosto, Madonna Bianca's child was sudden taken with an impostume and griping in the guts and Madonna Bianca clasped the baby close to her bosom and came down with the sickness herself. So that for a while both mother and child were despaired of but by God's help and the ministrations of a Hebrew physician whom Andrea brought to their notice and by the blessed conjunction of fortunate stars and the assistance of the maid Diana's priest-necromancer, both mother and child recovered. And for several months afterward did Baldassare Balducci make daily

communion and offer money to the Cardinal de St. Denys for the Chapel of Our Lady of the Fever in Santa Petronilla where Michel's statue was going to be placed.

And with November's wind, the Duke marched into the Romagna and by a series of brilliant betrayals conquered many towns. And at Fiorenza a whip-sinewy young man, six years older than Michel, with a small head round as a falcon and with a falcon's eyes and nutbrown hair tightfitting as a skullcap and lips thin as razor slashes, grinned a furtive flickering grin as he observed, as any new-appointed Secretary to the Eight should observe, the swift maneuvers of the Fox, Cesare. And with November's blasts and the explosions of the Duke's French falconetti and Machiavelli's smile, Princess Lucrezia brought to light at Rome a son and the infant was named Roderigo which was the name of the Holy Father.

And on that day Michel's Mother gazed with cool Greek despair at her Son almost totally freed now of the encumbering stone, and the flesh milkywhite with death and limp with the first moments of a vessel from which soul has been poured, as Michel circled round and round, biting his lips, brow furrowed, mallet in left hand and a small chisel in right, and only stopping now and then to dart like a bird at some wormlike protuberance of the stone.

Then it was Christmas time and the Duke was besieging Forlì and Pasquino wanted to know would the great virago, Caterina Sforza, mount the ramparts again? Would she defy the besieging Borgia as she had defied the murderers of her husband a decade ago? For the tale was much spoken of, how when her rebellious subjects had threatened to kill her sons whom they held for ransom, unless she yielded the castle, then did Caterina climb upon the merlons of the tower and lift up her skirts so that the captains below could see her pistoning thighs, her flaming bush, her prodigious machine—"a me rimane lo stampe per farne altri! . . ."—laughing in their faces— "I've still got the mold to make others! . . ." And would she now, asked Pasquino with a smile, lift her skirts so to the Borgia Fox, or would she rather, as had her kinsman, the Cardinal Raffaele Riario, show her behind? And when Michel heard speech of the Virago's old defiance, he praised Caterina's saying, for he too in his innermostness was an unbreachable castle with frailty on the ramparts. And he was rubbing with fine pumice the spaces between his Saviour's fingerlong toes—the second longer than the first—which he had shaped in the manner of the Master Donatello and after the toes of the criminal

whom Master del Medigo had dissected. And it was freezing Decem-
ber as he polished the metatarsal and the tibia till they shone and
stepped back to look at his completed work and to blow on his blue
hands for there was no fire in the studio and even his long lucco-cloak
and hood did not suffice to keep out the cold.

XIII

That was the very day there came a group of men to Michel's
shabby studio. When he heard the tramping in the hall, he suddenly
remembered the nature of this delegation: he rushed frantically
about, almost knocked over the tall mirror leaning against the wall,
gathering up the scattered hose and doublet, the unlaced boots, the
piled books, and everywhere like autumn leaves, the sheets of
sketches. He was just drawing the coverlet over the straw pallet
when knocking sounded at the door.

It was Gallo and Baldassare Balducci; behind them, brilliant in
his scarlet cape, the French Cardinal de St. Denys, patron of the
Pietà, and his servant. Michel had not seen the Cardinal since the
signing of the contract, more than a year before. He saw the delib-
erate face light up at the sight of the marble group that dominated
the poor room, seeming to radiate a nimbus around it; with a waved-
off greeting, the Frenchman approached the work and stood before
it, lost in thought. Then, blowing on his hands—

"Pardi!" he cried, "how can you work in such a freezing room?"

"Forgive me, Your Reverence, but I lack fuel."

Impatiently the Cardinal dispatched his man to get wood. Swing-
ing his arms he resumed his attentive study of the Pietà.

Watching out of the corner of his eye, Michel continued his
whispered conversation with the two bankers.

"And is Mona Bianca well?"

"With God's grace, completely recovered," said Baldassare. He
crossed himself.

An unfamiliar piety, Michel thought. Was it the presence of this
Cardinal? Or had Monna Bianca's brush with death frightened him

so? The Cardinal was scratching his cheek. Now he touched Madonna's finger. Was he pleased?

"And the infant?"

"Ah, he is no longer an infant," Gallo said with animation. "Already he sits up and grabs at my finger as if it were a piece of sugar."

The Cardinal's man was staggering through the door loaded down with logs and faggots. Soon a fire hissed on the hearth. The Cardinal murmured something to his man who got up off his knees in front of the fireplace and trotted to his master like an obedient horse. He handed the prelate a small velvet case. The Cardinal put on a pair of spectacles which sat halfway down his ivory-pale nose. Now, he leaned closer, examining the Virgin's outstretched left hand, the half-opened supplicating fingers that Michel had fused to the white arm of the Forum. He was nodding now with satisfaction, slowly circling around the statue. Glimpses of his cope swished redly under Madonna's armpit.

"I have a bit of news that should interest you, Michel," Baldassare was saying. "Did you know that your erstwhile patron the Cardinal Riario has fled Rome?"

"Indeed? Why has he fled?"

"Well, apparently he drew certain inevitable conclusions," Baldassare chuckled. "It was rather confusing for the poor man when you think about it. At first, one cousin, the Cardinal Giuliano accompanies the Duke into Milano. Therefore the Duke must be an ally of the Rovere and since the Rovere are related to the Riario, all betides well. Ah, but then, despite the fact that Giuliano has posted surety for his Milanese loan, the Duke blandly attacks another member of the same family, Caterina Sforza at Imola. And now that Imola's taken, and Forlì will surely fall, the Cardinal of San Giorgio reads the writing on the wall. *Mene mene . . .*"

The pale face of the French prelate was peering deeply into the Saviour's face; all unwittingly the expression of his living flesh assumed the expression of the tormented stone. Michel recalled how he always automatically stiffened at the stiff posture of Master Donato's San Giorgio in the niche at Orsanmichele. Yes, that was how statues spoke. His Virgin was speaking to the Cardinal.

"It was a rather ingenious departure . . ." Tinily, the scimitar smiled. "To pretend he was leaving for the hunt at Castel Giubileo, but playing rather the hare than the hound and turning up in our country."

"In our country?"

"In Tuscany, they say."

Michel smiled with bitter satisfaction. So that Cardinal who had wasted a full year of his life, promising commissions which he never fulfilled, that Cardinal who was too busy staging plays to buy the Minerva he claimed he wanted, now he too had fled, made subtle-fine in the unspinning of Plautian plots, knowing rightly well that the Cesare who attacks the widow of the Riario at Forlì was not likely to engage in love-feasts with the Riario of Rome.

The Cardinal's face was shining like the hearth as he approached.

"It surpasses my expectations!"

Michel bowed ever so slightly.

"Not mine, Monsignore," Gallo rumbled. "Did I not pledge you in the contract itself that this would be the finest—"

"You also pledged surety the work would be completed within a year. That year was up on—let me see—August twenty-sixth, was it not?"

"I am quite willing to forego my surety," the banker said stiffly.

"Monsignore," Michel said quietly, "the delay is not Messer Gallo's fault. I simply could not permit the work to be pushed faster than it would go. In my art one cannot always—"

"Young man, I am altogether willing to overlook a few months. But you are prepared to install it in the chapel next week? I should like it there for Holy Year."

"Oh, Monsignore, there are certain details that do not quite satisfy me yet. I feel that—"

"Next week," the Cardinal said abruptly. He spoke Italian with just a trace of the French 'r', gargling it in his throat, *"la prrrrossima settimana . . ."* Then he added amiably. "It seems quite complete to me. Perhaps a bit of polish here and there."

Curse these great lords, Michel fumed within, what do they know of my art? His anger stirred up heat; he unwound the muffler from around his neck and took off the cloth cap. How the devil was he going to rework the scapula of the Madonna's back? A bad miscalculation. He had taken away too much already. Better leave it alone.

". . . truly superb," the Cardinal was saying. "But I must admit one thing troubles me . . ."

"Yes, Your Reverence?—"

"That gentle Maria . . ." gazing up into the brooding sweet sorrow of the face, ". . . isn't she rather young to have borne that Son? She seems scarcely your age."

"I am twenty-four."

"Yes, I know," the Cardinal smiled. "Messer Gallo seldom fails

to remind me of it. But Our Saviour was thirty-three when He was crucified."

He was surveying him as the Cardinal di San Giorgio had surveyed him, from a distance, with that smug smile of those who buy what makers have made and presume to pass judgment upon it. Did he know that the color of this marble was the color of Girolamo's ashes? Michel heard himself saying—

"Monsignore, was she not a virgin when she conceived?"

The Cardinal lifted finely arched brows. The servant coughed.

"—and did she not remain a virgin? And is it not observed that chaste women maintain their freshness far longer than the unchaste? Especially a virgin whose body was never tarnished with the slightest lascivious desire? And besides these natural causes, might not this unsullied bloom have been a miracle wrought to convince the world of the virginity and perpetual purity of the Mother?"

The Cardinal's eyes lighted up with amused admiration.

"Well, that is reasoning worthy of a learned theologian. But then why do you not make Our Lord correspondingly young? Was he not also pure?"

"Ah, I pray you pardon my presumption, Reverence, but this was not necessary for the Son."

"And why not?"

"Because the Son of God truly took upon himself a human body, did He not? So He became subject to all that an ordinary man is subject to, except sin. His human nature, instead of being set aside by His divine nature, was left to its own course, so that time might fulfill what it did indeed fulfill. So, Monsignore, there is nothing strange in the fact that I have made His person to reveal the exact age at which He died."

The Cardinal burst out laughing. By the door the servant was staring at Michel as if he were a sorcerer. The Messers Balducci and Gallo had on their faces the expressions of parents whose son reveals an unsuspected but frightening gift. They did not know that Michel had heard this entire argument from the lips of his brother, Lionardo, who had in turn heard it from a fellow Dominican at San Marco.

"Ah, but you are subtle as the Great Ox, Saint Thomas, himself!" the Cardinal laughed.

"I know nothing of the Great Ox, Monsignore. But I think I do know something of my art."

And again Michel inclined his head.

What was there in that little gesture? Gallo asked himself—true humility? or a pinch of scorn?

The Cardinal had it installed in the Chapel of Santa Petronilla in the Basilica of San Pietro and it was just before the century drew to its close.

XIV

Now the bells of all Rome rang in jubilee. A millennium and a half had passed since the birth at Bethlehem. The centuries had reached a hinge: the sound of a huge turning was in the air. At Christmas Eve the Holy Father marched in slow procession bearing a golden candle to the walled-up door of the Basilica. As he stood awaiting the silver hammer from the hands of his Magister Ceremoniarum, a deep-boweled sigh exhaled from the thousands kneeling in the square. Alexander smiled. He was seventy and hale, his son was carving out a kingdom in central Italy, his daughter was a princess of Naples, his mistress was young and beautiful, and the mother of his children was in pious retirement. The announcement of a crusade against the Turks should tidily cover the cost of Cesare's campaign. A careful scale of payments for the sale of absolutions must be worked out. He nodded to Burchard, took the silver hammer from gelid hands. Once, twice, thrice he struck the door. The masons began to unbrick the wall.

So the bull of Holy Year was proclaimed and it seemed the day was a constant ringing of bells. Swallows swooped wildly around the ever-echoing campaniles and from every corner of Christendom long lines of pilgrims poured into the city. On donkey-back and on foot they came—Spaniards and Frenchmen, converted Bohemians and Portuguese, lard-colored Swiss and clumsy Germans—kneeling to receive benedictions of a Borgia and to make the rounds of the basilicas and kiss Saint Peter's bronzen toe to an even shinier mirror of veneration and take in the sights. The section near the Pan-

theon particularly, where Andrea still lived, was a Babel of foreign voices.

Amongst the pilgrims of that year was Buonarroto Buonarroti. On a spring day crisp as lettuce, he was sitting his horse on the same hill overlooking the Porta del Popolo where his brother Michel had stopped four years before. Now, he too was looking down at pink domes, golden towers, notched crenelations of palaces and walls. But he was struck less by the sight than by the sound. This city, thought Narro, was like being up in Giotto's belfry when Jolly Tom jerked at the ropes. What a jingling of bells!

He descended into the ringing maze. He knew only that Michel lived somewhere near the Ponte quarter where most of the Tuscans congregated like bees around their banks. For after he had left the Riario Palace, Michel wanted to be, as he had written, "among people of my own nation." But he discovered soon enough that he could not afford a room in the rich Ponte quarter. He was no Baldassare, no Gallo. All he needed anyway was a large sunny room on the ground floor so that he would not have to haul the blocks of stone up a staircase. He found just what he wanted in a small house in Trastevere, just across the river from the Quarter of the Florentines.

Stopping again and again to ask his way, Narro rode down the sun-speckled Corso, where churches interspersed with open gardens, then across the Ponte into Trastevere. Now he found himself in the densest section of the sprawling city. Here resided those whom the Romans had always regarded as the lowest of the low: in earlier days no Trasteverino could become a senator. All around him Narro saw fragments of medieval and classic Rome: he passed a marble gate, the architrave inscribed with the word *Portus* and other Latin inscriptions. Narro could make out only the names of the Emperors Arcardius and Ororius. He had to guide his horse, a frisky jennet, through an intricate labyrinth of dingy alleys; he jogged past ancient basilicas, and red brick dwellings in pre-gothic style with columned porticos. Then he was on a street of small houses with pointed gabled roofs and tiny windows and open stone staircases. He was at the city's rim, a steep silver-leaved olive orchard was just at the end of this street, and Narro cursed. He must have gotten lost. He asked his way of a barefooted girl dressed in rags who was carrying across naked shoulders a pole with two heavy squash dangling from the ends. She pointed back to the river, and Narro wheeled his horse after watching her swing into the orchard path with a delicious shivering of buttocks. O Lord, he thought, the last time was with

hairy Grisalda on the Erta Canina and the grove so steep it was like doing it standing up and she had a big mole under her left breast and little stiff hairs growing out of it so that when I tickled her there with my tongue she squealed and threw her fur bag right in my face O God two weeks or three or whatever it is it's bad for the health.

He rode back to the river on Grisalda, Lucia, Marina, Gianna, Flavia, Flaminia, Sister Clelia, Limpida, Rualda, and by the time he reached the bank he was galloping. A mill was creaking here with a swish of long wooden vanes; he heard the spittle-grunt of Genovese, more like the clearing of throats than human speech; above his head flapped intimate flags of washed-out blue and faded mauve and weary white, drawers and doublets dancing emptily. The cobbled streets disgorging to the muddy bank were choked with venders, bravos in mail and feathered coifs, black soutaned priests, sellers of sponges, beggars, braying donkeys. There was a smell of vegetables and tanned leather and fish. It was impossible to ride here. He left his horse at a stable, feeling a pleasant relief in his loins as he dismounted. Out on the muddy stream flat-bottomed ferries were being poled across. The neighborhood seemed to be the quarter of ferryboatmen, leather tanners, wool carders, fishermen.

Ahi, it surely is nothing to our Fiorenza, Narro said to himself, sniffing with pride.

He was surprised. He had heard so much about Rome. But it seemed a strange combination of ruins and goats, fields and palaces, clustered dark towers and desolate stretches strewn with bleached architectural bones. And it was hot. The sky was blue blue. He rubbed the sweat off his unshaven cheeks with a cloth cap. Damn that girl with her quivering squashables!

He was shocked to see the disreputable house in which Michel lived. Why, to judge by the letters he was writing home, you would imagine this brother of his consorted only with Princes of the Purse or Princes of the Church. How many Cardinals had he not mentioned?—the Cardinal of San Giorgio, and some French prelate named Dunagio and Piero de' Medici again and a rich banker named Gallano or Gallino or some such name. Then why does he live in a place like this? Beggars hobbled by, shoved skinny arms in his face, whined for *Carità Carità*. It was the Holy Year, how could he refuse? He gave away ten scudi. A butcher was standing outside the open cave of his shop, sharpening knives on rough stones of an ancient wellhead. Donkeys clonked by, dragging wooden-wheeled carts of farmers' produce.

He inquired of a toothless old lady shelling peas by the portal whether she knew the lodging of a Messer Buonarroti.

"That young stone mason?" the hag said, grinning like a squeezed lemon. She spat green. "The Tuscan fellow? . . . Right in the back there. I don't think he's in, though."

He wasn't. Narro waited in the street. The noise and jostle were pleasant, it reminded him of the Old Market at home where the boys always sat on the white pedestal of the column, playing fingers. The horses were tethered there to iron rings, and there was the same damp sweet country smell, the same dung, the same bellowing and calls. But whoever expected Rome to be so much a country town?

Now he saw his brother's familiar short figure working through the crowds.

"Michel!" he yelled and waved, "Michel!"

Michel's dour inward face flowered; he ran, flung his arms around his brother, kissed his cheeks. "Ahi! You've got real whiskers! Porcamiseria! How you've grown! Bigger than I! Biggest in the family, vero? How was your journey? How is Father? What news from Lionardo?—"

"Well, hold on!"

"—is Gian home yet? What a happy surprise! I hadn't expected you for many months. How long will you stay?"

"Oh, until the autumn perhaps. The Strozzi have sent me here on business. And since it's Holy Year I figured I might combine a bit of piety with prudence, eh? Perhaps—"

But he couldn't cope with the bombardment. Michelangiolo was already leading him down the foul-smelling hall, then into a dim-lit room. His brother pushed open the shutters: abruptly the room was flooded with sunlight. The studio, Narro saw, was spartan simple: a cot, a plain wooden table and chair, several gutted candles, a straw pallet, dirty clothes all around. Wherever he walked he crunched on marble dust. An assortment of chisels and pointing irons was fanned out on a shelf, together with two wooden mallets, a compass, a set of calipers, a drilling bow. Several panels leaned against the walls: a half-done Madonna and four saints, a sketched-in Entombment. Tin cups of dried pigment littered the area in front of the panels. A fistful of brushes protruded from a dingy wine jar. Drawings in charcoal and sepia and silverpoint on green paper were scattered on a chair. Michel had pinned several of these over his bed: a Pietà which had served as his sketch for the French Cardinal's Madonna and the spontaneity of which he regretted having failed to capture in the

stone, a naked discus-thrower and the Apollo Belvedere which he had copied in the garden of the Cardinal Giuliano della Rovere.

Outside the window Narro saw a weed-grown patch amongst which marble blocks were scattered, giving the odd impression of an abandoned cemetery; the corner of a convent wall, a campanile with the bells' black throats silhouetted against the bluest sky he had ever seen, a huge umbrella pine.

It was pleasant enough, Narro said to himself, as Michel continued to pepper him with questions, but if Lodovico ever saw this place he would consider himself dishonored. And if he saw Michelangiolo, he would be troubled too, for he surely didn't look very well. Perhaps it was that scraggly beard which made him seem so much older, darkening the lines around his full lips. It was only four years but already there were such deep lines in his brow. He smiled a lot but he didn't look right.

"How are you feeling?" Narro finally managed to ask.

"Like ancient Rome," Michel answered with a deprecatory fling of his hard hand.

"What is it, Michel?"

"Oh, I don't know. I really don't know. But I have a constant stab in the side, right here, you see"—opening his shirt so that his brother might touch his hand—doubting Thomas—to the spot—"Here . . . and headaches too . . . A misery. I can't work when I feel so, and if I don't work, a devilish melancholy begins to prod me and then I can't sleep and can't eat . . . But let's not talk about it. Tell me of Granacci. Has he opened his own shop yet? The mascalzone never writes."

"Oh, he's doing very well. He built up quite a reputation during the carnivals, you remember, and whenever any of the Guilds want a banner or a plaque or some decoration for a ceremony, you may be sure Francesco is the first to be called."

"Per Bacco! I'm pleased. Does he talk of coming to Rome?"

"No, why should he? He's prospering in his own country."

Michel nodded. Suddenly he seemed sad. The sight of his brother brought the familiar images flooding: he saw the adagio yellow river, the orange dome, the stalked campanile of the Palace of the Signory, the gentle hazed hills; he heard the swallowed 'c' and the 'l' become 'r'; he smelled the rosemary-scented fragrance of arista roasting on a charcoal grate; he tasted the snowy silky beans of Tuscany. Accidenti! it had been a long time! Four years, and if this Pietà did not bring in many more commissions, he would go.

But Narro's picture of conditions in Tuscany was not very encouraging.

—the Piagnoni and the Arrabbiati were still at each other's throats as though the Friar had never been fried—

Michel winced at Narro's roughness.

—And ever since the Duke Valentino had invaded the Romagna there was fear that he would march on Tuscany soon. So thousands of poor devils from the countryside were flocking into Fiorenza. They were pouring in through all the eleven gates in such a flood that finally the Signory simply had to put a stop to it. And though the wool business was flourishing, thank God, everybody was holding his breath to see what the Duke was up to.

"And the work with Ser Lorenzo . . . it is going well?"

"Sì. Molto bene. When I told Ser Lorenzo of my desire to visit you during Holy Year, he entrusted me with several important commissions. You see," he said stiffly, "the Strozzi have a large branch of our business here in Rome."

"Indeed!" Michel laughed. He slapped his thigh. How solemn Narro was all of a sudden! Apparently, nothing had changed much with him except his body. That absurd moustache. He still smelled too strongly of goat cheese. The moustache was stretched now in a smile.

"I have accomplished a nice bit of business for you, too," Narro was saying.

"For me?"

"Well, remember the Hercules you made after the Magnificent's death?"

"Hercules? I made no Hercules."

"The figure we took down into the cellar."

"That was a Samson."

"Now, it is a Hercules," Narro said blandly. "You see, my employer, Ser Lorenzo, advised me one day that his kinsman, Ser Alfonso, desired a Hercules to be placed in the cortile of the Strozzi palace. And with the very words, fratello mio, like—" Dry fiscal fingers snapped. "—magic, your Samson became a Hercules—"

"But I had him slaying a Philistine!"

"Now he slays Cacus. Is the change worth two hundred ducats? He stands already in Messer Strozzi's courtyard."

Michel flung arms around his brother and kissed him. The shrewdness of a Florentine! Goat cheese smell and all. How marvelous to see—

He gasped and clutched his side.

"What is it, Michel?"

"Nothing. Nothing . . . that stab again . . ."

"Why don't you lie down?"

"I am all right, I tell you. It comes and goes. I must have strained a muscle."

"What say the physicians?"

"I have seen no physicians . . . Tell me . . ." Nevertheless, he sat down on the cot, breathing heavily, kneading the flesh over his ribs. It felt as if a knife had been thrust in there. ". . . you are pleased then to be working for the Strozzi?"

"Well, you realize there's nothing like owning your own shop."

"Dio mio!" Michel exclaimed with sudden annoyance. By the roast skin of San Lorenzo, didn't any of them realize that he was doing all he could do? The Cardinal still hadn't made the final payment on the four hundred and fifty ducats for the Pietà. And the cost of installing the statue in Santa Petronilla had proved greater than he foresaw. Besides, if Giovansimone was away at the wars, what was the use of putting up good round ducats for a shop? Gian was flighty as a pipistrello: most likely he would be off again before the business was firmly established—

"Oh, he'll settle down," said Narro. "As soon as the money is forthcoming."

That was all they were waiting for.

"Nothing more, eh?" Michel muttered. He stretched out on the cot; the room was permeated with a thick, somewhat oppressive familiarity.

"Besides, Father wants you home. He thinks you should return with me. He says four years are enough."

"I have work to complete here."

"Father says you can find work enough now at Fiorenza. Your name and fame have spread."

"Even to my own country?"

Narro cocked his head. There was a note in his brother's voice he had never heard before. He is different, Narro thought. But he couldn't quite place what it was.

Stretched on the pallet, Michel was staring up at the tiresome discolored stain on the ceiling. Torso of a centaur. But so badly drawn. Two strokes would set it right. As he had set right the Master Ghirlandaio's sketch long ago. A pleasant breeze fluttered the sheets of drawings. A spring smell, wet with grass. Perhaps a storm was blowing up. Gray clouds hung over the pine. He was disturbed.

Somehow, the presence of his favorite brother after four years of absence was not altogether a joy. Narro's deep droning voice was relating the situation at home: Lodovico either glum or irascible because, as an ex-official of the Medici, he was never considered for any post in this government and always fighting with his brother and the endless and idiotic lawsuit with Consiglio the mercer over ninety florins (*"Porca miseria! And is that still going on?"*), and on Saint Joseph's day he almost tossed a chamberpot full of piss at his old friend Silvio, the apothecary (*"Slight difference of opinion"*) and evenings you felt like crying, the poor old man looked so damn lonely sitting at the big table with only me and Gismondo there, and you gone and Lionardo gone and Giovansimone gone and he staring into the pasta and grumbling at Marina, he doesn't like this and he doesn't like that and why the devil has she left the salvia out of the sauce? this was fit only for hogs or Pisani and you may be sure that he, a civilized man, had no intention of eating it . . . "It's been like that ever since poor Monna Lucrezia died," Narro said with unaccustomed gentleness. "You know, our Messer Lodovico still has plenty of juice in him and it's not easy for a man alone . . ."

So, listening to this family chronicle Michel felt as if he were being sucked back into a domestic quicksand. And yet he knew he was going home. He had to go home.

Oh Lord, if he could only learn to want what he did not want!

They both slept on the straw pallet that night. But it was so uncomfortable that for the rest of the week Michel spread his tunic on the floor and slept there. Finally he found quarters for his brother at the Mentone where Andrea lodged. He had no place for Narro. And besides he could not work with anyone else around. Not even with a brother whom he loved. He loved his solitude more. She was a mistress he could caress with a hard calloused hand. He wanted only her in his room. She lay with him and comforted him and when he was in the shadow, she touched him with a silvery compassion, responding to his irritable bursts with a white lunar smile. She was intimate and distant as the moon.

And he was irritable these days. For he had no assigned work on hand now that the Pietà was installed in the chapel of the French kings. He was working desultorily at a painting of an entombment but he couldn't get himself to bring it to completion. Reflecting on the fate of Fra Girolamo the theme had come unbidden into his mind. He felt that all the art of his youth—the sweet little smiles of Desiderio's children; the delicate traceries, too refined, of Benedetto's

cherubs; the gentle wistfulness of della Robbia's Madonnas—all that
had been consumed in the flames. There was too much death in
the air. The whole world was an entombment.

Sometimes he tried to sketch, scribbling occasional verse over the
drawings. But many days he spent stretched out on the cot, scratch-
ing his nose while lines of Dante and Petrarch wove madrigals in his
mind. Narro observed this somnolence with astonishment. What
was the point of all this staring into space? If he would bestir him-
self there were many contracts to be secured. No wonder he had
not sent more money home during the past few years.

Michel smiled. He could read the burgher disapproval on his
brother's heavy features. He was glad that Narro was already busy
in his tasks for the Strozzi. He couldn't have this goatsmelling
brother around all day with his righteousness written on his face and
his amorousness jutting out of his trunk-hose.

It was sufficient, more than sufficient, to have him in the same city.

XV

Again and again Andrea found himself wandering to the fish market
in the ruins of the Portico of Octavia. What led him to the fish-reek-
ing shade of these broken columns? this place of stinks and poverty?
of Christian churches barnacled upon Roman ruins? of Jews? . . . ah,
that was it, yes, he was drawn for a sight of his own people, he was
seeking to exorcise those gray eyes that always seemed to float in
the dimness of the vault. These days Andrea was engaged in a church
near the Campo dei Fiori, resetting chipped mosaics in the vault.
Often, leaving the church, he found himself unthinkingly wander-
ing to the Pescheria. He would traverse stretches of barren land and
occasional gardens, then go past the hulking brownblack palazzo of
the Mattei and down the Street of the Dark Shops to the Theatre of
Marcellus. Piled up within this moldering ruin was a hill of rubbish
and above this, within the walls encircling the theatre, rose the tur-
reted fortress of the Savelli. In the dark grottoes of the vaults, rope-
makers had located their shops.

The neighborhood was a labyrinth of dark humid streets insinuating themselves amongst the ruins. Set into smoky redbrick walls, like fruits and nuts in a Siena tart, were fragments of architraves, chipped capitals, hands and legs of Roman statuary. Several corinthian fluted columns of the ancient vestibule still stood amidst the poverty and filth.

Terribly alone, he would pass through the ruins of a gate still echoing with the triumph of Titus and Vespasian after their destruction of Jerusalem. For Andrea had read his Josephus and he could never pass through this portico without recalling the treacherous scribe's enthusiastic description of the triumph—the twin Emperors crowned in laurel and wearing the traditional purple, Vespasian covering his head with his mantle (like the old men in the synagogue) as he recited the prayers, and then the procession flowing all day long like a river through this very gate where he, Andrea, was walking now . . . He saw the huge gold and ivory images of the gods, the caparisoned elephants and dromedaries, the moving stages, enveloped in tapestries of rare purple and Babylonian embroidery, three storeys in height so that their bearers staggered under the load, and on each platform, a captured commander of one of Israel's cities in the attitude in which he had been taken. And at last—*if I forget Thee O Jerusalem, may my hand lose its cunning!*—at last the spoils of the Temple: the golden table, the silver trumpets of the Jubilee, the seven-branched Menorah, the Torah of the Most Holy of Holies. And company after company of tall, especially-chosen captives, seven hundred of them, including the general Simon, son of Gorias, with a halter around his neck and scourged until his execution was announced at the temple of Jupiter Capitolinus . . .

No, it was impossible for Andrea to pass through this gate without hearing the crack of the whips, the roar of the mob, the tread of the legions. Then, once beyond the Portico, he found himself in a fish-reeking sun-and-shade and there was the bawling squawling son of Simon splashing buckets of water over a heap of slimy mullet squirming on a slab. "*Peeeeeeesce freeeeeesCO!!! Peeeeeesce freeessSCO!*" The armored legions had been replaced by armored lobsters, the naked slaves by naked cuttlefish. Titus' pennants were laundry flapping blue and white and green against grimy brick walls cracked by fire.

Here was a portal from the age of Septimius Severus. A rag-seller had his shop under the egg and cup of the lintel. "*CCceeeennn-CCII!! CCcccceeeennnnnnCCCII!!!*" He plucked at Andrea's arm: "Old rags, young fellow? Old rags . . . ?" Angrily, Andrea pulled

himself free. He disliked these chaffering habits. All at once Venice came into his mind. A similar bazaar. Had Sebastiano also come to Rome yet, he wondered. All roads lead to. "We shall probably meet on some scaffold or other . . ." Above the head of the Jewish rag-seller, in a niche that had once contained a pagan god, was a Madonna with an onion-shaped lamp flickering in front of her. Andrea smiled.

And there it was that he saw her. He could not believe his eyes. She stood behind one of the slimy slabs, and a bar of sunlight slanted down between the chromátic display of strung wash onto the fish so that they glistened like captured rainbows. And now the girl was nodding to a customer with that familiar sheepsoft gesture, and Andrea saw the dimpling of the full cheeks, olive and dawn. "O God!" Andrea cried and pushed his way through bawling crowds of venders and buyers: "Tsiporah! Tsiporah!"

Her startled glance was a sparrow on a branch. Her face changed; she seemed about to burst into tears. "Andrea! . . . *Shem!*" Then off she flew. He followed but she was more agile; twisting through the dense crowds, she fled small and twinkling across the Piazza degli Ebrei and suddenly was gone into an old tenement. Breathlessly Andrea knocked against the gate. No one answered. He waited outside, banging the door from time to time. No one answered. A seven-branched candlestick was vaguely incised in the old wall. He began to bang again, certain that she was watching him through the shutters. But the gate remained obdurately shut. She had suffered too much at the sight of him, he decided, he brought back too many memories of Bartolomeo. She was trembling within that ancient. wall yearning for him to come and yet she would not open the door.

He stayed until the light dwindled. Then an idea struck him. He would be able to find old de Cases in the synagogue at evening, prayers. The synagogue was on the Piazza of the School: a simple building distinguished from its neighbors only by two pillars in front of the door and the golden inscription in Hebrew. He went inside, felt the swaying intonation of the worshippers descend upon him; he was a boy again, Elia was wrapping him in his cloak. A patriarchal figure with a white beard was reading from the Mishna. Ritually rocking was de Cases. He looked not older, but more intense, burned, braised to the bone, his beard seemed to grow out of a fleshless skull. His eyes were immense. He was flanked by a dignified old man with a straw-colored bifurcated beard and a dwarf chanting in strident mournful ecstasy.

After the services, as Andrea accompanied the Spaniard through the now dark streets, lighted only occasionally by spluttering torches set in iron rings in palace walls, de Cases spoke of many things but never once mentioned his murdered son. He acted, Andrea felt, as if that incident were another drop of blood in the Red Sea.

"And how long have you been in Rome?" de Cases finally inquired. His tone was discreet.

"Oh . . . I just came."

"Why did you come?"

"I? . . . Oh, I don't know. It is said this Pope is a friend . . ."

De Cases smiled thinly. "For ducats he is anybody's friend. But if you seek employment I might perhaps—"

"Thank you, Messere. But I have already received a promise. Yes, one who knew my father . . . One of our nation . . ."

"A Hebrew?"

"A Florentine."

"Ah . . ."

"Something to do with the shipments of corn from Marseilles . . ."

His face was hot. He had a sudden notion that the old man's eyes were Elia's eyes.

"And your father is still at Fiorenza?" de Cases said. His voice was innocent of irony but Andrea felt stricken. Elia had failed this man. And so he, Andrea, had failed him. He stammered some reply. The physician had returned to Crete. He was teaching philosophy there . . .

"False philosophy," de Cases said, a stir of passion in the depths. "I do not question your father's piety. But he has always leaned more heavily upon Aristotle's staff than upon our sacred Law. Perhaps if he—"

He did not finish the sentence. They trudged in silence through the dark quarter. Andrea felt called upon to be Elia's surrogate. But what could he say to assuage this man's unspoken bitterness? He cast about and found nothing but sorrow. So, to fill the void, he told how he had encountered Tsiporah in the Pescheria, how he had called to her and she had fled and shut the door in his face. "You must take no offense at it," the old man said. "The sight of you brings back things she had rather forget . . . But you shall come another time and dine with us. We cannot offer much, but whatever we have . . ." He shrugged narrow shoulders.

Andrea felt a lift of the spirit. Then de Cases did not visit what he considered the sins of the father upon the son! He would have the

chance to see 'Tsiporah again, to repair the rent of alienation and absence. But if she knew? . . . And if this old man knew the sacrilege he committed every day? . . . De Cases was mumbling in his beard, memories prodding him. Ahimè, he had abandoned everything when they fled Fiorenza. Now he heard that Fra Bernardino was dead. But what difference did that make? Would that bring Bartolomeo back among the living?

It was his first mention of his son. His voice was perfectly composed, on the nether side of sorrow, beyond agony; in the darkness Andrea could not see the expression on his face.

Besides, de Cases said after a pause, there were always new Bernardinos. And had Andrea heard that even Fra Girolamo—he who was finally hanged for a heretic—had set up the very Municipal Loan Bank that Bernardino had been howling for. And he a Dominican said to be an enemy of the Franciscans . . . But they were all the same . . . all Christian dogs.

Andrea chilled. For a flash he thought he heard Bartolomeo speaking.

But this was not the pawnshop on the Borgo San Iacopo. This was the Piazza of the Jews in Rome and besides de Cases no longer had a pawnshop. Now he peddled rags while his daughter sold fish for a vender. What did it all matter? Sevilla, that whiteness in the sun—a vision brought about by hashish. There was only the City ahead, the heavenly Jerusalem. Hang your harp upon the willows, O ye daughters. Selah!

They had arrived at the house with the abrased Menorah by the portal. Andrea shook the old man's hand. He felt as if he were grasping the branch of a tree.

XVI

On a glorious April day Michel, Narro, and Iacopo l'Indaco went together to the Piazza Navona to witness the procession of the Triumph of Julius Caesar. These festivities, dedicated to a bald-headed pagan emperor on the occasion of a pre-Lenten Christian

carnival, were actually being staged in honor of another Caesar, younger and with a full head of hair.

For the Pope's son had returned to Rome in February—abandoning his campaign in the Romagna. It was time for a breather. There was renewed war between Sforza and the French. Venice was at grips with the Turk. So young Borgia entered Rome with his captive Virago, Caterina Sforza, and at the Vatican no foreign ambassador or Cardinal felt it expedient to be absent from the reception. Dressed in black velvet with a gold chain around his neck, Cesare rode on horse to the Vatican flanked by a hundred equerries and pages also dressed in black. It was a sober spectacle. The Holy Father could not contain his joy at greeting the conqueror of Forlì. Ah, but it was most affecting to note, wrote the Venetian Ambassador, a man of sensibility, that the kneeling Cesare addressed his old father in Spanish and the father replied in kind. Was it not, after all, the language of their hearts? His eyes streaming with joy, the Holy Father appointed the Duke to his brother Gandia's previous position: Gonfaloniere of the Church. Most touching. The fratricide was awarded a rose of gold.

So now in further honor of the Duke, this great mythological procession was being held in the bowl-shaped piazza built over the ancient circus of Vespasian.

As the decorated chariots creaked slowly around the perimeter of the oval, Iacopo was recounting a fantastic story that he had heard at an inn the night before. It was an inn crowded with Holy Year pilgrims and amongst them was a dour German, an Augustinian friar ". . . he seemed to find this holy city of Rome, navel of our faith, not to his liking. First he objected to the sight of those criminals dangling from the merlons of the Castel Sant' Angelo. Says this is no spectacle for pilgrims still ecstatic with the image of the Redeemer on Veronica's veil. And then, after spitting and spluttering on in a most bestial Italian—for their own language, I am sure, was begot by a goat upon a hog—out he comes with this most marvelous story. It seems that a physician at the Lateran Hospital has been getting up at dawn to practice archery—"

'"—An ardent sportsman," said Narro.

"—He was indeed," Iacopo said wryly. "You see, he shot arrows out of his windows at those zealous pilgrims who came to attend early Mass. Then he despoiled his victims—"

"Bestia!" Michel exclaimed.

"But at last his greediness undid him. Not satisfied with the proceeds of his archery, he made an agreement with a frater at the hos-

pital. Fra Niccolò would point out wealthy patients in the wards, Master Diano would poison them; then they split the proceeds. But of course Fra Niccolò wasn't satisfied with his share—you know how greedy these monks are!—he suspected the doctor of robbing him. So he betrayed Master Diano to the authorities and now the poor man has been garroted."

He roared with laughter. From the far end of the piazza, slowly drawn by paired white oxen, came the chariots.

". . . and all night over the mulled wine, this Transalpine goat, you see, was gurgling on about the corruption of things here in our Holy City and how much need there was to purify Mother Church . . . You can imagine how—"

"Isn't that exactly what our Fra Girolamo was preaching?" Michel said quietly.

"And what did he accomplish," said Narro, "to be hanged for it?"

The sudden roar of the crowd swallowed Michel's angry response. The last of eleven elaborate chariots was passing now; in it sat Duke Valentino himself in a purple and gold toga. Along the side of the chariot was painted in cursive gilt script the motto of the ancient Caesar: *Victoria Iulii Caesaris Qui Sedit In Ultimo Carro.* The spectators spluttered with delight. This Duke, torero, bender of horseshoes, tall, straight, rider of wild horses—of course the Romans loved him. Michel looked with particular curiosity at the Pope's son who, according to Messer Gallo, was now expressing an interest in purchasing Michel's faked antique Cupid from the dealer Baldassare.

The chariot passed, the Duke nodding ever so slightly, almost scornfully, to each new spill of applause. All betided well for the success of this Holy Year, he was thinking. A month ago the Pope had issued a special Jubilee Bull specifying how much penitents must be expected to pay to gain absolution for consanguineous marriages, and how much it would cost the clergy to be forgiven simony and irregularity. Quite apart from the correction of morals that would result from this Bull, the Duke was thinking, as he acknowledged those roaring grapeclusters out there, those frantic tendrils, he should be well provided when he returned to the wars. A new burst of cheers. The Duke nodded, his manner steely, graceful. Gilt lettering glittered in the sun.

"What think you of our friend Andrea's calligraphy?" Iacopo asked Michel.

"Ah, is that Andrea's handiwork?"

"Well, we all had a hand in it, when the order first came into the shop. But most of the lettering is Andrea's."

"He does well."

Iacopo made a smirk. "He does lettering."

"Why did he not come today to see his handiwork on parade?"

"I think he takes little pride in it."

"But it's fine calligraphy," Michel said kindly. "Francesco Granacci can do no better."

"Ah, but Francesco is quite content to be a decorator of chariots. But Andrea would soar higher than his wings can carry him."

"He's a strange one anyway," interjected Narro with a trace of irritation. "Shortly after I moved into the Mentone, he moved out. You would think he would welcome the comradeship of an old friend from his own country. Instead it seems he prefers to reside amidst the fish-stinks of the Octavian Gate."

"So that's it," said Iacopo. "I suspect it's not fish draws him there. We always used to share a glass together at sunset. But now he's gone—Via!—as soon as the day's work is done. I think our Andrea is in love," he laughed, nudging Michel as if his sore rib-cage were the walls of a besieged city.

"Do Jews, you think, suffer pangs of love like proper Christians?" Narro said.

For it was Carnival and every day the atmosphere was mounting to the time-honored sport of that holy season. The sound of tambours ricocheted off curved brick walls. At the far end of the Piazza Navona where new companies were entering, the young men could make out a gay flapping of banners: it was the honor guard of Cesare, the troops who had fought with him in the Romagna. Here they came swinging: lancers, artillerymen dragging the new French falconets, staff bearers in criss-cross costumes of orange and black, crossbowmen, arquebusiers, infantry striding under bifurcated twin-colored pennants. The crowd clapped and roared. Oh, how marvelous to stand under this bluedomed April sky and welcome mighty Valentino home.

"Diavolo!" Michel suddenly growled. The infantry were passing. He pushed forward to the front rank and stared, his head thrust forward like a battering ram. Then he plucked at Iacopo's sleeve: "If my eyes don't fail me, isn't that fellow second from the left—?"

"Torrigiani!" Iacopo cried. "Pietro Torrigiani!"

The Florentine sculptor was swaggering past in hip-high leather boots, a huge feather in his floppy cap, his face beef-red, his grin a yard wide. Michel did not know that Torrigiani had been working on the Borgia tower in the Vatican, and of course when the Duke called for volunteers for his campaign in the Romagna, Torrigiani was

among the first to join. He had grown a fierce black beard and as he marched he was shamelessly scratching the inside of his thighs.

Now he had spotted them and he grinned evilly at Michel. Michel made a lewd gesture in reply: a fico, thumb between fingers. He felt the old shame and fury charging up, the fist against his nose, the purple screaming streak, the abrupt obliteration of Masaccio's painted walls. But Torrigiani was still grinning, wider it seemed. Then he passed.

Pennants pennants flapping in a painted wind.

XVII

He had vowed not to come. Yet here he was on the Corso in the very belly of this vile mob gathered in anticipation. Even the blind beggars, out in force today, knew it was Carnival: voices were shriller, girls were giggling, hands must be roving. Soon enough would be Lent.

Drenched in thick perfumes and sweat, immersed in all these colors and shouts, Andrea felt his aloneness more than ever. He was not a part of *this* . . . but he was not a part of those *others* either, those who barred themselves in their houses and sold no fish on this day. They would not be mangled in the shuttle of the Eastertide from licentiousness to piety. For this was the Romans' last pagan fling before Holy Week. Now they could indulge themselves in un-licensed tickling, in practical jokes, puppet shows and daily races of asses and old Jews down the Corso.

He had vowed never to come. He had vowed to remain with the de Cases behind shutters. Now that he lived with them, he felt the added weight of familial obligation. The few scudi he earned as an apprentice at Pollaiuolo's helped defray their expenses. Again he was in the bosom of a family. And yet, today, when families huddled together, he was on the Corso. He recalled another time when he had to see what he had better not have seen.

For the past two Carnivals he had always managed to be out of the City during this season. He would walk down the Appian Way:

the sight of those tombs embedded in the soft green campagna of the Roman spring, cheered his cheerlessness. Poppies shook their tissue-thin brilliance in the breeze. He would walk through fields of rebirth, entombed in himself amongst these tombs. Never did human vanity seem so vain or cruelty so remote. He never returned till after the passions of the first week of Carnival had subsided. At the shop, he had invented a Neapolitan cousin suddenly stricken two years ago; last year he had to invent another kinsman.

But this time he had not left the city. If he departed for a week who would replace those few scudi? How strange to wake up every morning and hear Tsiporah's liquid voice in the kitchen with her mother and to join the family at breakfast. He had begun, unconsciously, to consider de Cases a kind of father, but he was to Elia as burnt ash is to metal. And to think that he, Andrea, was sitting in what must have been (O Lord!) Bartolomeo's place; and the Señora de Cases placidly fluttering as she set the hot breads on the table, and across, next to her little sister, sat Tsiporah.

She had grown accustomed to his presence now. But all through that first uneasy dinner to which de Cases had invited him, Tsiporah had remained tomb-silent, her cheeks darkened. Andrea had not seen her for more than two years: she no longer wore her hair in braids but softly heaped up on her head, lending an unaccustomed statuesqueness. Her beauty had deepened; Andrea was stricken to the bone; only politeness forced him to pretend to be aware of anyone else. But she would not meet his gaze; all through the meal she kept nervously brushing at her garments.

But afterward, to his surprise, she walked with him downstairs to the portone, and in the dark corridor, they found an opportunity to speak:

"Why did you run from me?"

"I don't know."

"Why did you refuse to see me after Bartol—"

"I don't want to talk about that."

He took both her hands in his. Her hands felt hard, cracked, to his touch. She tried to withdraw them, but he clung to them. "Tsiporah . . . I was not responsible. He was always doomed . . ."

"Please . . ." Then suddenly words were stupid, years of absence melted in an embrace. She cried. As he held her in his arms he was disturbed at the unfamiliar odor of her body: the heavy perfume that could not quite disguise the reek of the fish market.

A week later, he moved in to contribute his earnings to the household. Now, morning and night, Tsiporah greeted him with timid

smiles like doves breaking into flight. She had begged him not to go into the streets this day. But he had to go.

Tang! Tang! Here came some jugglers—

Yesterday, the first Saturday of Carnival, old de Cases had returned after the ordeal of the delegation. Tsiporah sat in watchful stillness. The little girl was patting her belly like a drum. Señora de Cases regarded her husband as if she were looking at him through the lattice of the women's section in the synagogue. Neatly folding his shawl, de Cases took his place at the head of the table. His face wore that same burnt-out air he had worn the day he came to talk with Elia del Medigo. Andrea recalled the voices, the weary anger, and he staring out over the Arno at the sky-scrivening swallows.

So now, old de Cases was telling in his curious Spanish-tinted voice, how he as one of the heads of the Castilian community (five "schools" worshipped in the same synagogue) had been forced to walk bare-headed to the palace of the Capital where the Conservators of the Senate sat. And like his brethren, de Cases had thrown himself upon his knees and presented to those Conservators (whose faces were, he mocked in his humiliation, faces of outsized frogs) great bouquets of azaleas and prickly larkspurs: ". . . and twenty scudi," de Cases added with a tiny sneer—"twenty scudi which we *begged*, you understand, be applied to the decorations on the balcony of the Roman Senate in the Piazza del Popolo."

And then in similar petition they had proceeded to the Senator, and bowed their foreheads to the ground mumbling the ritual beseechment, that they be granted permission to reside for yet another year in this holy city of Rome where Jews had dwelt already for a millennium and a half, a city to which they had come, indeed, before Romans were Christians. And placing his foot upon each of their heads in turn—even now de Cases could feel that ungentle pressure pushing his face a little closer to the cold marble floor—the Senator acceded, declaring that although this tribe was not acceptable to Rome yet out of pity they would be permitted to remain.

So he told it and Tsiporah's eyes drank it in with the expression of a pond into which one tosses stones. Ah, de Cases was saying now, in answer to his wife's indignation, it was no better and no worse than the ordeal Giuseppe Raccà had undergone on the occasion of the Borgia's accession. For then, Raccà had told him, the procession of elders who had presented the new Pontiff with a gold-bound and veiled Pentateuch, had to listen as the Borgia received it with the rite: "We affirm your law but we curse your creed and your inter-

pretation of it . . . for He of whom you said *He will come* is already come . . ."

So in silence they ate. The races would begin tomorrow. Today, Andrea said to himself. *Now . . . Here . . .* The crowd was laughing. A grotesque parade of men were passing with long false noses in the form of the male member. Down the street above that cluster of guards the Pope was looking down from the balcony of the Orsini palace, flanked by many Monsignori in purple and scarlet. You could hear the laughter from the balcony as the long-noses passed. Coming to this post, Andrea had caught a glimpse of the Holy Father: his ruddy smiling face, his generous girth swathed in lace like a waterfall and on his head the triple tiara.

It was something like the white-fanning balzo Tsiporah wore last night, something like a turban. How sweetly her palm-waving figure had glided out the door when she took her little sister off to bed.

And de Cases waited till the girl had gone before he continued. For after yesterday's humiliation the deeper one would begin. Every day until Carnival was over. So it had been year after year since the days of Pope Martin.

"And were you—?" Señora de Cases feared to complete the question. Her fingertips touched tremulously the edges of her mouth; her eyes glistened, about to spill.

"No," her husband said simply. "They spared me that, praise the Unnameable." He shrugged thin bony shoulders, then pulled open his black tunic, touched his meager flanks. "The Senator took one look at these—and laughed—'*Not you, old scarecrow—you'd never last the course . . .*' You see, they'd not have enough of a show from me."

He let go the hem; it swung to like a curtain.

". . . but Mithridates from Siena . . . and Abramo da Pescara . . . and Reuben Cardoza . . . *they* have been chosen."

"Oh, the beasts!" Señora de Cases said, stifling a sob in her apron.

No, he had resolved he would not come. He would never see this race. Yet here he was on the Corso, drawn by a need to hurt himself. He heard the clattering of hooves and the first group of asses galloped past, then the stragglers—young jockeys thrashing sometimes at their mounts but more often swinging their canes into the faces of their competitors. And following the asses came the Jews—a dozen old men, naked except for dirty loincloths and with a hangman's rope around their necks. Andrea felt like retching. He recognized the dignified old man with the bifurcated straw-colored beard

whom he had seen in the synagogue and several other elders of the community who had visited de Cases' house. Down the Corso for more than a mile they were stumbling between two walls of howling and anathema, under showers of spit and confetti, laughter and epithet and rotten vegetables. And to fortify them for the ordeal—and lend a touch of piquancy to the spectacle—they had been stuffed with food before the race and plied with liquors and made drunk. So now, bony shanks and flesh-flapping thighs danced in obscene little circles. Bearded and skinny as partly-plucked chickens they were stumbling in the sun and laughter. One tiny man, with a silly vacant expression on his face, had one hand on his hips and the other curved over his head. He was dancing a tottering tarantella. It was the dwarf, the fierce-chanting dwarf. The mob hooted with delight.

"Ahi, little David, now the other way . . ."

"By San Niccolò, the Jew has talent!"

"Tsong! Tsong! Tsong! . . . Now back . . . now forward . . ."

They began to clap in unison. The crackling sound reverberated from the stone face of the buildings.

"A sponge of vinegar. The Jew is sweating . . ."

"Now back! O bravo! Bravo!"

The old man with the bifurcated beard fell. His eyes were frozen with hate. Several boys ran out into the street to help him to his feet. Madonna, they would not be deprived of a Jew's entertainment. Seeing the boys coming, the old man tried to spit at them but only succeeded in dirtying himself. In cruel sunlight he lay, his ribs a ladder of shadows, panting in the dirt like a wounded animal.

Oh, it was too much! Andrea cursed, broke through the howl of spectators and out into the street. Slipping his hand under the patriarch's arm, he helped him to his feet and pushed him down the Corso. All the way to the Church of San Marco in the Piazza Venezia, he stayed with the old man, staggering with his staggering. He was scarcely aware of the gantlet through which he ran. Rage walled him from all hurt.

When he returned home, hours later, he was still trembling. "Elia—" he cried out in his agony. But there was no Elia. De Cases was in the kitchen. He did not even lift his head when Andrea entered. He was reading Maimon's *Guide to the Perplexed*.

Michel had witnessed the start of the race at the tomb of Domitian near the Porta del Popolo. He sketched one of the old men with a straw-colored beard, split like his own, concentrating on the alternations of light and shade, the chiaroscuro in the skinny ribs.

Then he had begun another sketch. But it was impossible to hold the paper level in this mob. Besides there was that undertone to the screaming which disturbed the depths of him. He saw a swaying cart. And it was the very season, Carnival, he remembered. Leaving Narro, he went back to his studio, reflecting that the sketch of the patriarch might do for one of the figures in the Entombment he was now and then painting . . .

XVIII

In sleeping orange dusk they stood on the Palatine Hill overlooking the Forum. In the strange light the bones of empire seemed to be glowing: the dead reared to their feet, broken columns leaped erect, legions marched. In the shallow pit below, Andrea saw the shameful arch of triumph which had pronged their necks for fourteen centuries. The years have not yet abrased the carved humiliation of that victory from the Arch, Andrea thought angrily, and this afternoon, another . . .

Tsiporah's fingertips fluttered in his palm. She was indeed her name. A bird. He held a bird captive in his hand. And a bird must not be held too tightly or it would be stifled. He looked at the girl in the fading light. Her head was surrounded by a nimbus like the sacred figures he painted in the Christian churches. She knew nothing of that, thank the Lord. None of the de Cases knew what occupation Andrea pursued in Rome. Every so often he had to invent a source for his scudi, and the task was becoming onerous. Now with this girl he felt that he would not be able to withhold the truth from her much longer— Stray strands of her cedar hair floated in seeping light. It was like the light of the past, an ancient light. Crowning the soft slope of her neck like rubies he saw a sudden red twinkle, then another, another. The carnival revelers were still lighting bonfires. Thinned by distance, tiny voices floated like gnats. Tsiporah's lips were parted: her teeth were shining threads of captive light. Andrea felt a quivering run through his loins. He turned to her.

But she sensed what troubled him and walked away. She did it

with tactful grace, strolling out of the crooked reach of his arm as
if a sudden impulse had stirred her to do so, as if her withdrawal had
nothing to do with him. He hurried alongside and took her arm.
They continued walking, silent as they had been most of the time
since they had left the house. The afternoon's spectacle had drained
all speech out of Andrea; and though Tsiporah had not seen the
shameful race down the Corso, she had seen Andrea's face when he
returned, and it was not difficult for her to read what was contained
there. As they strolled Andrea felt the soft yet firm insistent pressure
of her breast. Her figure spoke to him without words.

On a grassy knoll near the Arch of Titus, they sat down, and be-
fore they realized what had happened, they were enlaced in each
other's arms. It was dark and Tsiporah's body was flowing against
him like a cloud, her lips crushing his lips. When at last he
opened his eyes he could see the shadowy horseshoe of the Arch
against a starry sky. All around the horizon the city seemed to be
burning.

XIX

He must get a new quill, Burchard thought. This one squeaked so
much that sometimes he had a rare imagining that it was shouting
his words, so that the guards outside the door must hear. And what
he wrote in his Diarium Romanum were surely not words to be
shouted.

He picked up a Verona poignard and tapped the enchased blade
against his fingernails. Then with the peculiar deliberateness with
which the Magister did everything, he slowly sharpened the point
of the white-feathered quill. He dipped it into the silver inkwell,
made a few experimental squiggles. Yes, decidedly better. He
scratched his pointed nose with the plume. Then with a hunch of
the red-mantled shoulders he began again:

"*The Serenissimo Don Alfonso, Duke of Bisceglie and Prince of
Salerno, who on the evening of the 15th of July had been gravely
wounded . . .*"

Pe..naps that went too far? He had been wounded, true. But that was only the reality. The problem was to indict shadows. Shadows were cast by realities. His task was to reverse nature's order: to shape shadows that cast realities. As he mused, his little flat green eyes seemed made of jade, reflecting in their shallow depths the precise degree of ambiguity he was seeking to capture.

"*. . . inasmuch as he would not die . . .*"

Indeed, he would not, poor Prince! Burchard could hear again the weeping in the bedchamber to which they had borne him. The assassins (*whoever they were*) had struck in the evening after d'inner when don Alfonso was leaving the Vatican for his palazzo across the square. How swift it must have been!—a thrust of knives on St. Peter's steps, a pummeling of blows, and then they (*whoever they were*) disappeared into a waiting group of mounted men who galloped off in safety toward the Portese Gate.

No, he did not wish to die, Burchard reflected, cleaning his nails with the daga. It was said that he had named the assassin (*or assassins*) to the Holy Father, when, bleeding, groaning, he had managed to stagger into the Pope's chamber. "I am wounded, Holy Father." And then he named the Name. Lucrezia fainted. Ach, if only he, Vater Johannes Burchard, had been summoned earlier. Then perhaps he might have heard the Name (*whoever it was*). Of no great importance, mayhap, but pleasing to a meticulous German mind and of interest to posterity.

But when the Master of Ceremonies arrived at the bedchamber, the Prince was no longer able to speak. The room was filled like a bellows with his breathing; he lay with pale eyes fixed upon the oaken beams of the ceiling, and two angels of mercy fluttered by his bedside: his sister, Madonna Sancia, and his wife, Princess Lucrezia. The Princess had regained an admirable self-control after that first shocking vision of her perforated spouse. When Burchard arrived, she was the very image of a resolute wife: sponging her Prince's brow, shading the candle-glow from his eyes, her voice lapping him with affectionate murmurs like wavelets of a lake, her long yellow hair glinting, her slim figure in an embroidered nightdress stooping gracefully over the bed.

And now and again, Burchard remembered—still astonished at the memory—Madonna Lucrezia turned aside and stifled her sobs in a silk kerchief. She truly loved this husband, and that would create, the Magister realized at once, certain difficulties.

"*. . . cum non vellet ex huiusmodi vulneribus sibi datis mori . . .*"

But of course the Prince did not want to die. Who did? That ringing down of the curtain, that black finality. For though Resurrection might be sure, there was still the waiting. The long dark waiting in worm-infested earth.

So the Prince had fought to remain alive and the ladies hovered over his bed and it seemed after several weeks he had indeed conquered his wounds and was likely to recover. And that there be no danger of poison, those good ladies, Madonna Lucrezia and Madonna Sancia, would give him nought to eat or drink that they had not prepared with their own dainty fingers; and the Holy Father himself had the door guarded by sixteen guards. How then had the assassin (*or assassins*) managed to slip in?

Ach, a strange inevitability about the whole affair, the Magister thought. A month later . . . *strangled in his bed*. Could anyone believe Madonna Sancia, who told him afterward that everyone knew who had done it? that indeed the assassin had boasted openly that he had killed the Prince because otherwise the Prince would have killed him? Was it believable? Burchard asked himself, could one take seriously this hysterical story of that plump pigeon of a Neapolitan? It was her brother after all and if Cesare had indeed come into the bedchamber and said what he had said, why had not Madonna Lucrezia spoken of it? For if Cesare loved her (as a brother, be it understood), she loved her husband, don Alfonso, more—she loved him indeed as if she had never known love before.

Then why had not Lucrezia corroborated her sister-in-law's story? She said nothing. Wept and remained silent. Not a word of the terrible Cesare coming alone to visit don Alfonso and murmuring to the convalescent on the bed: "What didn't happen at dinner will happen at supper." A veritable demon passing through the halls, the hangings gusting with his comings and his goings. His body hard as this Verona blade. Sheathed. And yet everybody knew what was going to happen. The Pope knew. The women of the palace knew. The servants knew. But no one lifted a hand. What could you do? Could you prevent a storm from breaking? Could you stop a thunderbolt from striking where it had to strike? Like that bolt which three weeks ago had shattered the very ceiling of the apartment in which the Holy Father was holding conference? And he buried under the debris of falling plaster and the bells ringing and the tidings flying about the City—*The Pope is dead! The Pope is dead!* A most impious rejoicing, Burchard recalled coldly. Providentially, only the banker Chigi's brother was killed. There was a destiny to all things.

So it was with the thunderbolt of the Duke Valentino. It had to strike. And yet it was too much to believe. The Duke had a violent temper. Had he not once stabbed his father's favorite valet, Pedro Caldés, right under the Pope's mantle so that the blood had splattered into the Holy Father's face? And the body afterward in the Tiber . . . *in nocte cecedit in Tiberim* . . . But that was understandable, Burchard reflected, recalling his Diary cryptogram for that occasion. Pedro had been caught making love to a damozél of Madonna Lucrezia's retinue, a certain Greek chambermaid named Panthasilea, who belonged to the Duke. Panthasilea had been found in the river too.

But this? What had the Duke to gain from this, if indeed it were his doing? Not striking the misericordia himself but—as Princess Sancia insisted, sobbing out the tale in the garbled manner of women who fail to understand the need for accurate records—striding into the chamber with that face of a storm terrible in its imminence, and ordering the women to leave, so that the Lady Lucrezia flung herself weeping upon her brother until he pushed her bodily through the arras. And then summoning Michelotto, his executioner. A swift and efficient job. Strangled in his bed.

The story of course might well be entirely false. In that event, the granitic figure at the Diary decided, it was best to leave it unrecorded. Not the wailings of wife or sister, but a certain fine laconicism —that was what the record needed—the saying and the not-saying, the holding of a door wide open and closed at the same time, the art of words and the art of silence.

". . . *inasmuch as he would not die* . . ." that was the last, yes, rustling back through the parchment pages ". . . *of these wounds, was, on the 18th of August toward the nineteenth hour, strangled in his bed. The cadaver was transported to San Pietro* . . ."

Yes! Perfect! Between those two sentences there was ample space for fantasy.

"*Don Francesco Borgia, the Pope's treasurer, accompanied it with his family. The dead man's doctors and a certain hunchback who used to attend the Prince were taken to Sant' Angelo and put under torture. But soon they were set at liberty since the one who had* . . ."

Ach, was it wise? But the new-sharpened quill was squidging along as if it possessed a will of its own.

"*. . . given the order went unpunished and who that was, was perfectly well known . . . cum essent immunes quod mandantibus capi, erat optime notum.*"

He set down the pen and closed the book. All this should have

been entered a month ago, but the press of events made it impossible to keep up to date under the circumstances. It was indeed a good thing that the Holy Father was dispatching the new widow to Nepi. Her grief and weeping have upset the order of things. Especially did her tears seem to find new springs in the presence of her brother. It was almost as if she charged him with widowing her. Cesare's displeasure was obvious, Burchard thought, as obvious as the fact that the Duke was now pushing his sister out of the Pope's favor. And that the Pope was yielding for fear of what Cesare was capable of doing.

Yes, it is best that she go to Nepi, Burchard thought. Peering into that perfectly round volcanic lake, that mirror of Diana at the bottom of which lay Tiberius' galleys, the Princess Lucrezia might reflect on the vanity of all human things. The blue perfect eye would reflect her own, and wash them clear of tears. She would get a grip on her emotions, he thought, pleased at the phrase: the proper note of restraint implied in it, the oblique thrust. The death of her husband was unfortunate, but surely she was wise enough to realize that if the Duke (if indeed the Duke had anything at all to do with it) had indeed dispatched her husband, he had not acted for selfish reasons. Like his father, he had only the welfare of his house in mind. If he had disencumbered her of don Alfonso, it was not done out of frivolity. He wished only to free his beloved sister's hand for a more propitious union—the house of Ferrara, for instance. Even through a waterfall of tears, the Princess could surely see the rocky truth: the house of Naples had lost all value to the Borgias.

Ach, if only these foolish women would understand the hard intricacies of the world.

XX

On the afternoon when twelve new cardinals were appointed in order to help defray the expenses of Cesare's war (the price was one hundred twenty thousand ducats per red cap), Narro Buonarroti stood in front of his brother's Pietà in Santa Petronilla. He had seen the work several times already, but he was leaving Rome in a few

days and he wanted to carry away a final memory of it. Besides, whenever he found himself near the Basilica he went inside to hear the wondering exclamations of the pilgrims. Narro didn't really care much about art but he was proud to hear the name of Buonarroti praised. It pleased him to know that his brother Michelangiolo had become the most famous sculptor in Rome as a result of this group and the Bacchus.

He was gazing at the familiar cool Madonna in the half-gloom of the chapel, when he heard steps of a company of men coming down the nave. They were Lombards, he could tell at once by their guttural accents. There were three of them, wrapped in brown cloaks like brigands; they halted in front of the Pietà and a tall thin man with a bloated red nose said in a loud voice: "Well, now, what do y' think of this, the work of our own Master Gobbo, the Hunchback? You know, the Holy Father is said to have rubbed good Gobbo's hump for luck while he was working on it."

Narro roared so loud that everyone in the church turned around. "What do you mean, the work of your Gobbo? My own brother carved that statue and everybody in Rome knows it! . . . Michelangiolo Buonarroti, remember the name, you Lombard swine!"

The thin man laughed, after a momentary recoil from this explosive stranger.

"And if your brother did it, as you claim, where's the signature, eh? Where's his name to prove it?"

"Porco! His name is written in every mark of the chisel . . ."

"His name is on your tongue only, Florentine."

With a curse Narro whipped the stiletto out of his belt and advanced threateningly on the three Lombards. The stiletto stabbed at the sacred air like a nervous insect. Stolidly, the three Lombards stood, their legs planted in V's, their dagas also in hand and for a few moments it seemed as if blood would flow at the very foot of the Prince of Peace. But swiftly some onlookers intervened, a priest reproved them all for daring to profane the House of God with such a disgraceful quarrel, and Narro finally desisted and left the church.

His face flushed with anger, he ran at once to Michel's studio. He found his brother stretched out on the straw pallet: his side was aching again. Narro prepared a poultice against Michel's grumbling protests (he hated anyone to attend to his needs) and while pressing the hot steaming cloths against his brother's bare white ribs, Narro told him the story. Even retelling it, he was furious and suffered pangs of remorse that he had acceded to the priest, and failed to deal with those cursed Lombards as they deserved.

". . . and for the honor of our family, you might at least be concerned . . ."

"Oh, you fool, what do you know about honor?"

". . . I know that this art of yours brings very few ducats to our house and I've been here in Rome long enough to see that you live like a dog, Michel. Look at this place! Are these appropriate lodgings for the most famous . . ."

"Oh enough with that most famous!"

"I say only that failing sufficient ducats no lousy Lombards have the right to rob you of your honor. And the fault is partly yours that you disdain even to carve the name of Buonarroti on—"

"Basta! Basta! And I've had enough of that damned poultice too. Let me sleep. My head is aching like a hammer . . ."

Shortly after Narro had returned home, Michel received a long letter from his father:

"Buonarroto tells me that you are living down there with great economy, or rather penuriousness. Now economy is good, but penuriousness is evil, since it is a vice displeasing to God and Man, and moreover it will cause you harm both in soul and body. So long as you are young, you will be able to endure these hardships; but when the vigor of youth fails, then diseases and infirmities make their appearance; for these are caused by personal discomforts, mean living, and stingy habits. As I said, economy is good; but above all, do not be stingy. Live modestly, and see that you have what is needful. Most of all, avoid physical hardships; because in your art, if you should fall ill (which God forbid!) you are a lost man. Above all things, take care of your head, and keep it moderately warm, and never wash: have yourself rubbed down, but never wash. Buonarroto tells me that you have a swelling on your side. Now, that comes from privation or exhaustion or eating something bad or windy or allowing your feet to get cold or wet . . ." Michel frowned irritably; he was scratching his nose, a familiar voice was droning in his ear. Now it was a prescription for that swelling.

The letter was signed *Lodovico Buonarroti di Simone, in Fiorenza* —and then a postcript: *"Again I remind you that you should try to return home as soon as possible, and have faith in my words, when you come here there will be work for you."*

It was all written in a tight curlicued hand that brought back to Michel's mind the great account book, the crinkle and smell of its brown pages, the feel of the oak table on which it rested. But as he read the letter his anger was mounting. What the devil had Narro

told old Lodovico to bring on all this fuss and froth? Penurious, am I? And what am I penurious for if not for the well-being of our family? O Lord, Michel thought, tossing the letter with its broken red wax seal on the floor, why does he fail to realize that his son is the foremost sculptor in Rome? And that the Holy Father himself knows of me from the Cardinal de St. Denys and that I need no real father to read me homilies on economy and stinginess and cover my head. Parsimonia!—he repeated the word aloud—is it parsimonia to live like this in order that I might set Narro and the mascalzone up in business? And is it parsimonia to bank money at the Spedale so that you up there—writing me lectures on the round oak table in a crabbed hand and wearing your long red cape as if you were still holding an official post—so that you might be spared the perils of old age?

There's a singular lack of respect in it, Michel raged, reading the letter again as one picks at the scab of a wound, a singular lack of respect. And as he reread the letter he wasn't sure whether to be more enraged against the father who had written it or the brother who had provoked it. When he saw Narro again he would shake this piece of paper under his red nose.

And suddenly his fury was gone. Because he knew that before long he would see Narro again, see them all, be back in his beloved Fiorenza, cradled in the hills of his boyhood. He walked out into the weed garden and scratched his nose and a smile crinkled into his eyes. Why, damn it, Narro wished him well, and so did Lodovico, no matter if his tone was a cross between a preaching friar and a Settignano midwife. He wished him only well—he loved him as Ser Baldassare loved his daughter Bianca.

And seeing in his mind the image of his father, the white-bearded widower bent over the oaken table, writing this very letter so slowly and so laboriously in a half-emptied house . . . Michel cried out to him, and tears flooded his eyes. He had to go home.

Crossing the dark piazza, a cold January wind bit his face. He wrapped the shawl around his mouth, shrank into his long cloak. By the side of the church he found the door which he knew was always open. He walked swiftly in. His swinging lantern seemed to macerate the incense-laden darkness and then vomit it forth again. In front of the Chapel of Our Lady of the Fever, Michel stood still a moment to see that no sacristan should emerge out of the shadows to disturb him. But the church was deserted. Then he removed his cloak, and flung it carelessly over the rail of the chapel, and opened the sack in

which he bore his mallet and several small-edged chisels. Standing on a prie-dieu he regarded with the eye of an estranged father the cool tender face of his Madonna and her limp emptied-of-blood Son. Then he set to work. He had already decided where he would incise his name. Right around that ribbon that crossed under Madonna's breasts. The quick sound of his tapping echoed against the gold mosaicked vault. In the dimness of the altar, banks of vigil lamps flickered redly in the gloom. The church was deserted save for him and his hammering. The saints seemed to be smiling.

By Bacchus! no hunchback of a Lombard was going to steal credit from him! Narro was right. Tchp tchp tchp. The white dust flew. He coughed once, the sound echoing hugely. If only the Cardinal had not forced him to install the work so soon. That right shoulder . . . for instance, why could he not . . . ? He selected another chisel, thought for the flash of a bird, made a tentative stab. Ah, see how much better! His signature forgotten, he worked swiftly at the offending shoulder, feeling with a smile that he was cheating the Cardinal. Then he went back to the ribbon on which he was carving his name.

MICHAEL · ÂGLVS · BONAROVS · FL☉EN · FAℭEBAT

He hopped off the prie-dieu and holding up the lantern stepped back to survey his work. Yes, that was it. He would leave his mark here in Rome.

BOOK FOUR

AND I WITH
THE BOW

FIORENZA

1501-1505

I

As they entered the Piazza dei Signori in the sifted dawn light, Michel saw that there were already women kneeling at the spot. Some of them were weeping. Heaps of white lilies and jasmine lay at their feet. Michel had to trot a little to keep up with Brother Lionardo. His habit flew though there was no wind on this still May morning. Fra Lionardo's jaw was set in a rigidity that reminded Michel of the prophet whose martyrdom they had come to commemorate.

Every year on the anniversary of Savonarola's death, those who still honored his memory gathered at the spot where Fra Girolamo had been burned. Hymns were sung in his honor, flowers strewn where the scaffold had been. These ceremonies had commenced only a few days after the monk's death; and for the first few years they were conducted furtively, before dawn. But the city authorities no longer paid any attention; they were less concerned about dead dogs of the Lord than the live fox, Borgia. Cesare was even now camped on the borders of Tuscany.

As he knelt amidst the keening women Michel stole glances at his brother. His face wore the same ravaged expression it had worn that owl-hooting night in Rome three years ago when Lionardo, gaunt and ghostly, had appeared at midnight and told the terrible story of his master's burning. And when Michel came home this spring, Father (*Oh, he had changed!*) said that Lionardo had returned to the Monastery of San Marco, and if Michel would wait under the rose tree of the courtyard at vespers, he might catch a glimpse of his older brother saying his prayers, strolling in the colonnade. So he did, but Lionardo wasn't strolling; he never strolled; even in that lovely Tuscan twilight, under that finger-to-the-lips hushed fresco of Fra Angelico's, Lionardo's steps were swift and driven. He was a true hound; his teeth were yellower and seemed longer, and he was no more content with the world today than the world that had been. He frightened Michel and yet Michel felt for this hound a respect that he felt for no other member of his family. For Lionardo was

possessed and that seemed to shape him, lend form to all his random acts; and this form which had nothing to do with art yet bestowed an art upon him.

By the Palazzo door two sleepy soldiers were leaning on their staffs. The lavender after-dawn light hazed the harsh outlines of Donatello's Judith who raised her sword menacingly over one soldier's head. The bronze had been brought here from the Medici Palace after Piero's expulsion. The women keened. Now from the river path appeared a group of men, all in long black mantles, except one in white, a Dominican monk. As they approached the spot of the martyr, Michel recognized jowly sad-eyed Master Sandro Botticelli and the frail poet and humanist, Ser Girolamo Benivieni, both of whom he had known in Lorenzo's garden. The one with the odd limping gait and quizzical face cocked sideways, spitting his way along, was the Master Piero who liked to paint dragons. The monk was Baccio della Porta, now cowled as Fra Bartolommeo. He nodded fraternally to Fra Lionardo, knelt and bowed his head in prayer. Michel stared curiously at this man, for Baccio was one of the very few artists who had actually carried out his vows to forsake his craft for the cloister. Fra Bartolommeo was Michel's age: a man mild as May. He seemed suffused with happiness even at this sad commemoration.

Soon, many other artists had arrived. It was, Michel thought, almost like a gathering of the Guild. There were nearly a hundred workshops in Fiorenza and at some time or other during the morning, a representative of each of them appeared to pay their respects to the preacher who had reviled them for their painted vanities and their paganism. Craggy Simone Pollaiuolo came—the architect whom everybody called Il Cronaca, the Chronicle, because of his penchant for long-winded story-telling. Simone used to go on forever about the marvels of Roman antiquities; now only the marvels of Savonarola bellied the sails of his discourse.

And there came pious Lorenzo di Credi, most ardent Piagnone of them all; and handsome Filippino Lippi, rich in an embroidered brocade cape, setting aside an hour of his commission-crammed schedule; and even Francesco Granacci, to Michel's surprise, for he had never considered his cynical friend—a successful pageant designer now—as a follower of the Friar. By noon, almost every important artist resident in the city had appeared to pay obeisance to the monk's memory. Only Master Lionardo da Vinci and Master Pietro the Perugian, failed to come: the wizard because he was in-

different to all such spectacles and the Umbrian because he was too busy painting a Passion to indulge himself in any passions.

Many of these artists who saw Michel now for the first time since his return to his native city were curious about the stocky taciturn young man who had gained such an enormous reputation in Rome for his Bacchus and Pietà and was already acknowledged, at the age of twenty-six, the first sculptor of Italy.

Girolamo Benivieni, seeing the frowning sculptor whom he had known as a boy, now the cynosure of all eyes, took a quiet satisfaction in the sight. For had not Ser Girolamo predicted just this outcome even as long ago as those vanished days of the Academy? Had he not, at a time when Michel had carved nothing but the Centauromachia and the Madonna of the Stairs, already predicted to a friend that Florence had engendered a giovanetto who would soon conquer in skill and fame every other artist in the peninsula? And that final vatic burst: ". . . e un giorno Roma stessa il confirmerò." "And one day, Rome itself would confirm it." So, Benivieni, a humble man who loved young people, seeing the throng now about Michelangiolo, felt that his prophecy had equally been confirmed, here at the very hearthstone of Prophecy. He smiled and murmured something to Botticelli. Sandro nodded.

But Michel was less aware of his fellow-artists than they were of him. He was not unconscious of his renown, but he was not self-conscious about it either. A vital sap was driving through him now; and back on his native soil he felt every morning alive with new enterprises, his head thronged with images, there were not enough hours in the day to realize the force he felt coursing through him. He had returned home to a Tuscan spring and he was revitalized by it, his fingers were all buds, all leaves, all a putting-forth after the drear Roman winter. Nothing seemed too gigantic for him now; in his colossal egotism he was prepared to carve mountains.

From where he stood, everything human seemed diminished—the affairs of the family into whose bosom he had physically returned, the judgments and even the praise of his fellow-artists, the warmth of being again in the City of the Lily, the political talk and talk of war— all this was a faint tintinnabulation from the valley below. He was on the heights.

Deeply content to be back in his own country, surrounded by the girl-sway of the cypress on the hills, the gold mosaic wink of San Miniato at sunset, the familiar bells and bells booming at all hours, he dwelt all the same in another country, a visionary land much less

gracious, whose only inhabitants were the creatures of his fancy. The Michel that his family and friends knew, vulnerable to every human concern, was not the Michel of this austere inner landscape. There he dwelt alone and furiously barred all intruders.

Even here, at the very place wherefrom the Friar had ascended to heaven, Michelangiolo discovered himself to be less moved than he had expected to be. He had come not only at his brother's behest; he had wanted to come: it was an act of piety, a repairing of the rents of his five-year absence. The piazza echoed with thunderous memories. The same piazza. The same three great arches of the Loggia. The same deep-throated thrust of the old palace. In skyey pastures the Vacca still mooed the hours. He felt familiar vibrations of the bell.

He was home. But he had changed. What Time had done to him place could not undo. His eye was not cool yet he felt farther than ever removed from popular passions.

Soon, a hundred persons were churning about the sacred spot, depositing their lilies on the fragrant white hill, kneeling briefly to pray, and then departing. But many remained to gossip as at a fair or a market. Besides the artists, appeared members of all the twenty-one guilds, some with banners, and men of the five Companies, especially the Standard Bearers and the Temple, and merchants of the Art of Wool with their flag: a most unsheepish sheep, proud as a lion, with a halo round his head and bearing, in a badly modeled but arrogant upraised paw, the staff of the cross. And many knights and artisans, and, of course, the steady stream of women and young boys. The monk was dead but he was very much alive. Ah my people, thought Michel, you sit upon the ringhiera and weep for tenderness and devotion. And hardly finished with weeping, no one swears more like a Turk. Stony natures. He felt a gruff affection for them. You needed good irons to shape a Florentine.

The artists clustered together and amongst them Michel heard the latest news: commissions in hand, scandalous anecdotes, prices and travels. They were a responsible-looking lot, these Florentine silver-smiths and sculptors, architects and painters—sober most of them in black mantles like the shopkeepers they were. But soon you saw that they were not merely shopkeepers: their sobriety was lanced with sparkle and eccentricity, odd glimmerings woven in the cloth. Though few of them wrought now the gay dancing figures, the dimpled nymphs, the bright-colored ornaments of an earlier day— the monk had swept all that aside—and though they all sought to be grave and grand with their Christs Crucified and their Entombments and their Descents from the Cross, yet their own natures had

changed less than their subjects. They were still fond of practical jokes, haggled about prices, and spread the reputation of their city as the place where the art was as excellent as the wool.

Now, seeing so many of his fellow-craftsmen together, Michel's pilgrimage was swept aside in a burst of civic pride. What would Italy be without these Florentines? Who was adorning the walls of Rome? erecting statues in the Marche? constructing palaces and strewing art from the Duchy of Milan to the Kingdom of Naples? Even in foreign lands were not his countrymen renowned? That little man there, leaning on the heraldic lion, and talking in a soft stammer, was Andrea Contucci, called Sansovino, recently returned after ten years in Portugal. And his excitable hand-gesturing inter- locutor was the most famous of the numberless architects and sculp- tors hailing from the San Gallo district—Giuliano, this one, member of the Guild of Woodworkers. In the service of his patron, the Cardinal della Rovere, San Gallo had spent several years at Lyons and Avignon, where the Cardinal still remained out of reach of Bor- gia horns. So it was everywhere—France, Portugal, even far-off Po- land—if there was art, there was a Florentine.

And if by chance an artist should be born elsewhere, you might be sure that sooner or later he would drift to Fiorenza, as Pietro Vannucci, the Perugian, had done two decades ago. And though he traveled widely in his work he always returned to his adopted city, for he was shrewd enough to know that you must breathe Tuscan air to make good art.

Besides, this is where the commissions came from.

Ahi, but it was good to be home, Michel said to himself, savoring the cool May morning. Strange that here where the monk had been burned, there should be little trace of the smoke pall that had haunted him so at Rome. Lodovico was right. He had written *Come home, Come home,* and what he had said was so. There was as much work as his ten fingers could cope with. If only the Gonfaloniere would decide soon on the assignment of the giant block. The choice was said to be between the wizard and himself. And perhaps Sansovino.

Meanwhile, he thought to himself with a malicious grin, he would repair Torrigiani's nose. He always thought of it as Torrigiani's nose, though it was really San Francesco's. It was the first task that had come his way after his return home, and Michel was overwhelmed again with the faith of his friend Gallo, at Rome, who had once more secured him the commission and vouched for his performance. A stupendous assignment—fifteen figures of saints, each two cubits

high, for the cathedral of Siena—and when Lodovico saw the contract (with that familiar spider-webbed guarantee: ". . . I Iacopo Gallo promise the Most Reverend Cardinal . . .") he withdrew the fingers that were always twining nervously in his white beard these days, and brushed his son's cheek and tugged Michel's tiny beard in a warm gesture of paternal pride and affection. It was the first time since his return that Michel had seen his father smile. And he was happy about the Piccolomini contract for that reason even more than for the fact that the first task was to repair the nose of the Saint Francis which Torrigiani had botched before departing for the wars. Every time Michel's chisel bit into the stone he felt as if he were paying him back for that blow in the Carmine.

So he enjoyed the several trips to Siena his task involved. Besides, he had to examine the site where his statues were intended to be placed, and to return a copy of the contract to old Cardinal Piccolomini who piously refused to abide in Rome while a Borgia was Pope. Michel liked Siena: that sepia-hued city with its bowl-shaped piazza and lithesome Mangia tower and steep stony streets. But the art of these former enemies was too fine-spun for his taste. It was all such a tracery of line, a gilded gauziness: there was no mass to any of it; and viewing the Martinis and Lorenzettis in the Palazzo Pubblico he felt remotely that the victory of Florentine arms against the Sienese in that long-ago war had been no accident.

But one long-dead Sienese master did stir him. On the fountain in the piazza he saw Iacopo della Quercia's high reliefs of the story of Adam and Eve. Accidenti! there was nothing gossamer about this man's work! These figures had a peasant vitality, a wonderful directness, rugged as the artist's name. Michel studied them carefully as five years ago he had studied Iacopo's robust treatment of the same theme on the central doorway of San Petronio at Bologna. The Creation of Adam and the Expulsion especially struck Michel's fancy and he made careful drawings of them. No work of art since the frescoes of the Master Signorelli at Orvieto had spoken to him so mightily as these rude and vigorous nudes of Jacob of the Oak.

So he had been busy since he came home, sketching for the Siena project, resuming old friendships. The fat Prior of Santo Spirito promised to arrange an anatomy for him if he could only lay hands on an unchristian corpse—making the rounds of the chapels whose painted walls had been his school: the Masaccios at the Carmine, the Giottos he had copied in Santa Croce, the Ghirlandaios on which he had worked as an apprentice at Santa Maria Novella. In the latter church he found the Master Filippino at work on the new

Strozzi chapel. Michel thought Filippino was terribly overcrowding his space, that his figures were strained, his archeologizing odd, his colors lurid, somewhat medicinal. But he said nothing to the genial and affluent Master.

One gusty afternoon in late March, shortly after he had returned, he persuaded Francesco Granacci to accompany him on another visit to the past. He called for his friend at his shop on the Via Ghibellina. Francesco was just putting the finishing touches to an orange and black guild flag for the Art of Blacksmiths. They went together to the Medici Gardens back of San Marco where both had studied. Now the gardens were closed, and Michel no longer had the key. Peering through the locked gate he saw that all the statues were gone. The republic had sequestered them, as well as all the books of Lorenzo's library and whatever gems remained in the palace on the Via Larga. The garden looked like a graveyard. It was overrun with weeds. Michel fancied he could hear the tchp-tchp-tchp of the boys in Bertoldo's school but it was only a woodpecker. The weeds whistled. A belfry boomed.

The belfry boomed. It was the Vacca, lowing. The third hour after sunrise. Most of the celebrants were departing to their affairs. The Piazza was bright with risen sun; the flagstones were already absorbing the heat they would retain all day. Michel thought of Rome—so much of it unpaved, muddy in winter rains—and this city of his, so civilized, so tidy. The soldiers were standing straighter now, their sleepy limpness stiffening like plants in the morning sun. For the past hour peasant carts had been coming in from the country, succulent with damp fresh greens. The carts were tied in a row in front of the Loggia, and soon the place was tangy with donkey ploppings. When one of the donkeys hee-hawed, it was as if it were a signal to disband the ceremonious vigil. The wailing women rose to their feet and departed, the artists went off to their bottegas or church walls, the merchants to their shops.

Michel and Fra Lionardo waited for Fra Bartolommeo. Then they all set off together on their peculiar errand. Michel had wanted to see this thing. Everything about his city fascinated him doubly now—he saw it with the eyes of a native and a stranger. He was like a lover whose fidelity is deepened by an interlude of infidelity. Crossing the city now with the two Dominicans Michel felt that he was indeed back among his own. For if there were four elements—earth, air, fire and water—then the Florentines surely constituted a fifth.

It was the element of intelligence. It danced in their eyes, in their quick birdlike movements, in their wit. Behind the Palace the

artists and the two monks entered the Street of the Hopeless, and there in shadowy recesses Michel saw artisans at work, chiseling frames, hammering metal, lugging wool, spinning silk. Emerging from their black caves into the bright street, they blinked like owls and went about their business. These Florentines—from childhood on they carried balls of wool and baskets of silk on their backs. From morning till long after nightfall they worked like drayhorses or slaves at loom and spindle. And yet they were not dulled by it, that was the marvel, Michel reflected, noting these mobile expressions, hearing the crackling cries and insults. A city of tradesmen, merchants, artisans—even the great families were that on a larger scale, amplified in power but not in nature—a city where qualities went to extremes, for the stupidity of Florentines was likely to be as extravagant as their wisdom. Nowhere else were there such blockheads and sages. What they abominated was the mean.

Perhaps it is because of the clear air, he thought with a patriotic inhalation, not too thin as at Arezzo, not too thick as at Pisa. But whatever the reason, how exhilarating to be treading these narrow streets between dun towers, exhilarating even on the day of Savonarola's martyrdom and on such a strange errand as this.

For they were on their way to the prison of the Bargello where one of their brother monks had been confined for two years now for having slain a man. They were bringing him sweetmeats and a loaf of bread and they were going to tell him that on this anniversary of his master's burning, they had not forgotten to leave flowers in his name.

Crossing the Street of the Proconsul, thronged with dyers' boys, Fra Bartolommeo told Michel the story of Bettuccio who became Fra Benedetto. Baccio felt a special kinship with Fra Benedetto, for they had both been artists before entering the order. Although Baccio had not lifted a brush for the year now since he had become a Dominican, he continued to draw gentle compositions in pen; he could not help it, his fingers itched and the rosary was not enough. Sometimes he visited the workshop which he had left to his partner Mariotto Albertinelli, and for an hour or two the incense in his soul was refreshed with the smell of lacquer, nut oil, lime and resin. He would listen to Mariotto curse this trade for its damned foreshortenings and its plaguey perspective, and threaten to forsake it all for the happy tavern-keeping which he had been idiot enough to give up for art.

Fra Bartolommeo laughed. He never became angry at Mariotto, not even when that wild fellow went rioting about the city with

the Compagnacci, ridiculing the Friar whom Baccio adored. Baccio was incapable of anger; he had always been sweet-tempered and yielding, a monk in spirit even before he became Fra Bartolommeo. Ever since the siege, Michel's brother was one of his favorite companions. "*Coraggio, fratello mio!*" Baccio never forgot that apocalyptic moment when Lionardo gave him back his courage and his crossbow. Nor did he forget his vow.

So Baccio della Porta became Fra Bartolommeo. Surely he had not become a monk out of repentance for the sins of his youth. He had nothing to repent, except perhaps a taste for mildly lascivious poetry. He had never been quick with his own tongue or with the tongue of steel. He had never killed a man, neither before he became a monk, nor like Bettuccio, afterward.

"Had Bettuccio devoted himself as ardently to the art of miniature, at which he was a master, as he did to quarrels and pleasure, he might not have suffered so when he encountered the Friar's sermons. Oh, of course," Bartolommeo added with a gentle smile, "he didn't succumb at once as I did. He continued to abandon himself to the gay brigade, he kept on fighting in the ranks of the Arrabiati. And he caracoled aplenty around the houses of prostitutes:

> *In those days I stank so much of musk,*
> *Such feckless days, such fornicating flings—*
> *By my soul, I flew without wings!*

"You do not approve, Brother Lionardo?"

Brother Lionardo did not approve.

"I fail to understand why Fra Benedetto wastes his time with such compositions," he said.

"He wishes to look back on the country from which he has departed."

"He would do better to look forward to the country to which he is going."

"Nevertheless, the tercet is a miracle," Bartolommeo said softly. They were entering the Via dei Lavatoi, the Alley of the Washers. It was a wide street, eighteen braccia, purposely constructed with two troughs running down the side. The street had been built years before by the Wool Guild in order that the dyers might be able to wash their cloths, especially in winter when the Arno was too high and too rough. The monks had to lift their long white habits to avoid being splashed. The noise was terrific, a fracas of black-smocked apprentices called jockeys were loading wet stuffs on the croups of unfortunate horses. They were taking the washed and

rinsed cloths to be hung for drying at the Piazza dei Trari and other sections of the city.

Above the yelling, bumping, joking, Michel could scarcely hear Fra Bartolommeo:

". . a woman, of course, a beautiful and gifted noblewoman. You might say poor Bettuccio fell in love with her. At any rate, to please her—for he was still fighting in the ranks of the Arrabbiati, remember—he began to frequent the Friar's sermons. It was like a bolt of thunder, he told me. For the first time in his life he began to wander alone and took a hard look at the festering sore of his soul.

Faithless, believing in nothing from head to foot

"A beautiful line, don't you think? . . ."

Michel nodded. But Fra Lionardo plunged straight ahead through the jovial fracas. The chattering and quarreling was especially noisy today, for this was a Monday, beginning of the work week. From both sides of the street came bursts of rude laughter, buffoonery, the regular rhythms of the boys beating the cloths on the cyma, the curved molding of the trough.

"Eh, Frater, before you get to Paradise, lend us a hand, will you?"

With a grunt, Fra Bartolommeo helped heave the heavy bolt onto the horse's croup.

"By Bacchus, out of my way, monk!"

". . . abandoned his music—he had a lovely voice, clear as Chianti —threw away his lute, left his companions, cast off his perfumed clothes:

Like a wind despoiled myself of all frivolity . . ."

Now they had reached the Stinche. Directly opposite the great municipal brothel, Il Gran Postribolo, was the Church of Santa Maria in Postribolo. In the Stinche, a huge fortressed building with merloned walls, harlots were obliged to live. On the walls Michel could still dimly make out the painted upsidedown pictures of traitors with mitres on their heads. *Bock bock bock* sounded the dyers' boys beating at the trough. Fra Bartolommeo was murmuring something about poor Bettuccio falling at the feet of the stern Friar, begging to be admitted. But Michel was flushed at the memory of a little girl with bud-breasts, cross-legged on the bed, and he weeping and cursing. He hated this part of town, so near his father's house, too near, too near. Fortunately there was no spectacle today. He had had enough of spectacles in the Holy City. That very

first day, what had her name been? Forset—Cors—Cursetta. Small
breasts. Gourds. The Moor's mahogany flanks. Here at the Stinche
women of good families who had disgraced their name were exposed
nude, whipped, and then led to the Ponte Santa Trinità where the
hangman dipped them three times in the Arno to wash away their
sins.

". . . but of course one cannot wash away one's sins so easily.
For a year Girolamo set him to nurse the ill and bury the dead and
only then was he permitted to take the habit. But changing one's
garb does not change the soul. Not at once. He remained a violent
man."

"Indeed he did," said Lionardo now. "During the siege he was
the first to seize a weapon and the last to relinquish it. And I'll
never forget that wild expression on his face when he came down
from the roof where he had been throwing stones."

Bartolommeo mildly shook his head. "Yes, and remember how
we had to restrain him from attacking Fra Malatesta when that
weak man suggested Fra Girolamo yield himself to the mob?"

"Ah, if that were only the end of it."

"It wasn't?" Michel said. Magnify the Moor's flanks. Huge. In
purest white. If he could only get the block.

"No. Fra Benedetto continued to quarrel. Even as a monk. And
then . . . But surely you wrote him about it?" he added, turning
to Fra Lionardo.

"My brothers never write," Michel said. Unless they want some-
thing, he added to himself.

"Well, two years ago Fra Benedetto stabbed a man. An Arrabbiati
maligning the memory of Savonarola. Right through the mantle and
jerkin though he wore a coat of mail beneath. Oh, a strong fellow,
our Fra Benedetto. And for that the authorities clapped him in
castigo. Eccoci, here we are."

Grated, grim, the Bargello loomed. Fra Bartolommeo hastened
his step. Within those frowning walls another Bartolomeo had once
been lodged. Michel was oppressed with a sense of inexorable Time
—the curer and the killer. He must write Andrea. Peculiar expression
in his eyes when last we met. Time's backward wheel. Still at
Pollaiuolo's? This building endured. A shell: the soft creatures in-
side die, their sculptured housing remains. Bartolomeo's pulpy re-
mains.

Through the barred windows, prisoners held out long bamboo
sticks with white purses attached and cried out their innocence
to passers-by. The bailiffs provided the prisoners with these sticks **and**

took a percentage of their alms. Outside, on the ledge that ran along the ominous building on the Via Sant' Apollinare, the bailiffs were sitting now, ostensibly to prevent friends and relatives from speaking to the prisoners.

Fra Bartolommeo approached a bailiff with whom he seemed to be familiar, whispered for several moments, and then dropped some scudi in his already open palm. Without another word, the bailiff led them around the corner and shouted into a barred window just above street level. A face appeared, pallid, eggwhite above a gaunt beard. It was Fra Benedetto. As soon as he saw his friends, his eyes glowed but he did not smile. He glanced with mild curiosity at Michel. Fra Lionardo reached up and handed him the sweetmeats and the bread.

"How are things, Brother?"

"With God."

"Do you desire anything?"

"I have completed another canto," the prisoner answered irrelevantly. A skinny hand protruded through the bars, fluttering a sheaf of papers. Benedetto took them, glancing at the manuscript, and then handed it to Michel. Across the top in nervous curlicued script was written *Fons Vitae, Canto twelve,* and the verses were signed, *Fra Benedetto, Homicide.*

"You might bring me some paper," the prisoner said, munching the bread. "These bailiffs rob me for every folio . . . This bread is good."

Behind the bars, in that dim light, his face seemed to glow, as if the waxen flesh were being consumed by an inner flame. It was the same light that emanated from Fra Lionardo. But not from mild Bartolommeo. Now in cowl and robe he was the same Baccio he had been in cape and jerkin. He would never become a saint since he had never been a sinner.

All around the prison the genial wet hive, the hurly-burly of life, the necessary vulgarity.

"And some tapers," Benedetto muttered. "I sleep poorly of nights and often write to pass the hours."

"You shall have them."

The monks began to talk about affairs of their order. How different they were from the artists of the piazza! And yet like them they shared a sense of belonging, a dedication and a discipline. Even here in this prison Benedetto knew he had brothers outside and they would provide for his body and pray for his immortal soul.

But he, Michelangiolo, had four brothers and none. He belonged to no order, neither sacred nor profane. He was alone and his prison was a block of marble.

II

Lodovico no longer grieved that his son was a stonecutter.

Indeed, his opposition ceased once the Magnificent had taken young Michel into the Medici household. Seeing his son dressed in purple beside the Magnificent's sons at table, Ser Lodovico decided that the profession had its merits. And now that Michel had acquired both fame and money at Rome, Lodovico was convinced that chipping stones was after all worthy even of a Buonarroti. His chief occupation—inasmuch as he had been chronically unemployed since the loss of his Customs post—was to keep a sharp eye out for opportunities for his son's chisel.

And so, as soon as Michel came home, his father lost no time in telling him about the huge block of marble lying idly in the yard of the Supervisors of the Cathedral Works. "A monstrous thing, a mountain," Lodovico said. "Half a century it's been waiting for a skillful hand. I would look into it, figlo mio. I understand Ser Soderini is searching now for a sculptor capable of extracting a figure from it. A Giant. A Prophet. Something symbolic of our regained libertà." There was a trace of bitterness in the tone. But the next sentences were spoken with deep sincerity. "Can you imagine the expense of hauling such a gigantic piece of stone from Carrara? And now to let it go to waste!"

Michelangiolo listened with interest, and also some wonderment. This was new—his father's professional manner of discussing stones, commissions, contracts. He was the self-appointed manager of Michel's affairs. It was embarrassing to hear him arguing now with the apothecary Manotti, not on politics or the corruption of the present generation or the errors of Holy Mother Church, but rather on the relative merits of the artists then resident in Fiorenza.

"Who? . . . that pumpkin head!—With all his instruments he

has no sense of proportion. Now, my son—ah, you will see—has no need for compasses. His compasses are in his eyes. There is no one in all of Italy to match him. Have you heard what the French Cardinal said of his—?"

So it went all day long. He had a full repertory of tales of Michel's Roman conquests, brought back of course by Narro, since Michel's letters had been infrequent and terse as nails. Ser Lodovico's greatest pleasure had been to bank his son's earnings at the treasury of the Hospital of Santa Maria Nuova. It was on one of these expeditions that he encountered the father of another prodigal who had recently returned to his native city, and the two men—neither of whom could draw a straight line—fell to noisy disputation regarding their sons' artistic merits. The Notary Messer Piero da Vinci was twenty years older than Lodovico but he had an even louder voice and apparently more virility. He lived around the corner on the Via Ghibellina with his fourth wife, a sixteen-year-old maiden, already visibly pregnant, and he was as relentless and stubborn in argument ·as Ser Lodovico—and considerably more profane. His natural son, Lionardo, was a stranger to the old man; the Master did not live in his household, and on the rare occasions when they met in the street or on the bridges, the artist greeted his father with polite but icy remoteness. Nevertheless it irritated the Notary to hear this pontificating Messer Buonarroti extol his son's artistic merits above all others. Their dispute caused much laughter in the Guild.

His brother also, Michel found, treated him with greater respect if not understanding. He had roasted Narro's ears for having told Ser Lodovico those tales of his penurious living at Rome, and of his constant headaches and the pain in the ribs. Narro listened, nodded, flushed, twitched, laughed and finally clapped him on the back. Michel forgave him; he forgave Narro anything.

Occasionally letters came from Giansimone who was a lancer in the Florentine infantry still camped before the walls of Pisa. The siege showed no signs of reaching a conclusion. Michel resolved that the next time he had to go to Siena on the Piccolomini commission, he would continue on to the camp before Pisa. He would like to see madcap Giovansimone again and perhaps purchase him out of the army and get him safely stowed away with Narro in a wool shop. They had already found a good location on the Street of the Stocking-Makers. Narro was surely ready: he knew the wool trade like his palm and he was sober as a judge—in all matters except women; apparently the energy he expended in that delicious pursuit

left him drained of everything except sobriety. At any rate, these days his amorousness was beginning to focus on a single well-shaped object named Barta. She lived at Settignano where Zio Francesco ran the Buonarroti farm and where the youngest brother Gismondo spent most of his time since he had left off schooling, preferring olive groves to Ovid and manure piles to Martial. Gismondo was red-faced as a beet, slow-moving as an ox, and seemingly devoid of speech. He was nineteen now but he might have been twenty-nine or even fifty-nine—his was the agelessness of a clod.

But annoyed though Michel might become at the inarticulate youth, he felt an earth-kinship with him. For up at the farm at Settignano, especially, in those heat-baked fields, fenced with poplar rows, and with a halo of insects buzzing round his head, Gismondo's silence seemed perfectly right, eloquent even. He ceased to be a clod then; he became a rock. And rocks spoke to Michel.

He began spending his Saturday afternoons at Settignano, ignoring the uncle whom he hated, visiting the cottages of the stonecutters amongst whom he had dwelt as a child. His wet nurse, Mona Clara, lived in the same little whitewashed stone house at the turning of the pebbly lane. She was in her middle years now, a widow, and if the milk in her breasts no longer ran there was nothing desiccated about her manner. She spoke loudly, the way mountain people do. Michel loved to sit outside the poor cottage and drink the sour wine and joke with the whitedusted workmen as they returned from the quarries.

"Ahi, you were always a stubborn one," Mona Clara said. "You were always pushing at my breasts with those ferocious little hands of yours. You bruised me black and blue—"

"Forgive me, Mona Clara," Michel smiled and kissed her leathery cheeks. He thought she was a handsome woman, straight-backed as a belfry and her luminous black hair pulled tightly over her ears.

"The only way to silence you was for Renzo—" and the fierce hawk eyes blurred "—to click two chunks of stone together at your ear. How that delighted you! You would strain your spine against the post and chortle and clench and unclench those tiny fists. Then when you were grown a bit Renzo took you with him into the pits and made you a toy mallet and all day long you hammered contentedly away with the men. What blackened nails you had!"

Michel extended his hands.

"And what do you think of them now, Mona Clara?"

She squinted. "Blacker than ever. And your father such a fine gentleman. Are you still cutting stones?" she said incredulously.

"I am still cutting stones, Mona Clara."

"Ah well, I warned your mother you were suckling it in with your milk. But she was so sickly she let me do as I list. And as for your father, he was a fine man, but difficult to discuss these matters with. Renzo never told him he was taking you into the pits."

"What was my mother like, Mona Clara?"

"Very gentle, Michele mio. Her voice was very low. She was always worried about you. She said you had been jolted too much in the saddle before your birth. Your father had just been appointed Podestà of Caprese, and so your poor pregnant mother had to ride mule-back up that steep mountain road."

"I suppose it addled my brains, eh Mona Clara?"

"You have fine brains, figlio mio," she replied almost fiercely. Then, after a moment's maternal contemplation of this bearded, furrow-browed young man: "You were joking before, of course?"

"About what?"

"About being a stonecutter."

Michel patted the dry-skinned barky brown hand. She was so thin, strong though she was. The cottage was empty as her breasts. She had given her milk to so many and had no sons of her own.

"I am a sculptor," he said gently. "One of my works is in San Pietro at Rome."

"Davvero!" The hawk-eyes were suddenly sparrow-bright. She touched the knot of her hair with an embarrassed womanly gesture.

Tchp. Tchp. Tchp.

And parings of a sickle moon.

The Garden of Paradise must have been like this—a high stony place amidst green fields.

After he departed, Mona Clara found several scudi under the plate. When he returned the following week, she upbraided him, then she broiled a country steak for him together with a plate of those crisp little white beans he loved, glistening in oil. The bread she had baked was brown and crusty as her arms and the inside white as the heart of the mountain. She listened to his stories of Rome, of the Cardinals and great bankers he had dealt with, and he didn't think she believed any of it. But he liked to tell her anyway. Here in the hills with Mona Clara and the stonecutters at dusk, Rome seemed like some fable of the ancients. Straight-backed she sat, severely listening. Had there really been a Messer Gallo? a Messer Balducci? had he really had dealings with the Cardinals di San Giorgio and St. Denys?

"*Cosa ferma non è sotto la luna.*"

"There is no solid thing under the moon," Pico had written. Flesh, even the lovely alphabet of flesh, was a cipher in Time's fell sum. He heard his own voice speaking, an alien voice. What survived? What could stay this frightful dissolvingness of all things? How could he get down below events that became dreams even as they happened, down and down and down to where God was and where the rocks endured?

The moment he saw the great stone he felt that it was his.

He went with Botticelli. Master Sandro had changed, you could see that at once. Some of the juices had been steamed out of him. Whether this was the drying-up of age—he was more than twice as old as Michel—or whether his soul too had sizzled in Savonarolean fires, it was difficult to say. He had never been as avowed a Piagnone as some of the other artists, as Baccio for instance, or Lorenzo di Credi. Oh, Master Sandro had believed in the monk as most of them did. But yet he held back a little. Was it perhaps that he could not quite expunge certain images from his head? It was said that the beautiful Simonetta had posed in the nude for his *Birth of Aphrodite*—and other things were said too. There were the pictures he had made for Matteo Palmieri's poem which fell under the ban of heterodoxy. There were villas all over this countryside containing Sandro's tondoes of naked women. And who could deny that even his melancholy Madonnas hinted a kind of refined sensuality, more sensual perhaps because they were so refined?

He was a strange man, Master Sandro. His jowls were too thick. His heavy-lidded pale eyes seemed brooding up with trouble like a storm-charging sky. His large bow-shaped mouth drained away at the corners in a persistent melancholy.

Michel had known the man since the time when Botticelli was practically the official painter of the Platonic Academy; later they had shared a common patron in Lorenzo di Pierfrancesco de' Medici. So Michel had come to know some of the oddities of Master Sandro. You could read the man on his face as well as in his pictures.

And yet no artist in all Fiorenza had such a reputation as Master Botticelli for mad pranks: his jolly burle were famous: the pleasure he took in mystifying the workmen of his bottega, the hoods of red paper he had fixed with wax to one of his apprentice's paintings so

that in the morning when the customer came to see it, he found the Madonna seated not in the midst of eight angels but in the midst of the Signoria of Fiorenza.

Michel called for him at the little farm which Botticelli owned with his brother outside the gate of San Friano. He was brown as an acorn and his body smelled of fields and manure. He had earned much money in his day, but always spent more than he earned. Now he derived a living from the farm and a small pension allotted by Lorenzo di Pierfrancesco. The house was in a characteristic state of disorder: pots of dry ground colors and lime mingled their scents with horse manure and scraps of food. When Michel came to the farm he found the older master hummingly at work on a Nativity. The picture fluttered with angels; one could almost hear the brush of wings—they flew and danced over the manger roof; they pointed out the miracle to the adoring Magi and the shepherds; and, in the foreground, they flung their arms around three witnesses in long cloaks, while tiny devils went scurrying off into the rocks. Who were the three witnesses? Michel wondered. Fra Girolamo and his two companions?

Botticelli was carefully inscribing a long motto in Greek lettering across the top of the picture.

"What does it say?" Michel asked.

Sandro peered at him learnedly over the tops of his small spectacles which had slid down his thick nose. He began translating, moving a paint-stained finger along the streaming letters:

This picture I, Alessandro, painted at the end of the year 1500 in the midst of the troubles of Italy, in the half-year after the years, according to Chapter Eleven of St. John, in the second woe of the Apocalypse, when Satan was unloosed upon the earth for three years and a half. After which he shall be chained, according to the Twelfth Chapter, and we shall see him trampled under the feet, as in this picture.

"Oh, the stravagante!" Michel chuckled to himself, "He can scarcely read his own tongue! And now he would have me believe he is translating from the Greek!"

Everybody knew Sandro had learned to read Tuscan only late in life, and when he presumed to expound Dante—which set the whole town laughing—he did so with the painful spelling-out of a peasant. Obviously, he had gotten all this Greek from Benivieni, old comrade of Lorenzian days, and memorized the meaning.

But to Michel it seemed that poor Sandro had lost faith in the power of his painted vision alone. Else, why that explanation? If

the picture did not bespeak itself, was it not a confession of ineptitude to have recourse to words? And all those curious angels? Did they add to the vision?

Leaning against the wall was an older work by Master Sandro. Today the man's head was filled with visions of the Apocalypse. But there, yesterday, in tempera on a wooden panel, was depicted the loves of Mars and Venus. The God of War lay stretched out sleeping, his head tilted back, his mouth slightly open, a tiny bubble of sleep on the wet lips. Around Mars' languid naked form played several naked children, one with his armor, one mounted on his long lance, another blowing on it with puffed cheeks as if it were a trumpet. *Sleep!* the putti seemed to say, *Sleep! How can you sleep with Venus awake! gazing at you with that cool, expectant, slightly mocking expression?* The goddess was half-seated, her ripe breasts and belly flowing in an undulation of lines, her manner patient passion certain of fulfillment.

With a stroke, Michel found himself again between Bacchus and Madonna.

Ahi! but they were all seeking to reconcile irreconcilables!

He felt a new sympathy for the man. When they left together to see the block, Michel slipped his arm under Sandro's. He had always admired his work, especially his draftsmanship, although that nervous line made him nervous; it was like the trackings of an ink-filled insect, fine traceries left by a spider on a branch. And it had a similar air of entrapment about it.

But the spider himself was not entrapped. Crossing the city Botticelli jested as if he had not, only minutes before, been deeply in a mystical vision.

They entered the courtyard of the Opera of the Duomo. All those strewn saints, half-finished caryatids, blanched torsos intended for the façade still under construction, made Michel think of his first view of the Roman Forum. Was that white arm of five years ago, he wondered, still reaching from the earth? Would it still be reaching when Bianca's arm—for it had become in his dreams Bianca's arm—was dust? Ah, Time was a tooth.

But there was something here not even Time could gnaw away. Dominating the courtyard was a huge marble block towering above their heads. By the flanks of the Virgin, Lodovico hadn't exaggerated! It must be at least nine braccia high! The two men standing in front of it seemed dwarfed: one was a heavyset gentleman whose friendly demeanor did not conceal a manner both authoritative and benign. Gathered in one hand, he held with a

kind of statuesque grace the long train of his official red robe. His companion, also middle-aged, was taller, thinner, and dressed, Michel thought, with abominable foppishness: his pink tunic was cut unusually short above the knee, he wore tight silk hose of a delicate dove color and a pleated jerkin. His long fair beard was exquisitely combed and from his soft black velvet cap a fund of silky hair, more honey-colored than the beard, rippled to his shoulders. His eyes were ice blue, and the voice that was now speaking was softly baritone, curiously melodious.

"I see that we have arrived at a crucial moment," Sandro whispered to Michel as they entered the courtyard. "Perhaps Master Lionardo has decided to accept Ser Soderini's offer after all."

Da Vinci greeted Botticelli with an urbane nod. They'd known each other as long ago as the days of the Pazzi conspiracy when both had made sketches of the hanged men—Sandro as an assignment, Lionardo out of curiosity. In his notebook he had made a precise inventory of the clothes—particularly the colors—the hanged men were wearing.

When Sandro introduced Michel, the bearded painter murmured with a cloudy smile: "Ah, you are the young man who is said to have shaped the softest-bellied Bacchus in Christendom . . . ?"

The Gonfaloniere already knew Michelangiolo. He had indeed sounded him out several times regarding his interest in the block, but always with the characteristic caution of one still shopping around. The gossip in the Guild was that Andrea Sansovino was also bidding for the commission, but that the Gonfaloniere was inclined to choose between Buonarroti and da Vinci.

Michel had returned home to find all Fiorenza agog over Master Lionardo's cartoon of the Virgin and St. Anne. He had gone to the Church of the Santissima Annunziata to see it, and had marveled at the intricate triangular composition, the incredible smoky depths and atmosphere, the odd glacial landscape, and the enigmatic smiles. There was surely something mysterious about this drawing: it vibrated more than any picture he had ever seen, and he examined it closely to learn how this master had gained such effects. The incised lines, he saw, had all been smudged away, softened, blurry depths fell away like music. He wondered if da Vinci would be able to preserve this effect when he applied the paint.

So now, as Michel met da Vinci for the first time, he felt uneasy and very young and his voice was gruff:

"It was the nature of the subject. And a fine stone."

"Do you think something might be done with this?" da Vinci

asked blandly, quite as if he had a geological and not a personal interest in the matter. But the Gonfaloniere attentively awaited Michel's reply. Michel did not answer at once. He was surveying the block with swift appraising glances. An awkward shape, too tall, too thin—whatever form lay within it must be cramped as in a coffin too small. To release it would be a magical, if not a holy act, as Jesus had raised Lazarus from the dead.

"Of course," said Michel. He was circling the marble now, running his thick-padded fingers over the rough stone. Sometimes he peered closely at it as if it were glass and he might see what it contained.

"Where has it been worked?"

"Up there, at the top, left side, not very much but you can see the biting of the irons."

There was a ladder in the court; Michel leaned it against the block and scurried up it. He stood there a moment, scratching the bridge of his nose, contemplating the botch work Master Guccio had committed forty years before. Lionardo was looking up at him with a cool air, his hands on hips making a pretty tent of the pink cape. Coming down the ladder Michel sniffed a fragrance of musk. By Bacchus, the man had perfumed his beard, he was sure of it! Curious pointed-up shoes. There was something Magian about this brooding presence, an air of unheard vibrations as after the last sounds of a lute string have died away.

"It is not beyond repair," Michel said. Then he added, with a suggestion of arrogance: "If the cutter knows his business. It might even be possible to extract a figure from it without adding a single piece."

"Ah!" Soderini smiled broadly. He turned to da Vinci. "Are you in accord?"

Lionardo nodded with an enigmatic smile. Master Sandro was suddenly humming a stornello, a nasal grating sound. Soderini gathered the folds of his lucco closer.

"Well, we shall see, we shall see."

As soon as he had departed with Lionardo, Master Sandro burst into rude laughter. "Che furbo! He will keep you all dangling until the last minute! But I think, amico mio," he added, "the choice will fall on you. Master Lionardo seemed quite disinterested."

"Might be a ruse. Besides, what of Sansovino?"

"Oh, he's too delicate a workman for this stone."

"And the wizard? . . . He is not delicate?" Michel snorted. "That pink cape! That scented beard! Is it possible a man with such damsel-

like fingers shaped a huge horseman of the Sforza at Milan? I find it difficult to believe!"

"He did it all right. San Gallo saw it. He said it was a marvel." But then, observing the young man's frown: "But you needn't worry. The truth is Master Lionardo really doesn't care to work in stone. I have heard him say it is too obdurate a medium to express the subtlety of his thoughts."

"It is too obdurate because he fears to stain that pink cape with honest artisan's sweat!"

"No, I don't think it's that," Botticelli rejoined seriously but with mischief in his eye. "It's simply that he considers painting a superior art, as requiring more intellectual effort, and being capable of perspective and the representation of luminous bodies, and delightful with color, and more comprehensive in every way . . . And of course," Sandro added as he saw Michel's frown deepen, "I cannot but agree with him . . ."

Michel was about to reply heatedly when he realized he was being twitted. But for the next few days, as he anxiously awaited the Gonfaloniere's decision, he seemed to feel the air still vibrating with that mysterious presence in the courtyard.

III

A week after All Saints' Day, the Gonfaloniere Pietro Soderini received a letter from the Florentine Ambassador at the Vatican. The letter was a 'relation' of a certain celebration which the Ambassador had recently attended in the apartments of the Duke Valentino in honor of the impending marriage of his sister Lucrezia to the Prince of Ferrara.

As he read the letter, the stout-faced, sober-minded Soderini flushed and he shook his head and made clucking noises with his tongue. When he brought the document to be filed with his first secretary of the Second Chancery, Niccolò Machiavelli, he carried it pinched in forefinger and thumb, as if it contained festering matter, and fumes were rising from the neatly-penned pages.

Ser Niccolò however read it without a glimmer of distaste on his fine-etched features, and burst out laughing. A rare story, he thought, he would amuse Buonaccorsi mightily with it.

But the event that so scandalized the Florentine Gonfaloniere and tickled the risibilities of his ironic secretary, posed a greater challenge to poor Burchard, the Magister Cerimoniarum, at Rome. Once again he faced the ungrateful task of inditing the uninditable, torn between a chronicler's conscience and a keen appreciation of the armor-plate of silence. He had been fighting this battle for too many years now and he was tired: the neatly trimmed columns of Latin were, in their ranked blandness, as terribly eloquent as the scattered bits of armor found on a battlefield long after the dead have been removed, the blood dried, and the birds have resumed their song.

The party had begun simply enough. The usual dull dinner (His Holiness was entirely too conscious of his fine figure), the usual festivities afterward: the game of Essences, the charades, the lutes. All this the Magister had already committed to the record when he arrived at the event for which he was now seeking the appropriate neutral words. The lighted candelabra had been brought in, yes, and Alexander was laughing so that everyone could see his amazingly strong white teeth, and it seemed incredible that he was more than seventy years old, so tall, so virile, radiating that good health and vitality that so impressed all who came within his presence. And then the other lights had been darkened so that only the candelabra on the floor flickered and then into the room entered—

The Master of Ceremonies pulled on his ear and sniffed and began hurriedly to write in his quirky hen's-track hand:

". . . fecerunt cenam cum duce Valentinense in camera sua, in palatio apostolico, quinquaginta meretrices honeste . . . *And that evening fifty reputable whores, not common but the kind called courtesans, supped with the Duke Valentino in his apartment in the apostolic palace, and after supper they danced about with the servants and others in that place, first in their clothes and then nude. After supper, candelabra with lighted candles were set on the floor and chestnuts were strewn about and the naked courtesans on hands and feet gathered them up, wriggling in and out among the candelabra while the Pope, and the Duke and his sister, Madonna Lucrezia, looked on and applauded. Afterward, prizes were offered, silk dresses, shoes, hats and so on to those who—"* and here the sharp nose twitched, the shivering quill hesitated a second *"—who knew the*

said courtesans carnally the most times (. . . *pro alies qui pluries dictas meretrices carnaliter agnoscerent*)."

Burchard coughed, then plunged ahead with the final sentence: "*Then all those present in the hall were carnally treated in public* (*in aula publice carnaliter tractate*) *and prizes distributed to the victors by the judges present.*"

The Master of Ceremonies put down his quill and shut the book. He stood up and bestrode the room, twice, thrice. He had many things to think about and the images summoned up by what he had just indited were distracting. Of course it was to be expected that a recreation of this sort—should it become known—would fan to flame even the cold ashes of Savonarola, dead these three years. Yet it was altogether suitable as preliminary to the marriage of Lady Lucrezia to the Prince of Ferrara, now that she had apparently conquered her grief over don Alfonso's unfortunate demise. As suitable as the other spectacle which His Holiness had contrived for his daughter a few weeks before the dance of the chestnuts on the eve of All Saints' Day. The Master of Ceremonies suddenly wondered whether he had neglected to make an entry of that curious episode, and he returned hastily to his Diary and leafed back through the pages. Ach ja, there it was under the date of 11 October:

". . . *While the Madonna Lucrezia and His Holiness looked on from a window of the Apostolic Palace, four stallions from the pontifical stables fought for two mares in the Piazza di San Pietro. After much furious kicking and biting, the stallions finally mounted the mares and copulated with them* (*ascenderunt equas et coierunt cum eis*). *This spectacle had been contrived by the Pope for the edification of his daughter soon to be married, and indeed they both seemed to take great pleasure in it.*"

No, it was not easy to be a Magister Cerimoniarum, even if icebergs floated within one's veins. And though Vater Burchard had accustomed himself over the years of the Borgia to swim calmly as a fish through the most turbulent and dirty waters, though he might tolerate chestnut dances, bodies fished out of the Tiber, father and son competing for Lucrezia's twice-plucked flower, indecent theatrical performances, and the ever-present scandal of the beautiful Concubina Papae, Madonna Giulia Farnese, whose golden hair, undone, spilled to the floor—none of these monstrosities touched the cold core of the German to any appreciable extent. Like the seventh circle of Hell, his plumb center was a frozen lake and there was Satan fixed eternally. One learned to live with Borgias.

But one thing disturbed him mightily. Now, pacing the floor he

thought of it again and flushed with anger. It was the easy way this Pope had with the divine service. Oh, that was truly insupportable! It mattered less to Burchard that fifty whores had danced naked before the Pontiff than that Alexander two days ago had handled the Host so carelessly that it had crumbled in his fingers and he had crushed a piece of it beneath his heel. And when he, Burchard, had stooped to recover Christ's body, the Pontiff had observed what he was about and angrily ordered him to desist (*Sic volumus*). The meticulous German had made an indignant note about that in his Diarium. After all, it was a fact worth recording in apostolic annals if the Vicar of Christ was so careless in his divine functions . . . And the rushing through the Mass in half an hour (*vix duravit ad mediam horam*) and the perpetual disorder of the sacred offices in which either the thurible or the wax candles or some necessary vestment was sure to be missing, or the outlandish costumes the Pope sometimes wore, or the manner in which he permitted friars to prostrate themselves to the earth before him (*contra bonas cerimonias*) as if they were Turks, and the day his daughter Lucrezia and his mistress Giulia and other ladies of a not too nice reputation climbed up to the altar with him (*res inaudita!*) and laughed and chattered like birds all through the sacred rite and His Holiness laughing and chatting with them even while the Host was elevated (. . . *ignominia et scandalo nostro et populi*) and several jolly Cardinals also taking exceeding liberties with the established order of things.

Ach, it would all lead to ruin, Vater Burchard reflected sadly. For once the proper order of the ceremonial was disturbed, there was no telling what would be the retaliation of an offended God.

IV

During this week of piety for all the Saints and chestnut dances for all the Borgia, Michel was pacing back and forth in front of the marble block in the courtyard of the Opera. Surrounded by a roofless wooden shed now, the huge stone dominated the constricted space

even more than it had dominated the court; Michel felt as if he were about to attack a mountain with bare hands. Soderini's choice had fallen on him as Sandro had predicted and his sense of triumph was not mitigated by the fact that Lionardo was said to have withdrawn of his own volition. It was a good contract too, allowing him two years for the completion of the work at a salary of six golden florins per month with provision for a bonus at the conscience of the Supervisors.

And at his request, his friend Il Cronaca had been assigned to construct this wooden shed around the block so that Michel might work in his habitual fashion: shut off from the world, alone with his vision and the obdurate raw medium in which he would fix it.

Overhead the pale autumn sky was like the awnings stretched across the streets for nuptial feasts. There was a nip in the air. He would have to get the shed covered if he hoped to work here through the winter.

The subject had not been stipulated in the contract, other than the fact that he was to "finish to perfection that male statue called the Giant (*hominem vocate Gigante*) . . . existing in the workshop of the cathedral . . . and badly blocked beforetimes . . ." When Michel proposed that the Giant be a David, the Gonfaloniere agreed without hesitation. It was a favorite subject with the Florentines: Master Donatello had done it, and Master Verocchio, and Master Sansovino and a dozen others. Having expelled the Medici, stood up to Charles of France, burnt Savonarola, flung stones at the Holy Father, they fancied themselves giant killers.

Where was that cursed boy? Michel ceased pacing, stopped in front of a wooden stand on which stood a model in black wax, about a foot and a half high, of his giant. For several moments he regarded the armless figurine. He scratched his nose, spat. No, it was all wrong! The leg must be further extended, almost to a stride, the head pulled back. Create a tension. This figure was altogether too slack. Damn this wax! He kneaded another lump of the stuff in preparation for the new figure. Then impatiently he leafed through a sheaf of drawings lying at the foot of the block. They were all David sketches, some in pen, some in pink chalk. One showed fierce eyes under a knitted brow, gazing at an Enemy. Another was the drawing he had made of Andrea the Hebrew many years before at the door of the Palazzo. He had never thrown away that swift impression. He liked the strained position of the left hand at the shoulder, a contortion that swelled the biceps of the upper arm. That posture was probably the best, he decided, an odd point of balance

between action and repose. Determined, he took a wet sponge and went to the block that stood like a white upended coffin and began to wipe off the frontal drawing in charcoal he had already transfered to the face of the stone. A faint breeze stirred the drawings. He laid a chunk of marble on them. Across the boxed sky, a swift cloud floated. Sails of a caravel, embarking on a voyage.

He felt indeed a trembling on the brink. For two months, since he had signed the contract, he had been wrestling with this idea, carving it out again and again in his mind. Weeks had gone by in the construction of the shed, in sketches, in studies, in false starts. He looked at every David he could find—and found fault with all of them. The best were the bronzes of Verocchio and Donatello, but these pretty shepherd boys posed too languidly with the Philistine's head at their feet. No, he wanted a hero, fierce, terrible. Every day he thought he had the image clear in his mind. But he had not yet dared to strike a blow.

And as the Giant grew ever more heroic in his imagination, it overshadowed completely the task to which he had previously committed himself. In June, he had signed the contract with the Piccolomini; in August with Soderini and the Art of Wool. Lodovico was puffed up to the point where he almost caused the Notary da Vinci an apoplexy. Surely these assignments were stupendous recognition for so young a sculptor who did not even keep a bottega.

But, with all his pride, Lodovico was concerned:

"Michele mio, don't you think you may be over-reaching yourself?"

"How? Over-reaching myself?"

"Well, you have not completed—indeed, not really begun—the Sienese Cardinal's commission. Fifteen figures in three years. Surely that is a herculean enough task. And now this Giant—"

"But you yourself urged me to—"

"Yes. Yes." Ser Lodovico waved the indignant rejoinder off. "Yes, I know. But I assumed you would employ assistants as is the custom. Now I see you wish to do everything alone."

"I need no assistants."

"Figlio mio, surely you should complete one undertaking before embarking on another. You pledged your word. More important, you have signed your name. The name of Buonarroti di Simone."

Ser Lodovico was disturbed by what he sensed was his son's casual air toward contractual obligations. Had he not agreed to a stipulation in the Piccolomini contract that he would undertake no other sculptures for three years? Yet two months later, he signed

for the David. And once in the embraces of the Giant, Michel had simply lost interest in the Siena figures; he made no more trips to that city, he banged no more on San Francesco's nose. But now, as he listened to his father's homily, Michel realized he could not disengage himself entirely from the Siena responsibility. It was not his word alone that had been pledged; it was his good friend Iacopo Gallo's. He nodded with grudging acquiescence. Father was not altogether a fool.

So he reflected on it for several days and then said to his father: "Messer Lodovico, I have considered your counsel. Here are some careful drawings of all the required saints. Now I am certain I shall find someone capable of executing the work to my satisfaction— and to the satisfaction of the Cardinal."

Lodovico was pleased at this sign of filial respect.

"Bene," he said, twining his beard. "But doesn't the contract stipulate the work must be shaped by your hand?"

Michel flushed. "I am not certain."

"Allora, let's examine the contract, figlio mio."

They examined it together on the great oak table. Diavolo! Old Lodovico was right. There was the damning clause—*fare di sua mano* . . .

So Michel said, after a pause:

"Need the Cardinal know? . . ."

And they eyed each other, father and son, and smacked palms like the farmers in the market, concluding a deal.

Ahi, the cunning of a Florentine! Michel gave his sketches to Il Cronaca and Il Cronaca gave them to a young sculptor named Baccio da Montelupo who thought to try his hand. Michel indifferently agreed. Baccio had been a fellow-student in the Medici Garden. The Cardinal Piccolomini did not expect to see any of the figures for at least two years anyway. So Michel felt free now to devote all of his attention to the David. He knew he was not acting altogether honorably. But he could not help it. He was in the Giant's grip. He had lain in agony between the soft belly of Bacchus and the hard breasts of Madonna. Now he would rise up into the figure of this Giant Boy, heroic shepherd, man of piety and passion.

He had never used a live model. Now for the first time in his life he felt the need for one. Everything resided in the nude, Master da Vinci to the contrary. Let the man from Milan confound honest Florentines with his sublunary smiles and smoky sfumatura and ingenious drapery. He would confound them with a naked body that was God's prime creation. The Prior of Santo Spirito was still

promising to arrange an anatomy. But even more was the living body; he felt the need to observe it more closely than ever before. This Giant must not be fantasy alone but the aggrandizement of a living boy, a marriage in stone of Michel's fantasy and someone's flesh.

And so he employed Andrea the Tailor's Son to pose for him.

He had first seen the lad in the workshop of Piero di Cosimo. Piero was wagging an admonitory paint-stained finger at a blur of sepia the apprentice had just glazed over the corner of a landscape. It was difficult to follow his master's pedagogy since it was uttered through a yellow-white spray of munched egg. Michel saw the boy suddenly turn his face up to the spluttering master and smile with the melancholy radiance of sunshine in mist. He was sixteen and beautiful, with downy upper lip, long lion-colored hair, and extraordinary violet eyes. His expression was usually ingenuous but sometimes the large mouth was capable of smiling in a rather bold way, almost cynical. He was Piero's favorite apprentice; the Master thought that if his talent continued to grow as it had these last two years, all the artists in Fiorenza had better look to their laurels.

Meanwhile, whoever saw the beauty of Andrea the Tailor's Son was eager to use him as a model. He moved with music which was all the more remarkable considering that he was situated at that awkward age between boyhood and manhood, when limbs are coltishly too long, and hands and feet laughably large. But though his torso was still that of a stripling while the rest of him had already reached man's estate, he bore himself with remarkable grace; his adolescent chest was brown and flat-rippled with a sweet-scaled ladder of muscle above the ribs, and his thighs, though outsized, were firm-fleshed and scratched with mementos of calcio and berry-picking. The hair on his pubis was ringleted and a shade darker than the hair on his head. Usually silent, his manner was to indicate his discomfort at holding a pose by commencing to chatter about his current girl. He also knew some rather salacious gossip about various artists for whom he had posed: a stream astonishingly contaminated, Michel thought, to bubble from those pure-seeming lips.

Someone was knocking on the door of the shed. Michel always kept this bolted. A boy smiled in the doorway. It was Andrea.

"Scusi," he said. "My father asked me to deliver a new cape to the Palazzo della Stufa? You know the—?"

"Never mind," Michel said gruffly. "There's not much daylight left." He looked up swiftly at the square blue space. A bird darted across it, stroke of a pen.

The boy stripped, took his accustomed position.

"No. I want to try another today."

Michel walked over to him, took Andrea's left arm and lifted it to his shoulder in the position another Andrea had taken long ago. "And the right hand here, you see. Alongside this thigh." Inadvertently he touched the boy's flesh. Andrea glanced swiftly at him. "As if you were dangling a sling, you see? Now tilt your head more to the left. A bit more. That's it. Now don't move."

"It's a strain," Andrea said.

"Never mind the strain. Just hold it till I tell you to move."

He sketched the figure silently for several moments. Then with pliant palpating movements he began to shape the black wax around the wire armature. For almost an hour he worked thus on the eighteen-inch figurine, trying to capture in that tiny human form the grace of the boy before his eyes and the grandeur of the boy imprisoned within the block.

"I'm tired, Master."

"Rest a moment."

The sky was lacy with sunset. Andrea's body seemed softer, suffused in the pink glow.

"Let's try it again," Michel said.

Professionally, Andrea took the required pose. Michel decided to forego the wax. He had prepared the other model primarily to study the head, hence he had not bothered to put arms on it. Now he wanted to capture the pose of the body. Better to do several more sketches. There was a subtlety in the boy's gesture now that could best be caught with the pen. For was not the pen feather of a bird: swift, swallow-swift? Later he could make the necessary modifications in the model. As his quill flew over the paper, Michel's eyes rose and fell from the gracious young figure beside the block and the figure growing beneath his pen. He felt as he always did when he was drawing—that he was touching what he drew, his quill was his own hand, prodding and caressing, exploring the secret hollows and curves of this exquisite body.

Michel frowned. Once more Andrea had slipped from the held pose. The hand twisted in front of the left shoulder had dropped absently to his smooth chest.

Curtly Michel called: "Figliuolo mio, put your hand back."

But Andrea was distractedly watching a brilliant moth that had fluttered into the enclosure and now was banging against the marble block. With a sigh Michel rose and took the boy's hand to correct the pose. Suddenly he was trembling. The boy's naked

flesh smelled of sun and fields. A terrible impulse seized him. Andrea read it in his face: his violet eyes darkened, he dropped his arms.

"Never mind, it's getting dark anyway," Michel said loudly. He gave him several scudi. Then, as the boy was drawing on his long white breeches, Michel flung a cloak over his shoulders. "Wrap yourself well, figliuolo. It's getting cold . . . No . . . not tomorrow . . . Perhaps Friday . . . I don't know . . . I shall inform you at Piero's . .

"Addio, Maestro."

"Addio, Andrea . . . bello."

V

"Are you content where we have hung it?" He pointed up.

The Prior was still fat but age had crept into his sheath and his good nature had a touch of mortality about it now. He was garrulous.

"Behind the altar, there . . . a handsome place, vero? You'd think another crucifix in the church would pass unnoticed but it's not so. Our worshippers take inventory every time they enter. You'd imagine that in the ecstasy of devotion they'd be oblivious . . . but they pray with one eye open as a dog sleeps. If there's a new chasuble, of if a piece of mosaic is missing from the table, or if the flavor of the incense has been changed, you may be sure that someone will remark about it. I've been asked a hundred times 'And who made that new wooden crucifix?' and so I've spread your name, young master Michelangiolo, all through this quarter . . . You are content then? I'm pleased. Well, stay a while and see our church. A limpid lovely separation of space, is it not? Come here, just inside the central door . . . Tok, tok, tok, column after column, and the cool swoops of arches, like swallow dips. Ah, but Master Brunelleschi knew how to carve space! He molded air the way you sculptors mold clay . . . What? *That* kind of carving? I fear it will be difficult. You see, the plagues have ceased, grazie a

Dio, and there are few crimes under this admirable government of Messer Soderini. So how can we make an anatomy if there are no bodies? You might ask the Master Lionardo . . . I understand he wields the knife with great skill, but where he secures his bodies and performs his dissections I do not know. I have never been invited . . ."

They were crossing the central nave in front of the main altar. Without ceasing to talk, Fra Niccolò knelt swiftly and rose, like a fisherman's cork bobbing in a wave.

"I've asked to attend . . . Every artist and physician in Fiorenza knows my interest in these experiments, but never a word from him. Have you heard the rumor? No, not that . . . Do they say *that* too? . . . No, I mean where he secures his bodies . . . ?" His voice dropped, he crossed himself. "Perhaps from the Evil One himself. He is said to be on very good terms with the Devil . . . No, not that way. Through this door. Ah, you stop. Do you think our Last Supper has faded on the wall? The sacristy is just a sacristy, alas. Remember those marvelous anatomies of the Maestro del Medigo? I am told he was a Hebrew. Do you believe it? And yet the Magnificent called him friend. Where is he now? Ah, his son you say . . . at Rome? . . . I don't recall the young man at all . . . I didn't even know the Maestro had a son. How he could lay bare the muscles . . . bello! bello! . . . Well, come again, Michele mio . . . You wish to make an offering? . . . But your offering hangs there . . . Oh well, if you insist . . . Dominus vobiscum, figliuolo . . .

VI

In the mocking eyes of the Secretary of the Second Chancery, the Gonfaloniere of Justice, Pietro Soderini was a foolish man, if not a child. Publicly, Machiavelli always praised him; privately, he laughed. The Secretary, whose political reports to the Signory were rigorous as steel, had a lighter side. He liked—most conveniently

when on foreign missions—to dally with ladies not his wife, and he wrote verses of no great literary merit but of considerable, if often obscene wit. He was showing one of these—an anticipatory epitaph —to his great friend, Biagio Buonaccorsi, an assistant in the Chancery, and since the joke was at the expense of their superior, they both had a good laugh over it. Of Soderini, Machiavelli had written:

> *La notte che morì Pier Soderini,*
> *L'alma n'andò dell'inferno alla bocca;*
> *E Pluto le gridò: anima sciocca,*
> *Che inferno? va nel limbo de' bambini.*

> *The night Pier Soderini died,*
> *His soul fled to the mouth of Hell;*
> *"O silly spirit!" Pluto cried.*
> *"Hell's not for babes. In Limbo dwell."*

The wit, like so much wit, was unjust. Soderini was neither a silly spirit nor a child. He was keeping the Republic afloat in a stormy sea: and if the siege against Pisa was still unresolved, and if the Fox still snarled at the frontiers of Tuscany, and if the balance between French, Spaniard, Venetian and Pope was constantly upset, the fault was surely not his. Soderini steered his way through the misfortunes of the time with an admirable lack of hysteria; the Florentine Republic could not have had a better captain at the helm.

He was certainly no fool; he simply possessed too diffused a fund of common sense, and that was irritating to those whose uncommon sense in one direction left them devoid of almost any sense at all in every other direction. The artists laughed at his burgher want of taste; the captains sneered at his ignorance of warfare; the wits said he was witless; and Ser Niccolò mocked at his political naïveté. Yet under Soderini's dispensation, the best artists had flocked to Fiorenza to receive commissions from the Signoria; the wittiest wits were at work; the most worthy captains were in the field; and Machiavelli had been appointed Secretary of the Second Chancery.

Thus is common sense usually rewarded.

On this gray November day, Soderini had need of all his good nature and common sense. He was sitting behind his oaken desk in the Municipal office facing a very angry deputation from one of the city's leading families. A heavyset man in a fur-lined dark brown doublet was pointing his finger straight as a pistol at the Gonfaloniere's mild gray eyes. The finger-firing gentleman, whose face was as

red as Soderini's robe of office, was flanked by two wailing women, his wife and his daughter-in-law.

"A scandal, Messere! A monstrous offense against every precept of Holy Church. Worse than a scandal! A crime! By all the Saints! If the authorities do not punish this villain suitably, here is the hand that will!" The elderly gentleman agitatedly shook his fist. "Send him to the Bargello and let him suffer what he has inflicted upon others. Disembowel him, I say!"

"And what good, prego, will that achieve?" Soderini asked mildly. He glanced out of the tall windows at the swaying point of a cypress. Around the corner, the lions roared.

"To dissect a Christian! My own son—!"

The ladies burst into fresh agonized wails.

"—as if he were a criminal or a Jew!"

"But, Ser Corsini, I am assured that Master Michelangiolo did not know the identity of the—of the—deceased."

"The deceased was my son!"

"I know that. Everyone in the City knows it now. Unfortunately, at the time the anatomy was arranged nobody was acquainted with the remains—"

"Remains! You go too far, Messere!"

"Deceased. The deceased. I have made a thorough inquiry into the matter," Soderini said with a soft placating wave of the hand. "The gathering was arranged entirely by Fra Niccolò da Fiorenza, Prior of Santo Spirito, who seems to take peculiar pleasure in these experiments. I've already spoken to Fra Niccolò—and to his Abbot too, I may say—and it's all been a ghastly error. The good friar was in tears. He said he had long been promising young Buonarroti—"

"Who?"

"Buonarroti . . . Master Michelangiolo, the sculptor."

"Yes, that is the one!—"

"—to arrange an anatomy for the benefit of his art—and that he was under a special obligation to do this inasmuch as Master Michelangiolo had carved a fine wooden crucifix for him, gratis. Just how Fra Niccolò came by the—uh—deceased is still not clear. There seems to have been an unfortunate mix-up. The men of the Misericordia who brought it in said it was the—forgive me—remains of a Jew stabbed in a quarrel over usury. At any rate, Fra Niccolò was friendly with the grave-digger at the Misericordia, and when he heard there was a—uh—a body that might be dissected without incurring church ban, he had it swiftly transported at night. So you see, my dear Messer Corsini, if it is revenge you are after, I would suggest

you discover who circulated the false rumor at the Misericordia.
Perhaps your son had enemies?"

"None!" the women wailed.

"My husband was an angel!"

"How could anyone hate my son?"

"Of course he had enemies," Messer Corsini said, ignoring the
female outburst. "Who does not?"

Soderini shrugged his shoulders. The man was showing signs of
reason: "Well, then, reflect that it might all have been a scheme in
which the Prior and Master Michelangiolo were unwittingly involved
—in a sense, were victims—quite as much as you."

"I beg your pardon, Ser Soderini! I never wielded the knife on a
Christian corpse."

"And I tell you for the tenth time, Master Michelangiolo was
unaware of the fact that it was a Christian corpse. I know the
young man, and I assure you he was only interested in improving
his art."

The finger shot out again, quivering with rage.

"Improving his art! Improving his art! You speak as if you were in
league with that band of Turks!"

"Calma, Ser Corsini! I am in league with nothing and nobody
but the best interests of our country. If anything might be achieved
by punishing the Prior or Master Michelangiolo, I would not hesi-
tate a moment. But would that bring your son back to life? An
error has been committed. But consider that your son himself
might approve of this accident whereby his own body served to
better the very art he loved. Loved so much, I am told, that on his
dying bed he refused to kiss the crucifix that had been brought to
him because it was so poorly carved, and waited to die until they
had brought him another. Surely so noble a man would understand
and forgive and perhaps even approve the use that was made of
his flesh . . ."

He had delivered this speech in ever sharper tones, his body
stiffening in the chair, his authority manifesting itself with every
sentence.

Now he rose. The interview was over.

"Ladies," he said, turning directly to the weeping women for the
first time. "No expression of my regret can mitigate your sorrow. I
can assure you, however—if that will prove of any comfort—that
there will be no more of these experiments. It's possible that being
in the same guild with the physicians has instilled this strange
passion for anatomizing amongst our stonecutters and daubers.

I shall communicate with the guild . . . Meanwhile, have you given thought to the tomb? . . . Sansovino is said to carve exquisite ones . . ."

So gently, firmly, he urged them out the door.

VII

Narro's announcement that he would marry the girl from Settignano came as no surprise. He stated his intention calmly at the dinner table one evening on the fifth of March, and since tomorrow was Michel's twenty-seventh birthday, the Buonarrotis celebrated by breaking out two extra flagons of Chianti. They all knew Barta and liked her. If Lodovico was not quite as enthusiastic as his sons, it was only because he knew that although Barta's family—tavern-keepers—were richer in ducats than the Buonarrotis, their name possessed no resounding ring of ancestry. His attitude therefore was that as the creditor in the situation, he would have to engage in some rather delicate but firm negotiations on the matter of dowry. But Narro's burly sensuality was hardly likely to win him a truly gentil donna, Ser Lodovico reflected; his third son had not done too badly. Narro was nearing twenty-five and hairy as a bear. He was doing well in the Strozzi shop, and it was indeed time for him to marry.

So in dour and rather heavy Buonarroti style they all celebrated. Only the maid, Marina, could not behave so heavily. She wept into the soup and Lodovico, instead of berating her, slapped her gaily on the buttocks. Gismondo sipped his wine with an inscrutable light in his gray flinty eyes: he knew Barta well, he had watched her for many years, in the fields and in the village. He had dreamt about her. If Narro knew what he had dreamt, he would break a stick over his head.

That evening Ser Lodovico dictated (bestriding the salotto with an important swish as if he were in the Podesteria), and Michel wrote, a letter to Giansimone. Narro said he would tell Fra Lionardo himself tomorrow at the monastery. It was altogether a

happy evening. A new principle was coming into the household; they all felt premonitions of rising beneficent light; the atmosphere was dawn—pink and pearl.

Michel had met the girl the previous summer on one of his weekly expeditions to Settignano. On the goat-path leading to Mona Clara's, a long-stemmed girl was laughing. She was surrounded by a buzz of boys. It was hot; she pulled her sticky blouse away from her body and blew down the décolletage. The boys buzzed. She fanned herself with an oak-leaf. It was a honey-sweet day: the sky pollinated with wisps of cloud. Birds twittered in green-flecked woods. The bee-boys buzzed. Narro was one of these and he was sweating badly. In the hazed heat of the valley below, the campanile stood stiffly by the bulging Dome.

Before her marriage Barta was one of those women who were unable to say "Pleased to meet you" without making it sound like "But when shall we *really* meet, just you and I?"

But after her marriage she changed: she grew stouter, her inconsequential bosom acquired respectable proportions, her earlier air of provocative invitation gave way to one of boisterous fulfillment. Her favorite game now was outrageously flirting with Fra Bartolommeo or whatever other monk Fra Lionardo brought home with him on his occasional visits to the family. Fra Bartolommeo was handsome but impervious. Her favorite victim was poor Fra Pandolfo, a tiny Cappuccino called by everyone Topolino, Little Mouse. He was the only Franciscan Lionardo tolerated—probably because he was so pathetically incapable of replying to the Dominican's animadversions against his order. Fra Pandolfo was wasted as the begging bag he jingled; his bare feet in the sandals were like carrots just pulled out of the ground, he had eyes color of spit and a tremulous pale mouth, the corners of which were always greasy with some evidence of his last meal as if he were reluctant to have done with it. He could not tear his eyes away from Mona Barta's undulant presence. She teased him unmercifully, always managing to brush her breast against him as she passed, or bumping him with her hips, or singing bawdy country stornelli while he gazed at her with a silly stricken expression, playing with his beads. She would seize the rope girdle around his waist and draw him toward her as if he were a tethered goat: "Eh, Frater bello, and where is that miraculous medal you promised? Is that how you keep your holy promises?"

"Domani," burbled Fra Pandolfo.

"Domani è troppo tardi," sang Mona Barta. "Tomorrow is too late." She extracted from the song every latent double meaning,

tugging the tiny Franciscan around the kitchen by the rope girdle, and when she let it go, he tottered and almost fell. All the Buonarrotis laughed, even Fra Lionardo. Barta was pious, he knew, she never missed Mass; and besides, Capuchins were everybody's butts.

In addition to this game, Narro's wife liked to cook, and bully the entire household. Even Ser Lodovico took this in good grace; it was plain that his bumbling objections were not to be taken seriously.

Michel loved her. Indeed, he felt now that his love for Narro had doubled. Whenever he felt knotted, whenever the giant boy proved too stony and the living boy too fleshly, and he came home, shoulders aching, forehead more deeply ridged with lines, his tiny beard flecked with white dust like a baker, and growled irritably, at bay with a reluctant vision, Barta would slap him on the backside and shout: "*Calma e a letto!*" Calm and to bed!—that was her philosophy. She cried as easily as she laughed; the sight of any suffering creature released the fountains of her eyes but after the first passionate gush, she acted promptly to relieve the suffering. Kittens, lambs, chickens, a runny-nosed child, or a melancholy young sculptor—one of the most famous in all Italy—it didn't matter to Barta: she pressed them all to her bosom.

When Narro announced, less than a month after their marriage, that Mona Barta was pregnant, it seemed too natural an occurrence to warrant any comment. She had seemed somewhat round at the altar and as the days passed and she grew rounder, her laughter and her burle filled the household with a delightful sound. It was as if a brook had commenced to run through an arid land. Even Marina, the old housekeeper who might have been expected to resent this displacement of her hitherto exclusive female sovereignty among the Buonarrotis, accepted her new mistress with more than good grace. Marina was getting old anyway; she was grateful to surrender the grill. And Barta made it easy—as she made everything easy—so that the old housekeeper thought of it less as an abdication than a succession, natural as the shedding of leaves. Barta possessed above all this gift of bestowing the benison of naturalness upon any event.

To Michel, the maker, comment was always supererogatory. He loved Barta especially because she was one of those rare persons who did not "understand"; she *knew*.

VIII

The Giant had become his passion.

All through the fall days when the wild west wind whirled the dry leaves along the river bank, and through the blistering Florence winter, and into balmy spring, he hammered blows against the block. He lived in two worlds: the shed which Simone had built for him, and the world of his family, his friends, his city. But he was truly alive only within the shed: everything else was but a waiting or a resting.

He permitted no one to enter. Once when he forgot to lock the door Narro came in unannounced and Michel flew into a rage. He would not be surprised at such an intimacy. Fellow-artists asked to be admitted—but only Il Cronaca succeeded in catching a glimpse of the Giant. Michel could not very well lock his door against the man who had built it. Besides, Simone had to stretch an awning over the shed for the winter months. Michel's hands turned blue with the chisel. Closed in now, the block seemed more immense, though great gashes of it had been smashed away and the shepherd boy was partially revealed.

So swift had been his progress once he began the actual cutting, that by February, less than five months after he had begun, he permitted the Gonfaloniere to take a look, and Soderini was so pleased that he arranged to have Michelangiolo paid the full balance of his contract, four hundred golden florins. Michel found the mild sensible man the easiest patron he had ever had. He did not feel in his presence that resentful uneasiness he had felt when dealing with red-robed prelates at Rome or even with Messer Iacopo Gallo. For Gallo's very interest in the art, his desire to be present at the making, was in itself an intrusion. But Soderini took the view that the artist would reveal his work in his own good time. He never asked to enter the shed again.

When the Gonfaloniere told Michel of the scandal stirred up by his dissection, he was deeply concerned and offered to go at once to Ser Corsini and proffer his sympathy. What other restitution could he make? But Soderini vetoed his offer. "No need to stir sleeping dogs," he said. "The corpse—whatever was left—was given Christian burial. And there's a fine tomb already under way . . ."

But there were no more anatomies for Michel. He had no time

for dead bodies. He had no time for living ones either. Andrea the Tailor's Son no longer posed for him. After the initial sketches and the two wax models, Michel had no need for the boy. He felt relieved indeed that he saw the beautiful youth now only on the occasions when he attended a gathering of the Guild or visited Piero di Cosimo's studio. It was better so. Andrea had stirred up the devil in him.

That very night, Michel had wrestled with the demon and vanquished him. He dreamt he was naked in the Colosseum under a fiery sky. A butterfly was fluttering around his head, occasionally striking his brow with a soft ticking kiss. From the dark arches he heard a hissing sound and turned. A tiger was creeping toward him, smiling, undulant, then the tiger was a ram with serpentine horns. The ram butted; he felt a sharp stab in his side and awoke. Tremblingly, he tossed the night hours away, and finally rose and lit a candle and idly tried to sketch the ram's head he had seen.

But for days afterward he could not work at all and the sight of his own face in the mirror was an abomination.

Michel was forging his own irons now at a smithy just outside the gate of San Pier Gattolini, next door to the mill where Gismondo worked. Gazing into the glowing red embers at the blacksmith's shop, striking sparks from the points of augers and chisels of his own design, Michel felt that he was forging the weapons by which alone he could slay his devil. By his art alone must he conquer. By his art alone—mistress, tyrant, comforter, garzone. He hastened back to his shed, to the beautiful Giant whitely birthing from its marble matrix. He worked hard and long and to such good effect that he was able to jest with Barta about their respective pregnancies:

"The figure you made by night, I make by day . . . But mine is superior."

"Perchè?"

"Because yours grows by addition but mine by subtraction."

"Eh!" Her head cocked, fox-bright. "And why is that superior?"

"Because I need no midwives and no husband, being myself mother, midwife and husband. And what I make shall always remain beautiful but yours shall dwindle with age and finally pass away."

"Via!" she laughed, stabbing a finger like a lance at his chest. "You are a fool! This one live finger is worth a ton of your dead stone."

He did not dispute with her. Her belly was round as the watery globe. *That* refuted all reasoning.

When his work went poorly, Barta's hymn to life seemed a denigration of his art. Any face on the street—even the incredibly ugly face of Cecco, the watchman at Porta Santa Croce, renowned all over Fiorenza for the hairs sticking from his nose, and for his ears like cabbages and his mottled complexion like a worn-out patched jerkin—even this phenomenon of ugliness, merely by possessing life, reduced all art to nothingness. Then the terrible headaches came and he lay for hours on a straw pallet he had brought into the shed and gazed at the striped awning, bellied in the winter wind like the sails of a galleon.

But when his work went well, he could smile with quiet assurance at Barta. For what was her loveliness but dew upon the rose? *Di doman non c'è certezza.* And to seize momentary pleasure as the Magnificent had sung—Was that the anodyne to this pain of transcience? this awareness of death-in-life? The Magnificent himself was gone and all that remained of him was the funeral mask Michel had seen in a pious visit to the now municipally owned (and looted) Medici Palace. Over the mask were three initials: PPP—*Plato Pater Philosophae.* Afterward, walking down the Via Larga, Michel thought he saw the skull in every face, the skeleton in every shapely damozel. Flesh was dew.

He hammered blows at the stone. That was not dew. It was hard as Truth. The shape he endowed upon it would not crumble tomorrow. Of this *domani* there would be a certain *certezza.* Let rain rain and wind blow, his David would stand perpetual guard at the Palace door. He would show him at the brink of action. He would quiver with life as Barta quivered, he would be as sweetly shaped as Andrea the Tailor's Son, and his face would brood with the sad beauty of Andrea the Hebrew. Slayer forever about to slay, actor who never acted . . . knitted brows . . . A furious glance that would strike everyone with terror . . . But the terribilità would be suffused with melancholy . . .

He saw him, he saw him! The mallet smashed, pale blue veins of stone flesh leaped into view; it was almost like the anatomy he had made upon poor Corsini.

Day after day, week after week, month after month he smashed and chipped at the block. Spring came—merloned towers against a pastel sky. The ring of his chisels against the stone was sweeter than the birds of May. The inner figure was more than three-quar-

ters revealed. He was stripping it of its mineral cape, bidding it step forth. Nude bodies and movement—was not everything else a sham?

Whenever he saw the work of his contemporaries he had to bite his tongue. Francesco Granacci's banners and Perugino's golden light and Master Sandro's Madonnas bejeweled as for a ball and all these marigolds and gilded filigree of cypresses— Trivia! Trivia!

Only one master in all Fiorenza troubled his assumption of supe- riority. Again and again Michel went back to the chapel of the Servites to look at that magical cartoon of the Virgin and Saint Anne. He could not deny the power of da Vinci's drawing despite what he thought was an excessive treatment of landscape. But what was landscape? What was nature without Man? For, how could the artist—who dealt in appearances and not directly in essences as did the philosophers—how could the artist present the essence of Man except in his nakedness?

One afternoon Andrea climbed with him to Settignano. Mona Clara fussed over the boy; she made him eat a bowl of boiled fag- gioli; she urged him to be obedient to Michel in every way.

"But I do not work for him," Andrea protested with a smile.

"Isn't the young man your assistant?" Mona Clara asked Michel.

"Cast me in the Arno!" Andrea exclaimed. "Assistant to Master Michel! He keeps no bottega."

At dusk they sat outside and greeted the returning stonecutters. Andrea had an appointment; he returned to the city alone. Michel remained until the sky blued. Below, Fiorenza was a cast of spark- lings under a sky sparkling with stars and all about him fireflies. He drained his final cup of wine and kissed Mona Clara's leathery cheek.

"Mind the path down," she called. "It's dark and rocky, fit only for a goat."

Ahi, but he looked like a goat! His projecting ears, his tiny beard, his little yellow-gray eyes. How beautiful the boy had been in the rouge of sunset. The leaping jugular as he turned his head. And be- hind him Monte Morello, a violet breast. Whenever Michel gazed at the circumambient hills now, he saw in every promontory pro- jections of faces, bossy flanks, hillocks that were breasts and swollen bellies.

The round earth was an anatomy; he would dissect it out.

Barta was coming upon her time.

At Ponte a Mensola the woods beckoned. A full moon had risen, dimming her cortege of stars. He passed an olive grove. He was

alone, far from any habitation. The air was warm. Below, the river glimmered snakily.

He stepped into the grove and stripped himself naked. He hung his clothes on the gnarled branch of an olive tree and stretched forth his arms to the moon. David was coming upon his time. Through the black shimmering lace of leaves, the moon hung, full-breasted. A cypress whispered, he felt the wind licking at his belly, the soil harsh under his feet. He was bathed in space, light as an angel. The nude was all; even the earth, the very shape and feel of it made more sense to his unshod heel, the touch of a twig upon his arm was a just reminder of kinship, his long toes clasped the pebbles with prehensile fraternity.

He sat on a dry rock still warm with daylight sun. He must have dozed there, his mind filled with the hushed wonder of the night, and confused thoughts of the burgeoning of his brother's wife, the figure he was shaping, the boy who had posed for it.

He awoke. A fragrant breeze was kissing his flesh. Wanton gentle lips . . .

But there was no Eve.

In his loneliness he loved the empty air, embraced a vision. She was beautiful in her absence, unbesmirched by reality.

But always these ethereal couplings left him with a terrible sense of sadness.

And self-disgust beyond utterance.

IX

Barta's lying-in came with the Calends of December. The house on the Via Bentaccordi was a bustle of feminine voices and rushing figures, all shunting aside the reigning Buonarroti males like useless drones on the porch of a hive. The queen was the moaning figure on the bed, for Mona Barta cried out her labor pains with the regularity and volume of a church bell. Mona Clara had come down from the hills to supervise the parturition, and she crackled orders

with stony authority to the old housekeeper, Marina, and the various girls from the neighborhood who had been enlisted to help. The girls rushed to and fro with pans of hot water and cloths, their skirts flying in their passage. Narro meanwhile talked wool with Lodovico and pretended to be calm. But every time his wife cried out upstairs, Narro turned pale and jumped as if a pin had been stuck into him.

The boy howled into the world at two in the morning. Ten days later as Michel held the tiny swaddled infant over the baptismal font in the ancient octagonal baptistry, he was startled to learn the name that Narro had decided to give his son.

"I want him to be a pious and upright man," Narro said, hands clasped behind his back. "I want him to possess the order and righteousness that Fra Girolamo Savonarola instituted in this city. And so I shall call the babe Lionardo after our brother at San Marco . . . and may it be a good omen!"

X

Francesco Granacci had not told Michel of the order he had received for an altarpiece for the Convent of San Pier Maggiore. For one thing, Francesco, sly like most Florentines, was chary of discussing his business with possible competitors; and for another, he was reluctant to subject his work to Michel's criticism. Francesco had been quick to note the growing acerbity of his friend's judgments; they could indeed be withering, and it was wisest to guard one's blossoms, especially in their tender growing stage, from that blast. So Francesco waited until he had completed the work to the farthest reaches his good honest craftsmanship could go. Then, after it was installed, he invited Michelangiolo to see it.

Francesco was especially cautious because of what he had observed the afternoon he and Michel visited Master Pietro Perugino's bottega. Francesco admired Master Pietro: he had an uncanny gift for making money; he had acquired a beautiful young wife whom he decked out like a princess in jewels and dresses and coif-

fures of his own design; he had a dozen assistants and students; and orders flowed in from all over the peninsula. But Michel sniffed about in the midst of this impressive successful enterprise, scratching his nose, making little snorting sounds as the two young men stopped before partially completed altarpieces, predellas, sword-handle designs, palio flags, guild banners, goldsmith art, portrait miniatures, and heap after heap of tempera paintings on gesso panels. Master Perugino was also beginning to work in oils though he preferred the older techniques. He was a middle-aged, middle-sized man, with a quiet self-sufficient air, shrewd little brown eyes round as coins, a clean-shaven burgher face, a prosperous chin. He didn't seem at all impressed by the famous young sculptor who came to see his work. As for Michel, his only comment after they had left the shop was that the Master Perugino was a "blockhead." He didn't expand on this theme, and Francesco asked no questions.

He was very fond of Michelangiolo even as he saw the rudeness thickening day by day like bark over some inner green tenderness. And Michel was very fond of him. In his growing complexity Francesco was a pure link to a simpler past. His perfumed presence—he still dressed like a fop although he had grown heavier and his hair was already prematurely graying—his frank love of money and ease, his straightforward respect for craft, were easy to understand and comfortable to be with. He was not one with whom one might share the perplexities of existence; he was a better friend than that. His mere presence automatically summoned up lost youth. They spent much time together. Francesco was almost another brother amongst the Buonarrotis. Yet Michel would no more open the door of his shed to him than to Narro.

For quite a while Michel stood in silence before his friend's altarpiece. Francesco had painted a Holy Family in a pleasant greengold light which he had learned from Master Perugino. He had learned that much, Michel reflected. This Holy Family, ingenuous as it was, was certainly an improvement over the horrible boiled-beef angel choirs and levitating Marias that had hitherto issued from his brush. Unimaginative as the composition was, the golden atmosphere lent a certain poetry to it, and these sacred actors—old grizzle-haired Giuseppe and the Madonna and the Bambino and the pointing-fingered baby San Giovanni—they were all certainly real as Tuscan peasants. Over Maria's head floated a fat naïve cloud, pink as a baby's buttocks. Michelangiolo didn't permit Francesco to see his smile.

"Allora, amico mio?"

"I like the light." He bit his lip. He distrusted his own irascible nature. Getting worse lately. Sometimes he felt as if his nerves were all on the outside of his skin, ready to leap at the touch. If he could not say nice things about his friend's work, he preferred to say nothing. And the truth was there were few friends whose work he admired unqualifiedly. Indeed, were there any? So now he scratched away at the bridge of his nose, coughed, and added as graciously as he could: "However, the articulation of that joint is imperfect, caro mio. You cannot disguise it with a spray of color."

"But that is exactly how Master Lionardo drew it in his cartoon," Francesco said ingenuously. "I modeled that section exactly on it."

"Well, I would suggest you study it again," Michel said. His voice had become sharper. He could not deny the mastery of the damned cartoon which every artist in Fiorenza was copying. Had he not copied it himself? And yet was there not something basically wrong in the Milanese's (he persisted in thinking of da Vinci, Florentine as himself, as a Milanese) emphasis on chiaroscuro? Was it not a mere conjuring trick, an illusion, to blur the clean sculpturesque line? to conceal in a haze of magical light and shadow the true hard unalterable shapes of things?

"What would you have done with it?"

Michel showed him. Francesco listened calmly, attentive to his friend's darting pedagogical finger. He realized that today, at any rate, Michel was not venting spleen; his anticipated anxiety about his friend's reaction was dispelled. And since his emotions were seldom involved, Francesco was capable of calmly accepting advice from a greater master as something advantageous to his business. Of course, he was doing well, working always in a leisurely manner, although he already had so many commissions that he was hiring assistants. In his bottega he painted emblems for ships, and for the various orders of knights with their spurs of gold. Granacci's special pleasure was the decoration of cloth banners for pageants and celebrations. Sometimes he painted for his own amusement. Michel, a porcupine, all bristles, found Granacci wonderfully easy to be with; he always avoided discomfort and restraint.

". . . then you see, the elbow would be turned thus, and the foreshortening would be much more severe." He looked at his friend's fine-featured attentive face, the long hair falling over the ears as Granacci leaned forward, listening. Michel put his arm around Francesco's slender shoulder. "But the depth is marvelous,

friend Francesco, truly marvelous. The eye penetrates deep and deep, right to that glowing woody horizon."

"I borrowed that from Master Perugino." Francesco said simply. "You know, the Crucifixion in Santa Maria Maddalena dei Pazzi."

Michel laughed gruffly. Yes, he knew that Crucifixion. It was a good work. Perhaps Perugino's best. At any rate, it was the only thing he'd ever seen of Master Pietro's that didn't look as if the figures had been set in with a stencil. A manufacturer, Michel thought. So many orders to fulfill and so he stamps them out one after the other—a Crucifixion with two female saints or an Ascension with four male saints . . . It didn't matter: they were all the same—the same Madonna with her head tilted at exactly the same degree of inclination, the same bare feet twinkling at the same angles from beneath the robe, the same expression of idiotic bliss on the faces of his male and female saints, eyeballs turned whitely and glassily to heaven, tiny insipid mouths, bodies swaying in a soft dance, ritualistic, symmetrical, and fatuous as the inscribed ribbons and garlands twining in and out among the figures.

Michel laughed. The creator of all this stereotyped piety was a known atheist! And although it was perfectly obvious the man did not believe at all in his interchangeable saints, no one—not even Michel with his indifference to color and to light—could deny the beauty of the golden glow that suffused Pietro's deep-spaced compositions, and the cypresses, refined as a discussion with Marsilio Ficino, filigreed against the far horizon.

And this much, Michel thought now as he looked at his friend's work, Francesco has learned from that blockhead. Diamine! so much to learn, and sometimes so difficult to know from whom to learn it.

But what was the use of skill—even if there were more skill than poor Francesco possessed—when there was no brain to command it? A learned fist and an empty brain. It was like a mule in the shafts without a driver in the cart.

But he spoke none of this to his friend. Michel knew what he had to do, but he had no desire to teach others.

Was marble ever as obdurate as another man's skull?

"La man che ubbidisce all'intelletto" . . . He had idly scrawled it over the face of one of his drawings, shortly after he saw Francesco's altarpiece. There were many learned fists in this city of artists—but how many hands that obeyed the intellect?

He was contemplating David's right hand. The head and torso of his Giant were fully clear of the block now, though still rough; the arms were almost completed; only between the inverted V of his legs did much of the original stone remain.

Michel was sitting cross-legged on the scaffold contemplating the Giant's hand. Enormous, half-opened like a lily, it rested lightly against what would be the polished thigh, but which was now a triangle of crude marble. The hand was almost three times life size. Even in proportion to this Goliath of a David (Michel smiled), it seemed excessive. True, Andrea del Sarto's hand was also outsize in relation to his stripling body—but magnified to this scale, the disproportion was grotesque.

And yet it was not grotesque. It was not a hand. It was the Hand.

The ridged knuckles were the knobs of God's hills, the lines of the joints were the dried bed of the Arno in August when the muddy bottom cracked in the burning sun, the pads of the huge fingers were the footfalls of antediluvian behemoths. Into that Hand Michel had molded every hand he had ever known: his own with its short spatula fingers, blunt and broken-nailed and powerful; and the hand of Lodovico with high blue veins and hairy as a bear to the knuckles; and the hand of Barta that was a tool for seizing life, a plump hand yet strong and firm and pink as a cow's nipples; and Mona Clara's hand, brown and gnarled and dry as a twig but with green leaves in its doing, and strong with half-moons in the nails like Settignano's sickle moon.

And Bianca Balducci's hand, he remembered, tinkling on the lute and the banker Gallo's sensitive antenna fingers playing over the back of the Ganymede on his desk, and the long tapering hands of the Cardinal di San Giorgio, beringed with an onyx on the first finger and a ruby on the second so that he made a flashing in the air as he gestured with affectionate proprietorship toward the statues in his collection. And there were the hands of that Hebrew, Barto-

lomeo—which had been chopped off—and the trembling hands of Andrea afterward. And the Maestro del Medigo's hand emerging from the mystery of the viscera and holding aloft, in precise bloody fingers, the glistening kidneys, *viscus elegantissimum* . . .

Oh, there were so many hands—the quick and the dead—that white marble hand in the Forum which he had clasped across the centuries . . . and the limp hand of his Redeemer and the pudgy pink wine-soaked hand of his Bacchus.

Compare the calloused pad of the dog, the claw-sheathed foot of the cat, the woody hoof of the horse—how inept, awkward, unmalleable beside this creation. For if any single part of the body distinguished man from the beasts, it was the hand. This was the beautiful tool God had devised so that flesh might obey what intellect willed. What were we without this Hand?—this odd-shaped five-pronged member, capable of seizing, striking, stroking, able to be bundled into a fist that broke noses, hard as a hammer, precise as a pointer, eloquent as a lyre, useful for digging, prodding, exploring, instrument of love, prober of clocks, clasper of sword handles and maces, pincher of clay, puller of church bells, scratcher of bald heads, picker of fleas, maker of Davids.

All humanity was in the Hand. And so when God made Adam he touched him with his finger. Then life was in him.

Cross-legged, Michel sat looking at the hand he had wrought. The Hand of David was not merely "la man che ubbidisce all'intelletto," but the mind made hand itself, expressing itself as hand. One was inseparable from the other. For those giant fingers lightly hefting the wooden handle of the sling were, in their very crook and gesture, the brain itself resolved upon its act. How else could he, as artist, reveal intellect except it be made incarnate in significant postures of the flesh?

He was pleased with his Hand. He was almost more pleased with it than with anything else he had done. The thumb still needed a nick or two; he must use the finest of chisels for that. He looked at the chisel he bore, then leaped catlike off the scaffold, and chose another from a group of eight or ten projecting from a terra-cotta jar. Soon he was at work, not in his usual impetuous way, but carefully, with long pauses between each stroke, tapping ever so gently for fear of cracking the long marble digits.

He was humming vilely through his teeth, his hair powdered with white, when he heard someone knocking at the door of the shed.

"Who is it?"

"Ser Machiavelli, Secretary of the Chancery."

Mallet in air, Michel hesitated. Porcamiseria! He wanted no one in here. But this man was an official of the Signory. Perhaps—?

"I am working," he grumbled. "Could you not return tomorrow?"

"I bring a message from the Gonfaloniere Soderini," the dry voice said. "Shall I tell him that you choose not to accept it—?"

"Dio! . . . Momentino . . ." Michel unlocked the door. Lithely, with a kind of dance movement, the slender Secretary sidled into the white-dusted enclosure. He wore a maroon doublet of simple cut, red stockings, and a soft cap with a quill stuck in it. He glanced coolly and briefly at the Giant and then said:

"Might I suggest, Maestro, that we talk at the Osteria del Povero Diavolo? I am dry as a withered tit . . . and this place is hot. Besides, there's scarcely room for flesh to think with that monstrous chunk of stone . . ."

"What does the Gonfaloniere want of me?" Michel said rudely, ignoring the Secretary's suggestion.

Ser Niccolò eyed him before answering: a gleam of amusement flickered in his keen little cat's-eyes, then his thin lips pursed into a faint smile, and his voice purred—

"Another David."

"Another David!?"

"Sìssignore, another David. Ser Soderini rightly assumes that any man who can make a David of this size should have no difficulty making one, let us say, of normal dimensions."

"I don't understand. I still have much to do to complete this one, as you can see. Does Ser Soderini suggest that I abandon—?"

His voice was becoming edged with acrimony, remembering the procrastinations of the Cardinal di San Giorgio during his first year at Rome. Perbacco! He would not be dangled like that again—

"No! No! No!" Niccolò said. He spoke now with a tact trained in many foreign missions. Ser Niccolò was accustomed to sovereigns who took fire easily, and when he saw the young man flush, he realized at once that he was dealing with a sovereign in his own realm. Even the pettiest, most absurd commissions, he thought wryly, called for diplomacy. "Nothing of the sort," Ser Niccolò said. "You will continue on this work—" He gestured casually toward the Giant "—and make this other—if you agree to do so, of course—as a useful political gift."

"Political gift!"

"Già. And if you will deign to accompany my parched throat to the Povero Diavolo I can explain it all." He smiled smally.

Reluctantly, Michel accompanied the lean Secretary to the inn. Two tin mugs of wine were set before them on the oaken table. Machiavelli lifted his in a silent toast, took a long swallow, then began—

"I assume you are a loyal citizen of our Republic . . . No, don't take fire so . . . I ask only rhetorically. At any rate, as a good citizen you must realize the importance of our French alliance. It is the only thing that keeps Duke Valentino in check. Were it not for fear of King Louis, the Borgia would undoubtedly attempt to add our domains to his conquests in the Romagna."

"What has all this to do with me? I am a sculptor."

"Pazienza, Messer Michelangiolo. Even a sculptor is affected by affairs of state. Unfortunately we cannot avoid—"

"What does the Gonfaloniere want?"

The Secretary chuckled. He snapped his fingers at the white-aproned boy serving the tables. "Garzone! Another mug. Will you join—?"

"I have work to do."

Machiavelli leaned back in his chair and looked at Michel with admiration. "If only our captains were as responsible as you. Allora, to the point then. For the past year we have been receiving a number of letters from our ambassadors at the French court. It seems that on his last visit to our city, Pierre de Rohan, Maréchal de Gié, took a fancy to a David carved by Donatello. I'm not familiar with the piece myself."

"Is it the statue now in the cortile of the Palazzo?"

"Ah, that one? . . ." The Secretary's thin eyebrows were raised in a mocking arc. "At any rate, the Maréchal inquired of our ambassadors if a copy of the work might be made for him. In bronze, life-size like the original, not—" he added hastily "—like your Giant. Our ambassadors felt it would be altogether circumspect to present such a gift to the French Marshal. The Priors would pay for it of course. In ducats, round and large—"

"Does Ser Soderini intend for me to do the work?"

"He suggests it." The Secretary's tone stroked, a furry paw. "You see, when the requests first started coming in from our orators in France, Soderini wrote that there was a dearth of craftsmen capable of doing such a work. Of course, I know nothing of these matters but I saw the letter, since it passed through my chancery. Well now, apparently, your progress on the Giant has convinced our good Gonfaloniere that there is a sculptor here in Fiorenza capable of casting the bronze and thus aiding his country in difficult times.

As I say, I know nothing about the *artistic* side of the affair . . ."

The Secretary was not indulging in his frequent wry game of pretending ignorance. He was indeed purblind to every art except politics. In this city of a hundred workshops—this city of Michelangiolo and da Vinci and Perugino and Botticelli and the San Gallos and Sansovinos and Piero di Cosimo and Filippino Lippi and Lorenzo di Credi—the Secretary of the Chancery saw nothing but the abstract shapes of alliances and the threatening designs of a Cesare Borgia.

". . . that is altogether outside my province. Messer Soderini was certain you would accept the undertaking but he has been loath to interrupt your present work. Hence he has not summoned you to the Palace. When I heard of the matter I felt that we should delay no longer. I know nothing about art but I do know the importance of small gifts of this kind. Sometimes they are useful all out of proportion—"

"It is hardly the function of my art to prove *useful*."

"Davvero?" Ser Niccolò cocked his small head. His movements were swift but yet they always seemed well-considered, the sharp face radiating intelligence. "I can conceive of no more admirable purpose for these chunks of marble and bronze than to strengthen the security of our State. It seems to me that—"

"It seems to me, Ser Niccolò, that you understand your profession better than you understand mine. I am delighted if a work of mine might please the French Marshal and so prove serviceable to my country. But I will not shape this bronze David unless I feel so disposed, and I cannot tell you now whether I feel so disposed. I keep no shop wherein you may enter and order whatever merchandise suits your taste and your purse. The only taste I care to consider is my own. Messer Soderini knows that very well. Does he think now that out of patriotism I shall be obliged to set aside my work on the Giant?"

"Not unless you care to," said Machiavelli placatingly. Diavolo! he thought, he's touchier than the King of France. "Our ambassadors write that the French Maréchal is quite willing to wait for his David . . . provided only we assure him it has been commissioned."

"Ah . . ." Michel nodded his head thoughtfully. "In that case let me consider it for a while."

"I beg you consider it carefully. But time is not unlimited. I depart soon on a crucial mission and I should like before my departure to be able to frame a favorable reply to our ambassadors."

The Secretary was scheduled to go to Cesare Borgia's camp at

Imola in the hope that he might give assurances of peace and friendship to the terrible Duke, and thereby deflect him away from Tuscan domains.

"I shall consider it."

"Surely you won't reject the commission out of hand simply because it might be *useful?*" the Secretary said with an ironic smile. Then, regarding the bunched frowning face, he pursued his argument. "You are undoubtedly acquainted with Master Lionardo da Vinci? For many years he served Duke Lodovico of Milan. Now he has entered the employment of the Duke Valentino. You see, artists may also prove—"

Michel made a scoffing sound.

"And if his talents aid an enemy of his country, that doesn't matter?"

"Well, his own country failed to take sufficient advantage of his talents. I cannot find it within myself to criticize him for it."

The Secretary had met Lionardo several times in connection with a scheme for deflecting the course of the Arno from before Pisa, and thus making it impossible for the besieged city to receive supplies by river. He looked forward to meeting him again at Cesare's camp. Ser Niccolò had gotten along very well with the older master. He was an artist, yes, but not at all like this cantankerous young man with the bristly beard and bristly manners. The fact that Master Lionardo was now serving Borgia as military engineer and that he had offered his services after having been home less than a year following eighteen years at Milano, and that the Duke was an enemy of Fiorenza—none of this troubled Machiavelli any more than it had troubled the serene flowing-bearded philosopher. It was precisely this abstract aloofness from commonplace loyalties and burgher morality that had made the Secretary and the engineer resonate so well on the few occasions they had met. Machiavelli's icy shield undoubtedly concealed a more passionate man: with all his cynicism he loved his country and indeed his secret dream was to unite all of Italy against the foreign invaders who were ravaging her from snowy head to sunburnt toe. But like Master Lionardo his prime loyalty was to an abstract realm of truth in which domain each man considered himself sovereign and subject.

"Then I might expect a reply within the week?"

Michel nodded. He left the Secretary on the terrace, ordering a third mug of wine. Ser Niccolò thought swiftly and furiously, but he was fond of his comforts and in no hurry to return to the stacked-up documents of his Chancery.

Back in the shed for the rest of that afternoon Michel worked with a new zest. His head was filled with David thoughts. And although Ser Niccolò would not have known it, Michel was flattered by Soderini's new request, nor did he entirely discount the importance of the work.

And so in three days he sent an affirmative reply to the Palace of the Priors. In Ferragosto when Narro and the others sought refuge in the cool family farm up in the hills, Michel continued to work through the heat, shielding his head from the blazing sun with a paper cap. It was then, quite casually while he was boring out the triangle of the Giant's legs, that he signed the contract for the small bronze David—signed it indifferently, almost without thought, although it was impressively drawn up in Latin between the Lords Priors and 'Michelagnolo Ludovici Bonaroti de Florentia.' The new work was to stand two and a quarter braccia high and Michel was promised fifty large golden florins.

But when he signed the contract, his third in the little more than a year since his return, Ser Lodovico again remonstrated. By the Holy Rood, did Michel think he was an Atlas? How much would he take upon those sturdy shoulders? He had sloughed off one obligation in order to devote himself to this Giant, and now when the Giant is not even all carved out he agrees to cast a new piece in bronze!

Lodovico did not like it. An arroganza. The Siena contract should first be fulfilled. It was only in abeyance; once this Giant was completed, you might be sure that some one or other of the Piccolomini would exact its fulfillment. Michel was at fault. He must recognize legal obligations and human limitations.

At which his son flared. The mere suggestion of limitations set him afire. The pains in his side had vanished since he came home. He had fewer headaches. It was the clear air of his native city, the pure oil. What limitations!? He could do anything. Carve mountains. Anything he chose— At his present rate the Giant would be completed perhaps in six months. Meanwhile the Marshal could wait. And did Lodovico perchance object to banking fifty more large golden florins of which Michel was pledged part payment as soon as he gave evidence of merely planning the work?

So Lodovico acquiesced. His homily was mumbled to himself. With hands pensively linked behind him, he wheezingly climbed upstairs to Narro's apartment. It was the hour of nones and Donna Barta was about to give suck to his grandson. He liked to watch the young woman unlace her bodice, he liked to see the eager leaping

of her breast, and the assured grace with which Donna Barta made the nipple stand between her first and second fingers and introduced it into the baby's mouth. Then, as the infant gurgled, a pensive expression would cross his daughter-in-law's face and she would demurely cover her bosom with a scarf. It was a sight that always gave great pleasure to Lodovico. In the lee of that life-giving mound, he liked to tickle baby Lionardo's bare foot.

When tramontana began to howl down from Fiesole, Simone of the Fowlers, Il Cronaca, came once again to install the awning. He was amazed at what he saw. The upper part of the Giant was almost entirely detached from the block. Perched atop the scaffolding, fourteen feet from the ground, Michel was working on the fierce frowning face, his own face frowning and white as the statue.

But he had done nothing except a few sketches for the bronze, and in the dreary Christmas drizzle the permanent Gonfaloniere was dictating a letter to his embarrassed ambassador at the French court:

"Every day we inquire about the statue for the Maréchal de Gié and we've already paid most of the money. But as you know, in matters of painting and sculpture, one can hardly make any definite promises . . ."

Poor Soderini was having his troubles. The Secretary's mission to the Borgia had provided Ser Niccolò with some harsh maxims about foxes and lions but hardly any tangible benefits to the state. It was irritating, reflected Ser Soderini—that uncommon-sensical man who believed only in promising within his grasp—it was irritating to have to wait upon the vagaries of this talented stonecutter who seemed indeed to have gotten an excess of gravel into his voice of late. An abrasive man, Messer Michelangiolo, not easily to be smoothed.

The abrasive man was smoothing the Hand. He was polishing the joints gently with a pumice stone. Now and again he wet the area with a sponge dipped in a pail of water. Agile as a monkey, he leaped off the scaffold and stepped back, tripping over a jar of irons. He cursed and rubbed his bruised ankle, surveying what next to attack. The Hand was completed and so was the frowning fierce small head with its tousled mass of ringlets. And most of the torso too was carved out although he had not yet polished it. That hand holding the sling on the shoulder needed a cut or two. But the bulk that remained was to drill away the last triangle of stone between the legs, and to round out the giant thighs and the sex that hung

like plums between them and to make more elastic the tensions of groin and buttock and then to get at the great feet.

Oh yes, he had plenty to do, but already he felt the task was done. He had been working on David for almost sixteen months; for almost sixteen months, here in this enclosure, he had dreamt and sweated and seen skies modulate from autumn blue to winter gray until Il Cronaca came for the first time and put up the striped awning that billowed and flapped in February rains. And then it was spring again and the awning was down and day after day it was tchpp tchpp and the sky blueing and the Giant growing tchp tchp and autumn pale again and cloud-scudding and Cronaca's flattering amazement and now another spring . . . He sat down, fist-rubbed his eyes, removed the paper cap, shaking its marble dust to the ground. He was weary-happy. Might not the Giant have had a son? A son who slew another Philistine? For there were always Philistines to be slain.

Already the other David, the bronze, was growing in his mind. It must be *another* David, he had decided, not just the copy of Donatello's which the French Marshal wanted. It didn't matter what the French Marshal wanted. Nor was it to be merely a reproduction of this Giant on a smaller scale. He riffled through some sketches he had prepared for the bronze. One in particular pleased him. He had drawn it swiftly one evening, side by side with Lodovico at the oak table—the both of them dipping their quills into the same ink: he for his drawing and his father for his account book— while Narro and Gismondo were playing cards and Barta diapering the baby. He had drawn it in a few minutes in a tangled web of evocative lines, nervous and sure, with no cross-hatching or shading. A David fierce as this Giant and as beautiful, but with an indolence in the pose, for he had already acted whereas the Giant trembled at the brink of action. He contemplated the sketch. Yes. David the conqueror. Goliath's head underfoot. He studied the drawing, thoughtfully scratching his nose.

The light dimmed. Still another hour to sunset. He sighed. He had to knock that last remaining chunk of stone out from between the thighs. Setting the paper cap back on his head, he crossed the shed and took down the sculptor's bow which hung from a hook on the wooden wall. Selecting a drilling auger which he had forged himself, he carefully twisted the tense bowstring around the shaft. He fitted the auger into the last drill-hole on which he had been working and drew the bow back and forth. The auger spun, biting into

the stone in a cloud of pearly dust. David with his sling and I with my bow, Michel thought triumphantly.

Now he had enough drill-holes around the triangle. Seizing a mallet in his left hand for greater strength, he smashed with all his might. With a metallic clang the last bit of placenta-stone gave way, lightning leaped between the legs, the Giant stood free.

XII

For one hundred and seventy-four days—from the twenty-second of February to the twelfth of August, fifteen hundred and three, the Magister Cerimoniarum wrote not a single word in his Diarium. Ach, that blessed interval bounded by deaths, Burchard was thinking now. The Vatican seemed empty; Piccolomini wore the tiara and Roderigo Borgia was dead. It was incredible: Borgia dead, twelve years and four days after he had ascended the throne of Peter, and his son, the Duke, in mortal jeopardy too, his domain crumbling like sand castles hit by the waves.

How swiftly it had all happened and how hard to believe! Pope Alexander dead! Pink-cheeked, fat-jowled, jocund Alexander who had savored of life so much that to deprive him of it seemed more unjust than with most. He had drained life to the lees. Then he had drained the wrong cup.

Ja, the tightening and tightening of events! Like a crossbow being cranked. Burchard remembered it all, notch by notch. The parchment book on the table with its purple velvet covers and brass buckles and studs was nothing to the Diarium of his brain. He forgot nothing; he absorbed like a sponge, but he squeezed only reluctant and reticent spurts upon these pages.

Sinagaglia, the German prelate was thinking now, was the first notch, the beginning of the end. Yet at the time what a triumph it had seemed! What lovely deceit! How beautifully the Duke, patient as a spider, had lured his rebellious captains into the net and then had them strangled back to back. A work of art! The congratulations that flowed in from all over the peninsula!

Burchard had been present at a Carnival masquerade in the Vatican when the great news of Sinagaglia arrived. The Duke's masterstroke had been played on the very day Soderini was writing his embarrassed letter to his ambassadors in France, the very day Cronaca came to put up the awning and was amazed at looming David. And when the news reached Rome it was right in the midst of Carnival, for the Holy Father had decreed festivities to commence earlier this year, at Christmastide, and it was already the sixth day of celebration. A rather amusing masquerade, Burchard recalled, featured by equerries and valets dressed as cardinals wearing long fat priapus noses, who after mock-blessing His Holiness and the apostolic college (how they roared with laughter) rode off on asses to bestow their blessings all over Rome.

When the emissary entered with the news the Pope jigged for joy. Ah, his roaring boy! His exterminating angel! His dragon devouring lesser serpents! And the marvel was that Cesare was doing it all so peacefully. He never fought a battle. He could make money explode. He breached fortresses with bribes. He was conquering all of central Italy with florins instead of firearms. Sometimes, of course—Sinagaglia, for instance—there had to be an assist or two, a necessary expungement by Michelotto his assassin.

The crossbow cranked. Notch by notch. The flight of Cardinal Ippolito at the merest gossip of the Duke's imminent return. Not surprising. Burchard interrupted his meditations to laugh almost silently. But not altogether silently. For he could at last afford to indulge himself in this rasp of glee, this wheeze of jollity. On that occasion he had written: *The Duke hated Ippolito because he was fond of Sancia, Gandia's widow, whom the said Duke had—* Well, there were words in German, Italian, and Spanish, but the Latin said most and least—*whom the said Duke had known carnally (cuam ipse dux cognoscebat carnaliter).*

He must have had a prescience, Burchard mused. How else explain the sudden crude candor of that malicious little notation? It bubbled over with feeling, it simply frothed. Why was he beginning to write like that? He must have known without knowing; he must have been sniffing like a dog at events to come.

So another month went by. The son was exterminating his enemies in the field; the Holy Father was exterminating them at home. A busy winter. Cardinal Orsini found himself in the Castel. Fortune was a bitch. Orsini had helped elect the Borgian Pope.

One afternoon the Magister was present when a young man was granted audience with the Pope. A most beautiful young man with

large glistening eyes and well-turned legs in tight hose. He was pleading for the imprisoned Cardinal . . . a melodious voice . . . low pitched. He reached into the laces of his jerkin and extracted a huge pearl and offered it to the Pontiff. The Magister's ice-eyes melted. The young man was the Cardinal's mistress in disguise. Quid pro quo. A pearl for her lover's freedom. So Alexander took the pearl, graciously, oh graciously, and patted the young man's soft cheeks and blessed him and a few days later the Cardinal was dead. A pity. Fever had taken him off just when it seemed he might be released. His Holiness showed his deep sympathy by ordering forty persons with torches to accompany the corpse to San Silvestro.

And that was when the Master of Ceremonies decided it was time for a vacation. For twelve years, almost uninterruptedly, he had been recording these day-by-day doings in the Vatican, but now he was tired and he was sick and he was getting old and it was time for a rest. His feelings were getting the better of him. In his weariness he found himself writing German instead of Latin in the great book. He could not sleep. The Diarium was an incubus. Cardinals were disappearing at an appalling rate. The Borgia seemed to have a special scent for uncovering Marranos; so that every other day, now, Cesare, as Captain General of the Faith, had to dispatch Michelotto with an armed band to sequester the property of these heretics. They were inevitably rich. Which was not surprising. The Devil rewards his own.

Yes, Burchard had decided when the Cardinal Orsini was laid away, it was time for a rest. Some found it as the Cardinal had, and some as the Lady Lucrezia, now Duchess at Ferrara, safely removed from the whirlpool. But he was ever in the midst of it and he was tired. He could not keep up with this Pope, who for all his seventy-two years glowed with health like a furnace. Now His Holiness was speculating whether he might not name his son King of the Romagna (which he was in all but name) and he questioned his Magister whether the creation of a Borgian monarchy would prove an offense to France. Burchard's answer was such a diplomatic marvel that he had a raging headache for four days.

So he had decided to suspend his cursed Diary. His emotions were becoming too exposed. He had no armor left. He was all vulnerability. So he had broken off with that last brief note on the Cardinal Orsini's obsequies:

Papa commisit socio meo, ut haberet curam funeris defuncti. Ego nolui interesse; nolui enim sapere plusquam oportet.

The Pope entrusted my colleague to take charge of the funeral of

*the defunct. I was unwilling to be involved; I was unwilling to know
more than was necessary.*

A petulant note. But he let it stand. And there it stood, shoring
the blank space in the Diary for the next six months, while Cesare,
masked, attended theatrical performances, or rode in and out of
Rome from his domains, slender and hard and straight in the saddle,
with his piercing jeweled eyes and his beautiful carved nose, and
his hair gathered in a Spanish net and his lips thin as a sword edge
in the small neatly trimmed tawny beard. And although his father
would not risk naming him king, he was truly a regal figure and his
dispatches, which Burchard saw occasionally, were signed: Cesare
Borgia of France, by the grace of God, Duke of the Romagna and
of Valencia and of Urbino, Prince of Andria, Lord of Piombino,
Gonfaloniere and Captain General of the Holy Roman Church.

Six months, in happy truancy, the Magister watched events pass
by without making any effort to ensnare them with his pen. Six
months in which he grew less fretful, like all writers when they have
relieved themselves of the necessity of writing. Six months he
watched, from a cove of blessed silence, as Spanish prefects were
installed in every castle of the ecclesiastical state, as the great pa-
trician families groveled in the dust, as father and son conferred,
mapped plans, nodding their heads together—sometimes even quar-
reling over money—and at their nodding, as by necromancy, old
red hats disappeared and new ones were created.

And then poor Burchard could not maintain his silence any
longer. How could he fail to make mention of the fact that on the
same day in malarial August, father and son had been stricken after
dining in the vineyard of the Cardinal Ascania? The Magister had
been present at that dinner. He had observed, through green algaeic
eyes, the curious passage of the cups, and then the Holy Father and
his son staggering from the table, vomiting, clutching their bellies.
Had they drunk from the wrong cups? Had their wine-taster been
bribed? A curious coincidence. But there was much malignant fever
this month. The Cardinal Romolino had also been at the dinner and
now he too was dead—he whom the Holy Father had sent to Fiorenza
as Commissioner when Savonarola was burned. And two other Car-
dinals present at the dinner had been stricken gravely ill, as well as
Valentino. Perhaps it was just a curious coincidence after all?

With a sigh, Burchard sharpened a new quill and resumed his
task. There were not many entries because in six days the Pontiff
was dead. Were it not for Cesare's vigorous youth he would have
died too.

Ach, how bare, how utterly cold and bare, Burchard thought, were mere words for an event so startling, the opening of a door at the end of a long gloomy corridor.

So the Borgia had passed to his heavenly rest and there was talk of devils in his chamber, but he, Burchard, had not seen them and he preferred to write only about what he had seen or what he was certain of. He had observed—and put it all down in his gelid style— that not once, as the Pope lay dying, did the Duke come to see his father, not even in death (*nec in morte*). Nor had the moribund Pontiff ever made mention (*in aliquo minimo verbo*) of his beloved children Cesare and Lucrezia.

Yet withal, the sequel stirred the Magister most. For as soon as Alexander's soul had fled, his body began to putrefy: black juices foamed from his mouth as from Vesuvius and the corpulent figure swelled until it ceased to look like anything human. When he left the chamber the Magister was sick but he girded himself to write what had to be written: *Factus erat sicut pannus, vel morus nigerrimus . . . os apertum et adeo horribile quod nemo viderit unquam vel esse tale dixerit.*

Well, that was a dry enough description of such a festering corpse. Alexander's body may have swollen but Burchard had no intention of swelling his periods to accommodate the theme.

That night (O that eternal night!) the Magister had trouble with the porters. They refused to touch the corpse, mumbling something about having seen a black dog running down the marbled halls just after Alexander died. So then the German lost his patience and lifted his staff to strike, and the men tied a cord to the Pope's foot and dragged the body off the bed onto the floor and rolled it in a carpet for fear of the plague. Then they carried it away, first to the high altar where it was to lie in state, and then because it became too awful to look upon, to the chapel of Our Lady of the Fever in Santa Petronilla.

Oh, everything went wrong, and it was all on poor Burchard's shoulders, since he, as Master of Ceremonies, was responsible for such matters. The coffin was too small; the carpenters had not anticipated such a terrible swelling of the corpse. And since, for sanitary reasons, swift burial was advisable, the Magister ordered the carpenters to fit the Vicar somehow into the wooden box they had already made; and so they did, pummeling it and ramming it down with fists and boards until they squeezed it in.

And so it lay all night in the chapel of the French Kings which was certainly just, the Magister thought, inasmuch as the fortunes

of the Borgia had always floated on the French tide, though later they sought to repudiate what had lifted them . . . Oh, an endless night, he remembered, the small company of prelates gathered in the chapel, the echoing prayers, the gulping candles about the black bloated body which lay in front of a pure white statue of a girl-Madonna with crucified Christ in her lap. During the weary night hours of his vigil, Burchard idly observed that the sculptor had had the poor taste to inscribe his name on the riband encircling the Virgin's breast. A Florentine named Michael Angelus, and surely it was an arrogance, the Magister thought, if not an actual breach of ecclesiastical decorum.

Of the interment he had written nothing. It was just too wretched. Everything went wrong. The grave-diggers were abominable. He couldn't sleep for a week. Rome echoed with Pasquino's laughter.

Well, he was gone now. And on the pontifical throne sat a pious old man who called himself Pius, and although he loved his twelve children, he loved his Church more. Simony would be kept within the bounds of sanctity: the order of ceremonies would be respected.

Perhaps from now on he wouldn't even mind keeping this daily journal.

XIII

Iacopo l'Indaco came to Fiorenza in November, shortly after the Cardinal Giuliano della Rovere had assumed the triple tiara under the name of Julius II. The aged Pius III, the Sienese, Piccolomini, had died only ten days after his coronation.

To his native city Iacopo brought his carrot-colored hair, his buoyant good nature and a headful of Roman gossip. Iacopo and Michel were the kind of friends who delighted in each other's presence but would not bridge absence with a single written line. Thus it was that Iacopo arrived home knowing nothing of the Giant, so that when he saw it (for the David was almost completed now and Michel permitted his old friend in the enclosure) he was astonished. Round and round the figure he circled, to Michel's amuse-

ment, making grunting noises, sucking in his breath, muttering a steady stream of *Porcamiseria! Diamine! Incredibile! Madonna in Trono!* and various other pious and profane exclamations. Finally, after a full fifteen minutes of expostulatory circumnavigation, he stopped in front of the Giant and stood there with his sturdy green-stockinged legs V-planted, his hands on hips, his head cocked, orange-bright in front of the white stone. Then he walked closer and patted the Giant's genitalia.

"I see you've not forgotten our friend," he said with a chuckle.

Michel made no comment. Iacopo resumed his examination of the figure. This time he wanted to see it with his fingers, he probed and patted and thumped every inch within reach, and even clambered up the scaffold to run his hands over David's mighty ringlets, and frown mimickingly into the Giant's frown.

He seemed such a clown, Iacopo, a jester at the throne of a fierce marble king. But Michel suffered him because he knew that beneath the grunting and the thumping, the odd sounds and the funny faces, there was a true love of art and a true admiration for Michel's achievement.

After dinner with the Buonarrotis, the two friends strolled along the gray Arno. Iacopo told Michel of the excitement in Rome upon the news of Alexander's death.

". . . and when the Holy Father was taken ill, armed men of the Duke filled the Borgo, and you could hear the tambours all day and all night summoning those poor souls pledged to arms to report to the Vatican. And those that didn't were gibbeted, so it was best to keep under cover to avoid the tricks of those cursed Catalans. We didn't do much painting those days, as you can imagine. Well, then the Devil came bounding into his chamber in the guise of a baboon—"

"Ahi, do you really believe that?"

"Ma certo! Everybody in Rome knows Roderigo became Pope only because he signed an agreement with the Devil. An exchange, you see—his soul for the papacy—and he'd had twelve merry years of it and now his time was up. I guess Alexander must have known it too because when a Cardinal tried to shoo away that baboon, the Holy Father sat bolt upright in bed and cried—"Lascialo! Lascialo! Leave him alone! Leave him alone!"

Michel crossed himself. A bleak wind stirred the dry weeds of the embankment. Gray mist shrouded the hills.

". . . he honored his agreements, you see."

More than I, Michel thought ruefully. He wrapped his rough-

spun cape tighter against the wind. He had had such a twinge of fear when the news came of the Cardinal Piccolomini's election. One couldn't expect to deal as frivolously with a Pope as with a Cardinal. Lodovico was full of forebodings and righteous reminders. Every day Michel awaited a summons from the Vatican ordering him to abandon his Giant forthwith and resume work on the figures he had contracted for the Siena cathedral. Baccio di Montelupo already had four of the statues well under way, and when Michel visited his bottega and saw the botchwork going on in his name, he had to bite his tongue. He didn't want to be further involved and yet he feared what the new Pope would say when he saw these clumsy approximations of his drawings.

Oh what relief then to learn that doddering Piccolomini was dead, scarcely ten days after his coronation! Now he only had to worry about his heirs. But they could be put off more easily than a Pope.

". . . and all this time—the tambours I mean, and the Duke recovering and the old man dying like a scorpion of his own venom and the Spanish Cardinals gathering in one place and the Italian Cardinals in another, and the armed men of the Duke galloping furiously all over the city—while all this was going on, you could hear Pasquino laughing his head off. You could hear his laughter from the Piazza del Popolo all the way to the Foro. Every day he fluttered forth with new epigrams like a miracle-tree—white spring, you know—blossoms and blossoms. Andrea translated some of them for me but I have no head for such things. Otherwise, Michele mio, I would make you burst your codpiece for laughter . . ."

"And Andrea? Come sta?"

"More curious every day. He has abandoned the craft, you know."

"I didn't know. We exchange no letters."

"È un tipo strano. Three months ago he ceased coming to the bottega. Then after several weeks, he appears again, gaunt as a scarecrow, but with a strange new light in his eye—hard to explain —burning as always and yet *assured*, as if he *knew* something . . . At any rate, he had a long discourse with the Master and the upshot of it was that he purchased a release for the balance of his term. The Master was quite willing to let him go; he's a mediocre artisan at best."

Michel nodded. "His vision outreached his grasp. I saw it immediately in the sketches but I never told him."

"Now," continued Iacopo, "I see him only once in a while. He comes to the bottega sometimes to take a walk with me. But he seldom speaks, I don't even know where he lives, and I surely don't

know what he's doing. Perbacco!—he's an odd one—all these He-
brews—seems all aglow about something. Some secret knowledge.
It's magic, I am sure. They all have their familiars and can conjure
them up any time they want."

"Does he ask about me?"

"Often. But of course I had nothing to tell him." He picked up a
flat pebble and sent it skipping over the slatecolored waters. "I
didn't even know you were putting him into stone."

XIV

Andrea was always the last to leave the shop. He had convinced
the Master that he was trustworthy and would lock up well. So
now, as every late afternoon during these past few weeks, he was
remaining alone in the bottega, contemplating in the waning golden
light the wooden panel on which he was painting a Moses receiving
the Tablets. It was not a private commission; nor was it a task as-
signed to him by the Master. He was painting it because he had
become increasingly dissatisfied with his ability, and had decided to
test himself on a subject of his own choosing.

For perhaps—so he had reasoned—perhaps it was the necessity
of depicting, for the most part, Christian iconography that stayed
his hand, made thumbs of all his fingers, resulted in his ineptness
that he unhappily recognized even before the Master made gentle
reproof about it. For five years Andrea had been trying to perfect
his art but no one saw more ruthlessly than himself the inadequacies
of his performance. Garlands, yes, lettering to perfection, draperies
sometimes even skillful, especially if they happened to be working
in the oil technique which permitted endless revisions. And he could
lay in the wet plaster for fresco as smoothly as anyone, nor was he
a bad colorist. But he could not draw; his figures were *goffe*—
clumsy. Between the lofty conceptions of his mind and the execu-
tion of his hand yawned a pit he could not bridge. Into that darkness
his imaginings always plunged, and what emerged—if they emerged
at all—were broken bodies, cripples, abortions.

It was the eye of Elia, he told himself. It was not so much his own lack of skill as that Eye always mocking his efforts to paint bleeding saints, racked bodies, the nailed Man, the self-lacerating martyrs, the starved anchorites, the gaunt figures worshipping skulls in the desert. They surrounded him now—hung and leaning on the walls—all this iconography of self-inflicted suffering, and they were not his; he felt alienated from them; he hated everything he saw in the Pollaiuolo workshop, even as he envied the growing skill of his fellow journeymen.

Iacopo, for instance. He could munch a turnip with one hand—spitting out the fibers, and belching and breaking wind—and all the while be brushing in the tears of the Magdalen with such art that you could see the windows of the bottega reflected tinily in each tear and he almost made you believe he wept with her.

How could Iacopo manage it? Andrea wondered. How could he paint so well without feeling the inwardness of what he painted? Perhaps—so Elia's voice echoed in his ear—because he is interested solely in appearances and you are my son and therefore—

—Therefore what?

—Therefore you scorn appearances and seek the Truth.

—The Truth! the Truth! What is the Truth, Father?

—The Truth is the Unnameable, the Unknowable, Elohim, the Point to which all aspires. The Truth is the ultimate of aspiration, invisible nest of unseeable angels. The Truth is the Ineffable Name, Adonai.

—Adonai!?

—Adonai. And never has He condescended to take upon Himself the fleshform of a man. For the Messiah whom He will send is not He. He is One and the One is beyond seeing. Abjure the surface. Seek like Leviathan deep waters. The World is a skin. You cannot image the One; you can only know Him—

—But how—?

Elia did not answer. He had disappeared again. Silence echoed. Andrea regarded his painting. Oh clumsy! clumsy! Iacopo had hinted as much, but gently, you could see he was not saying all he thought. The Master was gentle too, but more blunt. The others simply laughed, some rudely, some good-naturedly. But the only man in the bottega whom he really cared about was soon to depart. Iacopo's japes were brighter than the brightest incarnadine in the shop—but in a few weeks he would be gone. He was planning to visit Fiorenza for the first time in two years and he would stay there from Natale until Carnevale.

Why didn't Andrea come along? He would have no difficulty con-
vincing the Master that a few weeks . . . Iacopo tried to keep his
voice noncommittal as he said it. Vieni, Andrea, vieni! It would be
joy for both of them to breathe good Tuscan air again, and to see
Michelangiolo again after these two long years and find out what
the devil he was up to. Perhaps they might even induce him to re-
turn to Rome with them, now that Julius wore the tiara. Things
were surely going to look up for Florentines under this new Pope.
Hadn't the Florentine San Gallo been his personal architect dur-
ing all those years of his exile in France? Andrea could help con-
vince Michel of the advantages. Michel always liked him—by Bac-
chus—he, Iacopo, never could understand why—

—No, he would not go, Andrea said.

He could not explain to the carrot-top. He loved Fiorenza; it was
his own. He missed the swallows swirling over the Arno. He felt
ever a nostalgia for the Duomo that was not his.

—Then why not come along—?

No, he would not understand. Michel might understand.

Michel might understand. Because was he not also a man on the
rack? Was he not torn between his Bacchus and his Madonna just
as Andrea was torn now between the Eye of Elia and these Chris-
tian images? Alone in the bottega that day Andrea did not know
that back home his friend had momentarily resolved his dilemma,
that he had found for a blessed interval his great point of balance.
Between the tipsy Greek god and the Man of Sorrows a Giant was
rising.

But Andrea had not found such a point of balance. He was still
imprisoned in his dilemma. Every morning he wrapped the phylac-
teries around his arm and prayed with old de Cases; then he came
here to paint Christian saints. At evening meals (he was still living
with the de Cases family) he had to face Tsiporah across the table,
and taste the bread she had baked: a bitter-sweetness. They had
resolved to marry in the spring: their troth had been pledged for
more than two years. Living in the household as he did, Andrea felt
indeed that she was already his wife.

Neither of them expected old de Cases to live out the winter.
He had been ailing of an ineradicable sorrow ever since he lost his
wife and little daughter in the miasmal plague that drifted into Rome
last summer from the swamps of Latium. He was gaunter than
ever, he had a racking cough, and the hours he spent in the damp
fish market were undermining whatever resistance was left. All that
remained now were the blazing Bartolomeo eyes over hollow cheeks.

As soon as he was dead, Andrea thought with bitter lucidity, we shall be married and leave Rome. What was there to stay for? He had misplaced his life. He was not an artist. The fish market stank. Tsiporah's hands were permeated with it no matter how much she doused them in perfumes. What had they to remain for?—he did not want to see any more deaths, any more Carnival races of old Jews down the Corso, he had remained only because of Tsiporah and because he was still struggling with his disenchantment. They would flee, yes—he was always fleeing, always shutting doors behind him—but he could not return to Fiorenza. Even though there was one there who would understand his trouble. No, he could not return ever.

So now with despair he looked again at the panel on which he had been working after hours during the past month. Mount Sinai was not too badly painted, he tried to convince himself. There was a crude power in that lightning, that storm-lashed landscape. But the prophet Moses looked something like the wine bibber whose daily gyrations were the ridicule of the Hebrew quarter. And the hands! the twisted and knotty knees that looked like gashed olive branches. He had never conceived it so. Yet so it came. Goffo. Crippled in the pit between dreaming and doing.

Even when the images were his own, he thought, facing the bitter fact. So it didn't matter whether one believed or not. Iacopo didn't believe in his saints any more than Andrea did—but he could paint.

And that was it, Andrea cried out unhappily to the botched panel resting against the wall. I lack the genius—I am only a journeyman, and I am not even a good journeyman as Iacopo is; I am just a garland-painter: that may suit—who was that friend of Michel's? Yes, that fop Granacci, yes—but it does not suit me.

Suddenly with a motion that was almost casual, he swept away the jar of brushes he had set on the table; it fell to the floor with a crash. He picked up the panel, and slowly, deliberately, without anger, split it in two against his knee. Then he lighted a fire in the furnace used for smelting silver, and pitched the pieces of his panel into the flames.

My private Bonfire of Vanities, he said to himself.

When he walked home afterwards, he felt light-hearted, pure, as if a great burden had been lifted from his shoulders. The sun was slanting golden and level on the Roman streets, making long aureate shadows of pedestrians, glinting the Tiber ripples, etching filigree within barred windows and deep velvet shade that coiled like cats in

the corners of corbels and ledges. And Andrea found that he reveled in God's creation more than he ever had before. He was free to admire without the torment of emulation.

After he had purchased his release Andrea came back to visit Iacopo several times at the bottega. It was not easy to rid himself of old associations—the pleasant smell of the shop, the banging of pigments in the jars, the jests of the apprentices, and most of all, Iacopo's good nature. But never in their somewhat silent strolls through the winding lanes of countrified Rome, did Andrea tell his friend of the new plan slowly maturing in his mind. All Iacopo noted was Andrea's new manner. A quiet certainty. An inner glowing. His eyes seemed larger, more luminous. Never once did he speak a word of the reasons which had impelled him to abandon the craft which had estranged him from his father and to which he had devoted five years of his life. Iacopo did not question him. He could guess. He had seen his friend's work.

Andrea sailed for Crete in January. Fortunately it was a mild month. The mountain passes to the Adriatic were clear, and though the landscape across the peninsula was forbidding, the hardships of the journey soothed his soul. There was no stage to Bari; he rode horseback all the way. Jogging long hours in the saddle, lying awake in rude inns, coming upon lonely shepherds wailing reed pipes to a patch of dirty gray beasts on a hillside, drinking the tart wine of the Abruzzi, Andrea felt that he was being purged of the foetor and hypocrisy and false ambitions of his life at Rome. For the first time, he had a vague premonition that his life was about to take a true direction, an arrow speeding to its goal. Even memories of the tearful departure from Tsiporah, who, despite his assurances, was certain he would never return, did not affect his new-won serenity. He found himself singing in the saddle.

At Bari, strange with its oriental domes and black-eyed veiled daughters, he sold his mount and took a Venetian caravel for Crete. The Mediterranean was turquoise and pearl, a steady wind bellied the orange sails, the captain spoke with a singsong that brought back memories of the lagoons to Andrea. Even when the captain cursed the pirates and Turks who infested these waters, his voice rose and fell like the gondolas. There had always been a trace of that song in Elia's speech too; it had tempered to some extent his patriarchal severity. For two nights, despite the cool weather, Andrea slept on deck, wrapped in his cloak, gazing deeply into the stars, trying to read his destiny in those sparkling configurations.

Crete proved an arid forbidding land. At Iráklion he sought out the chief rabbi. Rabbino Shemariah was a sandy-bearded man, mild as May. He seemed to speak apologetically as if he would withdraw each sentence before he had completed it. Only Andrea's eager questioning sustained their colloquy. They spoke in the synagogue: sunlight flooded the bare room. The walls were whitewashed, the benches plain, the Menorah of filigreed but simple design, and the embroidered lions on the curtain of the Ark were curiously oriental. Many lanterns of red Murano glass and brass censers hung from the low ceiling. The island was still under the sway of the Serenissima; reminders of Venice were everywhere, even in the speech of this sandy little rabbino.

Elia was dead. He had died several years after his return. Andrea did not weep; he had expected this news; he had known all along that he was journeying on a pilgrimage for his conscience's sake. He had known Elia was dead the first time he saw his Eye glowing in the vault.

So now with bowed head and tearless sorrow he listened to the Rabbino's halting story of his father's last days:

". . . he was much beloved here. He came at a time of plague when the usual accusations were flying about that we had poisoned the wells. But Maestro Elia demonstrated that the plague came from their filthy ways and he saved many by his arts . . . Then he undertook to give public lessons in philosophy. But for his teaching he would never take money. He did not believe in using the Torah as a spade to dig with. He had many followers—both Christian and Jew—and I was one of those who attended to my great advantage. In those classes there was a man named Shaul Kohen at whose request your father took up a work he had long meditated in the past, a work of religious philosophy composed in the Hebrew tongue, the *Bechinath ha-Dath* . . ."

"Where might I find this Messer Shaul Kohen?"

"Alas, he has gone to Padova. He could tell you most about Master Elia's last days for he was very close to him. He served as your father's scribe when Master Elia's fingers began to be crippled by some kind of palsy. Then he complained bitterly—the only time I ever heard him complain—that he was no longer fit to make anatomies or practice his art of medicine. He said his days were being gathered to a close like a sheaf of wheat and he was hastening to reap the final harvest of his thoughts. Then it was that his disciple Messer Kohen began to serve him as scribe since your father laid great weight upon this treatise, his examination of religion . . .

"What? . . . No, he never spoke of a son . . . You would think he had been born from the union of Aristotle and Maimonides. He never mentioned family. A cold-seeming man but much beloved. At his death—too soon, too soon, for he was not old—there were as many Christians as Jews in the procession following his bier."

Rabbino Shemariah paused, blinking his desert-colored eyes. Then he stooped and opened a floor closet next to the Ark where the holy prayer objects, shawls and phylacteries, were stored, and drew out a vellum scroll.

"Here is your father's *Bechinath ha-Dath.* We have had several copies made. One has already been brought to Italy by Ser Shaul."

Andrea's eyes welled as he took the scroll: he unrolled it and tried to read. The curlicued letters swam. It was impossible.

Andrea spent three weeks on the island, but he saw nothing. He had abandoned the journey of the senses. Twice daily he spoke the memorial prayer for the dead, the Kaddish, in the bare-walled synagogue. He spent many hours at Elia's grave. Gazing at the simple tombstone, he discovered in himself less grief than a kind of pensive acceptance. He could not conceive of tall Master Elia—that clean-shaven knife-like man—moldering. Elia could never molder. The empty vessel in this earth was of no importance. His father had passed here. He could only remember him alive.

There were Greek ruins on the island, fragments of a temple, some gracious thighs and torsos. But he had left all that. He had left it when he broke the wooden panel across his knee, and now with the sharp realization of Elia's irrevocable departure, he knew he had left it forever. Elia was right. What was the Greek passion? What was this bewitching obsession? All beauty was doomed to decay. There were many Greek women on the island with terra-cotta complexions and shapes like amphoras, women who walked slowly, with tight thighs, as if they were brimful of secrets which they feared to spill. He found himself looking at them as he had looked at the damozels walking in the Piazza Signoria while Michel sketched. And then a breath of mortality chilled his ardor. What did it matter if rounded limbs were flesh or stone? They were equally doomed to decay. Elia had known it. The Truth was not here, not in this childish game of seeking to perpetuate the impermanent. Not even in the stone Michel preferred.

The Truth was One, unseeable, beyond the senses, beyond a name.

He left some pebbles on Elia's grave and found a Greek vessel

sailing to Taranto. All the way back to Italy he continued the conversation with Master Elia. It was no longer a debate. Elia had won. He continued through a violent storm that rocked the small ship to its beams, he continued it even as he became sick at the rollicking horizon and the great frothy-maned seas roaring over the deck and the Greek crew cursing their Father Poseidon's bad-tempered display. The shuddering vessel was the shuddering of his soul.

In the calm after the storm he read Elia's treatise. Hour after hour, he sat on deck in the sun, puzzling over the scroll. It spoke with dry precision. Andrea could not follow it all: he was not interested in these close-meshed arguments against the Kabalists, these distinctions between various interpretations of the Talmud, this methodical biblical exegesis—what was obligatory to be believed and what was subject to individual interpretation. But Elia's central theme he could understand: his father was seeking to reconcile religion and philosophy as Pico had sought to do. He could hear the physician speak. If religion taught anything contrary to the postulates of human reason, then it was not necessary to lend it faith. But—Elia hastened to add—surely in the Hebrew religion there is nothing with which human reason could find itself in opposition. Andrea smiled: a porpoise leaped out of the blue: a glistening playful question.

When finally he got back to Rome, Andrea knew what he would do with his life. He would, as Elia had done, search out the mystery of Being in the mystery of the flesh. Not to mimic it nor vainly seek to render in paint and stone what Adonai had wrought. But to understand the processes with which He wrought.

So Andrea came back to Rome. He found de Cases dead, as he had expected. When Tsiporah saw him she flung herself in his arms and could not check her sobs. The man who held her felt differently than the boy who had left. He was harder, bones projected from the oval face, there was a new serenity in the eyes.

Soft as a bird, she nested against the rocky cove of his chest.

XV

The new Pope, Julius, was as unfond of Hebrews as he was unfond of the Borgia. Indeed, it was his conviction that they were the same. When he examined the apartments which Alexander had refurnished in the Vatican, Julius could not contain his rage. Ten years of exile had not softened his bellicose nature; he spoke French like a native but had absorbed none of the suavity that flowed like honey in the French court.

Now, accompanied by a small retinue, among whom was his Magister Ceremoniarum, Burchard, Julius stared up at the ornate coffered ceiling of the Borgia apartments where Pinturicchio had painted the likenesses of golden-haired Giulia Farnese in the guise of the Virgin and fat-jowled Alexander kneeling in adoration before her. He had certainly knelt in adoration before her, the Magister was thinking.

But hardly a—

He left even the thought unfinished. Burchard was still feeling his way with this new Pontiff. He was not even certain, not at all certain from day to day, that he would be retained in the post he had held for twelve years. This much he had already decided. It was just as wise, perhaps wiser, to keep the official visor shut down as tightly with Pope Julius as it had been with Pope Alexander. Della Rovere had already proved his mastery in the high arts of his predecessor. The Magister had not failed to observe how neatly the erstwhile Cardinal of St. Peter in Chains had won his election to the Papal throne: promising Cesare Borgia that he would guarantee his domain in the Romagna in exchange for the votes of the Spanish Cardinals. Then having secured the triple tiara, Pope Julius delivered the Duke into the hands of his enemies. Now he was said to be languishing—or lounging, no one knew which—in a castle at Ischia.

The Magister's reflections were interrupted by the Pope's burst of rage. "Marranos! Marranos!" he was shouting, shaking his fist at the adoration of the concubine on the ceiling. "Pigs of heretical Jews!" A curious accusation, Burchard thought, as the party continued their examination of the apartments, considering that His Holiness (he still thought of Alexander as Sua Santità) had employed precisely the same term whenever there was a necessity of

raising funds for some pious purpose, such as prosecuting wars against infidel Turks or forging leagues against His Most Christian Majesty of France. At such times there had always been many hidden Jews discovered, and now (*Dea Fortuna!*) dead Alexander was being accused of the same crime.

Nevertheless, Julius' animadversions against the Jews did not prevent him from continuing, as his personal physician, a member óf that cursed sect. Messer Rabi Shmuel Zarphathi, called Gallo the Frenchman, was renowned as the prince of the Jewish medical school of Rome. He had been Pope Alexander's personal physician for years and moved freely in Vatican circles. The Borgia had granted him all sorts of special dispensations—relief of taxes, and freedom to practice without wearing the yellow O even when his co-religionists were compelled to bear that badge of shame.

Andrea had often seen the Rabi Shmuel in the synagogue but he had never spoken to this amiable ruddy-faced man who was looked upon with such awe by the entire community. Andrea feared that the conversation would inevitably turn to medicine and this would bring back too many painful memories.

But now, after his return from Crete, his plan decided upon, he spoke to Rabi Zarphathi. He wanted to become a doctor. But he had no money to study. Would the Messer Rabi consider taking bond for—

"What need is there for bond?" the physician said, smilingly. He laid an affectionate hand on the young man's shoulder. "When you have learned the art, you might return here and assist me. My own son is too young, and I have need of an aide. I am certain that you shall make a good physician. Your father's heritage—"

"You knew my father?"

"Who did not know him? I met him for the first time at Montpéllier when I was a student. He had come with some count who had fallen into difficulty with the Church. Later, I heard him lecture at Padova. When Señor de Cases told me you were the son of Maestro del Medigo I wondered why you never spoke of him. He was a great man—"

"He is dead," Andrea said. He told Rabi Zarphathi of his trip to Crete. ". . . and there I decided. I want to be what he was."

Zarphathi nodded understandingly. "Then you will enroll at Padova?"

"No, not Padova. I—I would prefer another school. There are several open to us. Bologna is said to have a good faculty of medicine."

"But not as good as Padova."

"I—I cannot go to Padova."

"Why not?"

"I cannot explain, Messer Rabi. But I should prefer to go to Bologna."

The physician regarded the quivering-mouthed young man for a moment: "So be it," he said softly. "Have no fear for your living. At Bologna, you will find several of 'our people. I will give you letters."

In his double rôle of rabbi-physician, Zarphathi officiated at the wedding of Andrea and Tsiporah. For several months Andrea served as Zarphathi's assistant; and though he admired the man's skill, he found himself admiring somewhat less the rather grand airs Zarphathi assumed in the Vatican.

Just before Carnevale, Andrea learned that his Master had persuaded Pope Julius to limit the number of contestants in the annual footrace to a dozen, and to choose young healthy men in order that the contest might be more truly a sport and less of a spectacle. Pope Julius agreed: indeed it was arranged that the physician himself would be in charge of the race; Zarphathi would be honored with a special escort of more than a hundred Jews, armed and bearing olive branches. . . .

Andrea was happy not to have to witness these honors. The Campagna was still dry and dun with frost when he and Tsiporah departed from Rome. They took the post northward, traveling slowly, with many stopovers, in order not to weary Tsiporah who was already carrying their child in her womb.

XVI

Iacopo's plans to remain in Fiorenza until the end of Carnevale were unexpectedly altered with the arrival of Mario the Shirtmaker, a fellow journeyman in Pollaiuolo's shop. Mario's face was blistery red. Madre di Dio! but it was blowing wild on the mountain passes! He had almost been lifted clear off the saddle at Cortona. Right

at the lip of the cliff. The Madonna saved him. He quaffed a mug of heated wine, clutching the mug in the fingers of both hands and leaning his head against the rim like a child safe at last after great perils, arms around mamma's waist, head buried in her breast.

Then, from the laces of his jerkin, Mario extracted the sealed and folded message. It was from the Master and it advised Iacopo that he was sorely needed; there was a shortage of good hands: and this new Pope was beginning to tear up half of Rome with his enterprises.

Mario brought another piece of news that interested all Florentines. Piero de' Medici was dead. Bored with carousing and waiting in the Holy City for the Medici fortunes to turn, he had gone off to fight with the French against the Spaniards, and in December been drowned at the battle of Garigliano when his raft crossing the river had collapsed. Michel heard the news without emotion. It was, he thought, the ultimate liquefaction of a snowy Hercules.

But he was sorry that Iacopo had to depart so soon. He had hoped—and so had Iacopo—that the carrot-top might be able to attend the meeting which the Guild had called to determine the placement of Michel's almost completed David. Ah, what a triumph! Iacopo thought, to have not only the best artists of Fiorenza summoned to give counsel, but important municipal officials as well. That was certainly an honor not often bestowed upon an artist; no, not even when the work in question was intended to be a public monument.

"Of course," Michel said scornfully when he told his friend about the planned meeting. "I have already decided where to place my statue. But let them talk, if it suit their fancy."

The day before his departure, Iacopo came to the shed to take his last view of the white Giant. With him was Andrea the Tailor's Son. The door of the shed was no longer locked against visitors. The David was almost completed; what remained to be done were delicate touches: filings here and polishings there. Michel had not been able to efface entirely Guccio's chisel marks at the top of the back, but that didn't matter; from the ground the marks couldn't be seen anyway and besides he felt a small satisfaction in leaving them there. The stone became like the palimpsest on which the monks wrote; he was not only making something out of nothing, he was also completing with his genius another's bungled beginnings.

Del Sarto had not been inside the shed since he had posed for the second wax model. But that was almost two years ago; since then this stone Giant had emerged from the quadrangle of marble.

So now he gazed at it with a wonderment somewhat akin to that with which Michel gazed at him. At their occasional encounters in churches or studios or meetings of the guild Michel had not been aware of the relentless small file-work wrought by Time. But here in the shed he saw it with a bound: the beautiful stripling had become this handsome self-possessed young man; the velvet eyes were no longer innocent, the bow of the shapely mouth was more tightly drawn. Del Sarto was about to leave Piero di Cosimo's shop to establish one of his own. His immense talent—especially the luminous color so rare in this city of stonecutters and draftsmen—was already being talked about in the workshops of Fiorenza.

Coolly, but with a sigh of wonder, Andrea was standing transfixed now at the magnification of his flesh into stone, this huge yet boyish chest which was his own, these slender yet muscular arms, that monstrously eloquent Hand, the leap of the great tendoned neck, the huge milky thighs that were his own thighs . . . Himself and yet not himself; that small head was surely nothing of his, nor those fierce eyes peering into the unknown, nor that passionate small mouth, nor the thick froth of curls which were like those of a Greek discus-thrower he had seen in the Medici collection.

He murmured his admiration. It was altogether beyond him; in paint he could maneuver, mold, flow light over contours, set sweet smiles lurking in half-shadows. He could already paint these things almost as well as the Master Lionardo da Vinci whose work, lunar and mysterious, attracted Andrea's fluid nature as the moon draws the tide.

But this Giant was altogether beyond him. He could only admire it. He stared at it, murmuring his praises. Then, with a gentle smile:

"I see you have used me with discretion, Maestro."

"What do you mean?"

"The body, limbs, neck—that is myself, surely. At any rate as I was. But the head is not mine, nor—"

He pointed.

Iacopo burst into loud laughter.

"—am I made like that."

"No, you are not," Michel said. "But David was a Hebrew King"

"Are the Hebrews made like that?"

"They are."

"You think our Lord was so?—"

"Indeed, He was," said Iacopo. "In our bottega is a workman named Roberto and in the bath we saw how he was. made and won-

dered somewhat at it. Then he said he came from a city whose most precious relic is the foreskin of our Lord's circumcision so that many of the men undergo the same trial for His sake."

"Besides which," added Iacopo after a thoughtful pause. "It is said to add somewhat to a maiden's delight."

Michel smiled. Iacopo's way, he thought. Let the conversation take a serious turn and he must fillip it with a jest.

"Well," murmured Andrea thoughtfully, "if you choose to take liberties with the model—"

"I took no liberties, amico mio! I took only those liberties which were required of the subject. No more. No more," Michel said, and then he didn't know why but he was getting angry, he didn't always know why he became angry, but he felt the furies flaring inside him now, licking up from fires too long banked.

In the valley of the thighs of the man-mountain, the three artists sat and talked. Andrea was still much in demand as a model. Of late, he had been posing as Saint John the Baptist. He knew all the gossip of the hundred workshops of Fiorenza. The great news now was that Giuliano da San Gallo had already been summoned by the new Pope to come to Rome and serve as Architect of the Vatican.

"All the more reason for you to return with me to Rome," said Iacopo eagerly to Michel. He renewed his pleas—surely the field of possibilities was infinite now in the Holy City. Especially for a young Florentine with Michel's genius, there was no telling how far—

But Michel waved his friend's pleas aside. Why should he go to Rome? Was he not already deluged here at home with a multitude of commissions? Were they not pouring in every day?—requests for statues in marble and in bronze, for low reliefs, for paintings.

Why, he could not possibly do all he was asked to do. But he revelled in the challenge. He was twenty-nine years old. He had two hands, ten fingers. He was happier in Fiorenza than he had ever been in his life. All his senses and his powers were at floodtide.

XVII

Be it noted that I, Michelangiolo, Scultore Fiorentino, on this twenty-fifth day of January, fifteen hundred and four, find myself here in the hall of the Consuls of the Art of Wool who together with the Superintendents of the Cathedral Works commissioned me to make the white Giant now completed and so today have summoned to this meeting thirty of the finest craftsmen of my art to be found in this noble city of Fiorenza to offer their counsels upon the placing of my statue. And so they sit around me in a semicircle, head by head, most·in long sober cloaks of black serge down to the heels, & one, bearded like a patriarch, in a short cape of pink satin of curious cut. Head by head, side by side, an even row like those painted figures on the walls of the Brancacci wonderfully set down by Bad Tom, the line of them in their robes & scowls & solemnity & sculptured roundnesses right up to the kneeling naked boy who is my friend Francesco Granacci solemn at this meeting in a new embroidered cap ,and no longer naked. And Bad Tom died too soon so that the rest of that painted row had to be finished by Master Filippino, fruit of a nun and painter-monk & Filippino is also here today, & even though his fine lucco is lined with rabbit and he has wrapped the tassel of his berretto around his mouth to protect himself against the cold, he is coughing and coughing until his face is purpled with the paroxysm of it & I fear he is ill beyond repair. For he should not have come out in these January rains, but like the others he feels he must offer his counsel in a matter on which I ask no counsel.

But let them speak if it please them. Let them speak as Lodovico would speak ever on matters that do not concern him & as even Narro my brother is beginning to speak, now that he is aware of my fame. At any rate, I know there are some few here who will say things instead of words. For seated next to Filippino Lippi is his good friend & mine—Master Sandro, & I also see Master Piero and Il Cronaca & many others who wish me well though they do not understand the loneliness of those who carve Giants. And I note that Master Sandro is getting old, for wrinkles fret his mouth and his eyes are blear & now he glances oddly at the way Master Piero is ruminating the remains of a nut with toothless gums, & Sandro

turns to me & smiles and it is an underwater smile, sweet as Aphro-dite rising from the sea.

Who rises now, with such ponderous gravity clearing his throat—the long rose-red robe with folds carried on his arm, the red stock-ings, the red nose—first to speak upon this matter? Ah, now I see him clear, a friend of my father's, Herald of the Signoria, Maestro Francesco Filareti:

*Signori, I have considered carefully my judgment on this matter. There are two places that might accommodate such a statue: the first, where the Judith is now; the second, in the center of the Palace court where the first David now stands. Now, Signori, I adduce these reasons—*And you would think he were delivering an oration to the Lords Priors, with long rhetorical pauses & clearings of the throat and wagglings of fat fingers—*that the Judith is a mortif-erous symbol, and it is not well, especially for this city which has the Cross and the Lily as its insignia, it is not well, I say, Signori, that a woman should slay a man, especially when this statue was set in its present place under malignant constellations. And this is proved by the fact that since that time, our affairs have gone from bad to worse and now we have lost Pisa. As for the David in the courtyard, it is, in my opinion, a poorly-wrought figure inasmuch as, viewed from behind, the leg is sheer foolishness. Hence I would recommend that this statue be set in either one of these two places: but my first choice would be where the Judith is now.*

And that would be my first choice too, Master Herald. And my last choice. So that you, burgher-heavy & pompous as Lodovico lecturing Gismondo on the use of toothpicks, have withal a strong feeling about art works & an admirable sensitivity for those statues that come under the purview of this city. And if I were to stand up now and say—Signori, the Herald has said it & I say it & there is no more to say for I want my David to stand there to the left of the Palace door & . . . Who speaks? Francesco Monciatto, the wood-carver:

I believe that everything that is done is done for some purpose and so I believe. They laugh, for the philosopher has caught up with his tail & Francesco blushes furiously—*wherefore this statue was originally intended to be set outside the pilasters or near the but-tresses of the cathedral. Now I don't know the reason for not set-ting it there. It seems to me it would have been a worthy ornament of the Church and of the Consuls. But having changed your minds —I don't know why—I would recommend it as a good idea, since you've departed from your original plan, to set it up either at the*

Palace or somewhere near the Church. And if I have not well re-
solved the matter then let me defer to the recommendations of
others since my opinion may not be well considered because of the
limitations of time as to the most congruous place . . . He sits
down, poor man, redfaced, unaccustomed to so much speech, his
sentences all tangled & ungrammatical for he was ever more certain
of his hand than of his tongue & the shavings of his woodcarvings
are never so contorted as those of his mouth. So he takes his place
and now speaks Master Cosimo Rosselli, the painter, & his voice is
so mild I can scarcely hear . . .

"*. . . near the Palace . . . of the staircase of the Church . . .*
high ornament . . . and that's where I would place it according
to me. Worthy Cosimo, true Fiorentino, that you must circle round
and round as Francesco the woodcarver did, speaking those Tuscan
sentences whose tails devour their heads.

Now my friend Sandro rises & he agrees with Cosimo that my
statue be placed where it might be seen by all passers-by & so he too
would have it on the steps of the Duomo on the Lorini side. And
Master Sandro means well I know but in this matter he under-
stands me less truly than the Herald & though there is a wisdom in
Master Sandro's eyes, it is the wisdom of the old, of those who have
painfully learned that the sun must be looked at through smoked
glasses. So Master Sandro looks at the world through the smoke of
Fra Girolamo's pyre. But nonetheless he is a painter like all these
others & his knowing is the softer knowing, but of the harder know-
ing he is ignorant. For that comes only of hammering against the
resistant stone, & so, with all his love, Master Sandro is ignorant of
my hard core.

But he who speaks now, Giuliano da San Gallo, is an architect
and a sculptor & already he wears the serious and considered mien
of architect of the Vatican soon to depart & I strain forward to
hear what he has to say:

My feelings are inclined toward the corner of the Church where
Cosimo recommended and where the statue might be seen by all
pedestrians. But inasmuch as this is a public matter, and considering
the imperfection of the marble which is both tender and too well
done—and everyone laughs, appreciating Giuliano's jest of compar-
ing marble to meat yet withal he is no painter & his knowing is the
harder knowing . . . *and having been out in the rain, it doesn't seem*
to me very durable. But who knows better than I the durability of
this stone? Who has probed it & lain with it as with a mistress and
knows where it yields and where it will not yield and I tell you, Mas-

ter Giuliano, this stone can stand naked in the rain for three hundred years longer & the elements will not mark it more than a smudge . . . *would be well therefore to set it up under the middle arch of the Loggia of the Signoria exactly in the center so that you could pass around it, or else inside the Loggia on the side near the wall with a black niche behind like a little chapel. But if you leave it out in the rain it will crumble fast; it has to be set under cover.* So he sits down & I see the Second Herald rise and he has a flabby face & though he is not as rhetorical as the first, what he says adds up to nullity, since it is his desire to please everyone. He agrees with every man who has thus far spoken *according to his lights;* he finds that *each in their ways spoke good sense; &* he is indeed a bore as are all men who have no minds of their own but serve only as sounding boxes for the ideas of others & I sometimes think such flabby intellect is to true intellect as clay is to marble, for when you meet them & they speak you can see the last thumbprint in them and they are all imprinted with the most recent hands that have shaped them, but shape of their own they have none. And so finally by twisting & turning in his talk he comes to what troubles him most in Giuliano's suggestion and that is that the Giant being out there under the Loggia will disrupt the order of ceremonies of the Lords Priors when they hold public meetings. So to my great relief the Second Herald concludes & it is ridiculous to hear his final peroration in which our company is addressed as Your Magnificences which perhaps is not too lofty an appellation were we all sculptors or architects or painters but which is surely too grandiloquent a toga for the likes of Riccio the Goldsmith or Lorenzo the Mapmaker or Gallieno the Embroiderer.

So, now one after the other rise & support this notion or that and there is much wrangling in the hall while I sit huddled in my cape & say nothing & I am amused when Riccio points out that the figure must be placed where we can go to see it inasmuch as it cannot come to see us. And now Master Lionardo is on his feet and his pink satin cloak is odd in this sober company: not even Master Filippino who is wealthy and wears brocades or Francesco in his embroidered cap seem quite so fastidious as this man & most curious it is to witness the contrast between Master da Vinci and Master Piero di Cosimo who sits directly next to him. For the floor around Piero is already swimming with his spittle & it is an untidy nauseous sight indeed for any man to see. And to the right of Piero sits Andrea the Tailor's Son & he is looking at Master Lionardo as he rises to speak and there is much admiration in his violet eyes. So

I lean forward in my chair to hear the words of this man since he had been offered the block & refused it before he left to take service with Cesare Borgia & now I had extracted a Giant from it and he had extracted nothing but vaporous speculations. But that was Lionardo's way & everybody knew it except our Gonfaloniere who pressed new commissions upon him such as this wall painting he is now preparing for the Great Hall of the Five Hundred which Il Cronaca had enlarged to accommodate the greater parliament instituted by our Friar.

And so I wonder whether this man will judge me fairly considering I have succeeded in an enterprise which he had disdained even to attempt. And his voice is mild and resonant as it was the last time I had heard him speak which was at the camp before Pisa whence I had gone the summer before last to see my brother Giovansimone that I might purchase him out of the company of lancers & bring him back with me to Fiorenza and set him up in a shop with Narro. Now Narro was with me too that boiling July day when we came upon the camp after many hours of hard riding following the Arno valley through Empoli and Pontedera where the beauty of the maidens made Narro my brother almost forget he was a married man & father of a child and another to come. He talked on about the fine 'sparrows' of those Pontedera girls & I said: *How can you speak so when Mona Barta—?* And he laughed: *Every man has need of varied fare* & I thought ill of him for speaking so & I was glad I had no mistress but my art.

We were sweating in the saddle when we came to the camp: a line of colored tents on the horizon, & companies of infantry in leather breastplates and casques & carrying muskets some & some with crossbows and we passed on the outskirts of that camp a foul place of latrines for this siege of Pisa had dragged on for many years & the Pisans showed no disposition to surrender, so our armies under the command of Messer the Condottiere Ambrosio had dug permanent latrines and the stink of it was awful, & closer below the walls of the city there were permanent breastworks and cannon mounted & falconets & serpentines & machines for slinging casts of iron and shrapnel and rusted chains & arrows and lighted torches over the walls. And on a level plain not far from the walls, some soldiers were practicing tilting at a moveable quintain & from their laughter you would think it was a fair rather than a war. And riding down the street of tents to the Company of Lancers in which my brother Giovansimone was enlisted we came upon a group of soldiers bathing in a small outlet of the Arno and they were naked and surprised

& those upon the bank turned to see us pass, twisting their bodies in all sorts of positions so that my fingers ached for the chalk. Then we came to Giovansimone & he was happy indeed to see me again after all these years nor did he seem much to have changed though he was heavier & thicker round the waist, and he looked hard & military-proud. He had filled his leather coif with water & was shaving from it when we came upon him and he was singing a new ditty which he had composed to the delight of his company. I remember the words as I remember the clear bell-like tenor voice in which he sang them:

> Ragazzi, the lady is twice as wise
> For she has lips between her thighs . . .

So we stayed for many hours with Giovansimone and he proudly showed us his armour, a glistening hauberk, & his hose bright canary-yellow down one leg and yellow & lapis down the other, and his casque surmounted with a feathered crest. And he showed us his lance, fanged at the tip, & twice the length of a man, its shaft striped crimson and white like the piles of Venice. Stuck in his belt he wore a Turkish poignard with a black iron handle engraved with gold foliage. So, rigged up in all this bellicose regalia Giovansimone was fine-looking as a cock & I could see he was not disposed to leave this army. He said the life pleased him well & the thought of attending to a shop seemed boring. And considering Giovansimone's mercurial nature I could see at once that this life indeed pleased him, since there were fewer battles and skirmishing than idling and gaming & making excursions to brothels & the only blood that was spilt was when one soldier poignarded another in a quarrel. Meanwhile the captains sought to win their objectives by duplicity & purchase but they were apparently not so skilled as the Duke Valentino had been at this art of war & so the siege dragged on and on. And further, added Giovansimone, he had a mind to enlist in the army of Portugal where it was said the pay was fine & our sculptor Torrigiani had already gone there & Giovansimone even talked of sailing for the Indies. So we argued until nightfall but nothing of what I said about family responsibility or the need to care for Lodovico when he grew old or any other of my remarks seemed to have any effect upon Giovansimone & I found myself getting angry for he had indeed a singular talent for stirring my blood. So that night Narro and I slept in a lousy inn called the Broken Chalk outside of Pisa and we could see the leaning Tower against the moon and it struck me in all its white obliquity as a true sign of our times for surely everything is

falling. Then the next morning we bade addio to our brother after he had agreed to reconsider this matter about running off to Portugal but I was dour and unhappy when we left for I never took any faith in Giovansimone's words & the thought of old Lodovico's sorrow was displeasing to me and I thought of all the projects I had under way & grew irritated at this family in which it was my misfortune to be born.

Now as we approached the Castle of Francesco Giuduccio on the road back to Fiorenza, we came upon a group of men standing on the banks of the Arno and it was clear from their attitudes & the solemn expressions on their faces that they were officials of our country. We recognized Messer Alessandro Albizzi of our Signoria together with the Captain of this siege and sundry other officers and gentlemen. And being curious to know what they were talking about, we rode closer and I saw the Master Lionardo da Vinci among that company & he was being listened to with great respect for he had fame as a military engineer & this company was considering a new plan to reduce this stubborn city of Pisa which had already stood against us for more than ten years. But despite the respect accorded Master Lionardo's counsel, I could not help but remember that he was recently returned to our city after several years in the service of the Borgia & I thought: This is a sorry patriot indeed to serve whoever fills his purse without caring for what purposes that service would be put. For now he stood before the walls of Pisa and was giving advice to Florentine officials how to reduce that city when less than a year before he had been adviser to the Duke to whom these very Pisans had sent ambassadors that they might become allied with him as enemies of our country. But none of that seemed to matter much to Master Lionardo. He was satisfied so long as he had a task to perform & was being paid for his services. For more than eighteen years he had been absent from Fiorenza and within a year of his return he departed again as soon as the Duke Valentino had made that offer. And I found myself becoming angry until I bethought myself of my own services to the Medici though I was a partisan of the Friar and of the Republic.

Now, with the Master Lionardo in this company was the Secretary of the Chancery Ser Niccolò, and he greeted me with a quirky little grin & inquired about the progress of the bronze David. And I gave him sly answer for in truth I had done nothing yet about it, being consumed night and day with the Giant. But Ser Niccolò seemed to care little about my reply, I doubt that he heard it. He was in a gay humor, being on the field where several of his pet

theories on the art of war were being put to the test & one of these
was his project for the deflection of the river. We had all heard of
this scheme in Fiorenza, and now Master Lionardo had been sum
moned to the field to consider the feasibility of it. And I heard him
murmur in that vibrating baritone voice which I hear at this mo-
ment discussing the placement of my Giant, that Ser Nic-
colò's plan might very well be put into effect & the result would be
to leave the Pisans with no navigable stream on which to bring in
their munitions & their victuals and thus they would be cut off from
the sea & would have to capitulate.

At which saying, Ser Niccolò jogged happily & cracked dry fingers
and spoke with a terse but passionate voice. And I could see that
those two seemed indeed to hit it off very well & later I learned
they had been together in the camp of Borgia at Sinagaglia when
those captains were strangled. Then Master Lionardo said that he
had another plan which was to put sappers under the walls & the
Captain said: "We have tried that but the Pisans always discover
what we are up to before our sappers can proceed very far."

At which a curious expression crossed Lionardo's face and he
said: "How do they discover it?"

"Just outside the walls," said the Captain, "they have set huge
flat pans of water so that the slightest movement of our sappers un-
derground sets the water trembling in the pans."

Master Lionardo smiled. "They must have learned that from their
orators at Milano for it is a device which I invented for the Moor.
But every weapon has a counter-weapon and I have means of cir-
cumventing that, whereby we may dig beneath their fortifications
and they will know nothing about it. And I have also devised an
armored car in which our soldiers can ride like a juggernaut into the
midst of their infantry and scatter confusion in their ranks."

So he went on detailing his plans & he irritated me by the cer-
tainty with which he spoke all this, never once acknowledging my
presence although I am sure he saw Narro & me now at the fringes
of the company. And I thought that Master Lionardo spoke of
military matters with an assurance that might seem vain were it not
that I knew he was a man of doubts. And this is evidenced by
the trail of incompleted works he abandoned so that it was common-
place talk in the guild. There was the great equestrian figure in clay
he had made for the Sforza and failed to cast until the figure was
destroyed by French archers who used it as a target. And there was
a fantastic Adoration which rested in his studio & of which he had
only laid in the underpainting in sepia, so that the horses' heads &

heads of men seemed to be floating in a cloud. And there was the cartoon of the Saint Anne which he had not yet painted and for many years now the gossip was that he was doing a portrait of the merchant Gioconda's wife. He was indeed, for all the assurance with which he spoke of military affairs, of a procrastinating turn, & yet he charmed everyone with his dolce parlar so that I felt like a boor in his presence.

The last time I saw him before that encounter at the camp, was in this very guild hall & he was listening to an apprentice who was praising his master the Perugian (who is sleeping there with his mouth open) and the apprentice had a troubled frown on his face: "If only I could work with his swiftness and assurance. But I cannot. I always have doubts of what I do."

At which Lionardo laid his hand on the boy's shoulder and said calmly: "Good."

"Howso good?" the apprentice said, looking perplexed.

"A painter who has no doubts will have small success."

But then, to my surprise, he used this argument (with which I was in accord) to support the use of oil painting instead of tempera. Because, said Lionardo, the former permits of endless retouching and hence is more suitable to a man who is never satisfied with his work. And this seemed to me a specious argument for while it opened an avenue here by way of correction, it made it possible for any bungler to achieve a work or two by sheer trial and error & it was too soft a means, thus dispensing with the sure nature that must have compasses in the eyes & strike clean and true in the hard rock. But surely oil was made for such an eternal procrastinator as he was.

Yet, at the camp, talking of military affairs, he seemed to have no doubts at all. Then, having delivered his opinion, da Vinci took his leave, riding off on an ashblond mare, accompanied by two assistants in embroidered cloaks and orange stockings & plumes wagging in their caps. And as he passed me, he nodded for the first time.

So all these things crowd my mind while Master Lionardo speaks and though he says very little, everyone attends deeply to him as if he were the King of France or the Holy Father for the authority that is in his very presence & Lionardo is saying now . . . *should be under the Loggia where Giuliano recommended, against the low wall which may be fitted up with suitable ornaments, and being there it will not disrupt the order of ceremonies.* And I am angry at his saying this though I had not been angry when San Gallo had said exactly the same & been the first to say it. But it is always the bland assurance in Lionardo's manner that raises my hackles. So

that Master takes his place and sits stroking his long beard with slow graceful gestures as if he were stroking the back of a silky cat the while he surveys with his peculiar piercing blue eyes which have the icy brilliance of sapphires, the speaker who has just risen.

And this is Salvestro the Jeweler, a tiny fellow, in bright yellow jerkin with dark brown laces & he is lively, with a pipsqueak voice like a wood turner's lathe, and small fingers most apt for his craft. And for the first time in all the afternoon's discourse I hear words that go straight to my heart & I love this simple little man for it. For Salvestro says: *All the places have been spoken for and taken* (everybody laughs) *but it does seem to me that he who has made this statue is best qualified to select the best place where to put it. My own preference is somewhere around the Palazzo dei Signori. Nevertheless, as I have said, he who made it knows better than anyone else where to set this Giant and the effect of the air upon it and how best it would look.* So he sits down with the same alacrity with which he had risen & spoken and I think to myself: Salvestro, caro mio, you have more wisdom than a wizard & your simplicity is deeper than a sage's.

Now, to my pleasure Salvestro's recommendation is warmly seconded by Master Filippino Lippi though it is difficult to make out his words amidst the fit of coughing. And after him a dozen others in turn stand up & support the notions already put forth, or even put forth new ones, such as Gallieno the Embroiderer who thinks my David should be set on an ornamented pedestal where the Marzocca now stands, & others who say their say are David Ghirlandaio, brother of my old master, and Antonio the woodworker from San Gallo and Michelangiolo the goldsmith and Gaspare another goldsmith who pleases me by the terseness & directness of his speech though I do not agree with what he says.

And amongst those who support San Gallo's suggestion of the Loggia is Giovanni Cornuole who makes so much to-do about the precarious condition of the marble that you would think he has spent his life in carving large works in stone when the truth of the matter is that he is only a craftsman of medallions. His very name came about because of the fine likeness of Fra Girolamo he carved in a carnelian & from that time on he was called Giovanni the Carnelian-Maker. For it is indeed a curious penchant our Florentines have, never to call a man by his true name but to give him another so that he can never be freed of it & in time the soubriquet goes down to the sons until they in turn have been dubbed with

another. So I am amused at this carnelian-maker's concern in a mat-
ter of which he knows nothing.

Then rises up a tall thin man whose red eyebrows curve upward
& dance in little flames as he speaks and his name is Giovanni
Cellini, the piper, & I know him well for he is one of my father
Lodovico's cronies at the Dragon. He is a silversmith by craft & so a
member of our Guild & entitled to speak at this meeting, but his
greatest joy is blowing his fife in the municipal band, & when he is
not doing that, he sits around the inn with my father Lodovico and
speaks much about his four-year-old son Benvenuto & how some day
he will make a great musician of that lad & not merely a stonecutter
or a woodworker or a paintdabber or a silversmith. For this man
thinks music is the greater art even though its shapes are like the
shapes of clouds & of short duration, fading away even as they are
born. But to Giovanni this is of little matter since his soul swoons
at the merest tinkling of a lute or of a harp or the warm magical
interweaving of many viols or voices in a madrigal or the liveliness of
a caccia. And so he speaks now in a great tangle of words & the up-
shot of what this flutist has to say is that we should take into account
what everybody says & that we should note the consensus
and that he would second Giuliano da San Gallo's option for
the Loggia did everyone else see it that way but since everyone else
does not, we must take their ideas into account also & consider the
state of the atmosphere, the durability or porousness of the stone,
the order of ceremonies, the danger of rogues who would try to
damage the Giant if it is set in dark corners, etc., etc. And finally
after all this rigmarole he opts for the courtyard of the Palace as a
spot that would do great honor to me & provide the Giant with
protection against scoundrels who might want to take a crowbar to
it.

Now I am getting weary of all this talk, when Piero di Cosimo spits
out his last glob of spittle & remarks that though he would like to
agree with San Gallo the important thing is that I, the maker of the
Giant, be satisfied and he cries out *Enough of this discussion!
Let us vote upon the various proposals,* at which my friend Francesco
Granacci seconds *Sì! Sì!* And young Andrea the Tailor's Son also
cries accord though being but a journeyman he has no voice in this
Council. And now the babble is so great that Master Perugino
wakes from his snooze & inquires what the uproar is all about. The
urns are set upon the long oak table & the black and white balls
placed in trays and one by one these masters rise & go to the table

& drop their preference in the appropriate urn. And when the vote is counted I am gratified that there are most stones in that urn which would refer the choice of location to me. So I stand up now & say a few words of gratitude to that company, thanking them for their decision though I have to bite my tongue. For all through the chattering afternoon, the thought has been with me that these men, even my friends, know nothing of my stone, for none but I have lived with it, probed it, scratched it, and torn my vision out of it as a woman tears herself to give birth and bleeds as Donna Barta bled. So when they ask me what is my choice of location, I pause a moment to make it seem I am reflecting when the truth is I had decided from the beginning. And then I turn to the First Herald to give him pleasure, & I say where I want my Giant to stand. But I do not tell them that I want it to stand there because that was where Andrea del Medigo had posed for me so long ago, his hand on his shoulder, gazing at the swallows swooping in and out of the arches of the Loggia, there on the right side of the Palace door where the Judith now stands.

And so it was decided.

XVIII

Among the forty men who helped convey the Giant to its designated place were Michel's brothers: Narro and Gismondo and Fra Lionardo. In the cool of the May evening—for the crew waited till the sun went down before beginning the heavy work—the three Buonarrotis took their places with the other men hired by Il Cronaca who was in charge of the transportation of the Colossus.

When his brothers had volunteered to join the work gang, Michel was deeply touched. It was a backbreaking task, passing those rollers from hand to hand, and that his brothers—even the monk—should want to participate in it was evidence of family pride in him, a pride which Michelangiolo sometimes bitterly thought referred only to his earning powers. But now they insisted on soiling their hands, even old Lodovico would have pitched in had Michel not forbidden

it, and when the day came all the Buonarrotis were there, rallied, to witness this thing: a triumphant procession of his David across the heart of Fiorenza, from the workshop near the Cathedral to the Piazza of the Signory. Donna Barta had also come to see, smilingly watching, her strong arms folded, next to Lodovico in the throng. Michel only regretted that madcap Gian was not home to share in his triumph.

In the afternoon they had dismantled the shed and built a framework of heavy beams around the Giant. A big crowd pressed into the courtyard and watched the men as they attached, under Il Cronaca's supervision, a complicated webbing of ropes and pulleys around the Giant's thorax and legs. Then, like mariners hauling a heavy sail, with concerted groans and shouts they hoisted the statue from the ground and suspended it from the enormous beams of the cart. Michel trembled. Santa Maria! Would it hold? The crossbeams creaked. But Il Cronaca had done his work well. The framework held, the ropes were tightened but not too much so that there would be a safe margin of sway as the cart jolted through rough-paved streets.

Now the laborious job began. The men sang and shouted and groaned. As the cart screeched forward across the courtyard, the logs had to be extracted from the back of the carriage and hastily conveyed to the front to provide a continuous path of rollers. But when the men reached the gate they found that it was necessary to break the wall over the door in order to pass the Giant through. The Avemaria bells of Giotto's tower were ringing as they got David out; the sky over the west was streaked with gold and hyacinth. And then the bells of all Fiorenza chimed in one after the other in harmonious anarchy. Bells and shouts and crunch of rollers and squeaking of swallows racing round the flowered campanile.

That first night they did not roll the Giant very far, reaching only to the corner of the Street of the Proconsul. By that time the men were exhausted; their faces sweat-glistening. They were not familiar with this work, and many had bruised their fingers in snatching the heavy rollers from beneath the carriage as it was pushed laboriously through narrow streets. So now, they broke off for wine and talk, departing down dark alleys to the bobbing of lanterns. The Giant was left at the corner in charge of two guards.

Although the transportation was not due to re-commence until late the next afternoon, Michel arrived at the scene early in the morning. He was met by a couple of redfaced arm-waving young men.

"Maestro! Maestro! It is a good thing we were posted to keep watch!"

"Why? Is anything amiss?"

"You say it, Rodolfo."

"Well, along toward midnight, a gang of boys—we couldn't see them clearly but we think they were boys—came from behind the apse of the Duomo and when they saw the Giant they shouted maledictions and threw stones at it. Then, when Mario and I shouted, they ran off and we dared not follow for fear of leaving the Giant without any protection."

Michel did not wait for the end of the story. He was already climbing up the carriage and scrambling in and out of the rigging to see whether any harm had been done. His face was black with anger, his heart was pounding. But to his great relief, he found nothing smashed, not even a scratch. Either the stones had missed their mark, or they had been mere pebbles. He trembled at the thought of what a heavy rock might have done to his Hand.

"Grazie. You are good lads," he said to Mario and Rodolfo. He breathed heavily; his voice was quivering. "Bravi ragazzi. If I were David I would compose a psalm in your praise. As it is, I can only say, Thanks a thousand times."

"My only regret is we didn't lay our hands on those scoundrels!" Rodolfo growled. He was a sallow frail young man who was trying now to sound fierce.

"But why should anyone wish to harm it?" Mario said.

Michel shrugged his shoulders. He was too shaken to try to explain. And he didn't know himself.

"Ah, mascalzoni . . . knaves . . ." Rodolfo said. "If only we'd have knocked a couple of heads together."

"Perhaps it was just too much wine," Mario said.

Michel went home. A gimlet was boring through his skull. His headache raged all through the work of the second evening when they managed to roll the Giant just past the Bargello. But this second night a dozen brawny men—Gismondo among them—were posted as guards.

Yet, Michel could not get the thing out of his head. Who could it have been? he wondered. Who would want to disfigure this beautiful powerful shape he had wrought into being after two and one half years of labor? Why? Why should anyone do it? The gangs of Compagnacci who had vilified the followers of Savonarola were long since dispersed. Under the permanent Gonfaloniere Soderini there were no such gangs and there was no more fighting

in the streets. Fiorenza was a peaceful city. And yet, Michel knew, these townsmen of his were incapable of maintaining the peace very long. Contention ran in their veins. Had they not exiled the giant Dante and never received him home? Had they not hung the giant Friar and cast his ashes in the Arno? Was it memory or premonition that had made him shudder so terribly, that instant Cronaca cried *Ho!* and David was hauled aloft? The white statue? The white-tunicked monk?

Then a wayward thought came . . . Perhaps some followers of a rival artist, jealous for their Master's fame and fearful that this work would outdo any works of his . . . Perhaps da Vinci's . . . ? But almost as swiftly as it came, Michel dismissed the accusation. No, unworthy, he thought, wincing to his own lash. Master Lionardo was not a man of factions. He was not of a jealous temperament. He seemed indeed too quietly convinced of his own powers to shout about them. Besides, he always praised Michel's work although the manner of his praise seemed somewhat reserved. And for all the sweetness of his friendships, he was a recluse. It was doubtful that the gentle young men of his entourage would have committed such an outrage.

All that night Michel lay tossing in bed, still angry and puzzled. Those who had hurled the stones, he concluded, were simply motivated by sheer hatred of a Giant, at the mere conception of a Giant. They had walked down too many narrow streets under too many skies constricted by black eaves; they had brushed too often against each other's shoulders—and then, suddenly, there it was: a white Hero, pure and towering above their heads, and they hated him because he was too tall and intolerably beautiful. And like cowardly Philistines, out of the darkness, they flung their little stones. And fled.

On the fourth day David reached the Piazza. It was the twelfth hour when he came; the men had toiled all night to the light of torches. Dawn was breaking when the Giant in his aerial cage rolled into the great space. The sky was a pavilion of cloth-of-gold over Arnolfo's soaring tower and the matin bells were ringing. And this was on the eighteenth of May, fifteen hundred and four. Five days later, on the sixth anniversary of Savonarola's martyrdom, once more Michel accompanied his brother, the friar, to cast lilies on the sacred spot. With the two Buonarrotis came Fra Bartolommeo and as they walked along, Bartolommeo told Michel that he was sorely tempted to pick up his brush again. What did Michel think of this painting

in oils? Was it not a fine means for achieving more subtle grada-
tions of light? . . . A third monk strode beside the others: a cross-
bow of a man, a tensile containment. Fra Benedetto had been re-
leased from jail after his long travail. But his eyes were shining, his
step firm, his vital energy had flowed back with a rush, and he looked
like a man who could still handle a dagger, if need be, more ade-
quately than was fitting for a monk.

Everyone who came to the Piazza this May morning of commemo-
ration saw the White Boy. He was still suspended in his cage of
ropes at the foot of the ringhiera. Several weeks would be required
to get the huge statue up onto the platform beside the palace door
where the Judith was still standing.

As he cast his lilies Michel was not thinking of Savonarola. He was
thinking of his David in that public place, he was thinking of the
stone which had lain for aeons in the black earth and which he had
shaped into this image now hanging in the unfamiliar air. He saw
the amazed expressions on the faces of the farmers as they rode into
the square; he joyed in the astonishment—the awed up-staring si-
lence—with which the celebrants greeted his work. It was there,
publicly speaking, it was *his* voice speaking in the timeless eloquence
of art; and day after day, year after year, in rain and snow, in burn-
ing sun and the nine winds, it would speak to all who came into
this Piazza.

His long throes were over. He had achieved his point of balance.
Between Bacchus and Madonna had risen this Giant David: man
of piety and passion, an upright man, neither limp in death nor
tipsy in life, an eternal youth proud and fierce and melancholy with
the knowledge of the necessity—and nullity—of action.

And what was most strange was that it was he himself, Michel-
angiolo Buonarroti, short-limbed, broken-nosed, fawn-eared, it was he
himself who would stand there gigantically forever in the square.

Himself imaged in that shapely marmoreal man.

XIX

In 1482 when Lionardo da Vinci was scarcely thirty years old, he
had sent a modest employment letter containing a résumé of his
talents to Ludovico Il Moro, of Milano:

*Having, most Illustrious Lord, considered and observed carefully for
some time now the proofs of all those who deem themselves Masters
and inventors of instruments of war, and noting that the invention
and operation of the said instruments are in no wise diverse from
those in common use, I am taking this opportunity, without derogat-
ing from anyone else, to make myself known to Your Excellency,
opening up to you my secrets, and offering to demonstrate effectually
at any time suitable to your pleasure the matters succinctly listed
below:*

*1. I have methods for constructing the lightest, strongest and most
portable bridges, suitable for the pursuit and, if necessary, escape from
the enemy. I also have plans whereby one may simply and easily set
up and dismantle other bridges, secure and indestructible by fire and
battery. And methods of burning and destroying those of the enemy.*

*2. In cases of siege, I know ways of draining the waters from moats
and to make many bridges and mantelets and scaling ladders and
other instruments pertinent to the said campaign.*

*3. Item, if it is not possible to use bombards against a site because
of the strength of the terrain or the height of the banks, I have means
of reducing every fortress or other stronghold, unless it be built upon
rock.*

*4. I have other plans for easily portable and most convenient bom-
bards, with which a hailstorm of small stones might be hurled, the
dust of this bombardment inculcating terror and confusion and great
damage to the enemy.*

*5. Item, I have means of stealthily approaching any designated
place through caverns and secret twisting passages, constructed with-
out any noise even when it may be necessary to pass under moats or
streams.*

*6. Item, I can make armored cars, safe and unassailable, with
which one may enter into the midst of the enemy's artillery, and
smash no matter what concentration of men-at-arms. And behind
these armored cars, infantry may follow, safe and without any im-
pediment.*

7. *Item, should the need arise, I will make bombards, mortars, and light ordnance of most beautiful and useful design, quite unlike anything now in common use.*

8. *In cases when it is not possible to employ bombards, I will provide catapults, mangonels, trabocchi and other instruments of marvelous efficacy not to be seen elsewhere. In short, according to the variety of circumstances, I will contrive an infinite number of various weapons both for offense and defense.*

9. *And in cases of sea warfare, I have devices for constructing many machines most suitable for either offensive or defensive purposes, and ships able to withstand the fire of the heaviest bombards and powder and smoke.*

10. *In time of peace, I believe that I can give you as complete satisfaction as anyone else in the fields of architecture, constructing edifices both public and private, and in conducting water from one place to another.*

Item, I will execute sculpture in marble, bronze and clay, similarly in painting, beyond compare with anyone else no matter who that may be.

Also, I would create the bronze horse which shall redound to the immortal glory and eternal honor of Your Lordship's father, of happy memory, and of the illustrious house of the Sforza.

And if any of the aforementioned works should seem impossible and impracticable to anyone, I am prepared to perform experiments in your park, or whatever place should be convenient to Your Excellency, to whom I commend myself with all possible humility.

In 1504, being then twenty-nine years old, and having completed, or in progress, a David in Carrara marble, more than fourteen feet high, a life-sized Pietà, a Bacchus, three low reliefs in stone of the Madonna and Child, another Madonna and Child commissioned by some merchants in Flanders, a roughed-in block of St. Matthew, a faun with broken teeth, a Centauromachia, a Samson that had become a Hercules, a panel of the Deposition, a life-sized David to be cast in bronze, as well as several hundred sketches in ink, chalk and bistre, and a Cupid, falsely antiqued, now in the possession of Cesare Borgia—having already accomplished or undertaken all this—when asked to design a poignard which his younger brother thought might make an expedient gift to his employer Roberto Strozzi, Michelangiolo replied tartly:

"Questo non è il mio mestiere."

"That is not my craft."

Narro was to hear the same reply again when he told his irascible brother of Messer Doni's request. Narro and Gismondo had met that hot August afternoon at the tabernacle of the Virgin opposite the column of the Market, a typically Florentine congruence of piety and profits. They both had business at the Doni Palace: one to deliver a bale of wool, the other a sack of flour. And while there, in connection with the forthcoming wedding of Agnolo Doni, the young men were to take orders for their respective masters.

They pushed their way through the bristling market, passed many busy shops of all kinds, crossed the Calimala and the Piazza of the Orto San Michele, walked by the palace of the Art of Wool with its stone emblem of a lamb above the doorway, past the banks, the silk merchants, and through a winding series of alleys until they were disgorged back of the Palace of the Signory and so across to the Street of the Dyers where the massive brown-grim palace of the Doni stood.

Already, in preparation for the wedding, the street in front of the palace was taking on a new aspect. Blue awnings were being stretched across it; long wooden tables were placed out in the open along the building, tapestries and festoons adorned the austere rustico façade, merchants of all kinds were coming and going with donkey- and oxcarts laden with gabbling geese, casks of wine, quartered bullocks, sweetmeats, figs, buffalo cheese, capons, turkeys, and silver minnows from the Arno. A company of musicians were practicing in the courtyard: the tinkling of lutes and mandolins and the penetrating tootling of fifes mingled with the sacrificial cries of poultry, the shouts of tradesmen, the jingle of belled white oxen and donkey haws. Tailors were running in and out of the huge arched portone with needles in their mouths and cloths over their shoulders.

As the two young men completed their business, they saw a familiar figure directing a group of workmen who were stringing festoons of purple and gold from the great iron-bound door to a portable stage that had been set up in a loggia across the street. It was a blazing August afternoon; Granacci had taken off his embroidered jerkin; he was bare to the chest, slender but strong-looking.

"Salute!" he greeted the two Buonarrotis. He rubbed the sweat off his hairless chest with a silk handkerchief. "Porcamiseria, what weather! How does that cold-blooded brother of yours bear up under it?"

"He growls."

"When does he not?"

"When he sleeps."

"He growls even when he sleeps," said Narro. "I have seen him gnashing his teeth and frowning and his fingers twitching."

"Fighting with the stone," Granacci said. "That's your brother's way. He always fights. There's a terribilità about Michel. Frightens people. This morning— Ho! Not that way!" he shouted at a workman who was moving a piece of painted scenery into place on the improvised stage. Granacci darted across the street and instructed the workman where to fit the piece in. The set showed a tiny piazza with a fountain in the center. Francesco had painted it in black on white paper stretched on frames, a gay spray of lines. He returned to the brothers: ". . . What was I saying? Ah, yes, if it weren't for Michel's manners there would be a nice commission for him right here. Messer Doni asked me this morning whether as Michelangiolo's friend I might not convince him to paint a tondo of the Holy Family which Messer Doni would like to present to his bride as a wedding present."

That night at dinner Narro told his brother.

"Questo non è il mio mestiere."

"He'll pay you well for it."

"Messer Doni is an important citizen," Lodovico said, with just a trace of beseechment.

"Did you say Francesco has the contract for the festive decorations?"

"Yes."

"Well then, why not have him paint the tondo?"

"Sì, but Messer Doni explicitly wanted you."

"I am not a painter."

He was a sculptor, that was all. Everything else—if he sketched or painted—was preparation for the stone. For the stone. Not bronze if he could help it. Direct carving. Direct attack. He cared little for casting. Casting was for goldsmiths.

He was a sculptor and the Giant had spread his fame all over the land and he could not cope with the requests that were pouring in. For Messer Pitti he was carving a round low relief of the Madonna and Bambino, a plump-cheeked child playfully interrupting his mother's reading by leaning his elbow on the book. For Messer Taddei he was making a similar work. Now and again, he felt a twinge of conscience and ran off to cast a shamed supervisory eye at the monstrosities still being carved in his name for the Piccolomini altar at Siena.

In a fit of April audacity he had signed a contract for twelve statues of the Apostles, seven feet high, to be delivered one each year to the Art of Wool and the Supervisors of the Cathedral Works. Giuliano da San Gallo was among those who stood witness for him, and Michel thought it was a good omen that the name Gallo should figure again in one of his contracts, although the Florentine architect and the Roman banker were in no way related. In connection with this contract, a studio-house was being built for him at the corner of Borgo Pinti and Montislori. Il Cronaca, as Caput Magister of the Cathedral Works, designed the house for him. Michel was so pleased that he set to work furiously on a bigger-than-life-sized Saint Matthew which he had already blocked out, rough, contorted, struggling into birth. But he had to leave it in those throes and pass on to other obligations.

The bronze David had not yet been sent off to France; he had dallied so long that Monsieur Pierre de Rohan, the original Marshal for whom it had been intended, had fallen from favor. Now Messer Niccolò was busily sounding out the Florentine ambassadors for the name of another Frenchman to whom it might be politically useful to make this gift.

Thus far had the ripples of his fame reached. Not only to France. Flanders also wanted a work by his hand. Messer Lorenzo di Pierfrancesco de' Medici received a letter from the Bruges branch of the Medici bank: some Flemish merchants had heard of Michel's fame, they wanted a marble group of the Madonna and Child, they would pay well. And so, despite the mountain already on his shoulders, he accepted this new commission. He accepted everything. He had no bottega, he used no assistants except for casting. He was twenty-nine years old, at floodtide. He had extracted a Giant from an impossibly narrow, imperfect block; he had raised a Lazarus from the dead. He could do anything.

And so, against his deepest instincts, he would agree now and again to fulfill commissions which gratified only his turbulent competitive ego or would bring him favor in high places. He was not a painter, no. But now he would outdo any other painter in Fiorenza. He agreed to make the wedding gift for Messer Doni. Amidst all his other tasks this burning summer he found time to lay in the underpainting of the Holy Family.

When Narro saw it he was astonished.

"Why, that is my own Barta!" he exclaimed with great pleasure. "And that San Giuseppe is our own Lodovico to the puff under his eye! And the Bambino is *our* bambino!"

He embraced his brother. Michel drew away and gazed at the redfaced Narro: "What nonsense are you saying? I make no likenesses . . ."

But he had. Perhaps unwittingly. For this Madonna was indeed an angular peasant girl with Barta's air of good-humored strength and Barta's muscular arms, the arms of a reaper. And the other actors in this sacred drama were indeed his father and his nephew. St. Joseph had a shorter beard than Father, but it was Lodovico all right. He was hovering behind the baby exactly as Lodovico always did. And the Bambino had been lifted onto his mother's shoulder as Barta liked to raise him against Lodovico's worried protests: the baby had one chubby foot resting on the bicep of his mother's right arm, and he was gripping her hair with those tendrilly tiny fingers whose strength always astonished Michel. It was an audacious composition: arms, legs, draperies interwoven in an intricate round: he had resolved to outdo Master Lionardo's Virgin and Saint Anne, but Narro didn't know that. He saw only the Buonarrotis in it.

There was one element in the picture, however, that puzzled Narro. Lounging in the background, behind the baby Baptist, were five naked ephebes. What had they to do with Christian story? They had come unbidden into Michel's mind, although he may have been unconsciously echoing a similar theme of naked Greek youths in a Holy Family—also a tondo—painted for the Magnificent Lorenzo by Master Luca Signorelli. Michel had often seen that work in the Medici Palace. But whether from Master Luca's round picture or from more mysterious realms, the youths had simply appeared and it had pleased him to model those warm flanks and rounded bellies and arms. Their faces did not interest him. He left them vague: one was practically concealed behind Joseph's shoulder.

So, in the blaze of August, he continued to work, now on the Doni tondo, now on the stone reliefs for Messers Pitti and Taddei, now on the Madonna for the merchants of Bruges. Always there was a Madonna and Child in his thoughts and under his hand, and the Madonna was always young and beautiful but unapproachable, remote in some dream of stellar space, while the bulging-browed, chubby-cheeked Bambino played, his thighs and belly delicious earth, his lower lip stubbornly projecting a little, like Michel's.

Sometimes, oppressed by the multitude of these tasks, he would, like a miner weary of quarrying, lean back against his heap of stones and dream in the heart of the mountain. Then it was he would read Petrarca or his beloved Dante and try his hand at sonnets and

madrigals of his own contriving, addressing cloud-wreathed loves,
vague and distant as his Madonnas:

> *Come può esser ch'io non sia più mio?*
> *O Dio, O Dio, O Dio!*
> *Chi m'ha tolto a me stesso,*
> *Ch'a me fusse più presso*
> *O più di me potesse, che poss'io?*
> *O Dio, O Dio, O Dio!*

> *Why am I no more master of myself?*
> *O God, O God, O God!*
> *Who has wrenched me from myself? . . .*

He did not know whence the anguish came. But unaccountably it
came in these gloomy valleys between the peaks of creation. And it
was an anguish that demanded words harsh as chisel strokes. He
told no one of this secret poeticizing. He hid it like a vice. He was
not proud of it. But, at certain moments, he could not contain it
any more than the earth could contain hot springs.

Often, weary, he walked the Arno banks. The river was a mere
trickle; the clay dredgers were working directly in the bed of the
stream instead of straining against the long flexible shovels from
their boats.

One day he was summoned to the Gonfaloniere's office. What
did Soderini want? Michel wondered. He was a member of the
Operai of the Duomo. Was he going to reprove him for his laxness
with regard to the bronze David? Why, if need be, Michel could
finish the figure in a few weeks. He was doing it in clay so that
Montelupo might cast it. Perhaps that was why he delayed it so.
He hated to work in clay. Or perhaps he was simply weary of Davids.
Now it was the image of the girl-Madonna that seized him.

Soderini was cordial. Circuitous as a fox, he led the conversation
around to the subject on his mind. Would Maestro Michelangiolo
consider a commission to paint al fresco the long wall of the Sala del
Cinquecento? One wall only, of course. As Messer Buonarroti
undoubtedly knows, the commission for the other wall had already
been assigned last summer. Soderini was a wise man: he knew his
Michelangiolo.

"I realize, of course, Maestro, that you are overburdened with
tasks. And of course painting is not exactly your profession . . ."

The impassive face, pink, clean-shaven, illusively soft, watched the
gleam flash in Michel's gold-flecked gray eyes.

". . . but unfortunately we have very few—if any—artists—that is,

those that may be considered strictly *painters*—who could provide a worthy match to the masterpiece which Master Lionardo is preparing for the other wall. . . . Of course, you've seen his cartoon?"

"No."

"That is strange. All of Fiorenza is running to the Sala del Papa to see it."

"I have been busy."

The Gonfaloniere glanced oddly at the sculptor, then went on:

"You know, at any rate, that he is doing a cavalry charge? The Battle of Anghiari. Quite fantastic. The horses seem to plunge right off the paper sheets. Their nostrils flare, their teeth champ, you can hear the beat of their hooves. Truly astonishing. As soon as it's pocked onto the wall, Maestro Lionardo plans to lay in his colors by a method unknown to us but which he claims to have discovered in Pliny. Encaustic, he calls it. Perhaps an astrological term. I don't know. Something to do with mixing pigments with wax and then applying heat to them so that they remain glazed onto the wall. Da Vinci avers that by this method his pictures will last as long as Egyptian tomb paintings . . . An amazing man, Master Lionardo, don't you think? . . . Of course, you may paint *your* picture as you please. You needn't try to emulate what *he* is doing . . . The subject? . . . Anything you choose just so long as it be a scene from Florentine history . . . We of the Signory may have a few suggestions. But the ultimate decision is yours. We stipulate only that it be by your hand . . ."

Michel grumbled. He wanted a week or two to consider. He had so much to do. And yet, his first impulse had been to cry *Yes*. To be pitted against the Magician! Sì! Sì! Had he not succeeded with the block which Master Lionardo had so blandly refused? And yet that did not seem to trouble da Vinci. Shortly after the David had been set in place, Michel came to the guild hall and found the silky-bearded man there, surrounded by his usual coterie of admiring youths. His resonant voice flowed in melodious argument; the young men's heads nodded, they seemed enchanted as if they listened to music.

Master Lionardo was expounding on the superiority of his art—painting—over Michel's art—sculpture. Was it not more pleasant to sit down before one's easel in a clean frock? Lionardo was saying with a misty smile. And was not sculpture a less intellectual art inasmuch as it is dependent upon lights from above instead of creating its own light? . . . Nor could it render the varied hues of Nature. Nor could it create effects of aerial perspective. Nor could it rep-

resent luminous or transparent bodies or clear or cloudy weather or the infinite sfumatura of the atmosphere. Nor could sculpture be adjudged more noble—he stroked the beard, anticipating a challenge which had not been uttered—simply because a mistake in the stone could not be corrected. For surely it was even more difficult to correct—and here the Magician turned directly to him and smiled (or had Michel imagined it?)—more difficult to correct the mind of the master guilty of such errors than correct the work he had spoiled.

Michel flushed. But he could not dispute with the man. He was older and wiser: a philosopher of nature, not an artisan. Besides, he was not aiming shafts at Michel. He was never personal: his sole target was the truth.

The audience broke from its spell, awaiting rejoinder. But Michel stomped out of the guild hall. Word monger, he spluttered to himself.

The evening after Soderini's offer, Michel was strolling along the river bank in company with Sandro Botticelli. Approaching the parapet of Ponte Santa Trinità, he saw the familiar figure, tall with an inward tallness, golden in the sunset. The usual circle of adulatory youths were listening to the painter. As he spoke, he was combing his sensitive fingers through his beard. When Michel approached, he said loudly in a friendly voice: "Ah, what good fortune, amici miei. Here is Master Michelangiolo. Let us ask his opinion on the verses. He is said to be a fine reader of our Poet."

He recited the verses of Dante whose meaning they were attempting to unravel, but before he could speak less than a tercet, Michel cried: "Why do you not complete the exposition yourself, Signor Master of Abandonment, you who complete nothing, neither horses in bronze nor pictures in oil! . . ."

Botticelli was shocked. He exchanged a swift glance of sympathy with Lionardo, who seemed to have frozen with the unexpectedness of the attack, then he ran after his friend who was hurrying along the embankment, a dour hunched silhouette against the westering sun. Michel was panting heavily; he was as shocked at his own rage as the others had been. He had been seized by a demon and now he felt ashamed.

"Perbacco," Sandro said perplexedly, "why did you behave in such an unseemly fashion?"

"He was being sarcastic at my expense!"

"He was not being sarcastic. I have heard him many times express his admiration for your knowledge of the Poet."

"He— He—" No, he could not explain. He could not explain it to

himself. The man made him feel like a child, that was it, he was always too young in that eternal bland presence. Da Vinci was too cursedly sure of himself. Did he know what it was to struggle? Did headaches harrow his nights as the bore harrowed the marble? He was too impassive. He charmed where Michel had to conquer. Michel knew that his attack on da Vinci's seeming dilatoriness had been unfair. He knew that if he abandoned a work, it was not because of inability to finish it; it was rather that once having grasped the principle, the working out of its consequences held little interest for that curious probing mind.

For a week Michel thought about Soderini's offer. Oh, it was tempting to match his hand against Lionardo's. And then one evening another Lionardo told a story which pulled the trigger on Michel's already cocked decision.

Fra Lionardo had gone to take confession of one of his communicants—a lady whose spiritual adviser he had become since the spring. But he had mistaken the hour; he was ushered into the lady's chamber when she was posing for her portrait. He apologized but lingered, fascinated by what he saw. Madonna Lisa was the young wife of the merchant Zenobi del Gioconda. She was a Neapolitan, plump as a pigeon, with high plucked forehead, naked brows, narrow eyes pressed deeply above pudgy cheeks, and dimpled hands. Her chief attraction was a furtive little smile which teased one out of mind and promised a profundity which the simple lady did not possess.

Fra Lionardo was a good priest. If the secret of Madonna Lisa's sad smile had ever been divulged to him in confessional, it remained inviolate. But he did speak to his brother of what he had seen this afternoon when the good lady was having her portrait painted.

Madonna Lisa was amply swathed in a long gown of rich dark green velvet with a gathered bodice, cut low across her full bosom. Her dark slightly wavy hair depended loosely from beneath a thin veil and fell to her naked shoulders. It was a costume designed to enfold her particular charms in a kind of cloud of rich, yet restrained elegance.

The Master was dressed quite as elegantly as his sitter. Lionardo wore a purple silk blouse softly belted at the waist, his cuffs were foams of lace—

"Vergogna!" Lodovico interrupted with a grumble. "His father, that old puffball of a notary, may God rest his soul, died less than a month ago. Is there no respect left in this Republic? The least his

son might do is wear a simulacrum of mourning . . . a decent black for a while."

Lodovico regretted the notary da Vinci's death. Now what fit opponent remained for him to crow over?

"He wore no black," the friar said scornfully. "He was as particolored as Harlequin and scented as a lady's powder box." He went on to describe the vanities he had seen this afternoon with Savonarolean eyes: the cassia-scented beard, the pointed yellow shoes, the lacquered fingernails. Lionardo worked with a long brush held in scrupulously clean fingers. His eyes were of a bluish brilliance, glinting like pikes.

Near Madonna Lisa, within the deep-set ledge of the casement window, a lutenist plucked plaintive strains of a ballata by Ockeghem of Flanders, singing meanwhile in a piercing sweet tenor voice. The neck of the lute was a horse's head carved in ivory which had been designed by Master Lionardo, who loved to paint always to the accompaniment of music, considering, as he liked to say, that the subtle harmonies might thus insinuate themselves into his work. And he liked also the faint smile that crept like a cat onto the ledges of Madonna's lips when she heard the music . . . or perhaps as soon as the handsome lutenist entered the room.

It was late afternoon when Fra Lionardo came: the light was soft, vague, fading like smoke or the soft music which the painter loved. The lady had been posing a half hour; she sat very still with an air of tender melancholy, a bemused and shadowy charm.

What was she thinking of? the frater wondered. Music tinkled like water drops. Madonna Lisa's fingers rustled in her lap. The light suffused through leaded panes, broke into myriad mosaics of color on the tessellated pavement. The painter was silent. He worked with great care, Fra Lionardo observed, not at all like brother Michel. This man pondered every stroke for the longest while, his brushtip flickering like an insect's antennae. Then he stabbed an imperceptible dab of color on the canvas. He thought a moment more, stroking his beard, then said gently:

"I think that will be all today, my lady. The light fades."

Madonna Lisa rose, and in a cloudy green swirl, walked across to the easel.

"What did you do today?"

"That." He pointed.

The lady peered close to the canvas. She was very near-sighted. She giggled with incongruous childishness.

"It seems *exactly* the same as it was a week ago! . . . Indeed, a year ago. When will you finish this eternal thing?"

Lionardo smiled.

"Almost three years," the lady said petulantly in her high-pitched voice. "Three years on and off—nagging at it. Will the portrait age with me? Are you adding wrinkles with the years? Will you paint streaks of gray into my hair? My husband grows impatient. He considered the portrait completed even before you went off to the Duke's camp."

"Well, we shall see . . ."

Michel listened with mounting irritation. Everything about Master Lionardo seemed a deliberate condemnation of his own way, Michel's way. For Michel's face was, more often than not, smeared with white marble dust so that Gismondo called him "brother miller"; his hands were cracked and dirty; his clothes looked as if he had slept in them for a week—which frequently he had; his cordovan boots were sweaty; and he never combed that scraggly little beard. It was the nature of his profession, he told himself, that made him seem so boorish; but in the deepest recesses, he knew that this was not the reason. If Master Lionardo were to carve stone, he would be sure to do that also to the accompaniment of harps with angelic fingers.

No, it was not a competition of their several arts so much as of their several natures. It was the man's ease contrasted with his intensity; his manner of treating people, insects, waves, light effects, weapons of war, rainbows, siege machines, disease, friars, animals, cadavers with the same detached curiosity: it was his indifference whether his talents were put to the service of Sforza or Borgia or the Florentine Republic.

And so the next day Michel returned to the Palace and said—as Soderini had known all along he would—*Yes*, to the Gonfaloniere's invitation to paint the other wall.

XX

Pietro Soderini had just received from Lisbon a fantastic letter. It came from a school friend of his, son of one of the most prominent Florentine families, the Vespucci. Amerigo Vespucci had served in the Medici bank at Sevilla, where he met the mariner Cristoforo Colombo, and subsequently became a mariner himself.

The letter which the Gonfaloniere was now reading was similar in content to one which Lorenzo di Pierfrancesco de' Medici (no longer Popolano) received about the same time. Modestly, and yet with convincing detail, Vespucci described some isles which he had discovered in the New World. He enclosed several maps.

Soderini was enthralled. What an honor for Fiorenza! Her sons carried not only the light of learning and art throughout Europe; they even pushed beyond the reaches of the known world into that terra incognita beyond the ocean. In his office the Gonfaloniere had a planosphere drawn by the Florentine Rosselli. Letter in hand, he turned to the map now, tracing with an excited finger Vesp.cci's route across the southern sea. He read the missive again. It w.s written in such a friendly tone, recalling the time when Amerigo and Pietro had studied grammar together at San Marco under the Friar Giorgio Antonio Vespucci. And yet it was humble withal, addressing an old school chum with the respectful salutation *Magnifico Domine* due to his rank, so humble indeed 'that the Admiral suggested that his letters be read at the end of a meal, when it was the custom to chew fennel to facilitate digestion.

Obviously, however, the Admiral hoped that his letters would be circulated; else why would he have sent them to Soderini whom he hadn't seen in years, as well as to his former employers, the Popolano branch of the Medici? Soderini understood; Florentine pride could not be hidden under a bushel; he read the letters to the assembled Priors. The enthusiasm was so great that the Signoria unanimously decreed to "send the lights" to the palace of the Vespucci for three nights in a row. It was the highest honor the city could bestow on one of her sons.

Michel happened upon the procession on a golden September evening when he was returning home from his workshop in the Hospital of the Dyers, at Sant' Onofrio. Up until now he had been working on his various projects in the studio on Borgo Pinti, which

had been built for him by Il Cronaca in connection with the Apostles contract. But this studio was entirely too small for this enormous cartoon.

He was tired. All day long he had been supervising and working with a group of youths who were pasting up with flour huge sheets of strong, thick, royal folio paper on a linen backing. They had already put together more than a ream of the sheets but the great strip was not yet as long as the wall for which it was intended.

Michel enjoyed the work—these humble tasks of preparation always pleased him—while his fingers were pleasantly occupied, his brain continued restlessly at work.

He had already made several sketches of the theme he had chosen—an episode from the war with Pisa one hundred and forty years before, when the English mercenary whose equestrian portrait was painted on the Duomo wall, Sir John Hawkwood, had surprised some Florentine soldiers as they were bathing in the Arno. In truth, he was drawing upon those soldiers he had seen when he visited Giansimone at the camp.

He had not wanted to do this thing. But now he was doing it. He had not wanted to do it and he had wanted to. Yes and No.

Vorrei voler, Signor, quel ch'io non voglio.

When he emerged from his studio, the Street of the Dyers was strangely still. They had ceased work before sundown, which was unusual. Only a few late jockeys were carrying their stuffs into the shops. The street was still redolent with that pungent scent of the dyes. The deserted troughs glimmered wetly in the golden light.

He walked along the river. Behind San Friano gate the sun was sinking, an orange ball. Towers were etched brownmauve against striated gold; the river was a quick of aureate runningness over which swallows skimmed and looped. When the vesper bells began to clang, Michel felt an unaccustomed joy. Ahi, but it was good to be alive in this city, his own Fiorenza, good to feel one's powers and one's senses bathed in this golden light. Now a dozen campaniles had taken up the chorus, ringing together and across each other in magnificent anarchy. The light was pure gold and the air was filled with golden fibers of the bells so that you could not tell if you were hearing the light or seeing the sound.

At Ponte Santa Trinità he sat on the parapet dangling his legs like a boy, watching the miraculous sunset. Fishermen lined the bank below: pensive beside the molten stream. He felt filled with slanting rays of an inner light. The river darkened: elusive sensations eeled through the stream of his mind.

Deity, he thought suddenly, is man's responsibility, having created Him.

He shivered, not knowing where the thought came from.

Then he saw the "sending of the lights." They were swinging around Por Santa Maria into Lung' Arno Acciaiolo: hundreds of torches flickering in the violet haze. He sat on the parapet and watched them march by: first the city officials, mounted, the horses in trappings of brocade; then the trumpeters and fifers and tambours amongst whom danced on twinkling feet Master Giovanni Cellini, the piper; then representatives of the most important city families; and finally the captains of the four quarters with their gonfalon flags. Idly, in the gathering dusk, Michel followed the procession as it swung down Lung' Arno Corsini and then turned into the Borgo Ognissanti until it came to a halt in front of the palace of the Vespucci next to the Hospital.

A fanfare of trumpets, a roll of tambours, the torches were lifted high to loud huzzahs and set in the iron sockets projecting from the palace wall, and the speechmaking began. First came Girolamo Benivieni, his speech thick-studded with Latin quotations from Pliny and recondite references to the explorations of the ancients. Then came Soderini, dry and proud and brief; after the florid learning of the humanist, the Gonfaloniere's lack of eloquence was most eloquent. Then a member of the Vespucci family acknowledged the honor done their son.

After a few moments Michel left. It was time for dinner. Marina was very old now; she made no effort to conceal her irritation when any member of the household came late to meals. He would go home and play with baby Lionardo and discover again the unsuspected strength in those tendril-like fingers. Barta would be singing a stornello. Lodovico would be doing his accounts. The house would smell of rosmarino and fryings.

He hastened his steps homeward. Voyages, voyages, he was thinking, the Admiral searches for the other side of the ocean and I for the heart of the stone. All are departing. The Century gone. And the ultimate voyages. Last week Filippino. When I die will all the shops close in my honor as they did for him? Voyages. Two Holy Fathers in one year. And Piero drowned. There is too much death. Giovansimone wants to sail to the Indies. Barta blossoms again. She fashions her figures by night as I by day. Viaggi. Viaggi.

He was entering the Piazza dei Signori from the Street of the Stocking-Makers. Diagonally across the great space, against moon-streaming clouds, the lyrical throat of the tower soared, a stone

flower. The Piazza, pale and flickering under the inconstant moon, was silent as a dream, abandoned, for this was the dinner hour and Florentines, practical folk, did not eat dreams.

Slowly Michel walked toward the Palace of the Priors, watching the whiteness in front of its door grow more distinct with his approaching steps, until he stood at the foot of his Giant, high in the air now on the pedestal Cronaca had erected.

For several moments Michel stood there, alone with his David.

The figure seemed to be quivering in the moonlight, gazing with fierce eyes toward the Arno, sensing some enemy about to emerge from gloomy alleys. And Michel sensed him too, that Enemy— colossus of the commonplace, invisible Philistine—whom he had to slay again and again with his sculptor's bow as David slew him with his sling.

One moment more he stood, frowning up at his frowning boy, then crossed behind the Palace and continued home.

AUTHOR'S NOTE

Surely there is no lack of works on Michelangelo; biographies, art criticism, specialized studies abound: a mountain ready to topple on the head of anyone who enters the field. If I have chosen the novel as my vehicle it is precisely because that form seemed most likely to evoke the only thing lacking in all the Michelangelo studies—the living presence of the man himself.

To achieve the most vivid portraiture and sense of the period, I have tried as much as possible to draw from primary sources only. Three years of residence in Florence and Rome afforded the opportunity for frequent viewing of the Master's works as well as living in places, often little changed from those in which Michelangelo lived and worked. Florence, especially, is a mine of documentation. For many months I quarried happily and gratefully in the State Archives of the Uffizi, and in the Biblioteca Nazionale, the Mediceo-Laurenziana, Marucelliana, Moreniana, and Riccardiana. The Casa Buonarroti, the Berenson Library at I Tatti, and the library of the University of Florence were also of great service. Sources mentioned here necessarily represent only a skimming of all those consulted.

Milanesi's 1875 Florentine edition of the *Lettere di Michelangelo* is still the only collection; the same edition contains artistic contracts and the artist's household accounts.

Michelangelo's poetry is our most revealing evidence, other than the art works themselves, of the artist's state of mind and root-ideas, although the chronology of the poems is very much in dispute. For the English reader the sonnets have been translated—somewhat Swinburne-sweetened—by John Addington Symonds.

Gaye's three volumes, *Carteggi Inediti d'Artisti*, Florence, 1839-40, contain letters to Michelangelo as well as other useful documents bearing on the art life of the Renaissance.

All my quotations from Burchard's Diary are drawn from the *Diarium Romanum* (or *Liber Notarum*), 1483-1506, of Johannes Burcardus, in the complete Latin text edited by L. Thuasne. My account of the entrance of Charles VIII into Florence is based largely

upon a 1584 edition of Nardi's *Le Storie della Città di Firenze*. I have
drawn freely from the same responsible chronicler for Savonarola's
martyrdom, supplementing this with documentation found in Vil-
lari's monumental study and a reading of the Dominican's sermons.

The man of the Renaissance was likely to be articulate no matter
what his other activities might have been. Michelangelo was not the
only artist who wrote sonnets, nor.Cellini the only writer of memoirs,
nor da Vinci of notebooks. It is no accident that the author of
that delightful source-book of manners—the *Cortegiano*—was a pro-
fessional diplomat; and that a Monsignore wrote the most popular
etiquette book of the period—the *Galateo*. Particularly useful for
my purpose were such vivid glimpses into Renaissance life as are
afforded by Luca Landucci's *Diario Fiorentino* (1455-1516), the
Ricordanze of Tribaldo de' Rossi, Vespasiano's *Vite* and Varchi's
Storia Fiorentina.

All biographies of Michelangelo draw from the original font:
Ascanio Condivi's indispensable *Vita di Michelangiolo*, probably
written under the artist's own supervision, published in 1553, and
rewritten as a gossipy gloss in Vasari's second edition of his *Lives*,
1568.

My story of the Corsini dissection was suggested by a passage
in Giovanni Papini's *Michelangiolo*. I also benefited from conver-
sations with Papini in the summer of 1954.

Richest source materials relating to the Renaissance Jews, par-
ticularly in Tuscany, are to be found in Umberto Cassuto's *Gli
Ebrei a Firenze nell' Età del Rinascimento*. The story of Bartolomeo
de Cases is told here, and curious visitors to Florence may still read,
inscribed on the base of the Madonna della Rosa outside Orsan-
michele the following celebration of the event:

HANC FERRO EFFIGIEM PETIIT IVDAEVS ET INDEX
IPSE SVI VVLGO DILANIATVS OBIT
MCCCCLXXXXIII

A TREACHEROUS JEW ASSAILED THIS IMAGE
WITH A SWORD
WHENCE HE DIED, TORN TO PIECES BY THE MULTITUDE
1493

It would be impossible to list my indebtedness to all those who
have written both generalized and specific studies of the Italian
Renaissance. To do so, would mean summarizing two decades of
reading in this field. Many suggestions grew from the stimulating

and genial works of Jacob Burckhardt (the similarity of surnames
with that of the Renaissance Magister Cerimoniarum is accidental),
John Addington Symonds and Gregorovius. Specialized studies such
as della Torre's on Lorenzo's Platonic Academy; del Lungo's on
women of the Renaissance and the fascinating antiquarianism of
Guido Biagi and Giuseppe Conti have all contributed to this
narrative. With regard to Michelangelo and art studies generally,
I have profited richly from Berenson, de Tolnay, Panofsky, Wölf-
flin, Goldscheider, Grimm, Frey, Thode and others, although it is not
the function of the novelist to enter into the battle of attribution.

Inasmuch as the exigencies of fiction and history do not inevitably
coincide I have made several minor departures from traditional
documentation. Thus, Buonarroto's two known visits to his brother
in Rome (1497 and 1500) have, in the interest of unity, been
combined into one. I have taken advantage of the ambiguity of
Michelangelo's flights to keep him present in Florence during the
entrance of the French troops. The Pasquinade on Giambattista
Ferrari actually occurred several years later than I have put it.

All evidence regarding use of models by Michelangelo is internal
and deductive. The fidelity to nature of the huge David and the
youths of the Sistine Ceiling would indicate some life studies were
employed. With regard to Andrea del Sarto I have dramatized a
possibility.

Andrea del Medigo is a fictional figure. Berenson credits several
drawings to an Andrea del Michelangelo about whom nothing else
is known. Elia del Medigo, however, is a historical person and one
of the truly remarkable figures of the Renaissance.

The braccio is equivalent to the cubit or about 18-20 inches.
Goldscheider gives the height of the David (9 braccia according to
the contract) as 14 feet 3 inches, including base.

Renaissance Italians were as footloose in their orthography as were
the Elizabethan English. The artist's name was variously spelled—
Michelangiolo, Michelagnolo, Michelagniolo, Michel Angelo, Michel-
angelo, etc. In the text I have used the accepted Florentine spelling.

I wish to express my thanks to Pietro Aranguren, Director of
the Museo Topografico, for permission to examine old maps of
Florence before the museum was open to the public; to the late
Giovanni Papini, Arturo Loria, and Arturo Jahn Rusconi, former
director of the Museo di San Marco, for many stimulating talks
about a fellow Florentine; to Signor Leo Neppi Modena for kindly
making available valuable material relating to Italian Jewry; to the

Yaddo Foundation, and the New York Public Library; to Margaret R. Scherer, Research Fellow of the Metropolitan Museum of Art; to Leo Gurko, Chairman of the English Department of Hunter College, who helped set my spirit flowing at an icebound moment; and to Garrett Mattingly, Professor of History at Columbia University, for his witty cutting of the Gordian knot between history and fiction.

To Hiram Haydn, especially, my particular gratitude. An initial act of faith on his part precipitated me into the writing of a book which until then had remained in the realm of idea. His generous support and critical interest continued to sustain me throughout the work.

Manufactured in Italy by Parretti, Firenze